BEYOND MEASURE

A Guided Tour Through Nature, Myth, and Number

BEYOND MEASURE

A Guided Tour Through
Nature, Myth, and Number

K&E Series on Knots and Everything — Vol. 28

BEYOND MEASURE

A Guided Tour Through Nature, Myth, and Number

Jay Kappraff

New Jersey Institute of Technology
USA

World Scientific
New Jersey • London • Singapore • Hong Kong

Published by

World Scientific Publishing Co. Pte. Ltd.

5 Toh Tuck Link, Singapore 596224

USA office: Suite 202, 1060 Main Street, River Edge, NJ 07661

UK office: 57 Shelton Street, Covent Garden, London WC2H 9HE

British Library Cataloguing-in-Publication Data
A catalogue record for this book is available from the British Library.

BEYOND MEASURE
A Guided Tour Through Nature, Myth, and Number

ISBN 981-02-4701-X
ISBN 981-02-4702-8 (pbk)

This book is printed on acid-free paper.

Printed in Singapore by World Scientific Printers (S) Pte Ltd

Contents

Introduction

Blessed be you, mighty matter, irresistible march of evolution, reality ever new-born;
You who, by constantly shattering our mental categories,
force us to go ever further and further in our pursuit of the truth.

Blessed be you, universal matter, unmeasurable time, boundless ether;
You who, by overflowing and dissolving our narrow standards
of measurement reveal to us the dimensions of God.

Teihard De Chardin

This book has been written as an antidote to the present-day emphasis on specialization in which knowledge is compartmentalized. Not only are the arts and sciences separated from each other, but even specialists in different scientific disciplines find it difficult to communicate with one another. One consequence of this specialization is that context, passion, and spiritual content are often considered irrelevant. This narrowing of focus has enabled us to probe deeper into ever-narrower areas of study. While this has enabled us to create a world of technological wonders, it has also encouraged us to confuse ends with means. All too often great discoveries are accompanied by costs which outweigh their benefits.

Furthermore, despite successes in certain areas of science and mathematics, other areas, particularly those relating to the biosciences and cosmology, have not been amenable to standard scientific modeling. Recently we have begun to realize that our scientific theories and mathematical systems are incomplete, and we have attempted to create new models to explain the otherwise unexplainable. On the other hand, ancient cultures attempted to understand the natural world from their own perspective which may add novel and perviously undiscovered insights into the investigation and analysis of current problems. A theme of this book is that our efforts

to understand natural phenomena may be enhanced by broadening our approach to science and mathematics to include ideas from art and architecture, both ancient and modern.

Writing this book has been a personal journey. My training is in engineering, the physical sciences, and mathematics. However, in 1978 I helped to organize an interdisciplinary effort at the New Jersey Institute of Technology involving the Mathematics and Computer Science Departments and the School of Architecture, which resulted in a new course in Mathematics of Design [Kap1, 5]. In the process I discovered that common ideas span areas as diverse as art, architecture, chemistry, physics, and biology, with mathematics as a common language. My book, *Connections: The Geometric Bridge between Art and Science* was an attempt to explore this common language within the context of geometry and design. This book continues that exploration emphasizing the role of number and its relationship to geometry.

Beyond Measure is written in two parts. Part I presents several examples in which art, architecture, music, and design with interesting mathematical content might have been used by ancient civilizations and primitive cultures to represent aspects of the natural world. I present the work of several researchers who use number and geometry to guide them in this endeavor. Sometimes valuable insights can be found in questionable theories and hypotheses. I am sensitive to the concern of scientists such as Carl Sagan [Sag] that scientifically unsubstantiated ideas may be gaining undeserved credibility in our society. However, there is also the danger that in the process of stemming the spread of spurious ideas, valuable insights will be eliminated from consideration. I have widened my net to include ideas that pass the test of being mathematically consistent, even though they are part of unproven theories.

Part II focuses on several mathematical themes of current interest, such as the theory of chaos and fractals; the mathematical study of the growth of plants (also known as plant phyllotaxis); how the number system anticipates certain naturally occurring resonances at both astronomical and sub-microscopic scales; how mathematical logic relates to number and to the structure of DNA; and the importance of the study of dynamical systems as a way to describe natural processes. Many patterns of geometry and number, and even certain specific numbers such as the golden and silver

means, and geometric structures such as spirals and star polygons that arise in Part I are crucial for an understanding of the concepts of Part II. An intriguing discovery is included that shows an unexpected relationship between chaos theory and the geometry of regular polygons.

Chapters 13 and 14 serve as a bridge between the two parts of this book. These chapters examine the nature of systems that are created from within themselves, in other words self-referential systems. In Part I, such systems take the form of the creations of architects, artists, and designers, and patterns in nature. Part II focuses on the self-referential aspect of dynamical systems. In man's quest to bring order to the world of his senses, the invention of number is perhaps his greatest achievement. Are the patterns of number that we find through our observations of the world already present in our minds? Is number part of the self-referential apparatus of our brains? Questions such as these are always in the background of our discussions in this book.

Much of the material described in this book is not well-known and is the result of my travels along the back roads of mathematical inquiry. Some of the material comes from scientific sources; others I have drawn from individuals who are unknown in scientific circles, but who have worked over a lifetime to develop their area of knowledge. I have also contributed some of my own discoveries.

Artists and scientists both ancient and modern have searched for harmony in the natural world using number and geometry. While in modern times, these ideas have been pursued using the language of science, the ancient world used art, music, poetry, and myth.

In recent years science has come to realize the limits inherent in its ability to model reality. Chaos theory has been developed to deal with systems that are entirely deterministic, yet so sensitive to initial conditions that changes more minute than the tolerance of the finest measuring sticks can have measurable effects on the systems. This calls into question previously formulated models which have assumed that the results of an experiment were intrinsically reproducible. Just as in the ancient world myths were created in order to give man some control over the vicissitudes of nature, new mathematical theories are being posited which make relationships based on number the key to gaining some control over phenomena exhibiting this sensitive dependence. In other words, chaos

emerges at one level but, with the help of mathematics, it is replaced by order at a higher level. In Part II of this book, I will attempt to illustrate this interplay between order and chaos.

In an essay entitled *Science and Art*, the botanist Jochen Bockemuhl [Boc] states that the aims of art and science are almost diametrically opposed.

> "New faculties have been developed, but in either case they are one-sided. Artists have learned to let go of external objects and gain inner perception. Their works point to the inner life. — Scientists on the other hand, concentrate on the physical aspect of things and are able to handle this irrespective of content. They fail to realize that the experience gained in thinking has opened up a way to move consciously from outer phenomenon to inner experience."

Bockemuhl feels that the approaches used in science and the arts can complement each other. This book is my effort to move the discourse of mathematics and science in the direction of the arts to their mutual benefit.

Since ancient myth and history figure so strongly in Part I, I would like to state my perspective on their importance. The historical records of the ancient world are incomplete in every area. Most of the surviving records are little more than warehouse lists that shed little light on the thought processes of the people of that time. The best that we can do is piece together speculations of what occurred and why or how it occurred from the fragments that have survived the passage of time. Further clues can be obtained by studying myths that have been handed down to us through the work of artists and poets of each age. I support the belief of de Santillana and H. von Dechend in *Hamlet's Mill* [de-D] that ancient people were every bit as subtle in their understanding of the universe as are we.

It is my belief that astronomical and cultural information may have been geometrically and arithmetically expressed through the musical scale and the proportions of significant ancient structures. Artists and practitioners of folk arts and crafts have also given expression to certain patterns which carry geometrical relationships despite the mathematical naivete of their creators. Some of these ideas will be presented in this book.

We live in an age dominated by science and technology. To a great degree, we have derived great benefits from the fruits of technology. However,

the assumptions of our scientific paradigms lead us to believe that the machines that we have created and the scientific constructs of our minds have no limits. So long as the limitations of our scientific models are understood and these models are seen as tools to extend our perceptions we are on safe ground. It is only when we mistake the "scaffolding" for the "edifice" that we overreach the bounds of scientific validity [Rot].

I doubt whether a computer will ever be able to either compose or play a piece of music with the spiritual depth of a Bach partita executed by a great violinist. The composer and musician are engaged in processes that invoke mental and physical tolerances beyond measure. To create transcendent qualities of sound, a violinist engages in nuances of physical engagement with the violin beyond the limits of measure. In a similar way a great athlete has learned to control tolerances in timing in order to display the effortless mastery which so thrills the observer. Marcel Marceau has said that in order to create a smile in mime, the smile must come from within; otherwise, it is seen as a grimace. Although it may appear that a smile might be describable in physical terms as a mere tension of the cheeks and jaw, the smile cannot be abstracted from its subject without destroying its essence. What I am suggesting is that the things in our lives that mean the most may be beyond measure and reproduction by computers and science. This book speaks to the need to expand the discourse of science beyond its traditional boundaries.

The scientific method proceeds along a two-stage process. At stage one the scientist is presented with a medley of observations and perceptions which he or she must integrate, in stage two, into a coherent theory which has ramifications beyond the observer's power of prediction. In stage one, measurement plays an important role. However, measurement brings all attention to a single focus and has the effect of abstracting the phenomenon studied from its context, which may reduce its power. This effect is dramatically exhibited in the quantum world where the act of measurement so profoundly alters the system that the measuring process must be included as part of the system to be measured. Even when we have been successful in describing the primary genetic units of a living system in terms of its DNA coding and have developed the means to manipulate these genetic structures, its meaning to the organism is incomplete. The organism responds as much to its context as to its coding. For example, the outward form of

a plant depends crucially on whether it is grown on a north or south-facing slope, covered by shadow or open, in moist or dry soil. By focusing on the gene we miss the enormous plasticity that enables the organism to manifest its true nature [Hol].

The great mystery is how perceptions at stage one lead to a unified concept at stage two. It is here that I believe something akin to Polyani's notion of tacit knowledge comes into play [Pol]. Some aspect of our minds and prior experiences leads us to go beyond mere appearances to a higher level of understanding. In the act of comprehension or discovery we move from a focus on some aspect of our object of study to its meaning for us. According to Polyani,

> "To attend from a thing to its meaning is to interiorize it, and... to look instead at the thing (or measure it) is to exteriorize or alienate it. We shall then say that we endow a thing with meaning by interiorizing it and destroy its meaning by alienating it."

It is this transcendent process, as manifested in the pursuit of knowledge in both the ancient and modern world, that forms the focus of this book.

I have been told that an author of science books for the general public loses an ever larger part of his audience for each equation or number series he uses. In this respect, I have not exercised prudence. I have included all of the mathematical arguments necessary to present a meaningful discourse. Nothing has been hidden from view. Since this is meant to be more than a book about ancient and modern mathematics and science, it faces the mathematics squarely. However, I have endeavored never to go beyond the level of mathematics mastered in the early school years. Calculus is never needed (although it figures peripherally in Chapter 10), and only in rare instances is algebra called upon. It is the concepts of number and geometry which provide the mathematical substance of the book. Each chapter, particularly in Part I, can be read either on the level of ideas or in terms of the mathematical detail. The ideas are occasionally subtle and require careful reflection on the part of both professionals and novices. This is particularly the case in Chapter 2 on projective geometry, Chapter 19 on the relationship between chaos theory and number, and Chapters 22

and 23 on the relationship between polygons and theories of proportion and chaos theory. I have placed expanded mathematical discussions in appendices so as not to interrupt the flow of ideas.

The chapters of this book can be read as independent essays. However they are also woven together by several recurring themes. Since the golden mean plays a large role in this book, one warning to the reader is in order. I have chosen to use the symbol τ more in favor to mathematicians, throughout this book to signify the golden mean rather than the symbol ϕ more familiar to non-mathematicians.

Plato stated that if one is to learn the truth of the nature of the universe, one must keep his eyes on the unity of all things and immerse himself in the study of music, astronomy, geometry, and number, the so-called quadrivium. This book represents my attempt to follow this prescription. It has been an enriching personal experience. I have listened to the stories of individuals who have each spent years pursuing a single area of knowledge. I feel privileged to have been able to learn from them and to have the opportunity of distilling their work so that it can be understood and appreciated by others. At the same time, I have attempted to look beyond the individual stories to a greater synthesis of their ideas. I have discovered that many streams are flowing together into one. If we stand back, we can begin to understand how ancient knowledge and modern themes join together.

The chapters of this book can be read as independent essays. However, they are also woven together by several recurring themes. Since the golden mean plays a large role in this book, one warning to the reader is in order. I have chosen to use the symbol τ more, in favor, to mathematicians, throughout this book to signify the golden mean rather than the symbol ϕ more familiar to non-mathematicians.

Acknowledgements

This book presents the ideas of several researchers whose work I have felt to be important and not sufficiently known. I have been personally enriched by my contact with these individuals. Some like Ernest McClain, Lawrence Edwards, Tons Brunes, Stan Tenen, and Ben Nicholson are known to a small group of followers. Others like Haresh Lalvani, Roger Jean and Louis Kauffman are well respected academics who have endeavored to go beyond the common academic discourse in their own work. Others such as Anne Macaulay, Gary Adamson, and Janusz Kapusta are independent researchers whose original work deserves recognition. Still others such as Irving Adler, Ezra Ehrenkrantz, Gerald Hawkins, and John Wilkes have contributed a single idea that has enriched the content of the book. My involvement with these individuals has gone beyond that of a passive observer and has led, in many instances, to collaborations, the writing of articles, and friendships. Still others, most notably, Heinz Otto-Peitgen, Theodor Schwenk and Joscelyn Godwin came to my attention through their writings.

I wish to acknowledge the help given to me by Arlene Kappraff, Denis Blackmore, H.S.M. Coxeter, Rebeca Daniel, Stephen Edelglass and Ronald Kaprov who read portions of the manuscript and made helpful suggestions. I am also indebted to Janusz Kapusta and Doug Winning for creating many of the figures found in this book and to Javier Barrallo who contributed his beautiful fractal designs for the cover. It has been my pleasure to work closely with Ye Qiang at World Scientific and Louis Kauffman, the editor of the Knots and Everything Series. I, however, accept full responsibility for any errors or inaccuracies that may be found in the book. Finally, I wish to acknowledge the Graham Foundation for their support of my work.

Permission

Figures 1.1 and 1.2 By courtesy of Elemond Milano.

Figures 1.3 and 1.4 From Hamlet's Mill by Giorgio de Santillana and Hetha Von Dechend. Reprinted by permission of David R. Godine, Publisher.

Figures 1.5, 1.6, 1.7, 1.9, 1.10, 1.11, 1.12, 1.13, 1.14, 1.15, 1.17 and 1.18 From Sensitive Chaos by Theodor Schwenk. Courtesy of Rudolf Steiner Press.

Figure 1.8 Courtesy of the Granger Collection.

Figure 1.16 Courtesy of the Bodleian Library, Oxford, England.

Figure 1.19 Reprinted with permission from The Museum of Modern Art, New York.

Figure 1.20 Created by John Wilkes © with the collaboration of Nigel Wells and Hansjoerg Plam.

Figures 2.4, 2.5, 2.6, 2.7 and 2.9 By permission of Rudolf Steiner Institute.

Figures 2.13, 2.14, 2.15, 2.16, 2.17, 2.18, 2.19, 2.20 and 2.21 By permission of Floris books.

Figures 3.3, 3.12 and 3.16 From Myth of Invariance by Ernest McClain (York Beach, ME: Nicolas-Hays 1976). Material used by permission.

Figure 3.7 By permission of Musee du Louve, Paris.

Figure 3.10, 3.13, 3.14 and 3.15 From Pythagorean Plato by Ernest McClain (York Beach, ME: Nicolas-Hays 1978). Material used by permission.

Figure 4.3 From Pythagorean Plato By Ernest McClain (York Beach, ME: Nicolas-Hays).

Figure 4.4 John Anthony West, Serpent in the Sky (Wheaton, IL: Quest Books). Material used by permission.

Figure 4.5 *Adapted from J.A. West by S. Eberhart.*

Figure 5.2 *From Manual of Harmonics by Flora Levin. By permission of Phanes Press.*

Figure 7.7 *By Mark Bak from the Mathematics of Design class of Jay Kappraff.*

Figure 7.12 *From Pattern and Design with Dynamic Symmetry by E.B. Edwards (Dover 1967).*

Figures 7.13 and 7.15 *Courtesy of K. Williams.*

Figure 7.14 *From Architectural Principles in the Age of Humanism (John Wiley and sons). Reproduced by permission.*

Figures 8.10 and 8.12 *Courtesy of Stephen Eberhart.*

Figures 10.2, 10.11 and 10.15 *By permission of Ben Nicholson.*

Figure 11.1 *From Science and Civilization in China, Vol. I by J. Needham.*

Figures 11.4, 11.5, 11.8, 11.9 and 11.10 *Courtesy of Anne Macaulay.*

Figure 11.11 *From Time Stands Still by Keith Critchlow (redrawn by Bruce Brattstrom from a photo by Graham Challifour).*

Table 12.1 *Copyright © Stanley N. Tenen.*

Figures 12.1, 12.2, 12.8, 12.9, 12.10, 12.11, 12.12, 12.16, 12.17, 12.18, 12.19, 12.20 and 12.21 *Copyright © Stanley N. Tenen.*

Figures 12.13, 12.14 and 12.15 *From The Knot Book by C. Adams. Copyright © 1994 by W.H. Freeman. Used by permission.*

Figure 12.18 *From Newton's Clock by I. Peterson. Copyright © 1993 by I. Peterson. Used with permission of Thomas Banchoff.*

Figure 14.5 *From Newton's Clock by I. Peterson. Copyright © 1993 by I. Peterson. Used with permission of W.H. Freeman and Company.*

Figures 16.5 and 16.6 *From Another Fine Math You 've got Me Into... by I. Stewart. Copyright © 1992 by W.H. Freeman and Company.*

Figures 17.2 and 17.3 *From Chaos and Fractals. By permission of H.-O. Peitgen, H. Jurgens, and D. Saupe (1992).*

Figure 18.2 *From Fractals by Feder (1988).*

Figure 18.5 *From The Fractal Geometry of Nature by B. Mandelbrot.*

Figures 18.6, 18.8, 18.10, 18.11, 18.12, 18.13 and 18.14 *From Chaos and Fractals. By permission of H.-O. Peitgen, H. Jurgens, and D. Saupe (1992).*

Figure 18.19 By George Gerster from African Fractals by R. Eglash published by Rutgers Univ. Press.

Figure 18.20 Ethiopian Cross figure by C.S. Perczel from African Fractals by R. Eglash published by Rutgers Univ. Press by permission of the Portland Museum of Art.

Figures 19.2, 19.5, 19.8, 19.10, 19.11, 19.12, 19.13, 19.14, 19.15, 19.16, 19.17 and 19.18 From Chaos and Fractals. By permission of H.-O. Peitgen, H. Jurgens, and D. Saupe (1992).

Figure 19.6 and 19.7 From Beauty of Fractals. By permission of H.-O. Peitgen and P.H. Richter (1986).

Figure 20.5 Computer generated by R. Langridge. Computer Graphics Laboratory, University of California, San Francisco © Regents University of California.

Figure 20.6 Courtesy of H. Lalvani.

Figure 20.7a Created by Elyse O'Grady from the Mathematics of Design class of Jay Kappraff.

Figure 20.7b Created by Eileen Domonkos from the Mathematics of Design class of Jay Kappraff.

Figure 20.8, 20.9, 2.10 and 20.11 Courtesy of Janusz Kapusta.

Figure 20.12 From Chaos, Fractals, and Power Laws by M. Schroeder. Copyright © 1991 by W.H. Freeman. Used by permission.

Figure 20.15b From Beauty of Fractals. By permission of H.-O. Peitgen and P.H. Richter (1986).

Figure 20.18 From How Nature Works by Per Bak. Courtesy of Springer-Verlag.

Figure 22.2 Courtesy of Janusz Kapusta.

Figures 23.4 and 23.5 Computer graphics by Javier Barrallo.

Figure 24.2 Courtesy of John Wiley and Sons, Publ.

Figures 24.3, 24.4 and 24.5 From The Algorithmic Beauty of Plants by P. Prusinkiewicz and A. Lindenmayer. Springer-Verlag 1990. Used with permission of Springer-Verlag.

Figure 24.6 Courtesy of N. Rivier.

Figure 24.8 *From Patterns in Nature by Peter Stevens. Copyright © 1974 by P. Stevens. By permission of Little Brown and Co.*

Figure 25.1 N.G. de Bruin, Kon. Ned. Akad. Wetensch. Proc. Ser. A84 *(indaginationes Mathimaticae 43) 27–37.*

Figures 25.2, 25.4, 25.5, 25.7 and 25.8 *From Chaos, Fractals, and Power Laws by M. Schroeder. Copyright 1991 by W.H. Freeman. Used by permission.*

Figure 25.3 P. Bak and R. Bruinsma, Phys. Rev. Lett. 49, 249–251.

Part I

Essays in Geometry and Number as They Arise in
Nature, Music, Architecture and Design

1
The Spiral in Nature and Myth

> The ocean wave... in essence is a kind of ghost
> Freed from materiality by the dimension of time.
> Made not of substance but energy.
>
> *Guy Murchie*

1.1 Introduction

Our technological culture may learn much from primitive societies which express their understanding of nature in myths and rituals.

I shall examine the symbolic role of the spiral in the myths and rituals of the Australian Aborigines, and the Fali of the Cameroons (cf. [Eli], [Gui]). I shall also examine the possibility that ancient civilizations were aware of such astronomical phenomena as the precession of the equinoxes, and that the stars were pictured as rising in helices [de-D]. Finally, I will present an outline of the observations and ideas of Theodor Schwenk [Schw] on the creative force of water in the genesis of organic forms.

1.2 The Australian Aborigines

The Aborigines are a nomadic people who believe that in ancient times, known as the "epoch of the sky", gods inhabited the territory. At a later time, known as "the epoch of the dream" or "dreamtime", these gods were replaced by legendary heroes who were relegated to a mythical past time and to eternal idleness. The heroes, being less removed from man's experience than the gods, presented men with a model to emulate. Through the example of these heroes, men became capable of molding and controlling nature.

3

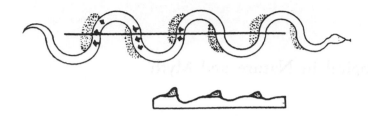

Figure 1.1 Australian aborigines: Mythical formation of the dunes along a river. Schematic representation of the river-as-serpent (Australia). By courtesy of Elemond Milano.

According to Guidoni the landscape was said to be formed by the mythical ancestor-snake. The legend suggests that when it emerged from the sea the snake crawled across the dry land leaving its sinuous track, a spiral form, imprinted there forever (see Figure 1.1). This relationship can be understood by looking at the undulating pattern of a river as it traverses the landscape and comparing it with the meandering course of a snake slithering along the Earth. There are many different tribal groups, each with its own interlocking myths which direct them along paths that often cross. The underpinning of tribal unity is, however, that the territory is conceived of as a network of sacred centers that represent the campsites along the wandering snakelike paths. These centers are located at water holes and the path takes the nomads to places of abundant food and water as the seasons change. These centers are thought to have been used by their mythic progenitors to issue from and reenter into the earth during their wanderings. These centers or water holes are symbolized by spirals.

More than one group can occupy a single campsite at the same time, but only according to specific rules laid down in the myths. Each tribe has a coat of arms consisting of connected bands cut with diagonal parallel lines inclined alternately to the left and the right to represent a particular stretch of watercourse inhabited by the tribe. The whole course of the river is thereby synthesized into a zigzag pattern that shows the position of the various tribes as they disperse themselves along the river relative to each other and as they follow the itinerary of the culture hero in their wanderings.

During their wanderings, the chief of the group carries a sacred pole to symbolize the sacred center. With it, he orients the tribe to the space and

points to the directions of the path through it. In one legend, it is said that the Achilpa tribe perished when this pole was accidentally broken and the people became disoriented and could not proceed. A myth tells that the Achilpa hero Numbakulla climbed to the heavens on the pole, again emphasizing the pole's connection of heaven with Earth.

Large numbers of vital spirits are always present at the sacred locations. Conception is portrayed by the passing into the uterus of one of these spirit babies. Since every individual existed prior to his life in a specific territorial center, he considers himself more intimately linked to the place of his conception than that of his birth.

Dances are used to reenact this creation story. In the Bamba ceremony of the Walbirti, a pole about three feet high is erected and, like the dance that follows, is intended to increase the ant species. First a hole is dug and water poured on the ground. The moist earth is then made sacred with "blood" by soaking it with red ocher. The pole is decorated with white spots representing ants and topped with a tuft of leaves of the bloodrot plant considered to be the source of life, containing a baby. The pole is placed in the hole, which symbolizes an anthill, while the circle and hole represent the encampment of ants. Dancers crawl across the symbolic campsite in imitation of the insect, coming closer to the center and finally symbolically entering the hole. This end to the dance represents the act of procreation that concludes every act of entering the sacred center. Viewing the ceremony in terms of a two-dimensional design, the center represents the hole, the sacred source, and the concentric circles stand for the degrees of distance from the center with vertical movement back to the surface of the earth and to the present. The combination of inwardly moving circular motion results in a spiral path.

The representation of the sacred hole and the path leading to it carries a great many associations. The center is the point of contact with dreamtime; the concentric circles represent the primordial campsite, the path leading to it signifies the present time; the movement of ascent and descent, the sexual act and the male organ. The complex geometrical symbolism also gives a summary picture of the territory. It represents the routes the tribes take in their movement through the territory and the seasons, giving primary attention to the need for water and the relationships between the other tribal groups.

1.3 The Fali

According to Guidoni, every interpretation of the Fali culture can be traced back to the mythic creation of the universe through the balanced correspondence between two cosmic eggs: one of the tortoise and the other of the toad. This subdivision between two unequal parts corresponding to the tortoise and the toad is also reflected in the organization of the society, the territory, and the architecture of the Fali. Every subsequent differentiation of elements within the society came about through a series of alternate and opposing movements or "vibrations" which guaranteed the maintenance of equilibrium between opposites. Every region, every group, or architectural element either participates in one of these opposing movements or is a fixed point that acts as a pivot for the motion of the parts around it.

The form of the Fali's dwellings is an example of how this mythical organizing principle works. The huts are constructed with a "feminine" cylindrical part made of masonry and a "masculine" conical part made up of rafters and straw, as is shown in Figure 1.2. Although they are stationery, these parts can be imagined to circle in opposite directions to each other.

Figure 1.2 Fali: Section of a granary of bal do type (Cameroon). By courtesy of Elemond Milano.

All points participate in a kind of virtual motion except that the vertex of the cone is fixed. According to Guidoni,

> "It was the tortoise that gave man the model for his house. Under its tutelage the first couple built the primordial house, whose constructive and decorative detail was established for all time and which must be faithfully imitated in all dwellings of the Fali."

The relationship between the Fali myths and the spiral will be made explicit in the next chapter.

1.4 The Precession of the Equinoxes in Astronomy and Myth

The Earth's axis is inclined at an angle of 23½ degrees to the normal (perpendicular) line to the plane of the sun's movement (*ecliptic plane*) as shown in Figure 1.3. This normal line is also known as the axis of the celestial sphere. There is evidence that ancient civilizations were aware that the Earth's axis makes one complete revolution about the axis of the celestial sphere approximately every 26,000 years and that some creation myths depicted stars moving on spiral paths (a star rising in the East makes a helical path in the night-time sky around the pole star), within this precession cone as shown for the representation of creation of the Bambara tribe of Africa [de-D] in Figure 1.4a. As a result, the star marking the direction of *north* changes over time. Whereas now the *north star* is alpha Ursae Minoris, around 3000 B.C. it was alpha Draconis and in 14,000 A.D. it will be Vega.

Twice each year, at the *vernal* and *autumnal* equinoxes, the Earth moves to a position in which it lies on the line of intersection of the *ecliptic* (the plane of the planet's movement about the sun) and the *equatorial* planes (the plane of the Earth's equator). The vernal and autumnal equinoxes along with the *summer and winter solstices* make up what is referred to as the "four corners of the quadrangular Earth", as depicted by the Bambara tribe in Figure 1.4b by four spirals. Angle is metaphorically used to emphasize the temporal rather than spatial element since angle is measured by units of

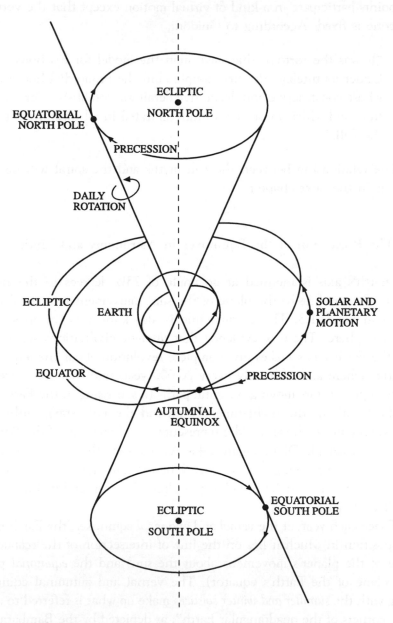

Figure 1.3 A diagram of the Precession of the Equinoxes. The symmetrical drawing shows that the phenomenon occurs at both poles.

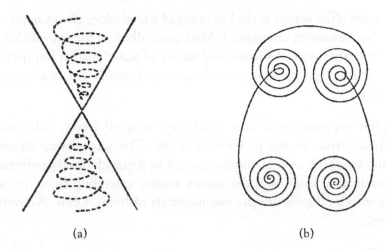

(a) (b)

Figure 1.4 The ways of the Demiurge during creation, according to the Bambara. (a) "In order to make heaven and earth, the Demiurge stretched himself into a conical helix; the turnings-back of that spiral are marked graphically by the sides of two angles which represent also the space on high and the space below." (b) "In order to mix the four elements of which all things are formed, and to distribute them to the borders of space, the movements of the Demiurge through the universe are figured by four spirals bound one to the other which represent at the same time the circular voyage, the four angles of the world in which the mixing of the elements takes place, and the motion of matter."

time (e.g., degrees, minutes, and seconds of arc). As a result of the precession of the Earth's axis, the location of the line of the equinoxes changes. For this reason, the movement of the Earth's axis is referred to as the *precession of the equinoxes*.

1.5 Spiral Forms in Water

The book *Sensitive Chaos* by Theodor Schwenk [Schw] is concerned with the creation of flowing forms in water and air. As Schwenk states:

"In the olden days, religious homage was paid to water, for men felt it to be filled with divine beings whom they could only approach with the greatest reverence. Divinities of the

water often appear at the beginning of a mythology (for example, the Australian aborigines). Men gradually lost the knowledge and experience of the spiritual nature of water until at last they came to treat it merely as a substance and means of transmitting energy."

Water expresses itself in a vocabulary of spiral forms. Schwenk feels that these forms are the progenitors of life. The meandering stream, the breaking wave, the train of vortices created by a branch or other obstructions hanging in the water, and the watery vortex extending from the water's surface into its depths are the raw materials of living forms. According to Schwenk,

"Every living creature in the act of bringing forth its visible form passes through a liquid phase. While some creatures remain in this liquid state or solidify only slightly, others leave the world of water and fall under the dominion of the earthly element. All reveal in their forms that at one time they passed through a liquid phase."

Let us take a look at how spiral forms arise in water and manifest in living forms. All material in quotation marks have been taken from *Sensitive Chaos*.

1.6 Meanders

A naturally flowing stream always takes a winding course. "The rhythm of these meanders is a part of the nature of a river. A stream that has been artificially straightened looks lifeless and dreary".

A closer look at the flow patterns in a meandering stream shows that in addition to the forward motion of the stream, the flow of water revolves in the cross-section of the river in two contrary directions. "Let us look at one point in the current, for instance near the bank on the inside of a bend. On the surface the water is streaming outwards" as shown in Figure 1.5. The movement downstream combined with the revolving circulation results in a spiraling motion. Actually, two spiraling streams lie next to each other

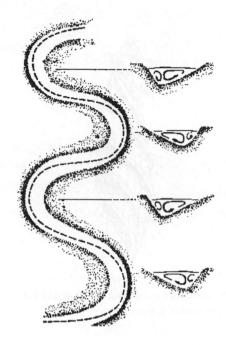

Figure 1.5 Representation of the meander of a river showing the revolving secondary currents in the bed of the stream.

along the river bed and form a kind of twisted rope of watery strands. To be more exact, rather than being strands, the water forms entire surfaces that twist together. According to Schwenk,

> "These movements are the cause of varying degrees of erosion of the banks of the river. The outer banks are always more eroded than the inner, which tend to silt up. The material scooped away from the outer bank wanders with the spiraling current to the inner bank further downstream and is deposited there. Because of this process the river eats its way further and further outwards at the outer bank, swinging from side to side as it flows, thus making the loops more pronounced...A meandering motion lengthens the course of the river and thus slows down the speed at which it flows. In this way the riverbed is not hollowed out, and the ground-water reserves are left intact."

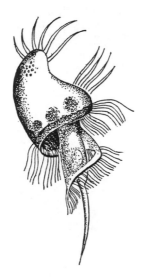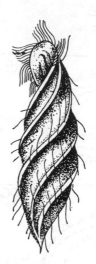

Figure 1.6 Many unicellular water animals have incorporated the spiraling movement of water in their shapes (from Ludwig, after Kahl). Courtesy of Rudolf Steiner Press.

Figure 1.6 illustrates two unicellular water animals that have incorporated the spiraling movement of water in their shapes. They usually propel themselves along like a meandering stream with a screw-like movement.

1.7 Wave Movement

A stone in a stream or a gentle breeze on the ocean will cause the water in its proximity to respond immediately with rhythmical movement. The patterns that arise from these external influences are characteristic of the particular body of water, be it a lake, a stream, or an ocean.

In spite of the ceaseless flow of the stream and its swirling nature as it moves around stones and boulders, the flow pattern is stationary. The same wave forms remain behind the same rocks. On the other hand, in the open sea, the wave form wanders across the surface, allowing the water to remain in the same place. As an experiment, throw a piece of cork in the water and watch it bob up and down while the waves sweep over the surface. Schwenk notes that the wave is a newly formed third element at the surface of

contact between water and wind. The wave is a form created simply out of movement. In this sense it is like all organic forms, which in spite of chemical changes, remain intact as entities.

Wave forms are replete with complex movements of different types. For example, they sort themselves out in different wavelengths, with the longer wavelengths moving faster than the shorter. Also, as the wave passes an element of water, the element rises and falls in a circular movement. Flowing movements can also be superimposed on a wave, so that as the wave moves forward, a strong wind can cause the moving current on the back of the wave to move faster than the wave and overshoot the crest and break. In this process, all that is rhythmic in a wave becomes altered. It takes on a spiral form interspersed with hollow spaces in which air is trapped. "Whenever hollow spaces are formed, water is drawn into the hollows in a circular motion, and eddies and vortices arise". This presents us with a new formative principle:

The wave folds over and finally curls under to form a circling vortex. This is illustrated in Figure 1.7 and also by the famous painting "The Great Wave" by Katsushika Hokusai, shown in Figure 1.8. Elements that until now were separate unite in turbulence and foam.

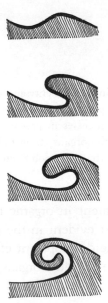

Figure 1.7 A wave curls over to form a vortex.

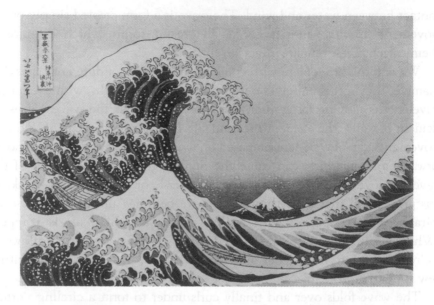

Figure 1.8 "The Great Wave" by Katsuhika Hokusai.

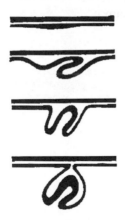

Figure 1.9 In the rigid chrysalis of a butterfly, growth takes place at varying speeds. This leads to folding processes in preparation for the forming of the organs (from Eidmann after Weber). Courtesy of Rudolf Steiner Press.

The different speeds of growth or development in organic forms also show evidence of the same folding. This is most evident in the process in which organs are developed. Schwenk offers the development of the pupa of a butterfly as an example. As shown in Figure 1.9, "the organs, which at first are curled up, are pushed out when fully developed and appear as feelers, limbs, etc".

1.8 Vortices and Vortex Trains

Wave-forming motion not only occurs between air and water but also in the midst of water, as when two streams of water flow past each other at different speeds. For example, in a naturally flowing stream we can observe the patterns formed in the water at a place where a twig from a bush hangs into the water. The flowing water is parted by the obstructions and reunites when it has passed. But at the same time, a series of small vortex pairs, spiraling in alternate directions, arise as shown in Figure 1.10, and travel downstream with the current. The vortices in this series or "train" of vortices are evenly spaced in a rhythm determined by the obstruction. These vortices have the same effect as the breaking waves. The boundary of the vortex train entraps the stagnant fluid on the inside of the boundary and mixes it with the water of the swiftly moving stream exterior to the boundary. In this way, fluids of different states of motion on either side of the boundary are gradually combined.

"A particularly clear picture of a train of vortices is exhibited by the bony structure in the nose of a deer, shown in Figure 1.11. Large surfaces are thus created past which air can stream, giving the animal its acute sense of smell". In Figure 1.12, the whole field of motion of a train of vortices is shown.

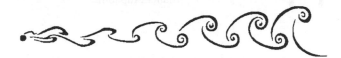

Figure 1.10 A distinct train of vortices (after Homann). Courtesy of Rudolf Steiner Press.

Figure 1.11 Enlarged detail of the bony structure in the nose of the deer.

Figure 1.12 A vortex train seen as a ball and socket joint with flow lines passing straight across joint.

Figure 1.13 Spongy bone structure in the human hip joint.

"Single vortices are clearly separated from one another by a dividing line or surface. The vortices are not fully formed, but the surrounding substance pushes into the space created by the moving rod. It first enters from one side then from the other, making visible the strict rhythm of vortex formation. The boundary of this advance can be seen as a kind of 'joint' where 'ball and socket' lie opposite one another. Closer inspection shows that flow lines pass straight across the boundary surface of this joint".

In a similar manner, the spongy structure that makes up the joints of humans and animals closely follows the form of a single link within a vortex train, as Figure 1.13 illustrates. The stress lines, take the place of flow lines in fluids, running directly across the gap. Striking images of a

Figure 1.14 Design on a palm leaf (May River, New Guinea), Volkerkundliches Museum, Basel.

vortex train have also been found in primitive designs, such as the one shown in Figure 1.14.

1.9 Vortex Rings

Aside from the rhythmic processes of vortex formation at the surface of the water, there is also the three-dimensional nature of the vortex to consider. As shown in Figure 1.15, "every vortex is a funnel of downward suction. All flowing water, though it may seem to be entirely uniform, is really divided into extensive inner surfaces, each rotating at a different speed. In the formation of vortices, these surfaces are drawn into the whirlpool". The inside of the vortex turns faster than the outside, and corkscrew-like surfaces appear on the surface of the vortex as the result of the disparity of the motion. The vortex is a figure complete in itself with its own forms, rhythms, and movements.

Figure 1.15 Vortex funnel.

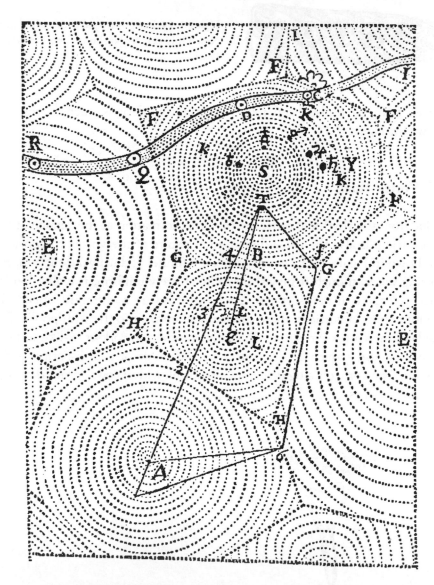

Figure 1.16 System of vortices with which Descartes sought to account for the motion of the heavenly bodies consisted of whirlpools of ether. In the case of the solar system the vortex carried the planets around the sun (S). Irregular path across the top of the illustration is a comet, the motion of which Descartes believed could not be reduced to a uniform law.

Figure 1.17 Spiral formation in snails and shells.

The vortex is like an isolated system closed off from the body of water around it. For the most part, the vortex with its different speeds follows Kepler's Third Law in which a planet moves fast when near the sun. In fact, Schwenk suggests that the vortex is a miniature planetary system with the sun corresponding to its center. The exception is that the planets move in slightly eccentric orbits in contrast to the circular vortex motion. It is interesting that Descartes' model of the universe consisted of vortices made up of the fine matter of "ether" with the stars at the center. Descartes' sketch in Figure 1.16 shows the planets being carried about in the sun's vortex S, and the moon being carried around the earth in the same way.

"The vortex has another quality that suggests [astronomical] connections". If a small floating object with a fixed pointer is allowed to circulate in a vortex, it always points in the direction that it was originally placed, remaining parallel to itself. In other words, it is always directed to the same point at infinity, "just as the axis of the Earth points in the same direction as it revolves around the sun". The center of the vortex would rotate at infinite speed if this were possible. Since it is not, it instead creates a kind of negative pressure, which is experienced as suction.

Many forms in the organic world manifest themselves in the form of a vortex. For example, the twisting antlers of a horned animal, snails and shells such as those shown in Figure 1.17, some spiral formations in the plant world, and most strikingly, the human cochlea. Figure 1.18 shows the

Figure 1.18 Fibers in the auditory nerve, arranged spirally just like a liquid vortex, as though picturing an invisible vortex of forces (after De Burlet).

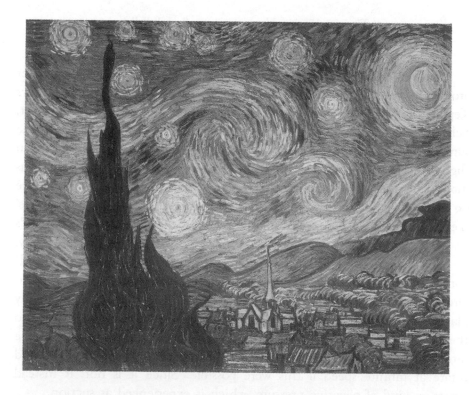

Figure 1.19 "Starry Night" by Vincent Van Gogh. About this affirmation of the swirling harmony between the forces of nature, Van Gogh wrote: "First of all the twinkling stars vibrated, but remained motionless in space, then all the celestial globes were united into one series of movements... Firmament and planets both disappeared, but the mighty breath which gives life to all things and in which all is bound up remain [Pur].

fibers in the auditory nerve arranged spirally just like in a liquid vortex. However, it is literature and art that has captured the essence of the vortex. Edgar Allen Poe's classic tale, "A Descent into the Maelstrom", presents a palpable description of the abyss at the base of the vortex and a description of the chaotic multitude of inner surfaces of the vortex. Van Gogh's art portrays nature in a perpetual state of movement. His masterpiece "Starry Night", shown in Figure 1.19, best dramatizes the place of the vortex in nature. As Jill Purce [Pur] observes,

> "Not only do the clouds spiral into a Yin Yang formation (a pair of alternately spiraling vortices), but the opposing forces of sun and moon are unified. For Van Gogh, this was a decisive moment of union between inner self and outside world."

1.10 Three Characteristic Features of Water

The preceding discussion illustrates three characteristic features of water. The first is the activity of water in all metabolic processes. The second is its close connection with all rhythmic processes. The third, lesser known characteristic, is the sensitivity of water's boundary surfaces, which Schwenk sees as a indication that water is a sense organ of the earth.

We have seen evidence of the metabolic function where water churns up silt from a river bed and redeposits it, or where a breaking wave incorporates the air at its boundary into itself. The rhythmic patterns are evidenced in the meanders of a river and moving vortex trains. The sensitivity at boundary surfaces is illustrated by the influence of the smallest environmental factors such as a mild breeze or whether it is day or night, on the formation of waves or the creation of vortex trains. This sensitivity is also expressed in such structures as the deer's nose, or the antelope's horns. The vortex itself is a mechanism that opens up the inner surfaces of water to the influences of the moon and the stars. This is due to the disparities of fluid velocity from the center to exterior of the vortex.

All of these functions are manifested in the world of living organisms. In humans, the intestines best represent an organ of metabolism; the heart, a center of rhythmic organization; the ear, a sensory organ. These three

organs are shaped by patterns similar to those found in flowing water. Though, as Schwenk shows, just as the three characteristics do not specialize to any of the fundamental patterns of the movement of water, they also do not specialize to any particular organ. In each movement of water and in each organ, all three are in evidence.

1.11 The Flowform Method

It was George Adams and Theodor Schwenk, who with a number of others, founded the Institute for Flow Sciences at Herrischried in South Germany. Adams was interested in investigating the effect of *path curves* (a family of curves discussed in the next chapter and first described by Felix Klein in the 19th century and which Adams considered to relate intimately to organic forms) upon the quality of water [AdamG]. In this chapter, I have described some of water's formative capacities and some of Schwenk's profound conclusions regarding the place of water as a mediator between heaven and Earth. A water quality test known as the Drop Picture Method was devised in [Schw-s]. Work has been continued by his son Wolfram Schwenk at the Institute of which he became Director.

In 1970, John Wilkes, who had been involved at the Institute since its beginnings, discovered a technique which he later named the Flowform Method [Rie-W]. This Method has to do with the generation of rhythmical processes in streaming water, achieved by the design of very specific proportions within Flowform vessels which resist the flow of water to the correct degree. It is namely resistance which leads to rhythm in all manner of contexts. All living organisms are dependent upon rhythms and these are in turn carried by water or water-based fluids, without which no organism can survive.

The research and development was continued at Emerson College, Forest Row, Sussex, England where, by the mid-seventies the Flow Design Research Association was founded. In collaboration with associates, projects have since been carried out in some thirty countries. The main emphasis of the work is related to supporting water's capacity to sustain life. Rhythm tends to sensitize the function of water in its activity as mediator between surroundings and organism. Incidental to this, oxygenation is achieved,

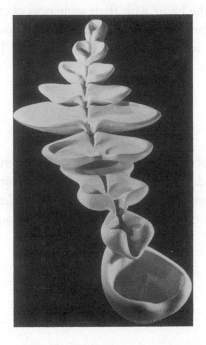
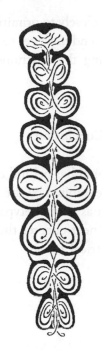

Figure 1.20 Sevenfold Flowform Cascade.

efficiency being related to the movement dynamic of the Flowforms in question. Naturally, the potentially vigorous lemniscatory or figure-eight movement activity with interposed chaos can be utilized for mixing processes of many kinds.

None of this activity can take place without the influence of surface. The Flowform Method also enables research to continue in terms of Adams' original hypothesis regarding the influence of surface and more specifically pathcurve surfaces upon the quality of water. Rhythmic lemniscatory movements make possible an intimate relationship of water to the surface over which it can repeatedly spread as a thin film. Figure 1.20 illustrates an exploration of a spectrum of rhythms in the so-called Sevenfold Flowform Cascade created by Wilkes with the collaboration of Nigel Wells and Hansjoerg Palm. The diagram shows the flowpath through a similar earlier edition of the cascade indicating a metamorphosis in the mathematical form known as the lemniscate. This "organ of metamorphosis for water"

relates closely to primitive forms of the heart with their sequences of cavities which tend however to remain similar to each other, and opens up questions regarding the rhythmic regulatory function of the heart such as [Mari], [Men].

1.12 Conclusion

The spiral lies behind the patterns of interconnectedness and the genesis of forms exhibited by the natural world. It is not surprising that the spiral was chosen as an archetypal form by primitive societies in their art and rituals. In the next chapter the spiral arises once again, this time as a fundamental geometrical form.

2

The Vortex of Life

> To see a World in a Grain of Sand
> And Heaven in a Wild Flower
> Hold Infinity in the palm of your hand
> And Eternity in an hour.
>
> *"Auguries of Innocence" by William Blake*

2.1 Introduction

Euclidean geometry (the geometry that we learned in school) has been the primary tool in formulating mathematical models of the physical world. However, there is a more general geometry, namely projective geometry, of which Euclidean geometry is a special case. Drawing on the work of Lawrence Edwards [Edw1,2,3], I will show that projective geometry can be used to describe the shapes of plants and other biological forms, as well as the watery vortex. Again, the spiral plays a key role in these descriptions.

The next section describes the general subject of projective geometry and then, in the following five sections, presents all of the fundamentals needed to understand Lawrence Edwards' application of projective geometry to plant form. The chapter concludes with a brief discussion of how the ideas of Guidoni, Schwenk and Edwards relate to each other. The chapter is written to inform mathematically sophisticated readers. Yet, it should also be accessible, with some difficulty, to mathematically inclined non-professionals.

My interest in presenting this material lies in the ability of projective geometry to represent natural form. In Edwards' description of organic form, all points that make up the form are in a state of flux. Nevertheless the overall form is maintained. Thus biological form is seen as a dynamical system.

25

2.2 Projective Geometry

When a two dimensional object is projected by a point source of light from one plane to another, a projective image results. The object and image are considered to be *projectively equivalent*. Artists of the fifteenth century such as Brunelleschi, Albrecht Alberti, and Leonardo da Vinci developed the art and mathematics of projections and understood that it is connected with vision. The eye projects a scene from the horizontal plane to an imaginary screen in front of the body. Rays of light can be thought to connect points on the scene to points on this imaginary plane, in which case the scene is viewed in perspective. When a canvas replaces the imaginary screen, the scene may be rendered by recreating it at the points where the rays pass through the canvas, as shown in Figure 2.1. When the eye is at point O, this projective mapping of scene to canvas transforms the infinitely distant line of the horizon onto a real line h on the canvas. Also, parallel lines receding from the viewer towards the horizon appear on the canvas as the oblique lines l meeting at some point on the horizon line.

The subject of projective geometry pertains to three primary elements: *points*, *lines* and *planes*, and the properties of these elements that are preserved under projective transformations. Projectively equivalent objects and images are considered to be identical in projective geometry just as congruent figures are indistinguishable in Euclidean geometry. The three primary elements are considered as separate entities; a line is not considered in the axioms of projective geometry to be a sequence of points, but an entity in

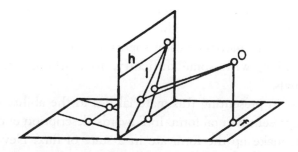

Figure 2.1 A road l receding to infinity depicted as converging to a point on the horizon line h of an artist's canvas.

itself. Also points and lines are considered to have equal status. In projective geometry, the *line at infinity* has as much reality as any other line. After all, it corresponds to the horizon and is projectively mapped by the artist to the horizon line of a painting. We are also justified in saying that every pair of lines has a single point in common; when the lines are parallel the common point is a point on the line at infinity. Each line is considered to have a single point at infinity. Imagine a rocket ship moving towards infinity along the right side of a line. If it continued through the *point at infinity* and kept going, it would return to its origin from the left side of the line. By pivoting a line about a single point, as shown in the so-called *pencil of lines* of Figure 2.2, the point at infinity on the line sweeps out the line at infinity. Alternatively, the line could be considered to have infinite points at either end, in which case there is an infinite point in the direction of each point of the compass and these points sweep out a *circle at infinity*. The line and circle at infinity are seen to be identical if points on the circle 180 degrees apart are considered the same (identified with each other). One of the most valuable features of projective geometry is its ability to make the infinite accessible to human thought; points and lines at infinity have the same reality as those from the finite realm.

Figure 2.2 A pencil of lines indicating the point at infinity on each line.

It is well known that depending on how a right circular cone is sliced by a plane, the boundary of the cross-section is either a *circle*, *ellipse*, *parabola*, or *hyperbola*, the so-called *conic sections*. Since a point source of light can be thought of as being located at the vertex, all conic sections are projectively equivalent. Each conic can be viewed projectively as a circle by singling out a special line in the plane, as shown in Figure 2.3. Figure 2.3a represents a projective view of an ellipse, Figure 2.3b a parabola, Figure 2.3c an hyperbola, while Figure 2.3d represents a circle when the special line is at infinity. When the special line is mapped to infinity, the usual pictures of the conics reveal themselves. The richness of projective geometry, in contrast to Euclidean geometry, is due to the fact that in Euclidean geometry the special line is always taken to be the line at infinity. As a result, conics always assume their familiar forms whereas projective geometry always has a representational flexibility. Yet, many of the theorems of Euclidean geometry are found to hold in the more general context of projective geometry.

Crucial to an understanding of projective geometry is the concept of *duality*. The axioms are so constructed that in two-dimensional space, their validity is unaltered whenever point and line are interchanged in any statement or theorem, while in three-dimensional space point and plane are interchanged while line is retained. Thus the statement, "any two points

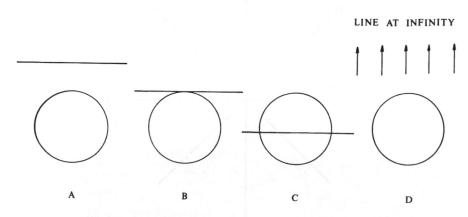

LINE AT INFINITY

A B C D

Figure 2.3 When the special line is projectively mapped to infinity, the circles become (a) an ellipse, (b) a parabola, (c) an hyperbola, (d) a circle.

contain a single line" (i.e., through any two points a single line can be drawn), is equivalent to "any two lines contain a single point" (i.e., any pair of lines define a unique point of intersection). Likewise, "three planes with no common line contain a unique point" is equivalent to "three points not all on the same line contain a unique plane" (i.e., three non-colinear points define a plane).

At one time, projective geometry was part of the repertoire of all mathematicians. Today, only a few specialists remain connected to this subject, and they relate to the subject in, primarily, an algebraic manner. In this brief introduction, we shall emphasize a constructive approach as can be found in several excellent books [Cox4], [Edw2], [Whi], and [You]. It is my feeling that the quiet contemplation of projective constructions can be enlivening to the mind.

2.3 Perspective Transformations on the Line to Points on a Line

One of the most elementary transformations in all of mathematics is the mapping of the points on line x to points on line x' from a point O not on lines x and x', as shown in Figure 2.4. A typical point A on line x and A' on line x' share a common line from the pencil of lines centered at the point of projection O. Such a projective transformation is called a *perspectivity*.

In Figure 2.5 the dual perspectivity is shown. Here two pencils of lines centered at X and X' are projected onto line o. Lines a and a' meet at a point on the line of projection o.

The perspectivity in Figure 2.4 is entirely specified by arbitrarily choosing two points A and B and their transformed points A' and B' since this determines lines x, x' and point O. In this case, x is the line through AB, x' is the line through $A'B'$, and O is the meeting point of AA' and BB'.

Referring to Figure 2.4, one can see certain special points of the transformation. The intersection of x and x' is mapped to itself and is the only *fixed point* of the transformation. Also, the line through O parallel to x maps the *point at infinity* on line x to the point where this line intersects x'. Likewise, the point at infinity on x' is mapped from point the on x where the line through O parallel to x' intersects x.

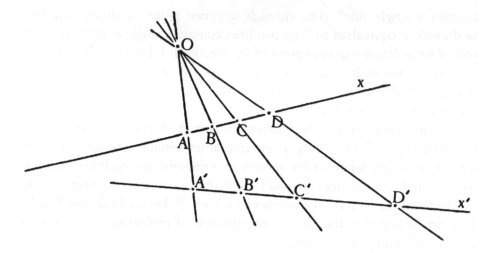

Figure 2.4 A perspective transformation of points.

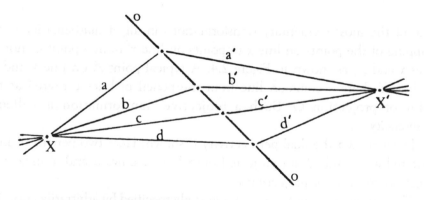

Figure 2.5 A perspective transformation of lines.

Although metric properties such as distance between points are not generally preserved by perspectivities, a somewhat obscure relation between any four points A, B, C, D, and their transforms is preserved, namely:

$$\lambda = \frac{AB}{BC} : \frac{AD}{DC}. \tag{2.1}$$

This relationship is known as the *cross-ratio*. It is of fundamental importance to projective geometry. In fact, projective transformations can be defined to be those transformations of points and lines that preserve cross-ratio. It should be mentioned that this definition of the cross-ratio assumes successive points are in the order A, B, C, D. There are 24 different orderings of these four points, and the cross-ratios in each of these definitions are also preserved. As a matter of fact, we will find the ordering $DBAC$ and its cross-ratio

$$\lambda = \frac{DB}{BA} \; : \; \frac{DC}{CA} \qquad (2.2)$$

most relevant in what follows.

2.4 Projective Transformations of Points on a Line to Points on a Line

The notion of the projective transformation of the points on line x to the points on line x' can be made more general by first relating the points on lines x and m by a perspectivity with respect to point O, and then relating the points on m and x' by a perspectivity with respect to O' as shown in Figure 2.6. In a similar manner, x can be mapped to x' via a series of intermediate lines m, m', m'', etc. Any such sequence of perspectivities is called a *projectivity*.

It can be shown that any three points arbitrarily chosen on lines x and x' can be mapped to each other under a projectivity. Since corresponding lines from the pencils of lines through O and O' meet on a common line m, Figure 2.6 also represents a perspectivity of these pencils of lines of the kind shown in Figure 2.5. However, for a general projectivity, lines OA and $O'A'$, OB and $O'B'$, OC and $O'C'$ do not meet on a common line. It is of fundamental importance to the study of projective geometry that these pairs of lines *do* meet on a *conic section*. (Note that a pair of straight lines can be thought of as the extreme case of an hyperbola.)

For a special class of projectivity called a *co-basal* projectivity, x and x' are the same line as shown in Figure 2.7 where A transforms to A', and B transforms to B' on line x. The transformation is carried out by first transforming A to T on m through O, and then transforming T back to A'

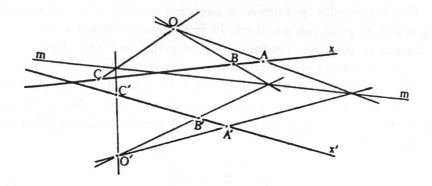

Figure 2.6 A projective transformation of points (it is also a perspective transformation of lines).

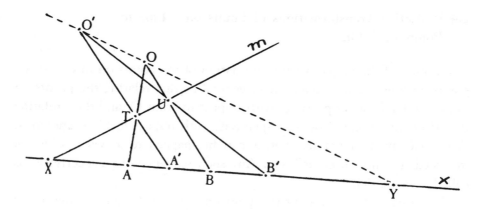

Figure 2.7 A co-basal projective transformation.

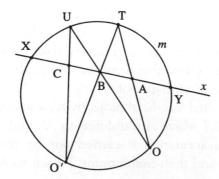

Figure 2.8 A co-basal transformation generated from a conic (circle).

through O'. In a similar manner, B is transformed first to U on line m through O and then back to B' through O'. It is evident that for these transformations, two points are generally fixed, the point X where lines m and x intersect, and the point Y where OO' intersects x. Since, in a general projective transformation, OA and O'A' meet on a conic m, the fixed points can also be pictured as the intersection of a line x with a conic m (circle), as shown in Figure 2.8, where A is projectively transformed to B on x by first projecting A to T on m through O, and then transforming T back to B through O'. In a similar manner, B is transformed to C via point U on m, etc. on line x. Conversely, a co-basal projectivity can be generated from an arbitrary conic (a circle in this figure) m and a base line x intersecting it, by choosing two points O and O' on the conic and relating the intersection points on the base line of pairs from O and O' that meet on the conic. It follows from glancing at Figure 2.8 that this co-basal projectivity has two fixed points X and Y. Co-basal projectivities have one fixed point when the base line is tangent to the conic, or no real fixed points when the base line and conic have no real intersection points (we shall see that it then has two *imaginary* fixed points).

2.5 Growth Measures

Now that we have defined a co-basal projective transformation of a line, let's see what sequence of points is the result of applying such a transformation repeatedly to an arbitrary point A on line x. Such a sequence of points is called the *trajectory* of A under this transformation. Referring to Figure 2.9, point A transforms to A', which we call B by first projecting to line m through O and then projecting the resulting point back to x through O'. Point B, in turn, transforms to C and C to D, etc. Such a trajectory is called a *growth measure*. If A begins near the left fixed point X and moves toward Y, then the trajectories start out with small step sizes, which increase in the mid-section between the fixed points and then decrease in size as they approach Y. To reach Y would take an infinite number of steps. If the order of the projections through O and O' are reversed, then the trajectory moves from A to the left fixed point X, which it also reaches after an infinity of steps. Thus, the entire growth measure represents a

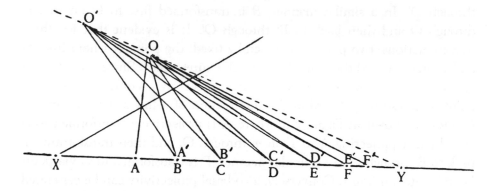

Figure 2.9 A growth measure.

doubly infinite set of points. Using the points X, A, B, Y to define the cross-ratio, or *multiplier* as we shall refer to it, from Equation (2.2):

$$\lambda = \frac{BX}{YB} \quad : \quad \frac{AX}{YA}. \tag{2.3}$$

Therefore, once the fixed points are chosen, the cross-product and hence the entire trajectory is determined by choosing the position of A and B. The multiplier of the reverse transformation is determined by the sequence YBAX, and it is the inverse $1/\lambda$ of the original multiplier.

Let's see what the effect on the growth measure is if we project the right fixed point Y to infinity. This is done by drawing an arbitrary line *b* and drawing a line through Y parallel to *b* as shown in Figure 2.10. If we project the trajectory of point A onto *b* from an arbitrary point on the line through Y, then X projects to a finite point X_1 on *b*, while Y projects to the infinite point on *b* and, since $\frac{YA}{YB}$ approaches the value of 1 as Y approaches infinity, the cross-ratio or multiplier reduces to $\lambda = \frac{X_1B_1}{X_1A_1} = \frac{X_1C_1}{X_1B_1} = ...$, which identifies the trajectory as the familiar *geometric sequence* (a sequence of the form a, ar, ar^2, ar^3, ..., in which the ratio between adjacent terms is constant, i.e., r in this case). In other words, growth measures can be viewed as double geometric series seen in perspective. Also, we see that if $\lambda = 1$ then all points of the growth measure are left unchanged, i.e., the growth measure is the identity transformation.

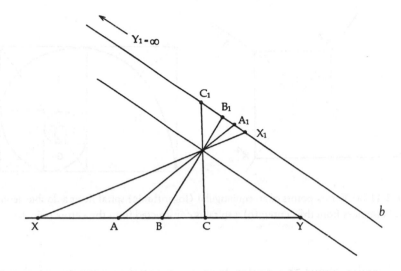

Figure 2.10 A growth measure with one fixed point mapped to infinity.

Next, consider the case of a growth measure in which the line through O and O' meets at the left fixed point X. Here, the two fixed points coalesce into one called a *double point* and the growth measure is called a *step measure*. This corresponds to the case in Figure 2.8 of a tangent line to the circle. In a manner similar to what we did for growth measures with two fixed points, we can project a step measure onto an arbitrary line, so that the double point is projected onto the point at infinity. We then discover that a step measure is the perspective image of an evenly spaced trajectory of points on line (an *arithmetic series*).

So we see that, even though projective transformations do not have obvious metric properties, they represent geometric models of *multiplication* in the case of growth measures and *addition* in the case of step measures. From the point of view of geometry, growth measures are far more likely to occur than the limiting case of a step measure. It is also interesting that it is the geometric series that manifests in the organic world. It is well known that shells of sea animals such as the Nautilus and the horns of animals grow according to *logarithmic* or *equiangular spirals*. Equiangular spirals are governed by the principle that radii from the center of the spiral at equally

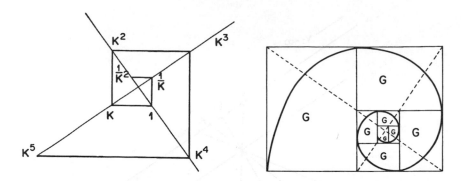

Figure 2.11 (a) Vertex points of an equiangular (logarithmic) spiral lie at a double geometric series of distances from the center; (b) a spiral is constructed from the vertex points.

spaced angles about the center from a geometric sequence, as shown in Figure 2.11. These curves were referred by [Coo] as "curves of life". We shall have more to say about this important curve in Sections 2.8, 7.5 and 18.4.

2.6 Involutions

There is one kind of growth measure that deserves special mention. It is depicted in Figure 2.12. Here, O and O' are on opposite sides of line m, and they are arranged so that point A transforms to B and B transforms back to A. Such a transformation is called an *involution*. By reversing the order of O and O', we obtain another involution that also transforms A to B and B back to A. Both of these transformations are called *breathing involutions* since the movement is back and forth across either of the fixed points with related points close to one of the fixed points playing the role of shallow breaths nested within the deep breaths of the point pairs more distant from the fixed point. In this sense, involutions are analogous to mirror reflections where the image approaches or recedes from the mirror as does the object.

Consider the four points: A, O, B, O' in Figure 2.12. A complex of six lines can be drawn through these four points. A cycle of four of these lines:

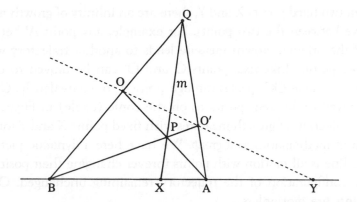

Figure 2.12 An involution sets up a pair of points A, B harmonic with respect to fixed points X, Y.

AO, OB, BO' and O'A forms a *quadrilateral*. *The other two lines OO' and AB join opposite vertices of the quadrilateral and are considered to be its diagonals.* The two diagonals intersect at the fixed point Y. On the other hand, opposite lines of the quadrilateral intersect in two additional points P and Q and line PQ intersects AB at the other fixed point X. It is fundamental to projective geometry that A and B are *harmonic* with respect to X and Y which means that the cross product of BXAY equals −1. Note that a composition of two successive applications of the involution results in the identity with $\lambda = 1$.

It is an interesting fact of projective geometry, and one that can be tested by construction, that if a single pair of points are found to be in involution then all points of the line are also in involution, or harmonic, with their transforms. Involutions carry with them another metric property, namely, the point harmonic to the point at infinity with respect to X and Y is the midpoint between X and Y. Any point between X and this midpoint is in involution with a point on the other side of X which serves as the *center* of the involution, whereas a point between the midpoint and Y is in involution with a point on the other side of the center, Y. Therefore, involutions can be directly correlated with the fixed points. Edwards has shown that involutions provide the key to understanding growth measures when the fixed points are not visible (see Section 2.7).

Given two fixed points X and Y, there are an infinity of growth measures that move between the two points. For example, any point A' between A and B of the original growth measure leads to another trajectory with the same fixed points. Likewise, points O and O' can be moved to different locations so long as OO' passes through point Y, or equivalently, O and O' can be moved to different positions on the conic (circle) in Figure 2.8. In fact, the collection of growth measures with fixed points X and Y form what is known in mathematics as a *group*. We have here a dynamic picture of a line. The line is all motion with points forever changing their positions yet with the configuration of the trajectory remaining unchanged. Only the fixed points are motionless.

2.7 Circling Measures

To complete the picture, we must also account for growth measures of co-basal projectivities for which there are no real fixed points. Edwards calls such growth measures *circling measures*. They are set up by transforming an evenly spaced set of lines from a pencil of lines centered at a point. For example, the 18 lines in Figure 2.13 are spaced 10 degree apart and each line undergoes a transformation of 60 degree in a clockwise direction. A circling measure is set up by the points of intersection of an arbitrary line such as the one shown in Figure 2.13, with this pencil. Unlike a growth measure, all points on this line are in motion. There are no fixed points. If we consider the line of the pencil that intersects the arbitrary line at right angles, that is where the movement along the line is "slowest" and this can be related to the imaginary value of the "fixed point". If the arbitrary line is moved towards the center in a perpendicular direction the movement slows down and comes to a halt when the line intersects the center. This is how a real fixed point emerges from the imaginary. It would require more space than we have in this chapter to describe these projectivities in further detail, so we direct the reader to *Projective Geometry* [Edw2] and summarize some of the important results.

We have already seen in Figure 2.8 that a conic and a base line cutting it sets up a growth measure on the line with the intersection points of conic and line as the fixed points. If the line and the conic do not intersect in

Figure 2.13 A circling measure.

"real points", they intersect in *imaginary points*. We shall now see how these imaginary fixed points come about. Consider a unit circle $x^2 + y^2 = 1$ and the line $y = \sqrt{2}$. Solving these equations for the intersection points, we find that $(X, Y) = (\pm i, \sqrt{2})$ where $i = \sqrt{-1}$ (see Sections 13.6 and 19.3 for a discussion of imaginary numbers). So we can say that, in some sense, the circle and the line share these two points. Let's now consider a circle and a series of parallel lines going to infinity. Each line shares a pair of points with the circle. We shall denote the two imaginary points on the line at infinity as I and J. Of course all circles share equally well these same points I and J.

Circling measures on a line induced by a circle or other conic can be created by the identical construction shown in Figure 2.8. The fixed points of this measure will be the two imaginary intersection points, I and J, and there is, once again, a group of circling measures that have the same two fixed points. In order to make these imaginary points and lines tangible, Edwards prefers to deal with the two involutions set up on this line instead of the imaginary points that correspond to them (the details are described

in [Edw2]). In Figure 2.13, transformations of a line through 90 degree in either a clockwise or counterclockwise direction results in an involution since two successive mappings of this kind brings the line back to itself. This transformation is known as a *circling involution*.

2.8 Path Curves

The remainder of this chapter deals with the mathematics of projective transformations and its application to generating a family of curves known as path curves. According to the research of Lawrence Edwards as described in his books, *Field of Form* [Edw1], *Projective Geometry* [Edw2], and *The Vortex of Life* [Edw3], these curves are close approximations to the spiral shapes of plants and other biological forms, as well as to the watery vortex.

Up to now we have been considering projective transformations of points on a line to points on a line, or lines in a point to lines in a point. Projective transformations of the plane that map points to points and lines to lines are called *collineations*. It is fundamental to projective geometry that collineations leave, in general, three points (real and imaginary) *invariant* (fixed). If the fixed points do not all lie on the same line, they define a triangle. Under a collineation any line in the pencil of lines centered at one of the fixed points is mapped to another line in the pencil. The points in which a pair of lines through a fixed point intersects the line making up the opposite side of the triangle sets up a growth measure on that line. The boundary lines of the triangle are invariant in the sense that any point on one of them is transformed by the collineation to another point on the same line, or sometimes, to the same point. This invariant triangle is the setting for a remarkable set of curves, known as *path curves*.

Given a set of fixed points A, B, and C and invariant lines a, b, and c as shown in Figure 2.14, a collineation is completely determined by choosing an arbitrary point M within the triangle and its transform M' under the collineation. This is obvious, since the projected points P, Q on line a and P'Q' on line c determine growth measures on those lines projected from auxiliary points O, O' of Figure 2.14 as described in Section 2.5. Therefore, the next point of the trajectory determined by the collineation is the point

Figure 2.14 Construction of a path curve.

in Figure 2.14 at the junction of lines AR and CR' where R and R' are the next points of the growth measures set on their respective lines. Thus the action of the collineation upon the initial point M sets up a trajectory of points, and these points lie on a set of invariant curves, known as path curves. As you can see, the path curves cut across the diagonals of the grid of quadrilaterals determined by the growth measure, i.e., the diagonal between M and M'. The path curves are invariant since any point that lies on such a curve is transformed to another point on the same curve. In general, any other pair of points not on the same path curve generates, by the same construction, another family of path curves. In fact, all path curves keeping the same triangle invariant form a group that mathematicians refer to as a *Lie group*. It can also be shown in [Clop] that all families of path curves of the plane can be described in *homogeneous coordinates* (see Appendix 2.A) as the solutions to three dimensional linear differential equations with constant coefficients.

One family of path curves is shown in Figure 2.15. All path curves have in common with this figure the fact that they pass through two of the fixed points, but not the third, and lie tangent to two of the invariant lines, but not the third. Edwards has this to say about path curves:

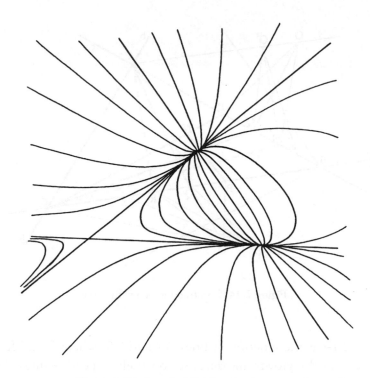

Figure 2.15 A typical family of path curves.

"We have a plane in which everything is moving. What can live, can hold itself intact within the flux? It is the whole set of path curves, and nothing else! Quantitatively we have a similar situation in any living organism; the substance of which it is made was not in it yesterday, and will not be in it tomorrow; as far as its matter is concerned it is in a state of continual flux; the substance flows in and flows out; if the organism was simply its substance we would not be able to recognize it from one day to another. Yet its being and largely its form are invariant from one moment to another and from one day to another. The form can live within the flux."

A family of path curves can also be determined by specifying multipliers, given by Equation (2.3) of the growth measures on any two invariant lines,

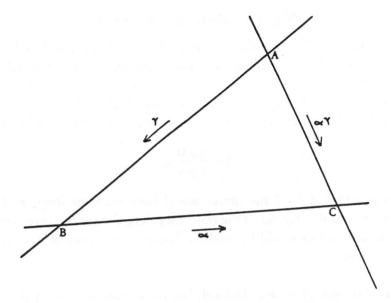

Figure 2.16 Orientations of the growth measures α, β, γ of a family of path curves. Growth measures a and γ are counterclockwise while $\beta = 1/\alpha\gamma$ is clockwise. By permission of Floris Books.

cross-ratio in the case of finitely situated fixed points, or geometric ratios in the case of a fixed point at infinity. For example, take α on line a and γ on line c, along with the directions of the trajectories on these lines, say counterclockwise. The growth measure β on the remaining line b is the product or composition of the growth measures on lines a and c, and has the effect of inducing a growth measure in the opposite sense (clockwise) with multiplier equal to the product of the two, i.e., $\alpha\gamma$. Since reversing the sense of a growth measure results in inverting its multiplier, then $\beta = 1/\alpha\gamma$ and α, β, and γ are related by,

$$\alpha\beta\gamma = 1, \tag{2.4}$$

when growth measures α and γ have the same sense (counterclockwise) as shown in Figure 2.16.

The equations of path curves have a surprisingly simple form. If we work in homogeneous coordinates, then the equation of the family of path curves is given by:

$$x^a y^b z^c = k, \quad \text{where} \quad a + b + c = 0$$

and a, b, and c are the logarithms of multipliers α, β, and γ and each value of k pertains to a different path curve of the family (homogeneous coordinates are described in Appendix 2.A). The fact that this equation is what mathematicians call *homogeneous* means that the shape of the curves depends not on the values of α and γ but on their *exponential ratio* Λ defined as,

$$\Lambda = \frac{\log \alpha}{\log \gamma}.$$

Thus if $\alpha = 16$ and $\gamma = 4$ the curves would have the same shape as if $\alpha = 9$ and $\gamma = 3$, only the step size of the trajectory along the curves corresponding to the smaller values would be smaller. Three special cases of path curves are of interest:

Case 1. Two multipliers are identical, but in opposite senses, say $\beta = 1/\alpha\gamma$. In this case the path curves (not shown) look much like the ones in

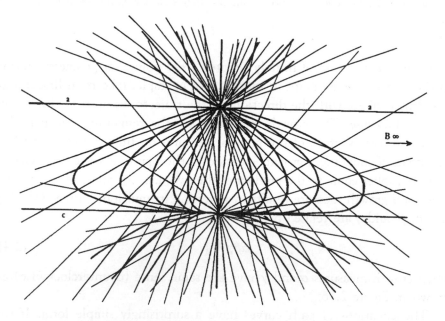

Figure 2.17 Path curves take the form of melons when one of the fixed points is transformed to infinity.

Figure 2.15 except that they are conics. But since, according to Equation (2.4), $\beta = 1$ (the points on AC are motionless), the pencil of lines centered on B must be the other family of path curves. Together, the two families form a grid of path curves.

Case 2. In Figure 2.17, point B is mapped to a point at infinity, while multipliers are taken on lines a and c in directions going counterclockwise from B to C and A to B. Notice that the path curves turn out to be egg-shaped, sharper at one end and blunter at the other. Much of Edwards'

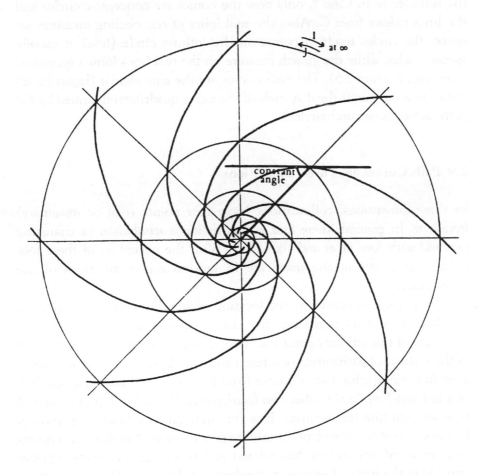

Figure 2.18 Path curves take the form of logarithmic spirals when two of the fixed points are transformed to I and J on the circle at infinity.

recent work has involved applying Case 2 to an analysis of bud forms. In the process he has discovered subtle changes in bud shape over fourteen day periods that are synchronized with lunar cycles [Edw3].

Case 3. Points *A* and *B* are mapped in Figure 2.18 to the points *I* and *J* on the infinite circle, while *C* remains fixed at a real point. In this case, the line of the invariant triangle connecting *C* to a point at infinity is real, while the other two lines of the triangle are imaginary. If the growth measures on these imaginary lines are identical, then the path curves are conics and the lines are as in Case 1, only now the conics are concentric circles and the lines radiate from *C*. Also, the multiplier of the circling measures set up on the circles result in points on the infinite circle (line) at equally spaced angles, while the growth measure on the real lines form a geometric series (see Section 2.5). The path curves are the equiangular (logarithmic) spirals that cut across the diagonals of the curvy quadrilateral formed by the path curves (lines and circles).

2.9 Path Curves in Three Dimensions

In three dimensions, collineations leave four points (real or imaginary) invariant. In general, these four points define a *tetrahedron* (a triangular pyramid with four faces and six edges). With the exception of these four points, all points of the space are in motion under iterations of the collineation.

Once again, by specifying the location of an arbitrary point within the tetrahedron and its transform, the entire transformation is fixed. The trajectory of this arbitrary point traces out a path curve through space. Most of the surfaces of path curves of interest to Edwards' studies of organic forms arise from tetrahedra, two of whose fixed points are the imaginary circling points *I* and *J* while the other two fixed points *X* and *Y* are finite and real (the semi-infinite tetrahedron). It is very difficult to visualize this surface. It is made up of two real planes at infinity (the equivalent in three dimensions of lines at infinity in two dimensions) and two imaginary planes (planes existing in the space of imaginary numbers), and two real lines, one joining *X* to *Y*, and the other one being the line at infinity which carries points *I*

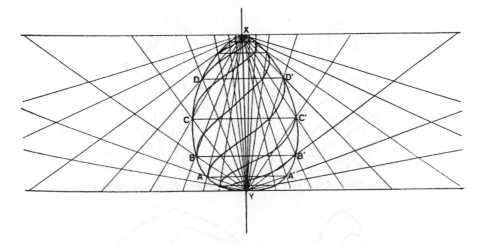

Figure 2.19 Spiral path curves on an egg-like surface. By permission of Floris Books.

and J. The path curves on the two real planes contain a family of equiangular spirals such as the ones shown in Figure 2.18. More details are given in Edwards' books.

Edwards' fundamental surfaces are egg-shaped forms, shown projected onto a plane in Figure 2.19, created by choosing a pair of congruent spirals on each of these real planes with spirals that lead out of Y and into X. The path curves on these surfaces are spirals of the type shown in Figure 2.18. Edwards then characterizes the shape of these surfaces by a parameter much like Λ but suitable for three dimensions, not mentioned here.

2.10 Field of Form

According to Edwards:

"When our attention is drawn to the various path curve surfaces previously described, and especially the egg-like forms which occur with the semi-imaginary tetrahedron, we immediately become aware that forms very similar to these are to be found

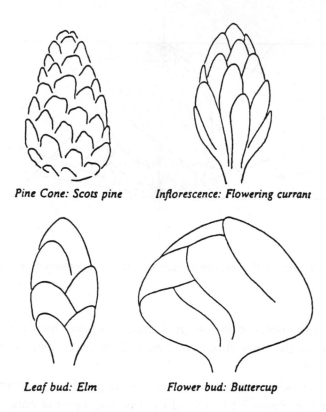

Pine Cone: Scots pine *Inflorescence: Flowering currant*

Leaf bud: Elm *Flower bud: Buttercup*

Figure 2.20 Four ways in which path curves are to be seen in the plant kingdom.

in at least four situations in the plant world (illustrated in Figure 2.20):

a) the numerous families of pine cones and related seed formations;

b) tightly packed bunches of flower buds (e.g., rhododendron and flowering currant) in which the separate buds are nearly always arranged in spiral formations;

c) leaf buds of deciduous trees (oak, beech, elm, etc.) in which the little leaflets are themselves set in spirals;

d) the large domain of flower bud where in a large proportion
of cases the petal edges climb spiralwise around the
egg-shaped form of the bud itself."

Edwards then sets out to meticulously measure, using statistical methods,
the outer shapes for many such plants, and he has been able to make a
convincing argument for their being path curves. A typical path curve
within the tetrahedron takes the form of a spiral on the surface of an
egg-shaped form. When two of the points of the tetrahedron are mapped to
points at infinity, the path curves take on forms remarkably like the shape
of plants, buds, and other organic forms. He has also applied his methods
to studying the shape of eggs of different species of animals, the shells of sea
animals, the shape of the hearts of animals, and the living human heart as
seen through an angiogram. All of these have corroborated his ideas about
the relation of path curves to living forms.

Edwards reports on an odd form that, until recently, resisted all of his
techniques of analysis, namely, the seed chamber buried within the depths
of the rose form with yet another fundamental idea of projective geometry
[AdamG]. He projected one of the remaining finite fixed points of the
semi-imaginary tetrahedron to infinity and applied a transformation which
he calls a *pivot transformation* in which the original transformation that
generated the rose bud, forms the basis of a new transformation between
elements from the dual spaces of planes (positive space) to elements of
the space of points (negative space). In this transformation, shown in
Figure 2.21, the plane at infinity, the absolute "point" of the positive space,
representing the "cosmic realm" is related to the pole at the remaining
finite point Y, the absolute point of the negative space, which represents
the "seed". The points on the infinite plane are dual to a cone of planes
centered at the absolute point.

The shape of the family of path curves of this transformation resembles
a "watery vortex", and this family was so named by Edwards. These path
curves have proven very good in describing the shape of the ovaries of
plants. Much to his amazement, using an apparatus for measurement designed
by a colleague, Edwards discovered that this form fits exactly to the shape
of actual watery vortices.

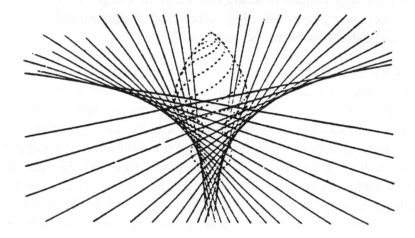

Figure 2.21 The form of the rose led to the concept that the bud would mediate between a planewise vortex and the form of the rose hip.

2.11 Comparison of Three Systems

Three systems of thought have been presented in Chapters 1 and 2: Guidoni's analysis of some primitive myths and rituals, Schwenk's observations of the living forces within water, and Edwards' field of form. Although these systems are quite different in their representations of the natural world, they also have much in common.

The most striking similarity between them is their dynamic vision of nature. For example, the act of conception is presented in the Bamba ritual of the Australian aborigines (Section 1.2) as a movement toward a sacred center. All creation in the Fali myth (Secton 1.3) is represented as a series of vibrations. Schwenk represents the genesis of form in terms of movements of waves, vortices, and meanders. The particles of water continuously change but the outward form is stable. The same holds for Edwards' path curves, which can be viewed as the trajectories of a moving series of points.

The three systems agree with each other concerning the role that astronomical influences have on earthly events. The sacred pole of the Achilpa serves as a direct link to transmit some form of life energy from

heaven to earth to nourish the tribe. The vortex, by opening up sensitive membranes of water to external influences, plays the same role in Schwenk's system. These influences are sucked toward the vortex center by negative pressure (Section 1.9). Edwards' watery vortex transformation places a plane at infinity to absorb distant influences that pass along spirals to a fixed center at the base of the plant's ovaries.

Each system is built on the notion of sacred centers with no fixed location within an otherwise undifferentiated chaos. Wherever the chief of the Achilpa placed the sacred pole, that is where the center lies. Each watery vortex functions as a closed system and carries the center of its own "universe", complete with its built-in direction to the "fixed stars". Edwards also sees every plant as being a closed system with its center located at the base of the ovaries.

The logarithmic (equiangular) spiral plays a key role within each of these systems. In the Bamba ceremony, the dancers crawl toward the sacred center along logarithmic spirals. Each of the fundamental patterns of water manifest in the natural world in spiral formations. The fundamental patterns of water manifest in the natural world in spiral formations. The fundamental surfaces from which Edwards develops organic forms are derived from logarithmic spirals. Even meandering streams can be looked at as helices that have been flattened onto a planar surface.

The mythic beginnings of the Fali people go back to two cosmic eggs. Schwenk feels that the forces of water are instrumental in the development of the embryo from the egg. Edwards' path curves always generate egg-shaped forms with spiral striations.

In Fali myth, all creation comes about through alternate and opposing movements. These alternate and opposing movements are evident in the oppositely directed spirals of vortex trains, and are also incorporated in the spongy structures of joint formations of humans and animals. Involutions that characterize the group of growth measures can be viewed as alternating and opposing movements or vibrations, and these growth measures are the key to deriving Edwards' field of form.

Finally, every element of Fali society either partakes in a positively or negatively directed motion or is a fixed center. As we saw, the "feminine" cylindrical walls of their huts are positively directed while the "masculine" conical roofs are negatively directed with respect to the fixed center at the

vertex of the cone. Is it far-fetched to imagine a connection between this image and Edwards' pivot transformation? Here, the infinite plane and the center of this transformation are conceived of as positive and negative dual spaces. Points of the positive space are transformed to planes of the negative space that envelope a cone about the center.

2.12 Conclusion

We have shown that spiral forms are ubiquitous in the natural world. Primitive people, understood the importance of the spiral as an expression of nature. Projective geometry and the mathematics of the spiral may help to bridge the enormous chasm between ancient systems of thought and the modern world of science. There are also benefits to be gained for science by bridging this gap.

Appendix 2.A. Homogeneous Coordinates

The points of a projective transformation can be described by a system of *homogenous coordinates*. First consider the points on a line. Each point on the line is represented by a pair of homogeneous coordinates, (kx, k) for any value of $k \neq 0$. Thus, a point on the line has many different representations. For example, the point one unit to the right of the origin can be represented by, (k, k) or $(1, 1),(2, 2),(3, 3),\ldots$, for $k = 1, 2, 3,\ldots$, etc. The point 2 units to the right of the origin is: $(2k, k)$ or $(2, 1)$, $(4, 2)$, $(6, 2),\ldots$ for $k = 1, 2, 3,\ldots$, etc. The origin of the coordinate system is also represented by $(0, k)$.

Notice that the usual cartesian coordinate of the line is the x-coordinate of the homogeneous coordinates when k is set equal to 1, e.g., $x = 1$ corresponds to homogenous coordinate $(1, 1)$ while $x = 2$ corresponds to $(2, 1)$, and the origin $x = 0$ is $(0, 1)$. The value of this system is that it enables the point at infinity to be represented by finite coordinates. The point at infinity is represented in homogeneous coordinates as $(q, 0)$ for q finite. This makes sense since, as k approaches 0 in (kx, k), kx remains finite only if x approaches infinity. Thus, with all generality the point at infinity can be represented by $(1, 0)$, with q set equal to 1. The geometry of this

system will be described in Section 4.2 in connection with a representation of the tones of the musical scale.

In terms of homogeneous coordinates, a co-basal transformation between fixed points X and Y, as shown in Figure 2.9, can be represented on the unit interval, in homogeneous coordinates where X represents the origin $(0,1)$ and Y represents the point at infinity, $(1, 0)$.

In a similar manner, the points of the plane can be represented in homogeneous coordinates by (kx, ky, k) for $k \neq 0$. The line at infinity consists of all points of the form: $(p, q, 0)$.

3
Harmonic Law

> Music is the hidden arithmetical exercise of a
> soul unconscious that it is calculating.
>
> *Gottfried W. Liebniz*

3.1 Introduction

In this chapter and the next two I will present some of the materials that make up the study of what may be termed "speculative music". There have been many attempts to trace the significance of the musical scale in ancient cultures as a tool for understanding astronomical and cosmological phenomena [Boe]. Scientists such as Kepler and Newton, in their search for the musical harmonies in the natural world, felt themselves part of a chain which stretched back through the logic of Ptolemy, Plato, and Pythagoras to the mythology of Apollo, Hermes, and Orpheus.

The musicologist Ernest McClain has gathered a great deal of suggestive material connecting musical tuning systems with the numerology in such ancient books as the Rig Veda, the Dialogues of Plato, and the Holy Bible. McClain believes that quantifying the location of musical tones in the cyclic octave presented early cultures with problems similar to those faced in defining solar and lunar cycles. Rational numbers, the only kind then available, proved inadequate. This fostered an art of approximating irrationals by a slight excess or deficiency, a task demanding strict discipline and a comfortable literacy. A spiritual "warfare" thus developed within the number theory required for cosmology, and its metaphors were absorbed into the sacred scriptures of surviving cultures. McClain believes that ancient

mythology is thus inspired harmonical allegory, descending from an early professional scribal virtuosity in algebra.

Drawing on the direct epigraphical evidence of Egyptian arithmetic, Babylonian astronomy, Assyrian lyre tunings, Platonic musicology, references to number in the Bible, Ptolemaic science, and later Alexandrian philosophy, McClain imaginatively reconstructs a plausible musical correlation. His methods must be evaluated by their self-consistency in shedding new light on otherwise obscure passages in ancient literature. In the first part of this chapter I present McClain's archaic reconstructions, and then follow with a modern explanation. To avoid assuming any musical knowledge on the part of the reader, I will explain certain necessary musical fundamentals.

My personal interest in McClain's recreation of ancient harmonic law are two-fold:

1) his portrayal of a tension between the incompleteness of the number system when restricted to rational numbers and the continuum of geometry;

2) the importance of the ratio of small whole numbers in the representation of tones from the musical scale.

Part two of this book is devoted to showing that these are still issues of importance in modern mathematics, only now in the context of dynamical systems.

3.2 Musical Roots of Ancient Sumeria

The Sumerian culture of Mesopotamia during the fourth millennium B.C. was far more advanced than its neighbors. Many aspects of this culture were incorporated into the societies that followed, such as those of the Babylonians and the early Hebrews. There is evidence from testimonials of Greek historians such as Iamblichus and Diogenes Laertius [Far] that much of Greek knowledge and wisdom came from this part of the world, and that this ancient knowledge may have been transmitted to Pythagoras. We know little about the details of Sumerian civilization. However, from the great storehouses of musical instruments found at Sumerian burial sites, we

know that this was an aural culture in which music played a significant role [Far].

McClain points to a great advance in mathematical thinking in ancient Mesopotamia, based on the relationships inherent in the musical scale. Certainly, man had conceived of numbers long before recorded history. Early man used numbers to count objects of importance, such as animals or arrowheads. But this is not real mathematics. It was a great revelation when the first man realized that the sensation of sound was based on the *ratio* of string lengths and not on their absolute lengths. For example pluck a string and then shorten the string by $\frac{1}{2}$ and pluck it again; you experience an octave increase of the original pitch. The same sensation of an octave occurs independent of the fundamental tone giving alternate aural images of the same reality. Although there is no clear record of these events, McClain believes that this discovery may have taken place in Mesopotamia between 3 and 4 millennia B.C. [McC4].

Harmonic law may have been the first organized system in which rational numbers played a major role. In fact the ratio of small whole numbers organized in a cyclic pattern is the key to understanding the musical scale. Divorcing number from pure magnitude and centering it on showing the relation between things (in this case musical intervals) was a big step in the direction of abstract mathematical thinking. By early in the third millennium the Sumerians had achieved considerable musical development and may have created a sophisticated musical theory to accommodate these developments, although there is only circumstantial evidence to support this view.

The theory of the musical scale may have been one of several factors that led the Sumerians, sometime in the third millennium, to create the sexagesimal (base 60) system, and with this, the ability to do mental arithmetic of a high order. The sexagesimal system represents numbers in terms of powers of 60 much like the decimal system uses powers of 10 [Barr]. The musical matrix that I shall describe in Sections 3.3–3.5, based on the sexagesimal system, may have been the equivalent of the first digital computer in its ability to facilitate rapid calculations. Whereas the origin of this base 60 system is unknown, it was known to the Sumerians [McC4]. At the same time, there is some evidence that the musical scale was used as metaphor in mythology and sacred scriptures. The pantheon of

Sumerian gods were assigned numbers relating to the musical scale [Hoo], [McC4].

Around 2100 B.C. the Babylonians developed a particular virtuosity for computation and began to apply it to astronomy. The ideas were somewhat transformed and diffused into the numerology of the Hebrew Bible (cf. [McC5,6], [McC-S]). The musical scale is based on ratios of the first six integers, 1:2:3:4:5:6. McClain feels that this may be related to the Biblical six days of creation, with the number 7 reserved for the realm of the sacred or God. Pythagoras brought these ideas to Greece from his travels to the East. They became part of the basic education of every Greek youth. Recent research of Anne Bulckens [Bul] shows that many of the measurements within the Parthenon can be expressed as integers related to the musical system of Pythagoras. Even as late as 150 A.D., Ptolemy was still using the base-60 system to do his very accurate astronomical calculations. Indeed our system of angle and time measurement in degrees, minutes, and seconds reflects this ancient system.

These themes will be explored later in this chapter. The musical scale will be shown to be based on a symmetry of opposites, a rising and falling scale. The tension between opposites has been also illustrated by such star hexagon symbols as the Hindu Sri Yantra and the Star of David shown in Figure 3.1, and in Schwenk's and Edwards' theories, described in the previous two chapters, in which plants are both rooted to the earth and open to the heavens. It is McClain's theory that these star hexagons lie behind the structure of the musical scale.

3.3 Musical Fundamentals

Sound manifests itself in the form of vibrations of air. Vibrations of high frequency give rise to high-pitched sounds while low frequencies are perceived as low tones. Our perception of sound is very much bound up with the anatomy of the ear. Any pair of tones whose frequencies are in the ratio 2:1 are perceived as being of the same *pitch class* although at differing pitches. Such tones are said to differ by an *octave*. This latter term (*eight*) reflects the now almost universal acceptance of an ancient Middle Eastern preference for cyclic heptatonic (seven-tone) structures which repeat on every eighth

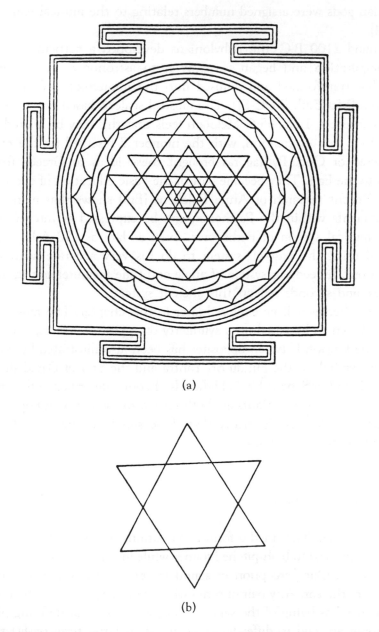

(a)

(b)

Figure 3.1 The tension of opposites illustrated by the (a) Hindu Sri Yantra diagram; (b) the star of David.

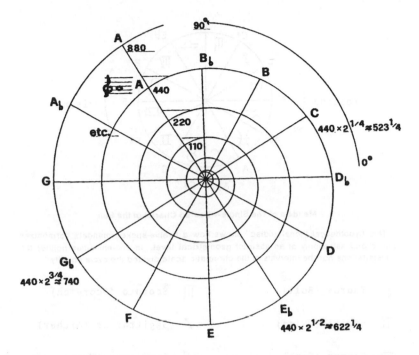

Figure 3.2 The 12-tone spiral with sample vibration rates at four quarters.

tone (i.e., like our names for the seven days of the week). The present musical scale known as the equal-tempered scale, involves placing twelve *evenly spaced* tones into the space of one octave, where what we mean by evenly spaced will be made clear. The letters A through G are used to represent tones along with sharps and flats, called *accidentals*.

If the 12 tones of the *equal-tempered* scale are placed on a polar coordinate graph at equal angles, and the ratio of frequencies is represented by the radial distance to the origin of the coordinate system, the equal-tempered scale lies on a *logarithmic spiral* (see Section 2.5 and Figure 2.11) as shown in Figure 3.2. Appendix 3.A gives a brief introduction to logarithmic spirals and logarithms, and its relationship to the equal-tempered scale. Higher octaves spiral outwards while lower octaves spiral inwardly, with the radial distance of the fundamental note represented by the sequence:

$$\ldots, 2^{-3}, 2^{-2}, 2^{-1}, 1, 2, 2^2, 2^3, \ldots \text{ or } \ldots, \frac{1}{8}, \frac{1}{4}, \frac{1}{2}, 1, 2, 4, 8, \ldots$$

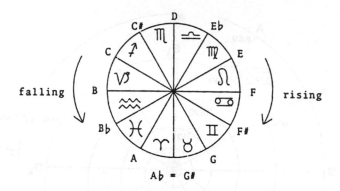

Mandala of The Single-Wheeled Chariot of the Sun

This hypothetical "tonal zodiac" shows how a twelve-spoked mandala harmonizes music and astronomy at an abstract geometrical level. In ancient times neither the constellations nor the intervals of the chromatic scale divided the cycle equally.

♉	Taurus (Bull)		♏	Scorpio (Scorpion)
♊	Gemini (Twins)		♐	Sagittarius (Archer)
♋	Cancer (Crab)		♑	Capricorn (Goat)
♌	Leo (Lion)		♒	Aquarius (Water bearer)
♍	Virgo (Virgin)		♓	Pisces (Fish)
♎	Libra (Balance)		♈	Aries (Ram)

Figure 3.3 The equal tempered rising and falling scale depicted as a mandala of the single-wheeled chariot of the sun. This hypothetical "tonal zodiac" shows how a 12-spoked mandala harmonizes music and astronomy at an abstract geometrical level.

Because doubling and halving is an octave relationship, a twelve-tone cyclic group is generated by the 12th root of 2, that is by the ratio of 1.059..., very close to 6%. The radial distance of the spiral grows about 6% per tone, and like compound interest, the frequency (principal) doubles after 12 tones (years).

If we are indifferent to the physics of sound and concerned only with tonal function, as musicians normally are, then the spiral can be collapsed into a tone circle as shown in Figure 3.3. The twelve signs of the zodiac

have been placed on the circle. This hypothetical *tonal zodiac* shows how a twelve-spoked mandala harmonizes music and astronomy at an abstract geometrical level although in ancient times neither the constellations nor the intervals of the chromatic scale divided the cycle equally. The ratio of frequencies between any tone and the central tone D are indicated on the circumference. (Note that in comparing the tones of Figures 3.2 and 3.3 the following tone pairs are equivalent to each other: A sharp = B flat, C sharp = D flat, D sharp = E flat, F sharp = G flat, G sharp = A flat). On either circle or spiral, the scale can be thought of as rising in pitch by reading the circle or spiral in a clockwise direction or decreasing in pitch by reading it counterclockwise.

Each division is called a *semitone* and the distance between tones, measured in semitones (s), is referred to as an interval. Some common intervals and their semitone values are listed in Table 3.1 assuming *D* as the fundamental tone.

Note that in Figure 3.3 the octave from *D* to *D'* can be subdivided into a *perfect 4th* from *D-G* (four tones from *D* to *G*: *D, E, F, G*) and a *perfect 5th* from *G-D* (five tones from G to *D*). Such pairs of intervals are called complementary. Similarly, the major 3rd and minor 6th, and the minor 3rd and major 6th are also complementary.

From the viewpoint of the 12-tone theorist, any diameter through opposing points in Figure 3.3 locates the square root of 2 which defines the

Table 3.1 Tonal intervals.

semitone	*D-D* sharp	1s
wholetone	*D-E*	2
minor 3 rd	*D-F*	3
major 3 rd	*D-F* sharp	4
perfect 4 th	*D-G*	5
tritone	*D-G* sharp	6
perfect 5 th	*D-A*	7
minor 6 th	*D-B* flat	8
major 6 th	*D-B*	9
minor 7 th	*D-C*	10
major 7 th	*D-C* sharp	11
octave	*D-D'*	12

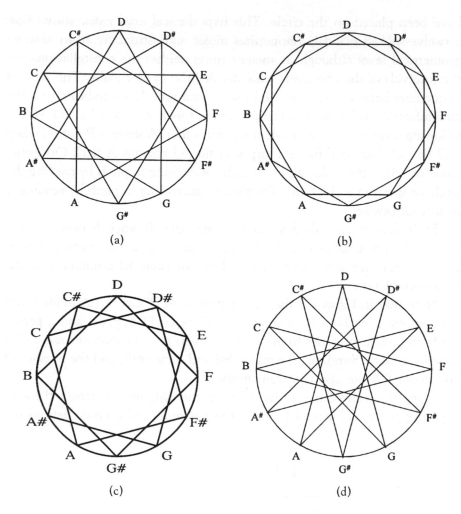

Figure 3.4 Cyclic subgroups represented on 12-pointed stars; (a) four-cycle (major thirds); (b) a two-cycle (whole tones); (c) five-cycle (fifths).

musical tritone for its own pair of tones. The twelve pointed stars of Figure 3.4 illustrate cyclic subgroups of the 12 tone scale. In Figure 3.4a, every fourth point is connected (the star {12, 4}). The sides of any triangle in this figure define major thirds. If every second vertex is connected, as shown in Figure 3.4b (the star {12, 2}), the sides of any hexagon define a wholetone scale while the sides of any square of star {12, 3} define minor

thirds shown in Figure 3.4c. These exhaust the cyclic subgroups within a model octave, but the gamut, of piano, organ, and orchestra (eight to nine octaves) creates a "space" for cyclic subsets of even larger intervals.

Notice that star {12, 5} in Figure 3.4d does not disconnect into cyclic subsets but results in a connected star (the mathematical consequence of 12 and 5 having no common factors). This so-called circle of fifths will be exploited in the next section to determine the relative frequencies of the 12-tone scale in the manner of modern piano tuners. However, we shall see that this tuning tradition goes back beyond recorded history.

3.4 Spiral Fifths

In the ancient world, with its restriction to rational numbers, harmonic theory was essentially the study of numerical coincidences in approximating the idealized structures described above. The relationship between pitch and the length of a plucked or bowed string was probably the first instance of a relationship that required the concept of rational numbers. When other factors are held constant, the doubling or halving of string length produces, respectively, a lower or higher octave respectively. This is illustrated on a single string lying above a resonating chamber called a monochord, as shown in Figure 3.5(a). Here, a string is stretched between two fixed bridges at the ends of the string. The length of the vibrating portion of the string is controlled by a movable bridge. If the movable bridge is set at an arbitrary position, shown in Figure 3.5(b), and the string is plucked it gives off a resonant tone called the *fundamental or tonic*. If the movable bridge is moved to the location $\frac{1}{2}$ (see Figure 3.5b), the resulting tone is the fundamental raised one octave. Any octave is suitable for a theoretical model (i.e., the string length is arbitrary).

Pitch names are merely local conventions. Arithmetical reciprocals produce the same intervals, but in opposite directions. In other words, if the bridge is moved to the location 2 thus lengthening the string, the plucked tone is the fundamental lowered one octave. In this way any ratio, $x:y$ or $y:x$, can be represented by a monochord bridge position. Thus tuning theory concerns a two-dimensional realm (measured by x,y-coordinates

(a)

(b)

Figure 3.5 (a) A monochord; (b) schematic diagram of a monochord showing the positions of the octave, fourth, and fifth, and their reciprocals.

[see Section 4.2]) of perfect inverse symmetry whose matrix or "Great Mother" is the ratio 2:1. For this reason all even numbers are similarly considered by ancient cultures to be "female". Harmonic theory also shows us that the ratio of pitch frequency of an interval is inversely related to the string ratio. The most remarkable of all coincidences is that intervals within the octave 1:2 which musicians prefer to tune by ear — namely, perfect fifths have a ratio 2:3 while complementary perfect fourths correspond to the ratio 3:4 (they neatly divide the octave double into 2:3 and 3:4) — are worth almost precisely seven semitones and five semitones respectively (the ratio of frequencies of the fourth and fifth, or the wholetone, is only slightly more than its counterpart in the equal-tempered scale). Notice that according to the definition of the logarithmic spiral in the last section, whereas intervals add, the ratio of frequencies (or string lengths) multiply, e.g., $\frac{2}{3} \times \frac{3}{4} = \frac{1}{2}$ (an octave) while $5s + 7s = 12s$, and $\frac{2}{3} : \frac{3}{4} = \frac{8}{9}$ while $7s - 5s = 2s$ (a wholetone).

An up and down succession of these intervals in preferred tuning order is easily contrived to closely simulate 12-tone tuning. This musician's spiral, with tones descending a fourth and ascending a fifth is illustrated in Figure 3.6. There is a very slight cyclic excess in the tuning ratios by comparison with the equal-tempered scale, unnoticeable until it accumulates

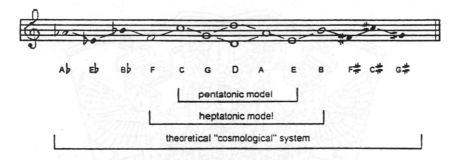

Figure 3.6 Serpent power: the spiral tuning of fourths and fifths. Courtesy of Ernest McClain.

through several pitch classes. This excess is just sufficient to make the distinction between the first tone (A-flat) and the 13th tone (G-sharp) noticeable under laboratory conditions. Thus the natural tuning process proves intrinsically cyclic if it is continued this far! (Five to seven pitch classes were the usual ancient norm, East and West.) The barely perceptible overlap between the 1st and 13th tones is known as the *Pythagorean comma*. Its value is computed in Appendix 3.A. Notice that alternate tones in this sequence belong to wholetone progressions easily mapped (and with adequate accuracy) by a hexagon (see Figure 3.4b), so that an ancient scientist possessed tools as convenient as our own for explaining tuning theory via visual geometrical aids. The cumulative cyclic excess encourages us to view this system from its center, taking pitch-class *D* (center of symmetry in our modern naming system) as representing an all-purpose "Deity" (and immutable reference center), embracing the universe with his two "arms". There is a gradually increasing internal *dissonance* as we move outward from the center into a world considered as "emanating" from "Him". Thus the ancient Pythagorean dedication to the *symmetry of opposites* was required by the model it used, and it continues to encourage us to view the tone system from its middle; we introduce sharp and flat symbols only as needed (raising and lowering pitch class by a semitone), and use them as sparingly as possible. Pentatonic and heptatonic scale systems suffered no problem with this concept of tuning for as long as musical styles remained essentially melodic and the word "symphony" implied, as it did in Greece and many Eastern ensembles, playing and singing in parallel octaves. *Twelve-tone* music

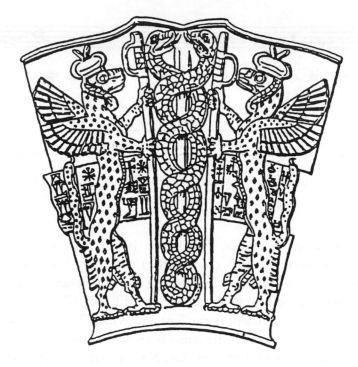

Figure 3.7 Sumerian double-serpent symmetry; from the steatite vase of Gudea in the Louvre, Paris.

requiring all pitches to be pre-tuned appears only much later in history with the advent of polyphonic music; ancient examples pertain only to theory.

McClain suggests that this musical spiral may be the basis of ancient dragon and serpent myths such as the one shown in Figure 3.7. Tuning theory begins with the arithmetization of this serpentine tuning progression. And it proves astonishingly simple. Some ancient maker of harps or panpipes, McClain assumes, must have noticed that successive lengths needed for this sequence vary about one-third, and so a rule was born:

"Add or subtract one-third"

(i.e., from successive string or pipe lengths). Pitch-class remains indifferent to this addition and subtraction because $\frac{2}{3}$ and $\frac{4}{3}$ are *octave equivalent*, i.e., $\frac{4}{3} \times \frac{1}{2} = \frac{2}{3}$. It is never necessary for a workman to know that the rule is

perfectly accurate only on an idealized monochord, and only approximately accurate for pipes of particular diameters, because ancient pipes and strings themselves were never perfectly uniform; final tuning always was, and still is, done by final adjustment of individual string tension (of pipe and tone-hole diameters, and breath control). Thus an approximate ancient craftsman's rule eventually would have been sufficient to give birth to a theory in somebody's mind. Judging from the contents of ancient ritual burials, pipes and strings were sufficiently abundant in the ancient Near East by the beginning of the third millennium B.C. to suggest such knowledge. Chinese ritual flutes appear at least 2000 years earlier, and a seven-holed flute was recently found in the Yellow River valley in Henan Province in central China dating to around 7000 B.C. in a condition playable today [Fou]. Therefore, the invention of tuning theory cannot be localized either in time or space, and may never have been thought of as an invention at all. Man simply awoke to an observation, a truth evident in the tuning of any harp.

The oldest expression of the "plus or minus one-third" rule is attributed to Kuan Tzu (7th century B.C.) [Nak], who explains how to apply it arithmetically and geometrically to the standard pentatonic scale. Since four new values (of relative string length) are to be computed from the reference value, he tells us to first "take three four times" (meaning $3 \times 3 \times 3 \times 3 = 3^4 = 81$) to compute four successive values from 81 through 108, 72, 96, to 64 ($= 2^6$), where factors of 3 are exhausted. For example,

$$81 + \frac{1}{3} \times 81 = 108, \quad 108 - \frac{1}{3} \times 108 = 72, \quad \text{etc.}$$

Taking C as the reference value results in the tone series,

$$
\begin{array}{ccccc}
C & G & D & A & E \\
81 & 108 & 72 & 96 & 64
\end{array}
\tag{3.1}
$$

which can be increased or decreased by powers of 2 and reordered into any one of five descending pentatonic scales, e.g.,

$$
\begin{array}{ccccc}
G & E & D & C & A \\
54 & 64 & 72 & 81 & 96
\end{array}
$$

each tonally equivalent to the succession of black keys on the piano.

Analogously, a heptatonic calculation begins on $3^6 = 729$ and ends on $2^9 = 512$ producing the Pythagorean scale. To arithmetize the entire spiral of thirteen tones, merely start with a reference value of $3^{12} = 531,441$ and zigzag appropriately to end on $2^{19} = 524,288$ (the Pythagorean comma is related to the difference (or ratio) between these values, as is shown in Appendix 3.A).

Notice that this process always begins with the largest "male", yang odd number (a power of 3) and ends with the largest "female", yin even number (a power of 2), e.g., 81 and 64. Thus the prime numbers 2 and 3, female and male respectively, inspire Chinese "five element" theory and yin-yang dualism, and are projected from Chinese musicology onto Chinese culture as a whole. These notions are indigenous also in Western theory under analogous rubrics such as the pentatonic structure of folk melodies, somewhat obscured however by the wider success of heptatonic thinking. Figure 3.8a shows that multiples of either frequency or string length by powers of 3 result in the seven-tone scale while Figure 3.8b illustrates that powers of 2

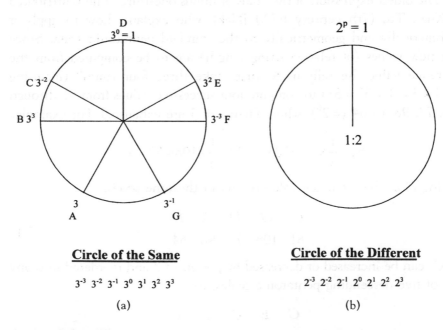

Circle of the Same

$3^{-3} \ 3^{-2} \ 3^{-1} \ 3^0 \ 3^1 \ 3^2 \ 3^3$

(a)

Circle of the Different

$2^{-3} \ 2^{-2} \ 2^{-1} \ 2^0 \ 2^1 \ 2^2 \ 2^3$

(b)

Figure 3.8 From Plato's *Timaeus*, (a) the "circle of the same" showing generation of the heptatonic scale from powers of 3; (b) the "circle of the different" showing octave identity between tones.

preserve the tone, merely altering the octave. McClain [McC2] sees these as the "circle of the Same" and the "circle of the Different", pertaining to the creation of the "World Soul" in Plato's Timaeus. The two systems reflect the fact that Chinese astronomy never counted the Sun and Moon as planets ("wanderers"), as Western astronomy did, requiring a heptatonic model (representing the seven wandering stars known to the ancients). In both East and West, for reasons we do not understand, heptatonic and pentatonic structures were both well-loved, enjoyed the same arithmetic, fueled the same cultural metaphors, and encouraged the same modal permutations. Any tone in a set of five or seven could be lowest, highest, or middle, and function as a modal identifier merely by doubling and/or halving its values appropriately, and so musical practice did not affect mathematical theory.

All of these spirals can be tuned in reverse order by inverting the tuning rule, and working from right to left. The reformulation proves less elegant:

"subtract one-fourth or add one half"

(i.e., to reach $\frac{3}{4}$ and $\frac{3}{2}$, which are octave equivalents), and thus exposes the superiority of the Chinese rule, which seems to have been forgotten in the West.

3.5 Just Tuning

We should expect that in the high civilizations of the ancient world, expert in handling fractions, arithmetized tunings suffering from an obvious cyclic excess would be paired with another tuning showing a compensating cyclic deficiency by comparison with the equal-tempered scale. It was in both Taoist China and ancient Greece that brilliant alternatives arose [Barb]. In the West we know this alternative tuning, with cyclic deficiencies, under the rubric of *Just* tuning.

Ancient harmonicists loved its arithmetical parsimony. It permits all twelve tones to be defined with integers of no more than three digits. In the previous section, the pentatonic scale was easily defined in either tuning

with two-digit numbers, but remember that spiral-fifths tuning requires six digits for the complete 12-tone system. This is numerically grotesque because nobody can hear the difference of plus or minus one unit beyond the third digit, and few of us notice such a distinction even in the third digit. Thus human convenience, affection for arithmetical parsimony, and the ear's benign tolerance of very small differences combine to encourage attention to a *Just* tuning whose smallest heptatonic pattern, we shall see, is placed within a 30:60 octave and whose 12 tones are placed in the 360:720 octave. The tones of the Just scale are arranged in a circle (see Figure 3.9), with their corresponding ratio of frequencies relative to the fundamental, *D*.

Notice that the semitones are not of equal length, as they would be in the equal-tempered scale, and that numerators and denominators of these fractions now have factors of prime 5 in addition to 2 and 3 of the "serpent" tuning.

This Just tuning arises from a very slight contraction in the two ends of the "Great serpent" shown in Figure 3.6. If we merely drop a unit from our pentatonic base of 81, we end up with the ratio 64:80 = 4:5, a *pure third* (*C:e*, or inversely, *E:c* rather than *E:C*). As a consequence of this contraction (by a *syntonic comma* of 80:81, imperceptibly smaller than our previous comma), the tones: *e-b-f* sharp-*c* sharp-*g* sharp are each a comma lower in pitch; and the tones: *a* flat-*e* flat-*b* flat-*f-c* are each a comma higher in pitch. We have merely shrunk the "serpent" a bit at two symmetric loci, just sufficiently to create a gap between *a*-flat and *g*-sharp (whereas before we had an overlap). These alternate Just pitches are designated in lower case letters by McClain to call attention to this slight modification.

The result is a fusion between perfect fifths and fourths with pure thirds at several loci. Figure 3.10 maps the resulting system through several stages of development. The original serpent is now distributed symmetrically in three successive rows, and more serpents are growing in adjacent rows. Although standard notation has been used for the tones in this matrix, the ones in rows 1 and 2 are excessively sharp while the ones in rows 6 and 7 are excessively flat compared to the equal-tampered scale. We are watching the tones multiply with each effort to bring the process to a close. Ancient tunings generate infinite groups, not cyclic ones as does the equal-tempered scale.

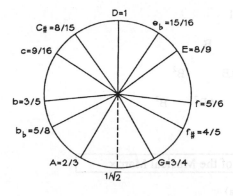

D:D' = 1:2
D:A = 2:3
A:D' = 3:4

$$\frac{2}{3} \times \frac{3}{4} = \frac{1}{2}$$

Figure 3.9 The Just scale with tonal ratios.

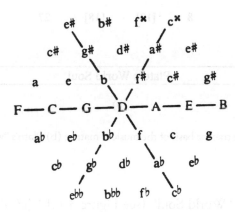

Figure 3.10 Thirty seven tones of the musical matrix generated by the ratios of the Just scale.

Figure 3.10 can be arithmetized by thinking of it as a multiplication table for the numbers A and B as shown in Figure 3.11a. This table is the origin of the sacred symbol of the Pythagoreans known as the *tetractys* and it is found in the writings of Nicomachus, the Pythagorean philosopher (2nd Century C.E.) (cf. [Kap10], [D'Oo], [McC2]). If A = 2 and B = 3, the powers of 2 and 3 give rise to the lambda figure found in Plato's *Timaeus*

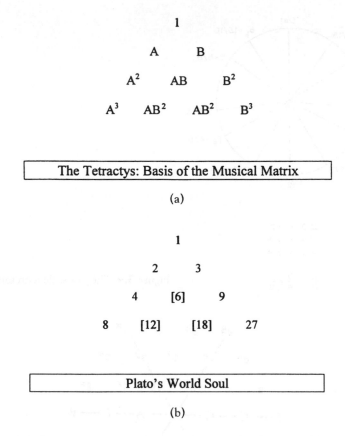

$$1$$

$$A \quad B$$

$$A^2 \quad AB \quad B^2$$

$$A^3 \quad AB^2 \quad AB^2 \quad B^3$$

The Tetractys: Basis of the Musical Matrix

(a)

$$1$$

$$2 \quad 3$$

$$4 \quad [6] \quad 9$$

$$8 \quad [12] \quad [18] \quad 27$$

Plato's World Soul

(b)

Figure 3.11 (a) The tetractys: basis of the musical matrix; (b) Plato's "world soul" conforming to the format of (a).

and known as the "World Soul" (see Figure 3.11b) (cf. [McC2], [Kap3]). If "one" is taken to be the frequency of the fundamental, then three successive multiples of 3 along the left leaning diagonal (\backslash) of Plato's lambda along with their reciprocals correspond to the tones of the heptatonic scale represented in Figure 3.8a. The right leaning diagonal ($/$) of the lambda figure are powers of 2 which do not alter the pitch classes of a tone from one octave to another as shown in Figure 3.8b.

If $A = 3$ and $B = 5$, then a similar multiplication table for 3 and 5 arises shown in Figure 3.12a. Each number in the matrix is multiplied by successive powers of 3 going from left to right, and powers of 5 going up the right

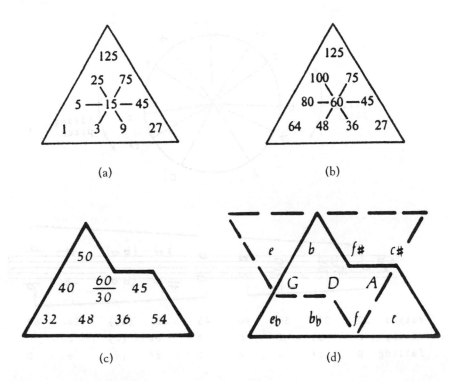

Figure 3.12 Multiplication table for tones based on primes 3 and 5, (a) smallest integers $3^p \times 5^q$, (b) 4:3 mated with 5; (c) diatonic scale order; (d) tonal reciprocals.

leaning diagonal. If the 1 in Figure 3.12a is raised two octaves to a 4, then Figure 3.12b is the end result of the following sequence of matrices. (Notice that the integers at the vertices of the triangles are powers of 3, 4, and 5):

$$
\begin{array}{cc} 5 \\ 1 \quad 3 \end{array} \rightarrow
\begin{array}{cc} 5 \\ 4 \quad 3 \end{array} \rightarrow
\begin{array}{ccc} 25 \\ 20 \quad 15 \\ 16 \quad 12 \quad 9 \end{array} \rightarrow
\begin{array}{cccc} 125 \\ 100 \quad 75 \\ 80 \quad 60/30 \quad 45 \\ 64 \quad 48 \quad 36 \quad 27 \end{array}
$$

Three ratios of a 3:4:5-relationship at the basis of the Just scale present themselves: 4:3 or a musical fourth from right to left ← (e.g., 80:60), 5:4, or a major third along the right-rising diagonal ↗ (e.g., 75:60), and 3:5, or a decrease in tone of a major 6th along the left-falling diagonal ↘ (e.g.

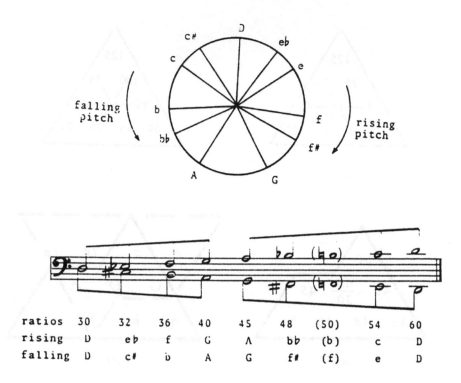

ratios	30	32	36	40	45	48	(50)	54	60
rising	D	eb	f	G	A	bb	(b)	c	D
falling	D	c#	b	A	G	f#	(f)	e	D

Figure 3.13 Poseidon and his five pairs of twin son's from Plato's *Laws*, representing all the tones from the seven tone rising and falling heptatonic scales.

36:60) where the ratios represent frequencies rather than string lengths. All of the tones shown in Figure 3.12b satisfy these same relations.

In Figure 3.12c, the numbers are multiplied or divided by powers of 2 (which do not alter their pitch classes) until they lie within the octave limit of 30:60, and the triangle is truncated to a ziggurat shape, allowing entry only to those numbers within the 30:60 octave limit. Notice in Figures 3.10 and 3.12b that tones equidistant but oppositely directed from the central tone are complements, and are represented by inverse ratios. Therefore, Figure 3.12c defines the inverted diagram of Figure 3.12d corresponding to a falling scale. All tones within the intersection of the inverted ziggurats have inverses within the octave 30:60. In this way all of the ratios of the seven-tone rising scale and its symmetric falling scale are derived and shown in Figure 3.13 in terms of integer values. Also notice

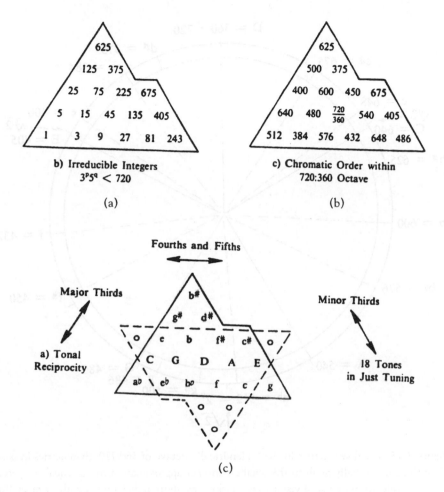

Figure 3.14 Multiplication table for 11 of the 12 tones of the Just scale. (a) Irreducible integers $3^p 5^q < 720$; (b) chromatic order within the 720:360 octave; (c) inverted ziggurats showing tones invariant under inversion.

that the three tones of the Pythagorean scale fundamental to the Western music, do fa sol do (e.g., $D\ G\ A\ D'$) lie on the central axis.

In a similar manner, the matrices can be extended to encompass 11 of the 12 tones of the 12-tone scale within the inverted ziggurats by merely enlarging it to one encompassing the octave from 360 and 720 as shown in Figure 3.14. The ratios of the 13 tones within the ziggurat reproduce the

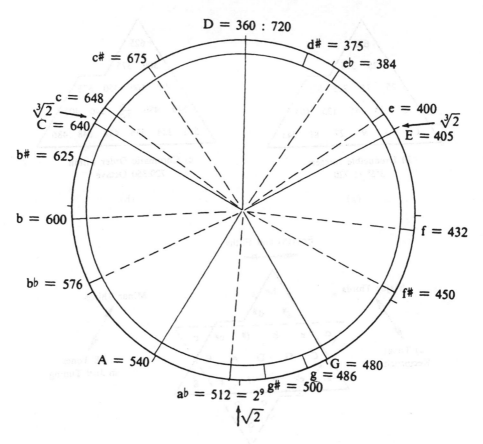

Figure 3.15 Tonal symmetries in the "calendrical" octave of 360:720. Symmetries in base 60-arithmetic naturally result in this smallest integer approximation to our equal-tempered 12-tone scale whose equal divisions are marked by short radial lines on the rim of the circle.

tones of the Just scale shown in Figure 3.9 along with the pairs e-E and c-C differing by the comma of ratio 80:81. Five tones of the Pythagorean tuning lie on the central axis, forming a pentatonic scale. The symmetry of the 13 tones of this so called *yantra* diagram (the same picture occurs by turning the page upside-down) results in the bilateral symmetry of Figure 3.15. The missing 12th tone is A flat or G sharp, the approximation to $\sqrt{2}$.

3.6 Music and Myth

We see through these tonal matrices the genesis of a number system base 60 which originated in Sumer about 3000 B.C. along with a calendar based on a *canonical* 360-day year and 30-day month which were musically if not cosmologically correct. Key numbers from this sexagesimal system were associated with a pantheon of gods. About 2100 B.C., the Babylonians became politically ascendant and reorganized the Sumerian pantheon, preserving the names of its gods, and keeping its mathematical terminology. They developed base-60 computation to a level of arithmetical virtuosity, as did the Egyptians. Between 500 B.C. and 150 A.D., Babylonian and Greek astronomy developed base-60 computation. The musical scale with its 12-tones became a model for the solar and lunar cycles. The incommensurability of solar and lunar cycles may have been associated with the need for a *comma* to close the tone cycle as is shown in Appendix 3.B. The yantra diagrams serve as a kind of cultural Rosetta Stone through which McClain has been able to show the common roots of many ancient mythologies with metaphorical imagery pertaining to the musical scale. I provide three examples.

Example 3.6.1 The Great Gods of the Babylonian Pantheon

Figure 3.12c can be associated with the great gods of the Babylonian pantheon — Enki 40, Enlil 50, Sin 30 (the moon god) and Anu 60 [McC4]. Notice their positions in the diagram, with Enlil 50, the "Lord Atmosphere" at the peak and Anu, the head of pantheon, in the center setting up a 3, 4, 5-relationship within the octave interval $\frac{60}{30}$. According to McClain,

> "Anu is essentially a do-nothing deity; a reference point, perfectly suited to represent simultaneously the middle band of the sky, the center of the number field, and the reference tone in a tuning system."

> "Ea/Enki, is 'god of sweet water'. In its double role of 40:60 and 60:40 it 'organizes the Earth' (as represented by the string) into do, fa, sol, do, the harmonic basis of the modern scale."

> "Enlil, the 'mountain god' was the active head of the pantheon."

Example 3.6.2 The Yantra for the Precession Cycle of the Equinoxes

We discussed the precession of the equinoxes in Section 1.4. The discovery of the precession of the equinoxes — a slow westward motion of the equinoctial points along the ecliptic — is generally credited to Hipparchus in 127 B.C. De Santillana and von Dechend [de-D] suggest that Hipparchus' discovery was actually the rediscovery of a fact known some thousand years previously. In Oriental Mythology, Joseph Campbell calculates the precessional cycle, which he believes may have been known to the ancient Babylonians, as 50 seconds of arc per year which amounts to a complete cycle in 25,920 years also known as the "great year". This compares within 3 parts in 500 to the currently accepted figure of 25,726 years. Now 25,920 divided by 60, the standard Babylonian unit of sexagesimal arithmetic, yields 432. By legend, 432,000 years was given by the last priest of Marduk (c.290 B.C.) as the sum of the reigns of the ten antediluvian Kings [McC1]. The seven tones of the Pythagorean scale (integer ratios divisible by primes 2 and 3) can also be placed in the octave interval between 432 and 846 (see the bottom row of Figures 3.14a and b). McClain has shown in Figure 3.16 that the yantra diagram can be widened to accommodate the seven tones of the Western scale along its transverse axis within the octave ratio 25,920: 12,960. Equivalent tones such as E, e and C, c are related to each other by the syntonic comma of 80:81. According to the computation scheme illustrated in Figure 3.12a, the fundamental tone D in Figure 3.16 corresponds to the integer $3 \times 3 \times 3 \times 3 \times 5 \times 2^6 = 25,920$, or the "great year". McClain believes that these tonal mandalas reflect the musician's problems with a tuning theory based on "perfect" relations between integers and symbolizes the astronomer's problems in defining celestial cycles from the platform of an earth which wobbles on its axis while viewing planets which wander by about the distance of our commas from the planes of the ecliptic.

Example 3.6.3 The Yahweh Diagram

McClain points out that — in Mesopotamian base 60 arithmetic — the 13 tones in the spiral of fifths require the monochord reference unit to be interpreted arithmetically as 60 to the fifth power, that is, as

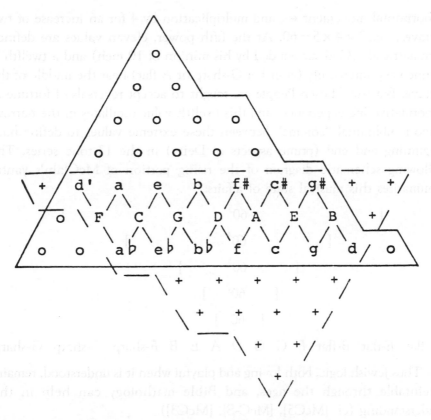

Figure 3.16 Yantra for the precession cycle of 29,520 years. Figuring from the lower left-hand corner, the fundamental tone $D = 3 \times 3 \times 3 \times 3 \times 5 \times 2^6 = 29,520$.

777,600,000 in base 10. And traditional Kabbalist interpretation of YHWH as 10-5-6-5 can be read as 10 to the fifth power (meaning 100,000) times 6 to the fifth power (meaning 7776)= 777,600,000. Is it possible that this reading is cleverly implanted in Genesis as the age of Noah's father (777) when the flood came in his 600th year, when his three sons were already 100?

The rationale is easy to follow if we remember that 60 integrates three pitch classes in the middle of this series. The musical proportion 6:8::9:12 multiplied by 5 into 30:40::45:60 defines $D:G::A:D'$ rising (or falling). Each multiplication by 60 adds another pair to this series. This corresponds to a multiplication by 5 for an upward movement ↗ in McClain's yantra, 3 for

a horizontal movement ←, and multiplication by 4 for an increase of two octaves, i.e., $3 \times 4 \times 5 = 60$. At the fifth power, eleven values are defined symmetrically (God surrounded by his minion of 10 men) and a twelfth is defined asymmetrically (at either G-sharp or A-flat) near the middle of the octave. But the Chosen People are taught to accept reversals of fortune as a normative life experience, and this twelfth value oscillates in the narrow, almost subliminal "comma" between these extreme values to define both beginning and end (prime aspects of Deity) in the 13-tone series. The following schematic diagram of the rising portion of McClain's yantra summarizes this musical state of affairs:

$$[\qquad\qquad 60^5 \qquad\qquad\qquad]$$
$$[\qquad\qquad 60^4 \qquad\qquad]$$
$$[\qquad 60^3 \qquad]$$
$$[\quad 60^2 \quad]$$
$$[\quad 60 \quad]$$

A-flat E-flat B-flat F C G D A E B F-sharp C-sharp G-sharp

Thus Jewish logic, both loving and playful when it is understood, remains irrefutable through the ages, and Bible mathology can help in this understanding (cf. [McC5], [McC-S], [McC3]).

3.7 Musically Encoded Dialogues of Plato

The reader may ask where the elaborate musical structure that forms the basis of McClain's musical matrices comes from, given the absence of explicit information about Sumerian musical theory. There are numerous suggestions by Greek philosophers of antiquity that Pythagoras' knowledge of music came from the East. McClain has made a careful study of the dialogues of Plato and has seen in them numerous references to the structure of the musical scale and its relationship to ethics, society, and politics.

The yantra diagrams were based on the concept of limit [McC2]:

"In political theory as in musical theory, both creation and the limitation of creation pose a central problem. Threatening

infinity must be contained. Conflicting and irreconcilable systems, be they of suns and planets, of even octaves and odd fifths, or of divergent political members of a republic must be coordinated as an alternative to chaos. What the gods have shown to be possible in the heavens, what the musicians have shown to be possible with tones, the philosopher should learn to make possible in the life political. Limitation, preferably self-limitation, is one of Plato's foremost concerns. His four model cities correspond to four different tuning systems each with its own set of generators and an explicit population limit."

The structure of the musical matrix found in Figure 3.12 is alluded to in Plato's Republic — the formula four-three mated with five, thrice increased, produces two harmonies.

This refers to the 3:4:5 "god" relationships that lies at the basis of the yantra as it is expanded three-fold to obtain Figure 3.10.

In "Laws", Plato refers to Poseidon who "begot five twin births of male offspring". This appears to be a reference to the eleven tones that can be derived from the yantra of Figure 3.14 symmetrically placed in Figure 3.15 excluding the tritone.

The 37 tones of Figure 3.10 are related to the 37 guardians of Magnesia described in "Laws". McClain has hypothesized that these 37 tones are also related to the 37 right triangles with integer lengths that exist at approximately 1 degree intervals up to the 3, 4, 5 triangle with base angle of approximately 37 degrees [McC2]. This discovery goes back to Babylonian times where the theory of Pythagorean triples is developed on a cuneiform tablet known as Plimpton 322 dating to 1900–1600 B.C.

McClain suggests that the tones on the central axis of the yantras, associated with the Pythagorean tuning, correspond to Plato's "Rulers" or "citizens of the highest property class" in the "marriage allegory" of Plato's Republic. The rows above and below the central axis, associated with the Just scale, refer to the "auxiliaries" or "citizens of the second property class". Beyond these rows the tones become more and more dissonant and they correspond to the "slave classes". In the Plato's Republic, Socrates comments that "our young have become more unmusical", a possible reference to the tones in distant rows.

Plato's metaphor requires imaginative interpretation, hence we can never achieve more than a "likely story" based on them. Nevertheless, McClain has shown them to be a rich source of information.

3.8 The Mathematical Structure of the Tonal Matrix

Now that we have seen how ancient civilizations computed the matrix of musical tones, I will summarize the mathematical structure of the musical matrices of Figures 3.12 and 3.14 in modern terms [Kap12]. All tones capable of being generated by primes 2, 3 and 5 are also related by the series 3, 4, 5, as we saw in Figure 3.12. Taking the ratios of these numbers in reverse cyclic order gives rise to three *primary tones*: $\frac{5}{4}, \frac{4}{3}$, and $\frac{3}{5}$, the musical major third and fourth, above a fundamental reference tone, and the major sixth below where these ratios represent frequencies. In what follows I shall interpret these ratios to refer to frequency rather then string length. It should be noted that if $\frac{3}{5}$ is raised an octave, ($\frac{3}{5} \times 2$ = $\frac{6}{5}$) it can also be interpreted as the ratio $\frac{6}{5}$, a minor third above the fundamental.

In Figure 3.17a, the three primary tones are represented by arrows or *vectors* in a musical coordinate system with three axes. (Appendix 3.C is devoted to a brief introduction to vectors.) The center of the coordinate system signifies the fundamental tone, which I shall take in this discussion to be D. The endpoints of the vectors then refer to f sharp, a major third, G a fourth above D, and f, a major sixth below D. The "sum" of two vectors (see Appendix 3.C) corresponds to multiplying their ratios. A vector in the opposite direction corresponds to the reciprocal ratio. In Figure 3.17b, which is a numerical and geometrical representation of Figure 3.10, these ratios are summed along their lines of action to yield higher powers of the primary tones.

In Figure 3.18a, $\frac{5}{3}$ results from the sum of $\frac{5}{4}$ and $\frac{4}{3}$ (i.e., $\frac{5}{4} \times \frac{4}{3} = \frac{5}{3}$), and the sum of $\frac{5}{4}, \frac{4}{3}$, and $\frac{3}{5}$ yields 1 or the fundamental (i.e., $\frac{5}{4} \times \frac{4}{3} \times \frac{3}{5} = 1$) which functions as the neutral or zero vector. In a like manner, every counter in Figure 3.10 represents a tone attainable from D by the appropriate sum of the primary vectors. For example, in Figure 3.18b, the

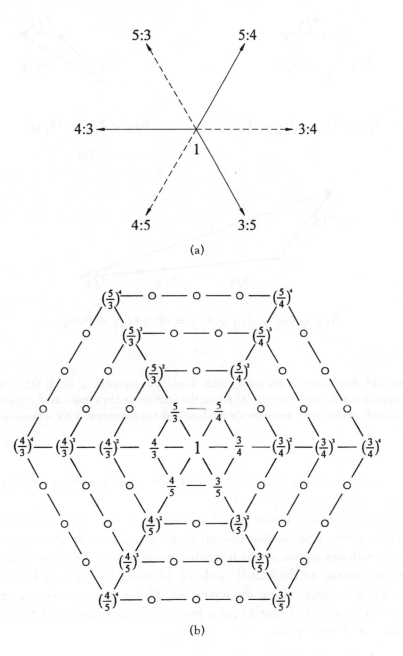

Figure 3.17 The musical matrix seen as a vector diagram based on the number 3, 4, 5.

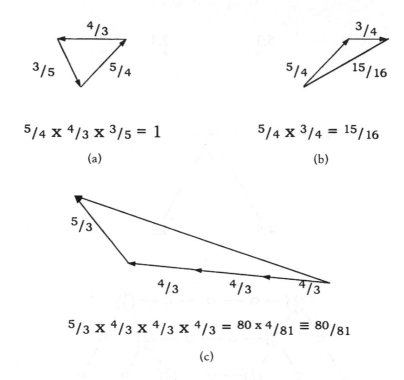

Figure 3.18 Application of the tonal vector diagram to representing tones, (a) a cycle of vectors yields the fundamental tone; (b) raising the fundamental by a major third and lowering it by a fourth yields a semitone below the fundamental; (c) generation of the syntonic comma 80:81.

note a semitone below D in the Just scale, i.e., the ratio $\frac{15}{16}$, is obtained by adding $\frac{5}{4}$ and $\frac{3}{4}$ (i.e., $\frac{15}{16} = \frac{5}{4} \times \frac{3}{4}$).

You will notice in Figure 3.10 that some tones such as C, c and e, E are repeated. These unavoidable discrepancies are the result of representing tones by rational numbers, which creates an endless proliferation of distinct tones in contrast to the closed circle of 12 tones for the equal-tempered scale. Let's compute these discrepancies. Using our vectors, we see in Figures 3.10 and 3.18d that to get e from E requires the addition of three $\frac{4}{3}$ and one $\frac{5}{3}$ vector, i.e.,

$$\left(\frac{4}{3}\right)^{3} \times \frac{5}{3} = \frac{(80 \times 4)}{81}.$$

Bringing this tone down two octaves yields the comma of 80:81 that results from cutting the "serpent" (see Section 3.4). By using this vector approach, you can find rational approximations to $\sqrt{2}$ by computing the ratios associated with A flat and G sharp.

3.9 The Color Wheel

It is much debated among philosophers and musicologists as to whether ancient cultures were oriented more towards the visual or aural senses. In either case it is fascinating that the tonal structure described in the last section also forms the mathematical basis of the color wheel shown schematically in Figure 3.19. The three primary colors take the place of the three primary tones, while the complementary colors are analogous to the reciprocals. (A complementary color is the color that is created by the mind's eye and superimposed on the object when you stare at a primary color.) Anharmonic shades (A) of white, black, or gray play the role of the fundamental.

The primary colors:

$$\text{Cyan}\,(C) \qquad \text{with } \frac{3}{5}$$

$$\text{Magenta}\,(M) \qquad \text{with } \frac{5}{4}$$

$$\text{Yellow}\,(Y) \qquad \text{with } \frac{4}{3}$$

The complementary colors:

$$\text{Orange}\,(O) \qquad \text{with } \frac{5}{3}$$

$$\text{Green}\,(G) \qquad \text{with } \frac{4}{5}$$

$$\text{Violet}\,(V) \qquad \text{with } \frac{3}{4}$$

The anharmonic color (white, black, gray) A with 1.

Figure 3.19 Analogy of tonal vector diagram to the color wheel.

$$Y + C = G \qquad M + Y + C = A \qquad M + C = V$$

Figure 3.20 Vector addition of colors.

If the schematic diagram of the color wheel in Figure 3.19 is taken to be a vector diagram, then the primary and complementary colors are shown in the diagram in clear analogy to Figure 3.17.

Furthermore, (see Figure 3.20) if equal amounts of C and M are "added" (i.e., the ratios are multiplied) they make V, i.e.,

$$C + M = V,$$

also,

$$M + Y = O \text{ and } Y + C = G.$$

The result of adding all three primaries is a shade of gray (see Figure 3.20), i.e.,

$$M + Y + C = A.$$

Therefore the musical scale and the color wheel have analogous structures.

3.10 Conclusion

To ancient mathematicians and philosophers, the concept of rational number was thought to lie at the basis of cosmology, music, and human affairs. Using imagery of the Rig Veda, McClain says:

> "The part of the continuum which lies beyond rational number belongs to Non-being (Asat) and the Dragon (Vtra). Without the concept of an irrational number, the model for Existence (Sat) is Indra. The continuum of the circle (Vtra) embraces all possible differentiations (Indra). The conflict between Indra and Vtra can never end; it is the conflict between the field of rational numbers and the continuum of real numbers."

Chapters 20–25 will show that this battle between rational and irrational numbers continues to the present where it lies at the basis of chaos theory and the study of dynamical systems:

The impossibility of rationalizing either the musical scale or the cycles of the heavenly bodies was the great lesson of Mesopotamia, Kuan Tzu, the Rig Veda, and the allegories of Plato. It also led, as McClain states, "to the insight that number must be dethroned as an absolute and viewed instead as a tool for human rationality to order as best it can the evidence of the eye and ear".

Looking back to the way in which musical metaphor led ancient people to an understanding of the universe reinforces the modern notion that there is not a single path that leads to truth. The kind of relativistic thinking in both music and projective geometry in which all tonal frames of reference and all locations of the observer are equally valid prepares the mind well for absorbing this lesson.

Appendix 3.A

3.A.1 *Logarithms and the logarithmic spiral*

Consider the geometric series,

$$..., k^{-2}, k^{-1}, k, k^2, k^3,$$

Table 3.A1 The logarithmic spiral.

$\dfrac{\theta}{90}$	r
\vdots	\vdots
-2	$2^{-2} = \frac{1}{4}$
-1	$2^{-1} = \frac{1}{2}$
0	$2^{0} = 1$
1	$2^{1} = 2$
2	$2^{2} = 4$
3	$2^{3} = 8$
4	$2^{4} = 16$
5	$2^{5} = 32$
\vdots	\vdots
x	$2^{x} = y$
$x = \log_2 y$	y

If successive numbers from this series are taken to be the distance to the origin of an x,y-coordinate system at increments of 90 degrees, then they determine a set of *vertex points* of a logarithmic spiral as shown in Figure 2.11a. Notice that the radii form a geometric series while the corresponding angles of the spiral and the exponents of the series form arithmetic series. Table 3.A1 shows the points on a logarithmic spiral for $k = 2$.

Although this table defines only the *vertex points* of the log spiral, the other points can be computed by inputting other angles, e.g., the radial distance at 45 degree is $2^{1/2}$ since $\frac{45}{90} = \frac{1}{2}$.

Besides defining the points on a logarithmic spiral, Table 3.A1 also represent the following pair of inverse functions:

i) exponential to the base 2 written as, $y = \exp_2 (x)$ and $y = 2^{x}$, and
ii) logarithm to the base 2 written as, $x = \log_2 y$.

3.A.2 *Properties of logarithms*

Table 3.A1 also illustrates four major properties of logarithms:

i) the logarithm of 1 to any base equals 0; e.g., $\log_2 1 = 0$;

ii) the log of the base equals 1, e.g., $\log_2 2 = 1$;

iii) as two numbers multiply their logarithms add. For example, while the numbers 2, 3, and 5 from the left hand column of Table 3.A1 add, i.e., $2 + 3 = 5$, the corresponding numbers in the right hand column multiply, i.e., $4 \times 8 = 32$.

iv) as a number is taken to a power, its logarithm is multiplied by the power.

We have limited ourselves in Table 3.A1 to finding logarithms of numbers that are powers of 2. How can we compute $\log_2 3$? You may be inclined to use your calculator, but you will be disappointed to find that calculators have no direct way of computing $\log_2 3$. The answer is found in a formula that we introduce without proof,

$$\log_a y = \frac{\log_b y}{\log_b a}. \tag{3.A1}$$

If we take $b = 10$ then we see that calculators are able to compute logarithms to the base 10, and for $a = 2$ and $b = 10$, we find that,

$$\log_2 y = \frac{\log_{10} y}{\log_{10} 2} = 3.322 \, \log_{10} y.$$

Therefore,

$$\log_2 3 = 3.322 \, \log_{10} 3 = 1.585.$$

To summarize the properties of logarithms to any base $k > 0$,

$$\log_k k = 1,$$

$$\log_k 1 = 0,$$

$$\log_k (ab) = \log_k a + \log_k b \quad \text{and} \quad \log_k \frac{a}{b} = \log_k a - \log_k b,$$

$$\log_k a^b = b \log_k a.$$

3.A.3 *Logarithms and the musical scale*

The frequency ratio, r, of each of the 12 tones of the equal tempered scale from the fundamental tone of value 1 to the octave of value 2 is given by the following geometric series,

$$1, 2^{\frac{1}{12}}, 2^{\frac{2}{12}}, 2^{\frac{3}{12}}, \ldots, 2^{\frac{11}{12}}, 2. \qquad (3.A2a)$$

The corresponding \log_2 series is,

$$0, \frac{1}{12}, \frac{2}{12}, \frac{3}{12}, \ldots, \frac{11}{12}, 1. \qquad (3.A2b)$$

Since the product of tonal ratios is equivalent to the sum of their intervals, the logarithm can be used to measure intervals since logarithms have this property. In order to give each interval a value of 100 cents we multiply the tones of Series (3.A2b) by 1200 so that, each of the 12 semitones within an octave are assigned a value of 100 cents. Since the interval scale is logarithmic, to convert a ratio r, to cents use the formula,

$$r_{cents} = 1200 \log_2 r = 1200 \times 3.322 \log_{10} r \, .$$

Appendix 3.B The Pythagorean Comma

The *Pythagorean comma* approximates the degree to which the canonical year of 360 days differs from the solar year of 364.25 days and the lunar year of 354 days (twelve 29.5 day months). Twelve musical fifths amount to approximately seven octaves, the degree of approximation being the comma, i.e.,

$$\left(\frac{3}{2}\right)^{12} = 129.746 \quad \text{and} \quad 2^7 = 128.$$

Therefore, the comma is related to the ratio,

$$\frac{129.746}{128} = 1.01364.$$

In units of cents,

$$r_{cents} = 1200 \times 3.322 \times \log_{10} 1.01364 = 23.45 \text{ cents}$$

or 0.2345 part of a semitone.

However, the ratio of the solar to the canonical year is $\frac{364.25}{360} = 1.0118$ or 20.31 cents differing from the comma by about 3 cents. The ratio of the lunar to the canonical year is, $\frac{360}{354} = 1.0169$ or 29.10 cents differing from the comma by about five cents.

Appendix 3.C Vectors

Why use vectors to represent tones? A vector is a quantity with magnitude and direction but is independent of its point of origin as shown by vectors a and b shown in Figure 3.Ca. In other words, move a vector in space without altering its length or direction, and its identity does not

(a)

(b)

Figure 3.C (a) Equivalent vectors; (b) addition of vectors.

change. We say that vectors are *translation invariant*. On the other hand, musical tones are independent of their identification with a particular fundamental tone, i.e., they are *tonally invariant*. In Section 3.8, we used the concept of addition of two vectors to represent the product of musical intervals. In Figure 3.Cb, vector b is added to a by translating b so that the tail of b touches the tip of a. The vector sum is then the vector obtained by connecting the tail of a to the tip of b.

4
The Projective Nature of the Musical Scale

> Music is the true element from which all poetry springs
> and to which it flows back.
>
> *Richard Wagner*

4.1 Introduction

McClain's research suggests that the musical scale was a key factor in the advancement of mathematics and cosmology in ancient civilizations both Eastern and Western. Pythagoras became a student of these ideas and through him they became a part of Greek culture.

After the fall of Greece, the ideas expressed by the musical scale went underground and were revived during the Renaissance when the writings of classical Greece that survived the passage of time, formed the intellectual basis of this age. The artists and architects of the Renaissance are considered by historians to be among the greatest mathematicians of their age. The development of perspective is often considered to be the most significant mathematical creation of the Renaissance, and it is interesting that it is based on the same concepts of projective geometry as the musical scale. In fact perspective presents the eye with multiple versions of reality depending on the position of the observer in much the same way, for the ear, that the perception of tone does for the ear is dependent on the choice of the fundamental tone.

This chapter explores the direct connection between projective geometry and the musical scale.

4.2 A Perspective View of the Tonal Matrix: The Overtone Series

Section 3.4 stated that the pitch classes can be mapped onto a two-dimensional grid. Assign a pair of integer values (p,q) to the coordinates of a Cartesian coordinate system in the positive quadrant to form what mathematicians refer to as a lattice shown in Figure 4.1a. A rational number is defined to be the ratio $\frac{p}{q}$ when p and q have no common factor, i.e., they are in lowest terms, or as mathematicians say, they are relatively prime. If (p,q) is connected by a line to the origin $(0,0)$, the line with slope $\frac{q}{p}$ can be associated with the rational number $\frac{p}{q}$. The first lattice point encountered by the line is (p,q), e.g., $(3,2)$ in Figure 4.1a, and each line contains an infinite number of lattice points, e.g., $(6,4)$, $(9,6)$, etc. An irrational number I, e.g., $\sqrt{2}$ cannot be represented by the ratio of integers so that a line with slope $1/I$, e.g., $1/\sqrt{2}$ intercepts no lattice point. The family of lines representing the rational numbers cuts the line $y = 1$ at coordinate points $\left(\frac{p}{q},1\right)$. In Figure 4.1b a subset of lines representing several musical ratios from either the Just or Pythagorean scales are shown with the lattice points deleted. For example, $\frac{2}{3}$ represents the interval of a fifth, while $\frac{1}{1}$ represents the fundamental tone and $\frac{2}{1}$ represents an octave interval below the fundamental. Below the line $x = y$, the tones are from the falling scale, while above $x = y$, the tones are from the rising scale.

In Figure 4.1b the intersection of lines: $\frac{1}{2}$, $\frac{2}{3}$, $\frac{3}{4}$, $\frac{3}{2}$, $\frac{4}{3}$ and $\frac{2}{1}$ with $y = 1$ is shown. These are the positions on a monochord at which the movable bridge should be placed to give rise to string length corresponding to the intervals of an octave, fifth, and fourth above the fundamental located at the bridge position $(1,1)$. Tones from the rising scale are found to the left of the bridge while and their reciprocal values from the falling scale are found to the right. What we have here is a *perspective transformation* of points in the plane to points on the line from a projection point located at the origin, $(0,0)$. The points $\left(\frac{p}{q},1\right)$ are known as the *homogenous coordinates* of line $y = 1$ (see Appendix 2.A). The point at infinity on the line $y = 1$ has projective coordinates $(1,0)$. The projective coordinate $(0,1)$ represents the placement of the monochord bridge to the point of zero string length.

If the tonal values are interpreted as frequencies, then the tones and lines are represented by the ratio, $\frac{y}{x}$. The series of tones $\frac{1}{1}$, $\frac{2}{1}$, $\frac{3}{1}$, ..., occur quite naturally. When the string of an instrument is plucked, not only the

Figure 4.1 (a) Coordinates of a Cartesian Coordinate System are assigned integer values; (b) Representation of tones on a two dimensional grid. The numbers on the line $y = 1$ are expressed in homogeneous coordinates and represent the ordering of tones on a monochord.

fundamental tone is heard, but also a less prominently expressed sequence of overtones, known as the *acoustic scale* emerges with the tonic. The frequencies of the overtones are all multiples of the fundamental, i.e., if the fundamental has frequency f_0 then the overtone series is: $2f_0$, $3f_0$, $4f_0$, ... The first eight overtones when lowered to fit into a single octave are given in Table 4.1, along with their tonal names considering the fundamental at C.

The 7:4 ratio defines the natural seventh slightly lower than B flat in the scale. In Figure 4.2a these ratios are placed on a number line, and they are seen to subdivide the octave interval between 1 and 2 evenly into four

Table 4.1 The overtone series.

f_0	f_0 lowered to the octave	Tone name
1	1:1	C
2	2:1	C′
3	3:2	G
4	2:1	C′
5	5:4	E
6	3:2	G
7	7:4	B flat
8	2:1	C′

Figure 4.2 Overtone sequence: (a) subdividing the octave into one interval; (b) two intervals; (c) four intervals.

intervals. In Figure 4.2b the first 16 overtones divide the interval between 1 and 2 into eight subintervals. This can continue indefinitely in theory, although all but the first few overtones are inaudible.

While the *overtone* series, 1,2,3,4,..., is manifested, its reciprocal series, the *undertone* series, $\frac{1}{2}$, $\frac{1}{3}$, $\frac{1}{4}$,..., is a kind of phantom in that it is implied by the first series but not present in naturally occurring sound. The overtone series and its reciprocal can be viewed in a revealing way in the *Lambdoma* diagram of the 19th century musical scholar, Albert Von Thimus,

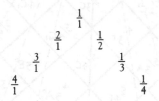

in which the overtone series is placed on the right-leaning diagonal (\nearrow) while the reciprocal undertone series is on the left-leaning diagonal (\nwarrow). Both emanate from the point $\frac{1}{1}$. When the lambda is expanded to the grid shown in Figure 4.3, it is seen to be none other than a somewhat transformed version of the perspective diagram of Figure 4.1 with the lines identified by the inverse ratios, $\frac{y}{x}$.

The Lambdoma has been endowed by the musicologist, Hans Kayser, with much theological and philosophic importance [Haa]. Whether this figure arose first in ancient neo-Pythagorean writings as Von Thimus says, or as others say in modern German texts, it does serve as an interesting metaphor. For example, the idea developed in *Timaeus*, is that there is a highest divinity who created the plan of the world and who then instructed an under-god, the "demiurge", to create the material world according to the model of the plan. In the Lambdoma, the demiurge can be represented by the symbol, $\frac{1}{1}$, while the highest divinity is $\frac{0}{0}$. The Lambdoma itself will then be the created world. (The demiurge can also be identified with the founders of religions — Buddha, Christ, Mohammed, Moses, etc.) The fact that every point of the Lambdoma connects by a line to $\frac{0}{0}$ was seen by Kayser as an expression of the "inherence of the divine in all that is created" [Haa].

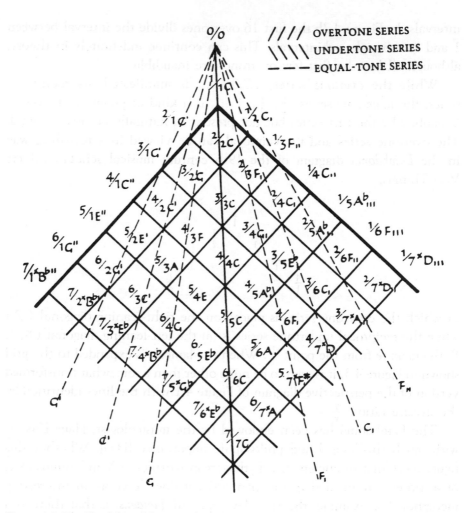

Figure 4.3 The "lambdoma" diagram of Von Thimus representing tones in a perspective diagram projected from the point $\frac{0}{0}$.

Another example of the relationship between projective geometry and the musical scale was discovered by R.A Schwaller de Lubicz on an ancient Egyptian table. Before describing this discovery we must take a brief detour in order to gain an understanding of the concept of the three *means* of importance to music.

4.3 The Three Means

Various intervals of the scale can be related to each other by splitting the octave by its arithmetical, geometrical, and harmonic means, all good candidates for the title *mese*, or mean between the lowest tone of the octave known as the *hypate* and the highest tone an octave above the fundamental called the *nete*.

i) The *arithmetic mean* of an interval $[a,b]$ is the midpoint, c, of the segment and the points a,c,b form an arithmetic progression (e.g., 1,2,3,4,...), i.e., $b - c = c - a$ and $c = \frac{a+b}{2}$.

ii) The *geometric mean* is the point, c, such that $\frac{a}{c} = \frac{c}{b}$, i.e., $c = \sqrt{ab}$ and a,c,b form a geometric progression (e.g., 2,4,8,16,...).

iii) The *harmonic mean*, which is less familiar, is a point, c, such that the fraction by which c exceeds a equals the fraction by which b exceeds c, i.e., $\frac{c-a}{a} = \frac{b-c}{b}$. As as result,

$$\frac{1}{c} = \frac{1}{2}\left(\frac{1}{a} + \frac{1}{b}\right) \quad \text{or} \quad c = \frac{2ab}{a+b} \tag{4.1}$$

and the series a,c,b is referred to as an harmonic sequence (e.g., $\frac{1}{1}$, $\frac{1}{2}$, $\frac{1}{3}$, $\frac{1}{4}$,...).

In Chapter 7 these three means will be seen to be the key to relating the musical scale to systems of architectural proportion used by the ancient Romans. A geometrical construction of the harmonic mean of two lengths is presented in Appendix 8.A.

4.4 Projective Analysis of an Egyptian Tablet

We have seen that the same mathematics, namely projective geometry, can be used to characterize both the musical scale and visual perspective. This is another instance, in addition to the color theory discussed in Section 3.9, of the similarity of underlying mathematical structures. I will now present another example of this relationship between the senses.

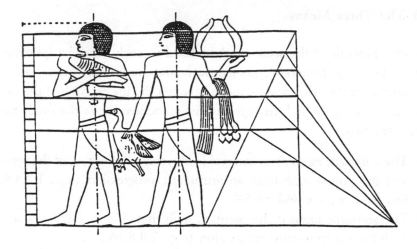

Figure 4.4 An ancient Egyptian harmonic grid.

There is a suggestion that Egyptian art and architecture of the Old, Middle, and New Kingdoms was set out upon a grid of 19 squares. R.A. Schwaller de Lubicz is an archaeologist who devoted his life to studying the metaphysics and meaning of the Temple of Luxor in Egypt [Schw], [Lam]. In the process he discovered the Old Kingdom tablet shown in Figure 4.4 displayed on a grid of 18 by 19 [Wes]. Note that the grid cuts through the top of the figure's head. This is the location of the neocortex, thought to be the seat of consciousness and sense of self or ego.

The grid shown in Figure 4.4 was drawn on the back of the tablet and then superimposed by Schwaller de Lubicz over the front in order to show its relationship to the actual drawing. Notice that the human figure has been divided into 19 equal parts with the uppermost grid line cutting off the nineteenth unit of the grid. Then 18, 16, 14 $\frac{2}{5}$, 12, 9, and 6 of these parts from head to foot have been selected as heights for key elements of the engraving.

How can we make sense of this sequence? Figure 4.5, adapted by [Ebe], from a diagram found in West, shows that if the height, 18, is taken as unity, the numbers of the series correspond to ratios of the Just scale. But this is only part of the story. To delve further into the mathematical significance of this series requires us to take a brief detour in order to

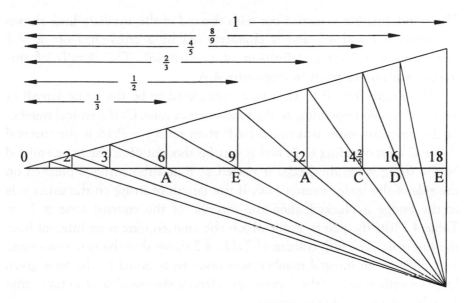

Figure 4.5 Harmonic construction of a lyre scale correlated with the Egyptian grid of Figure 3.21 adapted from West by Eberhart.

gain an understanding of the concept of the three *means* of importance to music.

4.4.1 An analysis of Schwaller De Lubicz's Number Sequence

Returning to Schwaller De Lubicz' Egyptian number series, Eberhart [Ebe] recognized that each number of the series: 6, 9, 12, $14\frac{2}{5}$, 16, 18 is the harmonic mean of 18 and the preceding number, e.g., using Equation (4.1),

$$9 = \frac{2 \times 6 \times 18}{6 + 18}.$$

In fact, this sequence can be extended to a doubly infinite series extending from 0 to 18. The series can then be seen to be a manifestation of a projective transformation of the interval of [0,18] onto itself in the manner described in Section 2.5 (i.e., growth measures) in which both 0 and 18 are transformed to themselves, i.e, they are *fixed points* of the transformation.

The transformation is carried out with the aid of the auxiliary lines shown in Figures 4.4 and 4.5 and is characterized by a cross-ratio of $\lambda = 2$ (see Section 2.3 for a definition of cross-ratio). The details of this transformation are given in Appendix 4.A.

The length from 0 to 18 is now considered to be the string length of a monochord corresponding to the fundamental tone, C. If a typical number in the Egyptian series is denoted by P then ratio $r = P{:}18$ is the interval above C corresponding to P, and it can be thought of as the tone emitted by the string when the bridge is placed at P and the string is plucked on the side of the bridge nearest to 0. If the length of string on the other side of the bridge is plucked, then the interval of the emitted tone is $1 - r$. Table 4.2 lists the points, P, for which the emitted tone is an interval from the Just scale. The fifth column of Table 4.2 shows that the two tones r and $1 - r$ differ by an integral number of octaves represented by the tone given in the fourth column (the superscripts denote the number of octaves that $1 - r$ lies above the fundamental).

Eberhart has shown that if the Egyptian series is mapped by a perspective transformation in which the fixed point, $Y = 18$, is mapped to infinity, then

Table 4.2 Di Lubicz's analysis of the New Kingdom Tablet in terms of the musical scale.

P	P:18 = r	1−r	Tone	r:(1−r)	P′
0	0	1	C	0	0
2	1:9	8:9	D	1:8	$\frac{1}{8}$
$3\frac{3}{5}$	1:5	4:5	E	1:4	$\frac{1}{4}$
6	1:3	2:3	G	1:2	$\frac{1}{2}$
9	1:2	1:2	C^1	1:1	1
12	2:3	1:3	G^1	2:1	2
$14\frac{2}{5}$	4:5	1:5	E^2	4:1	4
16	8:9	1:9	D^3	8:1	8
18	1	0	C	∞	∞

Ↄ	$\frac{1}{2}$	∠
○	$\frac{1}{4}$	ᴄ
∕	$\frac{1}{8}$	∫
◁	$\frac{1}{16}$	⊓
◡	$\frac{1}{32}$	౨
∤	$\frac{1}{64}$	✝

Figure 4.6 The "eye of Horus" constructed from Egyptian glyphs.

the other points P are mapped to the geometric sequence P' with ratio 2 (the cross-ratio of 2 is preserved and becomes the multiplier of the geometric series) given in the last column of Table 4.2.

There may be a relationship here to the "right eye" of Horus, the hawk, symbol of Pharoah, shown in Figure 4.6. McClain conjectures that the glyphs for $\frac{1}{2}$, $\frac{1}{4}$, $\frac{1}{8}$, $\frac{1}{16}$, $\frac{1}{32}$, and $\frac{1}{64}$ which constitute this eye — Horus always symbolized the ruling Pharoah — may be musically determined. It is McClain's hunch that the "left eye" of Horus, usually not shown, may have symbolized integers (i.e., arithmetic ratios) while the right Eye symbolizes the intellectual artistry inherent in the ability to manipulate integer inverses. This fits nicely with the late historian of ancient mathematics Otto Neugebauer's observation [Neu1] that the only ancient "book of secrets" he ever discovered concerned computation with fractions.

So we see that the harmonic mean is related to a kind of *generalized octave*. Looked at in another way, if the bridge of the monochord is placed at a length from the Egyptian series, the preceding length is the *generalized midpoint*. For example, if the bridge is placed at 9, which projects to 1, then the preceding length, 6, corresponds to $\frac{1}{2}$. This justifies the reference to harmonic means in music as *mese*. Details about how to carry out this perspective transformation are given in Appendix 4.A.

It is not likely that the ancient Egyptians had any knowledge of projective geometry, yet the similarity of the structure of projective transformations and the musical scale is dramatically demonstrated by this example.

4.5 Conclusion

Music is not built around an absolute space of tones. Each musician can define his or her own fundamental tone, and build a musical fabric from this base. A musical composition is essentially unchanged by the choice of a different fundamental tone, although certain emotional elements are determined by such a choice. McClain refers to this lack of absoluteness in music as "the myth of invariance". It is the relative basis of the tonal matrix that also makes projective geometry the natural framework within which to express the structure of the musical scale.

Appendix 4.A

The most general projective transformation with two fixed points (co-basal transformation) is shown in Figure 4.A1 (see Section 2.5). The fixed points are located at X and Y on line l. An arbitrary line m is drawn incident to X and an arbitrary point of projection is placed at O. Locate a second point of projection, O', on the extension of line segment, OY. The location of O' on this line is determined by the location on l of an arbitrary point A and its transformed point B. Line segment OA transforms A to A' on m while the location of O' is determined by the intersection of $A'B$ with the line through OY. The pair of transformations of first A to A' through O, and then A' to B through O' results in the projective transformation of A to B. Notice that any point between X and Y has a projective image under this pair of perspective transformations. Only X and Y are transformed to themselves. The cross-ratio of this transformation is defined as:

$$\lambda = \left(\frac{BX}{YB} \right) \bigg/ \left(\frac{AX}{YA} \right). \qquad (4.A1)$$

Now let's see how the Egyptian number series conforms to this picture. Let line l be the x-axis of a coordinate system in Figure 4.A2. Let X be the point $x = 0$ (the origin of the coordinates) and locate Y at $x = 18$. Choose arbitrary line m drawn through the origin and choose O located at infinity in a direction perpendicular to line l (remember that in the projective plane there are different points at infinity in each direction, (see Section 2.2)).

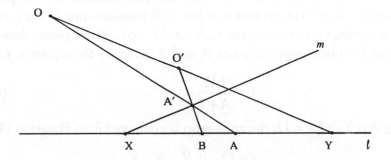

Figure 4.A1 A co-basal projective transformation (see Section 1.4.3).

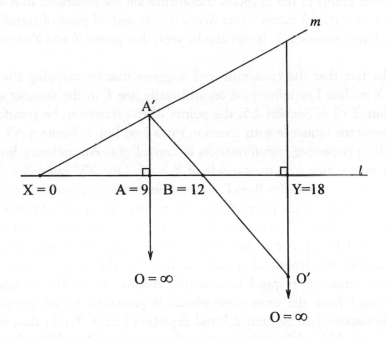

Figure 4.A2 Projection point O is transformed to infinity to yield the harmonic sequence of tones in Figure 3.22.

Therefore O' is located on the line perpendicular to l through $x = 18$. Call this line YO. To determine O' consider the point, A, located at $x = 9$ and its transformed point, B, at $x = 12$. The line perpendicular to l at point A intersects m at A'. The extension of line $A'B$ intersects line YO at point O'. This determines the transformation. A careful analysis (not given) shows that B is the harmonic mean of point A and Y given by the equation for the

$$B = \frac{2AY}{A+Y}.$$

(4.A2)

Using $A = 9$ and $B = 12$, the cross-ratio is computed from Equation (4.A1):

$$\lambda = \left(\frac{12}{18-12}\right)\Big/\left(\frac{9}{18-9}\right) = 2.$$

The other points of the Egyptian transformation are generated in a similar manner by a *growth measure* (see Section 2.5) and all pairs of transformed points have cross-ratio 2. It can also be seen that points X and Y are indeed fixed.

 The fact that the cross-ratio is 2 suggests that by mapping the fixed point Y on line l to infinity on an arbitrarily line l' in the manner shown in Figure 2.10 of Section 2.5, the points of the series can be transformed to a geometric sequence with common ratio 2 on line l'. Figure 4.A3 shows how this perspective transformation is carried out. An arbitrary line l' is drawn intersecting l on the far side of $Y = 18$. Line XX' maps $X = 0$ on l to an arbitrary point $X' = 0$ on l'. Draw a line through Y parallel to l'. This maps $Y = 18$ on l to the point, Y', at infinity on l'. The point of perspective, O, is located where YY' intersects XX'. Now the point $P = 9$ is transformed to the point $P' = 1$ at the intersection of the extension of line OP with l' (this defines the length of a unit on line l'). The other points of the Egyptian series are mapped in a similar manner to l'. Their values are determined from the cross-ratio which is preserved by all perspective transformations (see Section 2.3 and Equation (2.2)). To do this, rewrite Equation (4.A1) as follows for two transformed points A and B on line l and their corresponding transformed points, A' and B', on l':

$$2 = \left(\frac{B'X'}{A'X'}\right)\left(\frac{Y'A'}{Y'B'}\right).$$

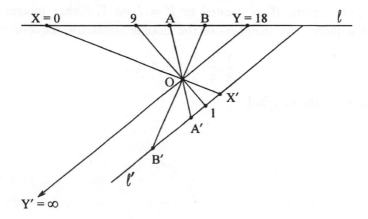

Figure 4.A3 Transformation of the fixed point at $Y = 18$ to ∞ yields a growth measure on a semi-infinite line.

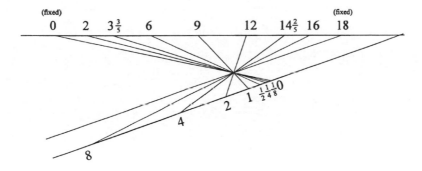

Figure 4.A4 West's Ancient Egyptian grid revealed by Eberhart to be geometric, doubling when carried out in one direction, halving in the other.

But since Y' has been transformed to infinity, the ratio $\frac{Y'A}{Y'B} = 1$, and this equation reduces to

$$2 = \frac{B'X'}{A'X'},$$

the multiplier of a geometric sequence for the transformed points on line l'. If A' is taken to be the point 1. Then it follows from this equation that

$X'B' = 2$, i.e., point B' is located at $P' = 2$ on l'. Other images of the Egyptian sequence are members of the double geometric sequence:

$$\ldots, \frac{1}{8}, \frac{1}{4}, \frac{1}{2}, 1, 2, 4, 8, \ldots$$

as Figure 4.A4 shows [Ebe].

5

The Music of the Spheres

Next I saw the most lucid air, in which I heard... many kinds of musicians praising
the joys of the heavenly citizens... And their sound was like the voice of a
multitude, making music in harmony.

Hildegard von Bingen

5.1 Introduction

According to the research of Ernest McClain, the relation of music and
number to cosmology may go as far back as the ancient civilizations of
Mesopatamia, India, and China. Twenty five hundred years later Pythagoras
was recorded as saying:

"There is geometry in the humming of the strings. There is
music in the spacing of the spheres."

To a degree that we have difficulty understanding in modern terms,
there exists a rich ancient lore expressing the belief in a cosmic harmony
loosely referred to as "the music of the spheres." In this chapter I will
relate some of this lore and then examine its influence on Johannes Kepler
(1571–1630).

Although Kepler is known primarily for his astronomical discoveries, he
also attempted to relate his observations of the movement of the planets to
imagined sounds they created during their motion. I shall explore Kepler's
musical theories and another number series discovered by the German
astronomers Titius of Wittenberg (1729–1796) and Johann Elert Bode
(1747–1826) that predicts the positions of the planets.

Kepler is the last of an ancient tradition that sought to find meanings in the natural world for musical harmonies. This chapter is dedicated to examining the root of this tradition. Although Kepler put forth a Herculean effort to find a workable correlation between the movement of the planets and the tones of the musical scale, we shall see that he largely failed in his effort. In Section 5.6 I will describe a musical correlation between the planets discovered by atronomer Gerald S. Hawkins and myself, that is statistically meaningful. Also, in the last chapter, I will show that Kepler's hunch that phenomena of the heavens are related to the ratio of small whole numbers (tonal ratios) now have a plausible explanation in terms of dynamical systems theory.

5.2 The Music of the Spheres

The Greek myths of Apollo, Orpheus, and Hermes Trismegestus illustrate the spiritual power of music. Joscelyn Godwin [God] has examined the rich ancient lore pertaining to the "music of the spheres" as it appears in all of the religions of the world, as discussed in his book *Harmonies of Heaven and Earth*. In this section I shall excerpt some of his writings on this subject.

"There is a characteristic passport to the Celtic Otherworld, reminiscent of the Golden Bough with which Aeneas descended to Hades in Book VI of Virgil's *Aeneid*. It is a silver branch with golden fruits, three or nine in number, which strike together to make an enchanting melody. In *Sickbed of Cuchulain* we meet the tree again in the island palace of Labra, actually giving off its music:

> From a tree in the forecourt
> Sweet harmony streams;
> It stands silver, yet sunlit
> With gold's glitter gleams.

The hero, Bran, was lulled to sleep by sweet music coming from he knew not where. When he awoke, he discovered a musical branch by his side."

"Another legendary king of Ireland, Cormac MacAirt, came upon this same branch in the hands of an unknown man. Its music seduced him so that he sold his own wife and children in exchange for it. It was his quest,

Orpheus-like, to retrieve them that led him through the mist of a Paradise teeming with white birds and watered by a fountain with five streams 'more melodious than mortal music'."

Godwin follows the approach of the French savant Henry Corbin in referring to "this World of the Imagination" or of the "Soul" as an "Imaginal" world. The Imaginal World has its elements, its cities, and its heavenly spheres even they have no material substratum.

"Armed with the concept of the Imaginal World, we can make an intelligent approach to the age-old myth of the Ascent through the Spheres and the music that is heard there — Pamphylian soldier in Plato's 'Myth of Er' saw the system of the seven planets (Mercury, Venus, Mars, Jupiter, Saturn, the Sun, and the Moon) and fixed stars with a siren standing on each sphere 'uttering one tone varied by diverse modulations; and the whole eight of them composed a single harmony'." (See Figure 5.1.)

"Following Plato, Cicero ended his *Republic* with a cosmic vision, presented as a dream. The Roman hero Scipio Africanus saw nine spheres (including the Earth) making a 'grand and pleasing sound'. His deceased grandfather, acting as a guide, explained that it came from the rapid motion of the spheres themselves, which although there are nine, produce only seven different tones, 'this number being, one might almost say, the key to the universe'."

"The Indians of the Peruvian Andes, who have a rich cosmological system, say that the Sun makes a sound when rising. A passage in the Talmud regards the Sun's noise as something to be taken for granted, unnoticed by its very familiarity like the din of the Nile cataracts, the Catadupa, which classical writers often compared with the music of the spheres. 'Why is the voice of a man not heard by day as it is heard by night? Because of the wheel of the Sun which saws in the sky like a carpenter sawing cedars'."

"During the Dark Ages the hymns of the Church Fathers blossomed into *plainchant*. What we know today as *Gregorian chant* is only one branch from the fertile stem of Christian monophony. The others were suppressed, lost, or largely forgotten. The seven tones can be heard as the notes of the planets, the wandering of the melody through them feels like a journey around the spheres. Plainchant, like the mystery of the Mass, offers to each what he or she is able to receive."

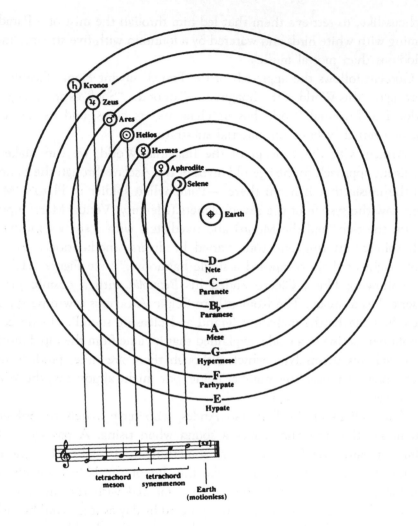

Figure 5.1 The seven planets of ancient times (Mercury, Venus, Mars, Jupiter, Saturn, the Sun, and the Moon) each assigned to its own sphere.

"The writings of the Kaballah contain a vision of a harmonious universe in which not only the angels sing: the stars, the spheres, the merkavah (Chariot–Throne) and the beast, the trees in the garden of Eden and their perfumes, indeed the whole universe sings before God. Although this source says that only Moses and Joshua could hear such music, in later Kaballistic

schools, particularly the Hasidim, the privilege is extended to the zaddiks, or living spiritual masters."

"In the public worship of Islam, music has no place beyond the simple chanting of the Koran. As if in compensation, the Moslem esoteric orders — the Sufis — have made music one of the strongest features of its religious practices. The general term for it *sama*, stresses the passive nature of this musical way. The *Whirling Dervish* of the Near East is one such development. Properly called the Mevlevi Order, and founded in Konya, Turkey by the Persian poet Rumi (1207–1273), these people still practice a sama or whirling dance accompanied by the music of the nay, or reed flute. They dress in tall felt hats shaped like truncated cones, and white gowns with broad skirts that stand out as they whirl. Their hats are said to be tilted at the same angle as the Earth's axis, and their dance to symbolize the movement of the planetary spheres as they circle in perfect order and love for their Lord. Rumi, explains the purpose of this devotion:

We all have been parts of Adam, we have heard these melodies in Paradise.

> Although the water and earth of our bodies
> have caused a doubt to fall upon us,
> something of those melodies comes back to our memory."

The Kaaba is the most sacred structure in Islamic tradition. Each year pilgrims make a tawaf, a counterclockwise walk consisting of seven revolutions around the Kaaba starting at a meteorite set in a silver yoke at the southeast corner. They make 3 revolutions quickly and 4 more slowly. Some traditions say the tawaf ritual represents the cosmos: 3 circuits for the fast-moving moon, Mercury, and Venus, and 4 for the sun and outer planets Mars, Jupiter and Saturn. In this sense the tawaf represents a kind of silent music of the spheres [Haw1].

"In the Hindu world, the use of music for the attainment of higher states merges into a whole science of sound and its practical application to Yoga. In Shabda–yoga, one sets out to discover the Inner sound and to identify oneself thereby with the universal Sound Current. The inner ear may perceive it at first in a variety of forms: noises as of bells and other instruments, of animal and human voices, of waters and thunders, sometimes in systematic sequence and with reference to various energy-centers in the

body in which they seem to occur as one's practice progresses. Clearly the Shabda–yogin is exploring the same worlds, or states as the Jewish and Muslim mystics, only more particularly in aural mode:

> Terrestial music lets us hear a feeble echo of those sweet modulations which the ear of common mortals cannot grasp, and awakens in them the uplifting memory of what they heard in a previous life — Of all instruments, the seven-stringed lyre is the most apt for recalling to men the eternal concert of the grand cosmic symphony. Those who cultivate the art of music are preparing themselves a path through the heavens to the place of the Blessed, just as surely as the most powerful geniuses — Macrobius says that 'The laws of many people and lands set down that one should accompany the dead to their burial with song: this usage is founded upon the belief that souls, on quitting the body, return to the origin of music's magic, that is to heaven'."

The music of the spheres and other neoPlatonic ideas were embraced by Pico della Mirandola and Marsilio Ficino (1433–1499) and found their way to the Italian Renaissance.

5.3 Kepler's Music of the Spheres

Throughout his life, Kepler pursued his quest for evidence of a harmony of the world alluded to in ancient writings. He believed that the geometry of the planetary orbits was in some way connected to the musical scale.

Kepler's *Mysterium Cosmographicum*, was his first attempt to explore these connections. Published when he was 23, long before he discovered that the planets revolved around the sun in ellipses, the orbits of the six known planets, were correlated with the harmonic relations between the five Platonic solids each inscribed and circumscribed about each other as shown in Figure 5.2. Twenty five years later, making use of the observations of the astronomer Tycho Brahe, he published *Harmonices Mundi* which included, coincidentally, his famous three laws which led Newton to his discovery of

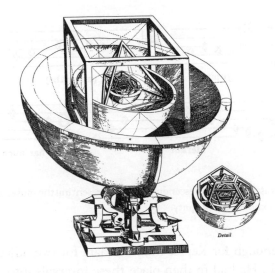

Figure 5.2 The planetary system of Johannes Kepler.

the laws of motion [Kep]. However, these laws were not of primary importance to Kepler. It was actually his hypothesis that the movements of the planets coincided with musical intervals that captured his imagination. It was Kepler who first introduced the notion of major and minor scales in a modern sense in order to study the harmony of the planets. He was a serious student of music who learned the relationship between pitch and string length directly from experiments with a monochord [Gin].

Kepler's most important discovery was that the planets move around the sun in ellipses and not in circles as in Copernicus's model and as all previous geocentric models required. In Chapter 4 of *Harmonices Mundi*, Kepler examines the ratios of many different data for the planetary orbits including their distance from the sun, solar years, daily arcs, etc. and compares these ratios to corresponding musical ratios from the Just scale. The results did not satisfy him until he tabulated the motion of each planet at *perihelion* (the closest approach in its orbit to the sun) and *aphelion* (the furthest approach from the sun in its orbit) as measured from the sun over a 24-hour period and took the ratio of the angular traversal of one planet at aphelion with either the same planet at perihelion or an adjacent planet at perihelion. The results are tabulated in Appendix 5.A (Table 5.A1).

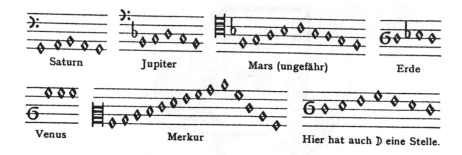

Figure 5.3 Kepler's ascending and descending scales representing the music of the Earth, Moon, and the five planets known to antiquity.

It was not enough for Kepler to relate data for two adjacent planets to musical intervals. He had to then place these intervals into a musical scale into order to create the music of the spheres. Kepler made a point of the fact that while a pair of planets can be simultaneously at perihelion and aphelion and thereby harmonize with each other in their musical tones, a single planet must sound its musical tones sequentially as was referred to in ancient polyphony as *figured song*. As a result, Kepler created musical phrases encompassing the musical interval of each planet as shown in Figure 5.3 in order to recreate how the planets might have sounded on the first day of creation.

5.4 Results of Kepler's Analysis

Kepler's first two laws state:

a) the planets circle the sun in ellipses with the sun at one facus, and
b) the planets traverse equal angles in equal times as seen from the sun.

The ratio of the angular traversals between a planet at perihelion to another planet at aphelion, $\Delta\theta_{p2}$ and $\Delta\theta_{a1}$, can be determined from these two laws as follows [Kap-H],

$$\frac{\Delta\theta_{p2}}{\Delta\theta_{a1}} = \left(\frac{1+e_2}{1-e_1}\right)^{1/2}\left(\frac{r_{a1}}{r_{p2}}\right)^{3/2}, \qquad (5.1a)$$

$$\frac{\Delta\theta_{a2}}{\Delta\theta_{p1}} = \left(\frac{1-e_2}{1+e_1}\right)^{1/2}\left(\frac{r_{p1}}{r_{a2}}\right)^{3/2}, \qquad (5.1b)$$

where e is the eccentricity of the planet's orbit and r_p and r_a are the radial distances of the planets at perihelion and aphelion. However, Kepler, not being privy to Newton's Laws, based his computations on the observational data of Brahe. Table 5.A1 compares Kepler's results with the results computed from Equations (5.1) and compares both with the value of the appropriate musical ratio.

Just how close were the musical tones to Kepler's ratios? Two historians of Kepler's musical theories have concluded in their excellent treatises that his analysis was reasonably accurate [War], [Ste]. In my analysis, of the 16 tones tabulated by Kepler, five values of the angular ratios were within a tolerance of 15 cents (100 cents equals a half-tone) to their corresponding tone, taking C as the fundamental. This is roughly the accuracy that the equal-tempered scale of the piano approximates the Just scale. Five more had a distance between 15 and 32 cents from each of its associated tone or about the proximity of a Pythagorean comma (about 25 cents). Five were off by approximately a quarter-tone while one was off by nearly a semitone. However, using the theory of probability, it is over 90% certain that five tones out of 16 are within 15 cents of an musical tone purely by chance. Kepler was well aware of the discrepancies between planetary ratios and tones but nevertheless considered them to be tolerable. However, this falls far short of the standards of modern science.

While Kepler's association of angular ratios with tones are questionable based on these results, the data from which he made his deductions are remarkably accurate as has been noted by other researchers [Gin]. Using modern data and the benefit of Newton's laws of motion, I checked Kepler's computations and found them to be close to the exact values computed from Equations (5.1). In order to make the computation I assumed that the orbits have constant eccentricities which modern astronomy knows to be in error. However, the errors in eccentricity have only minor effects on the computations, not changing them significantly. Perhaps more seriously, the center of gravity of the solar system is not centered about the sun as Kepler assumed but is a wandering point over time, and therefore his angular

traversals with respect to the sun, do not have quite the significance that he attributed to them.

Despite these inaccuracies, we are struck by how steadfast Kepler was in the pursuit of a relationship between planetary ratios and consonant musical tones. Kepler considered the discovery of these musical laws to be his greatest discovery, and in the ninth chapter of *Harmonices Mundi* he says that "the eccentricities of the individual planets have their origin in the concern for harmonies between the planets". Kepler argues that the elliptical form is necessary for the intervals to have been generated at all since this would have been impossible with circular orbits. The world was merely following the creator's will so that "thy Church may be built on Earth, as Thou didst erect the heavens themselves out of harmonies". In this way he claimed his discoveries appeared to support the view that since neither the elliptical forms of the planetary orbits nor the musical laws governing these orbits made sense on their own, they must have been related through a common source, referred to as the "music of the spheres".

5.5 Bode's Law

Kepler recognized that there was a vast expanse between the orbits of Mars and Jupiter when he once declared, "I have become bolder, and now I place a planet between these two".

Johann Elert Bode was a German astronomer famous for publishing a catalogue of 17,240 stars and nebulae. He is ironically now more famous for re-publicizing, in 1800, a number series postulated a few years earlier by Titius of Wittenburg that approximately predicted the planetary distances of the seven planets known at the time. In this series, a number appeared between the numbers associated with Mars and Jupiter with no planet correlated with it. In 1801 Ceres, the largest asteroid in the asteroid belt, was discovered by Guiseppi Piazzi in the gap between Mars and Jupiter, and thereafter Titius' number series became known as the *Titius-Bode law*.

This law can be illustrated with the aid of a structure invented by Buckminster Fuller known as the "jitterbug" [Kap3]. Figure 5.4 shows how the jitterbug works. It can be used to transform a point (0 edges) to an

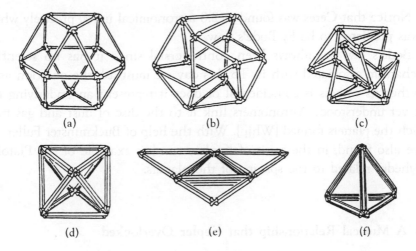

(a)　　　　　　(b)　　　　　　(c)

(d)　　　　　　(e)　　　　　　(f)

Figure 5.4 The jitterbug of Buckminster Fuller.

Table 5.1 Bode's Law.

	Predicted Value	Actual Value	
0 + 4 = 4	.4	.39	Mercury
3 + 4 = 7	.7	.72	Venus
6 + 4 = 10	1.0	1.0	Earth
12 + 4 = 16	1.6	1.52	Mars
24 + 4 = 28	2.8	2.8	Ceres
48 + 4 = 52	5.2	5.2	Jupiter
96 + 4 = 100	10.0	9.5	Saturn
192 + 4 = 196	19.6	19.2	Uranus

equilateral triangle (3 edges) to a tetrahedron (6 edges) to an octahedron (12 edges) to a cuboctahedron (24 edges). This leads to the series: 0, 6, 12, 24, which can be continued to 48, 96, 192. Adding 4 to each number of the sequence as shown in Table 5.1 results in Bodes law where the numbers represent astronomical units in which the Earth's distance to the sun, 93 million miles, represents 1 unit.

Notice that Ceres was found at 2.8 astronomical units, precisely where it was predicted to be by Bode's Law.

Bode's law has always been controversial since it has no scientific mechanism associated with it. To this day we must ask the question as to whether its success is coincidental or does it represent an underlying law not yet understood? Astronomers link it to the disc of dust and gas from which the planets formed [Whip]. With the help of Buckminster Fuller, we have also found, in the spirit of Kepler, another example of the Platonic polyhedra related to the spacing of the planets.

5.6 A Musical Relationship that Kepler Overlooked

Near the end of his life, Kepler formulated his third law which states:

> The periods of the planets are proportional to the $\frac{3}{2}$ power of their mean radii, i.e., $\frac{T_2}{T_1} = \left(\frac{r_2}{r_1}\right)^{3/2}$ where T is the period of the planet and r is the mean radius.

Working backwards from this law, Isaac Newton discovered the *universal law of gravitation*. However, in his search for an harmonic law governing the planets, Kepler considered and then rejected ratios between the periods of the planets. "We conclude that God the Creator did not wish to introduce harmonic proportions into the durations of the planetary years".

In Harmonices Mundi he states that the periods of the planets are directly related to the angular traversals of the planets at perihelion and aphelion, but he does not derive this relation, finding it instead by interpolating Tycho's observations. Equations 5.1 make this relationship clear. If the orbits are taken to be circles (i.e., eccentricity equals zero in Equation 5.1) and the mean distances to the sun are used, then the ratio of the angular traversals between two planets equals the ratio of their periods. In this way we are reconsidering a result based on periods that Kepler rejected [Kap-H].

The ratios between the periods of adjacent planets are given in Table 5.2 based on values of the sidereal period listed in Table 5.A2. The sidereal period of a planet is the time it takes to make one revolution in

Table 5.2 Comparison of period ratios of the planets with tonal ratios where C is taken to be the fundamental.

Planet Ratios	Period Ratio	Tonal Ratio	Pitch Class	Error (cents)
Mercury/Venus	.3915	2:5	E	−37
Venus/Earth	.6152	5:8	A flat	−27
Earth/Mars	.5317	8:15	B	−5
Mars/Ceres	.3985	2:5	E	−6
Ceres/Jupiter	.3979	2:5	E	−9
Jupiter/Saturn	.4025	2:5	E	11

its orbits as seen from the stars. I have added the asteroid Ceres to this table and taken it to have a period of 4.72 years, the geometric mean between the periods of Mars and Jupiter, and corresponding to the radial distance from the sun of Bode's law. Four out of the six ratios are now within 13 cents of a corresponding tone from the diatonic scale (C, D, E, F, G, A, B) taking C as the fundamental tone.

Notice that the ratio of the period of Venus to Earth is approximately 5:8 (G sharp) although too small by 27 cents. But it had long been accepted in the ancient world that Venus makes five closest approaches to the Earth for each eight revolutions about its orbit as shown in Figure 5.5 which accounts for the period ratio of 5:8.

The ratios of Mars to Earth gives a musical ratio of 8:15 (B) while the next three ratios are close to 2:5 (E in the next octave). Today's celestial mechanics experts attribute "the great inequalities" between Jupiter and Saturn as due to the 2:5 relationship in the periods [Encyclopedia Brittanica]. Furthermore, astronomers and space scientists know that Mars makes its closest approaches mostly in 15-year intervals. Only the ratio between Mercury and Venus deviates by an unacceptable amount. Using the law of probability, I and astronomer Gerald S. Hawkins have determined that, assuming that period ratios are randomly distributed, there is only a 0.5% chance of the period ratios approximating the diatonic tones by accident to the accuracy that we have found.

Figure 5.5 Venus makes five closest approaches to Earth in eight years.

It has recently been reported that the star, Gliese 876, 15 light years from the Earth has a pair of planets with orbital periods of 61 and 30 days, close to an octave ratio [Mal]. A discovery reported at the 2002 meeting of the American Astronomical Society indicates that 10–15% of the small objects in the Kuiper belt beyond Pluto known as Plutios are tuned to the periods of 2:1 [Hol-Der], [Mal]. Also the orbital periods of the adjacent moons of Saturn and Jupiter have close to octave ratios.

Can these have been the harmonic intervals that Kepler sought? Since he already suspected the existence of the missing planet Ceres, he could have gone one step further and computed the geometric mean 4.72. Only adjacent planets are correlated to the musical tones, and an accurate musical scale involving all of the planets cannot be found [Gin]. If Kepler had narrowed his sights to pairs of planets, then he would have found his music. Moreover, modern theories of dynamical systems have taught us to expect correlations between frequencies of revolution of gravitating bodies under the direct influence of each other's gravitating fields. For example, the moon shows us only one face since its rotation about its own axis matches the rotation about the earth. (see Chapter 25).

Pairs of gravitating bodies such as the asteroids or orbiting particles around Saturn tend to create gaps in which gravitating bodies are repelled (see Section 14.6). However, there is yet no theory to explain these dynamics.

5.7 Conclusion

Scientists of the caliber of Kepler and Newton had a firm belief that the universe expressed a certain harmony, and that they were following representatives of a line of inquiry that went back to antiquity. Despite the fact that Kepler was using Tycho Brahe's data obtained before 1600 without the aid of a telescope, the difference between Kepler's observed values and our values computed with idealized equations and modern data amounted, in 14 out of 16 cases, in an error of less than 18 cents and were, in several cases, in nearly exact agreement. If Kepler had used adjacent planets and focused on periods he would have found the "music".

In Chapters 14 and 25 of this book, we shall see that, in modern terms, there is reason to expect that natural resonances, be they of quantum phenomena, spacing of the asteroids and the rings of Saturn, or positioning of leaves in a plant, are related to the ratios of small whole numbers.

Appendix 5.A Kepler's Ratios

Table 5.A1 lists musical ratios (column 4). The deviations of the theoretical and the observed ratios from the musical ratios in units of cents are listed in columns 5 and 6 while the deviation of Kepler's ratio and the theoretical values from each other are listed in column 7. The letters in column 1 correspond to angular values of the various planets at aphelion and perihelion, i.e., Planet $(\Delta\theta_a, \Delta\theta_p)$ where Saturn (a,b); Jupiter (c,d); Mars (e,f); Earth (g,h); Venus (i,k); and Mercury (l,m).

The data for mean eccentricity, perihelion, and aphelion radii of the planets are listed in Table 5.A2.

Table 5.A1 Comparison of theoretical and computed values of Kepler's musical ratios of angular traversal for adjacent planets (C is taken to be the fundamental).

	Computed Ratio	Observed Ratio	Musical Tone (cents)	Comp. Error (cents)	Obs. Error (cents)	Comp.–Kep.
a:b	.8000	.7562	4:5(E)	0	−32	32
a:d	.3272	.3272	1:3(G)	−32	−32	0
c:d	.8253	.8180	5:6(E flat)	−20	−32	12
b:c	.4963	.5000	1:2(C)	−13	0	−13
c:f	.1189	.1183	1:8(C)	−86	−95	−9
e:f	.6872	.6900	2:3(G)	53	60	−7
d:e	.2099	.2097	5:24(E flat)	13	12	1
g:h	.4282	.4280	5:12(E flat)	47	46	1
f:g	.9335	.9307	15:16(D flat)	−4	−1	−3
f:g	.6661	.6664	2:3(G)	−2	−1	−1
g:k	.5873	.5844	3:5(A)	−37	−47	10
i:k	.9867	.9715	24:25(C sharp)	26	21	5
h:i	.6444	.6464	5:8(A flat)	53	58	−5
i:m	.2492	.2470	1:4(C)	−5	−21	16
l:m	.4343	.4270	5:12(E flat)	71	45	26
k:l	.5889	.5952	3:5(A)	−32	−14	−18

Table 5.A2 Planetary data.

Planet	e_{mean}	r_p (km)	r_a (km)	Sidereal Period (yrs)	Angular Traversal Harm. Mundi (sec. of arc) aphel.	perihel.
Saturn	.05564	1347.6	1506.4	29.4707	106	135
Jupiter	.04844	740.6	816.0	11.8628	270	330
Mars	.09346	206.6	249.2	1.8809	1574	2281
Earth	.01671	147.1	152.1	1	3423	3678
Venus	.006470	107.5	108.9	.61520	5810	5857
Mercury	.2055	46.0	69.8	.24085	9840	23040

6

Tangrams and Amish Quilts

The artist is like Sunday's child; only he sees spirits.
But after he has told of their appearing to him everybody sees them.

Goethe

6.1 Introduction

While driving with my family on a vacation in Lancaster County, the home
of the Pennsylvania Dutch, I began to make plans for my course on the
Mathematics of Design. I wanted to find a way of linking ideas from the the
history of design to the world around me.

I had just been reading *Secrets of Ancient Geometry* by Tons Brunes [Bru]
in which he analyzes an enigmatic eight-pointed star that will be the subject
of Chapter 8 (see Figure 8.1). He describes his theory that this star, along
with the subdivision of a square by a geometrical construction that he calls
the "sacred cut", formed the basis of temple construction in ancient times.
To construct the *sacred cut* of one side of a square with compass and straight
edge, place the compass point at a corner of the square and draw an
arc through the center of the square until it cuts the side as shown in
Figure 6.1. This arc cuts the side of the square to a length $\frac{1}{\sqrt{2}}$ as large.
Four such cuts determine the vertices of a *regular octagon* as shown in
Figure 6.2.

Kim Williams, an architect living near Florence, also described to me
how she had found the system related to Brunes's sacred-cut geometry
embedded in the proportions of the pavements of the baptistry of the church
of San Giovanni which itself is shaped like a regular octagon [Will1].

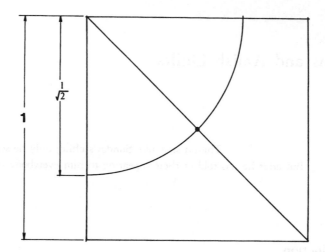

Figure 6.1 The sacred cut.

Figure 6.2 Construction of a regular octagon from four sacred cuts.

The pavements themselves had many star octagonal designs engraved in them. The star octagon, an ecclesiastical emblem, signifies resurrection. In medieval number symbolism, eight signified cosmic equilibrium and immortality.

6.2 Tangrams

Recently, I had been showing my son the fascinating tangram puzzle in which thousands of pictograms, such as the one shown in Figure 6.3a, are created from the dissection of a square into the seven pieces shown in Figure 6.3b. A tangram set can be created from a single square piece of paper by simply folding and cutting. The pieces consist of a 45-degree right triangle at three different scales along with the square and diamond formed by juxtaposing two 45-degree right triangles as shown in Figure 6.4. The side of the larger triangle is equal in length to the hypotenuse of the next smaller. Each pictogram must be formed from each of the seven pieces with no repeats and no overlaps. Enlarge the pieces, cut them out, and try your hand at constructing the pictogram shown in Figure 6.3b. Exactly 13 convex polygons (polygons with no indentations) can be constructed from the tangram set including one rectangle (other than a square) and one triangle (other than an isosceles right triangle). However, it is enough of a challenge to reconstruct the square.

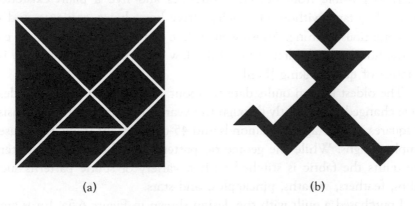

(a) (b)

Figure 6.3 (a) The tangram set; (b) a pictogram constructed with the tangram set.

Figure 6.4 The 45 degree right triangle is the geometric basis of the tangram set.

6.3 Amish Quilts

On our vacation to Pennsylvania Dutch country we were able to explore the countryside, visit working farms, and delve briefly into the rich history of the people. The Amish and Mennonites settled in Pennsylvania during the eighteenth and nineteenth centuries as refugees from religious persecution in Germany and found a haven of freedom and rich farm lands in Lancaster county. While the Mennonites are devoutly religious and live simple lives devoid of materialistic pursuits, they do enjoy a few of the comforts of modern society. The Amish, however, attempt to insulate themselves as much as possible from outside influences and live a plain existence in which they farm without electricity, drive horsedrawn carriages, and wear unostentatious clothing. Amish women live extremely proscribed lives caring for the house and children. One of the few outlets for their creativity is the practice of quilt making [Ben].

The oldest known quilts date to about 1850. However quilting designs have changed only slightly through the years. Geometric patterns consisting of squares, star octagons, diamonds and 45-degree right triangles are used in simple designs. While the geometric patterns are the manifest content of the quilts the fabric is stitched with a variety of subtle patterns such as tulips, feathers, wreaths, pineapples, and stars.

I purchased a quilt with the design shown in Figure 6.5a. I was amazed to see that it consisted almost entirely of pieces from the tangram set.

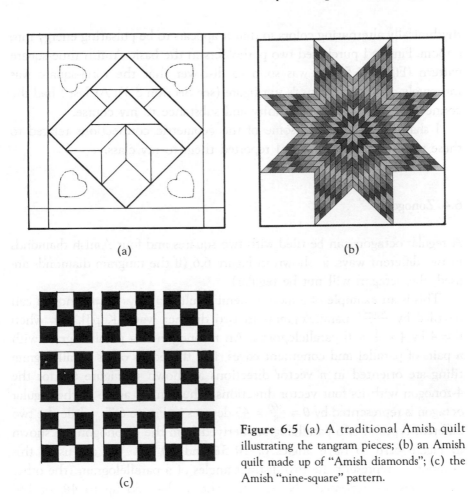

(a)

(b)

(c)

Figure 6.5 (a) A traditional Amish quilt illustrating the tangram pieces; (b) an Amish quilt made up of "Amish diamonds"; (c) the Amish "nine-square" pattern.

You can see that it has 45 degrees right triangles at three different scales, squares, and diamonds that have the same internal angles as the tangram diamond, namely 45 degrees and 135 degrees. However, the Amish quilt diamonds differ from the Tangram diamonds by having all equal edge lengths. The ratio of the diagonals of the Amish diamond is $1 + \sqrt{2} : 1$, an important number that will be considered in greater depth in the next chapter. This is identical to the ratio of line segments into which the sacred cut divides the edge of a square. I shall refer to these as *Amish diamonds*.

I also purchased a larger quilt which utilizes the pattern of the star octagon shown in Figure 6.5b. It is made of the tangram diamonds in

rhythmically alternating colors so that it appears to be pulsating energy into a room. Finally I purchased two potholders in the basic Amish nine-square pattern (Figure 6.5c). I was soon to discover that the nine-square was intimately related to Brunes's star figure (see Section 8.3). At last I had the connections that would give unity and substance to my course.

I shall now summarize some of the geometric connections related to these personal discoveries, as I reported them to my class.

6.4 Zonogons

A regular octagon can be tiled with two squares and four Amish diamonds in two different ways, as shown in Figure 6.6 (if the tangram diamonds are used, the octagon will not be regular).

This is an example of a more general result that says an n-zonogon can be tiled by $\frac{n(n-1)}{2}$ parallelograms in two distinct ways [Kap3], e.g. when $n = 4$ by $4 \times \frac{3}{2} = 6$ parallelograms. An n-zonogon is a parallelogram with n pairs of parallel and congruent edges, i.e., the edges of its parallelogram tiling are oriented in n vector directions as shown in Figure 6.6 for the 4-zonogon with its four vector directions. The central angle of the regular octagon is represented by $\theta = \frac{360}{8} = 45$ degrees in Figure 6.7a, while the two different types of two parallelogram derived from the 4-zonogon are shown in Figure 6.7b to have angles of $1\theta, 3\theta$ and $2\theta, 2\theta$. We are using this notation to represent the two distinct angles of a parallelogram (the other two angles are repeated). Notice that the angles add up to 4θ, or 180 degrees, whereas the angles surrounding each vertex in Figure 6.6 sum to 8θ [Lal3]. This can easily be generalized to n-zonogons and their derived parallelograms [Kap3].

A key property of n-zonogons is that their edges line up in a series of n sets of parallel edges or *zones*. The edges of each zone are oriented in the direction of one of the n vectors that define the zonogon. You can observe this in Figure 6.6 for the 4-zonogon. If the length of one of the vectors is shrunk to zero, then one of the zones is eliminated and the n-zonogon collapses to a $(n-1)$-zonogon. Alternatively, each of the n vectors can be expanded or contracted, with the effect that the shape of the zonogon is distorted without altering the internal angles of its parallelograms.

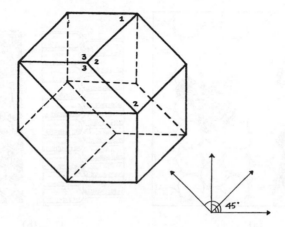

Figure 6.6 A regular octagon tiled with two squares and four Amish diamonds in two ways.

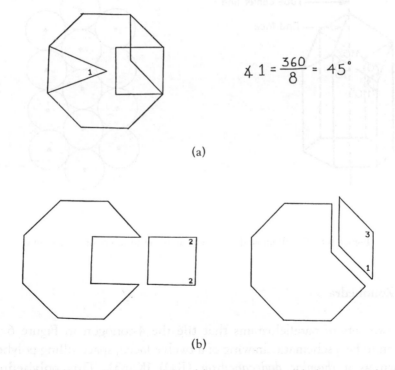

$$\angle\,1 = \frac{360}{8} = 45°$$

(a)

(b)

Figure 6.7 (a) The parallelograms defined by a 4-zonogon; (b) the two angles of the parallelograms add to 4.

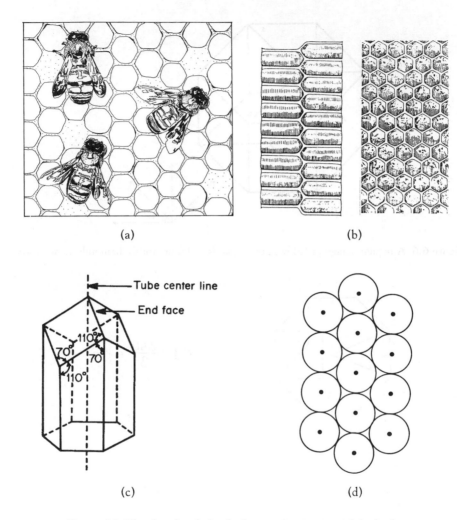

Figure 6.8 The rhombic dodecahedron as the structure of the beehive.

6.5 Zonohedra

The two sets of parallelograms that tile the 4-zonogon in Figure 6.6 can be seen to be a schematic drawing of a twelve-faced, space-filling polyhedron known as a *rhombic dodecahedron* (RD) [Kap3]. This polyhedron is representative of a class of polyhedra with opposite faces parallel and congruent known as *zonohedra*. If the two sets of three-connected edges are

removed from this figure it is easy to see that it represents an *hexagonal prism*. In fact if all the faces of the RD are taken to be rhombuses with diagonals in the ratio $\sqrt{2}:1$ the polyhedron that results is precisely the form that caps the hexagonal prisms that make up the structure of the beehive (see Figure 6.8). It also represents the configuration of the garnet crystal. Here are the links to the natural world that I was looking for. Similar to zonogons, *n*-zonohedra are defined by *n* *zones* of parallel edges. Likewise, if the zonohedron is made of linear rods, one zone of parallel rods can be eliminated and the sticks reconnected, the result being a zonohedron of one order less [Kap3]. This concept was cleverly used by Steve Baer [Boo1], [Bae] to create zonogon shaped houses which could be easily renovated by changing their size and shape in a manner forbidden by geodesic domes. Change a single edge of a geodesic dome and all edges must change size accordingly. However, transformations of zonohedra can be limited to one zone at a time.

6.6 N-Dimensional Cubes

Just as the *n*-zonogon can be subdivided into parallelograms, an *n*-zonohedron can be subdivided into two interlocking sets of,

$$C(n,3) = \frac{n(n-1)(n-2)}{6} \tag{6.1}$$

parallelopipeds where $C(n,3)$ is the number of ways one can choose three objects from a group of *n* where order is not important. If this is done, then *n* edges are incident at each vertex giving a projection of an *n*-dimensional cube in 2 or 3 dimensions. But what do we mean by an *n*-dimensional cube?

Let's consider a 4-dimensional cube, or tesseract as it is called, the boundary of which, in one of its two-dimensional projections, is a 4-zonogon. We see it pictured in Figure 6.9 as the fifth in a series of 0,1,2,3, and 4-dimensional cubes. The 0-dimensional cube (see Figure 6.9a) is a point with no degrees of freedom. The surface of a 1-dimensional cube (line segment) is gotten by translating the 0-dimensional cube (point) parallel to itself (see Figure 6.9b). One has freedom to move left or right along the line. The surface of a 2-dimensional cube (see Figure 6.9c) is gotten by

Figure 6.9 Diagrams of 0,1,2,3, and 4 dimensional cubes.

translating the line segment parallel to itself to obtain a square. Movement is possible on the surface of the square: left–right or up–down. A 3-dimensional cube (see Figure 6.9d) is obtained by translating a square parallel to itself, resulting in a surface with freedom of movement: left–right, up–down, in–out. Finally, the 4-dimensional cube (see Figure 6.9e) is obtained by translating the 3-dimensional cube parallel to itself. You can see that now 4 degrees of freedom are possible: left–right (x), up–down (y), in–out (z), and movement in the elusive fourth direction (w). Of course Figure 6.9e is only the projective image of a 4-dimensional cube the same way that Figure 6.9c is only a projection of a 3-dimensional cube. In an actual 4-dimensional cube there would be no intersecting lines, planes, or volumes just as a 3-dimensional cube has no crossing edges despite the crossing edges that appear in its 2-dimensional projection.

As predicted by Equation (6.1), the tesseract has two sets of 4 intersecting cells projected into the 4-zonogon. Notice the star octagon in Figure 6.9e, reminiscent of my Amish quilt.

6.7 Triangular Grids in Design: An Islamic Quilt Pattern

A 3-zonogon is shown in Figure 6.10. The two sets of 3 parallelograms that tile the hexagon can be seen to be an ordinary cube in perspective. The hexagon is also subdivided into a triangular grid. This triangular grid is useful as a design tool.

In Figure 6.11b we see a triangular grid developed from a family of closely packed circles shown in Figure 6.11a and created as shown in Appendix 6.A. Repeating patterns can be created by deleting lines from Figure 6.11. Two examples are shown in Figure 6.12, and additional designs recreated from a square grid of circles are shown in Appendix 6.A.

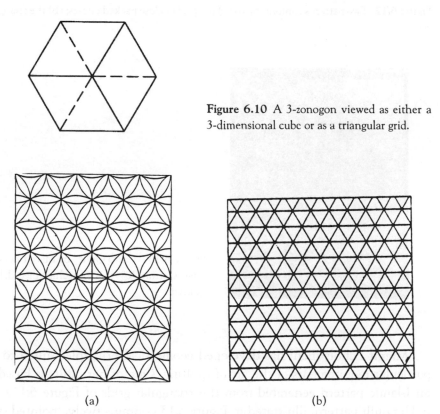

Figure 6.10 A 3-zonogon viewed as either a 3-dimensional cube or as a triangular grid.

(a) (b)

Figure 6.11 (a) A triangular grid of closely-packed circles; (b) a triangular grid.

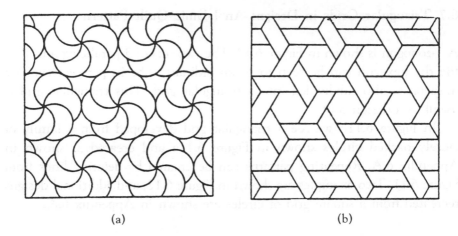

(a) (b)

Figure 6.12 Two patterns conforming to (a) the grid of close packed circles; (b) the triangular grid.

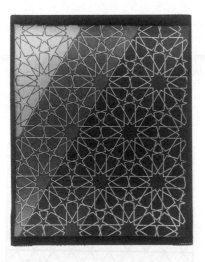

Figure 6.13 "Cairo Quilt" by Margit Echols© 1994, Cotton, 90" × 110", machine pieced, hand quilted.

Margit Echols [Ech] has developed geometrical principles suited to the particular requirements of the art of quilting. One of her quilts is based on an Islamic pattern generated from the triangular grids of Figure 6.11a and b. Her quilt pattern, illustrated in Figure 6.13 contains twelve pointed stars. Three pairs of bounding edges of the star, when extended, traverse the

entire pattern and form a triangular grid. Notice that pentagonal star-like figures make a surprise appearance in the final design.

Echols has the following to say about the art of quilt making:

> "The quiltmaker is faced with tremendous restrictions inherent in both the laws of geometry and the technology of patchwork. How is it we can bear the time it takes to make a quilt? — Besides the obvious rewards of accomplishing technical challenges, of making colors sing, the tactile sensuality of textiles, and the meditative quality of repetitive handwork — there is the pleasure of problem solving of putting the puzzle together, of playing the game, a serious game of a battle against chaos which has deep intellectual appeal."

6.8 Other Zonogons

For a 5-zonogon, the central angle is $\theta = \frac{360}{10} = 36$ degree and the two species of parallelogram are 1θ, 4θ and 2θ, 3θ (adding up to 5θ). These parallelograms have interesting properties since the ratio of their edge length to one of their diagonals is related to the golden mean, a number whose value is $\tau = \frac{1+\sqrt{5}}{2}$. These parallelograms will be discussed further in Section 20.4 and will arise in Section 25.2 in the context of quasicrystals. Designs with these parallelograms, such as the one in Figure 6.14, have approximate five-fold symmetry.

The design possibilities are all the richer for tiling a 6-zonogon. Tiling the 6-zonogon by its parallelograms, 1θ, 5θ; 2θ, 4θ; and 3θ, 3θ where $\theta = \frac{360}{12} = 30$ degrees, results in perspective diagrams of the *rhombic triacontahedron* (30 parallelogram faces) and the *truncated octahedron* (with 6 square and 8 hexagon faces) shown in Figure 6.15. By successively removing zones the 6-zonohedron (rhombic triacontahedron) collapses to a 5-zonohedron (rhombic icosahedron), then to a 4-zonohedron (rhombic dodecahedron), and finally to a 3-zonohedron (parallelopiped). In the last phase of this transformation there are two possible parallelopipeds, type 1 and type 2, that are the building blocks for all the other zonohedra derived from the 6-zonohedron, much as parallelograms are building blocks for zonogons

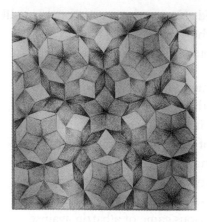

Figure 6.14 A pattern with approximate five-fold symmetry made up of the two parallelograms of the 5-zonogon from the Mathematics of Design class of Jay Kappraff.

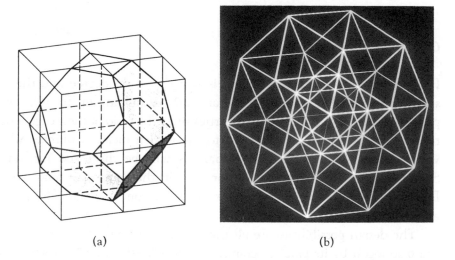

(a) (b)

Figure 6.15 (a) The truncated octahedron; (b) the rhombic triacontahedron.

(see Figure 6.16). All faces of this family of zonohedra are congruent rhombuses and have diagonals in the ratio, $\tau : 1$ and for this reason they are called *golden iso-zonohedra* [Miyazaki 1980]. Each zonohedron can be tiled by the number of parallelopipeds given by Equation (6.1). For example, the rhombic dodecahedron with $n = 4$ is tiled by 4 parallelopipeds, 2 of type 1 and 2 of type 2 as shown in Figure 6.17. The rhombic triacontahedron,

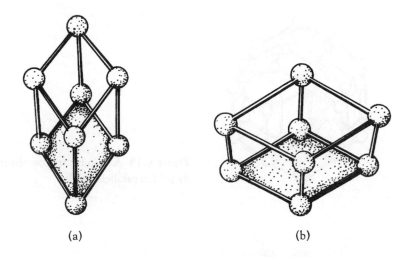

(a) (b)

Figure 6.16 A golden parallelopiped of type 1 and type 2.

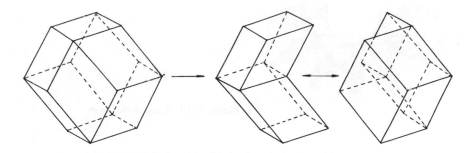

Figure 6.17 A rhombic dodecahedron tiled by by two golden parallelopipeds of type 1 and two parallelopipeds of type 2.

shown in Figure 6.18, with $n = 6$, is tiled by 20 parallelopipeds, 10 of type 1 and 10 of type 2.

The 6-zonogon can also be viewed as a distorted 2-dimensional projection of a 6-dimensional cube, and as for the 4-zonogon, it too has a star dodecagon (12 pointed star) at its center (see Figure 6.19). We also encountered this star in Figure 3.4c in connection with tone cycles of musical thirds, fourths, fifths, and wholetones. The cover of *Connections* [Kap3] shows the extraordinary result of truncating a 6-dimensional cube at one of its vertices.

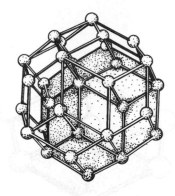

Figure 6.18 A rhombic triacontahedron tiled by golden parallelopipeds.

Figure 6.19 A star dodecagon.

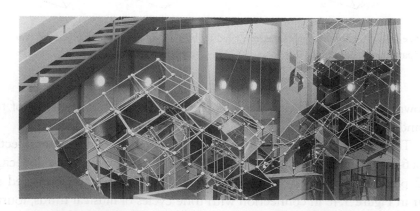

Figure 6.20 A 60-foot long rhombic triacontahedron sculpture with a quasicrystal interior at Denmark's Technical University in Copenhagen by Tony Robbin.

Alan Schoen [Schoe] has created a puzzle called Rombix in which multicolored tiles which are composites of 8-zonogons are used to create a prescribed set of designs. The artist Tony Robbin [Rob] has built a 60-foot sculpture, shown in Figure 6.20, based on quasicrystal geometry for the three story atrium at Denmark's Technical University in Copenhagen. The dome is a rhombic triacontahedron with a quasicrystal interior.

6.9 Conclusion

The concept of the zonogon is the key to understanding the system of design used by the Amish. It leads to a means of visualizing the two-dimensional projection of an important class of three-dimensional polyhedra known as zonohedra, and it places an understanding of the nature of three-dimensional geometry firmly in the context of higher-dimensional geometry. The 4- and 5-zonogons define systems with a repertoire of two parallelograms, the first related to $\sqrt{2}$ and the sacred cut, the second related to the golden mean. A system of architectural proportions developed by the Le Corbusier, known as the Modulor, is based on the golden mean [Kap3]. In the next chapter we shall explore the $\sqrt{2}$ system of proportions in greater depth. We shall also see that these two systems share a unifying structure with roots in the musical scale. The number of parallelograms proliferate for zonogons of a higher order which inhibits their usefulness to serve as systems of proportion.

My visit to the Amish country, examination of the quiltwork of Margit Echols, and the structures of Tony Robbin have reinforced my feeling that artists, and practitioners of the folk arts have infused their work with patterns that share themes of common interest to mathematicians and scientists.

Appendix 6.A

6.A1 *Steps to Creating a Triangular Grid of Circles*

1. Begin with a point at the center of a circle of arbitrary radius.
2. From an arbitrary point on the circumference of this circle draw another circle of the same radius through the center of the first circle

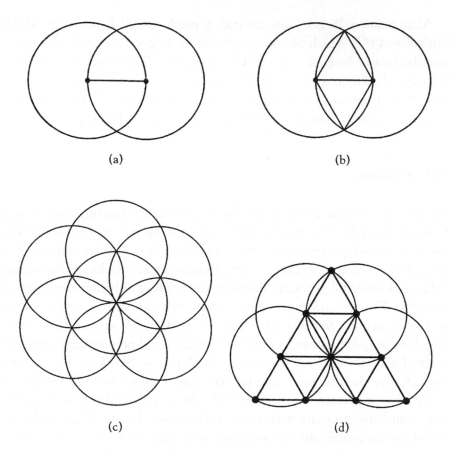

Figure 6.A1 Creation of a triangular grid of circles.

(Figure 6.A1a). This pair of circles is known as the Vesica Pisces. In ancient sacred geometry the Vesica had spiritual significance, and engravings of Christ were often found within the central region [Kap3]. A pair of equilateral triangles can be placed within the central region (Figure 6.A1b).

3. Where any pair of circles intersect, draw circles of the same radius with these points as centers to obtain a set of six circles surrounding a central circle, the beginning of a triangle circle grid (Figure 6.A1c).

4. If lines are drawn connecting the intersection points, a triangular grid results. Four circles create a ten-pointed grid known as the tetractys

(Figure 6.A1c) of great significance in Platonic numerology and discussed in Sections 3.5 and in the next chapter.
5. This process can be continued to generate a triangle circle grid covering the plane (see Figure 6.11a).

6.A2 *Steps to Creating a Square Circle Grid*

1. Begin with a pair of Vesicas generated by three circles (Figure 6.A2a). A pair of circles (light lines) are added to create two axes at right angles.
2. Six additional circles are added to create a circle grid based on a square of nine circles (Figure 6.A2b).

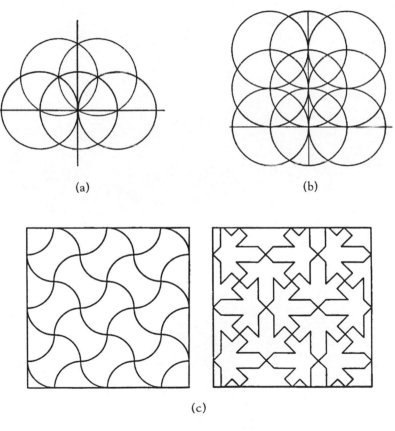

(a) (b)

(c)

Figure 6.A2 A square grid of circles

3. This procedure can be continued to generate a complete square circle grid. In Appendix 10.A we will show that the sacred cut is subtly embedded throughout the square circle grid.

4. You can create designs related to the square circle grid by drawing lines between any pair of defined points. You are also permitted to delete any lines or curves. Try recreating the designs shown in Figure 6.A2c.

7
Linking Proportion, Architecture, and Music

> The harmony of proportions should be achieved in such a manner that nothing
> could be added, diminished or altered except for the worse.
>
> *Leon Battista Alberti*

7.1 Introduction

Throughout the history of architecture there has been a quest for a system
of proportion that would facilitate the technical and aesthetic requirements
of a design. Such a system would have to ensure a repetition of a few key
ratios throughout the design, have additive properties that enable the whole
to equal the sum of its parts, and be computationally tractable — in other
words, to be adaptable to the architect's technical means. The repetition of
ratios enables a design to exhibit a sense of unity and harmony. Additive
properties enable the whole to equal the sum of its parts in a variety of
different ways, giving the designer flexibility to choose a design that offers
the greatest aesthetic appeal while satisfying the practical considerations of
the design. Architects and designers are most comfortable within the realm
of integers, so any system based on irrational dimensions or incommensurable
proportions should also be expressible in terms of integers to make it
computationally acceptable.

Three systems of architectural proportion that meet these requirements:
the system of musical proportions used during the Renaissance developed
by Leon Battista Alberti, a system used during Roman times, and the *Modulor*
of the twentieth-century architect, Le Corbusier [LeC]. All of these systems
draw upon identical mathematical notions already present in the system of

musical proportions as we shall show in Section 7.2. While the Roman system is based on the irrational numbers $\sqrt{2}$ and $\theta = 1 + \sqrt{2}$ the Modulor is based on the golden mean $\tau = \frac{1+\sqrt{5}}{2}$. Both of these systems can also be approximated arbitrarily closely (asymptotically) by integer series, and these integer series can be used to implement the system with negligible error [Kap6]. I shall demonstrate this for the Roman system since the Modulor has been adequately covered elsewhere (cf. [LeC], [Kap3]). I will also show that the basis of the Roman system is a geometrical construction discovered in the Renaissance, known as the *law of repetition of ratios*. The *sacred cut* will be shown to lie at the basis of the Roman system. I shall illustrate, by way of Kim Williams' analysis of the Medici Chapel [Will2], that both the law of repetition of ratios and the sacred cut are geometric expressions of the additive properties of the Roman systems and insure the presence of musical proportions in a design. I will conclude with a discussion of Ezra Ehrenkrantz' system of *modulor coordination* based on both musical proportions of Alberti and Fibonacci numbers [Ehr].

7.2 The Musical Proportions of the Italian Renaissance

During the Italian Renaissance Leon Battista Alberti and Andreas Palladio developed a system of architectural proportion based on proportions inherent in the musical scale (cf. [Schol], [Wit]). This movement was a response to the neoPlatonic ideas prevelant at the time. According to Alberti [Wit]:

> "The numbers by which the agreement of sounds affect our ears with delight are the very same which please our eyes and our minds. We shall therefore borrow all our rules for harmonic relations from the musicians to whom this kind of numbers is well known and wherein Nature shows herself most excellent and complete."

Alberti modeled his system on the Pythagorean scale based on the octave, musical fifth, and fourth. To achieve an octave above the fundamental tone, the bridge of a monochord instrument is moved to the midpoint of the string, (i.e., ratio of 1:2 as shown in Figure 7.1), and the string is

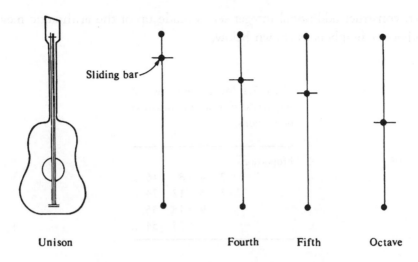

Figure 7.1 A sliding bridge on a monochord divides the string length representing the fundamental tone into segments corresponding to musical fifth (2:3), fourth (3:4), and octave (1:2).

plucked. The fifth is obtained by shortening the string by a ratio of 2:3 while the fourth shortens the string by a ratio of 3:4.

All musical proportions of the Pythagorean scale (see Section 3.4) can be expressed as ratios of powers of the prime numbers 2 and 3. For example, the whole tone corresponds to the ratio 8:9. The system of Palladio was based on the Just scale (see Section 3.6) which also included the prime number 5 [Kap3]. What is of greater relevance is the manner in which a system of architectural proportion was built from these scales. The first suggestion appears in the *lambda* figure (see Figure 3.9b),

$$
\begin{array}{ccccc}
 & & 1 & & \\
 & 2 & & 3 & \\
 & 4 & & 9 & \\
8 & & & & 27
\end{array}
$$

found in Plato's Timaeus and referred to as "world soul."

Consider the sequence,

$$1, 2, 4, 8, 16, \ldots$$

Next, construct additional integer series made up of the arithmetic means of adjacent numbers as shown below,

Table 7.1 Integer sequence of Alberti's system of musical proportions.

Proportions				
1	2	4	8	16 ...
	3	6	12	24 ...
		9	18	36 ...
			27	54 ...

I shall refer to this as Nicomachus' table since an identical table of numbers appeared in the *Arithmetic* of Nicomachus of Gerasa (circa 150 A.D.) (cf. [D'Oo], [Kap14]).

Notice that Plato's lambda appears on the boundary of these series. It is also evident that the ratio of successive terms in the horizontal direction is in the octave ratio, 1:2, while the vertical direction represents the ratio 2:3 (musical fifth) and the right-leaning diagonal (/) exhibits the ratio 3:4 (musical fourth).

The placement of the numbers in Table 7.1 is governed by the three means described in Section 4.3. Each number x of these scales is the geometric mean of the numbers y and z to its left and right, i.e., $x = \sqrt{yz}$. By its construction, each number x is the arithmetic mean of the two numbers y,z above it, i.e., $x = \frac{y+z}{2}$. Finally each number x is the harmonic mean of the two numbers y,z below it, i.e., $x = \frac{2yx}{(y+z)}$. Alternatively, any integer from Table 7.1 is either the arithmetic mean of an increasing octave or harmonic mean of a decreasing octave. For example, 12 is the arithmetic mean of the increasing octave, 8:16, bracing it from above, while it is the harmonic mean of the decreasing octave, 18:9, bracing it from below (see Section 4.3). As the result of these relationships, any sequence x,u,v,y that includes the arithmetic and harmonic means u,v of its endpoints x,y insures a repetition of ratios as illustrated for the sequence 6, 8, 9, 12. Here, $9:6 = 12:8$ and $8:6 = 12:9$.

$$2:3 \qquad 3:4 \qquad 3:4 \qquad 2:3$$
$$6 \underline{\qquad} 9 \underline{\qquad} 12 \; 6 \underline{\qquad} 8 \underline{\qquad} 12 \qquad (7.1)$$
$$1:2 \qquad\qquad 1:2$$

Musically, it is said that "when the musical fifth is inverted in the octave it becomes the musical fourth". All the tones of the Just scale can be produced in a similar manner by placing the arithmetic and harmonic means in the gaps formed by the intervals of Sequence (7.1) and in the successive gaps thereby formed (not shown). Architecturally, any relationship that incorporates musical proportions insures that key ratios repeat in the context of a design.

Alberti used this system in Table 7.1 to design his buildings [Alb]. The dimensions and subdivisions of the rooms of his buildings had measures given by adjacent numbers within the table. Therefore a room could exhibit a 4:6 or 6:9 ratio but not 4:9. This insured that ratios of these lengths would embody musical ratios. Wittkover [Wit] describes Alberti's use of musical proportions in the design of S. Maria Novella and other structures of the Renaissance.

Although the Renaissance system of Alberti succeeded in creating harmonic relationships in which key proportions were repeated in a design, it did not have the *additive properties necessary* for a successful system. However, a system of proportions used by the Romans and the system of proportions developed by Le Corbusier, known as the Modulor, both conform to the relationships inherent in the system of musical proportions depicted in Table 7.1 with the advantage of having additive properties.

7.3 The Roman System of Proportions

The well known integer sequence

$$1, 1, 2, 3, 5, 8, 13, 21, \ldots \qquad (7.2)$$

in which each term is the sum of the preceding two terms possesses is an example of a *Fibonacci sequence* or F-Sequence. The ratio of successive

terms approaches the *golden mean* $\tau = \frac{1+\sqrt{5}}{2}$ in a limiting sense. The τ-sequence (see Section 20.2):

$$\dots, \frac{1}{\tau^2}, \frac{1}{\tau}, 1, \tau, \tau^2, \tau^3, \dots$$

is not only a double geometric sequence but also a Fibonacci sequence (each term is the sum of the preceding two terms). It is the additive properties of this sequence that led Le Corbusier to make it the basis of his Modulor series of architectural proportions. It can also be shown that the Modulor conforms to the relations inherent in Alberti's pattern of the musical proportions exhibited in Table 7.1 [Kap6].

Another integer sequence possessing additive properties is

$$1, 2, 5, 12, 29, 70, \dots \tag{7.3}$$

known as *Pell's sequence* in which twice any term in the sequence when added to the previous term gives the next term. Theon of Smyrna, a second-century A.D. Platonist philosopher and mathematician first presented this sequence in his book *The Mathematics Useful for Understanding Plato* [The]. The ratio of successive terms from any Pell sequence such as Sequence (7.3),

$$\frac{2}{1}, \frac{5}{2}, \frac{12}{5}, \frac{29}{12}, \frac{70}{29}, \dots \tag{7.4}$$

approaches the irrational number $\theta = 1 + \sqrt{2}$, called the *silver mean*, in a limiting sense. We have already seen that the sacred cut (see Section 6.2) divides the edge of a square in the ratio $1:\theta$. Since the sacred cut is associated with the construction of a regular octagon (see Figure 6.2), it is not surprising that the diagonals of an octagon divide each other in the ratio $1:\theta$ as shown in Figure 7.2. This number is also known as the *silver means* since it is second in importance to the study of dynamical systems (see Chapters 22 and 25).

The θ-sequence

$$\dots, \frac{1}{\theta^2}, \frac{1}{\theta}, 1, \theta, \theta^2, \theta^3, \dots \tag{7.5}$$

is the only geometric sequence that is also a Pell sequence.

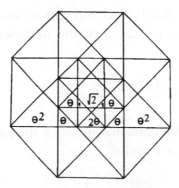

Figure 7.2 A star octagon. The diagonals cut each other in proportions 1:θ.

Table 7.2 The roman system of proportions based on θ.

$$\ldots$$

$$\ldots,\frac{2\sqrt{2}}{\theta^2},\frac{2\sqrt{2}}{\theta},2\sqrt{2},2\theta\sqrt{2},2\theta^2\sqrt{2},2\theta^3\sqrt{2},2\theta^4\sqrt{2},\ldots$$

$$\ldots,\frac{2}{\theta^2},\frac{2}{\theta},2,2\theta,2\theta^2,2\theta^3,2\theta^4,\ldots$$

$$\ldots,\frac{\sqrt{2}}{\theta^2},\frac{\sqrt{2}}{\theta},\sqrt{2},\theta\sqrt{2},\theta^2\sqrt{2},\theta^3\sqrt{2},\theta^4\sqrt{2},\ldots$$

$$\ldots,\frac{1}{\theta^2},\frac{1}{\theta},1,\theta,\theta^2,\theta^3,\theta^4,\ldots$$

$$\ldots$$

Thus,

$$\ldots,\frac{1}{\theta}+2=\theta,\quad 1+2\theta=\theta^2,\quad \theta+2\theta^2=\theta^3,\ldots \tag{7.6}$$

Therefore, a Pell sequence possesses many additive properties which is why it was used in ancient Rome as the basis of a system of architectural proportions (cf. [Schol], [Kap3], [Wat-W1], [Will1]).

Table 7.2 illustrates the infinite sequences that underlie the Roman system of proportions, and it is identical in its mathematical structure to

Nicomachus' Table 7.1 [Kap1]. Each element in this table is the arithmetic mean of the pair above it, e.g., θ^2 is the arithmetic mean of $\theta\sqrt{2}$ and $\theta^2\sqrt{2}$,

$$\frac{\theta\sqrt{2}+\theta^2\sqrt{2}}{2}=\theta^2 . \tag{7.7a}$$

Also each element is the harmonic mean of the pair below it, e.g., $\theta\sqrt{2}$ is the harmonic mean of θ and θ^2,

$$\frac{2\theta\theta^2}{\theta+\theta^2}=\theta\sqrt{2} . \tag{7.7b}$$

The algebra to carry out these operations can be seen more clearly by comparing the θ-sequence in the first three lines of Table 7.2 with the discrete version of this sequence.

$$2, 4, 10, 24, 58, 140, \ldots$$
$$1, 3, 7, 17, 41, 99, \ldots$$
$$1, 2, 5, 12, 29, 70, \ldots \tag{7.8}$$

Both of these triples of sequences have the Pell's sequence property: $a_{n+2} = 2a_{n+1} + a_n$ and the ratio of successive terms of Sequences (7.8) approaches θ in a limit sense as $n \to \infty$. Any algebraic operation that holds for the integer sequence also holds for the θ-sequence. This sequence has many additive properties, although we list only four fundamental properties from which the others can be derived.

(i) Each Pell sequence has the defining property,

x,x,x Property 1: $a + 2b = c$, e.g., $1 + 2 \times 2 = 5$ and $1 + 2\theta = \theta^2$,
a,b,c

(ii) and (iii) Other additive properties are,

 $c\ d$
 $x\ x$ Property 2: $a + b = d$, e.g., $2 + 5 = 7$ and $1 + \theta = \theta\sqrt{2}$,
 $x\ x$ Property 3: $a + c = b$, e.g., $2 + 3 = 5$ and $\theta\sqrt{2} + \theta = \theta^2$.
 $a\ b$

(iv) Property 4: Any element is the double of the element two rows below it.

Using these properties, it is an exercise to verify Equations (7.7). The integer Sequences (7.8) exhibit the same geometric, arithmetic, and harmonic mean relationships as Table 7.1 in an asymptotic sense. Thus each term is the approximate geometric mean of the terms to its right and left, e.g., $5^2 \approx 2 \times 12$. Each term in the Sequence (7.8) is the average of the terms above it, e.g., $5 = \frac{3+7}{2}$. Each term from Sequence (7.8) is approximately the harmonic mean of the two terms that below it, e.g., $3 = \frac{21}{7} \approx \frac{2 \times 2 \times 5}{2+5} = \frac{20}{7}$ with the approximation becoming asymptotically better for terms further to the right in the sequence. Finally, any term in the first sequence divides the interval below it approximately in the ratio $1:\theta$, e.g., $\frac{(41-29)}{(70-41)} = \frac{12}{29} \approx 1:\theta$.

Also the ratio of any term from Table 7.2 to the one below it equals $\sqrt{2}$ while the ratio of any integer from Sequence (7.8) to the one below it approximates $\sqrt{2}$ with the approximation asymptotically approaching $\sqrt{2}$ in the limit as $n \to \infty$. For example,

$$\frac{1}{1}, \frac{3}{2}, \quad \frac{7}{5}, \frac{17}{12}, \dots \tag{7.8}$$

approaches $\sqrt{2}$ in a limiting sense. It should be noted that since the sum of two integers in any row equals an integer from the row above it, an infinite number of rows are needed to insure that this proportional system has additive properties.

D. Watts and C. Watts [Wat-W1] have studied the ruins of the Garden Houses of Ostia, the port city of the Roman Empire, and found that they are organized entirely by the proportional system of Table 7.2 or its integer approximation, Sequence (7.8).

7.4 The Geometry of the Roman System of Proportions

The algebraic properties of the Roman system of proportion can be made understandable by considering the equivalent geometric properties. We find that three rectangles of proportions 1:1 (square − S), 1:$\sqrt{2}$ (square root of

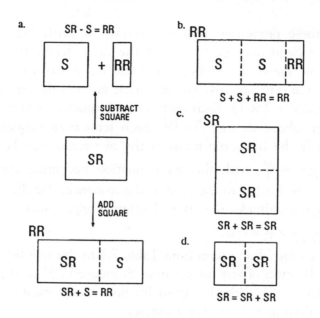

Figure 7.3 The square (S), square root rectangle (SR), and the Roman rectangle (RR) are interrelated.

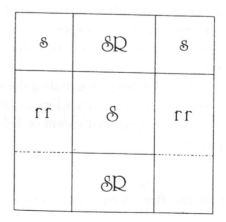

Figure 7.4 Subdivision of a square by four sacred cuts into squares (S), square root rectangles (SR), and Roman rectangles (RR).

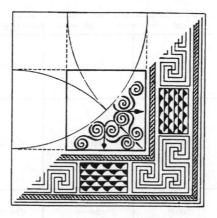

Figure 7.5 Mosaics and paintings in the Garden Houses of Ostia are in many cases laid out according to the geometry of the sacred cut. This photograph, following the pattern of Figure 7.4, shows a floor mosaic found in one of the houses. (By Tom Prentiss, photographed by John Moss. Reprinted with permission by Scientific American.)

2 rectangle – SR) and 1:θ (Roman rectangle – RR) form an interrelated system. For example, if S is either removed or added to SR, this results in RR as Figure 7.3a illustrates. This is equivalent to Properties 2 and 3. The relation, 2S + RR = RR, is equivalent to Property 1 (see Figure 7.3b). Finally, if SR is cut in half it forms two SR at a smaller scale, while two SR added together form an enlarged SR (see Figure 7.3c) corresponding to the doubling Property 4.

The key to understanding the Roman system of proportions is the sacred cut shown in Figure 6.1. Four sacred cuts drawn from each of the four corners of a square form a regular octagon as shown in Figure 6.2. These four sacred cuts also divide the square into four S at the corners, a larger central S, two SR, and two RR (see Figure 7.4). The Watts have discovered a tapestry preserved from the ruins of the Garden Houses of Ostia organized according to the pattern of Figure 7.4 shown in Figure 7.5. Figure 7.6 shows the breakdown of a square of dimensions $\theta^3 \times \theta^3$ into 16 sub-rectangles with lengths and widths from Table 7.2 satisfying,

$$\theta^3 = 1 + 2\theta + 2\theta + \theta\sqrt{2},$$
$$\theta^3 = \theta\sqrt{2} + 2\theta + \theta + \theta\sqrt{2}.$$

(7.9)

Figure 7.6 Subdivision of a square into 16 rectangles from the Roman system of proportions.

It is another exercise to verify Equations (7.9) using Properties 1–4 of the Roman system. These rectangles can be juxtaposed in many ways to give alternative tiles of the original square. A design by Mark Bak using the three species of rectangle, S, SR, and RR at three different scales is shown in Figure 7.6.

7.5 The Law of Repetition of Ratios

The computational properties of the Modulor and the Pell series are also the result of the *law of repetition of ratios*, well known in the Renaissance and revived by Jay Hambridge as the key to his concept of *dynamic symmetry* (cf. [Ham], [EdE]). To illustrate this law, draw a diagonal to a rectangle and intersect it with another diagonal at right angles as shown in Figure 7.8a. This subdivides the original rectangle or *unit* (U), of proportions *a:b*, into a rectangle referred to as *gnomon* (G) and a similar unit of proportions (U) (see Figure 7.8b) *b:c*, i.e.,

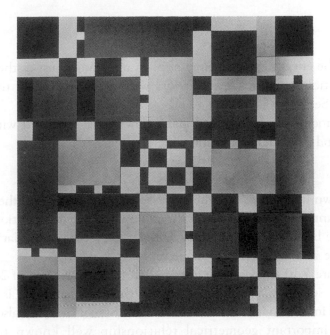

Figure 7.7 A design illustrating the tiling of a rectangle by S, SR, and RR at three different scales.

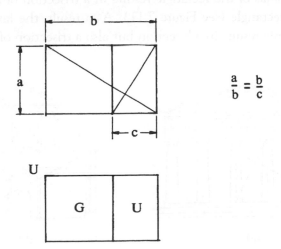

Figure 7.8 The "law of repetition of ratios" divides a unit rectangle into a gnomon and a proportional unit.

$$\frac{a}{b} = \frac{b}{c} \quad \text{and} \quad G+U=U. \tag{7.10}$$

This has the effect of reproducing ratios in a rectangle just as the insertion of arithmetic and harmonic means did within the octave for the musical scale (see Sequence (7.1)).

This process can be repeated many times to tile the unit with *whirling gnomons* and one additional unit

$$U = G+G+G+\cdots+U$$

as was shown in Figure 2.11b where we see that the vertices of the gnomons trace a *logarithmic spiral*. Figure 7.9 shows how the law of repetition of ratios might have been used by Alberti to remodel the facade of S. Maria Novella in Florence and an ancient Greek temple.

In Figure 7.10 this procedure is applied to a square root of 2 rectangle (SR). We see that the gnomon equals the (SR), and SR is therefore subdivided into two identical SR's. However, this construction also possesses a second important geometrical relationship well known to ancient geometers. Notice the upward and downward pointed triangles in Figure 7.10. It can be shown that for any rectangle, the intersection of such triangles with the diagonals of the rectangle results in a trisection of the length and width of the rectangle (see Figure 7.11). As a result, the law of repetition of ratios not only results in a bisection but also a trisection of SR. Therefore

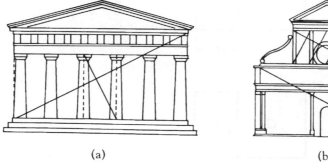
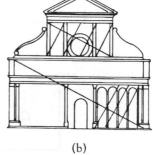

(a) (b)

Figure 7.9 Use of the law of repetition of ratios to proportion of (a) a Greek temple, and (b) S. Maria Novella in Florence.

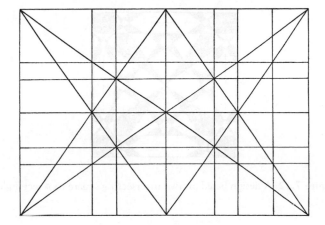

Figure 7.10 Application of the law of repetition of ratios to an SR rectangle.

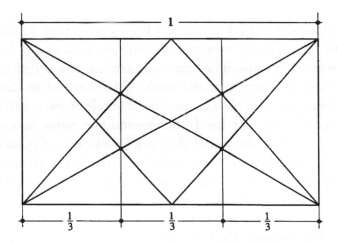

Figure 7.11 Trisection of the width of a rectangle.

SR achieves through the medium of geometry what the Pythagorean scale achieves of whole numbers with factors of 2 and 3. The design in Figure 7.12, based on two intersecting SR rectangles, [EdE], captures these relationships. In the next section I will show that these twin relationships lay at the basis of the architecture of the Medici Chapel as uncovered by Kim Williams.

Figure 7.12 A design based on two intersecting square root rectangles.

7.6 Relationship between the Roman System and the System of Musical Proportions

Since the time of the Greeks, there has been a tension in architecture and design between the use of commensurate and incommensurate lengths, i.e., lengths governed by rational or irrational numbers. It was Pythagoras who, it is said, first discovered that the ratio of the diagonal to the side of a square was incommensurable, i.e., no finite multiple of one equals a multiple of the other. On the one hand, incommensurate ratios were distressing since they did not fit the model that the Greeks had of number [Kap3]. On the other hand, they were easily constructible with compass and straightedge and had interesting geometric properties some of which have been outlined above. Although incommensurate measurements were equally incomprehensible from a number theoretic point of view to architects of the Italian Renaissance, Wittkover says:

> "Medieval geometry (with its use of incommensurate ratios such as $1:\sqrt{2}$ or $1:\sqrt{5}$) is no more than a veneer that enables practitioners to achieve commensurate ratios without much ado."

The architect, K. Williams, believes that one function of the system of musical proportions may have been to integrate the Roman system of proportions based on the incommensurate ratio $1:\sqrt{2}$ with the commensurate

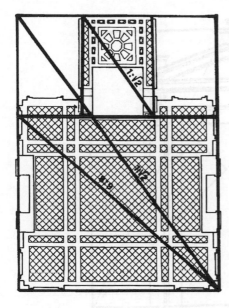

Figure 7.13 Plan of the Medici chapel. The proportion of the rectangular spaces are indicated over the diagonals of these spaces. Photograph of the Medici Chapel.

ratios at the basis of the musical scale. Williams made these discoveries while surveying the Medici Chapel in Florence built by Michelangelo [Will2].

The ground plan of the chapel is a simple square with a rectangular apse, called a *scarsella*, added to the north end as shown in Figure 7.13. The sides of the square which form the main space of the chapel measure 11.7 meters. The height of the chapel walls measure 11.64 meters, suggesting that the main space of the chapel was meant to be a cube. The overall perimeter of chapel and apse fit into a $\sqrt{2}$ rectangle. Williams recognized that a $\sqrt{2}$ rectangle is embedded in a cube as the rectangle formed by any pair of opposite edges. Thus the volume of the chapel and the shape of the ground plan are intimately related.

A second $\sqrt{2}$ rectangle is found in the chapel in the ensemble of the altar and the scarsella. Williams makes the important point that the altar protrudes into the Chapel to the extent that the ratio of the distance between the face of the altar and the opposite wall to the width of the chapel is 8:9, the ratio of the musical whole tone. Other dimensions within the chapel were derived from a combination of application of the law of repetition of ratios and the method of trisection illustrated in Figure 7.11. The method of trisection is itself a means of generating the musical ratios.

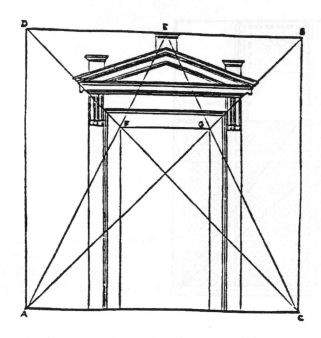

Figure 7.14 Construction of a door using the method of trisection. From Serlio's first book.

Figure 7.14 illustrates how this construction was used by the 16th century architect Serlio to proportion the portal of a church [Witt]. Notice the key ratio 1:2 (octave) in the proportion of the door and the ratios 2:3 (fifth) and 1:3 (fifth above an octave) in the positioning of the door.

K. Williams constructs a $\sqrt{2}$ rectangle with dimensions $27 \times 27\sqrt{2}$ as shown in Figure 7.15. Applying the law of repetition of ratios to this rectangle, the diagonal BJ bisects the long side while vertex C, the intersection point of BJ with diagonal AK, is at the trisection point of the long side (see Figure 7.11). As a result of this construction, another $\sqrt{2}$ rectangle is formed with side CD, $\frac{2}{3}$ of 27 or 18. This construction is repeated to yield a family of $\sqrt{2}$ rectangles, beginning with $ABKL$ with short side 27 and proceeding to 18, 12, 8,.... As is evident from Figure 7.15, the ascending sequence: 4, 6, 8, 9, 12, 18, 27 inherent in this construction is obtained. These numbers are recognized as being components of the musical proportions of Table 7.1 derived from Plato's lambda. Furthermore, geometric sequences were important to Renaissance architects.

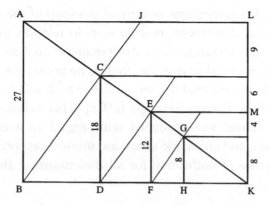

Figure 7.15 Derivation of the proportions of the Medici Chapel. Courtesy of K. Williams.

It was stated by Alberti [Alb]:

> "The geometrical mean is very difficult to find by numbers but it is very clear by lines, but of those it is not my business to speak here."

Williams supplies the demonstration that length BC is the geometric means of AB and CD, i.e., $BC = \sqrt{27 \times 18}$. In a similar manner, the zigzag path AB, BC, CD, DE, EF, FG, GH,…, yields a geometric sequence with common ratio $\sqrt{\frac{2}{3}}$ and another sequence of $\sqrt{2}$ rectangles beginning with the rectangle with sides $BC:CK = 1:\sqrt{2}$. Choosing a key dimension of the chapel, 3.52 meters, which is the overall width of the lateral bays from perimeter wall to the far edge of the *pilaster*, and using this as the value for side GK of the diagram, Williams found that the other proportional lengths generated in Figure 7.16 corresponded with other dimensions which appear in the chapel. For example side EM, calculated at 4.31 meters, corresponds to the clear width between pilasters of the scarsella, which actually measures 4.33 meters, with a deviation of only 0.46%. Making this the long side of a $\sqrt{2}$ rectangle, its short side, EF, is found to be 3.048, which corresponds to the dimension of half of the rectangle mentioned previously as circumscribing the ensemble of scarsella and altar, deviating by only 0.9% from the measured dimension of 3.02 meters. The altar completely fills the other half of the $\sqrt{2}$ rectangle, and likewise measures 3.02 meters. Work by historian Guglielmo De Angelis

D'Orssat has revealed proportions in vertical elements of the chapel which, like the ground plan dimensions, may be seen in relation to the repeated trisection of the $\sqrt{2}$ rectangle. In a diagrammatic analysis of the portal found in each of the lateral bays of the chapel, he points out the ratios 1:2, 1:3, and 2:3. He has also found the ratio 1:2.4, which will be recognized as the proportions of the Roman rectangle [D'Or]. This indicates that all the elements of the chapel were designed with regard to a comprehensive proportional system, and geometric series and musical proportions appear to have been the means of unification for all dimensions of the chapel.

7.7 Ehrenkrantz' System of Modulor Coordination

The architect Ezra Ehrenkrantz has created a system of architectural proportion that incorporates aspects of Alberti's and Palladio's systems made up of lengths factorable by the primes 2, 3, and 5, the factors of all integer representations of musical tones from the Just scale, along with the additive properties of the Fibonacci sequence [Ehr]. To picture this system requires a three dimensional coordinate system as shown in Table 7.3. As a number moves from left to right, in the X direction, it doubles in value. As a number moves from back to front, in Z direction, the number triples in value. The sum of two numbers in the vertical, or Y direction, equals the next number in the series. Also notice that the upper edge of Plate 1 and

Table 7.3

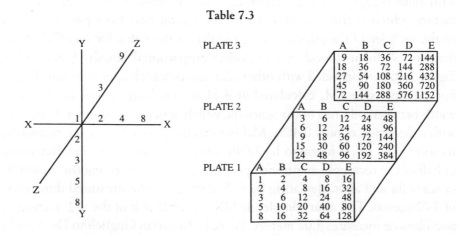

the upper-left corner points of Plates 1, 2, and 3 of Table 7.3 recreate Plato's lambda. The lambda, along with the Fibonacci sequence 1, 2, 3, 5, 8 that comprises the first column of Plate 1, provide the boundary conditions upon which all other numbers of Table 7.3 are generated. The Fibonacci sequence is truncated at 8 because the next number of this series 13 is a prime number other than 2,3, and 5.

This system is successful at providing the architect with standard lengths that insure many possibilities for the subdivisions of any length that appears in Table 7.4. For lengths up to 144 inches, 35 dimensions are available, 20 of which are greater than 2 feet. Of course, dimensions which do not appear in Table 7.4 such as 99 inches can be created as the sum of elements from the table, e.g., 99 = 27 + 45 + 27. However, compare all the possibilities

Table 7.4

Forc Intervals	Dimensions	Forc Intervals	Dimensions
12 ft.	144 in. 360 cm.	3 ft.	36 in. 90 cm.
11 ft.	135 in. 337.5 cm.		32 in. 80 cm.
	128 in. 320 cm.		30 in. 75 cm.
10 ft.	120 in. 300 cm.		27 in. 67.5 cm.
9 ft.	108 in. 270 cm.	2 ft.	24 in. 60 cm.
8 ft.	96 in. 240 cm.		20 in. 50 cm.
7 ft.	90 in. 225 cm.		18 in. 45 cm.
	81 in. 202.5 cm.		16 in. 40 cm.
	80 in. 200 cm		15 in. 37.5 cm.
6 ft.	72 in. 180 cm.	1 ft.	12 in. 30 cm.
	64 in. 160 cm.		10 in. 25 cm.
5 ft.	60 in. 150 cm.		9 in. 22.5 cm.
	54 in. 135 cm.		8 in. 20 cm.
4 ft.	48 in. 120 cm.		6 in. 15 cm.
	45 in. 112.5 cm		5 in. 12.5 cm.
	40 in. 100 cm		4 in. 10 cm.
			3 in. 7.5 cm.
			2 in. 6 cm.
			1 in. 2.5 cm.
		0 ft.	

Table 7.5

				96⁻		
				48	48	
	99⁻			32	32	32
27	45	27		64		32
36	27	36		56	60	
				30	36	30
				24	48	24
				36	24	36
			24	24	24	24
			24		32	
			24		45	27
			40		32	24

for creating 96, a number from the table, with 99 a number not in the table. Table 7.5 shows that there are 11 possible summations for 96 as compared to only two for 99.

According to Ehrenkrantz, and referring to Table 7.3:

> "This system helps to coordinate dimensions which may come from different base modules and therefore be normally considered [sic] incompatible. More directly, if one wishes to use multiples of 3 inches with those of 4 inches, one can move to the right on the X axis from 3 in. and down along the Y axis from 4 in. They intersect at 12 (Plate 2, Column C) and all the numbers below, to the right, or behind 12 are multiples of both 3 in. and 4 in., i.e., foot intervals. Multiples of other base dimensions may be related in a like manner."

7.8 Conclusion

I have discussed a series of relationships inherent in the musical scale well known to the Greeks and Roman civilizations. I have shown that they form the basis of three successful systems of proportionality (in addition to the

Modulor of Le Corbusier not discussed here): a system used by Alberti and other Renaissance architects, the system of proportions used by the Romans, and a System of Modulor Coordination of Ezra Ehrenkrantz. These systems insure a repetition of key ratios, and possess properties related to the musical scale, while the latter two systems provide for additive properties that enable designs to be carried out in which the whole equals the sum of its parts. These systems can also be expressed in terms of integers to facilitate their use. At the basis of the Modulor and the Roman system of proportion are two numbers, the golden and silver means. Chapters 20 through 23 are devoted to an extensive exploration of these numbers and to their application to the study of dynamical systems.

Appendix 7A An Ancient Babylonian Method for Finding the Square Root of 2

Neugebauer and Sack [Neu2] in their book *Mathematical Cuneiform Texts* report on a recursive algorithm that the Babylonians used to compute the square root of 2 to great accuracy. The Babylonian algorithm was expressed in base 60 numbers. McClain translated this method to base 10. I reproduce a facsimile of the method, give a recursion formula based on the method, and show that it is connected to the square root of 2 sequence derived from Pell sequences shown in Equation (7.8). The method draws upon harmonic law and makes use of the fact that $\sqrt{2}$ represents the tritone located between the arithmetic and harmonic means placed in the octave. The method converges rapidly and the 3rd iterate already agrees with $\sqrt{2}$ in five decimal places.

Begin with the octave: 1 2

Double it: 2 4

Insert the mean: 2 3 4

The initial approximation is : $\eta = \dfrac{3}{2} = 1.5$

Multiply by 3: 6 9 12

Subtract 1 from 9
to get harmonic mean: 6 8 9 12 (7.A1)

The 2nd approximation is : $r_2 = \dfrac{8.5}{6} = \dfrac{17}{12} = 1.4166...$

(8.5 is the average of 8 and 9)

Double Sequence (7.A1) : 12 16 18 24

Insert the mean between 16 and 18: 12 17 24

Multiply this sequence by 17: 204 289 408

Subtract 1 from 289: 204 288 289 408 (7.A2)

The 3rd approximation is : $r_3 = \dfrac{288.5}{204} = \dfrac{577}{408} = 1.41421568...$

Continuing $r_4 = \dfrac{665857}{470832} = 1.414213562...$

Motivated by this algorithm the approximations to $\sqrt{2} = 1.414213562...$ are generated by the following recursion formulas:

$$r_n = \frac{a_n}{b_n}$$

where,

$$a_n = 2a_{n-1}^2 - 1 \quad b_n = 2a_{n-1}b_{n-1} \quad \text{for} \quad a_1 = 3 \quad \text{and} \quad b_1 = 2.$$

It can be shown by mathematical induction (not shown) that sequences $\{a_n\}$ and $\{b_n\}$ are subsequences of the following pair of Pell sequences:

Pell's sequence:	1	3	7	17	41	99	239	577	...	665857 ...
	1	2	5	12	29	70	169	408	...	470832 ...
Term number:	1	2	3	4	5	6	7	8		16
Approx. number, n:	1		2					3		4

Therefore the nth approximation to $\sqrt{2}$ corresponds to the 2^n th Pell's approximation to $\sqrt{2}$.

8
A Secret of Ancient Geometry

To enter a temple constructed wholly of
invariable geometric proportions is to
enter an abode of eternal truth.

Robert Lawlor

8.1 Introduction

The quality of the work of an architect or designer is determined by how he or she comes to grips with the mathematical constraints on space inherent in all designs — "what is possible", in contrast with the designer's intention, "what ought to be" The history of architecture reflects the history of ideas in that "what ought to be" has changed from metaphysical perspectives of the natural world to explorations of the individual artist. Additionally, the history of technology is reflected in the changes of "what is possible".

There are two kinds of constraints on space that the architect or designer must confront:

- constraints imposed on a design because of the geometrical properties of space.
- constraints imposed on a design by the designer who creates a geometrical foundation or scaffolding as an overlay to the design. The designer's choice is based on the context of the design and on the effect that he or she wishes to achieve.

Without constraints, a design is chaotic, irrelevant and lacking in focus. Where do the designer's constraints come from? In ancient times they were derived either from spiritual contexts or handed down from generation to generation by tradition. The results were cathedrals such as Chartres and

Hagia Sophia or structures such as the Egyptian Pyramids and the Great Temple of Jerusalem or the temples of ancient Greece.

Modern architecture has replaced spiritual — and tradition-bound contexts with the private vision of the designer or architect and substituted diversity for tradition. However, the designer is left with few tools to deal with such a lack of constraint. After all, what should the designer do when each design breaks new ground? In an effort to recover the principles of ancient architecture, many researchers have studied the geometric and spiritual bases of ancient structures (cf. [Tyn], [Ghy], [Ver], [Wat-W1]).

This chapter will discuss the work of Tons Brunes, a Danish engineer, who hypothesized a system of ancient geometry that he believed lay at the basis of many of the temples of antiquity (cf. [Bru], [Kap4], [Kap11]). It was Brunes's belief that there existed until about 1400, a network of temples and a brotherhood of priests originating in ancient Egypt which had a secret system of geometry. At the basis of Brunes's theory is the eight-pointed star illustrated in Figure 8.1. Brunes claimed to have seen this star on a floor mosaic in a temple ruin in Pompeii where the public is not admitted. He tried to photograph it, but was forbidden to do so. I encountered this star as the ceiling structure in the entranceway of Antonio Gaudi's unfinished cathedral, Sagrada Familia, in Barcelona. From the geometry of this star he was able to reconstruct reasonably close facsimiles to the plans and elevations of the ruins of ancient temples such as the Pantheon, Theseum, Ceres, and the Temple of Poseidon, noting that certain intersections coincide with features of the temples [Kap4]. Unfortunately, although the examples he uses to illustrate his theories are cleverly rendered, there is no historical record to support his claims. As a result his research

Figure 8.1 The Brunes star.

has been met considerable skepticism. Nevertheless, as we shall see, the Brunes star expresses a geometry consistent with the ancient architecture, folk art, and the musical scale portrayed in the previous chapters. Even though it is unlikely to have played the all-pervasive role for temple construction that Brunes conjectured, it may well have been one of the organizing tools along with others such as the sacred cut (see Section 6.2) and the law of repetition of ratios (see Section 7.4). At any rate, the beauty of its geometry is reason enough to study it.

8.2 The Concept of Measure in Ancient Architecture

While modern scientific method relies on observation and measurement as the primary way to arrive at truth, ancient civilizations used myth and metaphor through the medium of poetry, music, and sacred scriptures to describe their realities.

R.A. Schwaller di Lubicz [Schw] felt that the combination of myth and symbol conveyed by ancient writings was the only way information about the workings of the universe could be conveyed. According to Di Lubicz for the ancient Egyptians:

"Measure was an expression of Knowledge that is to say that measure has for them a universal meaning linking the things of here below with things Above and not solely an immediate practical meaning — quantity is unstable: only function has a value durable enough to serve as a basis (for description). Thus the Egyptians' unit of measurement was always variable — measure and proportions were adapted to the purpose and the symbolic meaning of the idea to be expressed. (For example) the cubit will not necessarily be the same from one temple to another, since these temples are in different places and their purposes are different."

Even when standard measures were available, they may have been used only as an adjunct to pure geometry in the design of structures. In place of numbers to describe a measurement, a kind of applied geometry was developed in which lengths were constructed without the need to measure

them. All that was needed was a length of rope and a straightedge (the equivalent of our compass and straightedge). Methods were then devised to subdivide any length into sub-lengths, always by construction. Evidence of construction lines have been discovered on the base of the unfinished Temple of Sardis in Turkey and also in the courtyard of the Temple of Zeus in Jerash in Jordan [WatC]. Artmann [Art] has shown how such methods were used to construct the windows of the Gothic cathedrals. The geometry needed to build these cathedrals was learned from boiled-down versions of the first books of Euclid, known as pseudo-Boethius which highlighted the constructive methods while eliminating the proofs of the theorems. The knowledge to implement this geometry was taught to the guilds of masons, other artisans, and builders and then passed on from generation to generation by oral tradition. One can imagine learned constructive techniques based on the Brunes star being transmitted by this tradition and applied to the construction of sacred structures.

8.3 The Ancient Geometry of Tons Brunes

In ancient times it was an important problem to find a way to create a square or rectangle with the same area or circumference as a given circle — *squaring the circle* [Jos], as it was known. Since the circle symbolized the celestial sphere while a square or rectangle oriented with its sides perpendicular to the compass directions of north, east, south, and west symbolized the Earth, the squaring of the circle could be thought to symbolically bring heaven down to earth. Brunes demonstrates one way in which ancient geometers may have attempted to solve this problem using only compass and straightedge (we now know that this cannot be done exactly). In Figure 8.2 the reference square has a side of 1 unit. Arc AB of the sacred cut (see Section 6.1) and the diagonal CD of the half square are approximately equal (see Figure 8.2a). In fact,

$$AB = \pi \frac{\sqrt{2}}{4} = 1.1107 \ldots \quad \text{while}$$

$$CD = \frac{\sqrt{5}}{2} = 1.1118 \ldots.$$

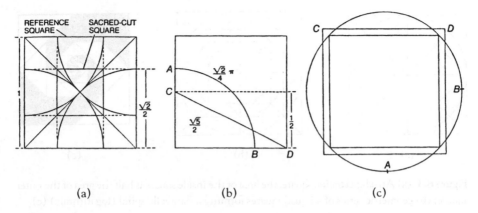

(a) (b) (c)

Figure 8.2 The Brunes star approximately "squares the circle" in circumference: (a) four sacred cuts; (b) $AB \approx CD$; (c) circle with arc AB approximately equals the perimeter of the square with side CD.

In Figure 8.2c four sacred cuts AB are placed into a square to form a circle equal in circumference to the perimeter of a square with edge CD to within 0.4%.

In Figure 8.3a, we see that a circle is drawn that is tangent to an outer square (inscribed circle) and touching the vertices of an inner square (circumscribed circle). This *square-within-a-square*, called an *ad-quadratum square*, was much used in ancient geometry and architecture [WatC]. The area of the inner square is obviously half the area of the outer square since the smaller square contains eight congruent triangles, whereas the larger square contains 16. In a sequence of circles and squares inscribed within each other, each square is $\frac{1}{2}$ the area of the preceding. Figure 8.3b shows a sequence of ad quadratum squares which are shaded to form a logarithmic spiral known as a Baravelle spiral. It is easy to construct, and with color makes an interesting design.

The upward-pointed triangle ABC in Figure 8.4 also has half the area of the circumscribing square $BCFE$. If the downward-pointed triangle DEF is constructed, then rectangle $HIJK$, formed by the vertical lines through the intersection points of the upward-and-downwards pointed triangles and the circle, has approximately the same area as the circle. It can be determined (not shown here) that the width of this rectangle is $\frac{4}{5}$ of the diameter of

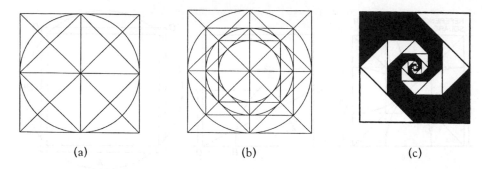

Figure 8.3 (a) An *ad-quadratum* square, the area of the inside square is half the area of the outer square; (b) geometric series of ad quad squares forming a Baravelle spiral (logarithmic) (c).

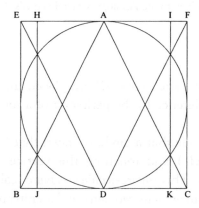

Figure 8.4 The Brunes star approximately squares the circle in area.

the circle. Taking the square to have length equal to 1 unit, i.e., the radius of the circle equals $\frac{1}{2}$,

$$\text{Area of circle} = \pi \left(\frac{1}{2} \right)^2 = .7854...,$$

$$\text{Area of rectangle} = \frac{4}{5} = .80,$$

an error of 1.8%.

In Figure 7.11 we showed that for an arbitrary rectangle of proportion *a:b* the line from a vertex to the center of the opposite side *AB* cuts the diagonal *CD* at the $\frac{1}{3}$ point. We now use this geometrical property to describe the structure of the Brunes star.

Take the circumscribing square and subdivide it by placing perpendicular axes within it, as shown in Figure 8.5. This divides the outer square into four overlapping half-squares. Place two diagonals into each of the four half squares and add the two diagonals of the outer square. Notice that the resulting diagram (also shown in Figure 8.6) is the Brunes star.

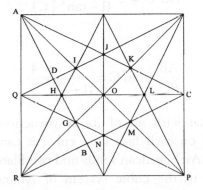

Figure 8.5 The construction lines for the Brunes star.

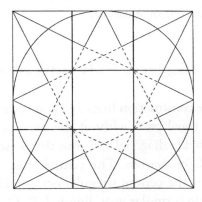

Figure 8.6 The relationship between the Brunes star and the inscribed circle within a square showing how the star divides the square into a nine-square grid.

Therefore, this star contains all the information needed to square the circle in both circumference and area. Also hidden within the Brunes star are numerous 3, 4, 5-right triangles. For example triangle ABC is a 3, 4, 5-right triangle because,

$$\tan \frac{1}{2} C = \frac{AQ}{QC} = \frac{1}{2}.$$

Therefore using the trigonometry identity,

$$\tan C = 2 \frac{\tan \frac{1}{2} C}{(1 - \tan^2 \frac{1}{2} C)},$$

it follows that,

$$\frac{AB}{BC} = \tan C = \frac{1}{(1 - \frac{1}{4})} = \frac{4}{3}. \tag{8.1}$$

If the Brunes star with all of its construction lines, depicted in Figure 8.5, is placed on each face of a cube, it can be shown that the vertices of all the six Archimedean solids and two Platonic solids (cube and octahedron) related to the cubic system of symmetry as well as the tetrahedron coincide with the points of intersection of the construction lines [Kap5], [Lal4]. The Brunes star also succeeds in providing the geometrical basis for dividing an arbitrary length into any number of equal sublengths without the use of measure.

8.4 Equipartition of Lengths: A Study in Perspective

Figure 8.5 contains the construction lines and points with which to subdivide lengths into 3 and 4 equal parts without the need of a standard measure, i.e., points I and M divide diagonal AP into thirds (see Figure 7.11) while H, O and L divide QC in quarters. The central cross and the diagonals are therefore subdivided by the central irregular octagon $GHIJKLMN$ into four and three equal parts in a similar way. Points I, K, G, and M then provide the points that subdivide the outer square into a 3×3 grid of subsquares, as shown in Figure 8.6, similar to the Amish nine-square in Figure 6.5c.

Figure 8.7a indicates that the Brunes star can divide a line segment into 2, 3, 4, 5, 6, 7, and 8 exactly equal parts using a procedure described in Appendix 8.A. Notice that the square framing one-quarter of the Brunes star has construction lines that can be completed to form a Brunes star at a smaller scale. The same is true for each of the squares of the nine-square grid. As a result of these and other self-similar properties of the Brunes star, it can be shown that line segments can be equipartitioned into any multiple of the integers from 2–7 without the use of standard measure, using only a stretched rope. Other self-similar objects known as fractals will be discussed in Chapter 18.

A sacred cut drawn from a vertex of the outer square in Figure 8.7b defines the level that partitions a line into approximately seven equal parts to within 2% error. In Figure 8.7c construction lines are shown to use the inscribed circle to partition the line into seven parts, again to within 2% error. In this construction, Brunes has shown the square subdivided into 28 approximately equal rectangles suggestive to Brunes of the 28 days of the lunar month (the lunar month is actually between 28 and 29 days).

This equipartitioning property of the Brunes star has its roots in another geometric construction [Kay] which was first related to me by Michael Porter, a Professor of Architecture at Pratt Institute. In Figure 8.8a the outer square of the Brunes star has been extended to a double square. The principal diagonals of the double square divide the width of the upper square into two equal parts. The principal diagonals intersect the two diagonals of the upper square at the trisection points of the width. At the same time, the trisected width intersects the long side of the double square at the $\frac{1}{2}$ point. Continuing one more step, two diagonals of the $\frac{1}{3}$-rectangle intersect the principal diagonal at points which divide the width into four equal parts. This width also divides the long side of the double square at the $\frac{1}{4}$ point. This construction may be continued to subdivide a line segment into any number of equal parts as is shown in Figure 8.8b up to eight subdivisions.

As is often the case with mathematics, a diagram set up to demonstrate one concept is shown to have a deeper structure. We could also view Figures 8.8a and 8.8b as a pair of railroad tracks receding obliquely to the horizon line. The diagonal and the right side of the double square play the role of the railroad tracks as shown in Figure 8.8c. If the observer is at an arbitrary location in the foreground (see the eye), then the distance between

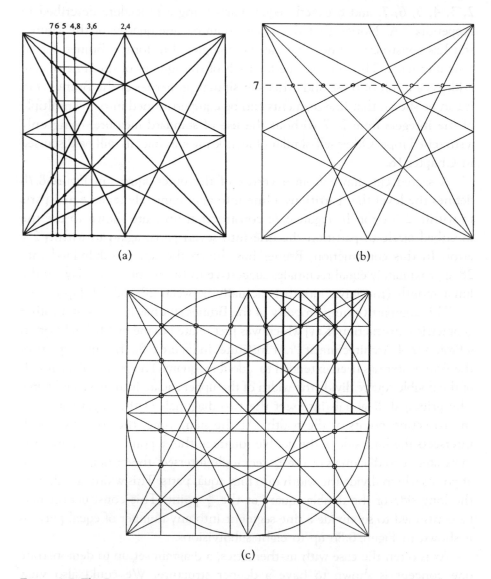

(a)

(b)

(c)

Figure 8.7 The Brunes star equipartitions a line segment into (a) 3, 4, 5, 6, 7, and 8 equal parts; (b) approximate equipartition into 7 parts; (c) Brunes's division of a square into approximately 28 equal parts.

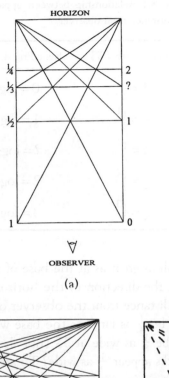

(a)

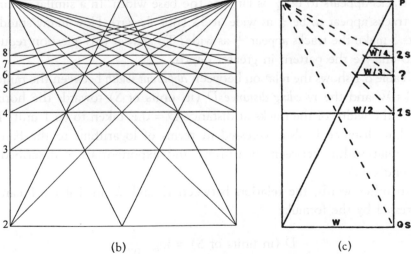

(b) (c)

Figure 8.8 (a) Equipartitioning property of the Brunes star seen as a perspective diagram. The diagram shows the relationship between apparent width W and receding distance D from an observer; (b) extension to eight subdivisions; (c) equipartition seen as a pair of railroad tracks receding to the distance.

Table 8.1 Relationship between apparent width and distance from observer.

Apparent width (W)	Receding distance (D)
$1 = \frac{1}{2}^{0}$	$0 = \log_2 1$
$\frac{1}{2} = \frac{1}{2}^{1}$	$1 = \log_2 2$
$\frac{1}{3} = \frac{1}{2}^{?}$	$? = \log_2 3$
$\frac{1}{4} = \frac{1}{2}^{2}$	$2 = \log_2 4$
$\frac{1}{8} = \frac{1}{2}^{3}$	$3 = \log_2 8$

the tracks appears half as great as at the base of the double square at some measured distance in the direction of the horizon referred to as a *standard distance*, or 1S. At a distance from the observer of 2S the distance between the tracks appears to be $\frac{1}{4}$ as large as the base width. In a similar manner, the tracks appear to be $\frac{1}{8}$ as wide at 3S (not shown). How many standard units S make the tracks appear $\frac{1}{3}$ as wide? To answer this question requires us to analyze the pattern in greater depth.

Table 8.1 shows the relation between *apparent width* between the railroad tracks W and the *receding distance* D (in units of S) towards the horizon where the width of the tracks at distance $D = 0$ is taken to be 1 unit. The receding distance is also expressed in terms of logarithms to the base 2. The relationship between logarithms and exponentials is described in Appendix 3.A.

In other words, the relation between D and W in Table 8.1 can be expressed by the formula:

$$D \text{ (in units of } S) = \log_2 \frac{1}{W}.$$

Setting $W = \frac{1}{3}$ in this formula and making use of Equation (3.A1), it follows that the value of ? is,

$$? = \log_2 3 = \frac{\log_{10} 3}{\log_{10} 2} = 1.58S.$$

If the left side of the double square in Figure 8.8a is considered to be a monochord, then the bridge positions of $\frac{1}{2}$, $\frac{1}{4}$, $\frac{1}{8}$,... correspond to integral numbers (1, 2, 3,...) of octaves above the fundamental when the bridge position is at 1. The sequence, 1, $\frac{1}{2}$, $\frac{1}{3}$, $\frac{1}{4}$,..., is an harmonic sequence of reciprocals (see Section 4.2). Any number from this series is the harmonic mean of the ones preceding and following it (see Equation (4.1)). Appendix 8.A shows how the Brunes star can be generalized to enable the harmonic mean of any two lengths to be geometrically constructed. It is generated by a projective transformation. This sequence is projectively transformed in Appendix 8.B to a sequence of evenly distributed integers, 1, 2, 3,..., by a step measure (see Section 2.5). The tones generated by either the harmonic or integer series correspond to the series of overtones that are heard when a violin string is plucked and a sequence of multiples of the fundamental frequency is generated, as we described in Section 4.2. In fact, if the line segments in Figure 8.7a are considered to be violin strings, the open circles are the positions at which a violinist evokes an harmonic tone (up to the eighth harmonic) by placing his finger lightly on the string at that position and bowing midway between a pair of partition points (see Section 25.7). So we see, as did Leonardo Da Vinci, that a similar law governs both eye and ear [Wit].

8.5 The 3, 4, 5-Triangle in Sacred Geometry and Architecture

8.5.1 Construction of the Brunes Star from 3, 4, 5-triangles

I have shown in Section 8.3 that triangle ABC in Figure 8.5 is a 3, 4, 5-right triangle. The 3, 4, 5-right triangle was called the Egyptian triangle by Vitruvius, the architect of the Emperor Augustus, and was used in the construction of the pyramid of Cheops (cf. [Ver], [Kap3]). Plutarch described this triangle as the symbol of the Egyptian trinity, associated with the three significant Egyptian deities [Ver]:

$$3 \leftrightarrow \text{Osiris,}$$
$$4 \leftrightarrow \text{Isis,}$$
$$5 \leftrightarrow \text{Horus.}$$

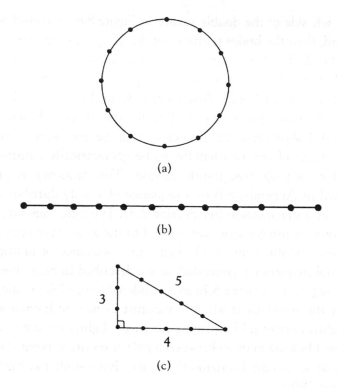

(a)

(b)

(c)

Figure 8.9 (a) Representation of the 12 seasons of the Zodiac by a knotted rope; (b) the rope is cut open to a straight line; (c) the line is bent into a 3, 4, 5-right triangle.

The key to understanding the geometry of the Brunes star lies in its construction. But how did ancient architects construct this star diagram? This diagram is easy to construct if one begins with a square, but it is not an easy matter to construct a large square if one has only a length of rope and some stakes to work with. However the entire diagram can equally well be constructed beginning with the 3, 4, 5-right triangle. The 3, 4, 5-right triangle can be constructed from a loop of rope with 12 knots, as shown in Figure 8.9. The 12 sectors of the circle shown in Figure 8.9 can also represent the 12 regions of the zodiac visited by the sun during the course of the year, as viewed from a geocentric standpoint. If we regard the 12 sectors of the circle as tones of the equal-tempered chromatic scale, we see in Figure 8.10a that a subdivision of the tonal circle into 3, 4, and 5 semitones gives rise to the tones A, C, E of the musical A minor triad [Ebe].

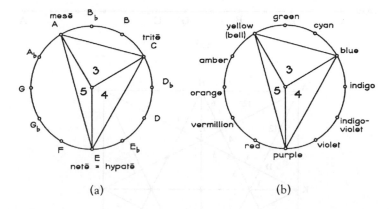

Figure 8.10 (a) The 12 sectors of a tonal circle viewed as the tones of a minor triad; (b) tonal circle related to the color spectrum.

I have created a videotape of a group of students constructing this star on an open field using four lengths of 50-foot clotheslines anchored by camping stakes [Kap5]. To construct the Brunes star, begin with four lengths of rope each length divided into 12 equal sections by 12 knots as shown in Figure 8.11a. Although the rope is shown stretched out in a straight line, the ends are connected so that it forms a loop. Four such loops: ADBGCA (see Figure 8.11a), FJDBEF, IBGJHI and LGJDKL are stretched into four 3, 4, 5-right triangles, each providing one vertex of the outer square of Figure 8.11b. The right angles of these 3, 4, 5-triangles are located at the vertices of the inner square DBGJ.

We have succeeded in constructing the outer square AILF along with the midpoints of its sides HKEC. Now that the outer square has been formed, we can stand back and observe the harmony of this figure. In order to better appreciate its geometry, we must make a brief digression and consider the geometry of the 3, 4, 5-right triangle.

8.5.2 The 3, 4, 5-triangle and its musical proportions

Let the 3, 4, 5-right triangle ABC in Figure 8.12 have lengths in the ratio:

$$L_1 : L_2 : L_3 = 3 : 4 : 5.$$ (8.2)

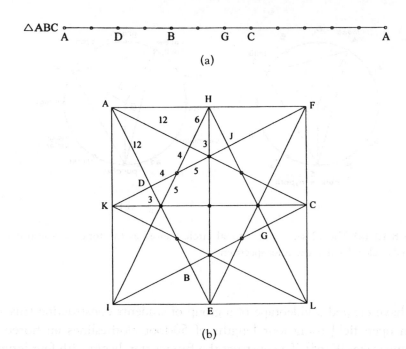

(a)

(b)

Figure 8.11 (a) Subdivision of line segment ADBGCA to construct one of the four 3, 4, 5-right triangles that make up a Brunes star as shown in (b). Lengths of the line segments are shown.

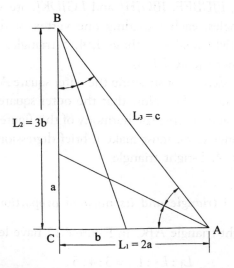

Figure 8.12 The geometry of a 3, 4, 5-right triangle.

It follows from trigonometry that the angle bisector of angle A cuts the opposite side L_2 in a length, $a = \frac{L_1}{2}$, while the angle bisector of angle B cuts its opposite side L_1 in $b = \frac{L_2}{3}$. In other words,

$$\tan \frac{A}{2} = \frac{1}{2} \quad \text{and} \tan \frac{B}{2} = \frac{1}{3}. \tag{8.3}$$

These two fractions have special significance in terms of the Pythagorean musical scale. In fact they represent the four tones:

$$1:1, \ 1:2, \ 1:3, \ 2:3$$

the unison, octave, and fifth above an octave, and the musical fifth. These ratios were displayed in proportions of the door constructed by the 16th century Renaissance architect Serlio shown in Figure 7.14.

Making use of Equations (8.2) and (8.3), it follows that:

$$2a : 3b : c = 3 : 4 : 5. \tag{8.4}$$

From Equation (8.4) it follows that:

$$\frac{a}{b} = \frac{9}{8} \tag{8.5}$$

(the ratio of a whole tone in the Pythagorean scale [see Section 3.4]). Using the Pythagorean theorem:

$$c^2 = (2a)^2 + (3b)^2.$$

With some algebra

$$c^2 = a^2 \left(4 + 9 \left(\frac{a}{b} \right)^2 \right).$$

Using Equation (8.5),

$$c = \left(\frac{10}{3} \right) a. \tag{8.6}$$

Let $a = 9$ in which case it follows from Equations (8.5) and (8.6) that $b = 8$, $c = 30$. So from Equation (8.4), triangle ABC has proportions:

$$18 : 24 : 30.$$

So our ancient geometer has now subdivided his rope into 18 + 24 + 30 = 72 units. The number 72 has great significance in ancient geometry. Its factors are arranged in Table 8.2:

Table 8.2 English measures based on human scale and Plato's World Soul.

1	2	4	8
3	6	12	24
9	18	36	72

Thus, Plato's "world soul" (see Sections 4.5 and 8.2) has made another appearance:

$$
\begin{array}{ccc}
 & 1 & \\
3 & & 2 \\
9 & & 4 \\
27 & & 8
\end{array}
$$

Section 7.2 demonstrates how the Pythagorean musical scale was derived from this series. The boxed numbers in Table 8.2 also correspond to English measures based on human scale, namely, the inch, hand (4 inches), foot (12 inches), span (9 inches), yard (36 inches) and fathom (72 inches). Without a standard ruler, our geometer could call upon human scale as a kind of personal scale of measure.

8.5.3 The geometry of the Brunes star

From Equation (8.1) it follows that triangle ABC is a 3, 4, 5-right triangle. All other right triangles in Figure 8.5 are either 3, 4, 5-right triangles or fragments of a 3, 4, 5-triangle obtained by bisecting its acute angles. (Compare this with the eight-pointed star of Figure 10.A1h which creates numerous 45 degree right triangles within a circle.)

In Figure 8.11b the dimensions of all the sublengths are indicated. These may be gotten from Figure 8.11a by assigning each segment of the string a

length of six units. The properties of 3, 4, 5-triangles given by Equation (8.1) can also be used to verify these lengths.

Figure 8.11b shows the star diagram to have 3, 4, 5-right triangles at four different scales. Referring to vertex labels of Figure 8.5,

$$ABC: \ 18 : 24 : 30;$$
$$ADJ: \ \ 9 : 12 : 15;$$
$$QDG: \ \ 6 : \ \ 8 : 10;$$
$$DHI: \ \ 3 : \ \ 4 : 5.$$

So we see that the star diagram is entirely harmonized by the 3, 4, 5-right triangle.

As we previously mentioned, Brunes used these principles of geometry to show how many of the structures of antiquity might have been proportioned. He subsumed the principles of this geometry into a series of 21 diagrams (not shown) related to the star diagram and the sacred cut [Kap4]. He claims that each step in the creation of a plan for one of the ancient structures follows one or another of these diagrams. Although Brunes has obtained close fits between key lines of the elevation and plan (not shown) of these structures, his constructions require an initial *reference circle* the choice of which is quite arbitrary. Despite the close fits between Brunes's diagrams and actual temples, one never knows the degree to which they have been forced by his imagination. In my opinion, it is unlikely that this method was actually used as described by Brunes. Nevertheless, the simplicity and harmony of Brunes's diagrams make it plausible that they could have been used in some unspecified manner as a tool for temple design.

8.6 What Pleases the Ear Should Please the Eye

We have seen that 3, 4, 5-triangles pervade the Brunes star. However, not all 3, 4, 5-relationships refer to right triangles. We have seen in Section 3.7 that 3, 4, 5-relationships between string lengths play a major role in the structure of the musical scale and make a surprise appearance in the structure of the color spectrum of light (see Section 3.9) which could be thought of as a kind of "musical scale" for the eye. The association between tones and

number ratios led the architects of the Italian Renaissance to build a system of architectural proportions based on the musical scale (see Chapter 7).

Eberhart [Ebe] has made the observation that the wavelengths of visible light occur over a range between 380 mμ (millimicrons; mμ = 10^{-7} cm) in the ultraviolet range to about twice that amount in the infrared, or a visual "octave". He states,

> "When the colors of visible light are spread out in such a way that equal differences in wavelength take equal amounts of space, it stands out that blue and yellow occupy relatively narrow bands while violet, green, and red are broad (see Figure 8.13). Observe that the distance from the ultraviolet threshold to blue to yellow to the infrared threshold is very closely 4:3:5 of that spectral octave, i.e., $383.333\ldots \times 2^{4/12} = 483$ mμ (mid blue) and $383.333\ldots \times 2^{7/12} = 574.333\ldots$ mμ (mid yellow). This means that if we subjectively identify the two thresholds of ultraviolet and infrared, as is commonly done in making color wheels, calling both extremes simply purple, then the narrow

Figure 8.13 The color spectrum illustrating the frequency ratios between purple: yellow: blue as 3:4:5. Courtesy of Stephen Eberhart.

bands of *blue* and *yellow* have approximate centers lying at points on the circle that divide the circle into segments in 3, 4, 5-ratios as for the A minor triad (see Figure 8.10b)."

Eberhart's observation adds some additional substance to the Renaissance credo that what pleases the ear also pleases the eye.

8.7 Conclusion

According to Plato, the nature of things and the structure of the universe lay in the study of *music, astronomy, geometry* and *numbers*, the so-called *quadrivium*. Built into sacred structures would be not only a coherent geometrical order but also a sense of the cosmic order in terms of the cycles of the sun and the moon and the harmonies of the musical scale. The Brunes star with its ability to square the circle, its equipartitioning properties, its relationship to 3, 4, 5-triangles, and its relationship to Archimedean and Platonic solids makes it a plausible tool for the builders of significant ancient structures.

In Chapter 10, I will show that the Brunes star is a natural tool for Ben Nicholson's reconstruction of one of the pavements of the Laurentian Library in Florence. In Chapter 11, I will show that the geometric mode of thinking inherent in the Brunes star was not merely the modus operandi of advanced urban societies of the ancient world but, it may have served equally well for the civilization of farmers that settled in Megalithic Britain. Their sacred spaces may also have been expressions of the spirit of the quadrivium.

In Chapter 20, I will show that the Brunes star serves as a natural setting for expression of the golden mean. In the next chapter I illustrate a Brunes star whose edges are composed of hyperbolic arcs related to the golden and silver means introduced in Chapter 7.

Appendix 8.A Harmonic Means

The sequence

$$1, \frac{1}{2}, \frac{1}{3}, \frac{1}{4}, \frac{1}{5}, \frac{1}{6}, \frac{1}{7}, \dots$$

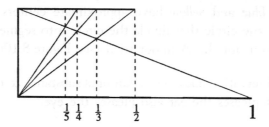

Figure 8.A1 Geometric construction of an harmonic series.

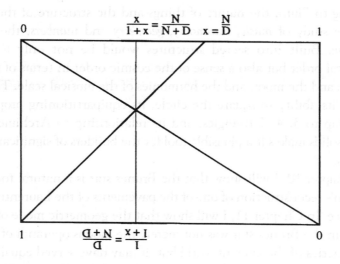

Figure 8.A2 Koepp's construction of the harmonic mean of two lengths.

corresponds to the undertone series introduced in Section 4.2. Each number of this sequence is the harmonic mean of the two numbers that brace it, e.g., $\frac{1}{3}$ is the harmonic mean of $\frac{1}{2}$ and $\frac{1}{4}$. Figure 8.A1 shows how to construct this series. It can be seen to be equivalent to Figures 8.7a and 8.8b. If this construction is applied to the Brunes star, the series at the top edge locates the positions at which a line segment is equipartitioned into 2, 3, 4, 5, 6, and 7 parts.

In Figure 8.A2, this construction is generalized so that if a rational number $x = \frac{N}{D}$ (N is the numerator and D is the denominator) is located

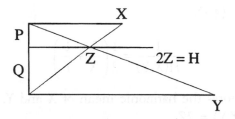

Figure 8.A3

on a number line between 0 and 1 on the top edge of rectangle, it gives rise to a pair of rationals $\frac{1}{(x+1)} = \frac{D}{(N+D)}$ and $\frac{x}{(1+x)} = \frac{N}{(N+D)}$. The second number is found by rotating the rectangle 180 degrees and reading its value on the number line on the bottom edge of the rectangle. For example $x = \frac{3}{5}$ gives rise to $\frac{5}{8}$ and $\frac{3}{8}$. This construction will be shown in Section 9.4 and (14.3.10) to be the key to generating the Farey sequence, important to the study of dynamical systems and the structure of numbers.

Dale Koepp [Koe] has generalized this construction to enable the geometric mean of any pair of numbers to be constructed. In Figure 8.A3 the harmonic mean of the numbers X and Y is sought. The harmonic mean is twice the length of the number Z. For example if X represents a length of string $\frac{2}{3}$ (a musical fifth) corresponding to the fundamental tone of a string of length $Y = 1$, the length 2Z represents the harmonic mean of $\frac{2}{3}$ and 1 or $\frac{4}{5}$ (a musical third). In this way the harmonic mean can be constructed geometrically. The proof is given by Koepp:

By similar triangles,

$$\frac{Z}{Y} = \frac{R}{(R+S)} \quad \text{and} \quad \frac{Z}{X} = \frac{S}{(R+S)},$$

$$\frac{Z}{Y} + \frac{Z}{X} = \frac{R}{(R+S)} + \frac{S}{(R+S)} = 1.$$

Therefore,

$$\frac{1}{Z} = \frac{1}{X} + \frac{1}{Y}.$$

But from Equation (4.1),

$$\frac{1}{H(X,Y)} = \frac{1}{2}\left(\frac{1}{X} + \frac{1}{Y}\right)$$

where $H(X,Y)$ denotes the harmonic mean of X and Y.
 Therefore $H(X,Y) = 2Z$.

Appendix 8.B Projective Analysis of the Equipartition Properties
of the Brunes Star

In Figure 8.B1 a projective transformation is set up between lines l and m representing a pair of "railroad tracks" from the double square diagram of Figure 8.8a. Lines l and m have been placed in a cartesian coordinate system in which the horizon line is located on the y-axis and the point of projection, O, is at $(0, \frac{1}{2})$. Since one of the "railroad tracks", line m, is the diagonal of the double square, its slope is $\frac{1}{2}$ and its equation is:

$$y = \frac{x}{2}. \tag{8.B1}$$

Consider point X_0 and its projection, X_1 on line l, the x-axis. Point X_0 is projected first through O to point (X_1, Y_1) on m and then to $(X_1, 0)$ through O' at infinity in a direction perpendicular to line l. The line of projection through O has the equation:

$$Y - \frac{1}{2} = cX \quad \text{where the slope,} \quad c = \frac{Y_1}{(X_1 - X_0)}. \tag{8.B2}$$

But since (X_1, Y_1) lies on m given by Equation (8.B1), Equation (8.B2) can be rewritten,

$$Y - \frac{1}{2} = \frac{X_1 X}{2(X_1 - X_0)}. \tag{8.B3}$$

Setting $Y = 0$ and $X = X_0$ in Equation (8.B3) and doing some algebra yields,

$$X_1 = \frac{X_0}{(1 + X_0)}. \tag{8.B4}$$

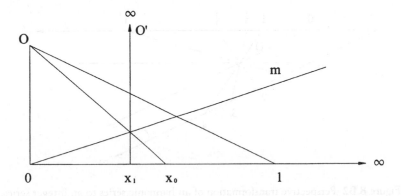

Figure 8.B1 Step measure transformation describes the structure of Figure 9.9a.

For example, if $X_0 = 1$ then Equation (8.B4) yields, $X_1 = \frac{1}{2}$. Likewise $\frac{1}{2}$ maps to $\frac{1}{3}$, $\frac{1}{3}$ to $\frac{1}{4}$, etc. Also notice that the point at infinity on line l maps to 1 in this transformation.

Taking points A, B, C, and D as 1, $\frac{1}{2}$, $\frac{1}{3}$, $\frac{1}{4}$ respectively, the cross-ratio can be computed as follows,

$$\lambda = \left(\frac{AB}{BC}\right)\bigg/\left(\frac{AD}{DC}\right) = \frac{1}{3}.$$

That point C is the harmonic mean of B and D follows from the equation for the harmonic means given by Equation (4.1), i.e.,

$$\frac{1}{3} = 2\left(\frac{1}{2}\right)\left(\frac{1}{4}\right)\bigg/\left(\frac{1}{2} + \frac{1}{4}\right).$$

The only fixed point of this projective transformation is located at (0,0). Therefore this transformation differs from the one in Appendix 4.A in which there were two fixed points. In a sense described in Section 2.5, the two fixed points of the transformation have coalesced into one resulting in what is called a *step measure*. To get another picture of this transformation we can do as we did in Appendix 4.A and map the fixed point to infinity. To do this, Draw an arbitrary line l' as in Figure 8.B2. A parallel line from (0,0) maps 0 on line l to infinity on line l'. The point at infinity on l maps to 0 on l'. This also establishes the point of perspectivity, O. Now it can be

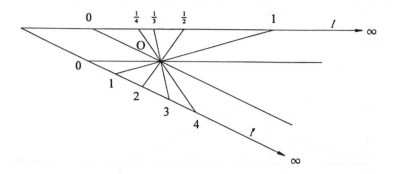

Figure 8.B2 Perspective transformation of an harmonic series to an integer series.

shown that the harmonic series of points ∞, 1, $\frac{1}{2}$, $\frac{1}{3}$, $\frac{1}{4}$,.... map to an evenly distributed set of points on (left to the reader), call them 0, 1, 2, 3, 4,.... You can check that the cross-product of 1, 2, 3, 4 is, $\lambda = \left(\frac{1}{1}\right)\Big/\left(\frac{3}{1}\right) = \frac{1}{3}$, and is therefore preserved as it should.

So we see that, in general, while a sequence of transformed points can always be mapped to a geometric series when the projective transformation has two fixed points, they map to an arithmetical series when there is a single fixed point.

9
The Hyperbolic Brunes Star

> Numbers are the sources of form and energy in the world.
> They are dynamic and active even among themselves...
> almost human in their capacity for mutual influence.
>
> *Theon of Symyrna*

9.1 Introduction

The Brunes star can be transformed by replacing each line within it by a segment of an hyperbola [Adam]. The mathematical functions that make up the hyperbolic segments of the new star are involved in countless problems in all of the sciences and we shall see them again in Chapters 14 and 22. "The little end of the stick problem" (LES) is one such illustration [Mos]. In this problem a stick is broken into two pieces at random. What is the average ratio of the smaller to the larger piece and what are their average lengths? Numbers that arise from the little end of the stick problem also make their appearance in problems of exponential growth and decay. In problems such as these, the probability that an event takes place either increases or decreases exponentially with the number of trials. Two examples are:

(1) the probability of tossing n heads in a row, and
(2) the probability that a radioactive atom will decay in a given time period.

LES also has a connection to Shannon's entropy function which comes up in many areas of mathematics and science.

9.2 A Generalized Brunes Star

The Brunes star can be generalized by replacing the eight line segments that make up the diagonals of its four half-squares by segments of an hyperbola juxtaposed in eight different orientations within a unit square, as shown in Figure 9.1.

Four of these hyperbolas intersect as shown in Figure 9.2 at three characteristic points p, q, r with coordinates:

$$p = (0.414\ldots, 0.707) = \left(\frac{1}{\theta}, \frac{1}{\sqrt{2}}\right), \quad \text{where, } \theta = 1 + \sqrt{2};$$

$$q = (0.707\ldots, 0.414) = \left(\frac{1}{\sqrt{2}}, \frac{1}{\theta}\right);$$

$$r = (0.618\ldots, 0.618) = \left(\frac{1}{\tau}, \frac{1}{\tau}\right), \quad \text{where, } \tau = \frac{1 + \sqrt{5}}{2}.$$

Therefore, the key numbers of the Roman system of proportions $\sqrt{2}$ and θ (see Section 7.4), and the golden mean τ (see Section 7.3) are represented in a single diagram. The hyperbolic Brunes star is shown in Figure 9.3. The

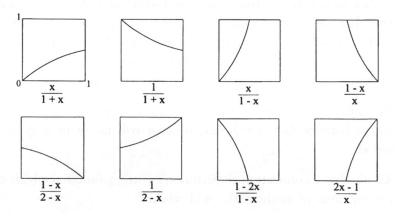

Figure 9.1 The eight hyperbolic segments that make up the "generalized" Brunes star inscribed within a unit square.

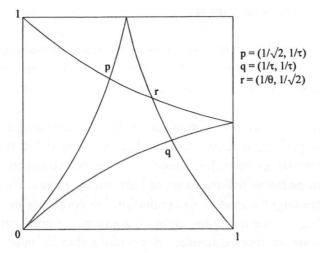

$$p = (1/\sqrt{2}, 1/\tau)$$
$$q = (1/\tau, 1/\tau)$$
$$r = (1/\theta, 1/\sqrt{2})$$

Figure 9.2 Two pair of these hyperbolas intersect at points related to the irrational numbers τ, θ, and $\sqrt{2}$.

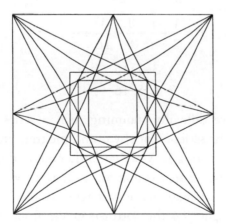

Figure 9.3 The generalized Brunes star.

points of intersection lie on the edges of the three inner squares. The edge length of the innermost square is τ^{-3}, the middle square is $\frac{1}{3}$, and the outer square is $\theta^{-1} = \sqrt{2} - 1$. The outer square is the central square in the subdivision of a unit square into S, SR and RR in Figure 7.4.

9.3 Zeno's Hyperbolic Paradox

Consider, in Figure 9.4, an exploded view of the space between two segments of a hyperbolic Brunes star, and compute the sum of the vertical and horizontal line segments that make up the zig-zag path between this pair of curves.

This leads to a modern version of one of three famous paradoxes expressed by the Greek philosopher Zeno who lived at Elea around 450 B.C.E. In this paradox, a tortoise traverses the distance between two points one mile apart. First the tortoise moves half the distance between the points. Then he moves half the remaining distance to the endpoint. He continues in this fashion always moving half the remaining distance from a new point to the endpoint. Since there are an infinite number of positions that he must pass before reaching the endpoint, it was a puzzle how the tortoise would ever reach its objective. At the end of the journey, the tortoise will have traveled distances given by the following infinite series,

$$1 = \frac{1}{2} + \frac{1}{4} + \frac{1}{8} + \frac{1}{16} + \cdots, \tag{9.1a}$$

$$\frac{1}{2}, \frac{3}{4}, \frac{7}{8}, \frac{15}{16}, \ldots. \tag{9.1b}$$

We no longer have difficulty summing such a series and resolving the paradox. If we cut the series off at any point, the truncated finite series sums to a number approximating 1. As we go farther out in the series these partial *sums* are better and better approximations to 1, as shown by Sequence (9.1b), approaching 1 in what mathematicians refer to as a *limiting* sense.

Returning to Figure 9.4 the tortoise moves from the lower left hand corner to the upper right hand corner of the square moving along the zig-zag path between the pair of curves of the hyperbolic Brunes star [Adam]. It is clear that the total distance traveled by the tortoise will be two units.

Using the two equations for the curves:

$$y = \frac{1}{2-x} \quad \text{and} \quad y = \frac{2x-1}{x},$$

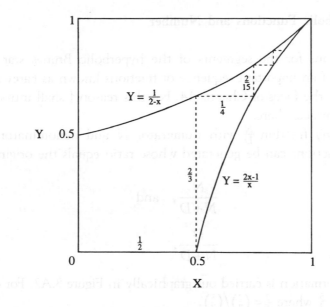

Figure 9.4 TA zig-zag path illustrating Zeno's hyperbolic paradox.

we find that the horizontal distances sum to 1 as,

$$1 = \frac{1}{2} + \frac{1}{4} + \frac{1}{12} + \frac{1}{24} + \frac{1}{40} + \cdots, \qquad (9.2a)$$

$$\frac{1}{2}, \frac{3}{4}, \frac{5}{6}, \frac{7}{8}, \frac{9}{10}, \ldots, \qquad (9.2b)$$

while the vertical distances sum to 1 as,

$$1 = \frac{2}{3} + \frac{2}{15} + \frac{2}{35} + \frac{2}{63} + \frac{2}{99} + \cdots, \qquad (9.3a)$$

$$\frac{2}{3}, \frac{4}{5}, \frac{6}{7}, \frac{8}{9}, \frac{10}{11}, \ldots. \qquad (9.3b)$$

Notice the elegant pattern that the *partial sums* in sequences (9.2b) and (9.3b) form as they approach their limiting value of 1. These are the distances that the tortoise traverses in the hyperbolic Zeno's paradox.

9.4 Hyperbolic Functions and Number

The equations for the segments of the hyperbolic Brunes star are also generators of an important sequence of fractions known as Farey sequence that will be the focus of Chapter 14. For this reason I shall introduce this generation process here.

From any fraction $\frac{N}{D}$ with numerator N and denominator D, two *successor* fractions can be generated whose ratio equals the original,

$$\frac{N}{N+D}, \quad \text{and} \tag{9.4a}$$

$$\frac{D}{N+D}. \tag{9.4b}$$

This transformation is carried out graphically in Figure 8.A2. For example, $\frac{2}{5} \to \frac{2}{7}$ and $\frac{5}{7}$ where $\frac{2}{5} = \left(\frac{2}{7}\right) / \left(\frac{5}{7}\right)$.

To recover the *parent* fraction from one of the *successors*, let the successor equal $\frac{N}{D}$, in which case its parent is,

$$\frac{N}{D-N} \quad \text{if} \quad \frac{N}{D} \leq \frac{1}{2}, \quad \text{or} \tag{9.5a}$$

$$\frac{D-N}{N} \quad \text{if} \quad \frac{N}{D} \geq \frac{1}{2}. \tag{9.5b}$$

Now let $\frac{N}{D} = x$ in Equations (9.4a) and (9.4b) to get,

$$\frac{N}{N+D} = \left(\frac{N}{D}\right) / \left(\frac{N}{D}+1\right) = \frac{x}{x+1}, \tag{9.6a}$$

$$\frac{D}{N+D} = 1 / \left(\frac{N}{D}+1\right) = \frac{1}{1+x}. \tag{9.6b}$$

In a similar way, Equations (9.5a) and (9.5b) result in

$$\frac{x}{1-x} \quad \text{for} \quad x \leq \frac{1}{2}, \quad \text{and} \tag{9.6c}$$

$$\frac{1-x}{x} \quad \text{for} \quad x \ge \frac{1}{2}. \tag{9.6d}$$

The graphs of Equations (9.6) are shown in Figure 9.1. It can be shown that each of them is a rotation or reflection of a segment of the hyperbola $y = \frac{1}{x}$. Also, the pairs given by Equations (9.6a) and (9.6b), and Equations (9.6c) and (9.6d) are reflections of each other, and they are segments of the hyperbolic Brunes star (see Figure 9.6).

9.5 Hyperbolic Functions in the Theory of Probability

The hyperbolic functions of Equations (9.6) arise in many mathematical and scientific contexts particularly those related to the theory of probability. For example, if p and q are considered to be the *probability* of guessing correctly or incorrectly on the roll of a dice or the probability of *winning or losing* upon the selection of a horse in a race, then the *odds* of *winning* or *losing* is defined to be,

$$\text{odds of winning} = p{:}q = \frac{p}{q} \quad \text{or} \quad \frac{p}{1-p} \quad \text{since } q = 1 - p;$$

$$\text{odds of losing} = q{:}p = \frac{p}{q} \quad \text{or} \quad \frac{1-p}{p}.$$

Therefore, interpreting x as p in Equations (9.6), the *parent* value can be interpreted as the odds of winning or losing when the probabilities of winning and losing equal the *successor* values. For example, if a horse has a $\frac{1}{3}$ chance to win a race and a $\frac{2}{3}$ chance to lose, then from Equation (9.6c) the odds of winning are 1:2 and the odds of losing are 2:1 (the odds of a horse race are generally expressed in terms of losing odds). The payoff in a horse race is figured by multiplying the inverse of the probability of losing by the amount of the bet. So a \$2 bet results in $\frac{3}{2} \times 2 = \$3$ winnings.

I shall discuss two additional examples of how Equations (9.6) arise in probability problems.

9.6 Gambler's Ruin

A gambler starts with \$1 and plays against the casino. He has the probability p of winning and $1 - p$ of losing. Visualizing his fortune on a number line,

If his fortunes ever reach 0, he has lost all of his money and is "ruined" and the game ends. It certainly makes no sense for him to play if his probability of winning is less than $\frac{1}{2}$. Eventually, he is sure to be ruined. It turns out that if $p \geq \frac{1}{2}$ then the probability that he begins with \$1 and is eventually ruined is $p_1 = \frac{1-p}{p}$ [Mos]. Figure 9.5 shows the dependency of p_1 on p. Note that when $p = \frac{1}{2}$ then $p_1 = 1$ and he is sure to be ruined. As p increases above $\frac{1}{2}$ the chance of ruin decreases.

When the chance of winning p equals the chance of beginning with \$1 and being ruined p_1,

$$p = p_1 \quad \text{or} \quad p = \frac{1-p}{p}. \tag{9.7}$$

The solution of Equation (9.7) is $p = \frac{1}{\tau}$ where $\tau = \frac{1+\sqrt{5}}{2}$, the golden mean (see Figure 9.5). This is the value of p where the line intersects the curve. If the gambler begins with m dollars, then [Mos] shows that the probability

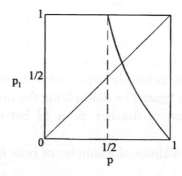

Figure 9.5 A graph of probability of ruin p_1 vs probability of winning p.

of eventual ruin is $p_m = \left(\frac{1-p}{p}\right)^m$. Furthermore, it can be shown [Schr] that if $p \geq \frac{1}{2}$, in order to maximize his winnings, the gambler must use *Kelly's optimum betting strategy* and bet the fraction $2p - 1$ of his capital.

9.7 Little End of the Stick Problem

If a stick is broken into two pieces at random, what is the average length of the small piece S_{avg}, the large piece L_{avg}, and the ratio of small to large $\left(\frac{S}{L}\right)_{avg}$?

Consider the stick to have unit length. Certainly the longer length L can have any value between $\frac{1}{2}$ and 1 with equal probability, so that the stick is divided into two parts,

where $L = x$ and $S = 1 - x$ where $\frac{1}{2} \leq x \leq 1$.

In the theory of probability, the average of some quantity $f(x)$ that depends on a continuous variable x whose probability of occurrence is given by the *probability density function* $p(x)$, is referred to as its *expected value* $E[f(x)]$. The variable x is called a *random variable*. If we wish to find the expected value of $f(x)$ where $a \leq x \leq b$, for those who understand calculus, it can be determined by evaluating the following integral,

$$E[f(x)] = \int_a^b f(x)p(x)dx \quad \text{where} \quad \int_a^b p(x)dx = 1.$$

When all values of the random variable x are equally likely,

$$p(x) = \frac{1}{b-a}, \quad \text{and} \quad E[f(x)] = \frac{1}{b-a}\int_a^b f(x)dx \tag{9.8}$$

which is equal to the area under the curve $y = f(x)$ divided by $b - a$.

Applying this to the *little end of the stick problem*,

$$L_{avg} = E[x] = \frac{1}{1/2}\int_{\frac{1}{2}}^1 x\,dx = \frac{3}{4}, \tag{9.9a}$$

$$S_{avg} = 1 - L_{avg} = \frac{1}{4},$$

(9.9b)

$$S_{avg} : L_{avg} = 1 : 3, \quad \text{and}$$

(9.9c)

$$\left(\frac{S}{L}\right)_{avg} = \frac{1}{1/2} \int_{1/2}^{1} \frac{1-x}{x} dx = \ln 4 - 1 = 0.38629...$$

(9.9d)

where ln stands for *natural logarithm* or \log_e.

Using knowledge of calculus to compute area A beneath the two hyperbolic segments of the Brunes star given by Equations (9.6c) and (9.6d) (see Figure 9.1), we find that area A is determined by Equation (9.9d), i.e., area A = 0.38629....

The evaluation of an average in mathematics is a tricky business. If we use Equations (9.6a) to determine the lengths of S and L whose sum is 1 and whose ratio is $\left(\frac{S}{L}\right)_{avg} = 0.386...$, then we find,

$$x = \frac{1}{1 + 0.38629} = 0.721...,$$

(9.10a)

$$1 - x = \frac{0.38629}{1 + 0.38629} = 0.2786....$$

(9.10b)

Therefore the unit stick with average value, with respect to x, of $\left(\frac{S}{L}\right)_{avg} = 0.386...$, has segments of length 0.278... and 0.721.... You will notice that these are slightly different from the values obtained in Equations (9.9b) and (9.9c), reflecting the fact that, $\left(\frac{S}{L}\right)_{avg} \neq S_{avg}/L_{avg}$.

Malcomb Lichtenstein [Lic] carried out a computer experiment to simulate the little end of the stick problem. He randomly selected 1000 values of x between 0 and 1 and computed the ratios of $\frac{S}{L} = \frac{x}{(x-1)}$ or $\frac{(1-x)}{x}$ obtaining an average value of 0.386.... He also found that the average values of S and L were 0.25... and 0.75... in agreement with results of Equations (9.9a) and (9.9b).

Lichtenstein also simulated the breaking of a stick of unit length into three segments and obtained the results:

$$L_1 = \frac{1}{12}, \quad L_2 = \frac{1}{4}, \quad \text{and} \quad L_3 = \frac{2}{3}.$$

This can be verified analytically as follows. First compute the average value of the largest segment L_3. Letting $L_3 = x$. Clearly $\frac{1}{3} \le x \le 1$. Using Equation (9.8),

$$L_3 = E[x] = \frac{1}{2/3}\int_{1/3}^{1} x\,dx = \frac{2}{3}.$$

The remaining $\frac{1}{3}$ of the stick is then broken into the other two segments L_1 and L_2 in the ratio $L_1:L_2 = 1:3$ as before (see Equation (9.9c)), i.e.,

$$L_1 + L_2 = \frac{1}{3} \quad \text{and} \quad L_1 : L_2 = 1:3.$$

Solving these equations we find that,

$$L_1 = \frac{1}{12} \quad \text{and} \quad L_2 = \frac{1}{4}.$$

Together with $L_3 = \frac{2}{3}$ this is in agreement with Lichtenstein's results. We also see that,

$$L_1 : L_2 : L_3 = 1:3:8. \tag{9.11}$$

Continuing in a similar fashion the result of Equation (9.11) can be used to find the segment ratios for the subdivision of the stick into four parts, etc. I have determined the result of breaking sticks into n-segments, and I have found that the ratio of segments exhibits a simple pattern. This pattern can be generated beginning with the numbers 0 and 1 as follows:

```
n = 1    0 1
    2    0 1 3 = 3 × 1 − 0
    3    0 1 3 8 = 3 × 3 − (0 + 1)
    4    0 1 3 8 20 = 3 × 8 − (0 + 1 + 3)
    5    0 1 3 8 20 48 = 3 × 20 − (0 + 1 + 3 + 8)
    6    0 1 3 8 20 48 112 = 3 × 48 − (0 + 1 + 3 + 8 + 20) etc.
```

Some of the numbers generated by the little end of the stick problem will be shown to have significance in the theory of numbers (see (14.4.11)).

9.8 Shannon's Entropy Function and Optimal Betting Strategy

There is a connection between the *LES* problem and *Shannon's entropy function* important in information theory [Adam]. Imagine trying to get information from someone by asking him to choose from a list of four equally probable possibilities. The correct answer carries more information H than if he chose an answer from only two possibilities. In the first case the probability of his choice is $p = \frac{1}{2}$ and in the second case $p = \frac{1}{4}$. In terms of p, Shannon's entropy function H is expressed as,

$$H = -(p \log_2 p + (1-p) \log_2 (1-p)). \tag{9.12}$$

The lower the entropy, the greater the information content. If $p = \frac{1}{2}$ then $H = 1$, a maximum value.

The entropy function is pictured in a unit square in Figure 9.7. The areas under (B) and outside (C), the entropy curve, equal the average values of the small and large portions of the broken stick, i.e.,

$$\text{Area } B = 0.72134..., \text{ and}$$

$$\text{Area } C = 0.27865..., \text{ while}$$

$$\frac{\text{Area } C}{\text{Area } B} = 0.38629...$$

which has the same value as Area A in Figure 9.6.

Figure 9.6 Area A under Equations (9.6c) and (9.6d) gives the ratio 0.386... of the small to large portions of the "little end of the stick problem".

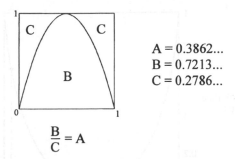

$$\frac{B}{C} = A$$

Figure 9.7 Areas under and over Shannon's information formula relates to the "little end of the stick" problem.

Schroeder shows that when the optimum betting strategy, $2p - 1$, is used the gambler in the previous example of gambler's ruin will see his fortunes grow at the rate r of,

$$r = 2^{1-H(p)} - 1 \qquad (9.13)$$

dollars per turn at the gambling table if his winning probability is greater than $p = \frac{1}{2}$. In this equation $C(p) = 1 - H(p)$ where $C(p)$ is referred to in information theory as the *channel capacity*. Notice that if $p = \frac{1}{2}$ then $H = 1$, and this formula indicates no growth, whereas if $p = 0.6$ (an exceptionally good probability at a gaming table), using Equation (9.12), $H = 0.971$ and the rate of growth is $2^{(1-0.971)} - 1 = 0.0288$ dollars per toss. At this rate the compound interest formula predicts that the number of tosses n (time periods) that it would take to double his fortune is given by $n = \ln\frac{2}{r}$ or about 34 tosses.

By a more direct route the *growth* rate of the optimal betting strategy $2p - 1$ is

$$r = 2Q - 1 \quad \text{where} \quad Q = p^p(1-p)^{1-p}. \qquad (9.14)$$

Figure 9.8 relates the *probability* p along the x-axis to *growth* rate r along the y-axis. For a probability of winning greater than 0.5 we refer to the right half of the graph which has bilateral symmetry (right half is the mirror image of the left half). However, the left half with p < 0.5 refers to negative growth

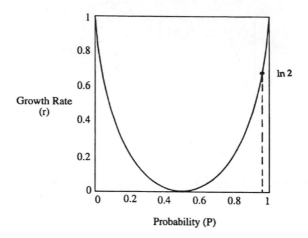

Figure 9.8 Rate of growth of "winnings" r plotted against probability of winning p.

rates. Notice that when $p = 0.96043...$ the growth rate is $\ln 2$. At this rate the gambler's fortune doubles on each "toss".

What if we attempted to use Shannon's formula to arrive at an estimate of the rate at which an evolutionary process in nature increases its *payoff* which could be a measure of the adaptability of the organism to its surrounding environment over some number of unknown time periods or tosses? A rough measure of the *average rate* at which an entirely random process grows is 2 raised to a power equal to Area C (the *expected value* of the channel capacity) in Figure 9.7 or $2^{0.27865} - 1 = 0.213$ increase in adaptability per toss. The *doubling time* for this rate is 3.25 tosses or time periods. So we see that evolutionary processes may be, intrinsically, quite adaptable at least compared to the rate of winning at a gaming table.

9.9 The Generalized Little End of the Stick Problem

The little end of the stick problem makes a surprise appearance in a class of problems in which the probability y that an event takes place either increases or decreases exponentially with the number of trials x. In other words, $y = k^{-x}$ or $y = 1 - k^{-x}$ where $k > 1$, which predicts the probability of tossing x heads in a row, the probability that a radioactive atom will decay

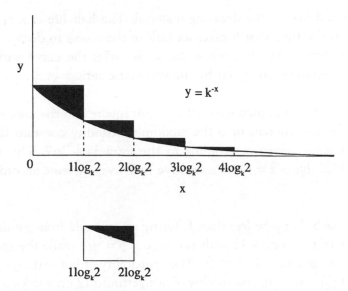

Figure 9.9 Probability that an event occurs y plotted against the number of trials x. The probability decreases exponentially.

in a given time period, the discharging of a capacitor, the cooling of a warm object and many other applications.

Figure 9.9 shows that when x increases from $n\log_k 2$ to $(n+1)\log_k 2$ the value y is reduced by $\frac{1}{2}$. Within each increment of this diagram there is a generalized increment rectangle (see insert). The total area beneath the curve is $\frac{1}{\ln k}$, while the area beneath the curve in each increment rectangle is $\frac{1}{2^n \ln k}$. (Note that $\log_k 2 = \frac{\ln 2}{\ln k}$ by Equation (3.A1).) The ratio of the area beneath the curve $y = k^{-x}$ (white area) to the area of the increment rectangle is $0.72134...$ while the area above the curve (black area) is $0.27865...$ (note that both numbers are independent of k), the lengths of the little end of the stick problem (see Equations (9.10a) and (9.10b)). Therefore, the increment rectangle acts as a kind of *two dimensional stick*. Although the value of y decreases by a factor of $\frac{1}{2}$ over the increment rectangle, its average decrease is $0.72134....$

Special Case 1. $k = e$. The curve corresponds to radioactive decay with a unit decay constant, and the x values: $\ln 2, 2\ln 2, 3\ln 2,...$ represent the

successive *half-lives* of the decaying material. The half-life of a radioactive substance is the time that it takes for half of the atoms to decay. The area under the entire curve is 1 while the areas under the curve within each increment rectangle are given by the geometric series: $\frac{1}{2}, \frac{1}{4}, \frac{1}{8}, \frac{1}{16}, \ldots$

Special Case 2. $k = 2$. Increment #1 is a unit square and the area under the curve in the first increment is the random probability constant 0.7213.... The other areas decrease according to the formula $\frac{1}{2}^n \ln 2$. This time the *generalized half-life* is $x = 1$ and successive half-lives increase according to 1, 2, 3, 4,....

Special Case 3. Let k be less than 1. Using an example from gambling, the probability of throwing a 12 with two dice is $p = \frac{1}{36}$, while the probability of not throwing a 12 is $1 - p = \frac{35}{36}$. The probability of not getting 12 on two throws is $\left(\frac{35}{36}\right)^2$ while the probability of not getting a 12 on x throws is $\left(\frac{35}{36}\right)^x$. We seek the number of tosses x needed to give us even odds (probability of $\frac{1}{2}$ of getting at least one 12).

Solution. Take the inverse of the probability of losing $\left(\frac{35}{36}\right)$ and turn it into a function $y = k^{-x}$ where k is the inverse of losing, i.e., $k = \frac{36}{35}$. The value of x at which $y = \frac{1}{2}$ is $\log_k 2 = \frac{\ln 2}{\ln k} = \frac{0.693\ldots}{0.2817\ldots} = 24.6\ldots$, therefore it will take 25 tosses to get a probability of $\frac{1}{2}$ of getting at least one 12. In other words, you get at least one twelve at most 50% of the time when you toss two dice 24 times.

The problem of getting a 12 on the throw of two dice can be generalized. Certain gambling problems ask for the *number of trials* necessary to insure one *success* given any probability of a *success* or *failure*. The number of trials n is given by,

$$n = \frac{\ln F}{\ln N} \qquad (9.15a)$$

where N is the probability of non-occurrence of the event, and F is the chance of failure to obtain a success during n trials. If $k = \frac{1}{N}$ then Equation (9.15a) can be rewritten,

$$n = \log_k \frac{1}{F}, \qquad (9.15b)$$

the equation for the decay problem in which a fraction F of the original material remains after one emptying period. For example, if $F = \frac{1}{2}$, we get $n = \log_k 2$, the half-life. In other words for the dice problem, $N = \frac{35}{36}$ and $F = \frac{1}{2}$ resulting in $n = 24.6$ or 25 trials. Likewise, to determine the number of tosses to guarantee a 12 on a pair of dice 90% of the time, let $F = 1 - 0.9 = 0.1$ in which case, using Equation (9.15),

$$n = \frac{\ln 0.1}{\ln \frac{35}{36}} = 81.7 \quad \text{or} \quad 82 \text{ trials}.$$

As another example, let's say you want to find someone whose birthday matches yours. How many people are you required to ask to get a 50:50 chance of making a match?

Answer. Each time you ask someone his or her birthday the chance that their birthday is the same as yours (a success) is $\frac{1}{365}$, and the chance that their birthday is not the same as yours (failure) is $N = \frac{364}{365}$. Since the chance of failing to get a match in n trials is 0.5, $F = \frac{1}{2}$. Therefore, using Equation (9.15), you must ask 252.65 or 253 people.

Compare this with the result of the more standard birthday problem in which one asks how many people, selected at random, are required in order to insure that there is an even chance (50% probability) that at least two of them have birthdays on the same day. The theory of probability shows that only 23 people are required.

9.10 Conclusion

There is a relationship between the Brunes star generalized to hyperbolic functions and a problem in probability theory known as the "little end of the stick" problem. The hyperbolic relationships arise naturally in the theory of odds making and betting. The solution to the little end of the stick problem also yields a constant that corresponds to the average value of an exponentially decaying material during its half-life. We shall again meet up with the little end of the stick problem in Chapter 14 in the context of number theory.

These wide ranging applications of mathematics leading from geometry and pure number have drawn people through all ages and civilizations to a study of this subject. During the Renaissance artists and architects such as Durer, Brunelleschi, Alberti, and Leonardo da Vinci with their studies of perspective and the theory of proportions had a profound influence on mathematics. In the next chapter I will explore the underlying geometry of a set of pavements which may have been designed by Michelangelo.

10
The Hidden Pavements of the Laurentian Library

> I would have nothing on the walls or floor of the temple that did not
> have some quality of Philosophy... I strongly approve of patterning the
> pavement with musical and geometric lines and shapes so that the
> mind may receive stimuli from every side.
>
> *Alberti*

10.1 Introduction

In the preceding chapters, I have conjectured that the architects of antiquity
used such tools of the trade as:

(1) the *sacred cut* (Section 6.2);
(2) the *Brunes star* (Chapter 8);
(3) *the square-within-a-square* or ad-quadratum square (Section 8.3);
(4) *circle grids* (Appendix 6.A);
(5) the Roman system of proportions (Section 7.3);
(6) the law of repetition of ratios (Section 7.4); and
(7) the golden mean (Section 7.3).

Unfortunately, there is scant evidence that the component parts of this
body of knowledge were ever considered as a whole; few architectural
drawings or mason's manuals from ancient times have survived. Several
scholarly investigations have been made of ancient Roman ruins that support
the existence of a geometer's "tool kit" (cf. [Wat-W1], [WatC]). However,
even in these studies there is a great deal of speculation. Therefore, it was
with great interest that I received a telephone call from Ben Nicholson, a
professor of architecture. He had become privy to a set of facsimiles of 15
pavement designs — possibly created by Michelangelo — that lay hidden

beneath the floorboards of the Laurentian Library in Florence. He was trying to decipher their geometries in order to reconstruct them at full scale. One thing led to another and I found myself part of Nicholson's team of researchers devoted to the study of the pavements. The results of this work have given additional evidence for the use of the ancient geometer's "tool kit".

10.2 The Laurentian Library

The Laurentian Library, which was designed by Michelangelo, is situated on the second floor of the San Lorenzo church complex in the heart of Florence. Work on the library was begun in 1523 by Pope Clement VII, alias Givlio Medici, the nephew of Lorenzo di Medici, as a monument to his uncle; it was opened to the public 48 years later by Grand Duke Cosimo I. The library was meant to be a home for the books from antiquity that survived to the Renaissance.

In 1774, a portentous accident occurred in the Reading Room of the Laurentian Library [Nic], [NKH1]. The shelf of desk 74, overladen with books, gave way and broke. In the course of its repair, workmen found a red and white terra-cotta pavement which had lain hidden for nearly 200 years beneath the floorboards. The librarian had trapdoors, still operable today, built into the floor so that future generations could view these unusual pavements. In 1928 the pavements were photographed for the first time when the desks were removed temporarily while structural repairs were made to the subflooring. Figure 10.1 shows a photograph of the Library both with and without the desks and floorboards.

Overall, the pavement consists of two side aisles and a figurative center aisle. Desks situated on a raised wooden dais have been placed over the pavements. On the side of each desk are listed the books that were to be stored in it. Beneath the desks are a series of 15 panels, of different designs, each about 8'6" × 8'6". The 15 panels along one aisle mirror the ones on the other aisle, but differ in subtle ways. When juxtaposed, the fifteen pairs of panels appear to tell a story about the essentials of geometry and number.

The design of each panel reflects a specific geometric structure: for example, the tetractys (Panel 5; see Section 3.5), Brunes's star (Panel 13;

(a)

(b)

Figure 10.1 The Laurentian Reading Room — with and without desks. Details of the floor of the Hall of Michelangelo. With permission of the Ministry/Department (further reproduction by any means is prohibited).

see Chapter 8), root-two and the sacred cut (Panels 7 and 11), Plato's lambda (Panel 14; see Sections 3.5 and 7.2), or the golden mean (Panel 13; see Section 7.2 and Chapter 20). When assembled together they encompass the essential principles known to early geometers.

Although hidden from view today, Nicholson believes that the panels were arranged according to a plan for a furniture layout that would have exposed the panels, but this plan was changed after the panels had been made. Thus, while walking through the Reading Room of the Laurentian Library, a person would have been surrounded by the foundations of ancient geometry, a perfect compliment for the 3000 classical texts chosen to reveal the body of ancient and modern learning of that day. In fact, it is Nicholson's belief that the pavements may have formed a pictorial catalog for the books adjacent to the panels, the geometry of the panels corresponding to the categories by which the books were to be arranged. Details of a system correlating pavements to books can be found in *Thinking the Unthinkable House* [Nic].

10.3 Reconstruction of the Pavements

Ben Nicholson has worked with students for 13 years to reconstruct the system which the team of geometers and theologians, perhaps including Michelangelo, might have used to create the original designs. He has recently collaborated with artist Blake Summers and architecture graduate student Saori Hisano to replicate all 15 panels at full scale, working with straightedge and compass. In the process, they have discovered tenets of geometry which may have formed the basis of an organized system or taxonomy. An early version of Nicholson's taxonomy has been described elsewhere [NKH1].

At first glance, the panels all appear to be square. However, curious irregularities guide the dimensions of each panel. Each panel is set into a rectangular frame that measures approximately 4 braccia (233 cm) by $4\frac{1}{4}$ braccia (248 cm), but the size of each panel is slightly different. Nicholson proposes that the geometric grids and associations to number found in the pavements respond to the essential theological and scholastic questions posed in the 16-th century. For example, Plato's Lambda orders panel 14, shown in Figure 10.2. The panel aligns well in its general

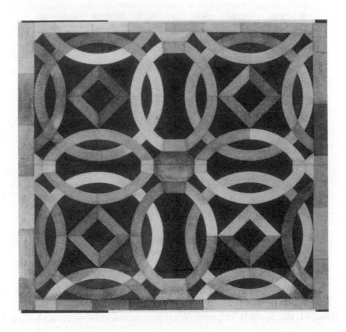

Figure 10.2 Panel 14, the Timaeus panel.

appearance with descriptions in the Timaeus which set the Lambda within four interconnecting circles [Kap8]. Nicholson's proposition that each pair of panels differs very slightly from East to West now becomes relevant to the discussion. For example, there is evidence to suggest that Panel 14 East is laid out on a grid of 81 parts, and that Panel 14 West is laid out on a grid of 80 parts. As discussed in Section 3.5, 80:81 is a measure of the comma's difference between the Pythagorean and Just musical scales. Could this have been intentional? In the remainder of this chapter, I will present details of three panel reconstructions.

10.4 The Sacred-Cut Panel

Nicholson refers to Panel 11, shown in Figure 10.3, as the "Sacred Cut Panel" because it is constructed from the sacred cut at four different scales.

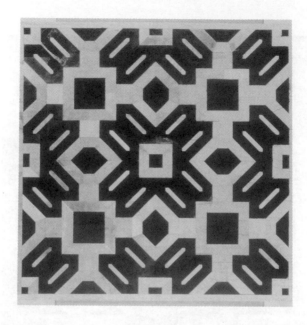

Figure 10.3 Panel 11, the Sacred Cut panel. With permission of Biblioteca Medicea Laurenziam.

Appendix 10.A describes a series of elements from the Nicholson taxonomy showing how the sacred cut and its relationships follow naturally from the square circle grid (see Appendix 6A). As with any mannerist design, there is always more than one way to view it, and when viewed along its diagonal, a cartesian grid structure reveals itself.

The panel can be seen to be made up of three classes of white strips: the eight strips radiating from the center square are referred to as *white bands*, the strips surrounding each of the squares are referred to as *white strips*, while the wider strips connecting one square to the next are referred to as *white band connectors*. What follows is an analysis of Panel 11.

10.4.1 In Figure 7.4 I showed how, using the sacred cut, a square could be subdivided into four corner squares, a central square, and SR and RR rectangles. I will refer to this subdivision as a *sacred cut subdivision of a square or SCSS*. Figure 10.4 shows this subdivision along with its dimensions: they assume that the corner squares have unit length. From Figure 10.4 we

Figure 10.4 Sacred cut subdivision of a square showing dimensions assuming that the corner square has unit length.

see that:

(a) The ratio of the sides of the outer square to the corner square is $\theta \sqrt{2}$:1;

(b) The ratio of the overall square to the central square is θ:1 where $\theta = 1 + \sqrt{2}$; and

(c) The sacred cut divides the side of the overall square in the ratio θ:1. These relationships can also be deduced from Table 7.2. If integer approximations are desired, corresponding values from Table 7.2 can be used.

10.4.2 The process of subdivision can also be carried out in the reverse direction. Begin with the central square and reconstruct the outer square from which it was derived. To do this draw four circles about the four vertices of the central square with radii equal to the distance from the vertex to the center of the square. The outer square inscribes these four circles as shown in Figure 10.5.

Figure 10.5 Reconstructing the outer square of the sacred cut subdivision given the central square.

Figure 10.6 Schematic subdivision of panel 11 into a series of three sacred cut subdivisions of a square.

10.4.3 In Figure 10.6 this method is used to explode the central square outwards to three successively larger scales. This series of sacred cut subdivisions of a square (SCSS) can be observed on Panel 11 (see Figure 10.3). If the central black square has a length of 1 unit, then the sequence of squares have lengths that increase in the series 1, θ, θ^2, θ^3 as can be determined from Step 1b, Figure 10.A1e of Appendix 10.A, or by using the Roman system of proportions described in Section 7.3. Using Sequence (7.8) we can also represent all lengths approximately in terms of integers.

10.4.4 Nicholson's team of empirical geometers note that if a square is rotated about its center through 45 degrees, the pair of squares recreates the SCSS as shown in Figure 10.7 and Appendix 10.A1b. Also a square-within-a-square creates a 4 × 4 grid of congruent squares as shown in Figure 10.8.

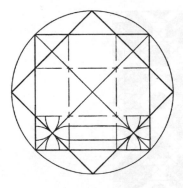

Figure 10.7 Rotating a square by 45 degrees creates a sacred cut subdivision of a square. Sacred cut squares are drawn in the corner squares to show how white band connectors are created.

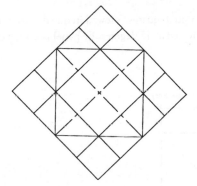

Figure 10.8 A square-within-a-square creates a 4 × 4 grid of congruent squares.

10.4.5 A sacred cut is drawn in one of the corner squares of the outer square of Figure 10.7. Since the outer square is the third in the sequence of SCSS, it measures θ^3. Therefore, by step 1a, the corner square measure $\frac{\theta^2}{\sqrt{2}}$ and the band connector is determined from step 1b to be $\frac{\theta}{\sqrt{2}}$.

10.4.6 In Figure 10.9 the first technique of Step 5 is applied to a pair of squares superimposed on panel 11. Within the first square the sacred cut geometry is evident. The second square, inclined at 45 degrees to the first, is subdivided into a 5 × 5 grid of squares. The central white square of the panel is inscribed as a square-within-a-square within the central square of the 5 × 5 grid. This provides the grid with a natural refinement into 4 × 4 subgrids. In this way the positions of the white strips are determined. The design becomes an elaborate interplay between *sacred cut squares* and *congruent squares*.

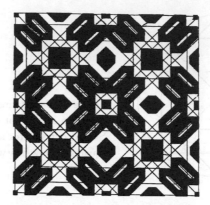

Figure 10.9 Panel 11 superimposed on a pair of rotated squares. Viewed in one direction the panel is organized by the sacred cut subdivision. Viewed at 45 degrees the panel is a 5 × 5 grid of congruent squares.

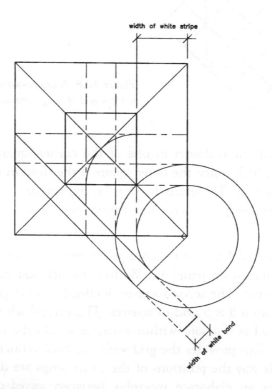

Figure 10.10 Subdivision of the central square to create the widths of the white bands and white stripes.

10.4.7 The width of the white strips are found by considering the central black square of width 1 unit to be the central square of a SCSS with the outer square measuring θ units. By step 1a, the white strips then have a width equal to the sides of the corner squares measuring $\frac{1}{\sqrt{2}}$. To find the white bands we must descend one more step into the black square to create another SCSS in which the center square has of width $\frac{1}{\theta}$ shown in Figure 10.10. The width of the white band is the width of the corner square of this SCSS measuring $\frac{1}{\theta\sqrt{2}}$ by step 1a. This white band can be constructed from a sacred cut of the central black square by the compass and straightedge construction shown in Figure 10.10.

It is worth noting that Nicholson has also drawn this panel without the use of geometry upon a series of four overlapping grids of 4, 5, 6, and 7 parts. Nicholson believes that the error of this construction was small enough to be buried in the grout of the interlocking terracotta pieces.

10.5 The Medici Panel

Panel 2, shown in Figure 10.11, is called the "Medici panel". It seems to be wholly symmetrical and it has the same appearance as the antique rosettes

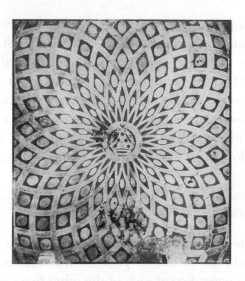

Figure 10.11 Panel 2, the Medici panel.

of which there are many examples in Renaissance design. At the center of the rosette lies the Emblemata of Cosimo I from the house of the Medici, advertising the 3-fold symmetry of the pattern. However, at second glance the panel exhibits the mannerist tell-tale irregularities that are common to all the Laurentian pavement designs. First, the panel is not square; it is a rectangle whose sides are in the ratio of 12:13 (the Laurentian Library kindly permitted Nicholson to make rubbings of this panel from which it has been possible to assemble a set of accurate measurements); second, curving white bands radiate from the center, never present in the antique form; and finally, ovals are set into the residual spaces between these bands. The following steps show that Panel 2 is created by superimposing 96 circles on a 12:13 rectangle that is composed upon a 13×13 square:

Step 1. The ratio of 12:13 is the ratio between the radius of an octagon and the radius of the circle circumscribed about the octagon, to 0.1% accuracy. This is also the ratio of a pair of sides of a 5:12:13 right triangle as shown in Figure 10.12a.

Step 2. Draw a second 12:12 square within the 13:13 square (see Figure 10.12b) and place the x and y axes at the center of the squares.

Step 3. Draw an equilateral triangle with side equal to the base of the 12:12 square. The distance from the apex P of this triangle to the center of the square determines the radius of a circle. This circle is called the *pitch circle* (see Figure 10.12b). The radius of the pitch circle differs from $\frac{1}{4}$ the diameter of the 12:13 rectangle by less than 1%. Either value can be used for this construction. However we use the first because of its elegance. This construction was also described by Paul Marchant [Mar], a member of Keith Critchlow's London based group studying traditional geometry.

Step 4. Place x and y axes at the center of the rectangle and draw a rosette pattern with 24 circles by the following procedure:

(a) Draw six circles whose radii are the same as the radius of the pitch circle. The first circle has its center point at the intersection of the pitch circle and the upper y-axis; each of the other five circles' center points

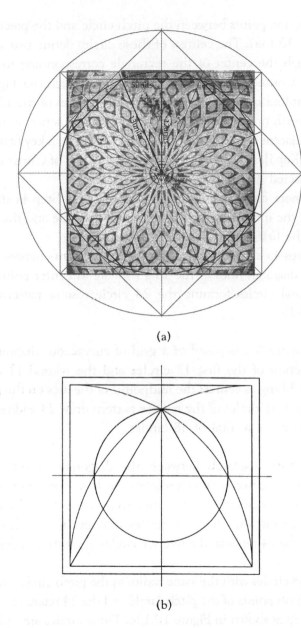

(a)

(b)

Figure 10.12 (a) An approximate 12:13 ratio of lengths constructed from an octagon; (b) a 12 × 12 square placed within 13 × 13 square. An equilateral triangle is placed on the base of the 12 × 12 square to locate the pitch circle.

are intersection points between the pitch circle and the preceding circle (see Figure 10.13a). The centers of these circles define two sets of three axes through the center of the rectangle corresponding to the 3-fold axes of the Cosimo symbol in the center of the design (see Figure 10.11). Notice that four of the circles intersect the vertices of the 12:12 square. It is also worth noting that the rosette produces a series of intersections between adjacent circles, known as the *Vesica Pisces*, a key figure of sacred geometry [Kap3]. It was in this region that images of Christ were placed in many sacred designs.

(b) Draw six more circles using the same method as Step 4a starting, this time, with the intersection point of the pitch circle and the right hand x-axis as the first center point (not shown).

(c) Repeat Steps 4a and 4b by using intersection points between the pitch circle and diagonal lines of the 13:13 square as center points to create 12 additional circles forming the 24 circle rosette pattern shown in Figure 10.13b.

Step 5. The rosette is composed of a grid of curvaceous diamonds formed by the intersection of the first 12 circles and the second 12 circles (see Figure 10.13b). Using as centers the midpoints of the arcs on the pitch circle connecting adjacent circles of the rosette pattern draw 24 additional circles (not shown) to make a total of 48 circles.

Step 6. The small mismatch between the diagonals of the square and rectangle leaves space to construct a *reference circle* as shown in Figure 10.13c. Replicate this reference circle at the intersection points of the pitch circle and the latest 24 circles. These 24 circles intersect the pitch circle at 24 points. Four of the 24 replicated reference circles are shown in Figure 10.13c.

Step 7. Draw 48 circles with the same radius as the pitch circle and centers at the 48 intersection points of the pitch circle and the 24 reference circles from the previous step as shown in Figure 10.13c. These circles are to become the white bands of the Panel 2. This step demonstrates how the panel makes "Mannerist space" out of the difference between the series of circles generated by the 12:13 and 13:13 diagonals.

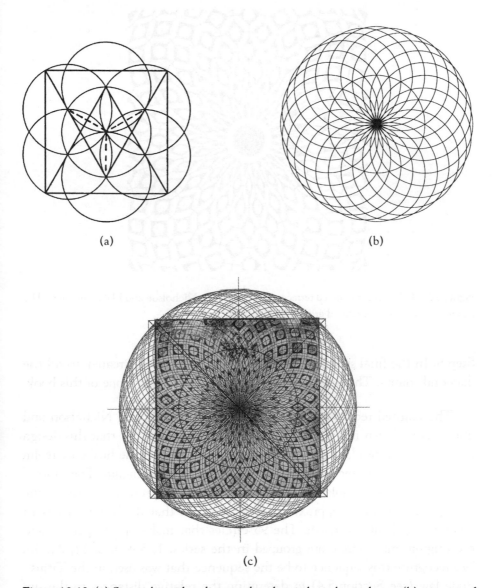

(a)

(b)

(c)

Figure 10.13 (a) Six circles with radius equal to the pitch circle are drawn; (b) a rosette of 24 circles; (c) 24 additional circles are drawn bisecting the curvy diamonds of the rosette, and a reference circle is shown with diameter equal to the gap between the diagonals of the square and rectangle. The intersection of 24 reference circles with the pitch circle (four circles are shown) locates the center of 48 additional circles marking the white bands of panel 2.

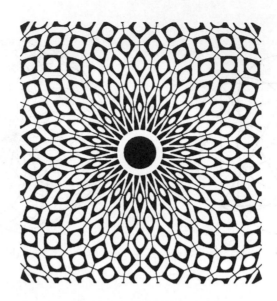

Figure 10.14 The reconstructed terracotta design of Ben Nicholson and Blake Summers. The panel is shown to be organized around 96 identical circles.

Step 8. In the final step ovals of eight different types are created, to fill the diamond shapes. The details of this step are beyond the scope of this book.

The painted reconstruction of the terracotta design by Nicholson and Summers is shown in Figure 10.14. Nicholson hypothesizes that this design represents an interplay between the circle representing the heavenly realm and the square and rectangle representing the earthly domain. The ratio of 12:13 represents the solar and lunar cycles since the sun goes through the 12 signs of the zodiac approximately in the time that the Moon makes 13 revolutions about the Earth. The 96 circles that make up the pattern and the original pitch circle are grouped in the series: 1, 3 + 3, 6, 12, 24, 48. We recognize this sequence to be the sequence that was used in the Titius–Bode law (see Section 5.4) to determine the relative distances to the sun of the planets up to Saturn (all the planets known in the year 1550). Therefore the designer of this pavement was able, either consciously or unconsciously, to compress a great deal of information into a geometrical setting.

The panel on the other side of the library is identical except that it fits into an 11:12 rectangle. Nicholson believes that the numbers 12 and 11 may refer to the number of Christ's disciples before and immediately after the removal of Judas from their midst. However it could also refer to the fact that fitting all 12 tones into the chromatic musical scale was seen in ancient times as a struggle between the rational and irrational, the finite and the infinite. We have seen in Section 3.5. that only 11 of the 12 tones of the musical scale can be expressed as the ratio of small whole numbers. The twelfth tone must be represented by an awkward approximation to $\sqrt{2}$.

10.6 The Mask Panel

Nicholson has chosen to name Panel 13, shown in Figure 10.15, the "Mask" panel. When looked at either directly or from the side it appears like the classical masks of the theater popular at the time with either a happy or sad face. In fact Michelangelo made a number of carvings of the "mask of night". Two members of Nicholson's team Saori Hisano and Hingan Wibisono were able to use a combination of the golden mean and the Brunes star to reconstruct this panel.

Figure 10.15 A terracotta reconstruction of Panel 13, the "Mask" panel.

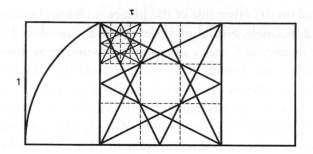

Figure 10.16 Schematic of the mask panel. A central square is juxtaposed with two golden rectangles. The central square is trisected by the Brunes square construction. Each trisection is then subdivided again into fourths by the Brunes star at a smaller scale. This produces a 12 × 12 grid.

Rather than go through his detailed explanations, we present in Figure 10.16 one of the diagrams in which Nicholson has defined a central unit square and two symmetrically placed golden rectangles (proportions 1:τ). The construction lines to create the golden rectangle are shown in the figure and will be described in greater detail in Section 20.4. The central square is trisected by the methods of Brunes into first a 3 × 3 grid. Then each third is divided again by the Brunes star into a 4 × 4 grid. As a result the original square is divided into a 12 × 12 grid. Notice that the Brunes star and the golden rectangle share construction lines. Once again, the panel is just off from being a square, with the difference between the length and width being equal to $\frac{1}{6}$, i.e., a width of $\frac{1}{12}$ placed on either side of short side.

In Figure 10.17 four circles of radius $\frac{1}{\tau}$ are drawn about each vertex of the central square as centers. The width of the four oblong regions of intersection of these circles equals the diameters of the four black circles of the mask pattern. They are equal to $\frac{1}{\tau^2}$ units. These oblong regions are somewhat reminiscent of the Vesica Pisces regions that formed the basis of panel 2. From this construction, Nicholson was able to deduce that the widths of the white annuluses around the black circles and the narrow white annuluses in the left and right sections of the pavement were related to the golden mean and summed to $\frac{1}{12}$, the width derived from the Brunes star.

The reconstructed terracotta Mask panel created by Nicholson, Hisano, and Wibisono is illustrated in Figure 10.15. The geometer appears to have

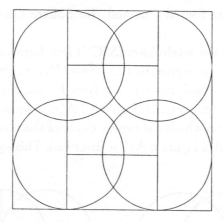

Figure 10.17 Four circles of diameter $\frac{1}{\tau}$ drawn at the vertices of the central square proportions the four black circles of the Mask panel.

found ingenious ways of wedding two geometrically different worlds, the one of the golden mean and the other of the Brunes star.

10.7 Conclusion

The pavements of the Laurentian library have presented us with a set of geometrical puzzles. They are remarkable because they present an almost complete set of the predominant forms of ancient geometry. The extensive occurrence in the pavement panels of particular geometries and the numbers they spawn suggest that the pavement designers were cognizant of the bond between number and myth that modern scholarship is once again making available for us.

Nicholson believes that the panels are an unambiguous expression of Mannerism. He considers that the pavement constitutes a document of Mannerist number theory, albeit expressed in the language of geometry, and that, in a wholly reasoned way, it presents issues of paradox and a confrontation with the status quo for which Mannerist art is so famous. It is also possible that the pavement forms the treatise on proportion that Michelangelo wanted to write and that was alluded to by Condivi in his 1553 biography — The Life of Michelangelo.

Appendix 10.A The Sacred Cut and the Square Circle Grid

10.A.1 The sacred cut subdivision (SSCS) lies dormant within the square circle grid described in Appendix 6.A. Saori Hisano [NKH1] has brought attention to these sacred cut relationships by focusing upon the square circle grid in the proper way. In Figure 10.A1a, a square and its diagonals are highlighted within which the center circle of the nine circles making up the square circle grid of Figure 6.A2b is inscribed. This square is divided into

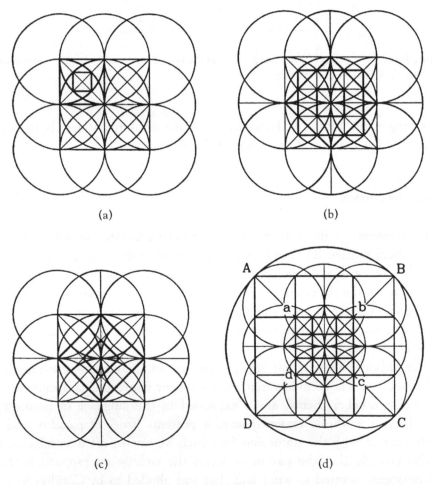

(a)

(b)

(c)

(d)

Figure 10.A1 Relationship between the sacred cut and the square circle grid.

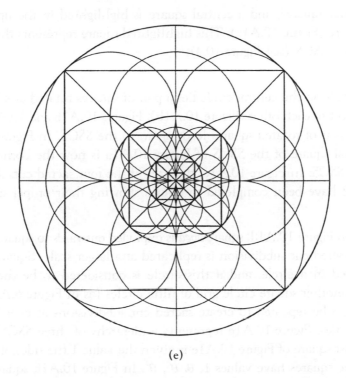

(e)

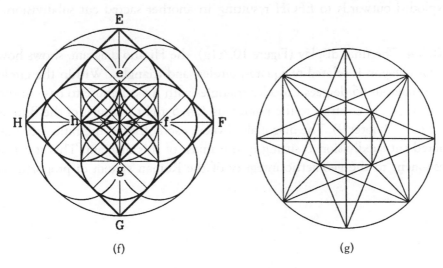

(f)

(g)

Figure 10.A1 (Continued)

four smaller squares, and a central square is highlighted in the upper left-hand square (Figure 10.A1a). This highlighted square represents the central square of a SSCS (see Figure 10.4).

10.A.2 Within the central circle lies a pair of squares rotated at 45 degrees with respect to each other (Figure 10.A1b). Figures 10.A1b and 10.A1c show that this pair of rotated squares leads again to the SSCS. In Figure 10.A1b the central square of the SSCS of Figure 10.A1a is now the corner square of a new SSCS. In Figure 10.A1c, the arcs of the four sacred cuts shown in Figure 6.2 have been completed to circles showing their proper context.

10.A.3 In Figure 10.A1d, square *abcd* is exploded outwards to square *ABCD*, and the sacred cut subdivision is replicated at a larger scale. Square *ABCD* is inscribed in a circle, and if this circle is considered to be the central circle of another square circle grid of nine circles (as in Figure 6.A2b), this process can be repeated to create sacred cut subdivisions at ever larger or smaller scales. Figure 10.A1e represents a hierarchy of three SSCS's. If the centermost square of Figure 10.A1e is given the value 1 the sides of the four concentric squares have values 1, θ, θ^2, θ^3. In Figure 10.A1f, square *efgh* is exploded outwards to *EFGH* resulting in another sacred cut subdivision.

10.A.4 The final display (Figure 10.A1g), the Hisano diagram, shows how a star octagon is related to squares, circles, and triangles. Within the circle are numerous 45 degrees isosceles triangles with hypothenuse to base in the ratio $1:\sqrt{2}$, in contrast to the numerous 3, 4, 5-right triangles of the Brunes star (see Chapter 9). The diagonals also cut each other in the ratio $1:\theta$. The sacred cut subdivision is sitting in the midst of this diagram. This star is a testament to the geometric integrity of the Roman system of proportions.

11
Measure in Megalithic Britain

> On Apollo's birth: The swans, the god's prophetic singers,
> circled Delos seven times. These Muse's birds sang at the delivery bed
> like bards. Because of this, the child later bound seven strings to his lyre.
>
> *Callimachus*

11.1 Introduction

There is a difference of opinion as to whether ancient cultures did or did not possess standard measures. Some students of ancient cultures feel that in place of a standard measure each construction site was developed independently, using pure geometry as a guide to planning and construction. Furthermore, many archaeologists simply feel that ancient cultures did not possess the level of social organization required to institutionalize a standard measure. However, there is evidence that in Megalithic Britain, as far back as 3200 B.C., standard measures may have been used. Anne Macaulay was an amateur archeologist who dedicated many years to a study of these questions. In this chapter I will report some of her discoveries and conjectures based on the measurements by the British engineer Alexander Thom of more than 200 of the approximately 900 megalithic circles throughout England, Scotland, Wales, Ireland, and Brittany (cf. [Bur], [Mac], [Lin], [Tho-T1], [Thom] and [Tho-T2]). It was Thom's belief that one of the functions of the circles was to serve as astronomical observatories.

11.2 A Standard Measure

What is the origin of the idea of the standard measure? The archaeologist, Colin Renfrew [Ren] has traced the movement of the first farmers from what is now modern Turkey and the fertile crescent both East and Westwards from before 6000 B.C. As a result, we now know that the first farmers to arrive in Britain in about 4500 B.C. were Indo European. Renfrew believes these first farmers brought with them a farming package consisting of *grain*; *domestic animals* and *pottery*. Anne Macaulay conjectures that we owe the origin of measure to these ancient farming communities. Farmers had to know how much grain when sown in the earth would produce enough surplus to feed their people. From this emerged the bushel type of measure. In order to know how much land to sow grain upon, they produced a measuring rod or yardstick. In order to make the corners of their fields square, the 3, 4, 5-triangle was used to produce a right angle. Thus was born another farming package consisting of a measuring rod, a *bushel* type of measure, and the knowledge of the 3, 4, 5-triangle that enabled local hunter-gatherers to develop the skills to cultivate grain.

A proof of the *Pythagorean theorem* for a 3, 4, 5-triangle survives from the Han period (c. 200 B.C. –200 A.D.) in China, shown in Figure 11.1 [Nee]. As you can see, this proof is based on the division of the side of a square of length 7 into 3 and 4 unit subdivisions. I leave the visual proof to the reader.

Figure 11.1 The proof of the Pythagorean Theorem in Chou Pei Suan Ching.

Not only is it likely that people of Megalithic Britain possessed Macaulay's farming package, but, based on the work of Thom, they may have possessed a standard linear measure. Macaulay conjectures that word about the standard measure was spread through England and Scotland by Bards who wandered through the countryside bringing news, singing songs and telling stories. She bases this on the discoveries by archaeologists of a few Neolithic and Bronze Age British burial sites each containing a horned ox-skull (no reference given). By studying ancient depictions of citharas, an early form of the ancient lyre and modern guitar, Macaulay surmises that they were constructed upon horned ox-skulls covered by a wooden casing with the horns forming the arms of the lyre. Macaulay feels that the discovery of ox-skulls in the ancient British burials suggests the possibility that they were the tombs of Bards buried along with their lyres.

The people of Megalithic Britain were seafarers. At first, they settled in France, then colonized all the islands around Britain — Man, the Inner and Outer Hebrides, Orkney, and Shetland, etc. Macaulay hypothesizes that they eventually established commerce with ancient Greece as tin traders. Although there is only circumstantial evidence to confirm Macaulay's hypothesis, the coincidence between a recent discovery of a Greek standard measure and the work of Thom in measuring megalithic stone circles and grids adds some credibility to this conjecture.

11.3 Megalithic British and Greek Measures Compared

Macaulay has shown that there is a strong possibility that the *Greek fathom* was identical to the *Megalithic British rod*. The *megalithic yard* (my), 32.64 inches, is $\frac{2}{5}$ of a megalithic rod (mr), and is similar to the *ancient Indus short yard*, 33 inches, and the *Sumerian shusti*, 33 inches.

Based on his exploration of megalithic sites throughout England, Scotland, and Brittany, Thom hypothesized that the spacing of the stones was related to integral numbers or simple fractions of megalithic rods, megalithic yards, or megalithic feet to be described below. As a result of these measurements, he conjectured that the megalithic rod was 2.072 meters (6.80 feet) in length. This resulted in a perfect match with the length of the Greek fathom reported in 1981 by E. Fernie [Fer] in the form of a

Figure 11.2 Met Relief Michaelis: A sculptured metrological stone illustrating the measure of the Greek fathom and the Greek foot. Courtesy of the Ashmolean Museum, Oxford, England.

sculptured Metrological stone in the Ashmoleam Museum, Oxford, thought to come from Samos from before 400 B.C. shown in Figure 11.2. As you can see, this artifact also represents one of several the Greek foot measures (see Appendix 11.A) as $\frac{1}{7}$ of a Greek fathom. I shall refer to this measurement as a megalithic foot (mf). It is important to note that Thom died in 1978 before the discovery of the Greek measure and so he could not have been influenced by it.

11.4 Statistical Studies of Megalithic Measure

Thom's original measurements were reported in a paper written in 1955. He subsequently re-approached the question of a standard measure with new measurements, as reported in a paper written in 1962. Douglas Heggie [Heg] has made an extensive survey of the statistical methods used to examine Thom's measurements. Heggie states,

> "Thom [Tho] presented his measurements of the diameters of the stone circles in a histogram. He discovered peaks at about 22, 44, 55, and 66 feet. This observation immediately suggests that many of the diameters lie close to multiples of some unit. Thus we are led to frame a *quantum hypothesis* that the diameters were intended to be multiples of 11 feet. Actually Thom settled on a unit or quantum of about $5\frac{1}{2}$ feet (actually 5.435 feet),

and since it is likely that it is the radius of a circle which would be measured out, Thom thought that a unit of about 2.72 feet was in use, and this was subsequently called the *megalithic yard*."

Thom also measured the perimeters of the stone circles and found that units of about $2\frac{1}{2}$ megalithic yards (2.072 meters) were most prevalent. He called this unit the *megalithic rod*.

The object of statistical studies of Thom's work has been to test the significance of the quantum hypothesis. If the hypothesis was correct, one would expect that measurements of diameters would exhibit only small deviations from the nearest multiple of 5.435 feet.

The problem of testing the null hypothesis was undertaken by several statisticians, most notably, S.R. Broadbent and D.G. Kendall. Details of these studies are described in *Megalithic Science* [Heg]. Although Thom derived his measure for the megalithic yard from his earlier data, he returned again to the megalithic yard in his later paper, and he reported measurements of many new sites. If the old unit of 5.435 feet is applied to the new data, since this value cannot have been influenced by the new data, a statistical test devised by Broadbent was most applicable. Heggie states:

"Omitting sites already discussed in 1955, or those with diameters noted as being particularly uncertain, we obtain a probability level far below 0.1%. This is a highly significant result, for it implies that such good agreement with Thom's unit would occur only once in many thousands of samples of random data."

Heggie feels that as striking as these results are, there are several reasons why they may not be as decisive as they seem. One of these is the suspicion that the choice of geometry open to Thom allowed the operation of a quite unintentional bias in favor of the megalithic yard. One way around this bias would be to analyze the results of other workers who have measured the megalithic sites but did not use Thom's special geometries. Unfortunately, there is sparse data of this kind yielding inconclusive results, and most of the support for Thom's theory comes from his own measured diameters. According to Heggie, "This situation is unlikely to change until other investigators summon the energy to survey comparable numbers of sites with comparable care".

11.5 Measurements at Mid Clyth

One of the problems with measuring the diameter of a stone circle is that one is limited to measuring the distance between two stones. A small error in the placement of one of the stones invalidates the measurement. On the other hand, Thom's measurement of a fan of stone rows at Mid Clyth, Caithness in 1964, shown in Figure 11.3, admirably satisfies statistical tests and confirms Thom's hypothesis of the megalithic rod being 2.072 meters. The geometrical pattern Thom arrived at for this site resembles the lines of latitude and longitude on a map. To measure this site, one chooses an arbitrary latitude line, and then measures the distances in the direction of the near-vertical lines of longitude of all stones from this line of latitude. If these distances lie close to multiples of some unit, in a statistically significant sense, then it may be inferred that the stones lie significantly close to evenly spaced lines of latitude. Using Broadbent's second paper, Thom found overwhelming support for a unit of 7.743 feet at a probability level much less than 1%. This unit happens to be close to $\frac{20}{7}$ my.

Heggie found it a pity that the unit of $\frac{20}{7}$ relates to the megalithic yard by such an awkward ratio. However, his study was made before the discovery of the ancient Greek measures, and this unit can now be appreciated in light of the 1981 discovery by Fernie of the *Greek foot = megalithic foot*. Since the megalithic foot is $\frac{1}{7}$ of the megalithic rod, it then follows that, the Greek foot is $\frac{1}{7}$ of the Greek fathom, which equals the megalithic rod. It then follows that,

$$\frac{20}{7}\,\mathrm{my} \times \frac{2\,\mathrm{mr}}{5\,\mathrm{my}} = \frac{8}{7}\,\mathrm{mr},$$

$$\frac{8}{7}\,\mathrm{mr} = 8 \text{ Greek feet}.$$

Therefore Mid Clyth divides equally into 17 lengths, each measuring 8 Greek feet. Macaulay has found 42 examples among Thom's data in which a quantum, equal to the megalithic foot equated to the Greek foot, was used for measurement.

Macaulay points out that the Megalithic rod = Greek fathom continued to be used for church dimensions in northwest Europe (but not in Italy) up until the latest Gothic churches (c. 1500 A.D.). It was a great surprise

THE STONE ROWS AND THEIR USE

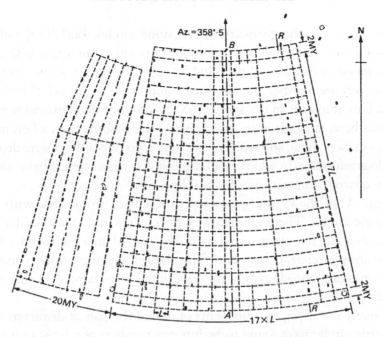

Stones shown thus ⁙ have fallen

1 MY=2·72 ft

L=20/7 MY=7·77 ft (as drawn)

0 10 20 30 40 50 60 70 80 feet

Figure 11.3 Thom's measurements of a fan of stone rows at Mid Clyth.

to the team of Macaulay, Gordon Strachan, and Fred Robertson, that measurements of the base lines of the Chartes Cathedral and St. Georges, Windsor were integral numbers of megalithic rods. It was only after discovering Fernie's article on the equivalence of the megalithic rod and the Greek fathom that this discovery began to make sense.

11.6 The Stone Circles

Next we examine the geometry of the stone circles. Burl [Bur] estimates that of the 900 rings still standing in Britain, there are about 600 circles, 150 flattened circles, 100 ellipses, and 50 eggs. Some were single circles and many others were either two or three concentric circles (cf. [Mac], [Cri], [Tho]). Unfortunately, in the 4000 to 5000 years since these sites were erected there has been much damage, mainly since the Reformation, when most of the sites in Skye, Iona, and much of the west coast of Scotland were destroyed by zealous reformers. In addition, in the last 200 years farmers have used the sites as quarries to get stones for building.

Figure 11.4 shows the geometry that comes from sites with three concentric circles. These are mainly Clava cairns and other similar burial sites, as well as a few other sacred sites. The central area was used for burials or deposition of cremated remains. The shaded area was built up and filled with stones and outside this is the functional area marked usually with a few tall standing stones.

In many instances, measurements of one of the pair of diameters of two concentric circles were found to be integral numbers of a basic unit related to megalithic yards, rods, or feet. In making his measurements, Thom assumed that the center of a stone was placed over the measured point, and he determined the measurement by measuring the distance to the four extremities of the stone as seen from the center of the circle and averaging

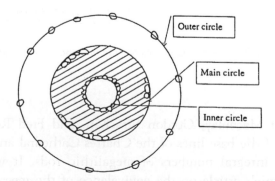

Figure 11.4 Three concentric rings typical of megalithic stone circles.

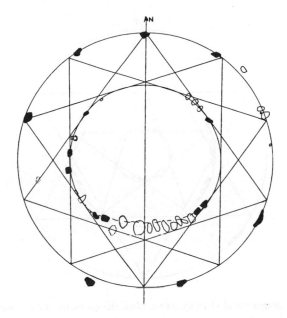

Figure 11.5 A ten-pointed star establishes the geometry of the stone circles at Farr West (Tordarroch).

these values. If a site was so badly in ruins that he could not determine the radius accurately, it is marked with its error, e.g., ± 3 inches. Some of the stones were rather large, weighing as much as 30 tons.

At the beginning of her investigation, Macaulay put a piece of tracing paper over a plan and drew tangents to the central circle from the main circle. To her surprise, a perfect star pentagon or *pentagram* emerged and with the next one, a 14-pointed star. It became clear to her that these sites required a proper geometrical framework. Macaulay has used Thom's measurements to infer a method of constructing the concentric circles by superimposing star polygons in the form of stretched strings. Stretching the string between equidistant points on the outer circle defines points of tangency or intersection on the inner circle, as shown in Figure 11.5 for a ten-pointed star at Farr West. Thom's measurement of the diameter of the outer circle was 113.2 feet, and of the inner circle was 66.8 feet. Macaulay determined the ratio of outer to inner diameter by geometry and trigonometry and then found that, given an outer diameter of 113.2 feet, the diameter of the inner circle to

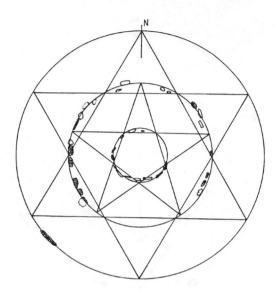

Figure 11.6 A pentagram and a hexagram establish the geometry of the stone circles at Milton of Clava.

be 66.54 feet, an error of 3.12 inches. An error this small is rather impressive given the size of some of the stones. Appendix 11.B shows how to make this computation.

A particularly interesting diagram shown in Figure 11.6, equally accurate in its geometry, depicts Milton of Clava, which combines a star hexagon (hexagram) and star pentagon (pentagram) in a single diagram. The position of the stones is defined by the intersection of edges of the star polygons (see Appendix 11.B).

It appears as though there was a *starting dimension* in each of the megalithic sites established by marking of integral multiples of a basic unit, after which the monument was completed using pure geometry. For example, Macaulay has discovered several sites spread widely throughout England in which the diameter of the stone circles measure exactly 51 units in units of Greek feet, megalithic yards, megalithic rods, or simple fractions of these measures. The size of the unit determines the overall dimensions of the site. The dimension of 51 units is suggestive of a circle broken into either 7 or 14 sectors since a chord of 22 feet then approximately

Table 11.1 Measurements at Riverness.

Thom's measurements			Calculated	Error
Diameter of outer circle	69.1′	= 35.04 my	69.36′ = 51 my/₂	3.12″
Diameter of main circle	29.5′	= 10.84 my	29.92′ = 22 my/₂	5″

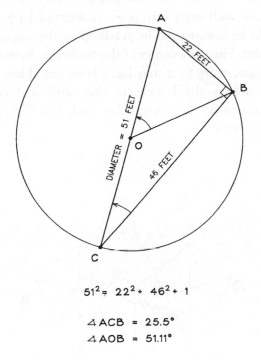

$$51^2 = 22^2 + 46^2 + 1$$

$$\angle ACB = 25.5°$$

$$\angle AOB = 51.11°$$

Figure 11.7 A diameter of 51 units and a chord of 22 units divides the circumference of a circle into seven equal parts.

spans $\frac{1}{7}$ of the circle. In Figure 11.7 the diameter and chord are placed in a semicircle to form a right triangle in which the chord subtends an arc of 51.11 degrees on the circle which differs from $\frac{360}{7}$ degrees by 0.6%. I have used a geometric theorem which states that the central angle ($< AOB$) of a circle equals twice the value of the inscribed angle ($< ACB$) that subtends the same arc. As a corollary, it follows that every triangle inscribed in a

semicircle is a right triangle. If the third side of the right triangle inscribed in the semicircle equals 46 then the Pythagorean theorem is approximately satisfied:

$$51^2 = 22^2 + 46^2 + 1.$$

(Several Pythagorean relationships, off by 1, were noted by Thom.) Marking the chord of length 46 units on the circumference of the circle results in a 14 pointed star with every fifth point connected $\left\{\frac{14}{5}\right\}$. In this way the outer circle could be constructed by subdividing the circumference rather than from its center. Since the center of the circle may have been considered to be a sacred space, entry to it may have been forbidden. Table 11.1 and Figure 11.8 shows how the Riverness site, with a diameter of $51 \frac{my}{2}$ (the unit of measurement is $\frac{1}{2}$ megalithic yard, i.e., $\frac{my}{2}$), may have been constructed in this way.

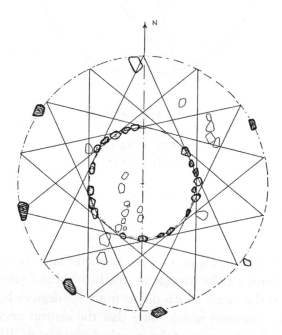

Figure 11.8 A 14-pointed star recreates the geometry of the stone circles at Riverness (Kinchyle of Dores).

Macaulay has also found other stone circles with a diameter of 13 units (Greek feet, megalithic yards, megalithic rods, etc.) and chord 5 units, based on a Pythagorean triple of 13, 12, 5 which divides the circle in a similar manner into 8 equal sectors to within 0.5%. Yet other circles have diameter and chord lengths of 37 units and 20 respectively, which divide the circle into 11 equal parts, and diameter of 14 and chord of 9 which divides the circle into eneagrams (nine–pointed stars). In each of these circles, the diameter of the inner circle is consistent with a star related to the given diameter. It is likely that other diameter–chord pairs were also used. However further research is needed to uncover them.

Since the relationship between circle diameter, chord length, and angle requires a sophisticated understanding of geometry and trigonometry it remains a mystery as to how ancient people gained knowledge of these concepts. However, it appears as though they used a combination of measurement and pure geometry to construct the stone circles. Macaulay believes that the star polygons may not have been used for construction purposes but had some unknown significance to the Megalithic British.

11.7 Flattened Circles and the Golden Mean

There are estimated to be about 150 remains of flattened circles spread widely about mainland Britain. Thom determined that there were four types of flattened circles which he identified as Types A, B, modified B and D. Of the four types, modified type B shown in Figure 11.9 is the most prevalent. Macaulay's analysis of Thom's diagrams indicates that all of the flattened circles can be related to the pentagram which in turn is related to the golden mean (see Section 20.4). The following construction of the Type B modified flattened circle involves the golden mean directly:

Step 1. Begin with a series of four circles, as shown in Figure 11.10, of diameter 1 unit from a square grid of circles (see Appendix 6.A).

Step 2. By the Pythagorean theorem, $AC = \sqrt{1^2 + \left(\frac{1}{2}\right)^2} = \sqrt{\frac{5}{2}}$ while $CD = \frac{1}{2}$. Therefore $AD = \frac{1+\sqrt{5}}{2}$ which is the golden mean τ.

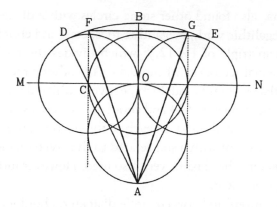

Figure 11.9 Flattened circle modified Type B.

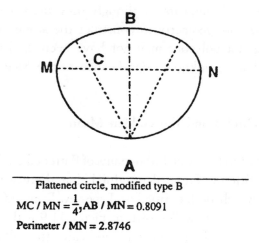

Flattened circle, modified type B

$MC / MN = \frac{1}{4}, AB / MN = 0.8091$

Perimeter / MN = 2.8746

Figure 11.10 Anne Macaulay's reconstruction of flattened circle modified Type B.

Step 3. Swing an arc from D to E with point of the compass at A. Points F and G on this arc along with A form isosceles triangle AFG with side AF and base FG in the ratio $\tau{:}1$, a *golden triangle* (see Section 20.4).

Step 4. The ratio of $\frac{AB}{MN} = \frac{\tau}{2} = 0.809\ldots$ in agreement with Thom's measurement (see Figure 11.9). Macaulay uses the golden triangle to construct a pentagram within the flattened circle as shown in circle at Whitcastles, Dumfrieshire (6 miles from Lockerbie, Scotland) in Figure 11.11.

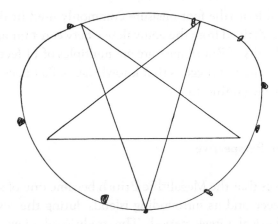

Figure 11.11 The flattened circle at Whitcastle, Dumfrieshire with inscribed pentagram.

Table 11.2 Measurents at Whitcastle.

Thom's Measurements		Error
Half the length of main diameter $\frac{1}{2}$ MN	34 MY	exact
Short diameter (AB)	55 MY	0.43″

Macaulay conjectures that the Megalithic geometers made one measurement exactly using Thom's measurements, and that in every case that she has studied, this measurement is one of the Fibonacci numbers from the F-series: 1, 2, 3, 5, 8, 13, 21, 34, 55,.... The second measurement is then approximated by the next Fibonacci number in the series since ratio of successive numbers from the F-series are approximately τ:1 (see Section 20.2). The results for Whitcastle are given in Table 11.2.

These are also the measurements of the base FG of the golden triangle and its side AF. Macaulay found that in almost all of the sites corresponding to flattened circles, a wide array of Fibonacci pairs were used as the side and diagonals of the pentagram.

Macaulay has conjectured that the British system of modern linear measure may trace its origin to megalithic metrology. Appendix 11.A shows

that the imperial foot (the foot measure commonly used in Britain and the United States) is derived from the equivalence between τ mr and 11 imperial feet and that all units of British measure are multiples of 11 feet. If Macaulay's conjectures are correct, it suggests that knowledge of Fibonacci numbers may have existed in megalithic times.

11.8 Historical Perspective

Macaulay believes that the Megalithic British became one of several peoples that settled Greece and its surrounding islands during the several centuries prior to the classical Greek period. The traditional view is that Greek civilization was the result of a cultural mixture that followed a conquest of an earlier pre-Hellenic people by Indo–European people from the North. A competing theory, put forth by Martin Bernal [Bern], suggests that the primitive tribes that inhabited pre-Hellenic Greece were civilized by Egyptian and Phoenician settlers. Bernal uses results of recent archaeology to account for the fact that Greek is fundamentally an Indo–European language.

If Thom's hypothesis of a standard measure in Megalithic Britain is correct, and if this measure precisely matches the standard Greek measure, then we have stumbled on a great mystery. How did the Greek measure of 400 B.C. derive from the megalithic measure which began well before 3500 B.C. and continued to the end of the megalithic period around 1200 B.C.? What would have brought people from Megalithic Britain to the Eastern Mediterranean around 2100 B.C.? Macaulay has found much evidence from historical and archaeological records, archaeo-astronomy, mythology, and studies of musical instruments to support her theories about the interaction between Megalithic British and classical Greek cultures.

Macaulay has hypothesized that the Megalithic British became involved in the tin trade. Tin, though very scarce, when combined with copper formed the bronze pertinent to the development of the European Bronze Age. There was an unreliable source of tin near Poland, and an Eastern source near the Gobi desert which was extremely expensive as it involved an overland journey of about 2000 miles. There was also only a minimum amount of tin in Brittany which was not worked until very much later. Cornwall, England has been shown by archaeologists to have been an important center of tin

mining from at least 2100 B.C., somewhat after the beginning of the European Bronze age. Tin was continuously mined there until only a few years ago [PenH]. Thus the British, who were known to be good sailors and tradesmen, began to meet this demand.

According to Macaulay, two major calamities, namely the eruption of Thera on the Island of Crete around 1628 B.C. and of Mount Hekla in Iceland in 1159 B.C., may have resulted in climatic disturbances that caused cultural upheavals in the Eastern Mediterranean region. This may have enabled proto-Greek settlers from Britain and elsewhere to take political control of mainland Greece. Whatever the truth is, the Iliad (c. 1250) reflects this unsettled and bellicose period.

The story of the Aratus star globe [Roy] lends further support to the idea of early British–Greek contact. Eudoxus, a Greek who lived from 409–356 B.C., traveled to Egypt where he obtained an old star globe from about 2000 B.C. (± 200) showing the constellations. What is of interest to us is that, according to Roy, the globe had representations of Greek mythology and that the latitude of the observations were at about 36 degrees North (± 1.5 degrees), the latitude of Gibraltor somewhat further south than Greece. But 2000 B.C. was long before the origins of classical Greek culture. Is it possible that proto-Greeks from Megalithic Britain were in the Mediterranean around 2000 B.C. using the same mythological symbols?

Eudoxus described the globe in detail in two books. These works did not survive, but a poet named Aratus recorded Eudoxus's findings in a famous poem, "Phaenomena" which exists in English translation [Mai]. In the second century B.C. Hipparchus discovered that the account of the old star globe as told by Aratus did not describe the constellations observed in his time. He realized that this must have been due to a shifting of the equinoxes, and he did a creditable approximation to the 26,000 year cycle governing this precession (see also Section 1.4 and Example 3.6.2).

Macaulay has also found clues from mythology that add credence to her theory of Megalithic British–Greek connections. Apollo is connected in Greek mythology with music and the lyre. The earliest lyres of the Mycenean and Minoan periods period had swans carved on the arm terminals [Ahl]. So Apollo's lyre is connected with swans. Taking the swan and lyre to be the constellations Cygnus and Lyra — Lyra being very close to Cygnus in the sky — a Greek myth has Zeus approach his future bride, Lato, in the

form of a swan (Lato being the mother of Apollo). Macaulay has found some evidence to suggest that Lada was the original "Earth Mother" of the neolithic era during which agriculture was developing. She conjectures that this "Great Lady" of the farmers, was the same person as Lato, and that later this name was misspelled as Leda, featured in swan myths.

If we trace the movement of Cygnus and Lyra as seen from Stonehenge at around 3400 B.C., we find that they move in circumpolar circles, tangent to the horizon. Note that recent dating of Stonehenge places its construction at around 3100 B.C. However Macaulay believes that a cruder version may have existed as far back as 3400 B.C. I checked this bit of archeoastronomy at the Newark planetarium. By setting the heavens back to megalthic and classical Greek times, I was able to verify this story.

Contrast this myth which makes sense when it refers to Megalithic Britain with another myth dating to Minoan times. In this myth Apollo was supposed to leave Delphi in the autumn for the land of the Hyperboreans, not returning till the spring. Hyperborea, meaning "beyond the North Wind" was to the Greeks a vague area in the north inhabited by unknown peoples — it happens that in ancient Greece these constellations were not visible in the night sky during winter, lying below the northern horizon. So Apollo's departure to and return from Hyperborea in the autumn and spring, respectively, coincide with the disappearance and reappearance of Cygnus and Lyra in the Greek night sky. In other words, Cygnus and Lyra were visible through the entire year in Megalithic Britain but only part of the year in Greece. Therefore the first Greek myth makes sense at the location of Megalithic Britain while the second appears to refer to Greece, but at a later date.

Apollo is also associated with a dolphin, implying navigational skills. Legend has it that Apollo's first act upon arriving at Delphi was to slay the dragon or python only to reinstate it as the Pythia. Macaulay has suggested an explanation to this puzzling myth. If the myth of Apollo had originated in Megalithic Britain, at that time the pole star was in the constellation of Draco the dragon. However, at the time of the settlement of classical Greece, Draco was no longer usable as a pole star due to the precession of the equinoxes (see Secton 1.4). It is therefore plausible that a remnant of the importance of this no longer usable signpost of navigation was retained as the name of the Sybil at Delphi.

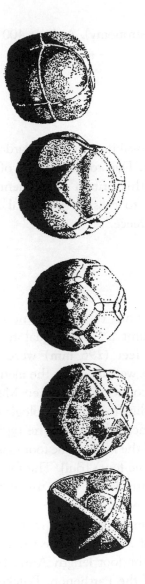

Figure 11.12 A full set of megalithic "Platonic solids". They are examples of megalithic carved stones found throughout England and Scotland.

Other hints are found in the association by Greek legend of amber with Apollo's tears [Ahl]. In ancient times amber was found in abundance near Glastonbury, which is near the site of Stonehenge. Finally, Figure 11.12 illustrates Megalithic carved stones in the form of the five Platonic solids as evidence of the interest of ancient people in geometry and stereometry (the

study of spherical forms for the purpose of astronomy). At least 400 of these stones are in existence [Cri].

11.9 Conclusion

The work of Alexander Thom raises the possibility that standard measure may have been used in megalithic Britain. Due to discoveries of Fernie, we know that the linear measures in Megalithic Britain and ancient Greece closely agreed. This invites hypotheses as to possible historical linkages between megalithic Britain and ancient Greece.

Appendix 11.A

Anne Macaulay conjectured that standard units of a megalithic rod (mr) equal to 6.8 British imperial feet and a unit a "foot" equal to $\frac{1}{7}$ of a megalithic rod or 0.971 British imperial feet (296 mm) were used in Megalithic Britain. Since these measurements were found on the metrological stone (see Figure 11.2), she saw this as a connection between Megalithic Britain and ancient Greece. However, according to the archaeological record there was no standard unit of a "foot" in ancient Greece. The typical foot of Attica, measuring 293–295 mm was called the Attic-Ionic foot (sometimes called the Solonic foot and also the Cycladic foot) [Bul]. The foot on the metrological stone measures 296 mm, slightly larger than the Attic foot. Still other units of a foot were used for temple construction. For example, 297 mm is the foot length used in the Temple of Apollo in Delos while 328 mm was used for the Great Temple of Athena at Paestrum and the Erechtheion in Athens, and 343 mm was the foot length Anne Bulckens used to describe the proportional system of the Parthenon. Bulckens feels that the Attic foot of 294 mm was scaled up a factor of $\frac{7}{6}$, the two integers assigned to Athena, to get the Parthenon foot, i.e., $294 \times \frac{7}{6} = 343$. The latter value differs from the Parthenon foot (308.76 mm) hypothesized by Francis Cranmer Penrose whose measurements of the Parthenon made in 1888 are considered the most reliable. These values of the Greek foot are summarized in Table 11.A1.

Table 11.A1 Foot measurements in classical Greece.

Foot Type	Measure in mm	Measure in Brit. Imp. Feet
Attic-Ionic	293–295	
Metrological Stone	296	0.971
Temple at Delos	297	0.974
Temple of Athena at Paestrum	328	1.076
Erechtheion	328	1.076
Parthenon (Bulckens)	343	1.125
Parthenon (Penrose)	308.77	0.999
Brit. Imp. Foot	304.84	1

Macaulay felt that the metrological connection between Megalithic Britain and classical Greece are made more vivid if one accepts her hypothesis that many of the stone circles were measured out using units based on the Fibonacci sequence. If one uses the best Fibonacci approximation to the golden mean from her analysis of the stone circles, $\tau = \frac{55}{34}$, then τ mr is equivalent, using 6.8 Brit. Imp. feet/mr, to 11 Brit. Imp. feet i.e.,

$$\tau \times 6.8 \approx \frac{55}{34} \times 6.8 = 11$$

Therefore $\frac{\tau}{11}$ mr ≡ 1 Brit. Imp. foot. Also after discovering the Erechtheion foot of 328 mm in 1890, Dorpfeld [deW] concluded that a foot varying from 326 − 328 mm was used for the design and construction of sacred buildings. While not universal for Greek sacred structures, this class of structures adheres to a $\sqrt{3}$ yardstick in that,

$$\frac{\sqrt{3}}{11} mr \equiv 1.071 \text{ Brit. Imp. feet} = 326 \text{ mm}.$$

By this analysis 11 imperial feet emerges as a natural standard of measurement. This finds validation in the following units of Old English land and sea measures all divisible by 11 illustrated in Table 11.A2.

Table 11.A2 Old English Measurements.

3 feet = 1 yard
2 rods, poles or perches = 11 yards
1 chain = 4 rods (11 × 2 yards)
1 furlong = 40 poles (11 × 20 yards)
1 mile = 8 furlongs (11 × 160 yards)
1 nautical mile = 1870 yards (11 × 170 yards)

It is also curious that 1870, the number of yards in a nautical mile, factors into 34 × 55, the highest Fibonacci pair commonly used in Megalithic Britain.

Macaulay hypothesized that while the small metrological foot (0.971 Brit. Imp. Feet) is found throughout megalithic measurements, the imperial foot may have been used in megalithic times to measure fields considered sacred areas where the Earth goddess produced grain to feed mankind. Thus, this measure which was adopted in Medieval times in England as the basis of all types of standard measurement may have had its origin in Megalithic Britain. It is a mystery as to how this yardstick disappeared after Megalithic times and then was reintroduced to England at a later date.

Appendix 11.B The Geometry of the Stone Circles

We shall compute,

(a) the vertex angle of a regular polygon or star polygon;
(b) the ratio of diameters of the circumscribed and inscribed circles of the polygon;
(c) the ratio of diameters of the circumscribed circle and the circle that goes through the intersection points of the edges of a star polygon.

We will then apply these computations to check Thom's measurements of Farr West and Milton of Clava.

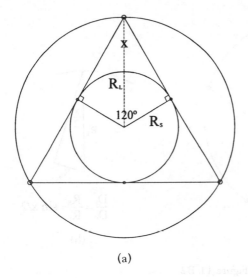

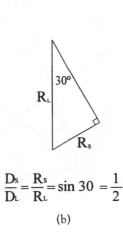

$$\frac{D_s}{D_L} = \frac{R_s}{R_L} = \sin 30 = \frac{1}{2}$$

(a) (b)

Figure 11.B1

First consider the equilateral triangle shown in Figure 11.B1. Its vertices are distributed evenly around the circumference of the circumscribed circle, the central angle between successive points being $\frac{360}{3}$ = 120 degrees.

Note that the radius of the inscribed circle is perpendicular to a side of the triangle tangent to it. Two such radii and two tangent sides form a quadrilateral from which the vertex angle, x, of the triangle can be computed as follows:

$$90 + 90 + 120 + x = 360 \text{ degrees or } x = 60 \text{ degrees.}$$

In Figure 11.B1b the radius of the circumscribing circle bisects angle x. Therefore the ratio, $\frac{R_S}{R_L} = \frac{D_S}{D_L} = \sin 30 = \frac{1}{2}$ where R_S and D_S are the radius and diameter of the inscribed circle and R_L and D_L are the radius and diameter of the circumscribed circle.

Next consider the star pentagon shown in Figure 11.B2a. This star pentagon is referred to as $\{\frac{5}{2}\}$ because it has five vertices evenly placed around the circumscribing circle, and each edge connects every second vertex. The angle between adjacent vertices is $\frac{360}{5}$ = 72 degrees. Using the

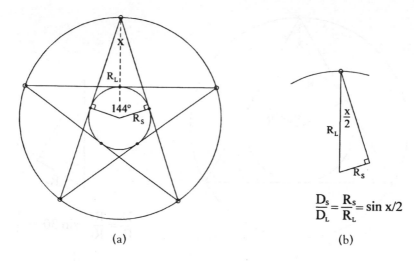

(a) (b)

$$\frac{D_s}{D_L} = \frac{R_s}{R_L} = \sin x/2$$

Figure 11.B2

same reasoning as for the triangle, we find that to determine the vertex angle, x,

$$90 + 90 + 144 + x = 360 \quad \text{or} \quad x = 36 \text{ degree.}$$

Likewise, $\frac{D_s}{D_L} = \sin 18$ where 18 degrees is half of the vertex angle.

In general, to find the vertex angle x of an $\{n, p\}$ star polygon (a polygon with n vertices connecting every p-th vertex by an edge), the computation is carried out as follows:

$$90 + 90 + 360\,\frac{p}{n} + x = 360$$

or solving for x,

$$x = \frac{180(n - 2p)}{n} \tag{11.B1}$$

and referring to Figure 11-B2b and using the trigonometry of a right triangle,

$$\frac{D_S}{D_L} = \sin\frac{x}{2}. \tag{11.B2}$$

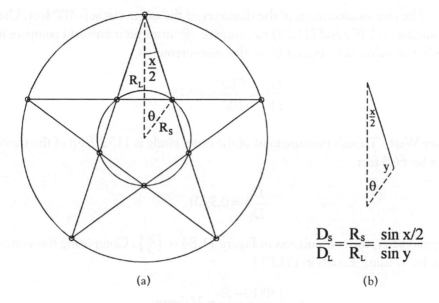

$$\frac{D_s}{D_L}=\frac{R_s}{R_L}=\frac{\sin x/2}{\sin y}$$

(a) (b)

Figure 11.B3

Figure 11.B3 shows a circle going through the five points of intersection of a star pentagon. The vertex angle x is computed from Equation (11.B1). However, R_S and R_D are no longer sides of a right triangle, so to compute their ratio requires use of the law of sines on Figure 11.B3b. Here x is half the central angle of the pentagon, or 36 degrees while $\frac{x}{2} = 18$ degrees as before. Therefore $y = 180 - 18 - 54 = 54$ degrees. Using the law of sines,

$$\frac{D_S}{D_L}=\left(\sin\frac{x}{2}\right)\Big/\sin y=\frac{\sin 18}{\sin 54}=0.3819. \qquad (11.B3)$$

Milton of Clava. Thom's measurment of the diameter of the middle circle is 57.8 feet (8.5 MR, where MR stands for megalithic rods). The inner circle is 22.0 feet. Therefore,

$$\frac{D_S}{D_L}=\frac{22}{57.8}=0.3801.$$

Comparing this with Equation (11.B3) gives an error of 0.47%.

The one measurement of the diameter of the outer circle is 100 feet. Use Equations (11.B2) and (11.B3) to compute $\frac{D_S}{D_L}$ from geometry and compare it with the value determined from the measurements,

$$\frac{D_S}{D_L} = \frac{57.8}{100} = 0.578.$$

Farr West. Thom's measurement of the outer circle is 113.2 feet; of the inner circle, 66.8 feet

$$\frac{D_S}{D_L} = 0.5901.$$

By geometry, the star polygon in Figure 11.B4 is $\{\frac{10}{3}\}$. Computing the vertex angle, x, using Equation (11.B1),

$$x = \frac{180(10-6)}{10} = 72 \text{ degrees.}$$

Using Equation (11.B2),

$$\frac{D_S}{D_L} = \sin 36 = 0.5878$$

with an error of 0.3%.

12

The Flame-Hand Letters of the Hebrew Alphabet

> In the beginning of heaven and earth there were no words,
> Words come out of the womb of matter.
>
> *Lao-Tse*

12.1 Introduction

In Part One, I presented several examples of ways in which numbers and geometry may have been used by ancient civilizations. I also described Kepler's attempt to create a planetary system from the music of the spheres and Theodor Schwenk's and Lawrence Edwards' work to find unifying principles that generate natural forms. Projective geometry, harmonic law, systems of proportion, the Megalithic stone circles, and the designs found in the pavements of the Laurentian Library can be thought of as symbolic languages in their ability to express relationships found in art, architecture, music, design, and patterns in nature.

In Part Two I take a more formal approach to number and geometry and describe how certain systems evolve by continually feeding back information about themselves. I will show that the dynamics of such self-referential systems is governed once again by number and geometry. I ask the reader to ponder the question as to whether the patterns of number and geometry that we observe in the natural world are intrinsic to nature or do we subtly project aspects of our own thought processes onto the world?

The ultimate self-referential system is written language. The biologist, Lewis Thomas, has commented that written language functions much like a genetic code; it serves as a carrier of meaning and culture across the

generations. New meanings take the place of the old, yet remnants of the original meanings become part of the philological roots. In this chapter, I will present a hypothetical geometrical system developed proposed by Stan Tenen, an independent researcher, that attempts to shed light on the origin of the Hebrew alphabet and the meanings of its symbols [Ten1]. The letters are obtained by projecting a specially, meaningfully-shaped spiral, vortex form onto a flat surface from a variety of points of projection. The spiral vortex suggests a flame, and the projection source could be a flame, thus my reference to the letters as "flame letters". Likewise, this vortex form can also be seen as an idealized human hand. When this model hand is placed on one's hand, the wearer sees each letter when making particular gestures related to the meaning of the name of the letter, thus my reference to this model as a "flame-hand" model.

Tenen's primary interest is in the recovery of what he takes to be an underlying geometric metaphor in Western traditions. My focus in this chapter is on the geometrical forms and mathematical content. Tenen's story and mine share a common interest in the importance of systems created from within themselves, or self-referential systems. In the next chapter, I will study the mathematics of self-referential systems.

12.2 The Flame-Hand Letters of the Hebrew Alphabet

The Hebrew alphabet, or aleph–beth, plays an important role in the historical evolution of written language. We attribute the first fully symbolic written language to the Semitic tribes dating to 1500 B.CE. Before this time written language took the form of pictorial systems such as Egyptian hieroglyphics (which first appeared in 3000 B.CE.) in which stylized images of humans and human implements were interspersed with those of plants, birds, and other animals.

Although the Canaanite/Phoenician ("Old Hebrew") written language is entirely symbolic, (every sound-syllable had its own character or letter), it does retain remnants of its pictorial predecessors. For example, aleph ℵ (the equivalent of the English "A") is the ancient word for ox (and the Canaanite Aleph looks like an ox-head on its side) while mem (the equivalent of "M") is the Hebrew word for water and is symbolized by a

Table 12.1 Shadowgrams of the 27 Meruba Hebrew letters.
They are all views of one physical system.

FLAME MODEL SHADOW-GRAMS	SAMPLE ALPHABETS FROM: "HEBREW ALPHABETS" c. 1950 REUBEN LEAF, BLOCH PUBLISHING 10–11th century Spanish Rabbinic 11 cent. NACHMANIDES "RASHI" Prototype "RASHI"-style Typography First printed Hebrew, Lisbon 1489 300 BCE, Elephantine Papyrus					
К	א א א א א	ALEF, אלף	A			
ג	כ כ ב ב	BET בית	B			
ג	ג ג ג ג	GIMEL גימל	C			
ד	ד ד ד ד	DALET דלת	D			
ה	ה ה ה ה	HE הא	E			
ו	ו ו ו ו	VAV וו	F			
ז	ז ז ז ז	ZAYIN זין	G			
ח	ח ח ח ח	cHET חית	H			
ע	ט ט ט ט	TET טית	J			
ı	י י י י	YOD יוד	I			
כ	כ כ כ כ	KAF כף	K			
ל	ל ל ל ל	LAMED למד	L			
מ	מ מ מ מ	MEM מם	M			

Table 12.1 (*Continued*)

SAMPLE ALPHABETS FROM: "HEBREW ALPHABETS"
c. 1950 REUBEN LEAF, BLOCH PUBLISHING
10–11th century Spanish Rabbinic
11 cent. NACHMANIDES "RASHI" Prototype
"RASHI"-style Typography
First printed Hebrew, Lisbon 1489
300 BCE, Elephantine Papyrus

FLAME
MODEL
SHADOW-
GRAMS

FLAME MODEL SHADOWGRAMS						Name	Code
ل	נ	נ	נ	ن	נֿוֹ	NUN — נון	N
ס	ס ס	ס	ס	ל	ן	SAMEK — סמך	$
ע	ע	ע ע	ע	ע	עۛ	AYIN — עין	O
כ	פ	פ פ	פ	פ	פ	PE — פא	P
ﬧ	צ	צ צ	צ	צ		ZADI — צדי	Z
ﬣ	ק	ק ק	ק	ק	ק	QOF — קוף	Q
ר	ר	ל ר	ר	ר		RESh — ריש	R
ﬦ	ש	ש	שׁ ש	ש	שׁ	SHIN — שין	S
ת	ת	ת ת	ת	ת	ת	TAV — תו	T
ו	ך	ך	ך ך	ך		KAF (FINAL) — כף סופי	U
ס	ם	ם	ם ם	ם		MEM (FINAL) — מם סופי	W
ו	ן	ן	ן	ן	ן	NUN (FINAL) — נן סופי	X
פ	ף	ף	ף ף	ף		FE (FINAL PE) — פא סופי	V
ﬥ	ץ	ץ	ץ ץ	ץ		ZADI (FINAL) — צדי סופי	Y

series of waves ⌇. Qof (the equivalent of "Q") is the word for skull and is drawn with a circular top (the "skull") and a vertical descender (the "spinal column") ዋ.

It was only after the transfer of phonetic writing to Greece with the transformation of the aleph–beth into the Greek "alphabet", that progressive abstraction of linguistic meaning reached completion. In his book, *The Spell of the Sensuous*, David Abram [Abr] traces the origins of written language and the effect this has had on the way we see the world.

The system proposed by Stan Tenen generates close facsimiles to the shapes of the 27 letters of the rabbinic form of the Meruba Hebrew alphabet shown in Table 12.1, while at the same time organizing them into a coherent pattern of meanings [Ten]. This system is also capable of generating the letters of particular forms of the Greek and Arabic alphabets. Tenen sees this as evidence of a common thread spanning many ancient systems of thought. The Hebrew letters in Table 12.1 are shown with English correspondences and correlations to the English alphabet (not all are phonetic equivalents).

It should be stated that Tenen's proposal is historically controversial, and while it has begun to be presented for peer review, it would be premature to comment on its authenticity. There is little that scholars know for certain about the origins of Hebrew letters. Scholars have never been able to fully penetrate the meaning of particular sacred books of Jewish mysticism such as the Zohar, nor related ancient Sufi texts. Yet Tenen believes that these works become precise, unambiguous and meaningful when they are interpreted through their inherently geometrical metaphoric imagery.

It is unlikely that our forefathers understood the geometrical concepts that we shall present in the manner in which we understand them. After all, they had their own symbolic languages. However, mathematical concepts are fundamental and can be understood in many different ways. I shall present Tenen's work as a kind of mathematical poem or metaphor. It will provide us with a model of a system generated from within itself.

12.3 The Vortex Defining the Living Fruit

Tenen first develops the concept of the life cycle of a living fruit. The idealized fruit is modeled by a "dimpled sphere" or *torus* (inner tube) whose

"Fruit tree yielding fruit whose seed is inside itself" Genesis I, 11

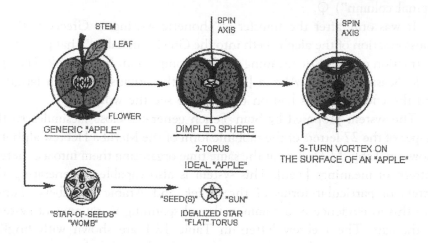

Figure 12.1 Idealized fruit modeled as a dimpled sphere.

inner radius shrinks to zero, as shown in Figure 12.1. The central sphere represents either the "seed-pod" of the current "fruit" or the next generation "fruit" nested within the current generation.

In vertical (stem up, flower down) cross section, the "dimpled sphere" or "generic apple" appears as two quasi-ellipses nested against and surrounding the central sphere, which appears as a circle sitting over the "kissing" point of the two ellipses. The ring of five seeds of the "apple" are arranged in a five-pointed star (the seeds in the core of an apple form a pentagon).

A seven-stage dynamic process through which the idealized fruit passes — the inherent propensity of the seed to grow — is modeled by considering the seed to be "containing" an internal increment (or quantum) of angular momentum. This is similar to the idea of *spin* in elementary particle physics, where the particle is considered to carry a quantum of spin in units of *angular momentum*. The seven-stage process unfolds as follows:

1) The potential angular momentum locked into the idealized seed-pod is expressed as an "impulse" that ejects the "sprout" from the "seed" as the

"fruit-tree" starts to grow. Initially all the angular momentum is expressed by the ejection of the "sprout" along its erupting "stem".

2) Later in the life-cycle of the *fruit-tree*, when the *stem* or *trunk* of the tree has reached its maximum extent, the angular momentum — representing the life-force of the fruit-tree throughout its life-cycle — must be transferred into the unfurlment (around the tree-trunk) of the leaves and branches of the fruit-tree.

3) The branches sprout buds.

4) Which give rise to new fruit.

5) From which emerge flowers.

6) Still later, near the end of the life-cycle, the angular momentum in the volume of the mature fruit must be transferred to the next generation of seed (represented by the central sphere), as its *flowers* decay (and fall to the ground, now devoid of *life-force* and angular momentum), and as this new seed (containing the passed-on life-force and increment of angular momentum of the life-cycle) is thrown to the wind.

7) The new seed falls to the ground to restart the next life-cycle.

The Sefer Zohar, quoting Genesis, describes the entire living system as a "fruit-tree, yielding fruit, whose seed is in itself". Each generation of fruit, in turn, is seen as nested within the previous generation giving rising to the recursive sequence: ...–acorn–oak–acorn–oak–.... We have here the quintessential self-referential process in which fruit is both a vessel and its contents. (The vessel is modeled as a torus, which as with vortices (see Section 1.11), is a minimal closed system, the first requirement for self-reference.) For example, a smoke ring maintains its integrity in the form of a torus.

The process of unfurlment and spin shown in Figure 12.2 is modeled by a ribbon with three turns. Since the original seed and the new seed within the new whole fruit are identical in their development, except for being a generation apart, they can be taken to be the ends of the developmental life-cycle strung between them. The ribbon represents the exchange and transformation of angular momentum that takes place during the seven-stage life cycle. This vortex form can also be taken to represent an individual. The living spirit of the individual is symbolized by his/her whirling motion as in Sufi or Dervish dancing. The philosopher, mathematician,

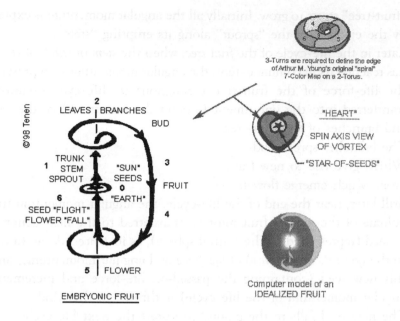

Figure 12.2 Cycle of life of a living fruit. The idealized embryology of a fruit-tree is mapped onto an ideal fruit.'

and engineer Arthur Young [Young] has written extensively in his book, *The Reflexive Universe*, about the seven-stage process under which all natural forms of the universe unfold. Tenen credits this system, and his fruit tree conforms well to it.

12.4 The Torus

The *torus* is the first structure of mathematical importance that we encounter in Tenen's proposal. What is a torus? Any circular (loop) cut made on the surface of a sphere divides the sphere into two pieces. However, Figure 12.3 shows that two loop cuts leave the surface of a torus (inner tube) in one piece and opens the torus up to a *period rectangle*. Each side of the period rectangle is *identified* with its opposite, since they represent the two loop cuts. The two circles that characterize the torus are its *meridian* and *longitude*, shown in Figure 12.4.

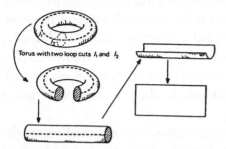

Figure 12.3 A torus is opened to a period rectangle by cutting two loops on its surface.

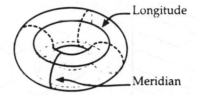

Longitude

Meridian

Figure 12.4 A meridian and longitude on a torus.

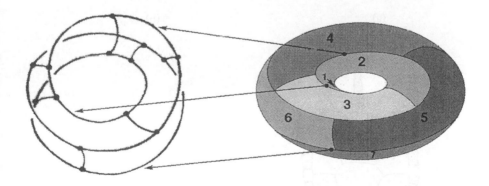

Figure 12.5 The surface of a torus divides itself naturally into seven regions.

In Figure 12.5, due to Arthur Young, we see that the ribbon of Figure 12.2 not only defines the structure of the torus but divides its surface in a natural way into seven regions. This is the *seven*-color *map* of the torus which states that a torus can be subdivided into seven regions, each region sharing an edge with the other six. If such a map were to be colored so that regions sharing an edge have different colors, clearly seven colors are needed. (It is well known that any map drawn on a sphere or the plane never requires more than four colors.)

Figure 12.6a shows a seven-color map redrawn on a period rectangle. Notice how the seven regions continue from the left to the right edge, and

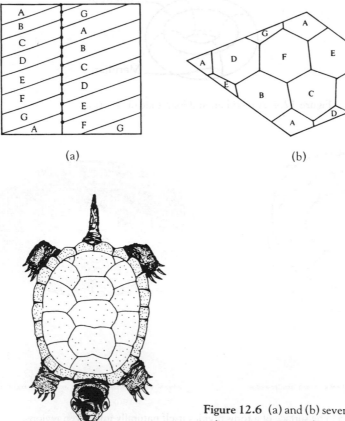

(a)

(b)

(c)

Figure 12.6 (a) and (b) seven-color map drawn as hexagons on a period rectangle; (c) hexagonal design on the shell of a turtle.

from the top to the bottom edge. Also notice that they are all hexagons (see Figure 12.6b). Tenen believes that this association of the torus with hexagons may lie at the basis of the ancient myths in which the world is brought into being on the back of a turtle whose shell is made of hexagons (see Figure 12.6c).

12.5 The Tetrahelix

A *tetrahelix* is a spiral column formed by combining a column of tetrahedra joined face to face, as shown in Figure 12.7. Three continuous spiraling ribs can be seen on the surface of the tetrahelix, forming a double helix. The tetrahelix can also be imagined to be formed by taking a triangular prism (see Figure 12.8) and giving it a $\frac{1}{3}$-turn so that top face is rotated 120 degrees with respect to the bottom face for each 11–tetrahedra. Actually, no integral number of tetrahedra results in a top face oriented identical to

Figure 12.7 A tetrahelix column.

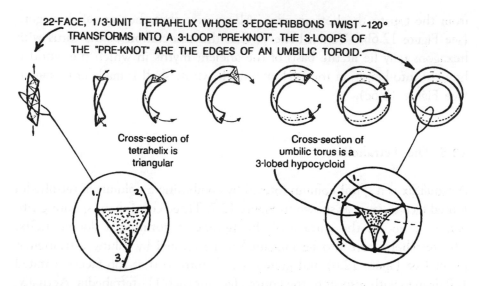

22-FACE, 1/3-UNIT TETRAHELIX WHOSE 3-EDGE-RIBBONS TWIST ~120°
TRANSFORMS INTO A 3-LOOP "PRE-KNOT". THE 3-LOOPS OF
THE "PRE-KNOT" ARE THE EDGES OF AN UMBILIC TOROID.

Cross-section of
tetrahelix is
triangular

Cross-section of
umbilic torus is a
3-lobed hypocycloid

Figure 12.8 A triangular prism is twisted into a tetrahelix and then rotated to form an umbilic toroid. Thirty three tetrahedra result in a column in which top and bottom faces are rotated approximately 360 degree.

the bottom face. In other words, the tetrahelix is not a *periodic* structure and so the column must be slightly strained to enable the top and bottom faces to meet. A tetrahelix with 33 tetrahedra results in a column in which top and bottom faces are rotated approximately 360 degrees with respect to each other. Tenen has shown that the two ends of the $\frac{1}{3}$-unit tetrahelix can then be bent around in a circular arc and joined together to form an "umbilic torus". Now the three disjoint spirals on the tetrahelix column form one continuous arc with three loops on the umbilic torus that precisely defines the edges of the seven color map on the torus (see Figure 12.5). A tetrahelix with 11−tetrahedra can be easily constructed by folding the triangular grid shown in Figure 12.9 up from the plane.

Notice that the outline of this folding pattern is a hexagon which can also tile the plane, as shown in Figure 12.10a (see also Figure 12.6). Notice how the $\frac{1}{3}$-unit of flattened tetrahelices form the six-around-one pattern of the seven-color map that characterizes the surface of a torus. Figure 12.10b shows seven clusters of seven clusters of seven $\frac{1}{3}$-unit tetrahelices.

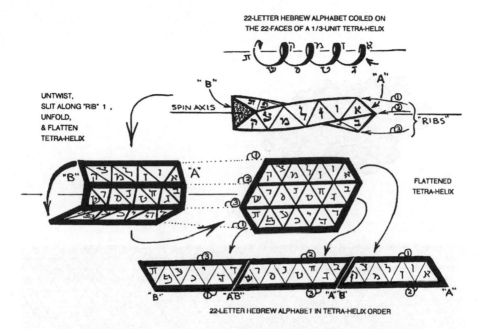

Figure 12.9 Paper folding construction of a tetrahelix with 11 tetrahedra.

We could make groups of seven at higher and higher levels indefinitely. The curve along the edge of this figure is called a "flowsnake" and is named after the "snowflake", or Koch curve, to which it is related (see Section 18.5). The 22 letters of the Hebrew alphabet "seed" this hierarchy.

When bent around and connected, the 11 tetrahedra exhibit 22 external faces (see Figure 12.9). Tenen has placed the sequence of 22 letters of the Hebrew alphabet (not counting the final letter forms) along these faces in alphabetical order. Notice that the letters of the Hebrew alphabet occur in sequential order on the hexagonal tiling of Figure 12.10b. In Figure 12.11, the edge of the umbilic torus has been isolated as a string, and Tenen has strung all 27 sletters of the Hebrew alphabet on the three turns of the string with nine letters for each of the three loops. In Figure 12.12 the second (bet) and last letter (tav) are merged to form the first letter (aleph) so that aleph is seen as both "head" and "tail" of the "Oroboros" or "snake that eats its tail".

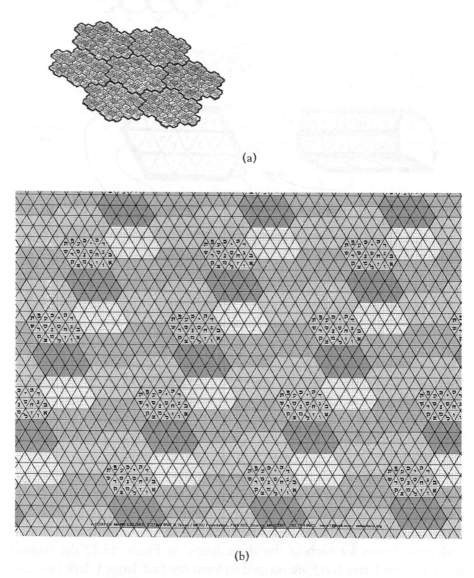

(a)

(b)

Figure 12.10 (a) Seven clusters of seven tetrahelices forming a fractal curve called the "flowsnake"; (b) the Hebrew letters superimposed on the hexagonal tiling.

ENNEAGRAM VIEW of the 3-Levels 1f the HEBREW ALPHABET

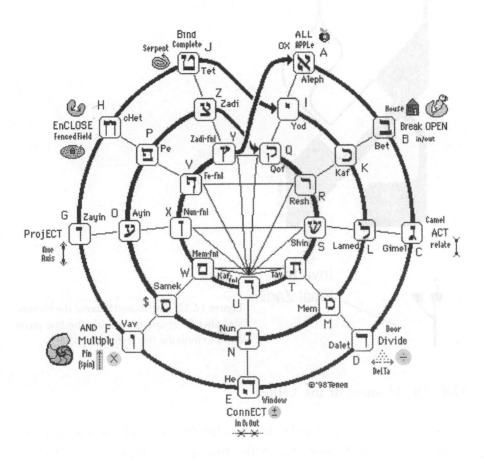

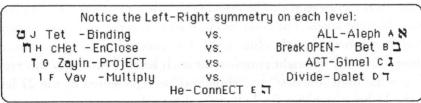

Notice the Left-Right symmetry on each level:

ט J Tet –Binding	vs.	ALL–Aleph A א
ח H cHet –EnClose	vs.	Break OPEN– Bet B ב
ז G Zayin–ProjECT	vs.	ACT–Gimel C ג
ו F Vav –Multiply	vs.	Divide–Dalet D ד
	He–ConnECT E ה	

Figure 12.11 The 27 letters of the Hebrew alphabet sequentially strung on the three loops of the umbilic torus form an enneagram (nine-sided) view of the three-levels of the Hebrew alphabet.

Inverted Final Zadi

Figure 12.12 The second letter of the Hebrew alphabet (bet) combines with the last letter (tav) to form the first letter (aleph).

12.6 The Meaning of the Letters

The umbilic torus necklace divides the alphabet naturally into three parts, to form a connected *enneagon* (circular nine-pointed figure). Each triple of letters in the enneagon can be associated with a common meaning but on three different levels. The outer level, or level 1, is the archetypal meaning; level 2 is inner/spiritual, while level 3 is outer/physical. Also notice in Figure 12.11 the left-right symmetry at each level. Tenen sees this process of moving from "oneness" to "wholeness" as represented by the 27 letters of the Hebrew alphabet (including final forms);

Oneness — Aleph, Yod, Qof;

Distinction — Bet, Kaf, Resh;

Action — Gimel, Lamed, Shin;

Division — Dalet, Mem, Tof;

Connection — Heh, Nun, Kaf-final;

Multiplication — Vav, Samek, Mem-final;

Projection — Zayin, Ayin, Nun-final;

Encompassment — Chet, Peh, Peh-final;

Wholeness — Tet, Zadi, Zadi-final.

So we have here the makings of a sacred alphabet, in which the letters are not merely abstract symbolic forms but also have meaning in and of themselves. Let's look in detail at the meaning of the first two letters of the alphabet at levels 1, 2, and 3.

12.6.1 *Oneness*

Level 1. Aleph Absolute, stands for All, Aloof, and Alp — a high point, a high mountain. It is All-One-Wisdom-Consciousness. Phela (Aleph in reverse) is a miracle and a mystery. Aleph as the singular is the sun-seed-center (the primal point), the Source; Aleph as the Whole, is the idealized Fruit — the Apple. Aleph represents the strongest most coherent Archetype. That is why Aleph means Ox or Master.

Level 2. Yod Our personal, individual consciousness is represented by the human hand, which projects our personal consciousness into the physical world. The Yod is the "seed" and is therefore associated with the male organ and with semen and it is a point (iota in Greek). Yod is an expression of our being (the psychologist's Id). That is why Yod means Consciousness, hand or point/pointer.

Level 3. Qof This is our outer "mechanical" or Monkey consciousness. It is the shell or physical copy of our inner Yod consciousness. When we "ape", we Copy. That is why Qof means Monkey, Copy or Skull.

Together Qia (Aleph-Yod-Qof) means Eruption. Qi is the name for the life-force in the Eastern traditions and "eruption" is what happens at the seed-center of Continuous creation — at the center of the torus.

12.6.2 *Distinction*

Level 1. Bet Partitions the Unity and Wholeness of Aleph. Aleph by itself is One. There is no opposition or polarity, and no need for action or change. Bet as the first possible distinction differentiates what is within from what is without. In his *Laws of Form*, G. Spencer-Brown [Spe-B] showed that a single mark of distinction separating inside from outside was capable of reproducing all of the laws of logic. From Bet on there is difference, complement, and contrast. There is spirit and matter, wave and particle. That is why Bet, two and duality is a "Housing" (which separates inside from outside). As a prefix, Bet means In or With.

Level 2. Kaf As the inner aspect of Bet, represents holding in, as in cupping in the palm of the hand. Cupping shapes the palm like that which it holds. That is why Kaf means palm and why, as a prefix, it designates Likeness and Similarity.

Level 3. Resh As the outer part of Bet, Resh represents the outer reaching of Bet. If Kaf is what is in the palm of the hand, then Resh is what radiates from the head. That is why Resh means Head, Reaching Rushing and Radiation. Together Buker (Bet–Kaf–Resh) means "first born son". These letters break open Unity and signify the birth of distinction at each of their levels.

In a similar manner Tenen has shown that all of the letters of the Hebrew alphabet participate in this three level process that integrates the inner world of our consciousness with the outer physical world. Mastery of the inner world leads to wisdom, while mastery of the outer world leads to understanding.

12.7 Generation of the Flame-Hand Letters

Tenen proposes that the rabbinic form of the Meruba Hebrew letters can be generated from a *knot* drawn on a dimpled-sphere-shaped *torus*. In order to better understand this construction, let us first consider the concept of a knot.

(a) (b)

Figure 12.13 (a) Example of a trivial knot or "unknot"; (b) the unknot drawn with a single crossover.

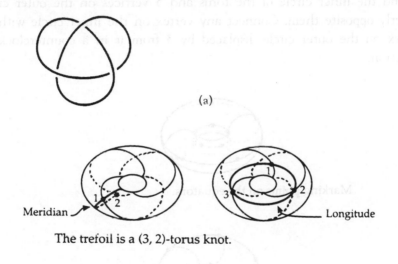

(a)

The trefoil is a (3, 2)-torus knot.

(b)

Figure 12.14 (a) The trefoil knot, the simplest nontrivial knot, drawn as an under-over-under pattern; (b) the trefoil knot on the surface of a torus.

The simplest form of a knot is gotten by connecting the ends of a string together to form a loop or *unknot* (see Figure 12.13a) [AdamC]. In Figure 12.13b the unknot, or trivial knot as it is called, is redrawn with a single crossing. Since the crossing can be removed without cutting the string, it is considered to be structurally identical or isomorphic to the unknot. The edge of the umbilic torus is an unknot.

The first nontrivial knot is the *trefoil knot* shown in Figure 12.14a with three crossings, none of which can be removed. The trefoil knot, as with

all nontrivial knots, is basically three-dimensional. However, to represent it schematically, mathematicians generally draw its projection in two-dimensional space as an under-over-under pattern in which a broken line indicates that the string passes under the over-stretched arc (see Figure 12.14b). The trefoil map is redrawn around the surface of a torus in Figure 12.14c. Notice that in a torus knot there are no crossovers. The trefoil torus knot is called (3, 2), since every longitude of the torus intersects the knot three times while every meridian intersects it twice. A (5, 3) knot is shown in Figure 12.15. To draw this knot, place 5 evenly–spaced vertices around the inner circle of the torus and 5 vertices on the outer circle, directly opposite them. Connect any vertex on the inner circle with the vertex on the outer circle displaced by 3 from it in a counterclockwise direction.

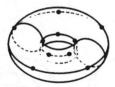

Marking points on the equators.

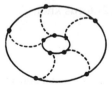

Attach points by strands across the bottom of the torus.

Constructing a (5, 3)-torus knot.

Figure 12.15 Steps to drawing a (5, 3) knot on the torus.

A torus knot can also be generated from a tetrahelix column by bending a column formed of multiples of 11 tetrahedra around to a torus, as we did for the umbilic torus. The spirals on the surface of the tetrahelix form continuous curves on the surface of the torus in the form of (n, 3) torus

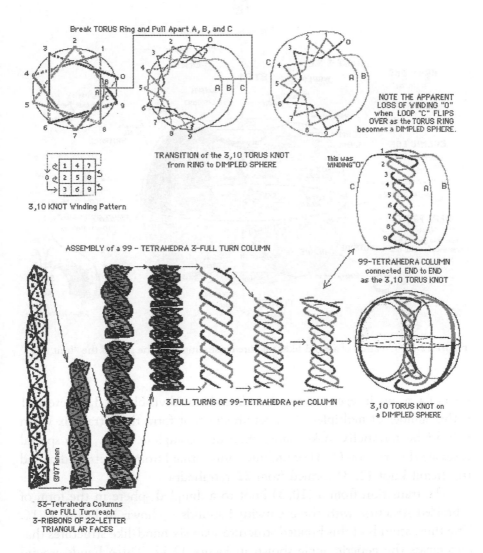

Figure 12.16 Transition from a (10, 3) and a 33-tetrahedra column to a dimpled sphere in the form of a braided structure.

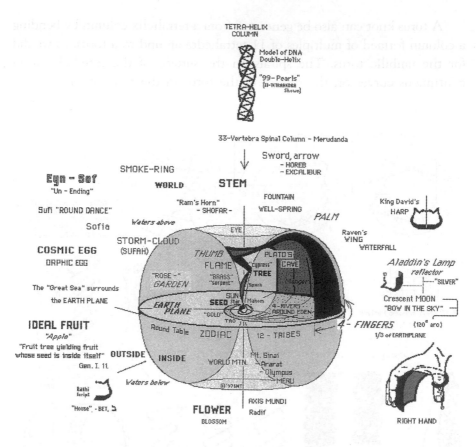

Figure 12.17 Creation of a hand-like structure emanating from the seed of the "fruit tree".

knots for *n*, an integer greater than 2 and not divisible by 3, where *n*−1 is the number of multiples of 11 tetrahedra that form the tetrahelix when *n* > 3 (the tetrahelix makes more than one complete turn). Two special cases are the tri-loop (1, 3) or umbilic torus formed from 11 tetrahedra, and the trefoil knot (2, 3) formed from 22 tetrahedra.

The transition from a (10, 3) knot to a dimpled sphere in the form of a braided structure with three entwined strands is shown in Figure 12.16. The three strands of this braided structure span six hand-like structures that encompass the generic apple shown in Figure 12.17. Three hands around the top and three around the bottom of the apple surround the seed at the

Figure 12.18 Image of a hypersphere.

center. From one of the strands, Tenen creates the hand-like structure shown emanating from the "seed" of the "fruit tree" with a protruding spiral "thumb". It is beyond the scope of this book to describe the spiral component of the hand in detail. However, its projection onto the plane can be expressed when the spiral is properly truncated, by the simple equation $r = \frac{1}{\theta}$ in polar coordinates. This is the same spiral curve illustrated in Figure 4.6 as part of the "eye of Horus". The *reciprocal or hyperbolic* spiral transitions smoothly from being asymptotic to a line, to being asymptotic to a circle. Unlike the common logarithmic spirals, the reciprocal spiral is completely asymmetrical — and this is essential to Tenen's proposal. Tenen also suggests that his "generic apple" or "dimpled sphere" is actually intended to represent the three dimensional projection of the surface of a four-dimensional sphere or hypersphere an image of which is shown in Figure 12.18. (This is also presented by Arthur M. Young in The Reflexive Universe.)

This vortex-like structure forms the "flame-hand" from which Tenen projects all of the letters of the Hebrew alphabet. To get some idea as to the versatility of this asymmetric form, Tenen places it within a tetrahedron, the simplest embodiment of symmetry (see Figure 12.19). He likens this metaphorically to the Old Testament reference to the "light in the meeting tent" in which the light is sometimes referred to as a "flame", while the tent is referred to as a "coal". A projected image of the flame is taken in the direction of the tetrahedron's seven axes of rotational symmetry, giving rise to the seven distinctly different images shown in Figure 12.20.

The LIGHT in the TENT of MEETING

The ETERNAL FLAME

Vortex
LIGHT

VESSEL
Tetrahedron - TENT

The BOW
in the SKY

PROCESS - INSIDE

STRUCTURE - OUTSIDE

(a)

(b)

TETRA-FLAME

THE LIGHT IN THE MEETING TENT

(c)

Figure 12.19 (a) The hand model, or vortex, is referred to as the "flame"; (b) the tetrahedron is the "tent"; (c) the combination represents the "light in the meeting tent" from Exodus.

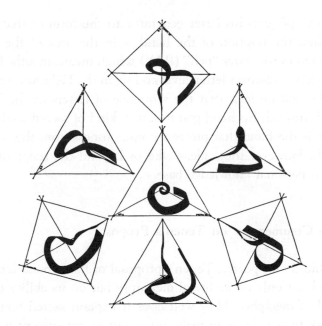

Figure 12.20 Flame images projected in the direction of the seven axes of a tetrahedron.

According to some scholars, up until the Babylonian exile, the Old Hebrew alphabet — that is the proto-Siniatic/Canaanite alphabet — consisted of 22 pictograms. During the Babylonian exile, about 500 B.CE. a new *square-form* alphabet came into use. The Assyrian-Babylonian square-form Meruba letters replaced the Old Hebrew letters in sacred usage. The new alphabet now had 27 letters, in which five additional final-form letters were added to the original 22. Early examples of the Meruba letters were found at Elephantine (circa 300 B.C.E.). These letters were also very similar to examples of the Rashi-Nachmanides style of rabbinic handwriting in use in Islamic Spain, but somewhat different from the formalized "squared-off" forms of the Hebrew letters used on modern Torah scrolls to reduce the possibility of ambiguous readings. The letters in the first column of Table 12.1 were created from projections of Tenen's hand form. Notice the similarity to the Spanish-era rabbinic forms of the letters, and even the somewhat distant relationship to the Elephantine script.

Tenen has gone another step with his proposal. He has found that the names of the letters give information as to a series of hand positions in

which the eye projects his letter generator to the form of that letter. For example when the position of the hand is in the area of the mouth, its projection creates the letter "peh" (PAY) which means mouth. He has also used his models to discover letter-level coding in the Hebrew text of Genesis in the Bible, and he feels that the sequence of letters in the Torah may have served, through his hand gestures, as a kind of sacred meditation. He feels that it is the hand that projects consciousness from the inner to the outer worlds. However these ideas take us beyond the scope of this book and my own personal knowledge base.

12.8 Some Commentary on Tenen's Proposal

As one would do for poetry, Tenen's proposal of flame-hand letters should be evaluated not only on its literal meanings but on its ability to ring true at the level of metaphor. How well does it explain sacred texts and how does it speak to our desire to make sense out of our present world?

Although Tenen has found no explicit evidence for the use of the hand-gesture system fot generating the letters, he has found references that point to the use of the reciprocal spiral (circle into line) in forming the letters, and he has found allusions to this in the so-called "Credo" of Judaism, the Sh'ma, from Deuteronomy, and elsewhere in ancient texts and practices. It is well known that Orthodox Jews wear two small cubical leather boxes with passages from the Hebrew Bible on their arms and foreheads during morning prayers. This is described immediately after the opening lines of the Sh'ma, and the descriptive text is what is placed in the two boxes.

The arm-*tefillin* (box with scripture) is held onto the upper arm by a leather strap, which is wound on the arm seven times, and then wrapped on the hand to form the outline shapes of some Hebrew letters, usually Shin, Dalet, and Yud, which spell the Hebrew word "Almighty" (a God-name). The letter Shin also appears on the tefillin-box worn on the forehead, and additional letters are sometimes found in the knot on the strap holding the tefillin-box on the forehead. So, in effect, Tenen is proposing an underlying source for the tefillin-hand-alphabet tradition, which is retained in the way tefillin are used by observant Jews today.

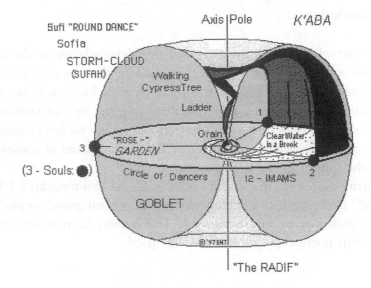

Figure 12.21 Tenen's hand figure captures the imagery of Rumi's verse.

There is also much imagery in the poetry of the medieval Islamic poet Rumi that could refer to a structure akin to Tenen's hand model. Some excerpts of Rumi's verse follow, correlated with the geometrical images in Figure 12.21:

> Come, Come! Let us whirl about in the rose-garden. —
> Let us now whirl about the grain
> which no granary comprehends. —
> I am like a goblet
> in the circle of dancers,
> turning from one hand to the other
> with my story. —
> Come, come, O thou, who are the soul
> of the soul of the soul of the round dance.
> Come thou who are the walking cypress
> in the garden of the round dance.
> Come thou, under whose feet is the fountain of light.
> The roof of the seventh sky —
> does not reach where reaches the ladder of the round-dance.

12.9 Conclusion

Tenen's metaphor relating the genesis of the Hebrew letters to the creation story relates, at least on the surface, to modern theories of consciousness and self-referential systems. In the next chapter knots will be used to mathematically characterize self-referential systems. Similar mathematical structures to the ones that Tenen has chosen to use for his proposal arise in other systems related to recent research into the nature of consciousness that is the subject of the next chapter.

Tenen's suggestion that the ancients made use of a torus knot ("basket-weaving") is also suggestive of modern theories of plant growth or phyllotaxis that we shall present in Chapter 24. The human heart is also toroidal, wound with microscopic tubular muscles [Pes].

Part II
Concepts Described in Part I Reappear in the
Context of Fractals, Chaos, Plant Growth and
Other Dynamical Systems

13
Self-Referential Systems

> Before creation a presence existed,
> Self-contained, complete,
> formless, voiceless, changeless,
> Which yet pervaded itself with
> unending motherhood.
>
> *Lao-Tse*

13.1 Introduction

We humans interact with the world externally through our five senses, and internally through our sense of consciousness and identity. Any system capable of portraying the inner nature of man must certainly be self-referential. Meditation and prayer are two ways of reaching inwards. In fact the Hebrew word TE-FEE-LAH (תְּפִלָּה) means both mirror and prayer. However, self-referential systems are not readily described by mathematics due to the unavoidable logical paradoxes that arise when such systems are modeled by the standard theory of two-valued (true and false) logic. However, drawing on the work of G. Spencer-Brown, the mathematician Louis Kauffman has shown that the theory of logic can be extended by adding elements, akin to imaginary numbers, in order to resolve these paradoxes. He has also used the theory of knots to describe the logic of self-referential systems.

Self-referential systems will play an important role in Part Two. Fractal patterns will be seen to be self-referential as will relationships involving the golden mean. I will examine how patterns of number created by our minds are encountered in our observations of natural phenomena. Do we, by some

self-referential process, project aspects of our minds upon our perceptions of the world?

13.2 Self-Referential Systems in Mathematics

In *Joseph and his Brothers*, Thomas Mann portrays time before recorded history as a spiral with no beginning. We are never sure at any moment whether Mann is referring to *the* Joseph or the countless Josephs that came before him. This is an excellent model for a self-referential system.

The theory of sets is the bedrock upon which mathematics is built. All of mathematical logic, the structure of the number system, and geometry rests on the notion of a set. In fact, a set is an undefined object and may naively be considered to be "a bunch of things" along with a precisely stated rule to determine whether a given entity is or is not in the set. For example, the set of positive integers less than or equal to 5 is the finite set, {1, 2, 3, 4, 5} whereas the set of even positive integers is the infinite set, {2, 4, 6, 8, ...}.

At the beginning of the twentieth century, most mathematicians thought that every mathematical truth, or theorem, could be proven from a sufficiently complete system of axioms or premises, and that the entire structure of mathematics could be expressed in terms of sets. The mathematician and philosopher Bertrand Russell and the philosopher Alfred North Whitehead set out to do just this in their classic treatise on logic, *Principia Mathematica*. However, the program of Russell and Whitehead began to founder when Russell discovered a class of sets that led to what seemed at first to be a bunch of silly sounding paradoxes. For example, consider a mythical town in which there lives a barber who shaves everyone in town who does not shave himself. Russell then considered the set of people who were shaved by the barber and asked whether or not the barber himself was in that set. If he is in the set then he does not shave himself. But this then implies that he is not in the set. In other words if he is in the set then he is not in the set. As trivial as this conundrum appears, it put an end to Russell's and Whitehead's attempt to axiomatize mathematics and led eventually to Godel's proof that such a program was futile. According to Kauffman [Kau4],

"At first it is not clear whether the difficulty with the Russell set is in the notion of set formation, the idea of self-membership, the use of the word "not", the use of the word "all", or elsewhere. The Theory of Types due to Whitehead and Russell placed the difficulty in the use of self-membership, and solved the paradox by prohibiting this and other ways of mixing different levels of discourse."

However, the notion of self-reference has many connections to important aspects of mathematical and cybernetic thinking. One of the pioneers in the study of self-referential systems was David Finsler. His work has recently been presented by David Booth in a book entitled *Finsler Set Theory* [Boo2]. Self-referentiality is connected not only with the concepts of feedback, recursion, and self-similarity, but also to those of knots, weaves, fractals, notions of infinity, and imaginary numbers. For this reason it is of great importance to find a place for the notion of self-referentiality in the Pantheon of mathematics, and to find some way to extend Russell's notion of a set to nonstandard sets.

13.3 The Nature of Self-Referentiality

The concept of self-referentiality is very elusive and difficult to express due to the limitations of language. Kauffman has done much to place the notion of self-referential systems on a firm mathematical foundation, and he has presented the following description of it [Kau2].

"What is self-reference? At least one distinction is involved in the presence of self-reference. The self appears, and an indication of that self that can be seen as separate from the self. Any distinction involves the self-reference of 'the one who distinguishes'. Therefore, self-reference and the idea of distinction are inseparable (hence conceptually identical)."

"We explore self-reference by examining what appears to us as distinctions. Through experiencing self-reference, we come to understand the possibility of distinguishing."

"A mark or sign intended as an indicator is self-referential. The self is the whole space including the mark and the observer. But the mark points, in the first place, to its own location, and in this process becomes a locus of reference. The mark refers to itself. The whole refers to itself through the mark. Pointing is represented by an arrow ———>. The anatomy of the arrow consists of a body, ——— , and a barb (or mark, or pointer) >. Together they accomplish directionality and indicate the possibility of movement from locale to locale:

Here To Here

When we turn the arrow on itself, we achieve self-reference with the whole as the arrow itself, and the barb and the tail as 'parts'" (see Figure 12.12).

"The self-pointing arrow becomes self-referential only through the agreement of an observer. Thus, it achieves self-reference through primary (primordial) self-reference. At the same time, the self-pointing arrow is a symbol for the condition of observation in which the self appears to divide itself into that which sees and that which is seen. Thus do barb and tail appear separate although they are joined."

"The self-pointing arrow creates a directed circle which invites us to travel around it from observed to observer to observed to observer... This circulation binds parts back into the whole,

and it has the geometry of what we might call the unidirectional circular unfolding as shown below.

In this unfolding, the individual arrow bent around to form a circle, has become an ordered infinity of arrows, each representing a particular trip around the cycle. In total, these arrows set tip to tail and create a directed line pointing off to infinity."

"Self-reference is the infinite in finite guise!"

This unfolding holds the simple aspects of any infinite form. These are *invariance* and *self-similarity*. Invariance manifests itself through the circumstance that after many turns of the wheel it is possible to lose count — lose the sense of difference between corresponding places on different cycles, just as with the countless Josephs at the beginning of this section. How long has it been? When did this process begin?

In a simple example, consider an infinite string of arrows. The invariance can be indicated symbolically as below:

$$a = >>>>>>>>>>>>>\ldots$$

Hence,

$$a = > a \quad \text{when} \quad a = >>>>>>>>>>>\ldots$$

The *infinite arrow* a is a form that remains the same when adding a single arrow to the left. Note that the equation, $a = > a$ is also an expression of self-reference, in that it describes "a" in terms of itself. And within the

present context, this is sufficient for the reproduction of "a" as an unending process. Quoting [Kau2]:

> "Self-similarity is embodied in the expressed fact that 'a' has a copy of itself within itself [as we shall see again in Chapter 18]. This is another reading of the equation, $a => a$. How is this formal self-similarity related to our intuition of self–within–self through introspection? I suggest that, in form, these circumstances are identical. It is in moving through the cycle and seeing the invariance that we come to a reflection of the self. But note that this personal process involves the non-mechanical aspect of integration of the parts into a whole. It is non-mechanical because there is no way to formalize the entire circumstance of human self-reference in a system of symbols devoid of an observer. But who or what is the observer?"

13.4 Self-referentiality and the Egyptian Creation Myth

The concept of self-referentiality as described by Kauffman is a kind of creation story. Form is brought into being from within itself. Let's compare this to Egyptian creation myths as enunciated by Lucie Lamy [Lam1], a scholar of ancient Egyptian mythology:

> "At Heliopolis the mystery of the Creation is described in its archetypal aspect. Here the name Atum is given to the One, the unique power which will become the Creator. Atum means All and Nothing, the potential totality of the Universe which is as yet unformed — for first Atum must 'project himself' or distinguish himself from the Nun, and thereby annihilate the Nun in its original inert state."

In one version, Atum gives birth to himself through masturbation causing "the seed from the kidneys to come". He then brings the twins Shu and Tefnut into the world. Atum is thus seen as the carrier of the invisible fire or seed, the cause of the first definition to arise from the undefined Nun.

He then brings forth from himself the group of nine divine principles (eight of them plus himself) which order the Becoming — the Great Ennead.

The archetypes enunciated by Atum at Heliopolis are materialized by Ptah. The Shabaka Text (710 B.C.) enumerates Ptah's eight qualities. Thus Ptah incarnates the primordial Eight. It is said that the Ennead, which was the "seed and hand of Atum", becomes the "teeth and lips of Ptah" and gives a name to each thing, bringing it into existence. Divine principles and qualities (the Ennead) can now "enter into all the species of things" — mineral, plant, or animal — and become manifest through them. This is clearly an account of Creation by the Word. As Section 12.6 showed, the Hebrew alphabet also had the effect of bringing things into being through the letters of the alphabet.

The primordial Eight are called the "fathers and mothers of Re" where Re or Ra represents the principle of light. Re is often said to be the Sun. However, according to Lamy, Re is not the light but that which provokes the phenomenon of light. Re is called Atum-Re at Heliopolis and Amun-Re at Thebes. The Egyptians considered numbers to have a generative function as evidenced by the association of number to the names of the Theban sanctuaries. There exists a hymn consecrated to Amun-Re, constructed on a series of plays on words and on numbers. This hymn (Leyden Papyrus 1,350) is composed of 27 stanzas and numbered with the first nine numbers. It is another reference to Tenen's enneagon.

13.5 Spencer-Brown's Concept of Re-entry

Another way to view self-referentiality is through the concept of re-entry. The philosopher, Spencer-Brown [Spe-B], was able to redevelop the system of mathematical logic by considering the idea of a form that *reenters* its own *indicational space*. A space is severed or taken apart; form appears in the process, and the form appears to enter or re-enter the very space that generated it, a kind of creation story. According to Spencer-Brown:

> "A universe comes into being when a space is severed or taken apart. The skin of a living organism cuts off an outside from an inside. So does the circumference of a circle in a plane. By

tracing the way we represent such a severance, we can begin
to reconstruct, with an accuracy and coverage that appear almost
uncanny, the basic forms underlying linguistic, mathematical,
physical, and biological science, and can begin to see how the
familiar laws of our own experience follow inexorably from the
original act of severance."

The concept of *re-entry* can be illustrated by a rectangle with an arrow
indicating the placement of a copy of itself at the point of the arrow. This
results, in the limit, in an infinite sequence of rectangles, as shown in
Figure 13.1.

Another example is the *Fibonacci form* shown in Figure 13.2a [Kau4]
which represents the infinite sequence of boxes shown in Figure 13.2b. The
number of divisions of this form at depth n is the nth Fibonacci number,
i.e., one of the numbers of the F-series: 1, 2, 3, 5, 8, A division is said
to have depth n if it requires n inward crossings of rectangle boundaries to
reach that region from the outermost region in the plane. Each rectangle
divides the plane into a bounded region and an unbounded region. A
crossing of the boundary of a given rectangle is said to be an inward crossing
if it goes from the unbounded region to the bounded region. In Chapter 18
we shall see that the notion of re-entry results in *fractal* curves.

(a) (b)

Figure 13.1 The concept of reentry: (a) a copy of a square is inserted within itself; (b) this
results in an infinite sequence of squares receding to a vanishing point.

(a)

(b)

Figure 13.2 (a) The Fibonacci form F seen as a reentry form, the entire diagram replaces F; (b) this results in a sequence of rectangles in which the number of rectangles at depth n follows the Fibonacci sequence: 1, 2, 3, 5, 8, ...

Such an unending form is evident when one attempts to find the truth value of a statement such as: "This statement is false". If the statement is true, then it is false; if it is false, then it is true. The re-entering mark is asked to satisfy the equation

$$\overline{f}\rceil = f.$$

In the form of the liar's paradox, the equation $\overline{f}\rceil = f$ becomes $f = -f$, where $-$ stands for *negation*. In other words any attempt to evaluate the truth or falsehood of f leads to an iterative pattern:

$$I = TFTFTFTFTFTF...$$

or (13.1)

$$J = FTFTFTFTFTFT...$$

depending on the initial truth value. The symbols I and J were first introduced in [Kau-V] and later expanded in [Kau3]. A discussion of the standard theory of mathematical logic will be presented in Chapter 16. Spencer-Brown uses his notion of the "form" as an alternative to the standard approach and an introduction to *form* logic is presented in Appendix 16.A. Self-referential statements such as those in Expression 13.1 are examples of the so-called "liar's paradox". They are beyond the capabilities of the standard logic.

13.6 Imaginary Numbers and Self-referential Logic

Complex numbers z have the form of $a + bi$ where $i = \sqrt{-1}$ where a and b are real numbers. The number "a" is called the *real part* of z and "b" is the *imaginary part*. Although imaginary numbers have always been mysterious and a bit suspect to non-mathematicians, they are part of the tool–chest of mathematicians, physicists, and engineers and have many important applications.

Once complex numbers are described geometrically, they are easier to comprehend. Each point x, y in the plane can be identified with a complex number $z = x + iy$ as shown in Figure 13.3. The *complex conjugate* of z is defined as $z* = x - iy$. If z is multiplied by i,

$$iz = i\,(x + iy) = -y + ix \quad \text{where} \quad i \times i = -1.$$

Therefore we see that the effect of multiplying z by i is to rotate z by 90 degrees in a counterclockwise direction.

Functions such as sin, cos, log, exp are generally defined for real numbers. However, to truly understand the inner workings of these functions, one must extend the domains over which they are defined to all of the complex numbers. We find that when we enter the complex domain from the real numbers, an unseen world opens. We saw this for growth measures induced on lines whose intersection points with a conic are imaginary (see Section 2.6). Although the fixed points of these transformations are not visible in real terms, they nevertheless exist in the unseen realm of complex numbers.

DIAGRAMS

Figure 13.3 A complex number $z = x + iy$, its complex conjugate $z* = x - iy$, and a 90 degrees counterclockwise rotation iz.

Besides being able to enter the imaginary realm from the domain of real numbers, one can also enter the real numbers from the imaginary by multiplying z by its complex conjugate $z*$ to get,

$$z\, z* = (x + iy)(x - iy) = x^2 + y^2.$$

Complex numbers are used to solve *differential equations* that describe all areas of physics and applied mathematics. For example, in quantum mechanics the location of a particle is determined from a complex valued function Ψ known as the *wave function* of the particle. The probability that a particle is located at a certain position is determined by multiplying Ψ by its complex conjugate Ψ^* to obtain $\Psi\Psi^*$, known as the wave *probability density function*. This real-valued function numerically describes observations

of the state of the particle, while the complex form provides the formalism to describe the wave properties of the particle and its evolution over time by way of *differential equations*.

Kauffman (cf. [Kau-V], [Kau2,3]), following the lead of Spencer-Brown, has shown that by widening the scope of logic to include imaginary numbers offers another way to enter the realm of self-referential systems. I showed above that the solution to $> a = a$, $\boxed{f} = f$, and $\overline{f|} = f$ for the liar's paradox were indicative of self-referentiality. But $T(i) = i$ where $T(x) = \frac{-1}{x}$ (since $\frac{-1}{i} = \frac{-1}{i} \times \frac{i}{i} = i$ where $i \times i = -1$) which shows i to be governed by a self-referential process. In Section 2.8 the imaginary number i was expressed in terms of an infinite process as were I and J. Kauffman has shown that the relationship between imaginary numbers and self-referentiality is a strong one. In fact I and J (different from the previous I and J) of Expression 13.1 correspond formally to a complex number (a number of the form $a + ib$) and its complex conjugate $(a - ib)$ [Kau3]. We encountered them in Section 2.6 as the intersection points of a finite circle with the line at infinity. The connection between complex numbers and logic is described more fully in Appendix 13.A. Quoting Kauffman:

"Both I and J may be regarded as particular ways of viewing an unending oscillation of T and F. In this sense, they are like two views of a Necker cube illusion (where a point on the cube appears to oscillate from foreground to background), and they represent the way the process of perception splits an apparently existent form into a multiplicity of mutually exclusive and yet related views. The complex numbers, $a + bi$ and the imaginary values I and J are the simplest mathematical forms that take into account a context combining evaluation and multiplicity. The imaginary Boolean values become an image of self-reference, a first description of the multiplicity in oneness that is a return to the self."

Kauffman believes that it is this resonance that accounts for the unreasonable effectiveness of the complex numbers in mathematics and physics and he concludes, "Only the imaginary is real".

13.7 Knots and Self-referential Logic

Kauffman has shown that knots lead to a natural means of characterizing the notion of self-referentiality in finite guise [Kau4]. Objects are indicated by non-selfintersecting arcs in the plane. A given object may correspond to a multiplicity of arcs. This is indicated by labeling the arcs with labels corresponding to the object. Thus the mark in Figure 13.4a corresponds to the label "*a*".

Membership is indicated by the diagram shown in Figure 13.4b. Here we have shown that $a \in b$. The arc b is unbroken, while "*a*" labels two arcs that meet on opposite sides of b. Following the pictorial convention of illustrating one arc passing behind another by putting a break in the arc that passes behind, one says that "*a*" passes under "*b*".

With these diagrams it is possible to indicate sets that are members of themselves as shown in Figure 13.5a and sets that are members of each other, as shown in Figure 13.5b.

(a) (b)

Figure 13.4 (a) An object is indicated by an arc; (b) two arcs indicating membership.

(a) (b)

Figure 13.5 Representation of sets that are members of themselves.

Figure 13.6 Sets may contain a multiplicity of identical members. For example $b = \{a, a\}$ is equivalent to $b = \{\ \}$ (the empty set).

Figure 13.7 Knots are considered indistinguishable under the three Reidemeister moves.

As they stand, these diagrams indicate sets that may have a multiplicity of identical members. Thus for Figure 13.6, $b = \{a, a\}$ and $a = \{\ \}$ (the empty set since it contains no element). However, identical terms cancel in pairs since the two loops can be topologically pulled apart. This corresponds to the second of three ways of redrawing a knot to an equivalent knot without cutting the strings called *Reidemeister moves* illustrated in Figure 13.7.

Although knots are generally indistinguishable (or isotropic, as mathematicians say) under Reidemeister moves, Kauffman has pointed out

Figure 13.8 The first Reidemeister move can be distinguished if the strings are considered to be bands with a twist.

Figure 13.9 A knot representing a self-referential set.

that the first move can be used to distinguish knots if the strings are considered to be bands rather than infinitely narrow strings. This time when the first Reidemeister move is carried out, the band in Figure 13.8 shows a twist which indicates the self-referential nature of the set represented by it. In this way the knot set gives a way to conceptualize nonstandard sets without recourse to infinite regress. Infinity has been transposed into topology where inside and outside can equivocate through the twist in the boundary. In knot sets we obtain the multiple levels of ordinary set theory without the seemingly necessary hierarchy.

Quoting Kauffman again:

"This is nowhere more evident than in the self-membering set represented by a curl (shown in Figure 13.9). Here an observer on the curl itself will go continuously from being container to being member as he walks along the ramp. The unknot can

represent a nonstandard set which is both 'not a member of itself' and 'a member of itself' at same time, thus resolving Russell's paradox."

13.8 Conclusion

Based on the work G. Spencer-Brown and L. Kauffman, imaginary numbers can be used to study self-referential systems. Mathematical concepts from the theory of knots can also represent self-referential systems.

Appendix 13.A

This part is excerpted from [Kau2]. In the language of [Spe-B], I and J (cf. [Kau1], [Kau5]) correspond respectively to initial assumptions of markedness or unmarkedness for f in the equation $\overline{f\rceil} = f$. If we think of the solution to $\overline{f\rceil} = f$ as the re-entering mark ∂ then we see that

$$I = \quad \cdots \underline{\rule{3mm}{0mm}}\sqcap\sqcap\sqcap\sqcap\sqcap \cdots$$
$$J = \quad \cdots \sqcup\sqcup\sqcup\sqcup\sqcup\rule{3mm}{0mm} \cdots$$
$$IJ = \quad \cdots \underline{\rule{15mm}{0mm}} \cdots$$

$$IJ = \quad \rceil$$

Any attempt to evaluate the re-entry will set it in an oscillation whose phase is determined by the initial conditions.

The two solutions I and J correspond formally to a complex number and its conjugate. And they can be combined to create a real value. For example, if I and J are regarded as oscillations between markedness and void, then IJ (the simultaneous combination of the oscillations) is always marked and hence represents a marked state.

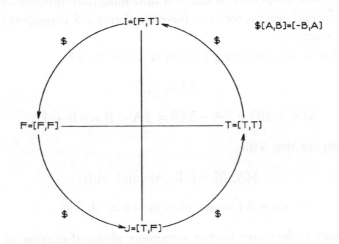

Figure 13.A1 A diagram illustrating an extension of logic to include self-referential states *I* and *J* in addition to *T* and *F*.

If we represent *I* and *J* by ordered pairs

$$I = [F, T], \quad J = [T, F],$$

then we can create a cartesian cross of real and imaginary logical values as shown in Figure 13.A1.

Here $T = [T, T]$ and $F = [F, F]$ represent true and false as indicators of a constantly true and constantly false process. The artifice of the ordered pair allows indication of the phase shift between *I* and *J*.

In Figure 13.A1, we have also indicated an operation \$ defined by

$$\$[A, B] = [-B, A].$$

Thus,

$$\$T = [-T, T] = [F, T] = I,$$
$$\$I = F,$$
$$\$F = [T, F] = J,$$
$$\$J = T,$$

and so we see that this cross of real and imaginary (I, J) Boolean values carries the same properties as the real and imaginary numbers $+1$, -1, $+i$, $-i$. In this formal version we even have an operator $ corresponding to the 90 degree rotation!

In fact it is very tempting to rewrite it in the form

$$\$\$ = -,$$

$$\$(A + \$B) = \$A + \$\$B = \$A - B = -B + \$A,$$

and to compare this with

$$\$[A, B] = [-B, A] \quad \text{and with}$$

$$i(a + ib) = ia + iib = ia - b = -b + ia.$$

Kauffman makes one further comment about the cross of real and imaginary values in logic (Figure 13A.2).

A useful interpretation ensues if we consider the vertical axis of Figure 13A.2 to be an axis of possibility, while the horizontal axis represents necessity. Thus "true" and "false" are states in the domain of necessity, while "possibly true" and "possibly false" are states in the domain of "possibility". According to Kauffman, if a proposition is viewed as possibly false, then one "looks for a counterexample". If a proposition is viewed as possibly true, then one looks for a proof. These are very different attitudes. The attitude of possibility is very free. The attitude of necessity is closed/complete. Possibility opens to verification or falsification.

14

Nature's Number System

> All mathematical forms have a primary subsistence
> in the soul so that prior to the sensible
> she contains self-motive numbers.
>
> *Thomas Taylor*

14.1 Introduction

Number has always been an object of fascination to both laypersons and mathematicians. In this chapter I will take a fresh approach to number. When organized according to a sequence known as *Farey sequence*, numbers are immediately expressive of relationships found in chemistry, physics, biology, and astronomy. It is for this reason that I refer to the Farey sequence as "nature's number system". In preparation for a discussion of nature's number system some general concepts are necessary.

14.2 The Nature of Rational and Irrational Numbers

According to Philolaus, "All is number". Yet Greek mathematicians did not use numbers to represent magnitudes. Rather number represented the relationships between magnitudes. Two lengths were said to be *commensurate* if each could be constructed from a finite number of units, known as *monads*, such that a finite multiple p of one equaled a finite multiple q of the other as illustrated in Figure 14.1 for the lengths of two and three units respectively. This relationship corresponds to what we now refer to as the rational numbers $\frac{2}{3}$ or $\frac{3}{2}$. In this way a *rational number* is defined to be a relationship between

309

Figure 14.1 The proportional relation 3:2 or 2:3. Three pairs of units equals two triples of units.

commensurate lengths represented by $\frac{p}{q}$ where p and q can always be assumed to have no common factors (i.e., the fraction is expressed in lowest terms) or as we say they are *relatively prime*.

We saw in Chapter 3 that the incommensurability of the solar and lunar cycles, on the one hand, and the musical scale on the other hand, presented great challenges to ancient cultures as they sought to express their observations in terms of number. The limitation of number to rational numbers finally broke down in the time of Pythagoras, when it was discovered that the side and diagonal of a square were incommensurate. These lengths have the property that no multiple of one equals a multiple of the other. This presented Greek mathematics with a dilemma since there was no body of knowledge with which to represent such numbers. No adequate theory was available until the nineteenth century when Richard Dedekind (1831–1916) found a way to characterize *irrational numbers*.

What was astounding about Pythagoras' discovery was the way he accomplished it. It certainly could not have been done by the means that we used to illustrate the rationality of $\frac{2}{3}$. After all, the monad might be small beyond the ability to physically construct it. The argument had to be carried out deductively — in other words, by using pure reason. Until Greek mathematics, the concept of a deductive proof did not exist. Pythagoras' well known proof that the square root of two is irrational can be found in any

book on mathematical foundations [Kra]. In modern terms, rational numbers are characterized by decimal expansions that are either finite or repeat after some point such as $0.35 = \frac{35}{100}$ or $0.43252525... = \frac{2141}{4950}$. On the other hand irrational numbers are represented by non-repeating decimals such as $0.1011011101111...$.

The profound differences between rational and irrational numbers also extend to their denumerability. Between any two rational or irrational numbers there is another rational or irrational. Thus the set of rationals and irrationals are both infinite. However, we shall see that while the set of rationals is *denumerable*, when the irrational numbers are added, it becomes *non-denumerable*. A set is defined to be denumerable if each number can be matched one-to-one with the natural or counting numbers 1, 2, 3, 4.... Loosely speaking, we say that a denumerable set has the "same" number of elements as the set of natural numbers. In this way the set of positive even integers is said to be denumerable since each even integer is 2 times some natural number. This presents us with the awkward realization that there are just as many even numbers as positive integers and makes it clear that when dealing with the nature of infinity, mathematics provides the only guide.

Although the set of rationals and irrationals are both infinite, the order of the infinity for irrationals is greater and so we are justified in saying that there are *more* irrationals than rationals. In fact, the rationals are *sparsely* distributed on the number line as compared to the irrationals, in a way that mathematics makes precise [Ruc]. I will show that the set of rationals are also denumerable and leave it to Rucker for a proof that the irrationals are non-denumerable. In the process, I will illustrate the way in which all numbers arise from the pair, 0 and 1.

14.3 Number

I will proceed to generate all numbers of the number line from the pair $\frac{0}{1}$ and $\frac{1}{0}$. This can be thought of as a kind of creation story in which a rich set of relationships arise from the duality initiated by 0 and 1. My examination of these ideas were stimulated by a conversation with the mathematician Irving Adler [Adl1].

14.3.1 All positive numbers of the number line are generated from the numbers $\frac{0}{1}$ and $\frac{1}{0}$. Of course $\frac{0}{1} = 0$, but what does $\frac{1}{0}$ signify? It is undefined but it can be taken to represent *infinity* by considering the sequence, $\frac{1}{1/2} = 2$, $\frac{1}{1/3} = 3$, $\frac{1}{1/4} = 4, \ldots, \frac{1}{1/n} = n$ and letting n get large while $\frac{1}{n}$ approaches 0.

14.3.2 Set up a number line as follows:

$$\frac{0}{1} \qquad\qquad\qquad\qquad \frac{1}{0}$$

14.3.3 Define an unusual kind of addition between two fractions, \oplus, in the manner so tempting but forbidden to children in the early grades, in which numerator is added to numerator and denominator to denominator. In this way the numbers 0 and 1 enter as "marks of distinction" in the sense of Spencer-Brown (see Section 13.5), upon the void, i.e., $\frac{0}{1} \oplus \frac{1}{0} = \frac{0+1}{1+0} = \frac{1}{1}$. Such an "addition" always produces a number intermediate between the two summands, referred to as the *mediant*.

14.3.4 Place $\frac{1}{1}$ on the number line. This defines two intervals, $\left[\frac{0}{1}, \frac{1}{1}\right]$ which I call the left (L) interval and $\left[\frac{1}{1}, \frac{1}{0}\right]$, the right ($R$). Any numbers occurring in these intervals will be referred to as left (l) or right (r) numbers respectively.

$$\frac{0}{1} \qquad L \qquad \frac{1}{1} \qquad R \qquad \frac{1}{0} \tag{14.1}$$

14.3.5 Two such numbers are now defined by adding the numbers bounding the L and R intervals, i.e., $\frac{0}{1} \oplus \frac{1}{1} = \frac{1}{2}$ and $\frac{1}{1} \oplus \frac{1}{0} = \frac{2}{1}$. With the mark of distinction $\frac{1}{1}$ as the vantage point, let $\frac{1}{2} = l$ since it is in the left interval and is gotten by addition of the endpoints of the interval; by the same reasoning, $\frac{2}{1} = r$.

14.3.6 Placement of $\frac{1}{2}$ and $\frac{2}{1}$ on the number line now divides the original two intervals into four intervals. Let $\left[\frac{0}{1}, \frac{1}{2}\right] = LL$ since it is the left refinement

of interval L and $\left[\frac{1}{2},\frac{1}{1}\right]=LR$ since it is the right refinement of interval L. By the same reasoning, $\left[\frac{1}{1},\frac{2}{1}\right]=RL$ and $\left[\frac{2}{1},\frac{1}{0}\right]=RR$.

$$
\begin{array}{cccccccccc}
\vdash & & + & & + & & + & & & \longrightarrow \\
\dfrac{0}{1} & LL & \dfrac{1}{2} & LR & \dfrac{1}{1} & RL & \dfrac{2}{1} & RR & \dfrac{1}{0}
\end{array}
$$
(14.2)

Any number occurring in one of these four intervals will be referred to as either a *ll*, *lr*, *rl*, or an *rr* number, their representations begin with *ll*, *lr*, etc. So we have two notations, the L, R-interval notation and the l, r-number notation.

14.3.7 Four such numbers are gotten by adding the endpoints of these intervals: $\frac{1}{3}$, $\frac{2}{3}$, $\frac{3}{2}$, $\frac{3}{1}$. Therefore $\frac{1}{3}=ll$, $\frac{2}{3}=lr$, $\frac{3}{2}=rl$, and $\frac{3}{1}=rr$. Notice that all additional numbers to the right of $\frac{1}{1}$ are reciprocals of the ones to the left. Therefore, in what follows we shall only consider the numbers less than or equal to $\frac{1}{1}$. The numbers, $\frac{1}{3}$ and $\frac{2}{3}$ divide the interval $\left[\frac{0}{1},\frac{1}{1}\right]$ into the four subintervals

$$
\begin{array}{ccccccccc}
\vdash & & + & & + & & + & & \dashv \\
\dfrac{0}{1} & LLL & \dfrac{1}{3} & LLR & \dfrac{1}{2} & LRL & \dfrac{2}{3} & LRR & \dfrac{1}{1}
\end{array}
$$
(14.3)

14.3.8 In the next iteration, to the left of $\frac{1}{1}$ we get the additional rationals: $lll=\frac{1}{4}$, $llr=\frac{2}{5}$, $lrl=\frac{3}{5}$, $lrr=\frac{3}{4}$, and this gives rise to eight intervals to the left of $\frac{1}{1}$.

$$
\begin{array}{ccccccccccccccccc}
\vdash & & + & & + & & + & & + & & + & & + & & + & & \dashv \\
\dfrac{0}{1} & LLLL & \dfrac{1}{4} & LLLR & \dfrac{1}{3} & LLRL & \dfrac{2}{5} & LLRR & \dfrac{1}{2} & LRLL & \dfrac{3}{5} & LRLR & \dfrac{2}{3} & LRRL & \dfrac{3}{4} & LRRR & \dfrac{1}{1}
\end{array}
$$
(14.4)

14.3.9 The next iteration yields eight new rationals to the left of $\frac{1}{1}$. In fact, each new group of rationals appears in the order found in successive rows of a mathematical structure known as the *infinite Farey tree* (see Table 14.1). Each number in the table is the sum \oplus of the two numbers that brace it to the left and right from above, and each number is connected to the two immediately below it by a left branch l and a right branch r.

Table 14.1 The infinite Farey tree.

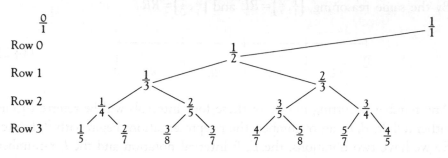

Taken together, the numbers in Rows 0–4 divide the interval $\left[\frac{0}{1},\frac{1}{1}\right]$ into 32 subintervals. Notice there is a unique path from $\frac{1}{1}$ to any number in the tree. For example, to go from $\frac{1}{1}$ to $\frac{2}{5}$ proceed in the directions $\frac{1}{1} \to \frac{1}{2} \to \frac{1}{3} \to \frac{2}{5}$ or llr which was the value assigned to $\frac{2}{5}$ in last section. This sequence represents the order in which $\frac{2}{5}$ was generated from $\frac{0}{1}$ and $\frac{1}{1}$ by adding endpoints.

14.3.10 Notice that the nth row of the Farey tree (see Table 14.1) contains 2^n rationals (starting with $\frac{1}{2}$ as row 0). Any *parent* fraction $\frac{N}{D}$ in one row gives birth to two *successor* fractions $\frac{N}{N+D}$ and $\frac{D}{N+D}$ in the next row whose ratio is $\frac{N}{D}$ and whose sum is 1 (see Section 9.4). A procedure for carrying out this transformation graphically is given in Appendix 8.A. Therefore, the successors can be considered to be the probability of winning and losing some event such as a game of dice or a horse race, and the parent is the odds of winning or losing that event. Also, if a successor $\frac{N}{D}$ is less than $\frac{1}{2}$, its parent is $\frac{N}{D-N}$; if the successor is greater than $\frac{1}{2}$, its parent is $\frac{D-N}{N}$. For example, the successors of $\frac{2}{5}$ are $\frac{2}{2+5} = \frac{2}{7}$ and $\frac{5}{7} = \frac{5}{2+5}$, whereas the parents of $\frac{2}{7}$ and $\frac{5}{7}$ are $\frac{2}{7-2} = \frac{2}{5} = \frac{7-5}{5}$.

14.3.11 I claim that in this way we generate all of the rational numbers. But how do we know this for sure? By rearranging these numbers in the manner illustrated in Table 14.2 we are assured that all rationals are listed. In this sequence all rational numbers in lowest terms with denominators n or less are listed in row n, F_n. Table 14.2 is intimately involved in the

Table 14.2 Infinite Farey sequence.

	$\frac{0}{1}$	$\frac{1}{11}$	$\frac{1}{10}$	$\frac{1}{9}$	$\frac{1}{8}$	$\frac{1}{7}$	$\frac{1}{6}$	$\frac{2}{11}$	$\frac{1}{5}$	$\frac{2}{9}$	$\frac{1}{4}$	$\frac{3}{11}$	$\frac{2}{7}$	$\frac{3}{10}$	$\frac{1}{3}$	$\frac{4}{11}$	$\frac{3}{8}$	$\frac{2}{5}$	$\frac{5}{11}$	$\frac{3}{7}$	$\frac{4}{9}$	$\frac{1}{2}$	$\frac{5}{9}$	$\frac{4}{7}$	$\frac{6}{11}$	$\frac{3}{5}$	$\frac{5}{8}$	$\frac{7}{11}$	$\frac{2}{3}$	$\frac{7}{10}$	$\frac{5}{7}$	$\frac{8}{11}$	$\frac{3}{4}$	$\frac{7}{9}$	$\frac{4}{5}$	$\frac{9}{11}$	$\frac{5}{6}$	$\frac{6}{7}$	$\frac{7}{8}$	$\frac{8}{9}$	$\frac{9}{10}$	$\frac{10}{11}$	$\frac{1}{1}$
\mathscr{F}_1	$\frac{0}{1}$																																										$\frac{1}{1}$
\mathscr{F}_2	$\frac{0}{1}$																					$\frac{1}{2}$																					$\frac{1}{1}$
\mathscr{F}_3	$\frac{0}{1}$														$\frac{1}{3}$							$\frac{1}{2}$							$\frac{2}{3}$														$\frac{1}{1}$
\mathscr{F}_4	$\frac{0}{1}$										$\frac{1}{4}$				$\frac{1}{3}$							$\frac{1}{2}$							$\frac{2}{3}$				$\frac{3}{4}$										$\frac{1}{1}$
\mathscr{F}_5	$\frac{0}{1}$								$\frac{1}{5}$		$\frac{1}{4}$				$\frac{1}{3}$			$\frac{2}{5}$				$\frac{1}{2}$				$\frac{3}{5}$			$\frac{2}{3}$				$\frac{3}{4}$		$\frac{4}{5}$								$\frac{1}{1}$
\mathscr{F}_6	$\frac{0}{1}$						$\frac{1}{6}$		$\frac{1}{5}$		$\frac{1}{4}$				$\frac{1}{3}$			$\frac{2}{5}$				$\frac{1}{2}$				$\frac{3}{5}$			$\frac{2}{3}$				$\frac{3}{4}$		$\frac{4}{5}$		$\frac{5}{6}$						$\frac{1}{1}$
\mathscr{F}_7	$\frac{0}{1}$					$\frac{1}{7}$	$\frac{1}{6}$		$\frac{1}{5}$		$\frac{1}{4}$		$\frac{2}{7}$		$\frac{1}{3}$			$\frac{2}{5}$		$\frac{3}{7}$		$\frac{1}{2}$		$\frac{4}{7}$		$\frac{3}{5}$			$\frac{2}{3}$		$\frac{5}{7}$		$\frac{3}{4}$		$\frac{4}{5}$		$\frac{5}{6}$	$\frac{6}{7}$					$\frac{1}{1}$
\mathscr{F}_8	$\frac{0}{1}$				$\frac{1}{8}$	$\frac{1}{7}$	$\frac{1}{6}$		$\frac{1}{5}$		$\frac{1}{4}$		$\frac{2}{7}$		$\frac{1}{3}$		$\frac{3}{8}$	$\frac{2}{5}$		$\frac{3}{7}$		$\frac{1}{2}$		$\frac{4}{7}$		$\frac{3}{5}$	$\frac{5}{8}$		$\frac{2}{3}$		$\frac{5}{7}$		$\frac{3}{4}$		$\frac{4}{5}$		$\frac{5}{6}$	$\frac{6}{7}$	$\frac{7}{8}$				$\frac{1}{1}$
\mathscr{F}_9	$\frac{0}{1}$			$\frac{1}{9}$	$\frac{1}{8}$	$\frac{1}{7}$	$\frac{1}{6}$		$\frac{1}{5}$	$\frac{2}{9}$	$\frac{1}{4}$		$\frac{2}{7}$		$\frac{1}{3}$		$\frac{3}{8}$	$\frac{2}{5}$		$\frac{3}{7}$	$\frac{4}{9}$	$\frac{1}{2}$	$\frac{5}{9}$	$\frac{4}{7}$		$\frac{3}{5}$	$\frac{5}{8}$		$\frac{2}{3}$		$\frac{5}{7}$		$\frac{3}{4}$	$\frac{7}{9}$	$\frac{4}{5}$		$\frac{5}{6}$	$\frac{6}{7}$	$\frac{7}{8}$	$\frac{8}{9}$			$\frac{1}{1}$
\mathscr{F}_{10}	$\frac{0}{1}$		$\frac{1}{10}$	$\frac{1}{9}$	$\frac{1}{8}$	$\frac{1}{7}$	$\frac{1}{6}$		$\frac{1}{5}$	$\frac{2}{9}$	$\frac{1}{4}$		$\frac{2}{7}$	$\frac{3}{10}$	$\frac{1}{3}$		$\frac{3}{8}$	$\frac{2}{5}$		$\frac{3}{7}$	$\frac{4}{9}$	$\frac{1}{2}$	$\frac{5}{9}$	$\frac{4}{7}$		$\frac{3}{5}$	$\frac{5}{8}$		$\frac{2}{3}$	$\frac{7}{10}$	$\frac{5}{7}$		$\frac{3}{4}$	$\frac{7}{9}$	$\frac{4}{5}$		$\frac{5}{6}$	$\frac{6}{7}$	$\frac{7}{8}$	$\frac{8}{9}$	$\frac{9}{10}$		$\frac{1}{1}$
\mathscr{F}_{11}	$\frac{0}{1}$	$\frac{1}{11}$	$\frac{1}{10}$	$\frac{1}{9}$	$\frac{1}{8}$	$\frac{1}{7}$	$\frac{1}{6}$	$\frac{2}{11}$	$\frac{1}{5}$	$\frac{2}{9}$	$\frac{1}{4}$	$\frac{3}{11}$	$\frac{2}{7}$	$\frac{3}{10}$	$\frac{1}{3}$	$\frac{4}{11}$	$\frac{3}{8}$	$\frac{2}{5}$	$\frac{5}{11}$	$\frac{3}{7}$	$\frac{4}{9}$	$\frac{1}{2}$	$\frac{5}{9}$	$\frac{4}{7}$	$\frac{6}{11}$	$\frac{3}{5}$	$\frac{5}{8}$	$\frac{7}{11}$	$\frac{2}{3}$	$\frac{7}{10}$	$\frac{5}{7}$	$\frac{8}{11}$	$\frac{3}{4}$	$\frac{7}{9}$	$\frac{4}{5}$	$\frac{9}{11}$	$\frac{5}{6}$	$\frac{6}{7}$	$\frac{7}{8}$	$\frac{8}{9}$	$\frac{9}{10}$	$\frac{10}{11}$	$\frac{1}{1}$

structure of *prime numbers* through *Euler's function*. This is described in Appendix 14.A.

14.3.12 The modulus of two rationals, $\frac{p_1}{q_1}$ and $\frac{p_2}{q_2}$, is defined to be $|p_1 q_2 - p_2 q_1|$ where $|\ |$ is the absolute value. Notice that any pair of adjacent rationals in Table 14.2 have modulus 1. For example the modulus of $\frac{2}{5}$ and $\frac{3}{7}$ in F_7 is

$$\left|\begin{matrix} 2 \\ 5 \end{matrix} \times \begin{matrix} 3 \\ 7 \end{matrix}\right| = |14 - 15| = 1.$$

The significance of the moduli of adjacent terms in Table 14.1 will be discussed in Section 15.5.

14.3.13 In Table 14.3 the pattern of the Farey tree is reproduced so that the vertices are labeled with 0 if they are a right branch or 1 if they are a left branch of the tree and the numbers are counted in the manner shown. In this way every number in the Farey sequence is assigned a counting number.

Table 14.1 can be assigned a binary number (see Section 15.2 for a definition of binary numbers). For example, $\frac{2}{5} = 110$, which reproduces its *llr* pattern if $l = 1$ and $r = 0$. Converting 110 from binary to decimal notation, $1 \times 4 + 1 \times 2 + 0 \times 1 = 6$, and we see that $\frac{2}{5}$ is numbered 6 in the tree. As another example, $\frac{3}{8} = llrl = 1101$, which in binary is $1 \times 8 + 1 \times 4 + 0 \times 2 + 1 \times 1 = 13$. Thus $\frac{3}{8}$ can be found as the 13th number in the Farey tree.

Table 14.3 Binary structure of the infinite Farey tree.

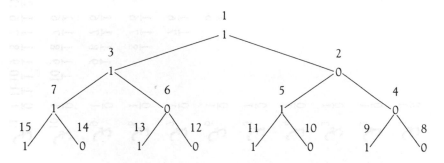

14.3.14 We see that each rational number is associated with a unique positive integer in terms of its binary representation, and each binary representation corresponds to some rational number. In other words, there is a one to one correspondence between the counting numbers and rationals, which means that the rationals are denumerable.

14.3.15 Notice in Table 14.2 that the fractions between $\frac{1}{2}$ and $\frac{1}{1}$ in F_8 constitute ten out of the 12 tones of the octave either from the Just scale (see Section 3.5) or the overtone scale (Section 4.2): $\frac{1}{2}$ = octave, $\frac{4}{7}$ = natural minor seventh, $\frac{3}{5}$ = sixth, $\frac{5}{8}$ = minor sixth, $\frac{2}{3}$ = fifth, $\frac{5}{7}$ = tritone, $\frac{3}{4}$ = fourth, $\frac{4}{5}$ = third, $\frac{5}{6}$ = minor third, $\frac{6}{7}$ = natural minor third, $\frac{7}{8}$ = natural wholetone. Farey series have been used by musical theorists to study systems of musical intonation [Ras].

14.3.16 Beginning with $\frac{1}{1}$, the sequence

$$\dots lll, \; ll, \; l, \; r, \; rr, \; rrr, \dots$$

corresponds to the sequence,

$$\dots \frac{1}{4}, \frac{1}{3}, \frac{1}{2}, \frac{1}{1}, \frac{2}{1}, \frac{3}{1}, \frac{4}{1}, \dots.$$

recognized to be the overtone and undertone series of music (see Section 4.2). The left half of this series appears at the left boundary of Table 14.1.

14.4 Farey Series and Continued Fractions

14.4.1 Consider the number $\frac{2}{5} = llr$. We see from Sequences (14.1) to (14.4) that $\frac{2}{5}$ is located in intervals L, LL, LLR, and forms the left endpoint of $LLRR$ and the right endpoint of $LLRL$. Let us associate $\frac{2}{5}$ with the latter two intervals in which it appears as left and right endpoints for the first time. Justification will follow in (14.4.12).

Let $LLRL = [2, 1, 1]$ and $LLRR = [2, 2]$. We have counted, here, the number of contiguous L's and R's in the L, R-representation. The numbers

in brackets are the *indices* of a compound fraction known as a *continued fraction* where,

$$LLRL = [2, 1, 1] = \cfrac{1}{2 + \cfrac{1}{1 + \cfrac{1}{1}}} \qquad \text{and} \qquad LLRR = [2, 2] = \cfrac{1}{2 + \cfrac{1}{2}} \, .$$

These expressions can be written in abbreviated form as:

$$[2,1,1] = \frac{1}{2+} \ \frac{1}{1+} \ \frac{1}{1} \qquad \text{and} \qquad [2,2] = \frac{1}{2+} \ \frac{1}{2} \, .$$

The indices have been represented in boldface and each compound fraction is easily shown to equal $\frac{2}{5}$.

In general the two intervals associated with each rational number are gotten by converting from the l, r-number notation to the L, R-interval notation by setting $l \leftrightarrow L$, $r \leftrightarrow R$ and adding either a final R or L. By convention, we make this representation unique by insisting that there be no final index of 1 so that $\frac{2}{5} = [2, 2]$.

14.4.2 Given a continued fraction $[2, 1, 3]$ what is its value? By direct computation,

$$[2, 1, 3] = \frac{1}{2+} \ \frac{1}{1+} \ \frac{1}{3} = \frac{4}{11} \, .$$

In other words, $\frac{4}{11}$ is located in the interval, $LLRLLL$, and it corresponds to the number $llrll$. Converting to binary, $\frac{4}{11} = (11011)_2 = 27$, or number 27 in the Farey tree, located in the 4th row 12th number from the right.

14.4.3 If the continued fraction is truncated at successive stages in its development, the resulting compound fractions approximate the value of

the continued fraction. These fractions are called the *convergents* of the continued fraction. For example, the first and second convergents of $\frac{4}{11}$ are

$$\frac{1}{2} \quad \text{and} \quad \frac{1}{3} = \frac{1}{2+1}\frac{1}{1}$$

Of course, the last convergent is the number itself $\frac{4}{11}$. What's more, each convergent is the best approximation to the continued fraction with the no larger denominator. In other words there is no better approximation to $\frac{4}{11}$ than $\frac{1}{2}$ with denominator less than or equal to 2, or $\frac{1}{3}$ with denominator less than or equal to 3.

14.4.4 The convergents of $\frac{4}{11}$ can be generated directly from Table 14.2 by either of the following two procedures:

Locate $\frac{4}{11}$ in row F_{11}.

Choose $\frac{1}{3}$ to the left of $\frac{4}{11}$.

Locate $\frac{1}{3}$ in row F_3 (the top of the column).

Choose $\frac{1}{2}$ to the right of $\frac{1}{3}$.

Locate $\frac{1}{2}$ in row F_2.

Choose $\frac{0}{1}$ to the left of $\frac{1}{2}$.

(Note the left–right–left–... pattern)

Locate $\frac{4}{11}$ in row F_{11}.

Choose $\frac{3}{8}$ to the right of $\frac{4}{11}$.

Locate $\frac{3}{8}$ in row F_8 (the top of the column).

Choose $\frac{1}{3}$ to the left of $\frac{3}{8}$.

Locate $\frac{1}{3}$ in row F_3.

Choose $\frac{1}{2}$ to the right of $\frac{1}{3}$.

Locate $\frac{1}{2}$ in Row F_2.

Choose $\frac{0}{1}$ to the left of $\frac{1}{2}$.

(Note the right–left–right–... pattern)

In this way the two sequences of convergents to $\frac{4}{11}$:

$$\frac{0}{1}, \frac{1}{2}, \frac{1}{3}, \frac{4}{11} \quad \text{and} \quad \frac{0}{1}, \frac{1}{2}, \frac{1}{3}, \frac{3}{8}, \frac{4}{11}$$

correspond to the two continued fraction representations of $\frac{4}{11}$. It is easy to see how this procedure can be generalized to any rational fraction. Try it for $\frac{7}{10}$.

14.4.5 There is an easy and direct way to generate all of the convergents of a continued fraction from its indices. Let me illustrate the method for [2, 1, 3]:

a. Write out the indices. The first convergent is gotten by inverting the first index (i.e., 2)

$$
\begin{array}{ccc}
2 & 1 & 3 \\
\dfrac{1}{2} & &
\end{array}
$$

b. The numerator of the second convergent is the second index. To get the denominator, multiply the denominator of the first convergent by the second index and add 1. For example,

$$
\begin{array}{cc}
2 & 1 \\
\dfrac{1}{2} & \dfrac{1}{3}
\end{array}.
$$

c. If there are any further indices, multiply the index by the previous numerator and add the numerator before; the denominator is gotten by multiplying the index by the previous denominator and adding the denominator before. For example,

$$
\begin{array}{ccc}
2 & 1 & 3 \\
\dfrac{1}{2} & \dfrac{1}{3} & \dfrac{4}{11}
\end{array}.
$$

It is important to note that the modulus between successive convergents is always equal to 1, e.g., $|(4 \times 3)-(11 \times 1)| = 1$.

14.4.6 To make sense out of these convergents requires us to interpret the continued fraction as a sequence of left and right intervals. For example, $\frac{4}{11}$ = [2, 1, 3] = *LLRLLL* where $\frac{4}{11}$ is included in the sequence of intervals –*L*, [*LL*], [*LLR*], *LLRL*, *LLRLL*, [*LLRLLL*]. The intervals with the maximum number of consecutive *L*'s and *R*'s have been placed in brackets; these always form a set of *nested intervals* (the later intervals inside the earlier ones) in which the convergents, marked by arrows, alternate as left and

right endpoints. For example,

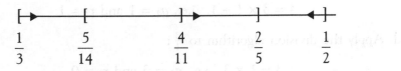

$$\left[\frac{1}{3},\frac{1}{2}\right]\leftarrow, \quad \rightarrow\left[\frac{1}{3},\frac{2}{5}\right], \quad \left[\frac{5}{14},\frac{4}{11}\right]\leftarrow$$

$$LL \qquad\qquad LLR \quad LLRLLL$$

where the convergents are indicated by arrows.

These nested intervals are shown below.

$$\frac{1}{3} \qquad \frac{5}{14} \qquad \frac{4}{11} \qquad \frac{2}{5} \qquad \frac{1}{2}$$

14.4.7 If I now have a fraction such as $\frac{4}{11}$, how do I write it as a continued fraction? To expand $\frac{4}{11}$, or for that matter any rational number, as a continued fraction,

a) write it as the inverse of an improper fraction, i.e., $\frac{1}{11/4}$, (if the number is already an improper fraction go to Step b).

b) write $\frac{11}{4}$ as a mixed number and replace it in a):

$$\cfrac{1}{2 + \cfrac{3}{4}},$$

c) repeat Steps a) and b) for $\frac{3}{4}$ to get:

$$\cfrac{1}{2 + \cfrac{1}{1 + \cfrac{1}{3}}} = [2, 1, 3].$$

14.4.8 This procedure is equivalent to a process known as the the *Euclidean algorithm* which is based on the familiar *division algorithm*. To divide a by d we get a *quotient* q and a *remainder* r:

$$d\,\overline{)a}^{\,qRr} \quad \text{or} \quad a = dq + r \quad \text{for} \quad 0 \le r < d.$$

Let's apply the Euclidean algorithm to the fraction $\frac{4}{11}$.

a. Invert $\frac{4}{11}$ to get $\frac{11}{4}$.

b. Apply the division algorithm to $\frac{11}{4}$:

$$11 = 4 \times 2 + 3, \quad \text{i.e. } q_1 = 2 \text{ and } r_1 = 3.$$

c. Apply the division algorithm to $\frac{4}{3}$:

$$4 = 3 \times 1 + 1, \quad \text{i.e., } q_2 = 1 \text{ and } r_2 = 1.$$

d. Apply the division algorithm to $\frac{3}{1}$:

$$3 = 1 \times 3, \quad \text{i.e., } q_3 = 3 \text{ and } r_3 = 0.$$

e. Since the remainder in the last step is 0 the process ends. The indices of $\frac{4}{11}$ are the sequence of quotients $[q_1, q_2, q_3] = [2, 1, 3]$.

14.4.9 The indices tell how to steer in Table 14.1 from $\frac{0}{1}$ or $\frac{1}{1}$ along a zigzag path to the rational number of interest. For the indices $[2, 1, 3] = \frac{4}{11}$, begin in the 2nd row of the table (Row 0) with $\frac{1}{2}$ directly to the right of $\frac{0}{1}$. Move down 1 row to $\frac{1}{3}$ directly to the left of $\frac{1}{2}$. Then move down 3 rows (Row 4) to $\frac{4}{11}$, the number directly to the right of $\frac{1}{3}$. This procedure begins with $\frac{0}{1}$ for rational less than $\frac{1}{2}$ such as $\frac{4}{11}$. For indices $[1, 2, 3] = \frac{7}{10}$, begin in row 1 with $\frac{1}{1}$. Then move down 2 rows to $\frac{2}{3}$ directly to the left of $\frac{1}{1}$. Then move down 3 rows to $\frac{7}{10}$ directly to the right of $\frac{2}{3}$. Since $\frac{7}{10}$ is greater than $\frac{1}{2}$, the procedure begins with $\frac{1}{1}$.

14.4.10 In general, any number α on the number line between, n and $n + 1$ can be written as the continued fraction:

$$\alpha = [n; a_1, a_2, a_3, \ldots] = n + \cfrac{1}{a_1 + \cfrac{1}{a_2 + \cfrac{1}{a_3}}}$$

or abbreviated as,

$$\alpha = n + \dfrac{1}{a_1+} \ \dfrac{1}{a_2+} \ \dfrac{1}{a_3}.$$

Here n refers to the number of R's at the beginning of the L, R-sequence. If the sequence begins with an L, then $n = 0$ and we shall omit it and write the continued fraction as $[a_1, a_2, a_3, \ldots]$ where the a_k are the *indices*. This always represents a number between 0 and 1.

14.4.11 Consider the decimal representation of a number between 0 and 1 gotten by randomly choosing its digits. Appendix 14.B proves that for such numbers, on the average, the proportion of indices in their continued fraction expansions that are odd are 0.69314... while the proportion that are even are 0.30685... the difference being 0.38629... [Adam1], a number related to the "little end of the stick (LES)" problem (see Section 9.7). For a random fraction, on the average 50% of the indices are 1. Among the odd indices, the fraction that are 1's is 0.72134... while the fraction that are odd numbers other than 1 is 0.2786..., two other numbers related to the LES problem whose ratio is again 0.38629.... Malcomb Lichtenstein [Lich] has verified this theorem by generating random numbers on a computer and computing their indices. He also did this for the digits of π. He discovered that, indeed, 50% of the indices equaled 1.

14.4.12 In Section 14.4.1 we saw that rational numbers can always be represented by sequences of L, R-intervals and that each rational number is the left and right endpoints of a pair of intervals related to the two continued fraction expansions of the number. For example, we have seen that $\frac{2}{5}$ lies in the sequence of intervals $- L$, LL, LLR, and it is the right endpoint of $LLRL$ and the left endpoint of $LLRR$,

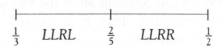

$$\frac{1}{3} \quad LLRL \quad \frac{2}{5} \quad LLRR \quad \frac{1}{2}$$

Next, interval *LLRL* divides into *LLRLL* and *LLRLR* with $\frac{2}{5}$ the right endpoint of the latter; *LLRLR* divides into *LLRLRL* and *LLRLRR* with $\frac{2}{5}$ again the right endpoint of the later interval. Continuing in this way, we find that $\frac{2}{5}$ is the right endpoint of the sequence of intervals,

$$\overbrace{LLRLRRR...R}^{n}, \quad \text{for all} \quad n.$$

Likewise, we find that $\frac{2}{5}$ is the left endpoint of the sequence of intervals,

$$\overbrace{LLRRLLL..L}^{n} \quad \text{for all} \quad n.$$

Thus, the intervals contract upon $\frac{2}{5}$ from the left in the first case and from the right in the second. They are the closest rational numbers to the left and right of $\frac{2}{5}$ in successive rows of the Farey tree. These series of intervals can be translated directly to continued fractions. Just count the number of contiguous R's and L's. For example,

$$\overbrace{LLRLRRR..R}^{n} = \frac{1}{2+} \frac{1}{1+} \frac{1}{1+} \frac{1}{n} \qquad \overbrace{LLRRLLL..L}^{n} = \frac{1}{2+} \frac{1}{2+} \frac{1}{n}.$$

As we take n approaching infinity, we find that the intervals converge upon $\frac{2}{5} = [2, 1, 1]$ and $\frac{2}{5} = [2, 2]$.

In general, any rational number located in the infinite Farey tree (Table 14.1) at the location given by the L, R-sequence — can be represented by two sequences of intervals

$$\text{——} \quad LRRR...R \quad \text{and} \quad \text{——} \quad RLLL...L. \tag{14.5}$$

This accounts for the two continued fraction representations of rational numbers.

14.4.13 In this way we can generate all of the *rational* numbers. But what about the *irrationals*? Irrationals differ from rationals in that their infinite strings are unique, and correspond to nested intervals of width decreasing to 0. All infinite L, R-strings other than Series (14.5) represent irrational numbers. For example, $LRLRLRLR... = [1, 1, 1, ...]$, which is abbreviated

as $[\bar{1}]$, results in the number sequence $\frac{1}{1}, \frac{1}{2}, \frac{2}{3}, \frac{3}{5}, \frac{5}{8}, \frac{8}{13} \dots$ and the corresponding sequence of nested intervals $[\frac{0}{1},\frac{1}{1}], [\frac{1}{2},\frac{1}{1}], [\frac{1}{2},\frac{2}{3}], [\frac{3}{5},\frac{2}{3}], \dots$

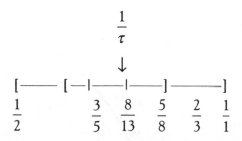

This sequence of numbers and nested intervals approaches $\frac{1}{\tau}$ where $\tau = \frac{1+\sqrt{5}}{2} = 1.618\dots$, the *golden mean*, and has the continued fraction expansion,

$$\frac{1}{1+}\frac{1}{1+}\frac{1}{1+}\frac{1\dots}{1+}\cdots$$

Each of the rational numbers in the approaching series to $\frac{1}{\tau}$ is the best approximation to $\frac{1}{\tau}$ with no larger denominator.

Also note that $RLRLRLRL\dots = [1; 1, 1, 1\dots]$, referring to the number line, gives the approaching sequence: $1, \frac{2}{1}, \frac{3}{2}, \frac{5}{3}, \frac{8}{5}, \dots$ to the golden mean τ. We also see that $\tau = RLRLRL\dots = R + LRLRLR\dots = 1 + \frac{1}{\tau}$.

14.4.14 I refer to any continued fraction whose convergents form a set of nested intervals of the form ---- $LRLRLR\dots$ after some initial sequence as a *noble number* and symbolize it by τ_G. When noble numbers are multiplied by 360 degrees, they yield special angles related to the growth of plants known as *divergence angles*. These angles describe the placement of florets on the surface of a plant such as the florets that result in the spiral whorls of a sunflower. They will be discussed in Chapter 24. For example, the irrational number,

$$LLRLRLRL\dots = [2,\bar{1}] = \frac{1}{\tau^2}$$

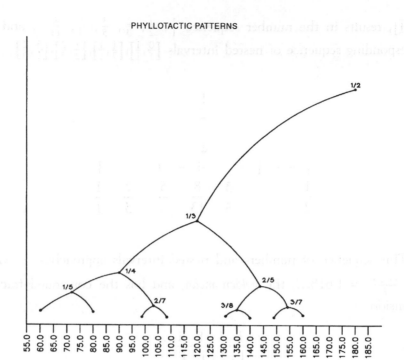

PHYLLOTACTIC PATTERNS

Figure 14.2 A global picture showing the relationship between Farey series and divergence angles. Each $0 \le \frac{p}{q} \le \frac{1}{2}$ corresponds to an angle $360 \times \frac{p}{q}$ degrees. Number pairs on the edges refer to phyllotaxis numbers discussed in Chapter 24.

is the most prevalent noble number, and it leads to the angle $\frac{360}{\tau^2} = 137.5$ degree The next most important angle is $LLLRLRL... = [3, \bar{1}]$ which, when multiplied by 360 yields 99.5 degree. The next angle in importance is $LLRRLRLR... = [2, 2, \bar{1}]$ and gives rise to 151.1 degree. In fact it can be shown that all noble numbers can be represented by the simple formula [Mar-K],

$$\tau_G = \frac{p_0 + p_1\tau}{q_0 + q_1\tau} \tag{14.6}$$

where $\frac{p_0}{q_0}$, $\frac{p_1}{q_1}$ are any pair of neighbors in Table 14.2 (i.e., they have modulus 1). Successive convergents beyond $\frac{p_0}{q_0}$ and $\frac{p_1}{q_1}$ are found by

zigzagging down the Farey tree one row at a time, $\frac{p_2}{q_2} = \frac{p_0}{q_0} \oplus \frac{p_1}{q_1}$, $\frac{p_3}{q_3} = \frac{p_1}{q_1}$ $\oplus \frac{p_2}{q_2}$, etc. For example, corresponding to $\frac{2}{5}$ and $\frac{5}{12}$, the noble number, $\tau_G = \frac{2+5\tau}{5+12\tau} = [2,2,\overline{1}]$, results in the unique zigzag series of convergents: $\frac{1}{2}$, $\frac{2}{5}$, $\frac{5}{12}$, $\frac{7}{17}$, $\frac{12}{29}$,

14.4.15 A global picture of how each of the noble numbers leads to a unique divergence angle is shown in Figure 14.2. Notice that $\frac{1}{2}$ lies at root of this tree, and each fraction when multiplied by 360 degree yields an angle between 0 degree and 180 degree Only the half of the Farey series between $\frac{0}{1}$ and $\frac{1}{2}$ is needed, the other half corresponds to divergence angles from 0 to −180 degree corresponding to spiral whorls in the opposite direction.

Beginning at any fraction in Figure 14.2, a divergence angle corresponding to one of the noble numbers is obtained by zigzagging left and right through successive branches of the Farey tree. These sequences correspond to the evolution in the growth of a plant. This hierarchy of Farey numbers is observed in many physical phenomena, and we shall have more to say about it in the the next section and in Chapter 24.

14.4.16 The numbers in each row of the infinite Farey tree of Table 14.1 can be pictured on an x, y-coordinate system as shown in Figure 14.3 where x = Numerator and y = Denominator. Notice that the points, when connected, take the form of "flames reaching towards heaven" [Adam1]. Also notice that the leading points of the flame in each row correspond to the fractions $\frac{1}{2}$, $\frac{2}{3}$, $\frac{3}{5}$, $\frac{5}{8}$, ..., and $\frac{1}{3}$. $\frac{2}{5}$, $\frac{3}{8}$, $\frac{5}{13}$,... the convergents $\frac{1}{\tau}$ and $\frac{1}{\tau^2}$ where τ represents the golden mean.

14.5 Continued Fractions, Gears, Logic, and Design

14.5.1 The subject of continued fractions can be elegantly pictured by a mathematical structure known as *Ford circles* (cf. [Rad1], [Rad2]. Each rational number $\frac{h}{k}$ is represented as a circle or "gear" with center at x

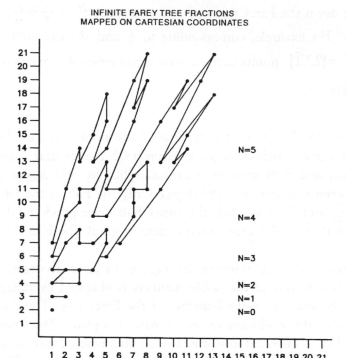

INFINITE FAREY TREE FRACTIONS
MAPPED ON CARTESIAN COORDINATES

Figure 14.3 Numbers from the Farey series pictured as "flames reaching to heaven". The fraction $\frac{p}{q}$ is graphed as point (p, q) of a Cartesian coordinate system. Golden mean convergents are peak values of the flame.

coordinate = $\frac{h}{k}$, y-coordinate = $\frac{1}{2k^2}$, and radius equal to $\frac{1}{2k^2}$. In this way the circle of each fraction is tangent to the x-axis and no two circles cross, as shown in Figure 14.4. However, two circles are tangent ("kiss") when their modulus equals 1 in the sense of Section 14.3.12. For example, the zigzag pattern of circles marked 1, 2, 3, 4 represent the sequence of rationals: $\frac{1}{1}$, $\frac{1}{2}$, $\frac{2}{3}$, $\frac{3}{5}$... circles that are approaching $\frac{1}{\tau}$. Notice that successive pairs in this series have modulus 1 and that the circles form a kissing sequence. For any number, its sequence of convergents always form a kissing sequence of gears. Although we have been using the term gear in a figurative sense, any family of kissing circles actually represents a series of compatible gears in the sense that their teeth can mesh with each other (see Appendix 14.C).

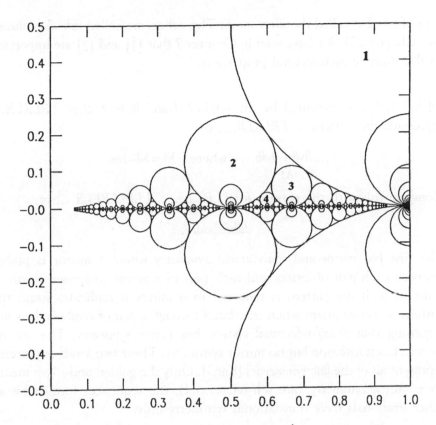

Figure 14.4 A sequence of Ford circles. Each Farey fraction $\frac{h}{k}$ is represented by the center of a circle with coordinates $\left(\frac{h}{k}, \frac{1}{2k^2}\right)$. Farey pairs with modulus 1 are tangent ("kissing circles"). The sequence of circles labeled 1, 2, 3, 4 represent fractions: $\frac{1}{1}$, $\frac{1}{2}$, $\frac{2}{3}$, $\frac{3}{5}$ from the Fibonacci series.

14.5.2 Notice that if the two golden mean sequences: *LRLRLR...* and *RLRLRL...* are extended to double sequences: *...LRLRLR...* and *...RLRLRL...* they are identical to the two imaginary numbers *I* and *J* introduced by Kauffman to represent the extension of Boolean logic to self-referential systems (see Section 13.6 and Appendix 13.A). For that matter, any sequence of the form: *LLRRLLRRLL...* or *LLLRRRLLLRRR...* etc. can be seen to be self-referential. Each of these numbers corresponds to a continued fraction with 1, 2, 3... or n down the diagonal, i.e., $[\bar{n}]$ (see Section 22.10). For $n = 1$, this results in the $\frac{1}{\tau}$. It is only fitting that the

case of $n = 2$ is called the *silver mean*. The others are called *nth silver means* (see Chapter 22). We have seen in Chapter 7 that $[\bar{1}]$ and $[\bar{2}]$ are important to the study of architectural proportion.

14.5.3 If L is represented by the symbol d and R by b then $LRLRLR...$ represents the pattern, $...LRLRLR...$, or,

$$...dbdb \mid dbdb... \quad \text{where} \quad M = \text{Mirror.}$$
$$M$$

Compare this with the pattern for LLR, i.e., $...LLRLLRLLR...$, or,

$$...ddbddbddb....$$

The first has *mirror* and *translational symmetry* where a mirror is placed between each pair of letters and each pair of symbols comprises a unit of translation. If the pattern is reflected in a mirror it replicates itself; the pattern is also invariant when translated through a pair of symbols. It is not surprising that a *self-referential* system has *mirror symmetry*. The second pattern has translation but no mirror symmetry. These two kinds of patterns represent all of the *line symmetries* [Kap3]. Only the golden and silver means have mirror symmetry (are self-referential), the sequences formed by all other irrationals have translational symmetry only.

14.6 Farey Series and Natural Vibrations

The Greeks spoke of the harmony of the spheres in a kind of metaphorical way. Plato felt that an understanding of the structure of the universe lay within the grasp of the human mind, if only humans could think about it in the correct manner. As we saw in Chapter 5, Kepler actually went so far as to attribute a musical phrase to each separate planet and to the ensemble of planets as they whirled about the sun. Modern science has shown that Kepler's ideas were not valid as he stated them. Yet scientists have recently been reporting phenomena in which the vibrations or oscillations of complex chemical reactions, quantum effects, vibrations of the beating hearts of chicken embryos, the variation in the intensity of light from binary

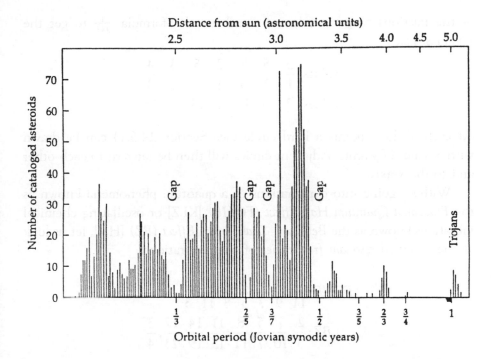

Figure 14.5 Number of asteroids plotted against distance from the sun (in units of Jupiter's orbital period).

stars, gaps in the asteroid belt, as well as the musical scale, and many other phenomena can be read directly from the Infinite Farey Sequence (cf. [Bak1], [Adam1]).

The distribution of catalogued asteroids at various distances from the sun [Pet] are recorded on the graph shown in Figure 14.5. According to Kepler's third law, the distance from the sun of an orbiting body depends only on the period of revolution; the greater the distance from the sun, the greater the period of revolution. The distance from the sun in Figure 14.5 is reckoned as a fraction of the period of Jupiter's orbital period. It is a remarkable discovery that there is an absence of asteroids with the following simple orbital periods, $\frac{k}{h}$: $\frac{1}{3}$, $\frac{2}{5}$, $\frac{3}{7}$, $\frac{1}{2}$, $\frac{3}{5}$, $\frac{2}{3}$, $\frac{3}{4}$.

Checking these fractions for unimodularity in the sense of Section 14.3.12, we see that all of them have modulus 1 and can be found as adjacent values of rows F_6 and F_7 of Table 14.2. Then we invert each

of the fractions to get x-values $\frac{k}{h}$, and use the formula $\frac{1}{2k^2}$ to get the y-values, i.e.,

$$x\text{-values}: \frac{3}{1} \quad \frac{5}{2} \quad \frac{7}{3} \quad \frac{2}{1} \quad \frac{5}{3} \quad \frac{3}{2} \quad \frac{4}{3}$$

$$y\text{-values}: 2 \quad 8 \quad 18 \quad 2 \quad 18 \quad 8 \quad 18$$

At each of these points a Ford circle (see Section 14.5.1) can be drawn with a radius of y units. Adjacent circles will then be tangent to each other and to the x-axis.

Without going into explanations of a quantum phenomena known as the *Fractional Quantum Hall Effect (FQHE)* [KLZ] or oscillating chemical vibrations known as the *Belousov–Zhabotinsky Effect (BZ)* [Hal], let us look at the observed *resonant frequencies* of their vibrations.

$$FQHE: \frac{6}{11}, \frac{5}{9}, \frac{4}{7}, \frac{3}{5}, \frac{5}{8}, \frac{7}{11}, \frac{2}{3}$$

$$BZ: \frac{2}{3}, \frac{7}{10}, \frac{5}{7}, \frac{8}{11}, \frac{11}{15}, \frac{14}{19}, \frac{17}{23}, \frac{3}{4}$$

With the exception of $\frac{5}{8}$ the other *FQHE* fractions appear in row F_{11} of Table 14.2 with modulus 1 between adjacent fractions. As for the BZ reaction, all fractions except: $\frac{11}{15}$, $\frac{14}{19}$, $\frac{17}{23}$ appear in row F_{11}. Furthermore, the exceptions can be derived from $\frac{8}{11}$ and $\frac{3}{4}$ as follows: $\frac{11}{15}$ is the mediant of $\frac{8}{11}$ and $\frac{3}{4}$, i.e., $\frac{8}{11} \oplus \frac{3}{4} = \frac{11}{15}$, $\frac{14}{19}$ is the mediant of $\frac{11}{15}$ and $\frac{3}{4}$, while $\frac{17}{23}$ is the mediant of $\frac{14}{19}$ and $\frac{3}{4}$.

Why is it that the Farey series is a kind of "book of nature"? In Chapter 25 we shall see that, to some degree, this can be explained by an important phenomenon know as *mode locking* and a mathematical structure called the *Devil's staircase*. Through the Devil's staircase, the Farey series will be shown to define a hierarchy of rational numbers in which numbers higher in the Farey table are more "stable" in some sense than lower numbers, e.g., $\frac{1}{2}$ is the most stable of rationals since it is highest in the table [Kap14].

Table 14.4 records the continued fraction values for *FQHE* and BZ.

Table 14.4 Resonant values of the fractional quantum Hall effect.

FQHE	BZ
$\frac{1}{2}$ [11]	$\frac{7}{10}$ [12]
$\frac{6}{11}$ [115]	$\frac{5}{7}$ [1211]
$\frac{5}{9}$ [114]	$\frac{8}{11}$ [1212]
$\frac{4}{7}$ [113]	$\frac{11}{15}$ [1213]
$\frac{3}{5}$ [112]	$\frac{14}{19}$ [1214]
$\frac{5}{8}$ [1112]	$\frac{17}{23}$ [1215]
$\frac{7}{11}$ [1113]	$\frac{3}{4}$ [121]
$\frac{2}{3}$ [111]	

What is involved here? This appears to be a sorting mechanism akin to the way electrons are filled in the outer shells of atoms. When I present, in Chapter 24, the manner in which patterns of pine cones, pineapples, and the florets of a sunflower organize themselves, a similar sorting mechanism will be seen.

14.7 Conclusion

Number can reveal information about the natural world from quantum phenomena to that of the universe. Just as number provides a framework for patterns of plant growth, we can uncover the secrets of number only by holding it up to the light in the proper way. Natural phenomena express themselves through number itself without the need to measure. Observation and measurement succeeds only in verifying what was already present within number itself.

Appendix 14.A Euler's γ-Function

The jump in the number of rationals from row $n - 1$ to row n of Table 14.2 is computed by *Euler's γ function*:

$$\gamma(n) = n\left(1 - \frac{1}{p_1}\right)\left(1 - \frac{1}{p_2}\right)\left(1 - \frac{1}{p_3}\right)\cdots \tag{14.A1}$$

where p_1, p_2, \ldots are the *prime factors* of n with *no* repeats. In general, this jump is greatest when n is a prime number, i.e., it is divisible by only itself and 1. When n is a prime, clearly $n - 1$ new rationals are added to the previous row, $\frac{1}{n}, \frac{2}{n}, \ldots, \frac{n-1}{n}$. For example, if n is the prime number 23, Equation (14.A1) yields, $\gamma(23) = 22$. However, if $n = 24 = 2 \times 2 \times 2 \times 3$, then the prime factors of 24 are are 2 and 3 and,

$$\gamma(24) = 24\left(1 - \frac{1}{2}\right)\left(1 - \frac{1}{3}\right) = 8.$$

Thus, F_{23} jumps by 22 new members while F_{24} increases by only 8: $\frac{1}{24}$, $\frac{5}{25}$, $\frac{7}{24}$, $\frac{11}{24}$, $\frac{13}{24}$, $\frac{17}{24}$, $\frac{19}{24}$, and $\frac{23}{24}$.

So we see that the Farey sequence is intimately connected with prime numbers. The 19th century mathematician J.J. Sylvester discovered a formula, $\frac{3n^2}{\pi^2}$, that approximates the total number of rational numbers in the nth row of the Farey sequence or $|F_n|$ (or F_n for short) as $n \to \infty$. Now we can determine the probability, P, that any two randomly chosen integers are relatively prime. Since all fractions in the Farey sequence have relatively prime numerators and denominators, all we have to do is compute the total number of fractions with denominator less than or equal to n, T_n, regardless of common factors, and the probability that a pair or integers less than or equal to n is relatively prime is:

$$P_n = \frac{F_n}{T_n}. \tag{14.A2}$$

To compute T_n list the fractions with denominator equal to n.

For $n = 1 : \frac{0}{1}$;

$\quad n = 2 : \frac{0}{2}, \frac{1}{2}$;

$\quad n = 3 : \frac{0}{3}, \frac{1}{3}, \frac{2}{3}$;

$\quad n = 4 : \frac{0}{4}, \frac{1}{4}, \frac{2}{4}, \frac{3}{4}$;

\quad ...etc.

We see that T_n equals the nth triangular number or $\dfrac{n(n+1)}{2}$, e.g., $T_4 = 4 \times \frac{5}{2} = 10$. From (14.A2) we find that,

$$P_n = \frac{F_n}{T_n} = \frac{6n^2}{\pi^2 n(n+1)} = \frac{6}{\pi^2\left(1+\frac{1}{n}\right)},$$

and as $n \to \infty$, $P = \frac{6}{\pi^2} = 0.6079....$ So in an *asymptotic* sense, about 61% of the number pairs are relatively prime.

The relationship between Farey sequence, prime numbers, and the Euler function may be connected with recent research on the spacing of energy levels of Hydrogen in a magnetic field (cf. [Berr], [Gut]).

Appendix 14.B The Relation between Continued Fraction Indices and the Little End of the Stick Problem

Gary Adamson [Adam1] has shown that the frequency in which indices of continued fractions appear is related to the "little end of the stick problem".

Section 14.4.7 described a procedure to convert a proper fraction x to a continued fraction. This amounts to computing $\frac{1}{x}$ mod 1. (See Appendix 23.A for a discussion of mod.) In other words, invert the fraction, extract the integer part and discard the fractional part. The integer part is the index of the continued fraction. Repeat this operation on the fractional part of the number. It is easy to see that if x is between $\frac{1}{2}$ and 1 (an interval of length $\frac{1}{2}$), $\frac{1}{x}$ mod 1 (i.e., the fractional value of $\frac{1}{x}$) yields an index of 1; if x is between $\frac{1}{3}$ and $\frac{1}{2}$ (an interval of length $\frac{1}{6}$), the index is 2;

between $\frac{1}{4}$ and $\frac{1}{3}$ (an interval of length $\frac{1}{12}$), the index is 3; etc. Therefore the unit interval is subdivided into intervals corresponding to the following lengths and indices:

$$1 \quad 2 \quad 3 \quad 4 \quad 5 \quad 6$$

$$\frac{1}{2}+\frac{1}{6}+\frac{1}{12}+\frac{1}{20}+\frac{1}{30}+\frac{1}{42}+\cdots=1. \qquad (14.B1)$$

Next we examine the series for ln 2 (where ln is the abbreviation for \log_e). It is shown in advanced mathematics textbooks that,

$$\ln 2 = 1 - \frac{1}{2}+\frac{1}{3}-\frac{1}{4}+\frac{1}{5}-\frac{1}{6}+\frac{1}{7}\cdots.$$

Grouping these by pairs, we get

$$\frac{1}{2}+\frac{1}{12}+\frac{1}{30}\cdots \qquad (14.B2)$$

which are alternate members of Series (14.B1), being all of the odd terms. Series (14.B1) is represented graphically within the unit square of Figure 14.B1. The white area in the unit square equals the sum of the odd terms in Series (14.B1). Therefore, using calculus to compute the area under the hyperbolic function $y = \frac{1-x}{x}$,

White Area = Odd Indices = ln 2 = 0.69314...,
Black Area = Even Indices = 1 − ln 2 = 0.30685....

Figure 14.B1

In other words, the probability of getting an odd continued fraction index is 0.693... and for an even index, 0.306... (the difference being 0.38629...). Now look at just the odd indices. The portion of the white area to the left of the dotted line in Figure 14.B1 equals $\frac{1}{2}$ the area of the unit square and represents the probability that indices equal 1. As a percentage of the white area, this equals 0.7213..., which represents the probability that an odd index is 1. The white area to the right of the dotted line represents the probability that odd indices are other than 1. As a percentage of the white area this equals 0.27865.... Therefore, these probability sets match our Little End of the Stick Problem (see Section 9.4) where we showed that

Long end of the average stick = 0.72134..., and
Short end of the average stick = 0.27865...

with the ratio being equal to 0.38629. So we see that these numbers arise in many different contexts.

Appendix 14.C "Kissing" Gears

Each rational number $\frac{h}{k}$ can be represented as a Ford circle or gear. When the modulus of two fractions equals 1, the corresponding Ford circles are tangent. These are referred to as "kissing" circles or gears. Consider the sequence of kissing gears : $\frac{1}{2}$, $\frac{3}{5}$, $\frac{5}{8}$, $\frac{8}{13}$, ... approaching $\frac{1}{\tau}$.

In Figure 14.C1 we see a pair of gears corresponding to $\frac{3}{5}$ from this sequence. Gear 1 has a radius 3 units and has three teeth and three indentations or slots numbered : 0, 1, 2, while gear 2 has a radius of 5 units and has five teeth and five slots numbered: 0, 1, 2, 3, 4. Each tooth of a gear with n teeth and radius n units spans a length of π units since,

$$\text{Tooth length} = \frac{\text{circumference}}{2} \times \text{number of teeth} = \frac{2\pi n}{2n} = \pi \quad \text{units.}$$

Since the teeth of gear 1 match the slots of gear 2, and vice versa, the gears *mesh*. We find that as gear 2 turns counterclockwise through 3 complete revolutions, gear 1 turns clockwise through 5 revolutions. Alternatively, hold gear 2 stationary, and dip tooth 0 of gear 1 into a red dye and place

KISSING GEARS

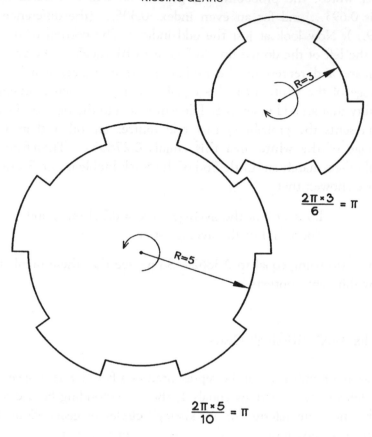

$$\frac{2\pi \times 3}{6} = \pi$$

$$\frac{2\pi \times 5}{10} = \pi$$

Figure 14.C1 Meshing gears. Five clockwise rotations of a 3-tooth gear produces three counterclockwise rotations of a 5-tooth gear.

it in slot 0 of gear 2, marking the slot with the red dye. As gear 1 rotates clockwise, the next slot of gear 2 that is marked by the red dye will be slot 3, and then, after another rotation of gear 1, slot 1, followed by slots 4 and 2, before the marked tooth returns to its original position after making five complete rotations. Whenever, the pair of tooth numbers (3 and 5 in this case) are relatively prime (both divisible by only 1) each slot of gear 2 will be marked by the dye, otherwise there will be unmarked slots. The movement of the marked point traces a star pentagon $\left\{\frac{5}{3}\right\}$. (See Figure 24.9a for a

diagram of $\left\{\frac{5}{2}\right\}$). During one rotation of gear 1, the marked point progresses through an angle of $\frac{3}{5} \times 360$ degree about the circumference of gear 2, an approximation to $\frac{1}{\tau} \times 360$ degree.

The same holds, in general, for any other kissing sequence $\left\{\frac{P_k}{Q_k}\right\}$, the continued fraction convergents of α. Gear 1 rotates P_k times clockwise while gear 2 rotates Q_k times in a clockwise direction. During a single progression of gear 1 about gear 2, gear 1 turns through an angle of $\frac{P_k}{Q_k} \times$ 360 degree on the circumference of gear 2, where $\frac{P_k}{Q_k}$ approximates the irrational number α. The sequence of turns follows the sequence of vertices of star polygon $\left\{\frac{Q_k}{P_k}\right\}$. (See Section 22.5 for a discussion of star polygons.)

15

Number: Gray Code and The Towers of Hanoi

> God made the integers;
> all else is the work of man.
>
> *Leopold Kronecker*

15.1 Introduction

In the last chapter rational numbers were expressed as continued fractions, and each rational number was related to an integer expressed in binary notation. A mathematical structure known as Gray code gives another way to relate rational numbers to integers. In this chapter, I will explore Gray code and its relationship to an old puzzle known as the Towers of Hanoi.

15.2 Binary Numbers and Gray Code

Any positive integer (i.e., counting number) can be represented in terms of the numbers 0 and 1. In the *binary system* numbers are represented by a kind of "decimal" system based on the number 2. In this system any integer N is represented by $N = (a_n a_{n-1} \ldots a_2 a_1 a_0)_2$ where

$$N = a_n \times 2^n + a_{n-1} \times 2^{n-1} + \ldots + a_2 \times 2^2 + a_1 \times 2 + a_0$$

and $a_0, a_1, a_2, \ldots, a_n$ can be either 0 or 1. For example,

$$(11010)_2 = 2 + 8 + 16 = 26.$$

Table 15.1 Rational fractions, Gray code, and the Towers of Hanoi.

N	Binary	Modularity	Gray	+0	TOH Sequence	Cont. Frac. Indices	Fraction	Pegs A	B	C
0	0		0	0		[0]	0	(Start)		
1	1	1	1	0	1	[2]	$\frac{1}{2}$		1	
2	10		11	0	2	[1,2]	$\frac{2}{3}$		1	2
3	11	3	10	0	1	[3]	$\frac{1}{3}$			1/2
4	100		110	0	3	[1,3]	$\frac{3}{4}$		3	1/2
5	101	3	111	0	1	[1,1,2]	$\frac{3}{5}$	1	3	2
6	110	5	101	0	2	[2,2]	$\frac{2}{5}$	1	2/3	
7	111	3	100	0	1	[4]	$\frac{1}{4}$		1/2/3	
8	1000		1100	0	4	[1,4]	$\frac{4}{5}$		1/2/3	4
9	1001	3	1101	0	1	[1,2,2]	$\frac{5}{7}$		2/3	1/4
10	1010	5	1111	0	2	[1,1,1,2]	$\frac{5}{8}$	2	3	1/4
11	1011	3	1110	0	1	[1,1,3]	$\frac{4}{7}$	1/2	3	4
12	1100	7	1010	0	3	[2,3]	$\frac{3}{7}$	1/2		3/4
13	1101	3	1011	0	1	[2,1,2]	$\frac{3}{8}$	2	1	3/4
14	1110	5	1001	0	2	[3,2]	$\frac{2}{7}$		1	2/3/4
15	1111	3	1000	0	1	[5]	$\frac{1}{5}$			1/2/3/4
16	10000		11000	0	5	[1,5]	$\frac{5}{6}$			51/2/3/4

Table 15.1 (*Continued*)

N	Binary	Modularity	Gray	TOH +0	Sequence	Cont. Frac. Indices	Fraction	Tower of Hanoi Positions Pegs A	B	C
17	10001	3	11001	0	1	[1,3,2]	$\frac{7}{9}$	1	5	2/3/4
18	10010	5	11011	0	2	[1,2,1,2]	$\frac{8}{11}$	1	2/5	3/4
19	10011	3	11010	0	1	[1,2,3]	$\frac{7}{100}$		1/2/5	3/4
20	10100	7	11110	0	3	[1,1,1,3]	$\frac{7}{11}$	3	1/2/5	4
21	10101	3	11111	0	1	[1,1,1,1,2]	$\frac{8}{13}$	3	2/5	1/4
22	10110	5	11101	0	2	[1,1,2,2]	$\frac{7}{12}$	2/3	5	1/4
23	10111	3	11100	0	1	[1,1,4]	$\frac{5}{9}$	1/2/3	5	4
24	11000	9	10100	0	4	[2,4]	$\frac{4}{9}$	1/2/3	4/5	
25	11001	3	10101	0	1	[2,2,2]	$\frac{5}{12}$	2/3	1/4/5	
26	11010	5	10111	0	2	[2,1,1,2]	$\frac{5}{13}$	3	1/4/5	2
27	11011	3	10110	0	1	[2,1,3]	$\frac{4}{11}$	3	4/5	1/2
28	11100	7	10010	0	3	[3,3]	$\frac{3}{10}$		3/4/5	1/2
29	11101	3	10011	0	1	[3,1,2]	$\frac{3}{11}$	1	3/4/5	2
30	11110	5	10001	0	2	[4,2]	$\frac{2}{9}$	1	2/3/4/5	
31	11111	3	10000	0	1	[6]	$\frac{1}{6}$		1/2/3/4/5	

The integers from 1–31 are listed in the first column of Table 15.1. However, the binary system has one disadvantage. Notice that more than one digit changes its value between successive numbers. For example, integer 3 equals binary 11 while integer 4 equals binary 100, a change in the units, 2's and 4's places. Gray code is a system which avoids this problem [Gard3]. The numbers 1–31 are represented in column 4 of Table 15.1 in Gray Code. The sequence of numbers is organized so that only a single digit changes its value from one integer to the next, and this change occurs in the least significant digit to give a number not already listed. Column 5 of Table 15.1 indicates the Gray code position in which this change occurs (this is also the binary position in which a 0 changes to 1). If the number of 1's in Gray code is even, then the next number replaces the 0 with a 1, or 1 with 0 in the last place; if the number of 1's is odd then change the 0 to a 1, or 1 to 0 in the place to the left of the rightmost 1 to get the next number. For example, integer 14 equals Gray code 1001 which has two 1's (even). Therefore integer 15 Gray code 1000 (change from 1 to 0 in the last place). Integer 13 equals Gray code 1011 has three 1's (odd). Therefore integer 14 equals Gray code 1001 (the 1 next to the rightmost 1 in 13 has been changed to 0).

Note that the Gray Code numbers in Table 15.1 are organized in blocks of size: $1, 2, 4, 8, \ldots, 2^n$ with the number of digits equal to $n + 1$. In this way, each Gray code number is uniquely associated with a decimal number. Also notice that each block reflects the digits of the previous block as in a mirror with the exception of the leading 1 or 0. For this reason the sequence is sometimes referred to as *reflecting Gray Code*. Figure 15.1 recreates the Gray Code as a design. This design is a template for recreating Gray Code up to 7 digits. To read this wheel, the black areas represent 1's, while the whites are 0's. In the outermost circle each black area and space represent a pair of 1's and 0's. Gray code numbers are read radially from the innermost black area to the outer ring. Reading clockwise from the top, the first number is 1 the next number is 11, then 10 and 110. In this way the Gray code sequence listed in Table 15.1 can be reconstructed. In Appendix 15.A, instructions are given for changing binary to Gray Code and Gray Code to binary.

Figure 15.1 Gray code design.

15.3 Gray Code and Rational Numbers

I will now correlate each Gray code number with a rational number from the Infinite Farey Tree represented by its continued fraction (see Section 14.4) by using the following set of deflation rules:

(a) Add a 0 to the end of the Gray code number, as shown in column 5 of Table 15.1. This insures the uniqueness of the continued fraction representation by making the last index greater than 1 (see (14.4.1)).

(b) Then, let $\quad 1 \to 1,$
$$0 \to 2,$$
$$100 \to 3, \text{ etc.,}$$

and proceed from left to right in the Gray code to determine the sequence of continued fraction indices, e.g. Integer 24 equals Gray code 10100. Add a zero to get,

$$101000 = [2, 4] = \frac{1}{2 + \frac{1}{4}} = \frac{4}{9} .$$

Try this for other Gray code values listed in Table 15.1.

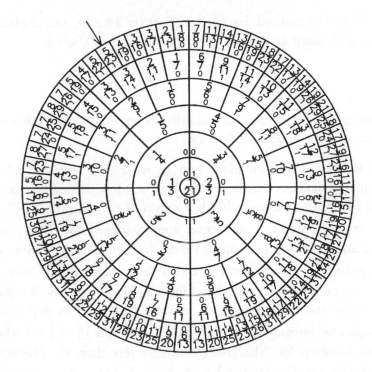

Figure 15.2 Adamson's Continued Fraction Wheel maps Gray code to Farey sequence. Read the sequence of 1's and 0's outwards from the center to each fraction to get the Gray code equivalent.

Gary Adamson illustrates this mapping of Gray Code to the Infinite Farey Tree with his *Continued Fraction Wheel* shown in Figure 15.2. Each ring of this Gray Code wheel corresponds to a row of the Infinite Farey Tree (see Table 14.1). The corresponding Gray Code is found by reading the sequence of 1's and 0's outward from the center in a straight line to the desired fraction. For example, a straight line from the center to the arrow yields 1000111 for which the corresponding continued fraction is found by adding one zero, i.e., 10001110 = 1000 1 1 10 ≡ [4, 1, 1, 2] = $\frac{5}{23}$.

The continued fraction can also be derived from the binary representation. As an example, Gray code 1000111 can be converted to binary 1111010 as shown in Appendix 15.A and directly translated to

[4, 1, 1, 2] by the method described in Section 14.3.13, i.e., duplicate the last digit and count contiguous groupings of 1's and 0's, e.g.

$$1111\ 0\ 1\ 00$$
$$4\quad 1\ 1\quad 2.$$

Referring to Table 15.1, the following observations can be made about the indices of the continued fractions:

a) The indices of the nth block sum to $n+1$ and represent all of the ordered sequences of indices from 1 to $n+1$ with final index greater than 1, e.g., the indices of block 3 sum to 4 : [1, 3], [1, 1, 2], [2, 2], [4].

b) The convergents of $\frac{1}{\tau}$ are found approximately one-third down the block and have indices of all 1's except for a final 2; the convergents of $\frac{1}{\tau^2}$ are found approximately two-thirds down the block and have indices of all 1's except for an initial and final 2. These two sets of indices are among the most dispersed of all continued fractions in that block. For example, for integer block 8–15, $\lfloor \frac{1}{3} \times 8 \rfloor = 2$ and $\lfloor \frac{2}{3} \times 8 \rfloor = 5$ where $\lfloor r \rfloor$ is the notation for "the greatest integer less than r". Therefore the convergents of $\frac{1}{\tau}$ and $\frac{1}{\tau^2}$, $\frac{5}{8}$ and $\frac{3}{8}$, are positioned at integer values $8 + 2 = 10$ and $8 + 5 = 13$ where $\frac{3}{8} = [2, 1, 2]$ and $\frac{5}{8} = [1, 1, 1, 2]$, the two most dispersed continued fractions among positions 8–15.

15.4 Gray Code and Prime Numbers

Gray Code is intimately related to prime numbers. In fact, to find the integer corresponding to a Gray code number, take any Gray code number and delete the first "1" starting at the left and replace the "0's" with the prime number from the sequence 2, 3, 5, 7, 11, The integer associated with this Gray code number is the product of these primes. Thus, 11010 becomes,

$$\frac{2\ 3\ 5\ 7}{1\ 0\ 1\ 0} = 3 \times 7 = 21$$

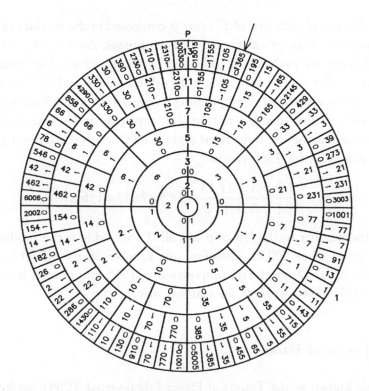

Figure 15.3 Adamson's Prime Number Gray Code Wheel maps Gray code to numbers composed of prime factors with no repeating primes. The prime factors of any number are located at the positions of the zeros of its Gray code equivalent.

Adamson's *Prime Number Gray Code Factor Wheel* is shown in Figure 15.3. This wheel makes use of the *Fundamental Theorem of Arithmetic* which states that any positive integer z can be written as a product of its prime factors p_1, p_2, p_3, \ldots, each raised to the appropriate power r_1, r_2, r_3, \ldots,

$$z = p_1^{r_1} \, p_2^{r_2} \, p_3^{r_3} \cdots .$$

The Factor Wheel considers only integers represented by primes to the 1st power, i.e., the r's are all 1. The probability that a positive integer has no repeated primes can be shown to be identical to the probability that two integers are relatively prime. Appendix 14.A shows that this probability is approximately equal to 61%.

In this wheel each ring of 2^n units is composed of the product of various combinations of the products of the first n primes, $2 \times 3 \times 5 \times \dots \times p_n$ (the highest prime for each row is indicated by the p radius). For example, all numbers in the circle labeled 5 are divisible by 2, 3, and 5. To convert a Gray code number to its corresponding integer, draw a line from the center (ring zero) to the number, noting the sequence of 1's and 0's in each compartment along the way. Then replace all 0's with the highest prime in each circle, e.g., for 1365 (arrow)

$$\frac{1\ 2\ 3\ 5\ 7\ 11\ 13}{1\ 1\ 0\ 0\ 0\ 1\ \ 0} = 3 \times 5 \times 7 \times 13 = 1365.$$

Since the number to the left of p has all 0's, its value is the product of all primes up to 13 or 30030. Therefore any number on the wheel is a factor of 30030. In fact, from the decomposition of 1365 into primes, it is evident that $30030 = 1365 \times 22$. (Can you see why?)

15.5 Towers of Hanoi

A puzzle known as the *Towers of Hanoi* (abbreviated TOH), an invention of the French mathematician Edouard Lucas in 1883, is rich in geometrical and numerical relationships [Gard1,3], [Hin]. In this puzzle, disks of decreasing size are placed on three wooden pegs, as shown in Figure 15.4. The poles are arranged clockwise as seen from above in the order A,B,C. The object of the puzzle is to transfer the disks from one peg to another in the minimum number of moves, one at a time, in such a way that a smaller disk always lies atop a larger one. For example, for three disks labeled 1, 2, 3 from small to large lying initially on peg A, the puzzle is solved by the following sequence of moves.

Move 1 to peg B, 2 to peg C, 1 to peg C, 3 to peg B, 1 to peg A, 2 to peg B, 1 to peg B.

The moves involve transferring the disks in the following order of their numbers: 1213121 or 7 moves. The sequence for 4 disks is 121312141213121 or 15 moves. In general, n disks require $2^n - 1$ moves. In the above example, note that odd numbered disks always move a single step in a clockwise (CW) direction while even numbered disks move a single step in the

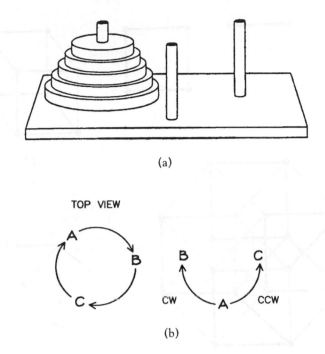

(a)

(b)

Figure 15.4 The Towers of Hanoi puzzle.

counterclockwise (CCW) direction, e.g., disk 1 moves initially from peg A to peg B (clockwise) while disk 2 moves from peg A to peg C (counterclockwise). With the prescription that odd numbered disks move CW while even numbered disks move CCW the solution to the TOH problem is unique.

These moves can be related to Gray Code. In order to understand these relationships, we must first reconsider the *n-dimensional cube* described in Section 6.6. The sequence of winning moves for the Tower of Hanoi puzzle is also the sequence of movements along a *Hamilton path* of an *n*-dimensional cube. The Hamilton path through any connected set of edges and vertices is a route through the edges that visits each vertex without revisiting a vertex (although the edges may be retraced and all edges need not be traversed). For example the Hamilton paths for the 1, 2, 3, and 4-D cubes are shown in Figures 15.5a, b, c, d. (See Section 6.6). These paths

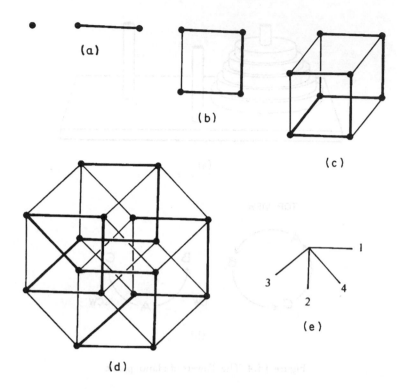

Figure 15.5 (a,b,c,d) Hamilton paths for 1, 2, 3, and 4-dimensional cubes are represented by the sequence of edges oriented as shown in (e). For the 3-dimensional cube the sequence 1213121 is the winning strategy of the Towers of Hanoi puzzle with three disks; the Hamilton sequence of the 4-dimensional cube 121312141213121 is the winning strategy of TOH for four disks.

are represented by the sequence of darkened edges oriented as shown in Figure 15.5e. For example, the sequence of directions along the Hamilton path of the 3-dimensional cube in Figure 15.5c is 1213121 and is identical with the winning strategy for TOH with three disks. The winning strategy for the TOH with four disks is 121312141213121 and is represented by the Hamilton path of the 4-dimensional cube in Figure 15.5d.

In Figure 15.6 the 3- and 4-dimensional cubes have been placed in cartesian coordinate systems and the vertices are labeled by 3 or 4 coordinates. Notice that by adding a leading 1, the sequence of moves reproduces the Gray Code of the numbers 4–7 for the 2-dimensional cube,

8–15 for the 3-dimensional cube, and 16–31 for the 4-dimensional cube in Table 15.1. So we have the connection between Gray Code and TOH.

The last column of Table 15.1 correlates the positions of the TOH for n disks with Gray Code. In Table 15.1 the notation, 1/2/3, denotes disk 1 on 2 on 3 all on one of the three pegs. The notation, 1 2/3, means that disc 1 is on one peg while 2 is on top of 3 on another of the three pegs. I assume that all n disks lie on peg A in the starting position.

For example, the correct movements of 3 disks from peg A to peg B in the above example can be read directly from the last column for numbers 0–7 in column 1. Since disk 4 is now the top disk on peg A it moves to peg C (even disks move counterclockwise), and numbers 0–15 mark the solution to the 4 disk problem in which disks 1,2,3,4 move from peg A to peg C. Likewise, 0–31 list the position for the movement of 5 disks from peg A to peg B. This process can be continued ad infinitum.

To convert TOH position directly to Gray Code follow these rules:

(i) begin at the rightmost digit of the Gray Code;
(ii) if disk n lies atop $n + 1$ then the nth place from the right gets a 0;
(iii) if disk n does not lie atop disk $n + 1$ then it gets a 1.

For example consider, 1/2/3 4/5. Disk 1 lies on 2, 2 lies on 3, 3 does not lie on 4, and 4 lies on 5. Therefore the Gray Code is 10100. You can also carry out this process in reverse and reconstruct the TOH position from the Gray code. In Appendix 15.A a procedure is given for converting a binary number directly to its TOH configuration.

There is an even more intimate relationship between Gray code, binary, and TOH. For the Nth move in the optimal TOH transfer:

1. The Gray code value corresponds to the number of moves per disk.
2. The binary representation corresponds to the cumulative total of moves for all disks.

To see how this works, consider the 24th move in the optimal TOH transfer:

a. Write decimal 24 as binary 11000.
b. Label the disk sizes, left to right, from large to small, i.e., 5, 4, 3, 2, 1.
c. Starting on the left with binary and proceeding to the right, if 0 then double previous result, if 1 then double previous result and add 1. This

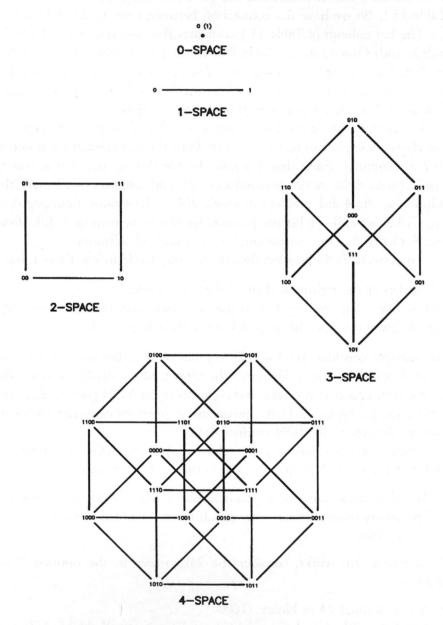

Figure 15.6 Cartesian coordinate representations of 1, 2, 3, and 4-dimensional cubes.

gives the cumulative total: 1, 3, 6, 12, 24. The cumulative totals correspond to the integer values of the homologous binary numbers: 1, 11, 110, 1100 and 11000.

d. The differences in successive values of the cumulative total correspond to the number of moves that the nth disk moves up to the 24th move during the optimal TOH transfer.

$$
\begin{array}{lccccc}
\text{disk} & 5 & 4 & 3 & 2 & 1 \\
\text{binary} & 1 & 1 & 0 & 0 & 0 \\
\text{cumulative total} & 1 & 3 & 6 & 12 & 24 \\
\text{\# of move per disk} & 1 & 2 & 3 & 6 & 12 \\
\text{Gray code} & 1 & 0 & 1 & 0 & 0 \\
\end{array}
$$

The cumulative total of TOH moves gives an alternate way to change a number from binary to decimal, always the last entry. Also notice that the parity (even \rightarrow 0, odd \rightarrow 1) of 1, 3, 6, 12, 24 and 1, 2, 3, 6, 12 reproduce binary and Gray code, respectively for 24. This procedure follows directly from the Farey sequence. In Table 14.3 successive numbers from the infinite Farey true are labeled with the counting numbers. The cumulative total is represented by the integers on the unique zigzag path from 1 to the decimal value (24 in this case) and the numbers of moves per disk by the differences in these numbers.

This procedure is quite simple and general. Check it for the 22nd TOH move corresponding to binary 10110. Find the number of moves for each disk and the cumulative total.

The pattern of winning moves of TOH arise from the moduli of the numbers in each row of the Infinite Farey Tree of Table 14.1 (see Section 14.3.12). They are listed for each block in column 3 of Table 15.1. For example, the sequence of moduli in Row 3 is 3537353, e.g.,

$$
\begin{vmatrix} 2 & 1 \\ 7 & 5 \end{vmatrix} = 3, \quad \begin{vmatrix} 3 & 2 \\ 8 & 7 \end{vmatrix} = 5, \quad \text{etc.}
$$

This is equivalent to the TOH sequence 1213121, where

$$
1 \leftrightarrow 3, \ 2 \leftrightarrow 5, \ 3 \leftrightarrow 7, \ 4 \leftrightarrow 9, \ldots .
$$

The winning moves for the TOH are also buried within each block of binary and Gray Code sequences in column 5 of Table 15.1 where they determine the place in which 0 changes to 1 or 1 changes to 0 in successive binary or gray code representations as described in Section 15.3. For example, the integers from 1–7 generated by these rules give rise to the sequence: 1213121 while the integers 1–15 generate: 121312141213121.

Notice that the TOH position with the greatest dispersion of disks always corresponds to the Gray Code value with all 1's, except in the first and last positions, and is a convergent of $\frac{1}{\tau}$ or $\frac{1}{\tau^2}$. For example, a glance at Table 15.1 reveals that within the 16–block, $\frac{8}{13}$ and $\frac{5}{13}$ are [11112] and [2112] respectively.

Also observe that the number of disks on the three pegs of the TOH puzzle that correspond to the convergents to the golden mean are the *Mod 3 clock* (see also Appendix 23.A). In this clock with three hours, noon corresponds to 3, 6, 9, ..., 1 o'clock to 1, 4, 7, ... and 2 o'clock to 2, 5, 8, ..., as shown in Figure 15.7. Observe this pattern in Table 15.1 for all TOH positions corresponding to all 1's in Gray code. This mod 3 clock also arose in Section 12.7 in connection with the (10, 3) knot which generated Tenen's dimpled sphere. It is quite extraordinary that a simple puzzle like TOH should be so rich in mathematical relationships. It has also been shown that TOH is structurally identical to Pascal's triangle (cf. [Hin], [Kap4-A], [Gard1]). In Chapter 17, TOH will be related to chaos theory. In Chapter 20, the relationship of the winning sequences of the TOH and a frequency of sound known as $\frac{1}{f}$ noise that occurs in music will be discussed.

15.6 The TOH Sequence, Divisibility, and Self-replication

Consider the never-ending and never-repeating sequence of moves:

$$121312141213121512131214121312 16 \ldots$$

that solves the TOH puzzle. Notice that this is the sequence of positions, listed in column 5 of Table 15.1 in which 0 changes to 1 or 1 changes to 0 in the Gray code representation of successive integers. This sequence has a self-replication property [Adam1]. For example, subtract 1 from

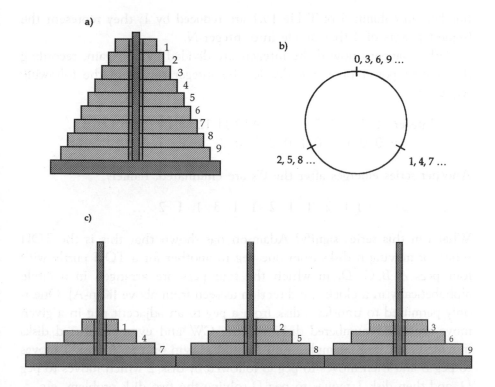

Figure 15.7 Tower of Hanoi positions for rational approximations of $\frac{1}{\tau}$ and $\frac{1}{\tau^2}$ is represented by a mod 3 clock.

each term in the series and remove the zeros, the TOH reappears. This property of self-similarity will be studied in Chapter 18 as the defining property of fractals.

This self-similarity conveys information about the divisibility of numbers by 2 [Kap-A]. The sequence of integers are listed below along with the number of times, n, that 2 divides into each integer:

Integer: 1 2 3 4 5 6 7 8 9 10 11 12 13 14 15 ...
 n: 0 1 0 2 0 1 0 3 0 1 0 2 0 1 0

For example, 2^2 divides 12 while 2^3 divides 8. Notice that if the 0's (2 does not divide odd numbers) are removed, then the TOH series remains. If the

numbers in column 5 of Table 15.1 are reduced by 1, they represent the highest powers of 2 that divide into integer N.

What happens now if the integers are divided by 3? Again, recording the highest power of 3 that divides the integer results in the following sequence:

Integer: 1 2 3 4 5 6 7 8 9 10 11 12 13 14 15 16 17 18...
n: 0 0 1 0 0 1 0 0 2 0 0 1 0 0 1 0 0 2...

Another series emerges after the 0's are eliminated, namely,

1 1 2 1 1 2 1 1 3 1 1 2 ...

What can this series signify? Adamson has shown that this is the TOH series for moving n disks from one peg to another for a TOH puzzle with four pegs A, B, C, D, in which the four pegs are arranged in a circle alphabetically in a clockwise direction as seen from above [Kap-A]. One is only permitted to transfer a disk from a peg to an adjacent peg in a given move with odd numbered disks moving CW and even numbered disks moving CCW. For example, if all the disks begin on peg A, disk 1 moves to peg B and then moves to peg C followed by disk 2 which moves to peg D, and then disk 1 moves to peg D solving the two disk problem, etc.

As for the TOH series with three pegs, this generalized TOH sequence also has a self-replication property. Likewise, the TOH puzzle with 5 pegs leads to a series corresponding to division by the number 4 and so on. The implications of the self-replication property for the divisibility of integers has been explored in [Kap-A].

15.7 Conclusion

Gray code was introduced and correlated with the integers. It was shown that Gray code expresses fundamental properties of the decomposition of integers into prime factors. Successive positions of the Towers of Hanoi puzzle are represented by Gray code and binary. Each TOH position corresponds to both a unique positive integer and to a rational number in lowest terms. TOH and its generalizations are directly connected to the divisibility properties of integers.

Appendix 15.A

15.A1 *Converting between binary and Gray Code*

The trick to changing a number from Gray code to binary or binary to Gray code is to use a triangular path and the following rules of combination:

$$11 \quad \text{or} \quad 00 \rightarrow 0, \quad 01 \quad \text{or} \quad 10 \rightarrow 1.$$

a. The following example shows how binary can be converted to Gray code:

Put a 0 in front of the binary number 11000 and use the two indicated legs of the triangle along with the rules of combination to generate the corresponding Gray code number 10100.

$$
\begin{array}{llll}
\text{Gray code} & 1\ 0\ 1\ 0\ 0 & \\
& |\ \ |\ \ |\ \ |\ \ | & \uparrow \\
\text{Binary} & 0\ -1\ -1\ -0\ -0\ -0 & \rightarrow
\end{array}
$$

b. The following example shows how Gray Code can be changed to binary:

Put a 0 in front of the binary number and use the two indicated legs of the triangle below along with the rules of combination to convert the upper Gray code number to binary.

$$
\begin{array}{llll}
\text{Gray Code} & 1\ \ 0\ 1\ \ 0\ \ 0 & \\
& /|\ \ /|\ /|\ /|\ \ /| & \\
\text{Binary} & 0\ \ 1\ \ 1\ 0\ \ 0\ \ 0 & \nearrow\downarrow
\end{array}
$$

15.A2 *Converting from binary to TOH position*

Decimal 44 equals binary 1 0 11 00. Under each group of
$$1\ 1 \quad 2\ \ 2$$
bits write the decimal number for the quantity of bits in each group as shown.

Taking the sequence of decimals, start from the right, and for each decimal number place that quantity of numbered disks, starting with disk 1, on a peg. Go to the next decimal number and do the same, continuing until all decimal numbers are exhausted. However in this process you must use the following three rules.

(a) Disks for a given move must go on a different peg than the last move.

(b) Adjacent disk numbers must have opposite parity; no two odds or no two evens together.

(c) If confronted with a choice of an unoccupied peg or an occupied peg, choose the latter.

Let's demonstrate this for our example.

The first decimal is 2, so place disks 1 and 2 on peg 1, i.e., 1/2. The second decimal is also 2. By rule (a) the next two disks must be placed on a different peg, i.e., 3/4 1/2. The next decimal is a 1. By rule (c) disk 5 must be placed on an occupied peg if possible, so place it on peg 1 (peg 2 is eliminated by rule (a)), i.e., 3/4 1/2/5 . The last decimal is 1. Disk 6 cannot be placed on peg 2 because of parity rule (b) nor on peg 1 because of rule (a). So the final configuration is: 6 3/4 1/2/5.

16
Gray Code, Sets and Logic

> You can find truth with logic if you have already
> found truth without it.
>
> G.K. *Chesterton*

16.1 Introduction

The foundation of mathematics rests upon the theory of sets and logic. Set theory and logic have much in common; in particular they share a common algebraic structure known as Boolean algebra. I will describe the analogies between these twin subjects and show that they have strong connections to Gray code and to the structure of DNA. The "Law of Form" developed by G. Spencer-Brown to study self-referential systems will be shown to provide an alternative path to the study of Boolean logic.

16.2 Set Theory

All of mathematics can be related to the undefined concept of a *set*. A set is naively considered to be "a bunch of things" called *elements* along with a rule for determining whether some entity is or is not an element of the set. Before considering set membership, one generally limits oneself to a certain a set of possibilities referred to as the *universal set* with all defined sets being *subsets* of this universal set. For example, if the universal set consists of the integers from 1 to 10, i.e., $U = \{1, 2, ..., 9, 10\}$, then two subsets of this universe are $A = \{3, 4, 5\}$ and $B = \{4, 5, 6, 7\}$.

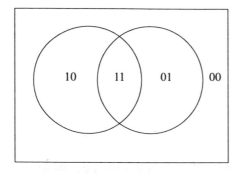

Figure 16.1 Venn diagram for a pair of sets. The sets are labeled by bit pairs in a Gray code sequence from right to left.

Sets can be combined in three elementary ways. The *union* of sets A and B, denoted by A ∪ B, is the set containing all elements belonging to either A or B or to both, e.g., A ∪ B = {3, 4, 5, 6, 7}. The *intersection*, denoted by A ∩ B, contains all elements that belong to both A and B, e.g., A ∩ B = {4, 5}, and the *complement* of A, symbolized by A′, is the set containing all elements of the universal set not in A, e.g., A′ = {1, 2, 6, 7, 8, 9, 10}. The notation A ∩ B′ is also used to refer to a set whose elements lie within A but not within B, i.e., A ∩ B′ = {3}. If two sets share no elements in common, they are said to be *disjoint*.

A pair of sets A and B can be pictured in what is called a *Venn diagram* shown in Figure 16.1. Here A and B partition the universal set U into four disjoint sets: A′ ∩ B′, A′ ∩ B, A ∩ B and A ∩ B′. I will refer to these subsets as *minterms* for reasons that will become evident. These sets are also represented by number pairs (bit pairs): 00, 01, 11, 10. The first bit of these pairs refers to set A while the second bit refers to set B, with 1 representing the presence of an arbitrary element of the universal set being in set A or B while 0 corresponds to the absence of that element. Therefore,

$$U = 00 \cup 01 \cup 11 \cup 01 . \qquad (16.1a)$$

With respect to the operations ∩ and ∪ sets satisfy all of the relationships of a Boolean algebra. The operation of intersection may be considered to be kind of multiplication so that A ∩ B is denoted by AB, while the operation of union is defined to be a kind of addition so that A ∪ B is denoted by A + B. As a result Equation (16.1a) can be rewritten as,

$$U = 00 + 01 + 11 + 01 . \qquad (16.1b)$$

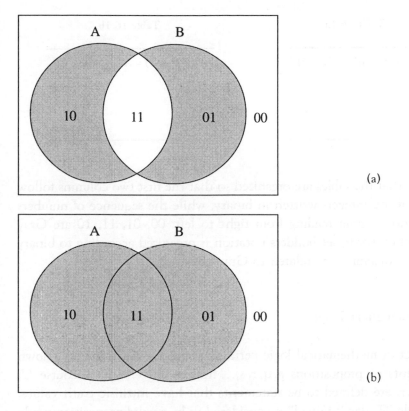

(a)

(b)

Figure 16.2 Venn diagrams representing two set functions: (a) $(A' \cap B) \cup A \cap B'$; (b) $A \cup B$.

The Venn diagram defines 16 subsets related to A and B that I refer to as *set functions*. Two of these subsets are indicated in Figure 16.2 by shading the appropriate regions. These shaded regions can also be represented by tables known as *set builders notation*. In this notation, whether an arbitrary element of the universal set is or is not in a given set is indicated in Tables 16.1a and b by a 1 or 0. The four regions are presented in the first two columns; if the region is shaded its set function is represented in the third column by a 1, otherwise by a 0.

The function of A and B can be read directly from the table as the sum of the minterms corresponding to function values of 1. By referring to Figure 16.2b, the rather complicated function in Table 16.1b is none other than $A \cup B$ or $A + B$.

	Table 16.1a

A	B	$f(A, B) = A'B + AB'$
0	0	0
0	1	1
1	0	1
1	1	0

	Table 16.1b

A	B	$f(A, B) = A'B + AB' + AB$
0	0	0
0	1	1
1	0	1
1	1	1

Notice that the tables are organized so that the first two columns follow the order of the integers written in binary, while the sequence of numbers in the Venn diagram reading from right to left: 00, 01, 11, 10 are Gray code. In other words, set builders notation is organized according to binary while Venn diagrams are related to Gray code.

16.3 Mathematical Logic

The subject of mathematical logic pertains to a class of statements known as statements or propositions p, q, r, s, \ldots from a universe of discourse U. Propositions are defined to be statements that have intrinsic truth values. For example "Today it rained" is considered to be a valid proposition while "$x + 5 = 3$" is not since its truth or falsity depends on the value chosen for x. Paradoxically, mathematical logic is unable to determine whether a simple proposition is true or false; it can only determine the truth or falsity of compound propositions given the truth values of the simple statements that comprise it.

Simple statements can be combined in three elementary ways. The statement "p and q", denoted by $p \wedge q$, is considered to be true if both p and q are true, otherwise it is false; "p and/or q", denoted by $p \vee q$, is true when either p, q or both are true, otherwise false; and the negation of p or p' is true when p is false and vice versa. Again, logical propositions satisfy a Boolean algebra in which \wedge is taken to be multiplication, i.e., $p \wedge q = pq$, and \vee is addition, i.e., $p \vee q = p + q$.

Just as I did for sets, a Venn diagram can be used to represent the 16 compound statements, or *logic functions*, related to p and q. Statements p

and q are represented as intersecting circles. If p or q are true, we denote them by a 1, otherwise we denote by a 0. In this way the minterms are $p'q'$, $p'q$, pq', pq, i.e., 00, 01, 10, 11 and compound statements are represented by shaded sets. Just as I did for set builders notation, the truth values of compound propositions are represented by tables called *truth tables*. For example, if A and B in Figure 16.2 are now considered to be p and q, the shaded regions lead to Table 16.2 with p and q replacing A and B.

If all of the regions of the Venn diagram are shaded, the truth function is true for all truth values of p and q. Such a compound statement is called a *tautology* T. Tautologies are analogous to the universal set in that,

$$T = 00 + 01 + 10 + 11.$$

The concept of a tautology is fundamental to mathematics and science since theorems of mathematics and laws of science are considered to be tautologies.

If none of the regions are shaded, the compound statement is considered to be a *contradiction* and denoted by F. The statement $p \vee p'$ is a tautology since it is true regardless of whether p is true or false, while $p \wedge p'$ is a contradiction. It states that a proposition cannot be both true and false and is also referred to as the *exclusion of the middle*. It is a consequence of the two-valued system of logic that underlies mathematics.

Once again truth tables are conveniently organized in binary while the Venn diagrams are related to Gray code. The truth values of compound statements can be organized by Gray code in another way by a table known as a *Karnaugh map* or K-map. Here the truth values of p and q are arranged along the left side and top of Table 16.2 leading to the integer sequence of Gray code shown by the arrows within the boxes.

Table 16.2 K-maps and Gray code.

q	q'	q
p	0	1
p' 0	$00 \rightarrow 01$	
		\downarrow
p 1	$10 \leftarrow 11$	

Table 16.3a

$$
\begin{array}{c|cc}
 & q & \\
p & 0 & 1 \\
\hline
0 & 0 & 1 \\
1 & 1 & 0 \\
\end{array}
$$

Table 16.3b

$$
\begin{array}{c|cc}
 & q & \\
p & 0 & 1 \\
\hline
0 & 0 & 1 \\
1 & 1 & 1 \\
\end{array}
$$

If a region in the Venn diagram is shaded, label the appropriate box with a 1 otherwise 0. Karnaugh maps corresponding to the compound statements of Figure 16.2 are given by Tables 16.3.

It is easy to simplify logical functions using K-maps. The minterms corresponding to a pair of adjacent 1's either horizontally or vertically can be replaced by the variable in common to them and the function is reduced to the sum of these terms. As a result, the function defined by Table 16.3a cannot be reduced while the function in Table 16.3b can be reduced to $p + q$. Whenever the Venn diagram representation of the truth table has a pair of shaded regions that share an edge, then the K-map can be reduced.

An alternative approach to mathematical logic based on Spencer-Brown's *Laws of Form* is presented in Section 16.8.

16.4 Higher Order Venn diagrams

In the above two sections I examined subsets and compound statements related to a pair of subsets. Everything continues to hold for Venn diagrams representing three sets shown in Figure 16.3. For example,

$$U = 000 + 001 + 010 + 011 + 100 + 101 + 101 + 111.$$

The Gray code structure of the Venn diagram is seen by observing that only a single bit changes when crossing a boundary. However, I had never seen a Venn diagram for four sets until one of my students showed me that the Brunes star can serve as such a diagram. In Figure 16.4 the region within the upward, downward, leftward, and rightward pointed triangles represent sets A, B, C, D or propositions p, q, r, s.

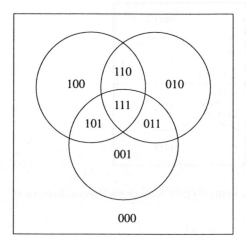

Figure 16.3 A Venn diagram for three sets: A, B, C.

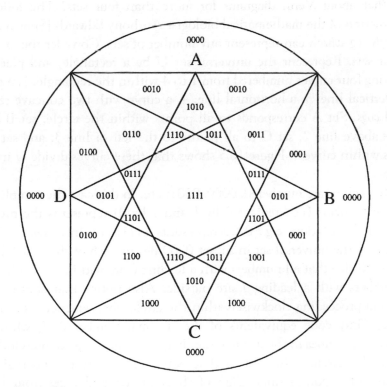

Figure 16.4 A Venn diagram for four sets in the form of the Brunes star.

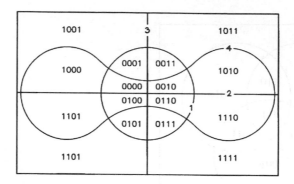

Figure 16.5 Edwards' cog-wheel represents a Venn diagram for four statements. Regions of the cog-wheel are represented by Gray code.

What about Venn diagrams for more than four sets? The following construction of the mathematical biologist Anthony Edwards [Stew2] called *Edwards cog-wheels* can represent any number of sets. Consider the example of four sets. Represent the universal set U by a rectangle, and place the following four curves numbered from 1 to 4 within the rectangle: 1, a circle; 2, a vertical line; 3, a horizontal line; 4, a curve with two concave regions called *cogs*. Set A corresponds to all points within the circle; set B to all points above line 2; set C to all points to the left of line 3; and set D to points within curve 4. Figure 16.5 shows that these curves divide U into 16 regions.

The regions are numbered, 0000, 0001, etc. In this case the complement of these numbers (i.e., replace 0 by 1 and 1 by 0) represents the previous set builder's notation, e.g., 0000 represents 1111, etc. In other words, an element of the universal set in subset 0000 lies in each of the four Edwards subsets. Notice that all numbers with a leading 0 are within the circle while all numbers with a leading 1 are outside. Also notice that starting with 0000 and proceeding clockwise within the circle, the sequences of numbers are the Gray code equivalents of the decimal number 0–7, while this sequence continues to the decimal numbers 8–15 running counterclockwise outside the circle. Also notice that when moving from one region to an adjacent region, a single digit of the Gray code changes from 1 to 0 or 0 to 1, where the number of the line specifies the number of the changing digit counting from the left, e.g., 0011 changes to 0010 by crossing line 4.

Figure 16.6 Cog-wheel for six statements.

For each additional set, a new curve must be added with twice the number of cogs as the previous line. Thus, a Venn diagram for five sets is constructed by adding a 5th curve with 4 cogs. Figure 16.6 illustrates the intriguing pattern that results from a 6th order Venn diagram.

16.5 Karnaugh Maps

K-maps for any number of simple propositions can also be formulated. For example a K-map for four simple propositions p, q, r, s is shown in Table 16.4. Truth values for the pq and rs pairs are listed on the left side and top in Gray code order: 00,01,11,10. Corresponding sets of four bits are placed within each square of the table. Note that moving from left to right in row 1 and right to left in row 2 and then back and forth again in rows 3 and 4 results in the integer sequence 0–15 in Gray code (see Table 16.1).

Notice that the K-map inherits the reflection property of the Gray code. Except for the leading 1 or 0, the numbers in the upper half of the table are mirror reflections of the lower half.

A truth function of p, q, r, s can be built by assigning 1 or 0 to each minterm if that minterm is true or false. In Table 16.4 this is done by using boldface for each minterm corresponding to a truth value of 1 for the logical function. For example, the truth function represented by Table 16.4 has 14 minterms.

K-maps have an advantage over truth tables. If two or more neighboring terms to the left or right, up or down, or wrap around (the first and last terms of a row are considered *wrap around* neighbors) have truth value 1,

Table 16.4 Karnaugh maps and Gray code.

pq \ rs	00	01	11	10
00	0000	0001	0011	0010
01	0100	0101	0111	0110
11	1100	1101	1111	1110
10	1000	1001	1011	1010

the truth function can be contracted to the sum of products of the elements in common to these neighboring terms. In Table 16.4, the last two terms in the first row have p',q',r in common so that these two terms can be contracted to $p'q'r$. The contracted form has the same truth table as the original truth function and are therefore considered to be *equivalent*. The four terms that make up the square in the upper left corner has p',r' in common and can therefore be simplified to $p'r'$. The 8 terms in the bottom two rows have only p in common and so they contract to the simple statement p. In other words the 14 boldfaced minterms have the same truth table as:

$$p'q'r + p'r' + p.$$

Also notice that this expression can be further reduced to

$$p + r' + q'$$

by recognizing that the boldface elements in rows 3 and 4 with p in common, columns 1 and 2 with r' in common, and row 4 and wrap around row 1 with q' in common.

16.6 Karnaugh Maps and n-dimensional Cubes

A K-map can also be represented geometrically by an n-dimensional cube in which the vertices, corresponding to minterms of the truth function, are darkened. Referring to Figure 15.6, 8 boldfaced minterms of Table 16.4

with p in common darken the vertices of the cube whose vertices all have 1 as its first coordinate; call this cube p. It is one of the 8 cubes that make up the 4-dimensional hypercube in Figure 15.6. The four vertices with $p'r'$ in common (the first and third coordinates are 0) lie on one face of this hypercube, while one of its edges corresponds to the two vertices with $p'q'r$ in common. Each of the other seven 3-dimensional cubes that make up a 4-dimensional cube represents one of the statements, p', q, q', r, r', s, s'. A tautology involving n simple statements would be represented by an n-dimensional cube with every vertex colored, while a contradiction would be represented by an uncolored n-dimensional cube.

Geometry and number are intimately connected in both the representation of the number system and mathematical logic. Haresh Lalvani [Lal1,2,3], a Professor of architecture, and Shea Zellweger [Zel1,2], a psychologist, have independently discovered deep correspondences between sign-creation in logic and crystallographic symmetry.

From this brief discussion of logic it would seem that the study of mathematics and science can be organized into the neat boxes of n-dimensional cubes. However, since Kurt Godel (1906–1978) formulated his famous theorem in 1931, we now know that there is an irreparable flaw in this system. It is impossible to create a mathematical system, rich enough to include arithmetic, that is both consistent and contains every true statement or tautology, derivable from its postulates. Another way to state Godel's theorem is that some theorems require an infinite number of steps to prove, and their representation would require an infinite-dimensional cube to represent. We have also seen in Sections 13.4 and 14.4.13 that logical paradoxes and irrational numbers can be reconciled within mathematical logic only by considering infinite processes.

16.7 Karnaugh Maps and DNA

The father of mathematical logic is thought to have been the mathematician, lawyer, and philosopher Gottfried Wilhelm Leibniz (1646–1716). Liebniz is also credited with having introduced the system of binary numbers after learning about the Chinese book of Changes known as the *I-Ching*. The I-Ching consists of 64 so-called *hexagrams* organized into two sequences of

triplets of two symbols, - - and —— . If the first is associated with 0 and the second with 1 then the hexagram,

$$\begin{matrix} = = \\ = = \end{matrix} = \begin{matrix} 0\ 1\ 1 \\ 0\ 1\ 0. \end{matrix}$$

In recent years, a number of researchers including J. F. Yan [Yan], K. Walter [Wal] and Kappraff [Kap-A] have recognized that there is a close connection between the I-Ching and the structure of DNA. DNA is constructed of sequences of four bases: Cytosine (C), Guanine (G), Adenine (A), and Thymine/Uracil (U/T). Each of these bases can be assigned an ordered pair of bits as follows:

$$C=0, \quad G=1, \quad A=0, \quad U/T=1.$$
$$0 \qquad\quad 1 \qquad\quad 1 \qquad\quad 0$$

Triplets of these bases combine to form the equivalent of *words* or *codons*, e.g., CGU = 011
 010.
Furthermore, in the double helix that makes up the DNA strands, C bonds to G, and A bonds to U/T. Therefore each codon bonds to an *anticodon*, e.g., the anticodon of CGU is GCA = 100 made up of
 101
complementary bits (1 replaces 0 and 0 replaces 1).

Both Yan and Walter organized all 64 possible codons into a chart in which the codons are denoted by pairs of integers from 0–7 written in binary. Here I depict the codons as pairs of Gray code numbers for reasons that will be explained. The 64 codons are mapped in Table 16.5 onto a K-map.

Along with every codon, a number 6, 7, 8, or 9 is listed, indicating the number of Hydrogen bonds per codon. The number is determined quite simply by subtracting from 9 the number of 1-bit differences between the upper and lower triplets, e.g., the triplets for GCU differ in only the last digit so that the number of H–bonds is 9 − 1 = 8. Table 16.5 has several notable properties:

1. There is a 1-bit (letter) change between any adjacent codons, up/down, right/left, including wrap arounds.

Table 16.5 Relationship between Gray code and the Number of DNA Hydrogen Bonds per Codon/Anticondon.

	0	1	2	3	4	5	6	7
	000	001	011	010	110	111	101	100
0	000	000	000	000	000	000	000	000
	CCC 9	CCU 8	CUU 7	CUC 8	UUC 7	UUU 6	UCU 7	UCC 8
	000	001	011	010	110	111	101	100
1	001	001	001	001	001	001	001	001
	CCA 8	CCG 9	CUG 8	CUA 7	UUA 6	UUG 7	UCG 8	UCA 7
	000	001	011	010	110	111	101	100
2	011	011	011	011	011	011	011	011
	CAA 7	CAG 8	CGG 9	CGA 8	UGA 7	UGG 8	UAG 7	UAA 6
	000	001	011	010	110	111	101	100
3	010	010	010	010	010	010	010	010
	CAC 8	CAU 7	CGU 8	CGC 9	UGC 8	UGU 7	UAU 6	UAC 7
	000	001	011	010	110	111	101	100
4	110	110	110	110	110	110	110	110
	AAC 7	AAU 6	AGU 7	AGC 8	GGC 9	GGU 8	GAU 7	GAC 8
	000	001	011	010	110	111	101	100
5	111	111	111	111	111	111	111	111
	AAA 6	AAG 7	AGG 8	AGA 7	GGA 8	GGG 9	GAG 8	GAA 7
	000	001	011	010	110	111	101	100
6	101	101	101	101	101	101	101	101
	ACA 7	ACG 8	AUG 7	AUA 6	GUA 7	GUG 8	GCG 9	GCA 8
	000	001	011	010	110	111	101	100
7	100	100	100	100	100	100	100	100
	ACC 8	ACU 7	AUU 6	AUC 7	GUC 8	GUU 7	GCU 8	GCC 9

2. The diagonal from the upper left to the lower right with all 9's is a mirror line; the triplets in reflected positions are inverted.
3. Codon–Anticodon pairs are indicated by using the following rule.

```
0 MATCHED TO:   5
1 (ROW OR       4
2  COLUMN)      7
3               6
```

For example CGU is found in Row 3, Col. 2. Therefore its Anticodon, GCA must be located in Row 6, Col. 7.

4. The numbers are written in snake-like fashion in Gray code (see Table 15.1). As soon as you reach 7, drop immediately down to the next row, continuing with 8... then back and forth in the same manner for the other rows:

$$0 \quad 1 \quad 2 \quad 3 \quad 4 \quad 5 \quad 6 \quad 7$$
$$...10 \quad 9 \quad 8.$$

5. Table 16.5 is a *magic square* with the property that the sum of the hydrogen bonds in each row and column = 60, with a binomial distribution:

> (1) 6
> (3) 7's
> (3) 8's
> (1) 9
> 60 Total.

The property of being a magic square is not restricted to the 8×8 square. A 4×4 square can be formed in a similar manner from the integers 0, 1, 2, 3. In place of the number of Hydrogen bonds we can use the number of bit changes between the integer pairs. They also have a binomial distribution.

6. The amino acids are formed from contiguous groups of codons, e.g., proline: CCC, CCU, CCA, CCG; glutamine: CAA, CAG, leucine: CUU, CUC, CUG, CUA, UUA, UUG; etc.

The advantage of using Gray code in genetics as opposed to binary is that Gray code eliminates the "cliffs" (mismatches between the number of bit changes and degree of mutation or differences between chromosome segments). The requirement in an encoding scheme is that changing any one bit in the segment of the chromosome should cause that segment to map to an element which is adjacent to the pre-mutated element.

16.8 Laws of Form

G. Spencer-Brown's "Law of Form" provides an alternative path to the study of Boolean logic [Spe-B]. In Boolean logic each proposition can take

$\sim p =$ p

(a) (b)

Figure 16.7 (a) "Not" statement as an on-off switch; (b) symbol of process of inversion.

$p \lor q =$

(a)

$p \lor q =$

(b)

Figure 16.8 (a) "Or" statement as an electric circuit; (b) junction diagram symbolizing the "Or" statement.

on two values, true or false, 1 or 0. The device with a single switch shown in Figure 16.7(a) inverts a signal, i.e., it represents the "not" statement. If p is considered false when the switch is open, then it is true when the switch is closed. Let the diagram in Figure 16.7(b) symbolize this process of inversion. We can also symbolize this process by $\sim p$ or by Spencer-Brown's symbol $\overline{p}|$ (see Section 13.6).

The device shown in Figure 16.8(a) has the effect of modeling an "or" statement. If either or both switches are closed then the signal reaches the downstream junction and the statement p or q is considered to be true. Only when both switches are open does the signal not reach the downstream junction and the statement "p or q" is false. The "or" device is symbolized by the junction diagram in Figure 16.8(b) and by the juxtaposition pq. (So as not to confuse the reader, I emphasize that here by pq I do not mean Boolean multiplication as I did in Section 16.3.)

(a)

(b)

Figure 16.9 (a) "And" statement as a circuit diagram; (b) representation of "And" statement as a junction diagram.

The device to create the compound statement "p and q" is shown in Figure 16.9(a). It is a pair of switches connected in series. When either or both of the p or q switches are open (false statement) then the signal does not reach the downstream terminal and the statement is false. The "and" statement can be expressed by algebraic relationship, $p \wedge q = (p' \vee q')'$ known as De Morgan's Law (both sides of De Morgan's Law have the same truth table). Using combinations of the "or" and "not" diagrams we can represent $p \wedge q$ as shown in Figure 16.9(b), or by the Spencer-Brown notation, $\overline{\overline{p}\,|\,\overline{q}}\|$.

In his book, Laws of Form [Spe-B], Spencer-Brown has another notational idea. He represents the two-valued system of Boolean logic by a closed curve separating an inner region and an outer region (see Figure 16.10(a)). His symbol ⌐ was an instruction to cross the boundary so that:

$$\overline{(\text{In})| = \text{Out}} \quad \text{and} \quad \overline{(\text{Out})|} = \text{In}.$$

Next Spencer-Brown denotes "Out" by a blank (see Figure 16.10(b)) in which case, these equations are rewritten as,

$$\overline{(\text{blank})|} = \text{In} \quad \text{and} \quad \overline{}| = \text{Out}.$$

(a) (b)

Figure 16.10 (a) System of two-valued logic severs the continuum into an inner region representing "false" and an outer region "true"; (b) the inner region is blank while the outer region is marked.

In other words, the symbol ⌐ has two uses

1) instruction to cross the boundary,
2) symbol to denote the Inside region.

He also associates the blank with "false" or 0 and the form ⌐ with "true" or 1. With this notation the juxtaposition ⌐⌐ = ⌐ symbolizes the fact that "a true statement or a true statement" is always true. We can summarize Spencer-Brown's two laws of form as:

$$\overline{}\,\overline{} = \overline{}, \tag{16.2a}$$

$$\overline{\overline{}} =. \tag{16.2b}$$

Using these laws of form, the truth or falsity of any compound statement can be easily determined. For example, consider the logical statement.

$$\sim((\sim p \wedge q) \vee (r \wedge s)) \quad \text{or} \quad \overline{\overline{\overline{p}\|\,\overline{q}\|}\,\overline{r\,|\,s\|}}. \tag{16.3}$$

To create a truth table for this compound statement, we must assign truth values to p, q, r, and s. Let's say false values are assigned to all of the variables, i.e., $p = q = r = s = 0$ (or blank), then a truth table shows that the compound statement is true. The equivalent logic device is shown in Figure 16.11. However, the expressions to the left of Figure 16.11 gives an alternative procedure using the Laws of Form in Equations (16.2) to determine the truth value of Expression (16.3). The expression is shown to have value of the mark ⌐ or "true".

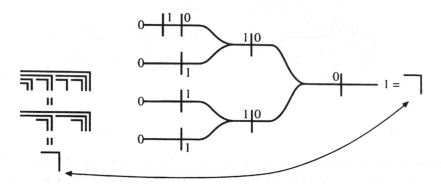

Figure 16.11 Use of the "form" to simplify and represent a logical expression.

The concept of duality arises in many branches of mathematics. We saw it at work in the theory of projective geometry discussed in Chapter 2. In the theory of logic, if the operations of "and" and "or" are interchanged but "not" maintained then the truth value of any compound statement remains valid if false and true are also interchanged. This gives Spencer-Brown's symbol system an advantage over the standard logic symbols. If juxtaposition is now interpreted as "and" and the value of the mark ⌐ is now interpreted as "false" while the "blank" is true, then each compound statement has dual interpretations depending on the preference of the observer. With the dual interpretation, Expression (16.3), although still having the value ⌐, is false for the "blank" values of p, q, r and s which are now interpreted as being true.

This path to logic reduces the representation of Boolean algebra to a single symbol. It also opens logic to the consideration of a self-referential system discussed in Chapter 13. The universe is seen to be an undifferentiated continuum. Polarities, such as hot-cold, moist-dry, up-down, etc. come into being only when we the observer sever the continuum by making a mark. Our self-consciousness is then represented by the total space and the mark. The notion of true or false is not intrinsic to the universe, but is only relative to each individual's personal system provided that it conforms to the established norms of mathematical logic. Everything within ones circle of discourse is considered to be "true" distinguishing from the "false" propositions lying outside the mark.

16.9 Conclusion

The structure of natural processes, the logical processes of our minds, and even our genetic makeup operate according to principles based on number. Does this isomorphy exist in nature or do we impose it upon nature? These are questions for philosophers to ponder. In the next chapter I will investigate some of the deeper implications of number and, again, show that numerical relationships appear to have an a-priori validity even beyond our ability to carry out measurements.

17

Chaos Theory: A Challenge to Predictability

> As far as the propositions of mathematics refer to reality they are not certain;
> and as far as they are certain they do not refer to reality.
>
> *Albert Einstein*

17.1 Introduction

Ancient civilizations tried to make sense of their observations of the natural world even though they often experienced the world as chaotic. Their very existence depended on reliable predictions of such events as the arrival of spring to plant, fall to harvest, the coming and going of the tides, the movement of the heavenly bodies, etc. Individuals deemed to have unusual powers to comprehend these forces were singled out as shamans and chiefs. There is strong evidence that many pre-scientific peoples were keen observers to the extent that they were able to predict eclipses, and to understand the existence of the lunar cycle of 18 2/3 years, and the movements of the stars and planets — no small feats. These observations were fashioned into models of how the world was organized, and ultimate causes were attributed to the gods [YouD].

However, until the Greeks, there was no attempt to build a philosophical system based on these observations, to attribute causes beyond divine intervention, or to generalize the results to earthly phenomena. Greek philosophers were the first to create scientific theories of the universe. It was an article of faith among the Greeks that all heavenly bodies moved in circles, with the Earth at the center. Aristarchus was the first to hypothesize that the planets moved about the sun, although still in circles.

While movement in circles, the most symmetric of mathematical objects, was philosophically appealing, the sun-centered system did nothing to improve upon the Earth-centered system in terms of its predictive power.

As early man observed and as Gustav Holst immortalized in his suite "The Planets" in contrast to the orderly movement of the stars, the planets appear to wander erratically about the heavens. To bring *order* to the *chaotic* behavior of the planets, Greek mathematicians hypothesized that they moved on circles which themselves moved upon other circles, and so on. Although this led to a great deal of computational complexity, it did lead to the Earth-centered system of Ptolemy which rivaled the predictive power of all other systems until modern times. Ptolemy's system was greatly improved by the meticulous measurements of the Danish astronomer, Tycho Brahe. Brahe's precise measurements of the motion of Mars, the most erratic of the planets, led Kepler to formulate his three laws, which constituted the first modern theory capable of bringing order to the movement of the planets (see Chapter 5). The first of his laws broke with the 2000-year-old faith in circles by hypothesizing that ellipses, with the sun at a focus, were the true paths of the planets. However, Kepler's laws were strictly empirical, not based on theory. Finally, Newton was able to hypothesize a single force, gravity, as the *cause* of the motion, and with the help of the calculus, which he invented for this purpose, was able to prove *Kepler's laws*.

Once the starting position and velocity of a particle (whether planet or stone) are known, its motion through all of time is preordained by *Newton's Laws*. In this sense, Newtonian physics is said to be *deterministic*. Although gravity is considered to be the *cause* of the motion, what gravity is and how it acts upon another body over great distances, with no time lag, was not explained by Newton. As a result, scientific theory made its first major split from the traditions of ancient civilizations in which the cause of things was attributed to some ultimate force. When Lagrange was asked by the King of France what place God had in Newton's system, he replied, "Sire, I have no need for that particular assumption". Ultimate causes were left to religion, and science contented itself with matters of prediction. Newtonian physics was seen to be precise in its range of applications, but devoid of internal justification — a purely *mathematical model*. It formed the prototype for all theories to follow.

In most people's minds the success of Newton's system put an end to the quest for answers to the questions as to the origin of order in the universe. All scientific questions could certainly be accounted for by careful application of the principles stated by Newton's laws along with the sophisticated mathematical apparatus developed to plumb the depths of these laws. Alexander Pope expressed the prevailing opinion when he wrote:

> "Nature and nature's laws lay hid by night. God said: Let Newton be. And all was light."

After Newton, all scientific development was thought to be merely a matter of detail, and completely deterministic. As Laplace said,

> "If the initial positions and velocities of all the particles in the universe were known, everything would be known thereafter."

Philosophers such as Kant, Locke and Hume, and economists such as Adam Smith, drew on the Newtonian concept of the universe with its strict determinism to build epistemological and economic systems. Gone were the days when everyone had their own model to explain their observations.

We now know that it was naive to imagine that Newton had all the answers. Even in his own time, it was well known that if a large planet such as Jupiter were taken into account, the orbits of the other planets would not be ellipses and the motion might not even be recurring or periodic. In fact, it is precisely because of the hypothesized effect on the orbit of Jupiter by an unseen mass that Neptune's existence was first determined by Le Verrier in 1846. Now that our instruments enable us to observe phenomena in greater detail, we see that Newton's laws are inadequate to explain them. The theory of relativity has eliminated the preferred position of any object — be it Earth, Sun, or other heavenly body — while quantum theory has done away with the notion of cause and effect. Jacques Merlo Ponti [Mer] believes that the very success of Newtonian physics resulted in an atrophy in the model-making capacities of modern scientists. For example, new models are needed to comprehend the flood of observations about the outer worlds of astronomy and cosmology, and the inner world of the mind. The artist Todd Siler [Sil] feels that the sensitivity of the artist can play a

role in helping the scientist to imagine new possibilities and create new models.

In the last two decades, the theory of chaos developed by Anosov, Ruelle, Smale, Sinai and other mathematicians has even cast doubts on our ability to develop any theory capable of predicting precise measurements over unlimited ranges of time (cf. [Dev], [Gle], [PJS] and [Stew1]). Up until now we have been living with the illusion of scientific predictability. Only if we ignore significant factors are we able to come up with the orderly results.

Even in a deterministic system, the smallest of causes can have significant effects if enough time elapses. In fact is was E.N. Lorenz, a meteorologist, who first noticed this *numerical instability* in his attempt to study some simplified equations that modeled the dynamics of weather systems. After carrying out a lengthy computer calculation, he wished to rerun the last phase of the calculation. Although he thought that he was beginning his rerun with almost the same values that had concluded his previous run, much to his astonishment, the rerun resulted in grossly different results. We now know that such problems are endemic to realistic weather systems. This phenomenon goes by the picturesque name *butterfly effect*, since the equations are so sensitive that, given enough time, the flutter of a butterfly's wings in Venezuela can have a measurable effect on the weather in New York.

Only systems insulated from extraneous factors are capable of analysis in the old sense. Realistic systems must take into account the effects of a myriad of seemingly unrelated factors. It is possible that the very bedrock of modern science — the theories that have helped give order to the ocean of observations of the world — correspond to a narrow range of outcomes in a sea of disorder. If we imagine the well–behaved theories to correspond to the rational numbers, all possible observations would correspond to the irrationals.

Let us consider a mathematical system that exhibits chaos, in order to understand the source of its unpredictability. Number lies at the heart of the problem and offers us a chance to give some order to the impending chaos. We shall also see that Gray code and the Towers of Hanoi present us with models to reproduce some of the dynamics of chaotic systems.

17.2 The Logistic Equation

Much of the early work of scientists and mathematicians concentrated on *linear systems* since they were easier to analyze than *nonlinear systems*. A linear function is represented by a *line* as shown in Figure 17.1a, while the simplest nonlinear function is depicted by the *parabola* shown in Figure 17.1b. Once scientists began to focus in detail on the results of nonlinear analysis, even nonlinear functions as elementary as the parabola exhibited startling results. So long as some perturbing force is kept below a critical level, the subsequent motion, or *trajectory*, of the system is entirely predictable. A small deviation from its starting position results in only a minor alteration of its motion. However, once the perturbing force exceeds a critical value, all predictability is lost. The slightest deviation from the starting position eventually leads to a grossly different trajectory. And, since from a practical point of view, the initial position is knowable only to the accuracy of one's measuring device, reproducibility of results, the most essential ingredient of scientific pursuits, is unattainable.

Let us consider the results of a simple numerical experiment carried out by H.-O. Peitgen, H. Jurgens and D. Saupe [PJS], with the parabola shown in Figure 17.1b given by the equation:

$$x_{n+1} = x_n^2 + c. \tag{17.1}$$

In this equation x_n plays the role of the position of a particle at time n, while c corresponds to the strength of the perturbation. Equation (17.1) enables knowledge of the system at time n to be used to determine the state one time period later. In Appendix 17.A this equation is shown to be a disguised form of the equation for population growth in which there exists

a b

Figure 17.1 (a) a linear system is represented by a straight line; (b) the simplest nonlinear system is represented by a parabola.

competition for scarce resources to limit the otherwise exponential growth of a population [PJS]. With this interpretation, c corresponds to some combination of the birth rate and level of competition, and Equation (17.1) is referred to as the *logistic equation*.

The experiment begins by choosing a value of $c = -2$ and an initial value of $x_0 = 1.97$. Replacing this value in the right-hand side of Equation (17.1) and using a Casio calculator, yields $x_1 = 1.97^2 - 2 = 1.8809$. Again replacing $x_1 = 1.8809$ in the right-hand side of Equation (17.1) yields, $x_2 = 1.53778481$. Continuing in this way, $x_{45} = -1.99232623$. Now let's check the sensitivity of Equation (17.1) to the initial conditions by using the initial value, $x_0 = 1.97$, but this time make the calculation with a Texas Instruments calculator. Table 17.1 compares the results.

Notice that up to x_5 there is agreement in 9 decimal places. For x_{10} there is agreement to the 8th decimal place after which the first deviation in the results occurs in the 9th place. After that point, the discrepancy between the calculators grows until by x_{40} there is only agreement in the 1st place and by x_{45} the values bear no relationship to each other. Table 17.1 shows how results diverge from each other even though the initial values agree to 10 significant figures. The discrepancy occurs because Texas Instruments calculators cut off the calculation after 12 significant figures while Casio uses only 10 figures. The result is so sensitive to computational error that even this minute difference results in major deviations in the trajectory.

If $x_0 = 1$ in Equation (17.1), the trajectory is $1, -1, -1, -1, \ldots$ If $x_0 = 2$, the trajectory is $2, 2, 2, \ldots$. Both of these initial values lead to constant states. However, we find that for any other value of x_0 in the interval $[-2, 2]$, the trajectory is as erratic as the one in Table 17.1. For example if we begin with $x_0 = 1.9999\ldots$, a tiny deviation from $x_0 = 2$, then the equation exhibits the non-computable behavior once again provided we allow a sufficient number of iterates.

The situation is quite different if we change the value of c to $c = -1$ and begin with $x_0 = 0.5$. Now the trajectory is shown in Table 17.2.

Notice that to the accuracy of the calculator, the trajectory approaches the periodic orbit, $0, -1, 0, -1, 0, \ldots$. The trajectory settles down to this same periodic orbit for any other starting point inside the interval $[-2, 2]$.

Table 17.1 Two different calculators making the same computation do not produce the same results.

n	$x_n^2 - 2$	$x_n^2 - 2$
	Casio	TI
0	1.97	1.97
1	1.8809	1.8809
2	1.53778481	1.53778481
3	0.364782122	0.364782122
4	−1.866934004	−1.866934004
5	1.485442574	1.485442574
10	−0.168742904	−0.168742902
15	−1.810785329	−1.810785307
20	0.210412598	0.210410962
25	−1.946761088	−1.946773155
30	0.877064961	0.878578871
35	−0.759852736	−0.809443757
40	1.990898806	1.439688097
45	−1.992332623	1.671012669

So for $c = -1$, we have perfect order and reproducibility so dear to the scientist.

In order to get a better feeling for what is happening, picture the trajectory on a graph. This time we shall use a form of the logistic equation equivalent to Equation (17.1) (see Appendix 17.A) but more suitable for the graphical demonstration,

$$x_{n+1} = ax_n(1 - x_n). \qquad (17.2)$$

A 45-degree line intersects the inverted parabola whose graph is that of the function, $y = ax(1 - x)$. When $x = x_0$ is placed into the right-hand side of this equation, the resulting value x_1 is replaced in the equation by moving horizontally from the curve to the line, as shown in Figure 17.2.

Table 17.2 (cf. [PJS])

Evaluations	x	$x^2 - 1$
1	−0.5	−0.75
2	−0.75	−0.4375
3	−0.4375	−0.80859375
4	−0.80858375	−0.3461761475
5	−0.3461761475	−0.8801620749
6	−0.8801620749	−0.2253147219
7	−0.2253147219	−0.9492332761
8	−0.9492332761	−0.0989561875
9	−0.0989561875	−0.9902076730
10	−0.9902076730	−0.0194887644
11	−0.0194887644	−0.9996201881
12	−0.9996201881	−0.0007594796
13	−0.0007594796	−0.9999994232
14	−0.9999994232	−0.0000011536
15	−0.0000011536	−1.0000000000
16	−1.0000000000	−0.0000000000
17	−0.0000000000	−1.0000000000

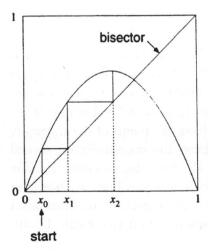

Figure 17.2 Principle of graphical iteration. The first steps in the graphical iteration of $x_{n+1} = ax_n(1 - x_n)$.

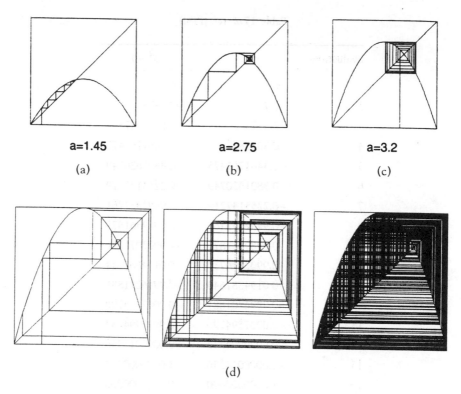

a=1.45 a=2.75 a=3.2

(a) (b) (c)

(d)

Figure 17.3 (a), (b), and (c) Graphical iteration for three parameter values leading to stable behavior (c) exhibits period 2 behavior; (d) unstable behavior for $a = 4$. The same initial value is taken with differing numbers of iterations.

First of all, notice that if $x_0 = 0$ is placed in Equation (17.2), then $x_1 = 0$ and, likewise, the trajectory is 0, 0, 0.... Therefore x_0 is called a *fixed point* of the transformation. Although this fixed point gives rise to very orderly behavior, it is also unstable. It is unstable because if we move x_0 away from 0, even slightly, the subsequent points of the trajectory move further away from 0. Figure 17.3 shows the trajectories for several values of the parameter, a. When $a = 1.45$, the values increase steadily to the point of intersection of the parabola and the line, as shown in Figure 17.3a. If "a" is increased to $a = 2.75$, the trajectory increases again to the intersection point, but this time it spirals into it (see Figure 17.3b).

Increase the parameter to $a = 3$ and this time, regardless of the starting point, the trajectory approaches an orbit that oscillates between the two values, $x_0 \to x_1 \to x_0$. We refer to this trajectory as an orbit with period 2. Since the same orbit occurs for any starting point other than 0 or 1, we say that the periodic orbit is stable. For example when $a = 3.23606...$ there is a *stable periodic orbit* of period 2, $x_0 = 0.5$ and $x_1 = 0.80901...$ as shown in Figure 17.3c. If "a" is increased to $a = 3.4985556...$, we discover that the trajectory approaches an orbit that oscillates between four values, $x_0 \to x_1 \to x_2 \to x_3 \to x_0$, i.e., it has a stable periodic orbit of period 4 where,

$$x_0 = 0.500, \quad x_1 = 0.874..., \quad x_2 = 0.383..., \quad \text{and} \quad x_3 = 0.827.... \quad (17.3)$$

If we increase "a" further, we find the remarkable result that the trajectories successively approach orbits of periods 2,4,8,16,..., a *period doubling* sequence of orbits. Finally, if "a" is increased beyond the value $a = 3.5699...$, the Feigenbaum limit, we reach the realm of chaos in which the resulting trajectories are supersensitive to the starting positions as we saw above for the logistic equation (see Figure 17.3d). Full-blown chaos corresponds to $a = 4$. The region beyond the Feigenbaum limit will be discussed further in Chapters 19 and 23.

The sequence 1, 2, 4, 8,... was previously encountered in our study of Farey series, Towers of Hanoi, and n-dimensional cubes. Can there be a connection here between these mathematical structures? The answer to this question is surprisingly, yes!

17.3 Gray Code and the Dynamics of the Logistic Equation

Associate each 2^n block of the Gray code in Table 15.1 with successive positions of an orbit of the logistic equation with period 2^n. The dynamics of the orbit of period 8 is determined by the integer block: 8–15. The iteration numbers of the orbit positions are listed in column 4 of Table 17.3 corresponding to the order of the magnitudes of the x-values listed in column 2. Order 1 corresponds to the largest x-value while order 8 to the smallest.

Table 17.3 Trajectory ordering and Gray code for the logistic equation.

Decimal	Order of magnitude of iterate	Gray code	Logistic equation iterate number
8	8	1 100	2
9	7	1 101	6
10	6	1 111	8
11	5	1 110	4
12	4	1 010	3
13	3	1 011	7
14	2	1 001	5
15	1	1 000	1

The values in Table 17.3 can be calculated from the Gray Code as follows [Adam1]:

(a) Separate out the first 1.
(b) From left to right, assign each of the remaining digits in succession the value 1, 2, 4, 8,....
(c) Add the values corresponding to the 1's in Gray code.
(d) Add 1.

For example, consider Gray code 1101. Extracting the leading 1 yields,

$$\frac{1}{1} \ \frac{2}{0} \ \frac{4}{1} = 5 + 1 = 6.$$

Therefore, the 6th iterate (6 in column 4) of the logistic equation corresponds to Gray code 1101 and represents the 7th largest value of x (7 in column 2) in the orbit of period 8. According to Table 7.3, the x-values satisfy the following order:

$$x_1 > x_5 > x_7 > x_3 > x_4 > x_8 > x_6 > x_2.$$

Using Table 15.1, this procedure can be used to show that the order of the values corresponds to the one listed in Sequence (17.3) for a period of length 4.

17.4 Symbolic Dynamics

How do *Gray code* and *Towers of Hanoi* positions relate to chaos? If a trajectory point of the logistic Equation (17.2) lies to the left of the maximum at $x = 0.5$, label it L, if it lies to the right of $x = 0.5$, label it R, and C if it lies at $x = 0.5$. Using Table 15.1, we can read off the sequence of points as to whether they are L, R, or C, directly from either binary or Gray code. Such a sequence is also known as the *symbolic dynamics*. Each of the period doubling orbits is determined from either binary or Gray code as follows, where $L = 0$ and $R, C = 1$:

(a) Choose a block of length 2^n from Table 15.1 and consider the numbers in reverse order.
(b) Note the first column (counting from the right) in the binary representation at which 1 changes to 0. If odd, assign 1; if even, assign 0. Alternatively, note the column (counting from the right) in Gray code at which 0 changes to 1 or 1 changes to 0. If odd, assign 1; if even, assign 0.

For example, consider the block of numbers 4–7 in Table 15.1 in reverse order, i.e., 7, 6, 5, 4. The symbolic dynamics is 1011. This compares to the symbolic dynamics, $RLRC$, of the sequence $x_1 \rightarrow x_2 \rightarrow x_3 \rightarrow x_0$ from Sequence (17.3).

The symbolic dynamics for each of the blocks of length 1, 2, 4, 8, 16 in Table 15.1, taken in reverse order, yields the following sequences:

> 1
> 10
> 1011
> 10111010
> 1011101010111011
>
>

Notice how the symbolic dynamics of each period is included in the dynamics of the previous periods.

The above sequence can also be obtained directly from the parity of the TOH sequence: 121312141213121..., i.e., set the odd numbers in this sequence equal to 1 and even numbers equal to 0.

17.5 The Morse–Thue Sequence

It is amazing that the complex dynamics of a mathematical system should be hidden within the sequence of counting numbers. The symbolic dynamics can also be found from the sequence of counting numbers written in the base 2 or binary notation. This approach yields a sequence called the Morse–Thue Sequence or MT with its own properties [Schr]. MT sequences arose originally in the symbolic dynamics for certain nonlinear dynamical systems arising in physics. First write the positive integers in binary:

$$0, 1, 10, 11, 100, 101, 110, 111,\dots$$

Next, add the digits. If even, assign 0; if odd, assign 1 i.e., find the sum of the digits mod 2 also known as the *digital roots*, to get the sequence,

$$0\ 1\ 1\ 0\ 1\ 0\ 0\ 1\dots$$

The MT sequence can also be generated by starting with 0 and iterating the mapping $0 \to 01$ and $1 \to 10$ to get,

$$0$$
$$01$$
$$0110$$
$$01101001$$

$$\dots$$

Notice how the length of the sequence increases in the sequence 1, 2, 4, 8,... and how each number of this sequence contains the previous sequence of numbers followed by their complements, i.e., 0 changes to 1 and 1 changes to 0. However, the entire sequence is, like the irrational numbers, non-repeating or a-periodic.

The symbolic dynamics of the logistic equation follows from the MT sequence taking the sum mod2 (i.e., even sum is 0, while odd sum is 1) of every pair of numbers from the sequence starting from the left,

$$1011101\dots$$

Alternatively, we could consider the Morse–Thue sequence to be a number in binary and obtain the symbolic dynamics by converting binary to Gray code as in Appendix 15.A.

Before we leave this subject, Consider another hidden pattern within the MT sequence. Although MT never repeats, it contains within itself a subtle repetitiveness. Underline every other digit, and notice how the entire pattern replicates,

$$\underline{0}\,1\,\underline{1}\,0\,\underline{1}\,0\,\underline{0}\,1\,\underline{1}\,0\,\underline{0}\,1\,\underline{0}\,1\,\underline{1}\,0\,\dots$$

Form pairs of these digits and rename the pair by its leftmost digit and notice the replication of the original pattern,

$$01\ 10\ 10\ 01\dots\ \rightarrow\ 0\ 1\ 1\ 0\dots.$$

Analogous results occur when any sequence of digits of length 2^n is underlined.

17.6 The Shift Operator

In Chapter 14, we saw that rational numbers were identified with finite processes while irrational numbers were related to infinite processes. An examination of the logistic equation for the value, $a = 4$, i.e., in the chaotic regime, illustrates the relationship between number and chaos. Equation (17.3) can be transformed [Schr] to the following simple form,

$$y_{n+1} = \lfloor 2y_n \rfloor_f \tag{17.4}$$

where $\lfloor\ \rfloor_f$ means that the *fractional part* of the number is taken and the *integer part* is discarded, e.g., $\lfloor 2.36 \rfloor_f = 0.36$. Therefore, if the irrational value, $y_0 = 0.1010010001\dots$, written in binary, is multiplied by 2, the decimal point moves one place to the right (just as a decimal number multiplied by 10 moves the decimal point one place to the right) to yield, $1.010010001\dots$. As a result, from Equation (17.4), $y_1 = 0.010010001\dots$. For this reason, Equation (17.4) is called a *shift map*. Likewise, $y_2 = 0.10010001\dots$, $y_3 = 0.0010001\dots$, etc.

Although this trajectory never repeats itself, it is "near" periodic orbits of all periods. For example, the orbit with initial value $y_0 = 0.101010\dots = 0.\overline{10}$ leads to a trajectory with periods 2, and 4. Yet it agrees with the first two positions of the irrational trajectory to 2 decimal place. Also the periodic

trajectory with initial value, $y_0 = 0.1010010010100100\ldots = 0.\overline{10100100}$ leads to a trajectory of period 8. Yet it agrees with the first four positions of the irrational trajectory to 4 decimal places. In this way, periodic orbits of all periods can be constructed "near" any irrational trajectory. Once again, the intimate connection between rational and irrational numbers and the dynamics of a mathematical system in the chaotic regime can be seen.

17.7 Conclusion

The logistic equation exhibits extraordinary subtlety despite its disarming algebraic simplicity. However, its simplicity is merely an illusion in view of the complex dynamics exhibited by this equation. This is all the more compelling when we consider the universality of the logistic equation. The same underlying structure is inherent in more complex and realistic nonlinear mathematical models. In fact, it can be shown that a wide class of nonlinear transformations exhibit behavior that can be characterized by certain constants known as *Feigenbaum numbers*, after their discoverer, even though the equations are quite different in their appearance.

Number lies at the heart of transformations exhibiting chaotic behavior. Chapters 19 and 23 will be devoted to studying the dynamics of the logistic equation in greater detail. We will show that chaos at one level leads to exquisite order at a higher level of analysis. The next chapter is devoted to a study of fractals, a subject closely related to chaos theory.

Appendix 17.A

The problem is to show that,

$$x_{n+1} = ax_n(1 - x_n) \tag{17.A1}$$

and,

$$z_{n+1} = z_n^2 + c \tag{17.A2}$$

are equivalent.

The standard form of the logistic equation is,

$$p_{n+1} - p_n = rp_n(1 - p_n). \tag{17.A3}$$

This equation says that the change in population during one time period is both proportional to the level of the population p_n and is limited by a term p_n^2 which reflects the competition for scarce resources.

We shall first show that Equation (17.A2) is equivalent to Equation (17.A3) and then that Equation (17.A3) is equivalent to Equation (17.A1).

Let

$$c = \frac{1-r^2}{4} \quad \text{and} \quad z_n = \frac{1+r}{2} - rp_n \tag{17.A4}$$

and replace these in Equation (17.A2). After some algebra the equation reduces to Equation (17.A3).

Next, let

$$p_n = \left(\frac{r+1}{r}\right)x_n \quad \text{and} \quad r = a - 1 \tag{17.A5}$$

and replace this in Equation (17.A3). After some algebra this reduces to Equation (17.A1).

From Equations (17.A4) and (17.A5) we find that,

$$a = 1 + \sqrt{1-4c} \quad \text{and} \quad x_n = \frac{1}{2} - \frac{z_n}{a}. \tag{17.A6}$$

From Equation (17.A6) notice that $c = -2$ corresponds to $a = 4$. This is consistent with the chaotic behavior demonstrated by the results of Table 17.1 and Figure 17.3.

18
Fractals

Symmetry, as wide or as narrow as you may define its meaning,
is one idea by which man through the ages has tried to
comprehend and create order, beauty, and perfection.

Hermann Weyl

18.1 Introduction

Euclidean geometry (the geometry most of us learned in high school) has had
a major impact on the cultural history of the world. Not only mathematics,
but art, architecture, and the natural sciences, have utilized the elements
of Euclidean geometry or its generalizations to projective and non-Euclidean
geometries. However, by its nature, Euclidean geometry is more suitable to
describe the ordered aspects of phenomena and the artifacts of civilization
rather than as a tool to describe the *chaotic* forms that occur in nature. For
example, the concepts of point, line, and plane, which serve as the primary
elements of Euclidean geometry, are acceptable as models of the featureless
particles of physics, the horizon line of a painting, or the facade of a building.
On the other hand, the usual geometries are inadequate to express the
geometry of a cloud formation, the turbulence of a flowing stream, the pattern
of lightning, the branching of trees and alveoli of the lungs, or the
configuration of coastlines.

In the early 1950s, the mathematician Benoit Mandelbrot [Man], aware
of work done a half century before, rediscovered geometrical structures
suitable for describing these irregular sets of points, curves and surfaces from
the natural world. He coined the word *fractals* for these entities and invented
a new branch of mathematics to deal with them, an amalgam of geometry,
probability, and statistics. Although there is a strong theoretical foundation

to this subject, it can be studied best through the medium of the computer. In fact, while fractal geometry is a subject in which mathematical objects are generally too complex to be described analytically, it is an area in which computer experiments can lead to theoretical results.

Mandelbrot created his geometry in 1974 after observing the patterns arising in such diverse areas of research as the structure of noise in telephone communications, the fluctuation of prices in the options market, and a statistical study of the structure of language. One of Mandelbrot's colleagues at Bell Labs, Richard Voss, has also pioneered the relationship between fractals and music [Vos-C]. In 1961 Mandelbrot turned his attention to an empirical study of the geometry of coastlines carried out by the British meteorologist Lewis Richardson. Mandelbrot recognized the theoretical structure behind Richardson's data and saw how this structure could be generalized and abstracted. This chapter is devoted to a discussion of how Richardson's work on the geometry of coastlines led Mandelbrot to formulate his fractal geometry, and is also meant to serve as an introduction to Mandelbrot's work. Since Mandelbrot's early work, fractals have become the visual language of chaos theory, this chapter and the next will describe the connections between these two subjects. The key to understanding fractals and their applications to the natural world lies in their embodiment of self-similarity, self-referentiality, and universality.

18.2 Historical Perspective

Before beginning a discussion of Richardson's approach to analyzing coastlines, it is useful to place the subject of fractals in historical perspective.

Calculus was invented in the latter part of the 17th century by Newton and Leibnitz in order to deal mathematically with the variation and changes observed in dynamic systems such as the motion of the planets and of mechanical devices. Through calculus, the concepts of *continuity* and *smoothness* of curves and surfaces were quantified. However, since the approach to this subject was intuitive, continuity and smoothness were limited in their range of possibilities to ordered or tame motions. When the logical foundation of calculus was completed by the middle of the 19th century, mathematicians were motivated to search for extreme examples of

variability with which to test the now rigorous definitions of continuity and smoothness. Much to the surprise of the mathematical community, Karl Weierstrass (1815–1897), Georg Cantor (1845–1918) and Giuseppe Peano (1858–1932) were able to create *pathological* curves and sets of points that confounded intuition. Weierstrass constructed a curve spanning a finite distance that was infinite in length, continuous but nowhere smooth. Peano created a curve that could fill up a square without crossovers (although segments of the curve touched). Cantor constructed a set of points as numerous as all the points within a unit interval yet so sparse as to take up negligible space — or in mathematical terms, of measure zero, justifying its characterization by Mandelbrot as a *dust*.

Most mathematicians considered these pathological creations to be interesting curiosities but of little importance. After all, their lack of smoothness rendered them not amenable to analysis with calculus. However, Mandelbrot, following on the footsteps of his teacher Paul Levy, the father of modern probability theory, saw these irregular curves and sets as models for the shapes and forms of the natural world, and he formulated his fractal geometry in order to *tame* these monstrous curves. We have already encountered one such curve as the flowsnake curve in Figure 12.10. Others will be described in Section 18.4.

In recent times many mathematicians and computer scientists, both professional and amateur, have done excellent work bringing fractal images and chaotic phenomena to light and exploring their theoretical implications. There are a few books enlightened this field such as [Barn], [Fed], [Fal], [Gle], [Pei-R], [Pru-L], [Schr]. In this chapter we will call principally upon the work of Heinz-Otto Peitgen, Jurgens Hartmut, and Dietmar Saupe from their book *Chaos and Fractals* [PJS] and Peitgen and Peter H. Richter from *The Beauty of Fractals* [Pei-R].

18.3 A Geometrical Model of a Coastline

Most people's concept of a coastline derives from two sources: observations of coastlines on a map and a vacation visit to the seashore. However, both of these experiences yield different impressions. A coastline shown in an atlas gives the impression of the coast as a comparatively smooth and ordered curve

of finite length, easily determined from the scale of the map. However, a visit to the coast generally reveals rugged and chaotic terrain with rocks jutting out to the sea and an undulating shoreline dynamically varying over time and space.

Look again at maps illustrating a coastline at an increasing sequence of scales. At a scale of 1 in. to 100,000 ft., the scale of a good roadmap, the coast appears quite smooth and indicates a bay by means of a small indentation. At a scale of 1 in. to 10,000 ft., a small inlet not indicated on the previous map is seen in the bay. At 1 in. to 1000 ft., a small cove is demarcated within the inlet. Finally, at 1 in. to 100 ft., the scale of a highly detailed map, the cove is seen to have almost as much detail as the original map of the entire coastline. In fact, Richardson discovered that the coastline has effectively unbounded length and is nowhere smooth; this ever increasing detail is taken into account at decreasing scales. Scales below 1 in. to 50 ft. are not considered since they bring into focus irrelevant details, whereas scales above an upper cutoff are also not considered, since crucial details of the coastline would be deleted.

I begin a study of the geometry of coastlines by finding the length of a smooth curve such as the one shown in Figure 18.1a spanning 1 unit of length. In the first approximation $L = 1$. With a compass, reduce the opening to a scale $r = \frac{1}{3}$ unit. Successively mark off, along the curve, lengths at this scale as shown in Figure 18.1b. The curve is now approximated by a polygonal path with $N = 4$ line segments each $\frac{1}{3}$ unit with a total length of $\frac{4}{3}$ units. Reducing the scale to $\frac{1}{9}$ results in a better approximation to the length of the curve as shown in Figure 18.1c. In other words, the length of a curve is approximated by subdividing it into a finite number N of line segments of length r units, summing these segments to get

$$L(r) = Nr \qquad (18.1)$$

where N is the number of polygonal lengths at scale r and $L(r)$ is the approximate length of the curve at scale r. If the curve is smooth, we find that as r approaches zero this process always approaches a limiting value called the length of the curve, i.e.,

$$L = \lim_{r \to 0} L(r).$$

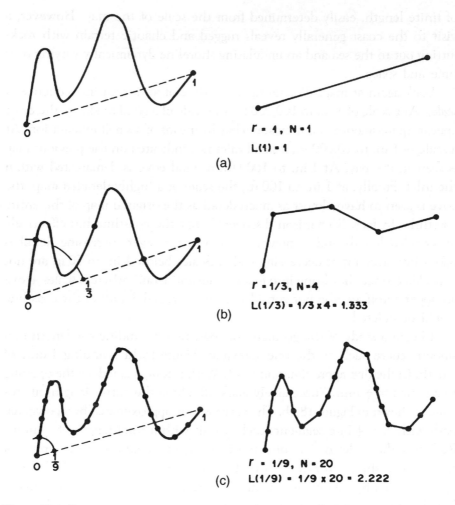

Figure 18.1 Determination of the length L of a curve spanning $[0, 1]$ by approximating the curve with N linear line segments. (a) Representation of curve at scale of $r = 1$; (b) representation of curve at scale of $r = \frac{1}{3}$; (c) representation of curve at scale of $r = \frac{1}{9}$.

However, this procedure will not work for coastlines which are not smooth. Consider the map of the coast of Norway. From the results of this exploration, the unexpected properties of coastlines can be seen. Proceeding as we did for the smooth curve, determine several values of N corresponding to a spectrum of scale lengths (polygonal path lengths) r measured in

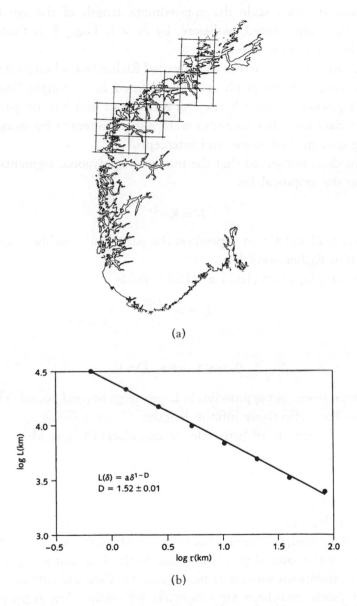

(a)

(b)

$$L(\delta) = a\delta^{1-D}$$
$$D = 1.52 \pm 0.01$$

Figure 18.2 (a) The coast of Norway. Note the fractal hierarchical geometry with fjords, and fjords within fjords, etc.; (b) the length L vs. scale length, r. The straight line indicates that the coast is fractal. The slope of the line yields the fractal dimension of the coast of Norway, $D = 1.52$ (Note that δ is used in place of r).

kilometers. At each scale the approximate length of the coastline, in kilometers, is represented, as before, by $N \times r$. $\log_{10} L$ is then plotted against $\log_{10} r$ in Figure 18.2.

One can sense the surprise that awaited Richardson when he discovered that the points of the graph are closely fitted by a straight line (a line has the equation $y = mx + b$ where m is the slope and b is the y-intercept) and that data for other countries were also represented by straight lines differing only in their slopes and intercepts.

Richardson recognized that the number of polygonal segments at scale r satisfies the empirical law

$$N = Kr^{-D} \qquad (18.2)$$

for constants D and K that depend on the particular coastline studied. This is known as Richardson's law.

Replacing Equation (18.2) in (18.1), yields

$$L = K\,r^{1-D}$$

where

$$0 < r \leq 1 \quad \text{and} \quad D > 1. \qquad (18.3)$$

As a consequence, as r approaches 0, L gets large beyond bound. Therefore, coastlines have effectively infinite lengths.

Taking logarithms of both sides of Equation (18.3) yields

$$\log_{10} L = (1 - D)\,\log_{10} r + \log_{10} K$$

validating the linear graph of Figure 18.2 where the slope is $1 - D$ and the intercept is $\log_{10} K$.

If a similar analysis is carried out for any segment of a coastline, the results are a line of the same slope. This is due to the fact that any portion of a coastline exhibits the same statistical spectrum of ins and outs as the whole. In other words, coastlines are *statistically self-similar*. Any segment of the coastline is governed by the same power law. The value of D is called the *dimension* of the curve forming the coastline. It is a measure of how rugged the coastline is. The more rugged, the higher is D. From Figure 18.2, the dimension of the coast of Norway is found to be approximately $D = 1.52$.

Solving Equation (18.2) for D yields the formula,

$$D = \frac{\log N}{\log\left(\frac{1}{r}\right)} .$$
(18.4)

Curves that have the properties of being self-similar at any scale, nowhere-smooth, and having finite segments of infinite length are called *fractals*.

18.4 Geometrically Self-Similar Curves

The only smooth curve that is self-similar at all scales is the logarithmic spiral, which is the configuration of many forms from the natural world such as shells, the horns of horned animals, and the spiral whorls seen on the surface of sunflowers (see Figure 18.3). In his book *The Fractal Geometry of Nature* [Man], Mandelbrot presents a procedure for constructing an infinite variety of nowhere smooth curves that are geometrically self-similar. To understand how self-similar curves relate to Richardson's law, it is sufficient to set $K = 1$ and rewrite Equations (18.1) and (18.2) as,

$$L(r) = r \times N \quad \text{and} \quad L(r) = r \times \left(\frac{1}{r^D}\right).$$
(18.5)

First consider a trivial example of a self-similar curve, the straight-line segment of unit length shown in Figure 18.4. This segment is self-similar at any scale. For example, at scale $\frac{1}{3}$, Figure 18.4 shows that three similar editions of the segment replicates the original. Thus, from Equations (18.5),

$$L\left(\frac{1}{3}\right) = \frac{1}{3} \times 3 \quad \text{or} \quad L\left(\frac{1}{3}\right) = \frac{1}{3} \times \frac{1}{\left(\frac{1}{3}\right)^1}$$

and consequently $D = 1$, the usual dimension of a curve in Euclidean geometry, also called the *topological dimension*.

Next consider a less trivial example of a curve, self-similar at a sequence of scales $\left(\frac{1}{3}\right)^n$, $n = 1, 2, 3, \ldots$, known as the *Koch snowflake*. Since the curve is infinite in length, continuous and nowhere-smooth, it cannot be drawn as a smooth curve like the one in Figure 18.1. However, it can be generated by an infinite process, each stage of which represents the curve as seen at one

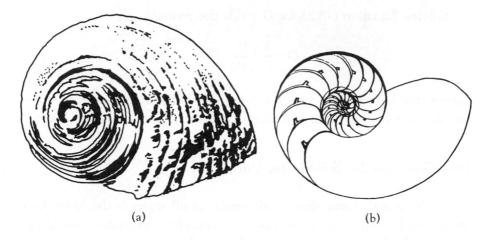

Figure 18.3 (a) A sea shell; (b) nautilus shell illustrating a logarithmic spiral.

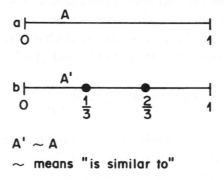

$A' \sim A$

\sim means "is similar to"

Figure 18.4 The unit interval, a trivial example of a self-similar curve with dimension $D = 1$.

of the scales in the above sequence. Figures 18.5a, 18.5b and 18.5c show views of the Koch snowflake at scales of 1, $\frac{1}{3}$, and $\frac{1}{9}$, respectively, both as linear segments on the left and incorporated into triangular snowflakes on the right. Each successive stage in the generation of the snowflake can be thought of as a close-up image of the curve, in which greater detail is visible.

The snowflake is generated iteratively by replacing each segment of one stage by four identical segments of length one-third the original in the next stage. Therefore, $N = 4$ when $r = \frac{1}{3}$. As a result, D can be algebraically determined from Equation (18.4) as, $D = \frac{\log 4}{\log 3} = 1.2168...$ which is the

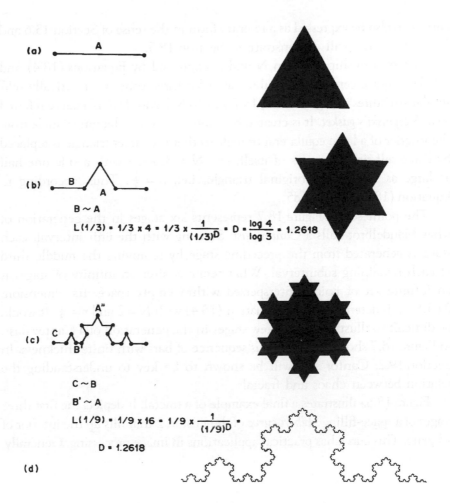

Figure 18.5 The Koch snowflake, a nontrivial example of a self-similar curve with dimension $D = 1.2618$. (a) Koch snowflake at scale of $r = 1$; (b) Koch snowflake at scale of $r = \frac{1}{3}$; (c) Koch snowflake at scale of $r = \frac{1}{9}$; (d) Koch snowflake at an advanced stage in its generation.

dimension of this unusual "coastline". Of course, unlike actual coastlines, we have limited ourselves to scales that are powers of $\frac{1}{3}$. However, as for actual coastlines any portion of the curve is geometrically similar to the whole. This property of self-similarity at a sequence of scales is more evident in Figure 18.5d, a Koch snowflake at an advanced stage in its development. This figure shows that it is made up of four self-similar copies of itself. The Koch

curve can also be expressed as a re-entry form in the sense of Section 13.6 and Figure 13.7, as I will demonstrate in Section 18.5.

The relationship between N and r, expressed by Equations (18.4) and (18.5), is quite general and is illustrated for three other geometrically self-similar structures in Figures 18.6, 18.7 and 18.8. Figure 18.6 is a curve referred to as *Sierpinski's gasket*. It is created by removing an equilateral triangle from the interior of a large equilateral triangle so that the larger triangle is replaced by three self-similar copies of itself, i.e., $N = 3$, each with a side one-half as large as side of the original triangle, i.e., $r = \frac{1}{2}$. Thus, according to Equation (18.4), $D = 1.585\ldots$

The point set in Figure 18.7 represents six stages in the generation of what Mandelbrot calls a *Cantor dust*. Starting with the unit interval, each stage is generated from the preceding stage by removing the middle third of each remaining subinterval. What remains after an infinity of stages is an infinite set of points interspersed within empty space. Its dimension, $0.6309\ldots$, is determined from Equation (18.4) with $N = 2$ and $r = \frac{1}{3}$. It would be difficult to illustrate even a few stages in the generation of a Cantor dust, so Figure 18.7 shows an analogous sequence of bars with finite thickness. In Section 19.2, Cantor sets will be shown to be key to understanding the relation between chaos and fractals.

Figure 18.8a illustrates a final example of a fractal. It depicts the first three stages of a space-filling *Hilbert curve* of dimension 2 that fills up the interior of a square. This curve has practical applications in image processing. Generally,

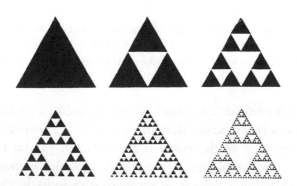

Figure 18.6 Sierpinski's gasket. The basic construction steps of the Sierpinski gasket.

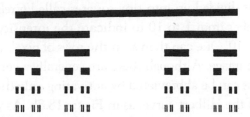

Figure 18.7 Six stages in the generation of a Cantor triadic bar, an approximation to a Cantor dust with dimension $D = 0.6309$.

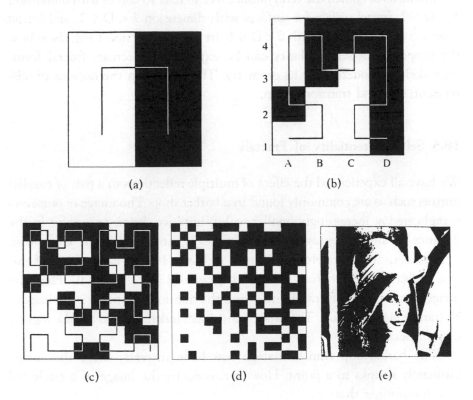

Figure 18.8 (a), (b), (c), (d) The first four stages in the generation of a Hilbert curve used to create an image by a dithering algorithm. From stage to stage, the size of the line segments are reduced by a factor of $\frac{1}{2}$; (e) final image.

a black and white photographic image consists of a continuum of shades of gray. The scene is divided up into tiny squares called *pixels*, and each pixel is assigned a number from 1 to 10 to indicate the intensity of shading from white, 1, to black, 10. One can then scan the rows of pixels and activate each site to recover the image. Although there are generally a very large number of pixels, this process can be abbreviated by activating only those sites along an advanced stage of the Hilbert curve, as in Figure 18.8b. As you can see, even though only black and white is used in this *dithering* process, even a relatively low stage in the development of the curve is dense enough in the image to recover a good facsimile of it.

Mandelbrot coined the term *fractal curve* to refer to curves with dimension $1 < D \leq 2$, *fractal surface* for surfaces with dimension $2 < D \leq 3$, and *fractal point sets or dusts* for sets with $0 < D \leq 1$. In the next section I will show how the properties of self-similarity can be exploited to recreate fractal forms from skeletal renderings of its geometry. The key lies in the notions of self-referentiality and transformation.

18.5 Self-Referentiality of Fractals

We have all experienced the effect of multiple reflections in a pair of parallel mirrors such as are commonly found in a barber shop. The image of ourselves is replicated at increasingly smaller scales, until we shrink to a point in the distance. A similar regressive set of images is generated by the cartoonist, Janusz Kapusta's self-referential painter in Figure 18.9. We can think of this as a *feedback process* such as the one diagrammed in Figure 18.10. Here the image is inputted, then transformed, and the transformed image is fed back to be transformed yet again. The process continues indefinitely as did the logistic map of Section 17.3.

The barbershop transformation has little interest, since the image ultimately shrinks to a point. However, consider the image of a circle fed to a transformer that:

(1) shrinks the image to a circle with radius one-half of the original;
(2) juxtaposes three copies of the shrunken circle in the manner shown in Figure 18.11 to form the transformed image.

Figure 18.9 A self-referential image by Janusz Kapusta.

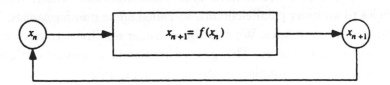

Figure 18.10 A one-step feedback machine.

Repeating this transformation results in a structure that resembles more and more the Sierpinski gasket. Figure 18.11b shows that what is chosen as the initial stage is unimportant; it is the rules of transformation and the feedback process that results in the ultimate structure. Figure 18.11c shows that if the limiting structure, the Sierpinski gasket, is taken to be the initial stage of this process, it remains unchanged, i.e., it is a *fixed point* of this transformation.

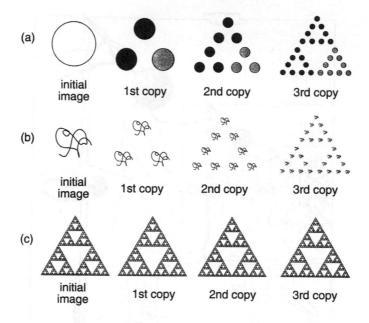

Figure 18.11 Three iterations of the transformation that produces a Sierpinski gasket.

The transformations that we have at our disposal are contractions, translations, rotations, reflections and transformations which transform rectangles to arbitrary parallelograms, so-called *affine transformations*. These all transform lines to lines. We can also consider nonlinear transformations which map lines to curves. This gives a tremendous amount of flexibility to the generation of complex results from simple rules.

The fact that the Koch curve can be subdivided into four self-similar copies of itself suggests a feedback process to generate Koch curves. Begin with a rectangular image, shrink it by a factor of three, and juxtapose four of the scaled images as shown in Figure 18.12. Repeating this process gives rise to the Koch curve. But an identical initial rectangular image when transformed to three rectangles of different sizes, proportions, and orientations and one line segment as shown in Figure 18.13a gives rise to the beautifully complex image of *Barnsley's fern* in Figure 18.13b. In Figure 18.14, Peitgen has shown that through an ordered series of transformations we can gradually transform the Koch curve to Barnsley's fern.

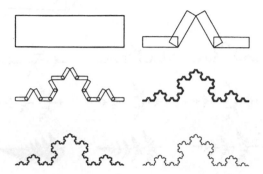

Figure 18.12 Starting with an arbitrary shape, a rectangle, iteration of the Hutchinson operator produces a sequence of images which converge to the Koch curve.

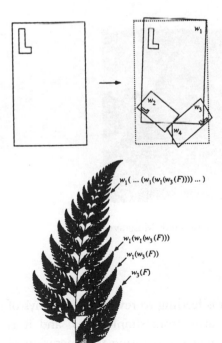

$w_1(\dots (w_1(w_1(w_3(F)))) \dots)$

$w_1(w_1(w_3(F)))$

$w_1(w_3(F))$

$w_3(F)$

Figure 18.13 Barnsley's fern. The small triangle in the initial image and its first copy on the right indicate where the "stem" of the fern is attached to the rest of the leaf.

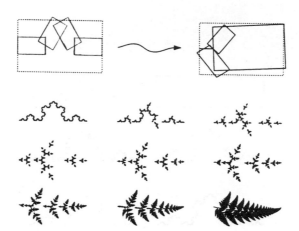

Figure 18.14 By changing the parameters of the transformation for the Koch curve continuously to those of the fern, the generated image smoothly transforms from one fractal into the other. The lower nine images of the figure show some intermediate stages of this metamorphosis.

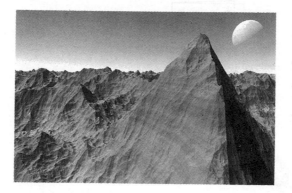

Figure 18.15 A fractal scene by Kenneth Musgrave.

This approach to generating fractals is leading to revolutionary ways of understanding how complex structures arise from simple ones, and it is being applied to may applications from image processing to generation of fractal scenes for movie sets such as that shown in Figure 18.15 generated by Kenneth Musgrave.

18.6 Fractal Trees

The complex patterns associated with fractals are the result of repeatedly applying a simple rule through a feedback mechanism. This has already been seen in Section 13.6, where the Fibonacci series is pictured in Figure 13.8a as a form F that re-enters its indicational space to give the series of boxes at varying depths shown in Figure 13.8b. The number of boxes at each depth represents the Fibonacci numbers: 1, 1, 2, 3, 5, 8,....

In Figure 18.16a F is represented as a structural tree where horizontal lines are drawn at successive depths. Counting the outside space as depth 0, there is a single F at depths 0, 1, and 2 represented by * s. This hierarchy of depths translates into the self-referential statement,

$$F = \overline{\overline{F} | F} .$$
(18.6)

Notice that this tree can be thought of as an infinite logic device of the form described in Section 16.8. If each of the horizontal lines is interpreted as a "not" gate and the star signifies F, Figure 18.16a is an expression of Equation (18.6) using the notation of Section 16.8. Below each * appears a replica of the basic form as shown in Figure 18.16b up to level five as the tree's branches unfold according to the Fibonacci series. Notice how a complete copy of the entire tree lies beneath each *, a manifestation of the self-similarity of fractals. Thus Figure 18.16b describes the tree just as Figure 13.8b describes the form by the recursion relation,

$$F_{n+2} = F_{n+1} + F_n ,$$
(18.7)

all aspects of the same fractal structure.

With this introduction to self-similar forms, return to the Koch snowflake. Kauffman [Kau1] has examined the Koch snowflake from this standpoint, and referring to Figure 18.17a, described it as follows:

> "These attempts to indicate the re-entry are both leading and misleading. It is composed with an embedded tree that is an obvious relative of the form of re-entry in Figure 18.16. K is the set of ends of an embedded self-similar tree T as shown in Figure 18.17b. Remarkably, T is the tree associated with the

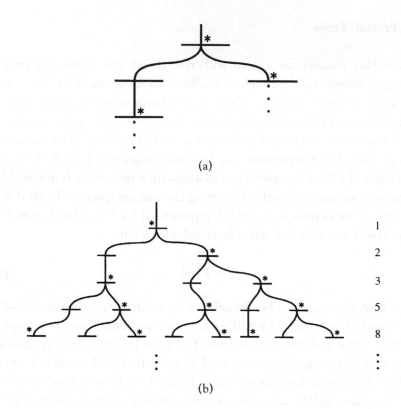

(a)

(b)

Figure 18.16 A fractal tree representing the Fibonacci sequence.

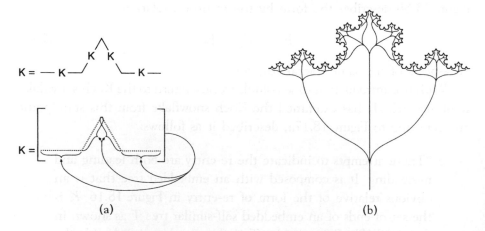

(a)

(b)

Figure 18.17 The Koch snowflake as a fractal tree.

form $T = \boxed{T \boxed{T\ T}\ T}$. Just as the middle parts of K are singled out geometrically, in T they are singled out formally. T embodies the abstract structure of K. There are two forms associated with K,

$A = \boxed{A\ A\ A}$ indicating the three-fold cut, and

$B = \boxed{B\ B\ B\ B}$ indicating the four-fold duplication,

i.e., $\rho(A) = 3$ and $\rho(B) = 4$ and the dimension D is given by,

$$D(K) = \frac{\log\rho(B)}{\log\rho(A)} = \frac{\log(\text{duplication rate})}{\log(\text{cut rate})}.$$

This holds for many simple recursions and allows a definition of dimension for abstract forms."

Thus the dimension of the abstract form given in Figure 18.18 is:

$$T = \boxed{T \boxed{T\ T}\ T}$$

where,

$A = \boxed{A\ A\ A}$ indicates the three-fold cut, and

$B = \boxed{B\ B\ B\ B}$ indicates the five–fold duplication.

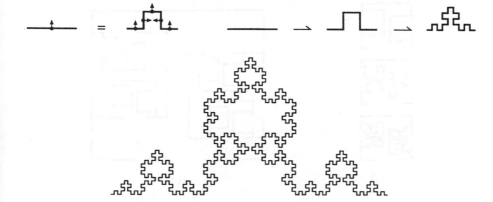

Figure 18.18 A fractal tree with dimension $\frac{\log 5}{\log 3}$.

Therefore, the dimension of this fractal is,

$$D = \frac{\log 5}{\log 3}.$$

18.7 Fractals in Culture

Structures and designs with fractal properties appear quite naturally in many cultures. I will present two examples from Ron Eglash's book *African Fractals* [Egl].

In the western part of the Cameroons lies the fertile grasslands region of the Bamileke. Eglash describes their fractal settlement architecture.

> "These houses and the attached enclosures are built from bamboo — Patterns of agricultural production underlie the scaling. The grassland soil and climate are excellent for farming, and the gardens near the Bamileke houses typically grow a dozen different plants all in a single space, with each taking its characteristic vertical place. But this is labor intensive, and so

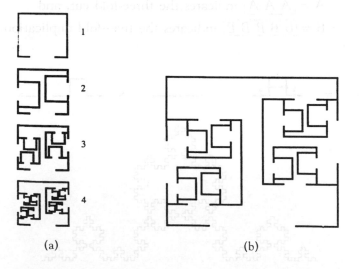

(a) (b)

Figure 18.19 (a) Fractal simulation of Bamileke architecture. In the first iteration ("seed shape"), the two active lines are shown in gray. (b) Enlarged view of fourth iteration.

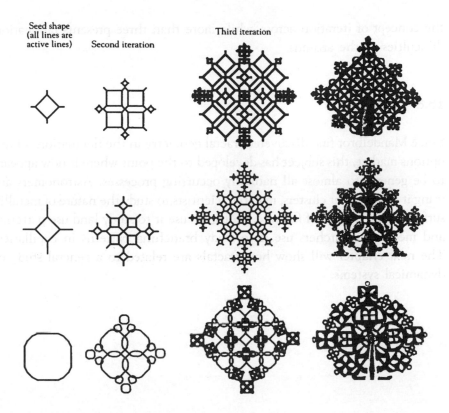

Seed shape
(all lines are
active lines) Second iteration Third iteration

Figure 18.20 Fractal simulations for Ethiopian processional crosses through three iterations.

more dispersed plantings are used in the wider spaces farther from the house. Since the same bamboo mesh construction is used for houses, house enclosures, and enclosures of enclosures, the result is a self-similar architecture — The farming activities require a lot of movement between enclosures, so at all scales we see good-sized openings."

Eglash's fractal simulation in Figure 18.19 shows how this scaling structure can be modeled using an open square as the seed shape.

Many of the processional crosses of Ethiopia indicate a threefold fractal iteration (see Figure 18.20). Eglash suggests that the reason that the iteration stops at three may be for practical reasons. Two iterations is too few to get

the concept of iteration across, while more than three presents fabrication difficulties to the artisans.

18.8 Conclusion

Since Mandelbrot first discovered fractal geometry in the fluctuations of the options market, this subject has developed to the point where it now appears to be generic to almost all naturally occurring processes. Astronomers are using it to study star clusters, material scientists to study the nature of metallic surfaces and patterns of fracture, geologists use it to study land use patterns, and medical researchers use it to study branching patterns in capillaries. The next chapter will show how fractals are related to a general study of dynamical systems.

19
Chaos and Fractals

> Mathematics is the only infinite human activity...humanity won't
> ever be able to find out everything in mathematics, because the
> subject is infinite. Numbers themselves are infinite.
>
> *Paul Erdos*

19.1 Introduction

The theories of fractals and chaos became areas of intense mathematical
study in the 1970's before mathematicians realized that they are intimately
connected. This chapter is devoted to gaining an understanding of that
connection. Again, number provides the key.

19.2 Chaos and the Cantor Set

Let us return to the logistic equation introduced in Chapter 17 and given by
the equation,

$$x_{n+1} = a\, x_n(1 - x_n) \tag{19.1}$$

with initial value x_0. It was previously seen that for values of $x_0 < 0$ or
$x_0 > 1$ the trajectories, i.e., the series of points, x_0, x_1, x_2, \ldots escape to infinity.
If $a \leq 4$, and $0 \leq x_0 \leq 1$, then it follows that $0 \leq x_1 \leq 1$ and all further
trajectory points reside in the interval between 0 and 1, $[0, 1]$. But this is no
longer true when $a > 4$. Even though the initial point x_0 lies in the interval,
$[0, 1]$, the image point x_1 may lie outside of $[0, 1]$ and therefore the trajectory
will escape to infinity. What is so special about the number $a = 4$ and what

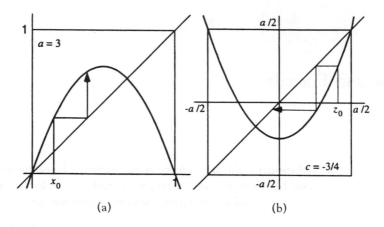

Figure 19.1 Graphical iteration $x -> ax(1 - x)$ (a) and $x -> x^2 + c$ (b).

is the structure of the set of points that are trapped in the interval $[0, 1]$ as compared to the points leading to escape? The parabola, $y = 3x\,(1 - x)$, corresponding to $a = 3$ is shown in Figure 19.1a. Notice that the portion of the parabola corresponding to the interval $[0, 1]$ lies in the unit square and the maximum point of the parabola is below the line, $y = 1$. For all values of $a < 4$, the peak value is less than $y = 4$. You can easily check that any initial point $0 \le x_0 \le 1$ maps to a point, x_1, in the interval $[0, 1]$ and all trajectories corresponding to such values of "a" must be trapped within $[0, 1]$.

For $a = 4$, the peak of the parabola is tangent to $y = 1$, whereas for $a > 4$, the maximum is above $y = 1$. Consider, $a = 4.5$, whose parabola is shown in Figure 19.2a, and consider the backwards trajectory of Equation (19.2). In other words, beginning with a transformed value y, what values of x map to y? Figure 19.2b shows that for $y = 1$, x_1 and x_2 map to y. Working backwards another step, four additional points map to either x_1 or x_2 (see Figure 19.2c). We expect a series of 2, 4, 8, 16,... points to map over successive stages to our starting value of y.

Figure 19.2 shows the dynamics corresponding to a value of $a = 4.5$ with $y = 1$. Any initial point, x_0, within the interval between x_1 and x_2 maps to $x > 1$ and leads to escape. The regions of capture are indicated by dark lines. Going back another step, four points map to x_1 and x_2. These points are boundary points of two additional escape regions of the next stage of this process. Reading the graph, it is easy to see that any point outside of the

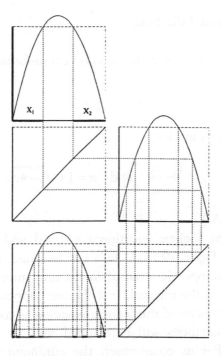

Figure 19.2 Backward iteration generating the Cantor set. Encirclement of Cantor set through backward iteration of the unit interval ($a = 4.5$).

darkened regions maps, in either one or two steps, to values of $x > 1$ and escape. The two new regions of escape lie in the midst of the two darkened regions of the previous stage. Going back yet another step, we see that eight intervals of escape are now demarcated. Four additional intervals have appeared in the midst of the four previous darkened intervals. This process continues ad infinitum, with new intervals of escape appearing in the midst of previous darkened intervals.

This dynamic was seen in the structure of the Cantor set (see Section 18.4), where intervals are removed from the midst of previously defined intervals leading at the end to a "dust". Here, only the points within $[0, 1]$ corresponding to a *Cantor dust* lead to bounded trajectories; all other points escape. In the next section I will demonstrate how Mandelbrot was able to generalize these dynamics to two-dimensional point sets with the result being the pictures that we now associate with fractals.

19.3 Mandelbrot and Julia Sets

I have shown that the logistic equation can be transformed to its counterpart equation,

$$z_{n+1} = z_n^2 + c \qquad (19.2)$$

by making the transformation,

$$x_n = \frac{1}{2} - \frac{z_n}{a} \quad \text{and} \quad a = 1 + \sqrt{1 - 4c}.$$

(See Appendix 17.A.)

For example, the logistic equation for $a = 3$ and its counterpart for $c = -\frac{3}{4}$ is shown in Figure 19.1b. Details can be found in [Pei]. Whereas all values in $[0, 1]$ are trapped (contained in the unit interval) for the logistic equation, all values in the interval, $\left[-\frac{a}{2}, \frac{a}{2}\right]$, are trapped for its counterpart. So long as the peak value of the logistic equation is contained in the unit square, all such trajectories will be trapped, and, as we have seen, this occurs for $a \leq 4$. For its counterpart, the minimum must be contained within the *essential square* (the square with vertices $\left(\pm\frac{a}{2}, \pm\frac{a}{2}\right)$ and this occurs for $-2 \leq c \leq \frac{1}{4}$.

What has been achieved? The form of our equation has been altered, but we are still considering only trajectories along a line. To expand the analysis to the plane we generalize x to a complex number z of the form $z = x + iy$ where $i = \sqrt{-1}$. We have already introduced the notion of complex number z in Section 13.4 and pictured z as the x, y-coordinate of a point in the plane, (see Figure 13.3). In Figure 19.3, z is represented by an arrow or vector with distance r from the origin called the *magnitude* or *modulus* of z or $|z|$, and orientation with respect to the x-axis by angle θ called the *argument* of z or arg z. Two complex numbers $z_1 = x_1 + iy_1$ and $z_2 = x_2 + iy_2$ can be added or multiplied in the usual way, e.g.,

$$z_1 + z_2 = (x_1 + iy_1) + (x_2 + iy_2) = (x_1 + x_2) + i(y_1 + y_2) \text{ and}$$
$$z_1 z_2 = (x_1 + iy_1)(x_2 + iy_2) = x_1 y_1 - x_2 y_2 + i(x_1 y_2 + x_2 y_1)$$

where we have made use of the fact that $i \times i = -1$. It can be shown that the result of addition is to add the two arrows corresponding to z_1 and z_2

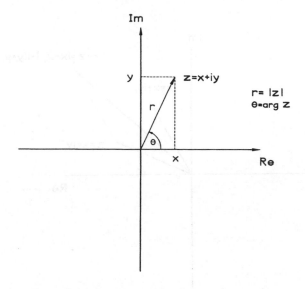

Figure 19.3 Representation of a complex number.

vectorially as shown in Figure 19.4a (see also Appendix 3C). On the other hand, multiplication results in a complex number with magnitude the product of the magnitudes of z_1 and z_2, $r_1 r_2$, and argument the sum of the arguments of z_1 and z_2, arg z_1 + arg z_2 as shown in Figure 19.4b.

Mandelbrot investigated the intricacies of the simple quadratic equation,

$$z_{n+1} = z_n^2 + c, \qquad (19.3)$$

for complex numbers z and c. He discovered that, for certain values of c, depending on the initial value z_0, all trajectories that start out in some bounded region of the plane are trapped in this region just as for the above case where c was a real number. These regions are called *basins of attraction*. For other values of c, all but an isolated set of initial values lead to bounded trajectories (again as we saw for the case of c real); the others escape to infinity. The set of c values that lead to bounded trajectories constitutes Mandelbrot's famous set shown in Figure 19.5.

Although at first glance the *Mandelbrot set* looks like nothing more than an amorphous inkblot, it has a complex and well studied structure. It first appears as a heart-shaped region with many discs of varying sizes attached

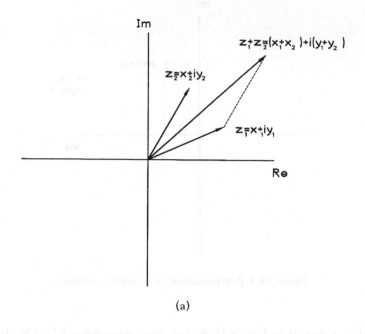

(a)

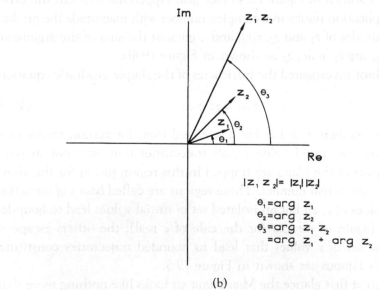

(b)

Figure 19.4 (a) Addition of complex numbers; (b) multiplication of complex numbers.

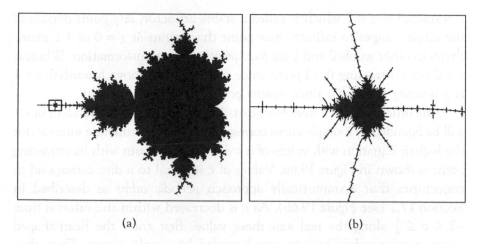

(a) (b)

Figure 19.5 (a) The Mandelbrot set; (b) a Mandelbrot at a smaller set appears in its tail.

to it and with additional disks and hair-like protrusions extending from the boundary of these discs. To really appreciate the complexity of this creature, we must descend into the depths of the computer by scaling up the region around the boundary. Much to our surprise, we see shapes of considerable beauty, variety, and complexity. Occasionally we even encounter an identical scale model of the Mandelbrot set as shown in Figure 19.5b.

The Mandelbrot set is sometimes said to be the most complex structure ever to be created by a computer. What is even more astounding is that it can be generated with only about eight lines of computer code. This is possible because whether a value of c is in the set, or not, can be determined by using $z_0 = 0$ as an initial value in Equation (19.2). If the ensuing trajectory:

$$0, c, c^2 + c, (c + c^2)^2 + c + c^2, \ldots$$

remains within some preset bound after some prescribed large number of steps, it is very likely that that value of c is in the set. Otherwise it is not.

Consider the basins of attraction in z-space that are associated with different values of c from the *Mandelbrot set*. The boundary of these sets are called *Julia sets* after the mathematicians Gaston Julia (1893–1978) and Pierre Fatou (1878–1929), who studied them. First of all, the Julia set for $c = 0$ is easily seen to be the unit circle. Any initial point within this circle

is attracted to $z = 0$ which is called a stable attractor; any point outside of the circle escapes to infinity. Any point that begins at $z = 0$ or 1 remains there; in other words 0 and 1 are *fixed points* of the transformation. Whereas $z = 0$ is an attracting fixed point since nearby points move towards 0, $z = 1$ is a *repelling fixed point* since nearby points move away from it.

Any other value of c from the heart-shaped region of the Mandelbrot set will be bounded by a simple curve corresponding to the attracting intervals for the logistic equation with values of $a < 3$. One such basin with its attracting point is shown in Figure 19.6a. Values of c internal to a disc correspond to trajectories that asymptotically approach *periodic orbits* as described in Section 17.2 (see Figure 19.6b). As c is decreased within the interval from $-2 \leq c \leq \frac{1}{4}$ along the real axis these values first enter the heart-shaped region corresponding to Julia sets bounded by simple curves. Then they enter a disc resulting in orbits of period 2, then a disc of period 4, 8, 16,..., accumulating at the point F called the *Feigenbaum limit* corresponding to $a = 3.569...$ (see Section 17.2). If c is decreased further, a point is reached corresponding to $a = 3.831...$ at which a 3-cycle is encountered after which the system enters the realm of full-blown chaos in which cycles of all lengths are possible. The c values are eventually decreased to a value outside of the Mandelbrot set, which gives rise to a Julia set that is a *Cantor dust's* worth of isolated points (see Figure 19.6c) which lead to bounded trajectories again analogous to the logistic equation in a state of full-blown chaos for $a > 4$ depicted in Figure 19.2. Yet another possibility is represented by *dendritic* structures like the one shown in Figure 19.6d. Diffusion limited processes of growth in nature have been found to produce dendritic patterns [San]. Sander describes this process:

> "Imagine growing a cluster by adding one particle at a time so that as each particle comes in contact with the growing object, it sticks and never tries another — such a process is called aggregation. No rearrangement takes place at all. Now suppose the particles diffuse to the cluster by means of a random walk: a sequence of steps whose magnitude and direction are determined by chance. The aggregation of particles by means of random walks is what is called diffusion-limited aggregation. That is, it simply stays put."

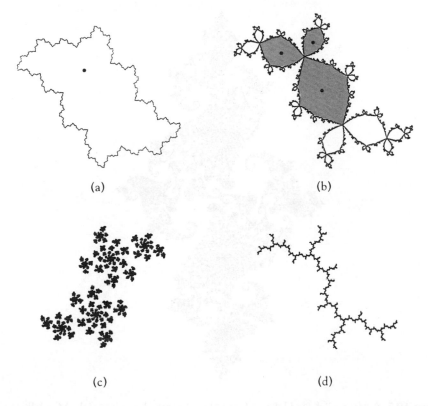

(a) (b)

(c) (d)

Figure 19.6 Julia sets. (a) Basin of an attractive fixed point; (b) basin of an attractive cycle of period 3; (c) Cantor dust resulting from a c value outside of the Mandelbrot set; (d) a dendritic structure.

The self-similarity of the Julia sets were well known to Julia and Fatou. They were aware that all of the points of a Julia set could be generated from iterations by Equation (19.3) of any of its finite connected parts. However, it is only in recent years, through the use of the the computer, that we have begun to appreciate what this means in aesthetic terms. It is easier to comprehend this self-similarity by examining the examples shown in Figure 19.6. However, things get more interesting when we consider values of c on the boundary of the Mandelbrot set. Here the Julia sets take on phantasmagoric images of spiral shapes, dragons, and organically-appearing spines such as the one shown on Figure 19.7. What's more, the Mandelbrot

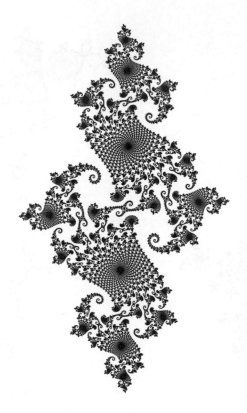

Figure 19.7 A "dragon" shaped Julia set for a value of c at the boundary of the Mandelbrot set.

set appears to be a catalogue of Julia sets in that, near a value of c on the boundary, there appears a facsimile of the Julia set corresponding to that value of c. The Mandelbrot set brings to light a tangible vision of the relationship between order and chaos and the boundary between them.

19.4 Numbers and Chaos: The Case of $c = 0$

In the simplest of Julia sets, the unit circle for which $c = 0$, consider an initial point z_0 of a trajectory located at a point in the complex plane with modulus $r = 2$ and angle, arg $z_0 = 45$ degrees. Replacing this value in

$$z_{n+1} = z_n^2 \tag{19.4}$$

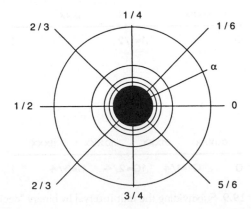

Figure 19.8 A coordinate system formed by field lines and equipotential lines for the unit disk. The angles of the field lines are given in multiples of 2π (i.e., $q = 2\pi\alpha$, $0 \leq \alpha \leq 1$). A two stage representation of the numbers on the unit interval in the base two "decimal system".

and using the fact that multiplying z by itself squares its magnitude and doubles its argument (see Section 19.3), we find that $r_1 = 2^2$ and $\arg z_1 = 90$ degrees. Likewise, $r_2 = 2^4$ and $\arg z_2 = 180$ degrees, $r_3 = 2^8$, $\arg z_3 = 360$ degrees, etc. A rapid escape to infinity along an angle-doubling route occurs. The same scenario holds for any point beginning its trajectory outside of the unit circle. If the point starts on the circumference of the unit circle, then it remains on the circle but moves along an angle-doubling trajectory.

Next we create a new coordinate system of radial lines and circles, as shown in Figure 19.8. The lines are labeled by angular fractions of a circle, e.g., $\frac{1}{8} = 45$ degrees, $\frac{1}{4} = 90$ degrees, $\frac{1}{2} = 180$ degrees, $1 = 360$ degrees while $\frac{3}{2} = 540$ degrees. Only fractions between 0 and 1 need be considered since larger angles represent a distance more than once around the circle, e.g., 540 degrees = 180 degrees = $\frac{1}{2}$. Angles can be represented either as angles mod 2π (where 2π radians equals 360 degrees) or by numbers mod 1 (the fractional parts). The circles are of radius 2, 2^2, 2^4, 2^8 etc. The dynamics can be visualized in terms of angle doublings.

To make the dynamics of the trajectories easier to compute, the angular positions of the radial lines are represented in base two, using only the digits 0 and 1. Figure 19.9 shows how this is done. First the unit interval is divided in two parts, with the midpoint indicated by $\frac{1}{2} = 0.1$ (in binary). Any

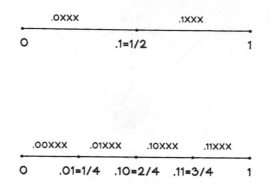

Figure 19.9 Subdividing the unit interval by binary "decimals".

point in the first half of the interval has decimal expansion 0.0xxx while any point in the second half of the interval is represented by decimal 0.1xxx. Now subdivide the unit interval into four equal parts with dividing points $\frac{1}{4} = 0.01$, $\frac{2}{4} = 0.10$, $\frac{3}{4} = 0.11$. Any point in subinterval (i) (resp. (ii), (iii) and (iv)) is represented by 0.00xxx (resp. 0.01xxx, 0.10xxx and 0.11xxx). Continuing in this way, any point in the unit interval can be represented by a sequence of 0's and 1's.

The main reason for using base two to represent fractions is that multiplication by 2 is carried out by merely shifting the decimal point one space to the right just as with multiplication by 10 for base 10 (see Section 17.6). Therefore a number represented by 0.01xxx has a represention 0.1xxx when multiplied by 2 and 1.xxx when mutiplied by 4. If these decimals represent angular positions on a circle, the 1 before the decimal can be eliminated since it merely represents once around the circle. The decimal part of the number is referred to as mod 1.

Figure 19.10 shows a binary decomposition of the radial lines and circles corresponding to the dynamics of the $c = 0$ Julia set. Here the unit circle is shown at the center in black. All radial lines in the upper half of the diagram are located at fractional parts of the circle with leading digits of 0, while all lines in the lower half have leading 1's. Note that the decimal point is eliminated. The first quarter within the circle has leading digits of 00, the second quarter 01, the third quarter 10 and the fourth 11. Doubling any angle in 00 and 10 leads to an angle in region 0 as can be seen by multiplying

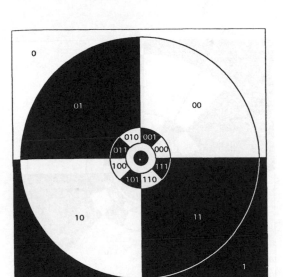

Figure 19.10 Binary decomposition for $c = 0$. The small black disk in the center is the unit disk, the large circle has radius 16. Pictured are the two stage-1 cells of level set, the four stage-2 cells, and the eight stage-3 cells. Cells are shaded according to their labels; even labels give white cells, odd labels give black cells.

0.00xxx and 0.10xxx by 2. Likewise doubling the angles in 01 and 11 leads to an angle in the region marked 1. The regions have been color coded with black and white so that a radial line always doubles from a region within one circle to another region of the same color in the next circle, i.e., white to white or black to black. Descending one more step, the circle is divided into eight sectors. Again multiplication of the angle by 2 results in sending two of the octants into one of the quartants of the next stage, e.g., 101 and 001 are mapped to 01. The sequence of colors corresponding to a given radial line can therefore be read from the outer to inner region with 1-black (B), 0-white (W), e.g., 101xxx = BWB.... Successive circles are spaced by the series of radial distances $2, 2^2, 2^4, 2^8, \dots$.

The dynamics can now be visualized as moving a trajectory point located in one sector to a transformed point in a sector of the next stage. The more articulated are the regions, the more accurate will be the dynamics. For example, five stages are shown in Figure 19.11 and the approximate positions of the repeating decimals $0.010101\dots = 0.\overline{01}$ and $0.101010\dots = 0.\overline{10}$ are

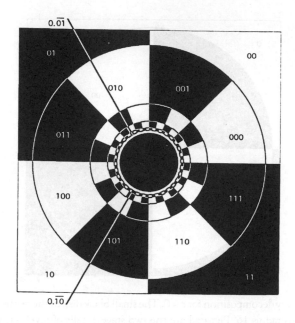

Figure 19.11 Binary decomposition and field lines. Binary decomposition allows us to identify the angle of field lines. Shown are the two angles $\frac{1}{3}$ and $\frac{2}{3}$ with binary expansions 0.0101... and 0.1010... which can also be read off from the labels of the cells that the field line passes through.

indicated. Notice that the placement of the lines becomes less precise as one goes to later stages in the dynamical process. It is for this reason that no degree of accuracy is ever enough to specify the initial point of the trajectory. There will always be a later stage in which the accuracy degenerates.

In this system, points represented by rational fractions have decimal expansions that repeat after some point. The number of repeating digits is called the length of its cycle. For example, consider the repeating decimal of cycle 2, 0.010101... or $0.\overline{01}$. Let $x = 0.\overline{01}$. Therefore,

$$x = 0.010101..., \quad 4x = 1.010101....$$

Subtracting the first from the second yields,

$$3x = 1 \text{ or } x = \frac{1}{3}.$$

Likewise $\frac{2}{3} = 0.101010... = 0.\overline{10}$ as seen by multiplying the decimal expansion of $\frac{1}{3}$ by 2. The expansion of $\frac{4}{3}$ is therefore obtained from $\frac{2}{3}$ by another multiplication by 2 or $\frac{4}{3} = 1.\overline{01}$. If $\frac{4}{3}$ is considered to be the angle 480 degrees on the unit circle, we see that by dropping the 1 this angle is the same as 120 degrees $= \frac{1}{3}$. We see then that a trajectory beginning on the unit circle at the position $\frac{1}{3} = 0.\overline{01}$ moves to $\frac{2}{3} = 0.\overline{10}$ and then returns to $\frac{1}{3}$ exhibiting a cycle of period 2. In a similar way, a trajectory beginning at any repeating decimal with a cycle of length n is periodic of period n.

Notice that the point, $z = 1$, at radial line 0 is a fixed point since iterations with Equation (19.4) leave it unchanged. However this fixed point is repelling, since perturbing by a small amount into the circle results in a trajectory approaching the attractive fixed point at $z = 0$; perturbing it outside the circle sends it marching towards infinity. The presence of two fixed points, z_1 and z_2, one attracting and one repelling holds for all Julia sets and is what was encountered in Section 17.2 for the logistic equation on the real line.

One further example will illustrate the close relationship between number and chaotic dynamics. Consider a point beginning its trajectory on the unit circle at the angle $\frac{1}{6} = 0.0010101... = 0.0\overline{01}$. Such a point must be *preperiodic* since its first angle doubling brings it to $\frac{1}{3}$ and thereafter it enters into a cycle of period 2. It can be shown by a simple calculation that all rational numbers with *odd denominators* have *periodic* decimal representations while those rationals with *even denominators* have *preperiodic* representations.

Therefore it can be seen that all rational numbers on the unit circle must represent points of either periodic or pre-periodic orbits. Any point on the unit circle beginning at a rational angle must be periodic, with period equal to the number of digits in its cycle. Likewise, any point that starts at an irrational angle, represented by a non-repeating decimal expansion, never repeats. In fact it can be shown that such points will visit an arbitrarily close proximity of each point on the unit circle during its trajectory.

19.5 Dynamics for Julia Sets with $c \neq 0$

This base 2 representation of trajectories can be exploited to track the dynamics of Julia sets for which $c \neq 0$. The key is an important theorem of

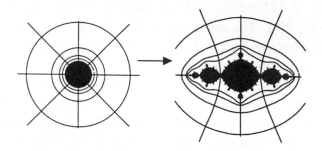

Figure 19.12 Riemann mapping theorem. A one-to-one correspondence between the potential of the unit disk and the potential of any connected prisoner set (Julia set).

complex variables known as the *Riemann mapping theorem* which states that a unit circle of the complex plane (with certain weak restrictions) can be mapped onto any region of the complex plane bounded by a closed curve so that the radial lines and concentric circles are mapped to curves that continue to be mutually perpendicular, as shown in Figure 19.12.

The mathematician Adrien Douady and John Hubbard [Dou-H] saw that this simple picture could be physically modeled by a cylinder of unit radius of negative electrical charge perpendicular to the unit circle and infinite in both directions. An *electrostatic field* is set up in which *field lines* project radially from the circle and concentric *equipotential circles* propagate into the space beyond the unit circle, as shown in Figure 19.12. By field lines we mean curves on which a negatively-charged particle introduced into this field will move. Equipotential curves are always perpendicular to the field lines and they are curves on which electrical charges can move freely without the expenditure of work.

A series of such transformations is shown in Figure 19.13. Notice how the attracting fixed point is displaced from $z = 0$ and the Julia set (boundary of the attracting basin) is deformed as c changes its value from $0 + 0i$ to $-1 + 0i$. Notice that the curve pinches in when $c = -0.75$ and thereafter gives rise to a pair of attracting points. Actually these points are periodic points of period 2. A trajectory beginning at one point oscillates back and forth between the two points. A trajectory beginning near one of the points approaches asymptotically to a periodic orbit between the two points. Whereas the unit circle has two fixed points, a repelling point at $z_2 = 1$ and

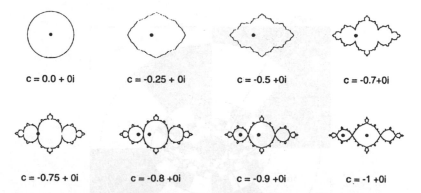

$c = 0.0 + 0i$ $c = -0.25 + 0i$ $c = -0.5 + 0i$ $c = -0.7 + 0i$

$c = -0.75 + 0i$ $c = -0.8 + 0i$ $c = -0.9 + 0i$ $c = -1 + 0i$

Figure 19.13 Starting from the Julia set for $c = 0$ (the circle) we decrease the parameter to $c = -1$. The Julia set develops a pinching point for $c = -0.75$ and is boundary of a period-2 attractor for the remaining plots.

an attracting point at $z_1 = 0$, each of the transformed Julia sets has its attracting fixed point, z_1, at a pinch and its repelling point, z_2, at the right endpoint on the real axis.

Figure 19.14 shows the binary decomposition of the field lines and equipotential curves for the last Julia set in this series, i.e., $c = -1$. Notice that the field lines and equipotential curves are perpendicular but no longer straight. The field lines with angles $\frac{1}{3} = 0.01$ and $\frac{2}{3} = 0.10$ are shown incident to the pinch point. With a higher resolution this diagram can be used to produce the more detailed result of Figure 19.15. The equipotential curves correspond to the circles from which they were mapped (see Figure 19.12), and the angular positions of the field lines refer to the corresponding positions on the circle. The dynamics are identical to the case of the unit circle but now mapped to the new context. Trajectories continue to evolve by moving from field lines labeled by $\arg z$ to lines labeled by $2\arg z$ while moving out to greater and greater moduli.

Notice that the pinching point has a pair of field lines attached to it and that these angles must correspond to $\frac{1}{3}$ and $\frac{2}{3}$ so that angle doubling keeps the pinch point unchanged, i.e., the pinch point is a fixed point. Notice that the field lines $\frac{1}{6}$ and $\frac{5}{6}$ are also pinch points (see Figure 19.15). This pinch point is preperiodic. After one iteration, the trajectory moves to the fixed point z_1. In fact, there are numerous pinch points, all preperiodic

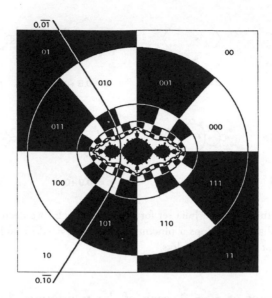

Figure 19.14 Binary decomposition for $c = -1$. The two field lines with angles $\frac{1}{3} = 0.01010\ldots$ and $\frac{2}{3} = 0.10101\ldots$ are shown.

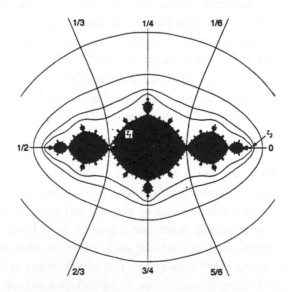

Figure 19.15 Equipotentials and field lines for $c = -1$. The angles of the field lines are given in multiples of 2π.

points with respect to fixed point z_1. A Julia set with a cycle of period three is shown in Figure 19.6b. At the pinch point, which is again an attracting fixed point of the transformation, we now have three incident field lines. Since angle-doubling must leave this point fixed, the lines must have values $\frac{1}{7} = 0.\overline{001}$, $\frac{2}{7} = 0.\overline{010}$, and $\frac{4}{7} = 0.\overline{100}$ whose decimal representations are permuted when multiplied by 2. Notice that the expansions of the field line angles indicate the nature of the dynamics. We should point out that not all fixed points represented by rational fractions are indicative of periodic behavior. For example, the dendritic structure shown in Figure 19.6d is a Julia set corresponding to $c = i$. It has a fixed point with three field lines attached to it with angles $\frac{1}{7}$, $\frac{2}{7}$, $\frac{4}{7}$ (not shown) yet this transformation has no periodic orbits.

A final example of a Julia set for a value of c in the realm of chaos is shown in Figure 19.16. Notice the field lines in the sector labeled 0110. The location of the trajectory point in the previous stage, i.e., its preimage, must be either in the sector 10110 or 00110. However, notice that the previous stage takes the form of a figure eight and that both 10110 and 00110 merge

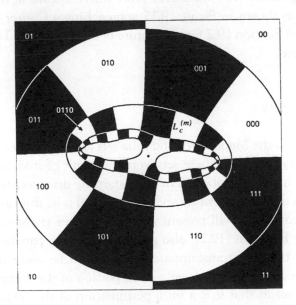

Figure 19.16 Figure-eight level set. If not all preimages of the cells at one level are disjoint, the sets at the next level form a figure-eight shape.

Figure 19.17 A Cantor set in the complex plane. For $c = -2.2$ the prisoner set is a Cantor set.

into a single sector which includes the fixed point $z = 0$. We have here a snapshot of the splitting of the Julia set into a Cantor dust. If the innermost region, the "prisoner set", is resolved more finely it splits again into two or more pieces, as shown in Figure 19.17 approaching a Cantor dust much as we observed in Section 19.2 for the picture of chaos restricted to an interval of the real line.

19.6 Universality

As interesting as the Mandelbrot and Julia sets are, they appear to have very little generality. After all, these sets were the result of studying one special equation, the logistic equation. The truly startling discovery that makes the study of chaos theory worthwhile and quite general is its *structural stability*. To explain this concept, I will present another iterative transformation of the type given by Equation (19.2), also governed by some parameter akin to c. Even though the new transformation is likely to be quite different, if it resembles Equation (19.2) in even a small portion of the complex plane (by resembles we mean that it is a *small* perturbation of the original), then its dynamics will be similar to the Mandelbrot map and it will produce Julia sets and Mandelbrot sets with a high degree of similarity to it. This similarity

does involve some rescaling, and also has some slight distortion, but it preserves all of the attributes of the Mandelbrot and Julia sets. Furthermore, it can be shown that, in general, Equation (19.2) is a close fit to most iterative functions in some region. Since problems of iteration arise in the study of the evolution of any system in science from astronomy to biology to economics, one begins to appreciate the importance of this work.

The fact that all of this information and generality comes about from only three or four lines of computer code leads Douady and Hubbard to compare this with the extreme compression of biological information held by DNA, whose description requires several enormous treatises on biology.

19.7 The Mandelbrot set Revisited

The Mandelbrot set may be the most complex mathematical structure ever conceived yet it can be transformed by a Riemann mapping from a unit circle. Figure 19.18 shows such a mapping. The angular positions of significant points of the Mandelbrot set correspond to positions on the original circle from which they were mapped. These positions are represented by fractional parts of 360 degrees. What makes these points significant is that they are either pinch points initiating discs of periodic orbits, branch points of *dendritic* structures, or ends of seahorse tails of the Mandelbrot set. Each value of c corresponding to one of these angles gives rise to a unusual Julia set image. The most prominent points are labeled by the ratio of small whole numbers. Observe that the most significant points tend to be rational numbers from the earlier rows of the Farey sequence shown in Table 14.2 between 0 and $\frac{1}{2}$. For example, the most significant points are found in row F_3: 0, $\frac{1}{3}$, $\frac{1}{2}$. The numbers in Figure 19.18, with the exception of $\frac{1}{5}$, are successive rational fractions from 0 to $\frac{1}{2}$ of line F_8 of the Farey sequence: 0, $\frac{1}{8}$, $\frac{1}{7}$, $\frac{1}{6}$, $\frac{1}{5}$, $\frac{1}{4}$, $\frac{2}{7}$, $\frac{1}{3}$, $\frac{2}{7}$, $\frac{2}{5}$, $\frac{3}{7}$, $\frac{1}{2}$. Once again, the Farey sequence has proven to be an indicator of significant occurrences, this time in the world of chaos and fractals. The point labeled F for Feigenbaum is the accumulation point for the period doubling bifurcations of the logistic equation (see Section 17.2). Its value is $c = -1.4011....$ It has as its external angle the Morse–Thue constant $0.0110100110010110... = 0.412...$ whose binary representation is the Morse–Thue sequence (see Section 17.5).

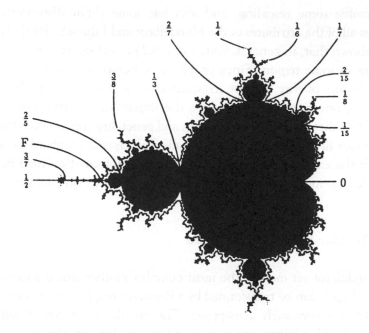

Figure 19.18 External angles for the Mandelbrot set. The fractions determine the period lengths of the iterates z_n for a given choice of the parameter c. The point "F" (Feigenbaum limit) marks the accumulation point of the period-doubling cascade. A. Douady: Julia sets and the Mandelbrot set.

As was noted in Section 14.3, rational fractions between $\frac{1}{2}$ and 1 of row F_8 of Table 14.2 represent the frequencies and string lengths of the tones of the Just or natural scales [Ras] as well as the critcal points symmetrically placed on the other side of the Mandelbrot set. Now it can be seen that there is a connection between the Mandelbrot set and the musical scale. Both are based ultimately on multiplication by 2, the Mandelbrot set by angle doublings of the shift map (see Section 17.6) and the musical scale by octave relationships and harmonic series (see Chapter 3).

19.8 A Mandelbrot Set Crop Circle

On August 12, 1991, a schematic replica of the Mandelbrot set appeared overnight in a wheat field near Ickleton, 10 miles south of Cambridge (see

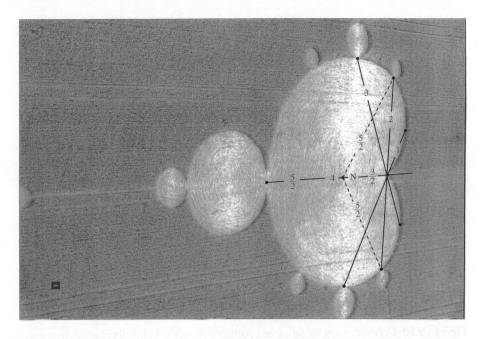

Figure 19.19 A Mandelbrot set on a wheat field near Ickleton. An overlay shows buds labeled 2, 3, 4, and 4 at angular positions 180 degrees, 120 degrees, 90 degrees, and 60 degrees.

Figure 19.19). While this shape was clearly recognizable as the Mandelbrot set, it lacked much of the fine detail and omitted the fractal structure on the boundary. This figure was accurately surveyed before it was harvested seven days later. It is one of many elaborate diagrams of mysterious origin that have appeared upon the landscape of England known as crop circles.

When analyzing the Mandelbrot crop circle, the astronomer, Gerald Hawkins, recognized that its principal part was the standard *cardiod* curve given by the polar coordinate equation: $r = 2(1 - \cos \theta)$ with origin placed at the cusp and θ measured counterclockwise from the axis through the cusp. The cardiod can also be created by rolling a moving circle of unit radius about a fixed circle of the same radius, referred to as the *generating circle*, and marking successive positions of one point on the circumference of the moving circle.

Surrounding the cardiod are four circular buds labeled 4, 3, 2, and 1 at angular positions 180 degrees, 120 degrees, 90 degrees, and 60 degrees shown

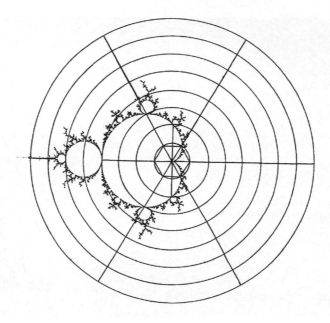

Figure 19.20 Concentric circles define bud positions along the Mandelbrot set. A hexagon in the unit circle radiates lines through its vertices to the sites of the buds.

in Figure 19.19. Buds 1, 2, and 3 each have mates symmetrically placed on the other side of the Mandelbrot set. Bud 4 is a circle of radius 1, the same radius as the generating circle. From experience with other crop geometries, Hawkins could see that the actual Mandelbrot set sits at the center of eight concentric circles with the first four circles intersecting the cardiod at buds 1, 2, 3, and 4 as shown in Figure 19.20. This geometry also holds for the crop pattern. The radial distances from the cusp of the cardiod to buds 4, 3, 2, and 1 are 4, 3, 2, and 1 respectively corresponding to the tones C in the 3rd octave, G, C in the 2nd octave and C. Hawkins has found many other instances in which important lengths within crop circles correlate well with frequencies of the diatonic scale [Haw3]. The iterative Mandelbrot set has a prominent node between buds 1 and 2. However, the distance to this node is not a tone from the diatonic scale, and the crop makers apparently chose not to include it. Also the bud between buds 3 and 4 does not match a musical tone, and does not symmetrically match its mate in the crop pattern.

An examination of the crop circle shows that the orbits of whirled wheat finished with a single stalk at a node N located at $r = \frac{3}{2}$ along the axis of the cardiod (see Figures 19.19 and 19.20). The radial distance from N to buds 2 and 4 are both $\frac{5}{2}$ or E in the 2nd octave.

If a hexagon is inscribed in the generating circle (unit circle) of Figure 19.20, the radii from the center to each vertex of the hexagon point in the direction of buds 1, 3, and 4 and their opposites while the perpendicular line through the top and bottom edges of the hexagon intersects bud 2. So we see that while the point by point description of the Mandelbrot set derives from dynamical systems theory, the crop circle artists have called attention to the relationship of the Mandelbrot set to Euclidean geometry, a level of analysis previously neglected. This is a geometry that does not reveal itself if one is restricted to the iterative, computer generated model.

19.9 Complexity

A group of scientists at the Los Alamos Institute have been developing a new concept to explain how complex forms of life develop from simple rules and how the great amount of diversity that we observe in the world around us is organized around a small repertoire of dynamic principles. These ideas have also been explored by Stephen Wolfram in his book, *A New Kind of Science* [Wol]. This may lead to a new interpretation of evolution in which the law of natural selection is of secondary importance as compared to the nature of dynamic systems.

The limited ways in which a dynamic system can unfold in time govern the patterns of growth that we see in the world. I have demonstrated that, although an infinite number of Julia sets are possible and that these depend on values of the parameter c, there are only several generic kinds of behavior that correspond to these possibilities: stable attractors, periodic orbits, dendritic structures, Cantor dusts, etc. Some of these principles for biological systems will be discussed in Chapter 24 as they apply to the growth of plants. According to Brian Goodwin [Goo] and Stuart Kauffmann [KauS1, 2], two spokesmen for a new area of study called *complexity theory*, genetic structure is of secondary importance as compared to the dynamic principles that guide the development of living things. They feel that genetics

merely sets the initial conditions of growth and development which then unfolds as a dynamical system within the constraints imposed by the environment.

It is their hypothesis, backed by careful observation of biological systems and theoretical considerations, that living systems exist in a state between order and chaos which they refer to as the *edge of chaos*. Dynamic systems in the ordered regime are frozen or lifeless, like crystals, while such systems lack structural coherence when they are chaotic. However, the edge of chaos, as we saw for the Mandelbrot set, is rich in structure much as a tidal pool at the edge of land and sea is the source of great biodiversity. It is this edge of chaos that can be shown to have a fractal structure.

In his book, *Why the Leopard Changed his Spots* [Goo], Brian Goodwin presents a charming hypothesis as to why young animals of all species from fish to lion cubs to humans engage in play even when it seems dangerous. He suggests that play is a chaotic activity with highly structured rules as compared to the ordered behavior of more serious business. Through play, youngsters may be skirting the edge of chaos, and the rich environment at this edge enables them to learn new patterns of behavior which help them to adapt to changing situations in their lives.

19.10 Conclusion

We have seen that the representations of chaos exhibited by Mandelbrot and Julia sets reduce to subtle properties of the real and complex numbers. In a sense these sets are number turned into geometry. It is the universality of the logistic map that makes this subject more than just a source of wondrous images and strikes to the heart of how nonlinear processes manifest themselves in the natural world.

20
The Golden Mean

> An asymmetrical division is needed in order
> to create the dynamics necessary for progression and extension
> from unity. The golden mean is the perfect division of unity.
>
> *Robert Lawlor*

20.1 Introduction

The golden mean has been encountered many times throughout this book: as the basis of 5-zonogons and the class of isozohohedra (Chapter 6); in Le Corbusier's system of proportions (Chapter 7); in the intersection points of the hyperbolic Brunes star and a critical value for the gambler's ruin problem (Chapter 9); in the measurements within a class of megalithic stone circles related to the pentagram (Chapter 11); in the geometrical structure of the Mask panel of the Laurentian library (Chapter 10); as an example of a self-referential form (Chapter 13); in the class of noble numbers that arise in plant phyllotaxis (Chapter 14); and in the self-similar Fibonacci fractal tree (Chapter 18).

In this chapter and the next two I will focus on some numerical properties of the golden mean and mention a few geometrical properties. In the last two chapters I will explore the importance of the golden mean to describe the growth of plants, and other dynamical systems.

20.2 Fibonacci Numbers and the Golden Mean

Consider the F-sequence (see Section 7.3):

$$1, 1, 2, 3, 5, 8, 13, \ldots \tag{20.1}$$

Any term of Sequence (20.1) is the sum of the two preceding terms, which makes it a *Fibonacci sequence*. It just misses being a *geometric sequence* since the square of any number in the sequence is off by 1 from the product of the two numbers that brace it, e.g.,

$$3^2 = 2 \times 5 - 1, \ 5^2 = 3 \times 8 + 1, \ 8^2 = 5 \times 13 - 1, \text{ etc.}$$

The *F*-series has many interesting properties, some of which will be explored in this chapter. Notice that in Figure 20.1 the *F*-sequence results in hierarchical patterns of sequences within sequences. At each level, a link acts either as an element in an ongoing chain or as one of the initiators of a new chain (also see Section 18.6). It was seen in Section 7.3 and Section 14.4.13 that the ratio of successive elements of the *F*-sequence,

$$\frac{2}{1}, \frac{3}{2}, \frac{5}{3}, \frac{8}{5}, \frac{13}{8}, \dots \tag{20.2}$$

approaches the irrational number $\tau = \frac{1+\sqrt{5}}{2} = 1.618\dots$ in a limiting sense. This number is known as the *golden mean*. The τ-sequence,

$$\dots, 1, 1, 1, \tau, \tau^2, \tau^3, \dots \tag{20.3}$$

is the only geometric series that is also a Fibonacci sequence just as the θ-Sequence (7.5) is the only geometric sequence that is also a Pell sequence. As a result the τ-sequence has many *additive properties* such as,

$$\dots, \frac{1}{\tau^2} + \frac{1}{\tau} = 1, \frac{1}{\tau} + 1 = \tau, 1 + \tau = \tau^2, \tau + \tau^2 = \tau^3 \dots. \tag{20.4}$$

From the 2nd and 3rd of these expressions it can be seen that the sequence,

$$\frac{1}{\tau}, \ 1, \ \tau, \ \tau^2 \text{ can be written in decimal notation as}$$

$$0.618\dots, 1, \ 1.618\dots, \ 2.618\dots.$$

The last expression of Equation (20.4) states that τ and τ^2 are two numbers whose sum and product are identical.

Second in importance to the *F*-sequence is another Fibonacci sequence known as the Lucas sequence,

$$1, 3, 4, 7, 11, 18, \dots. \tag{20.5}$$

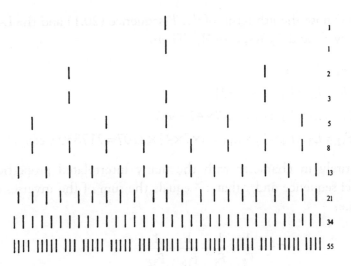

Figure 20.1 An illustration of pattern, order, and hierarchy in Fibonacci growth.

The ratio of successive terms of the Lucas sequence also approaches the golden mean in a limiting sense and it is also an approximate geometric sequence. The nth term of the Lucas sequence can be gotten from the from the $(n - 1)$th and $(n + 1)$th terms of the F-sequence (20.1) as follows,

$$L_n = F_{n-1} + F_{n+1} . \tag{20.6}$$

For example $3 = 1 + 2$, $4 = 1 + 3$, $7 = 2 + 5$,.... The Lucas sequence can also be obtained from the τ-Sequence (20.3) in terms of its decimal values:

$$1.618..., 2.618..., 4.235..., 6.853..., 11.089..., ... \tag{20.7}$$

by rounding the terms in the sequence successively up then down. In Chapter 22, the Lucas sequence will be shown to play an important role in the theory of proportion, and in Chapter 23 it will be a key to describing the periodic cycles of the logistic equation at full-blown chaos.

Volumes have been written about the fascinating properties of the F-sequence and τ (cf. [Kap3], [Hun], [Bic-H7]). In addition, a journal entitled The Fibonacci Quarterly is devoted to articles pertaining to the golden mean. I will present a typical example of the F-sequence's entertaining properties [Adam1].

First denote the nth terms of the F-sequence (20.1) and the L-sequence (20.5a) by F_n and L_n respectively. Then,

$$
\begin{aligned}
F_4 &= L_2 = 3, \\
F_8 &= L_2 \times L_4 = 3 \times 7 = 21, \\
F_{16} &= L_2 \times L_4 \times L_8 = 3 \times 7 \times 47 = 987, \\
F_{32} &= L_2 \times L_4 \times L_8 \times L_{16} = 3 \times 7 \times 47 \times 2207 = 2178309, \textit{etc.}
\end{aligned}
\tag{20.8}
$$

It is entirely in character with the many interrelated properties of the Fibonacci sequence and τ that τ^{-2} equals the sum of the inverses of F_4, F_8, F_{16},\ldots, i.e,

$$
\begin{aligned}
\tau^{-2} &= \frac{1}{F_4} + \frac{1}{F_8} + \frac{1}{F_{16}} + \frac{1}{F_{32}} + \cdots \\
&= \frac{1}{3} + \frac{1}{7} + \frac{1}{987} + \frac{1}{2178309} + \cdots.
\end{aligned}
\tag{20.9}
$$

This sum is rapidly converging; the sum of the first three terms already agrees with τ^{-2} to six decimal places, 0.381966.

Because of the additive properties of τ, it is an ideal number upon which to base a system of architectural proportion such as Le Corbusier did with his Modulor [Kap3].

20.3 Continued Fractions

Perhaps the most profound property of the golden mean is that it is the "most irrational" number in the number system. To make sense of this statement, let us review the subject of *continued fractions* [Khi]. It follows from Sections 14.3 and 14.4 that:

(1) Any number α can be expanded as a continued fraction,

$$
\begin{aligned}
\alpha &= [a_0; a_1, a_2, a_3,\ldots] \\
&= a_0 + \cfrac{1}{a_1 + \cfrac{1}{a_2 + \cfrac{1}{a_3}}} \cdots
\end{aligned}
$$

The expansion is finite if α is rational, infinite if α is irrational.

(2) By truncating the continued fraction at successive points in its development, we obtain rational approximations to α, called its *convergents*,

$$\frac{P_1}{Q_1}, \frac{P_2}{Q_2}, \frac{P_3}{Q_3}, \ldots$$

Each rational approximation, $\frac{P_k}{Q_k}$, is the best for denominators no larger than Q_k. For example the convergents to the golden mean are given by Sequence (20.2).

(3) The convergents $\frac{P_k}{Q_k}$ approach τ by oscillating on either side of it on the number line, i.e., $\frac{P_k}{Q_k} - \alpha$ oscillates about 0 while $\left|\frac{P_k}{Q_k} - \alpha\right|$ approaches 0 as $k \to \infty$.

(4) A measure of the approximation of $\frac{P_k}{Q_k}$ to α is,

$$\frac{1}{Q_k^2(a_{k+2}+2)} \leq \left|\alpha - \frac{P_k}{Q_k}\right| \leq \frac{1}{Q_k^2 a_{k+1}}. \tag{20.10}$$

In other words, the convergents of α corresponding to large values of the indices a_k approximate α closely since $\left|\alpha - \frac{P_k}{Q_k}\right|$ is small.

(5) In Section 14.4.13 it was seen that $\frac{1}{\tau} = [1,1,\ldots] = [\bar{1}]$. Since all of the indices are 1, as a result of Equation (20.10), its convergents are the poorest approximations to any irrational number on the number line. In fact, as described in Section 14.4.14 each number from the class of *noble numbers*

$$\tau_G = [a_1, a_2, a_3, \ldots, a_n, \bar{1}]$$

shares this property with the golden mean, which accounts for the occurrence of noble numbers in the study of plant phyllotaxis. For this reason, the golden mean is said to be the "most irrational" number.

(6) The golden mean is unique in one other respect. It is the only irrational number for which no integer n with $Q_k < n < Q_{k+1}$, has the property that $\left|\frac{P_n}{Q_n} - \frac{1}{\tau}\right|$, approaches 0 closer than for $n = Q_{k+1}$. This signifies that the golden mean has no *intermediate convergents*. This property is also manifested in the dynamics underlying the growth of plants as will be seen in Section 24.3.

20.4 The Geometry of the Golden Mean

Not only is the golden mean rich in number relationships, but it has an interesting geometry. The golden mean lies at the basis of the five Platonic solids that is the cornerstone of Greek geometry. The many instances in the natural world in which the golden mean arise, attest to the importance of these geometrical relationships. Some of the geometry of the golden mean is described in this section, leaving a more complete discussion to other books [Kap3].

20.4.1 The golden rectangle

To construct a *golden rectangle*, a rectangle with ratio of sides equal to $1:\tau$ (see Figure 20.2):

(i) Start with a unit square.
(ii) Add the semi-length of a side to the length from a vertex to the midpoint of the opposite side.

If a square is removed from a golden rectangle, another golden rectangle remains, indicating the self-similarity of the golden rectangle. This process of removing squares from golden rectangles can be repeated to obtain a series of "whirling squares" and one golden rectangle, in the manner shown in Figures 2.11. A *logarithmic spiral* connects vertex points of the squares.

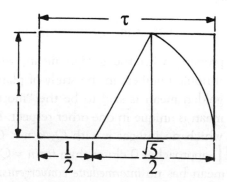

Figure 20.2 Construction of a golden rectangle using compass and straightedge.

20.4.2 The pentagon

According to legend, the secret society of the Pythagoreans used the *star pentagon* shown in Figure 20.3 as their sacred symbol. Just as the octagon (see Figure 7.2) symbolized the sacred cut, the pentagon is naturally associated with the golden mean. The ratio of diameter to side of a pentagon is $\tau:1$, and any pair of diagonals cut each other in the ratio $1:\tau$, the *golden section*. The decagon is also related to the golden mean since the ratio of radius to side is $\tau:1$.

It is well known that the *fivefold-symmetry* of the pentagon arises naturally in the world of living things, as illustrated in Figure 20.4. Another example of fivefold-symmetry in the world of living things is the star decagon, found to represent the cross-sectional profile of the DNA molecule, shown in Figure 20.5, where each vertex of the star represents one of the ten bases of DNA situated along one repeating segment of the double helix. In addition, the ratio of one of the periodic lengths of the ten bases of β-DNA, the most common form of DNA, to the diameter of the star decagon measures 34:20, which closely approximates τ.

20.4.3 Golden triangles

If diagonals are added to a pentagon, as shown in Figure 20.6a, two species of *golden triangles*, I and II, result. Figure 20.6b shows that if the base angle of triangle I is bisected, it subdivides the triangle into golden triangles I and II. This may be repeated, as shown in Figure 20.6c, to produce golden triangles at a variety of scales. This property of self similarity makes golden triangles the source of interesting designs such as "Elyse's Dragon" created by Elyse O'Grady shown in Figure 20.7a and some of which exhibit fivefold-symmetry, such as the one shown in Figure 20.7b created by Eileen Domonkos.

20.4.4 Golden diamonds

A pair of golden triangles I or II can be combined to form the two *golden diamonds* shown in Figure 20.8a. If these golden diamonds are juxtaposed in such a way that the arrows of adjacent edges point in the same direction, they create a class of *non-periodic Penrose tilings* of the plane which have been used as simple models in the study of newly-discovered crystal forms

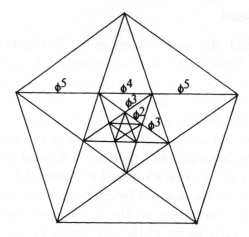

Figure 20.3 Star pentagons at decreasing scales. The edges of the star cut each other in the golden section 1:τ.

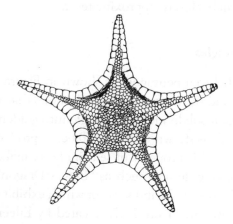

Figure 20.4 Star pentagons form a starfish.

known as quasicrystals (see Sections 6.8 and 25.2). A non-periodic tiling is a tiling that cannot be translated to a new position and superimposed upon itself as is possible with a regular lattice of points [Kap3]. Non-periodic tilings using golden diamonds are shown in Figures 20.6c and 20.8b and in Tony Robbin's quasicrstal tower shown in Figure 6.20.

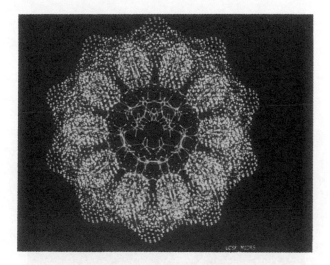

Figure 20.5 Detailed computer-generated model of DNA seen from above.

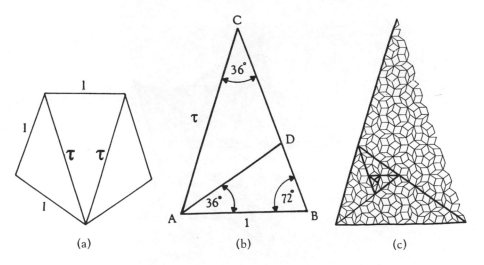

Figure 20.6 (a) A pentagon subdivided into one type 1 and two type 2 golden triangles; (b) the base angle of a golden isosceles triangle of type 1 is bisected to form a type 1 and type 2 golden triangle; (c) a pattern of "whirling" golden triangles with mirror symmetry formed by Penrose rhombuses.

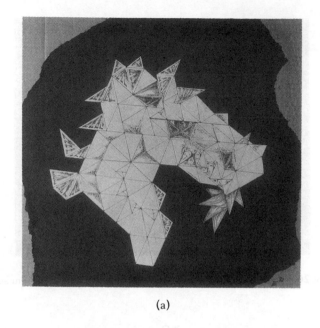

(a)

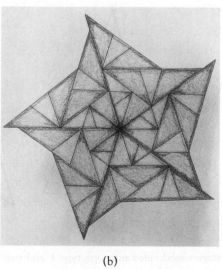

(b)

Figure 20.7 Two designs created from golden triangles of type 1 and 2. (a) "Elyse's Dragon". (b) "Fivefold-Symmetry".

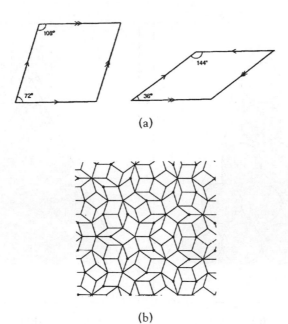

(a)

(b)

Figure 20.8 (a) Two Penrose rhombuses formed by combining two golden triangles of type 1 and 2; (b) they are fitted together so that the arrows on their edges match to form a design with approximate five-fold symmetry.

20.4.5 *Brunes star*

Janusz Kapusta [Kapu] has discovered an intimate relationship between the Brunes star and the golden mean. Figure 20.9a shows the Brunes star siting atop ten squares in which circles have been inscribed (the tetractys). When the upward pointed triangle defined by the outer vertices of the squares is moved so that it is tangent to the circles, the vertex of this triangle intersects the width of the square containing the Brunes star in the golden section as shown in Figure 20.9b. This enables a pair of circles to be constructed with diameters in the golden mean proportion. Figure 20.10 shows this pair of golden mean circles, in exploded view, to be the initiating circles of an infinite sequence of "kissing" (tangent) circles with negative integer powers of the golden mean for their diameters. Figure 20.11 illustrates a new compass and straightedge construction of the golden mean based on the relationships within Figure 20.9.

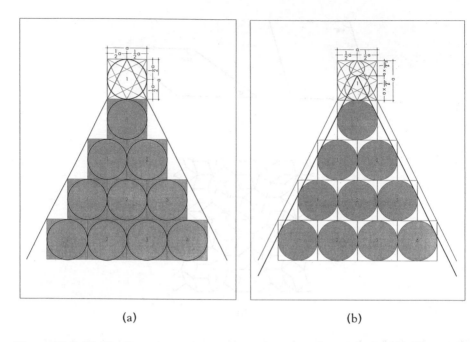

(a) (b)

Figure 20.9 (a) The Brunes star sitting atop ten squares with inscribed circles (tetractys). (b) The upwardly pointed triangle tangent to the inscribed circles define the golden section of the enveloping square of the Brunes star.

20.5 Wythoff's Game

My own interest in the fascinating world of Fibonacci numbers began as the result of playing *Wythoff's game* with my students at the New Jersey Institute of Technology [Kap1]. This game is played as follows:

> Begin with two stacks of tokens (pennies). A proper move is to remove any number of tokens from one stack or an equal number from both stacks. The winner is the person removing the last token.

The winning strategy is based on Theorem 20.1 due to S. Beatty.

Theorem 20.5.1. *If* $\frac{1}{x} + \frac{1}{y} = 1$, *where x and y are irrational numbers, then the sequences* $\lfloor x \rfloor, \lfloor 2x \rfloor, \lfloor 3x \rfloor, \ldots$ *and* $\lfloor y \rfloor, \lfloor 2y \rfloor, \lfloor 3y \rfloor, \ldots$ *together include every positive integer taken once* ($\lfloor \ \rfloor$ *means "integer part of" for example,* $\lfloor 3.14 \rfloor = 3$).

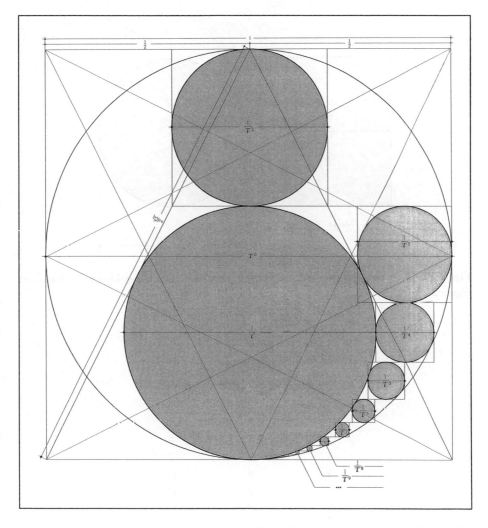

Figure 20.10 An infinite sequence of tangent circles with negative integer powers of the golden mean as diameters.

For a proof, see [Cox1]. Since $\frac{1}{\tau^2} + \frac{1}{\tau} = 1$ from Equation (20.4), Beatty's theorem shows that $\lfloor n\tau \rfloor$, $\lfloor n\tau^2 \rfloor$ exhausts all of the natural numbers with no repetitions, as n takes on the values $n = 1, 2, \ldots$. Table 20.1 shows results for $n = 1, 2, \ldots, 6$. Do you notice a pattern in these number pairs that enables you to continue the table without computation? These *Beatty pairs* are also

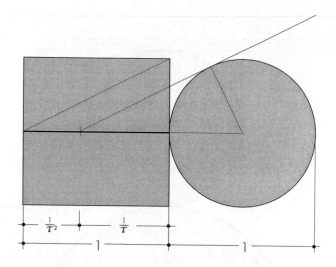

Figure 20.11 A new compass and staightedge construction of the golden mean based on Figure 20.9.

Table 20.1 Winning combination of Wythoff's game.

n	$\lfloor n\tau \rfloor$	$\lfloor n\tau^2 \rfloor$
1	1	2
2	3	5
3	4	7
4	6	10
5	8	13
6	9	15
⋮	⋮	⋮

winning combinations for Wythoff's game. At any move a player can reduce the number of counters in each stack to one of the pairs of numbers in Table 20.1. The player who does this at each turn is assured victory.

This sequence follows a rather subtle pattern. The differences between the numbers in columns 2 and 3 of Table 20.1 are:

$$2\ 1\ 2\ 2\ 1\ 2... \quad \text{and} \quad 3\ 2\ 3\ 3\ 2\ 3....$$

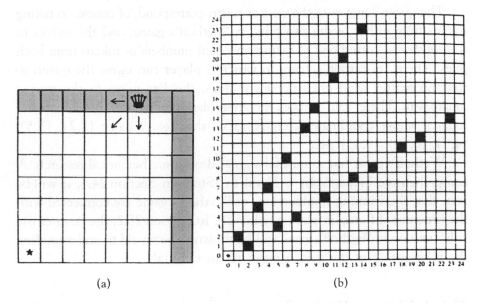

(a) (b)

Figure 20.12 (a) The board game "corner the lady" of Rufus P. Isaacs: The initial positions for the queen are shown in gray. The goal is to reach the lower left corner. (b) The safe squares for the lady are shown in dark shading. They are all those squares for which two opposing sides are pierced by one of two straight lines whose slopes equal the golden mean and its reciprocal.

Although both of these sequences follow a similar pattern (with 2 and 1 replaced by 1 and 0, respectively, in the first sequence and 3 and 2 replaced by 1 and 0 in the second sequence):

$$1\ 0\ 1\ 1\ 0\ 1... \qquad\qquad (20.11)$$

it is difficult to discern any order from this sequence. Its significance as a sequence will be revealed in the next section, and in Section 25.4. It will be shown to be symbolic of a dynamical system in the chaotic regime.

Another variation on Wythoff's game goes by the name "corner the lady". It works like this [Schr]:

"Take a chessboard and place a queen anywhere on the top row or the rightmost column, (shown in gray in Figure 20.12). Two players alternate moving the queen any number of squares either 'west', 'southwest', or 'south'. The first person to reach the starred corner wins."

The queen's moves to the west or south correspond, of course, to taking tokens from either of the two piles in Wythoff's game, and the moves to the southwest correspond to taking on equal numbers of tokens from both piles. There are certain squares to which a player can move the queen so that, no matter what one's opponent does, the last move to the starred square wins. These "safe" squares, shown in black on Figure 20.2, are therefore squares whose coordinates correspond to the Beatty pairs: $(1,2)$, $(3,5)$, $(4,7)$, $(6,10)$, $(8,13)$, etc.

Wythoff's game has stimulated a great deal of mathematical research. A comprehensive bibliography is found in [Stol]. In Section 24.4, it will be seen that the winning combinations of Wythoff's game are connected with the ordering of florets in plant phyllotaxis. In Section 25.2, the "corner the lady" version of Wythoff's game will be shown to be an aid to understanding the relationship of the golden mean to quasicrystals.

20.6 A Fibonacci Number System

Figure 20.13a shows a tree graph depicting the growth of rabbits described by Fibonacci in *Liber Abaci*:

> Each month a mature pair of rabbits gives birth to a pair of rabbits of opposite sex. However, a newborn rabbit pair must wait two months before it matures.

Compare the *Fibonacci tree* with the *binary* tree in Figure 20.13b which represents the geometric sequence: 1, 2, 4, 8, 16, 32,... (see Table 14.3).

The branches in Figure 20.13a are labeled in Figure 20.14 in such a way that the branches representing the mature rabbits are labeled with a 1, while young rabbit branches get a 0. Therefore, a 1 is followed in the next generation by a 1 and a 0 while a 0 is followed only by a 1. In this way the tree can be continued indefinitely.

The Fibonacci tree can be used to represent all of the positive integers in a kind of Fibonacci decimal system known as *Zeckendorf* notation. The method is similar to what was done in Section 14.3.13 to associate each element of the Farey tree with an integer. Begin at the root and follow the

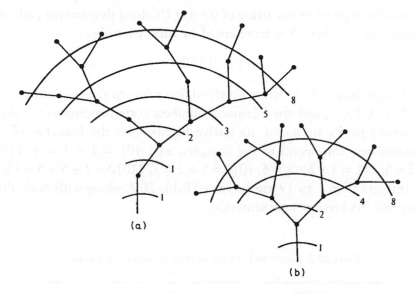

Figure 20.13 A tree pattern (a) from the Fibonacci series; and (b) from a geometric series.

RABBIT TREE

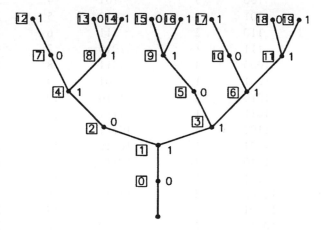

Figure 20.14 The branches of the Fibonacci tree are labeled with a 1 for mature rabbits and 0 for young rabbits. This tree is the basis of a Fibonacci number system.

unique path to any element of the tree. The Zeckendorf representation of that number is given by the string of 0's and 1's along that unique path. For example, the number 13 is represented in this system by:

$$13 = 10110.$$

If each digit from right to left is weighted according to the F-sequence, i.e., 1, 2, 3, 5, 8, 13,..., and the Fibonacci numbers corresponding to the digits represented by 1's are added, successive numbers on the branches of the Fibonacci tree correspond to the integers, e.g., $101 = 3 + 1 = 4$, $110 = 3 + 2 = 5$, $111 = 3 + 2 + 1 = 6$, $1010 = 5 + 2 = 7$, $11010 = 2 + 5 + 8 = 15$.... The integers from 1 to 19 are listed in Table 20.2, along with both their binary and Zeckendorf representations.

Table 20.2 Binary and Fibonacci representations of number.

	168421		85321		
0	0		0		
1	1	1	1	1	1
2	10	2	10	2	2
3	11	1	11	3	1
4	100	3	101	4	3
5	101	1	110	5	2
6	110	2	111	6	1
7	111	1	1010	7	4
8	1000	4	1011	8	1
9	1001	1	1101	9	3
10	1010	2	1110	10	2
11	1011	1	1111	11	1
12	1100	3	10101	12	5
13	1101	1	10110	13	2
14	1110	2	10111	14	1
15	1111	1	11010	15	4
16	10000	5	11011	16	1
17	10001	1	11101	17	3
18	10010	2	11110	18	2
19	10011	1	11111	19	1

Notice that the sequence makes up the last digit or 1's column in the Zeckendorf representation. I refer to it as the *rabbit sequence*:

$$101101011011011.... \qquad (20.12a)$$

This sequence was encountered in each column of Wythoff's sequence given by Sequence (20.11). This pattern of numbers also makes up the 2's column except that in place of a 1, two 1's appear. The pattern also appears in the 3's column with three 1's replacing each 1 and two 0's in place of each 0; in the 5's column, five 1's replace each 1 while three 0's replace each 0. This pattern continues and follows a *F*-sequence. The corresponding sequence for the binary representation is:

$$1010101010.... \qquad (20.12b)$$

The sequences of Fibonacci and binary representations are wound into spirals in Figure 20.15a (*Adamson's Rabbit Series Wheel*) and Figure 20.15b (Peitgen's binary fractal pattern [Pei-H]). The sequence of 0's and 1's within each circle of Figure 20.15a reproduces the sequence at each level of the Fibonacci or binary trees. In fact these wheels are identical to the trees. You can see that the Rabbit Sequence (20.12a) evolves as you go from circle to circle on the wheel.

RABBIT WHEEL

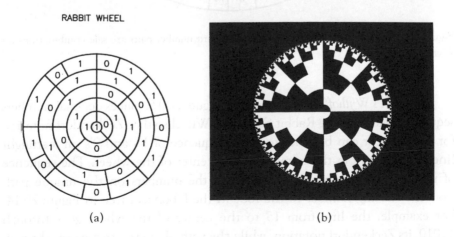

(a) (b)

Figure 20.15 (a) Adamson's Rabbit Series Wheel; (b) Binary decomposition.

ADAMSON'S WYTHOFF WHEEL

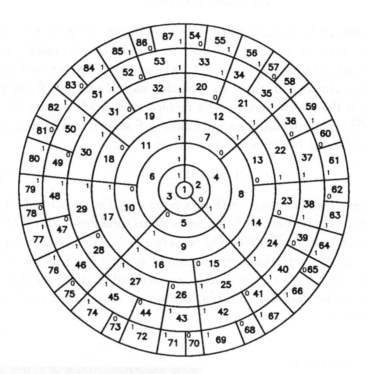

Figure 20.16 Adamson's Wythoff Wheel. Adjacent number pairs are safe combinations for Wythoff's game.

Adamson's Wythoff Wheel, shown in Figure 20.16, places decimal numbers sequentially around the Rabbit Sequence Wheel so that Zeckendorf notation for any number can be read from the sequence of 1's and 0's on a straight line extending from the number to the center of the wheel. The sequence of numbers intersected by this line are the numbers on the unique path from the starting number to the root in the Fibonacci tree in Figure 20.14. For example, the line from 15 to the center of the wheel goes through 11010, its Zeckendorf notation, while the path along the tree passes through 1, 3, 5, 9, 15.

20.7 Binary and Rabbit "Time Series"

The sequence in the last column of Table 20.2 represents the column number in which a 0 from the preceding number changes to a 1. They are:

Binary sequence: 1213121412131215121.... (20.13a)

Zeckendorf sequence: 1213214132152141321.... (20.13b)

Sequence (20.10a) represents the winning moves for the Tower of Hanoi puzzle (see Section 15.5). Sequence 20.13b is the analogous sequence for the Zeckendorf system. These sequences have many number patterns. For example, the 1's from the binary sequence follow each other after every 2 spaces. In other words it is periodic. In the rabbit sequence the 1's follow each other according to the sequence 232332..., which is the rabbit sequence if 2 is replaced by 0 and 3 is replaced by 1. While the Sequence (20.13a) is periodic in each of its digits, Sequence (20.13b) is almost periodic or *quasiperiodic*. You can check the comparable patterns within both sequences for the numbers 2, 3, 4, 5.

In Section 15.5 we were able to derive from Binary and Gray code the frequencies for the occurrence of the disk numbers in Sequence (20.13a). A similar procedure can be carried out to predict the frequency of occurrence of each number of Sequence (20.13b) as follows:

(a) Consider the Zeckendorf expansion of a number. Begin at the left with 1, and multiply by τ and round up to the next highest integer if 1 follows 0 or 0 follows 1, or round up and then add 1 if 1 follows 1 (0 never follows 0 in Zeckendorf notation). This gives the cumulative frequency. For example, from decimal 15 equivalent to Zeckendorf, 11010, we generate the third row of the following table, the cumulative frequency. These numbers: 1, 3, 5, 9, 15 are of the same genealogy in that they lead from 15 to the root 1 in Figure 20.14 and as we observed from Adamson's Wythoff Wheel (see Figure 20.16).

Magnitude	5	4	3	2	1
Zeckendorf	1	1	0	1	0
Cumulative	1	3	5	9	15
Frequency	1	2	2	4	6

(b) Take differences between elements of row 3 to get the frequencies in row 4. Therefore, up to decimal 15 there is one number of magnitude 5, two of magnitude 4, two 3's, four 2's and six 1's as you can check from Table 20.2. Notice that we have also found the frequencies of each number with the same genealogy as 15, i.e., 1, 3, 5, and 9.

If Sequences (20.13a) and (20.13b) are considered to be the magnitudes of earthquakes occurring sequentially in time, then the small earthquakes occur with great frequency while the larger ones are less frequent. In fact, in the case of Sequence (20.13a) the frequencies follow the exact power law

$$f = \left(\frac{1}{2}\right)^n,$$

where f is the relative number of occurrences of an earthquake of size n up to time N, e.g., up to the 16th term of Sequence (20.13a), or $N = 15$, one-half of the earthquakes are of order 1, one quarter are of order 2, an eighth are of order 3, and $\frac{1}{16}$ are of order 4, as you can verify. For the earthquakes in Sequence (20.13b) up to $N = 19$, there are 8 of order 1, 5 of order 2, 3 of order 3, 2 of order 4 and 1 of order 5, i.e., the numbers of earthquakes of a given order follow a Fibonacci sequence. But we have already shown in Section 20.2 that the F-sequence is almost a geometric sequence. As a result the earthquakes described by Sequence (20.13b) also follow a power law in an *asymptotic* sense. In Figure 20.17a the log to the base 2 of the frequency, N, of earthquakes is plotted against the size, S for Sequence (20.13a). In Figure 20.17b the earthquake size given by Sequence (20.13a) is graphed on a time line. Notice the fractal nature of this graph where a large peak is surrounded by two smaller peaks at three different scales. Compare this with the corresponding graphs for actual earthquakes. The straight-line relationship indicates a power law distribution (see Figure 20.18a). The time series of global temperature monitored by NASA since 1865 is shown in Figure 20.18b. The pattern of fast, slow, and intermediate range fluctuations indicates a signal known as one-over-f noise ($\frac{1}{f}$ noise). Compare this time series with the random, white-noise pattern shown in Figure 20.18c. This pattern has no slow fluctuations, i.e., no large bumps. Because the frequencies satisfy power laws for the number sequence and for actual earthquakes, both exhibit self-similarity and their geometrical representations are fractals. This

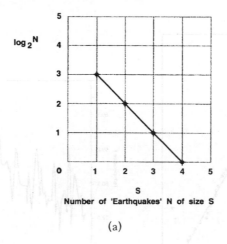

(a)

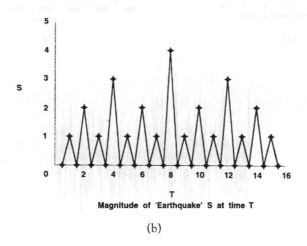

(b)

Figure 20.17 (a) Logarithm of the number of Tower of Hanoi discs ("earthquakes") N of a given size S. The straight line indicates a power law relationship; (b) sequence of disc sizes moved in winning Towers of Hanoi combination exhibits a $\frac{1}{f}$ spectrum.

was found for the representation of coastlines in the last chapter. Many other mathematical models studied by Per Bak exhibit similar behavior [Bak1, 2].

Instead of earthquakes, the variations in Sequences (20.13a) and (20.13b) could be thought of as a number of jumps in the 12-tone musical scale,

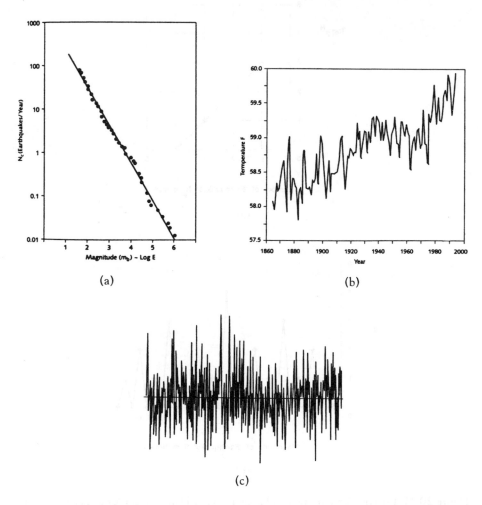

(a)

(b)

(c)

Figure 20.18 (a) Distribution of earthquake magnitudes in the New Madrid zone in southeastern United States during the period 1974–1983, collected by Arch Johnston and Susan Nava of Memphis State University. The points show the number of earthquakes with magnitude larger than a given magnitude m. The straightline indicates a power law distribution of earthquakes. This simple law is known as the Gutenberg–Richter law; (b) global temperature monitored since 1865 (NASA). Note the pattern of fast, slow, and intermediate range fluctuations. This type of signal is known as one-over-f noise ($\frac{1}{f}$ Noise), and is extremely common in nature; (c) for comparison, a "boring" random, white noise pattern is shown. This pattern has no slow fluctuations, i.e., no large bumps.

either in an upwards or downwards direction. The resulting *stochastic music* could then be termed "binary music" corresponding to Sequence (20.13a) or "golden music" corresponding to Sequence (20.13b). These two kinds of music display rather different characters. Both of these musical types conform to power laws known as $\frac{1}{f}$ noise which has been observed by Richard Voss to be inherent in the musical compositions of Mozart and Bach (cf. [Gard2], [Vos-C]. The music is neither too random, as it would be if it followed a spectrum of *white noise* (the jump at any given time step is determined by the roll of the dice with each jump equally likely), nor too predictable as it would be if it followed a spectrum of the $\frac{1}{f^2}$ noise of *Brownian motion* (the next step is up or down one tone in the 12-tone scale from the previous, as determined by the flip of a coin).

20.8 More About the Rabbit Sequence

The rabbit sequence can also be generated by beginning with 1 and 10 then adjoining successive numbers as follows:

$$1$$
$$10$$
$$101$$
$$10110$$
$$10110101$$
$$1011010110110$$
$$\ldots \text{ etc.}$$

Notice that this sequence appears at successive levels of the Fibonacci tree and spiral (see Figures 20.14 and 20.15a). Also, any term can be generated from its predecessor by replacing each 0 by 1 and each 1 by 10. In other words, referring to the Fibonacci tree, newborn is replaced in the next generation by mature, and mature is replaced by mature and newborn. If this substitution is performed on the entire rabbit sequence, the sequence reproduces itself (it is self-referential). The following are some additional observations about this sequence:

(i) The number of 1's and 0's in this sequence are both *F*-sequences, and the ratio of 1's to 0's approaches τ as you traverse the sequence.

(ii) The 1's appear in the 1, 3, 4, 6, 8, 9,... places in the sequence while the 0's appear in the 2, 5, 7, 10, 13,... places, precisely the winning strategies for Wythoff's game (see Table 20.1). Also notice the Wythoff pairs adjacent to each other along Adamson's Wythoff Wheel (see Figure 20.16). The integers of the left column of the Wythoff sequence in Table 20.1 are assigned to the 1's boxes, while integers of the right column gets the 0's.

(iii) Underline any subsequence of the rabbit sequence, e.g, the subsequence 10: 1011010110110.... Notice that 10 follows the preceding 10 by the following number of places: 2122121.... If 2 is replaced by 1 and 1 by 0 the rabbit sequence is replicated, which shows that it is *self-similar* at every scale as would be expected for a fractal pattern. This holds for any subsequence of the rabbit sequence.

(iv) In Figures 20.15a and 20.16 the inner circle has been divided so that the larger arc is $\frac{1}{\tau} \times 360$ degrees while the smaller arc is $\frac{1}{\tau^2} \times 360$ degrees, i.e., the circle is cut in the golden section (ratio of $\tau{:}1$). The largest interval is labeled 1 and the smallest is labeled 0. The largest interval is then subdivided again by the golden section, and once again the largest intervals are labeled 1 while the smaller intervals are labeled 0. This is repeated at successive levels of the figure. Notice that the lengths of the vertical lines descending from any circle to the center follow the pattern of Sequence (20.13b) in both the $\frac{1}{\tau}$ and $\frac{1}{\tau^2}$ arcs and also the complete circle.

20.9 Conclusion

The golden mean generates numerical and geometrical patterns that pervade mathematics and the natural world. Wythoff's game is the key to applications of the golden mean to dynamical systems. In the next two chapters, Fibonacci sequence will be generalized to *n*-bonacci series and the golden mean will be generalized to a family of silver means revealing further properties of this remarkable sequence and number.

21
Generalizations of the Golden Mean — I

> Behind the wall, the gods play; they play with numbers,
> of which the universe is made up.
>
> *Le Corbusier*

21.1 Introduction

In this chapter and the next the golden mean is generalized in two ways with the help of Pascal's triangle. The generalizations have applications to dynamical systems and the theory of proportions. The first leads to tri-Fibonacci, tetra-Fibonacci, etc. sequences, referred to as n-bonacci sequences. The second leads to generalizations of the golden mean to a family of silver means.

21.2 Pascal's Triangle, Fibonacci and other n-bonacci Sequences

Pascal's triangle is an array of numbers with many interesting mathematical properties. It has 1's along two of its boundaries, and each number off the boundary is the sum of the two numbers bracing it from above.

Notice that the geometric sequence, 1, 2, 4, 8, 16, 32,..., is generated by the sum of the numbers in each row. On the other hand, the F-sequence is the sum of numbers along the diagonals: 1, 11, 12, 131, 143, 1561,....

The numbers in Pascal's triangle relate to two problems concerning the arrangement of a row of pennies:

(i) The rows of Pascal's triangle give the number of arrangements of n pennies in a row when there are no restrictions, the so-called *binomial*

469

Table 21.1 Pascal's Triangle.

											Row sums
					1						1
				1		1					2
			1		2		1				4
		1		3		3		1			8
	1		4		6		4		1		16
1		5		10		10		5		1	32
1	6	5	20	15	6	1					64

Table 21.2 Binomial distribution of heads and tails.

no zeros	1 zero	2 zeros	3 zeros
111	011	001	000
	110	010	
	101	100	

distribution. For example, three coins result in the binomial distribution: 1, 3, 3, 1, i.e., 1 arrangement with 0 tails, 3 arrangements with 1 tail, 3 with 2 tails, and 1 with 3 tails listed in Table 21.2 where $1 = H$, $0 = T$.

(ii) Find all the arrangements, heads and tails, of n coins in a row, with the constraint that no two adjacent tails are permitted. For example, with three coins the arrangements are: HHH, HHT, HTH, THH, THT. Thus the number of combinations of 3 coins with 0 tails, 1 tail, and 2 tails is 131 respectively, one of the Pascal–Fibonacci diagonal sequences given above. The other Pascal–Fibonacci diagonals are similarly related to the arrangements of 2, 3, 4, 5,... coins. All of the possibilities are listed in the Zeckendorf system of Table 20.2 with H replacing 1 and T replacing 0. They are also listed in the Fibonacci tree of Figure 20.14 reading up from the bottom of the tree, not counting the root.

21.3 *n*-Bonacci Numbers

What if pennies are now arranged so that two but not three consecutive tails are permitted? For example, the seven arrangements for three pennies are HHH, HHT, HTH, THH, TTH, THT, HTT. The arrangements for 1, 2, 3, 4,... coins follow the *tribonacci sequence*:

$$1, 1, 2, 4, 7, 13, 24, 44, 81, 149, 274, 504,....$$

In this series each number is the sum of the preceding three numbers and the ratio of successive numbers approaches 1.8395... in a limiting sense. For example, $\frac{504}{274} = 1.839$.

Now permit 1, 2, or 3 tails but not 4 consecutive tails. The number of arrangements can be found in the *tetrabonacci sequence*:

$$1, 1, 2, 4, 8, 15, 29, 56,...,$$

in which each number is the sum of the preceding four numbers. The ratio of successive numbers approaches 1.927....

The infinite sequence of *n*-*bonaccis* are shown in Table 21.3.

Notice that the initial numbers in each sequence are from the geometric sequence: 1, 2, 4, 8, 16,... corresponding to the arrangements of pennies with no constraints. These series can be shown to be minimizing sequences for *Huffman trees* which arise in coding theory [Hor]. Blackmore and Kappraff [Bla-K] have discovered a fundamental role for *n*-bonacci series describing a class of energy minimizing, lattice and area preserving transformations on a

Table 21.3 *N*-bonacci sequence.

1-Bonacci:	1, 1, 1, 1, 1, 1, 1, 1, 1, 1, 1, 1,...
2-Bonacci:	1, 1, 2, 3, 5, 8, 13, 21, 34, 55, 89, 144,...
3-Bonacci:	1, 1, 2, 4, 7, 13, 24, 44, 81, 149, 274, 504,...
4-Bonacci:	1, 1, 2, 4, 8, 15, 29, 56, 108, 208, 401, 773,...
5-Bonacci:	1, 1, 2, 4, 8, 16, 31, 61, 120, 236, 464, 912,...
6-Bonacci:	1, 1, 2, 4, 8, 16, 32, 63, 125, 248, 492, 976,...
⋮	⋮
Doubling: (*n* = infinite)	1, 1, 2, 4, 8, 16, 32, 64, 128, 256, 512, 1024,...

torus. When the lattices are two-dimensional these are related to the growth of plants; when the lattices are n-dimensional they are related to n-bonacci numbers. These transformations will be described in the last two chapters.

21.4 n-Bonacci Distributions

Adamson [Adam1] has discovered an *n-bonacci distribution Triangle* in which the rows represent the number of coins while the columns represent the number of arrangements that have exactly n-adjacent tails (note that if $1 = H$ and $0 = T$ then 1101001000 fits into the category with 3 tails).

Table 21.4 is analogous to Pascal's triangle in that its rows give the n-bonacci distribution of coins in contrast to the binomial distribution specified by the rows of Pascal's triangle. The sum of the first two numbers of each row in Table 21.4 gives the Fibonacci sequence, while the sum of the first three numbers gives the tribonacci sequence, the first four results in the tetrabonacci sequence, etc. As an example, row 4 specifies the number of arrangements of heads ($H = 1$) and tails ($T = 0$) with repeated bits for three pennies, e.g., 1, 4, 2, 1, with the arrangements listed in Table 21.5.

However, unlike Pascal's triangle in which each number is computed recursively from the previous ones (e.g., add the two numbers above it from

Table 21.4 Adamson's n-bonacci distribution table.

Number of coins	Frequency of the coin toss outcome from 2^n possibilities Maximum number of consecutive zeros									
0	0	1	2	3	4	5	6	7	8...	Sum
0	1									1
1	1	1								2
2	1	2	1							4
3	1	4	2	1						8
4	1	7	5	2	1					16
5	1	12	11	5	2	1				32
6	1	20	23	12	5	2	1			64
7	1	33	47	27	12	5	2	1		128
8	1	54	94	59	28	12	5	2	1	256

Table 21.5 n-bonacci distribution of coins.

no zeros	1 zero	2 zeros	3 zeros
111	011, 010 110, 101	001, 100	000

the preceding row), the n-Bonacci Distribution Triangle of Table 21.5 has no known recursive definition.

Notice that Pell's sequence, 1, 2, 5, 12, 29,..., which arose in Section 7.4 as the basis of Roman architecture is incrementally developed along the rows and columns.

If the rows of Pascal's triangle are plotted on Cartesian coordinates, they reveal the familiar bilaterally symmetric curve peaked at its center, the bell-shaped curve of statistics. On the other hand, a similar curve for the columns of the n-bonacci Distribution Triangle reveals a skewed distribution such as the ones found in the *blackbody radiation curves* of physics.

Although the n-bonacci Distribution Triangle differs from the blackbody curves in its details, might it be possible that the characteristic shapes of blackbody radiation curves and related skewed functions are due to exclusion principles (restrictions on the numbers of consecutive zeros)? The blackbody radiation curve, for example, is premised on the exclusion principle that only an integral number n of energy packets hv are permitted by *Planck's equation*,

$$E = hnv,$$

where energy E is a function of frequency v and h (Planck's constant). In electron shells, exclusion principles determine the structure and properties of atoms. In the most fundamental sense, perhaps all exclusion principles have a parent in coin toss outcomes (no 2 tails together, no 3 tails together, etc.), these parameters being the extent to which the bits are prohibited from contact.

The n-bonacci numbers appear in the representations of integers expressed in Gray code shown in Table 15.1. Notice that within each 2^n block of Table 15.1, the number of integers with no two 0's together is a Fibonacci number; the number with no three 0's is a tribonacci number; no four 0's is a tetrabonacci number, etc.

21.5 A General Formula for Limiting Ratios of n-Bonacci Sequences

Martin Gardner [Gard1] has given the following formula for the limiting ratio of adjacent terms of the n-bonacci sequence, which I refer to as n-bonacci constants or b_n:

$$x^{n+1} - 2x^n + 1 = 0. \tag{21.1}$$

Alternatively, the n-bonacci constants are the roots of the polynomials

$$x^n - x^{n-1} - x^{n-2} - \cdots - x - 1 = 0. \tag{21.2}$$

Thus, for $n = 2$, $b_2 = 1.618...$, a root of either,

$$x^3 - 2x^2 + 1 = 0 \quad \text{or} \quad x^2 - x - 1 = 0.$$

Likewise, for $n = 3$, $b_3 = 1.829...$, $b_4 = 1.927...$, etc. with b_n approaching 2 as n approaches ∞.

N-bonacci constants form a sequence ranging from the golden mean, $b_2 = 1.618,...$, to $b_\infty = 2$, while the n-bonacci sequences range from the Fibonacci sequence to the geometric sequence with common ratio 2. Just as for the binary and Fibonacci (Zeckendorf) number systems, each n-bonacci sequence can be associated with a number system and a series of 0's and 1's in which the ratio of 1's to 0's equals the appropriate solution to Equation (21.1). They also possess time sequences analogous to Sequences (20.10a) and (20.10b).

21.6 Conclusion

The Fibonacci sequence is merely the beginning of a rich set of relationships associated with the golden mean. Pascal's triangle, despite its deceptive simplicity, is the matrix of these relationships. n-Bonacci sequences have been shown to represent the result of a family of constrained coin distributions problems. In the next chapter Pascal's triangle will again play a role in generalizing the golden mean to a family of silver means.

22
Generalizations of the Golden Mean — II

> Our soul is composed of harmony, and harmony is never bred save
> in moments when the proportions of objects are seen or heard.
>
> *Leonardo*

22.1 Introduction

The golden mean is one of a family of *metallic means* referred to as *silver means*. These numbers form a richly textured fabric of number patterns that have many physical applications (cf. [Spi], [Kap-A]). In the last chapter, n-bonacci sequences and constants were introduced as generalizations of Fibonacci and τ-sequences. Silver means enable Fibonacci and τ-sequences to be generalized (see Equations (20.1) through (20.5)) in another way. As with the Fibonacci sequence, each generalized Fibonacci sequence is an approximate geometric sequence in the sense of Equation (20.1) from which silver mean constants akin to the golden mean are derived.

Just as for n-bonacci sequences, these generalizations can be derived from Pascal's triangle. A sequence of polynomials is derived from Pascal's triangle and shown to be related to regular star polygons from which are derived all of the numbers that play a role in the theory of proportions. The edge lengths of these star polygons are shown to have additive properties which is why they are useful for building systems of proportion. The heptagon has particularly interesting properties and is studied in detail.

Finally, the family of silver mean constants will be shown to have self-referential properties. In fact they can be considered to be generalizations of the imaginary number i.

475

22.2 Golden and Silver Means from Pascal's Triangle

Consider the left leaning (\backslash) diagonals in Pascal's triangle.

Starting from the left in Table 22.2 the diagonals appear as columns in which each successive column is displaced, in a downward direction, from the previous column by two rows. The rows of Table 22.2 can be seen to be the diagonals of Pascal's triangle related to the Fibonacci sequence described in Section 21.2 with the sum of the elements of Row n being the nth Fibonacci number. This table, referred to as the Fibonacci–Pascal Triangle or FPT, is associated with the coefficients of a sequence of polynomials, $F(n)$ (the superscripts are the exponents of the polynomials) [Adam1].

Table 22.1 Pascal's Triangle.

					1							1
				1		1						2
			1		2		1					4
		1		3		3		1				8
	1		4		6		4		1			16
1		5		10		10		5		1		32
1	6		15		20		15		6		1	64

\cdots

Table 22.2 Fibonacci–Pascal Triangle.

$\frac{n}{k}$	1	2	3	4	5	Sum	
0	1^0					1	1
1	1^1					1	x
2	1^2	1^0				2	$x^2 + 1$
3	1^3	2^1				3	$x^3 + 2x$
4	1^4	3^2	1^0			5	$x^4 + 3x^2 + 1$
5	1^5	4^3	3^1			8	$x^5 + 4x^3 + 3x$
6	1^6	5^4	6^2	1^0		13	$x^6 + 5x^4 + 6x^2 + 1$
7	1^7	6^5	10^3	4^1		21	$x^7 + 6x^5 + 10x^3 + 4x^1$
8	1^8	7^6	15^4	10^2	1^0	34	$x^8 + 7x^6 + 15x^4 + 10x^2 + 1$

\cdots \cdots

Each column in Table 22.2 begins with a 1. The numbers (not the exponents) are generated by the recursion relation:

$$(n, k) = (n - 1, k) + (n - 2, k - 1) \qquad (22.1)$$

where (n, k) denotes the number in the nth row and kth column. For example, $(7, 3) = (6, 3) + (5, 2)$ or $10 = 6 + 4$. Also, beginning with 1 and x, each Fibonacci polynomial $F(n)$ is gotten by multiplying the previous one, $F(n-1)$ by x and adding it to the one before it $F(n - 2)$, e.g., $F(3) = xF(2) + F(1)$ or $x^3 + 2x = x(x^2 + 1) + x$.

Letting $x = 1$ in the polynomials yields the Fibonacci sequence: 1, 1, 2, 3, 5, 8,... The ratios of successive numbers in this series converge to the solution to $x - \frac{1}{x} = 1$ or the golden mean τ which I shall also refer to as the *first silver mean of type* 1 or $SM_1(1)$.

Letting $x = 2$ yields Pell's sequence (see Section 7.4): 1, 2, 5, 12, 29, 70,... (e.g., to get a number from this sequence, double the preceding term and add the one before it). The ratio of successive terms converges to the solution of $x - \frac{1}{x} = 2$ or the number $\theta = 1 + \sqrt{2} = 2.414213...$, referred to as the silver mean or more specifically as the 2nd *silver mean of type* 1, $SM_1(2)$.

Letting $x = 3$ yields the sequence: 1, 3, 10, 33, 109,... (e.g., to get a number from the sequence, triple the preceding term and add the one before it). The ratio of successive terms converges to the solution to $x - \frac{1}{x} = 3$ which is the 3rd *Silver Mean of type* 1 or $SM_1(3)$.

In general letting $x = N$, where N is either a positive or negative integer, leads to an approximate geometric sequence for which,

$$x_{k+1} = Nx_k + x_{k-1},$$

and whose ratio of successive terms is $SM_1(N)$ which satisfies the equation,

$$x - \frac{1}{x} = N. \qquad (22.2)$$

By an approximate geometric sequence, I mean a sequence for which the square of a given term differs from the product of the next term and the preceding term by a constant integer, i.e., $a_k^2 = a_{k-1} \, a_{k+1} + c$. In the case of the Fibonacci sequence, $c = 1$ (see Section 20.2) while for Pell's

sequence, $c = 5$. I refer to each of these sequences as a *Generalized Fibonacci sequence* or GF-sequence. Note that if x is a solution to Equation (22.2) then so is $\frac{-1}{x}$, e.g., $x = 1.618...$ and $\frac{-1}{1.618...} = -0.618...$ are both solutions to Equation (22.2) for $N = 1$. If Equation (22.2) is rewritten as:

$$\frac{1}{x} = x - N,$$

we see that when N is positive, negative solutions x to Equation (22.2) have the same fractional parts as their inverses, whereas if N is negative, positive solutions x have the same fractional parts as their inverses. For example, if $N = -2$, $x = 0.414$ while $\frac{1}{x} = 2.414$.

Alternating the signs for the terms in the polynomials of Table 22.1 generates the silver means constants of type 2 or SM_2. I will continue to refer to these polynomials as $F(n)$ unless this leads to confusion. For example, the polynomial $F(5)$ corresponding to row 5 would be $x^5 - 4x^3 + 3x$, and using $x = 3$ in row 5 yields 144, and the GF-series is: 1, 3, 8, 21, 55, 144,.... (The next term is gotten by tripling the previous term and subtracting the term before.) The ratio of successive terms converges upon $2.6180339... = \tau^2$, the $SM_2(3)$ constant.

For negative silver means the GF-series is generated by,

$$x_{k+1} = Nx_k - x_{k-1},$$

and the silver mean constants of type 2, $SM_2(N)$, satisfy,

$$x + \frac{1}{x} = N. \tag{22.3}$$

If x is a solution to this equation then so is $\frac{1}{x}$. Table 22.3 summarizes the properties of the two means.

Table 22.3 Summary of the two silver means.

$SM_1(N)$: $x - \frac{1}{x} = N$ or $x^2 - Nx - 1 = 0$	$SM_2(N)$: $x + \frac{1}{x} = N$ or $x^2 - Nx + 1 = 0$
Example: $N = 1$, then	Example: $N = 3$
$x = 1.618...$ and $-0.618...$	$x = 2.618...$ and $0.382...$
where $1.618 - 0.618 = 1$	where $2.618... + 0.382... = 3$

22.3 Lucas' Version of Pascal's Triangle

Fibonacci and Lucas sequences are intimately connected as can be seen from Equation (20.6). Adamson has discovered another variant of Pascal's triangle related to the Lucas sequence. In fact this Lucas–Pascal Triangle or LPT demonstrates that silver mean constants and sequences are part of an interrelated whole. Along with the FPT these tables are carriers of all of the significant properties of the silver means.

To construct the LPT create a new "Pascal's triangle" with 1's along one edge and 2's along the other as shown in Table 22.4.

Table 22.4 A Generalized Pascal's Triangle.

$$
\begin{array}{ccccc}
2 & & & & \\
2 & 1 & & & \\
2 & 3 & 1 & & \\
2 & 5 & 4 & 1 & \\
2 & 7 & 9 & 5 & 1 \\
& & \cdots & &
\end{array}
$$

As before each diagonal becomes a column of the LPT in which the elements in each successive column are displaced downwards by two rows. The exponents of the corresponding polynomials are sequenced as for the FPT. You will notice that the numbers in each row sum to the *Lucas sequence* and therefore I refer to the associated polynomials as Lucas polynomials $L(n)$.

Beginning with 2 and x, a Lucas polynomial is generated by the recursive formula:

$$L(n) = x\,L(n-1) + L(n-2),$$

for example $L(3) = xL(2) + L(1)$ or $x^3 + 3x = x(x^2 + 2) + x$.

Setting $x = 1, 2, 3,\ldots$ in the Lucas polynomials in Table 22.5 generates a set of *Generalized Lucas sequences* (GL-sequences) related to the $SM_1(N)$ constants. Setting $x = 1, 2, 3,\ldots$ in the polynomials with alternating signs, symbolized by $L(n)$, generates another set of GL-sequence related to the $SM_2(N)$ constants. Ratios of successive terms of these sequences converge

Table 22.5 Lucas–Pascal's Triangle.

$\frac{n}{k}$	1	2	3	4	Sum	
0	2^0				2	2
1	1^1				1	x
2	1^2	2^0			3	$x^2 + 2$
3	1^3	3^1			4	$x^3 + 3x$
4	1^4	4^2	2^0		7	$x^4 + 4x^2 + 2$
5	1^5	5^3	5^1		11	$x^5 + 5x^3 + 5x$
6	1^6	6^4	9^2	2^0	18	$x^6 + 6x^4 + 9x^2 + 2$
7	1^7	7^5	14^3	7^1	29	$x^7 + 7x^5 + 14x^3 + 7x$
	

to their respective SM constants. The following are some properties of the Lucas–PT sequences:

(1a) The nth number from the Generalized Lucas (GL) sequence corresponding to $SM_1(N)$ is the sum of the $(n-1)$th and $(n+1)$th numbers from the corresponding generalized Fibonacci (GF) sequence, i.e., $GL_n = GF_{n-1} + GF_{n+1}$ as we showed in Equation (20.6) for Lucas and Fibonacci sequences.

(1b) Corresponding to $SM_2(N)$, $GL_n = GF_{n+1} - GF_{n-1}$.

(2) Relationship between the GF and GL-sequences: Placing $x = 1, 2, 3,...$ into the Fibonacci and Lucas polynomials yields the sets of GF and GL-sequences.

Example: Setting $x = 1$ results in the F-sequence: 1, 1, 2, 3, 5, 8, 13,..., and the L-sequence: 1, 3, 4, 7, 11, 18, 29,..., related to $SM_1(1) = \tau$. If the terms of the L-sequence are divided by $\sqrt{5}$ and rounded up or down, the F-sequence results.

Example: Let $x = 2$. This results in the GF-sequence: 1, 2, 5, 12, 29, 70,... and the GL-sequence: 2, 6, 14, 34, 82,... where both sequences are related to $SM_1(2) = \theta$. GL is also gotten from GF by using Property (1a). If the terms of the GL-sequence are divided by $\sqrt{8}$ and rounded up or down, the GF-sequence results.

In general, if the terms of the Nth GL-sequence are divided by $\sqrt{N^2 + 4}$, the GF-sequence corresponding to $SM_1(N)$ results. For

$SM_2(N)$, the GF and GL-sequences are derived by letting $x = N$ in the sequence of polynomials $L(n)$ with alternating signs. If the terms of the GL-sequence are divided by $\sqrt{N^2 - 4}$ the GL-sequence results.

Example: Place $x = 3$ into the sequences of Fibonacci and Lucas polynomials with alternating signs to get the GF-sequence: 1, 3, 8, 21, 55,... and the GL-sequence: 3, 7, 18, 47,... corresponding to the $SM_2(3)$. Notice that GL is gotten from GF by applying Property (1b). Dividing the GL-sequence by $\sqrt{3^2 - 4} = \sqrt{5}$ and rounding up or down results in the GF-sequence.

(3) The numbers from a Generalized Lucas sequence are the sequence of powers of the silver mean constants of type 1 and 2 corresponding to that sequence rounded either up or down.

Example: Setting $x = 1$ in these polynomials yields the Lucas sequence: 1, 3, 4, 7, 11, 18,... . This sequence is generated by taking the sequence of powers of the $SM_1(1) = \tau$, i.e., the τ-sequence, and alternately rounding up and down (see Equation (20.7)).

Example: Setting $x = 2$ in the polynomials yields the GL-sequence: 2, 6, 14, 34, 82,... . This sequence can be gotten from the GF-sequence: 1, 2, 5, 12, 29,... by applying Property (1a). These numbers are generated by taking powers of $SM_1(2) = 2.414... = \theta$, i.e., the θ-sequence (see Equation (8.5)) and alternately rounding up and down.

Example: Letting $x = 3$ in $x^6 - 6x^4 + 9x^2 - 2 = 729 - 486 + 81 - 2 = 322$.

The Generalized Lucas sequence is: 3, 7, 18, 47, 123, 322,... . This sequence can be gotten from the GF-sequence corresponding to $SM_2(3)$: 1, 3, 8, 21, 55, 144,... by applying Property (1b). These numbers are generated by taking powers of $SM_2(3) = \tau^2 = 2.618...$ and rounding up.

22.4 Silver Mean Series

According to Equation (22.2) and Figure 22.1, $\frac{1}{SM_1(N)}$ are solutions to the following equation,

$$\frac{1}{N} = \frac{x}{1 - x^2}. \tag{22.4a}$$

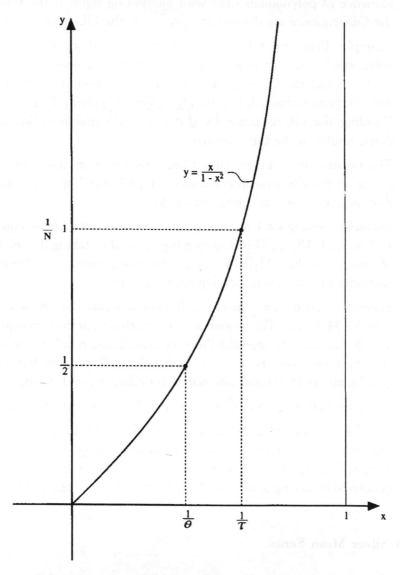

Figure 22.1 The equation $y = \dfrac{x}{1+x^2}$ maps the inverse silver means of the first kind, $SM_1(N)$ to $\frac{1}{N}$.

Expanding $\frac{x}{1-x^2}$ in a geometric series,

$$\frac{1}{N} = x + x^3 + x^5 + x^7 + \cdots. \tag{22.4b}$$

In other words, the odd inverse powers of the Nth silver means of the first kind, $SM_1(N)$, equals $\frac{1}{N}$. For example,

$$1 = \tau^{-1} + \tau^{-3} + \tau^{-5} + \tau^{-7} + \cdots, \quad \text{and} \tag{22.5a}$$

$$\frac{1}{2} = \tau^{-1} + \tau^{-3} + \tau^{-5} + \tau^{-7} + \cdots \tag{22.5b}$$

where τ and θ are the first and second SM_1 respectively.

Kapusta [Kapu] has found a sequence of circles with diameters that are odd inverse powers of the golden and silver means lying within a square and a half square as shown in Figure 22.2, a visual proof of Equations (22.5). The circles within the square are tangent to the upward pointed triangle of the Brunes star (see Chapter 8 and Figures 20.9 and 20.10). Adamson has discovered an amazing generalization of these series of inverse powers to series of inverse powers of both the Nth silver means of the first and second kinds. These are related to the generalized Lucas sequences expressed in Table 22.6.

Notice that each column to the left of the line is the Generalized Lucas sequence corresponding to Nth silver mean (the SM values are listed in the last column of Table 22.6) where N is the number at the top of the column. For example, the rightmost of these columns in Table 22.6a is the standard Lucas series corresponding to $SM_1(1)$ or the golden mean while the second column corresponds to $SM_1(2)$ or the silver mean. The inverses of these numbers equal the sum of a particular series of inverse powers of $SM_1(N)$. The inverse powers within each series are listed in the same row to the right of the line.

The numbers to the right of the center-line are derived in as similar manner (not shown here) as Equation (22.4b) is derived from Equation (22.4a) [Adam1]. The sign refers to the sign of that term in the series. For example, the series of odd inverse powers in Equations (22.5a) and (22.5b) refer to the odd integers to the right of the line in row 1 of Table 22.6a and sum

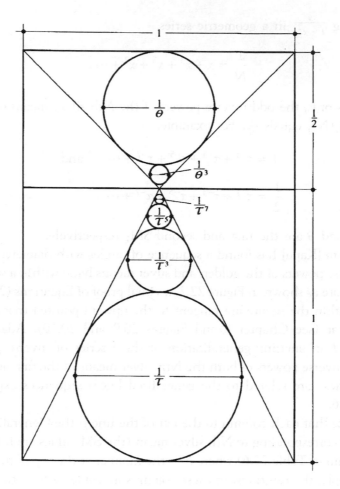

Figure 22.2 The sum of the odd inverse powers of $SM_1(N)$ sum to $\frac{1}{N}$ illustrated for $SM_1(1) = \tau$ and $SM_2(2) = \theta$.

to 1 and $\frac{1}{2}$ respectively. By the same token, the integers 3 and 6 in row 2 of Table 22.6a to the left of the line lead to the following pair of series,

$$\frac{1}{3} = \tau^{-2} - \tau^{-6} + \tau^{-10} - \tau^{-14} + \cdots,\qquad (22.6a)$$

$$\frac{1}{6} = \theta^{-2} - \theta^{-6} + \theta^{-10} - \theta^{-14} + \cdots.\qquad (22.6b)$$

Table 22.6a Sums and addition rules for $SM_1(N)$ series.

Generalized Lucas numbers						Exponents and signs						$SM_1(N) = e^{\sinh^{-1}\frac{N}{2}}$
6	5	4	3	2	1	1	3	5	7	9	11...	1. 1.618... $= \tau$
40	37	18	11	6	3	2	−6	10	−14	18	−22...	2. 2.414... $= \theta$
...	140	76	36	14	4	3	9	15	21	27	33...	3. 3.30277...
	...	322	119	34	7	4	−12	20	−28	36	−44...	4. 4.2360...
		...	393	82	11	5	15	25	35	45	55...	5. 5.1925...
			...	198	18	6	−18	30	−42	54	−66...	6. 6.16227...
				...	29	7	21	35	49	63	77...	...
								

Table 22.6b Sums and addition rules for $SM_2(N)$ series.

Generalized Lucas numbers						Exponents and signs						$SM_2(N) = e^{\sinh^{-1}\frac{N}{2}}$
8	7	6	5	4	3	1	−3	5	−7	9	−11...	3. 2.618... $= \tau^2$
...	47	33	23	14	7	2	−6	10	−14	18	−22...	4. 3.73205...
	...	198	110	52	18	3	−9	15	−21	27	−33...	5. 4.79128...
		...	527	194	47	4	−12	20	−28	36	−44...	6. 5.828...
			...	724	123	5	−15	25	−35	45	−55...	7. 6.8541...
				...	322	6	−18	30	−42	54	66...	8. 7.8729...
				

The same holds for the integers in Table 22.6b except that the inverse of the integers are now the sums of inverse powers of $SM_2(N)$ where N is the number at the top of the column. For example, using integers 3 and 4 in row 1,

$$\frac{1}{3} = \tau^{-2} - \tau^{-6} + \tau^{-10} - \tau^{-14} + \cdots, \qquad (22.7a)$$

$$\frac{1}{4} = \delta^{-2} - \delta^{-3} + \delta^{-5} - \delta^{-7} + \cdots \qquad (22.7b)$$

where $SM_2(3) = \tau^2$ and $SM_2(4) = 2 + \sqrt{3} = \delta$. Notice that Equations (22.6a) and (22.7a) are identical.

22.5 Regular Star Polygons

There is an unexpected connection between the polynomials of Tables 22.1 and 22.3, with alternating signs, and theories of proportion. Theories of proportion have their origins with star polygons such as those that were introduced in Figures 7.2 and 20.3 in connection with golden mean and the Roman systems of proportion [Kap9], and Figure 3.4 with regard to the cyclic subgroups of the twelve tone musical scale. The important constants of these systems τ and θ are related to the diagonals of regular polygons.

An n-gon is a geometric figure with n vertices connected by a cycle of edges as shown as shown in Figure 22.3 for three species of 7-gons. If the succession of vertices are arranged equidistantly around a circle, and the mth vertex is connected in a clockwise direction, to the $m + k$ vertex for $m = 1, 2, 3,\ldots, n$, then the n-gon is said to be *regular* and symbolized by $\left\{\frac{n}{k}\right\}$. For the polygon $\left\{\frac{n}{1}\right\}$, referred to simply as a regular n-gon; each vertex is connected to the adjacent vertex. When $k > 1$, the edges of the polygon self-intersect, and the polygon is referred to as a *star* n-gon.

In Figure 22.3 the three distinct species of star heptagon are shown and labeled $\left\{\frac{7}{k}\right\}$ where k indicates that a vertex is connected to the kth vertex distant from it in a clockwise direction (note the arrows). There are three additional star heptagons with retrograde directions. In Figure 22.4 the six distinct species of $\left\{\frac{12}{k}\right\}$ figures are shown. Only $\left\{\frac{12}{1}\right\}$ and $\left\{\frac{12}{5}\right\}$ are considered to be star 12-gons since only these form connected cycles of edges. In fact, it can be shown in general that species of $\left\{\frac{n}{k}\right\}$ form star n-gons only when n and k are *relatively prime*. In other words, they have no common factors, e.g., 12 and 5. Since all of the positive fractions, $\frac{k}{m}$, in lowest terms with denominator no larger than n are represented on row F_n of the Farey sequence of Table 14.2, this row also lists all of the species of star polygons $\left\{\frac{m}{k}\right\}$ where $m \leq n$. The *Euler phi function* $\phi(n)$ introduced in Appendix 14A tabulates the numbers relatively prime to n. Therefore since 1, 5, 7, and 11 are relatively prime to 12, $\phi(12) = 4$. It is also easy to see that $\phi(n) = n - 1$ when n is prime, e.g., $\phi(7) = 6$. It can be shown that there exist exactly $\frac{\phi(n)}{2}$ distinct star n-gons.

The edges of star n-gons are the *diagonals* of the regular n-gons. By determining the lengths of the $n - 3$ diagonals of regular n-gons we are also determining the lengths of the edges of various species of star n-gons.

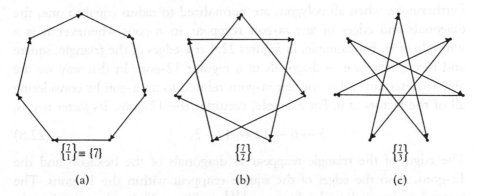

Figure 22.3 The three positively oriented star 7-gons.

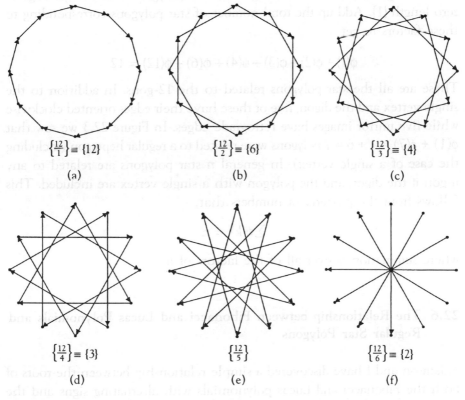

Figure 22.4 The family of star polygons related to the 12-gon. Note the small arrows indicating orientation.

Furthermore, when all polygons are normalized to radius equal to one, the diagonals and edges of any m-gon reappear in n-gons whenever n is a multiple of m. For example, in Figures 22.4 the edges of the triangle, square and hexagon appear as diagonals of a regular 12-gon. In this way we are able to determine all of the star m-gons related to an n-gon by considering all of the factors of n. For example, consider the 12-gons. Its *factor tree* is,

$$3 \to 6 \to 12 \leftarrow 4 \leftarrow 2. \tag{22.8}$$

The edges of the triangle reappear as diagonals of the hexagon and the 12-gons. Also the edges of the square reappear within the 12-gons. The factor 2 corresponds to the diameter $\left\{\frac{12}{6}\right\}$ in Figure 22.4 and can be thought of as a polygon with two edges, referred to as a *digon* {2}. In some limiting sense a single vertex can be thought to be a polygon with a single edge of zero length {1}. Add up the total number of star polygons corresponding to these factors to get

$$\phi(1) + \phi(2) + \phi(3) + \phi(4) + \phi(6) + \phi(12) = 12.$$

These are all the star polygons related to the 12-gons. In addition to the single vertex and the digon, five of these have their edges oriented clockwise while five mirror images have retrograde edges. In Figure 22.3 we saw that $\phi(1) + \phi(7) = 1 + 6 = 7$ polygons were related to a regular heptagon (including the case of a single vertex). In general n star polygons are related to any n-gon if the digon and the polygon with a single vertex are included. This follows from the property of numbers that,

$$\sum \phi(k) = n$$

where summation is over all of the factors of n.

22.6 The Relationship between Fibonacci and Lucas Polynomials and Regular Star Polygons

Adamson and I have discovered a simple relationship between the roots of both the Fibonacci and Lucas polynomials with alternating signs and the diagonals of regular polygons when the *radii of the polygons are taken to be 1 unit*. As mentioned in the previous section, the diagonals can also be

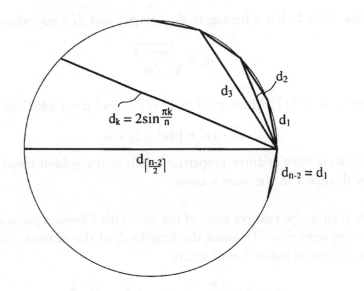

Figure 22.5 Notation for the diagonals, $d_k = 2\sin\frac{\pi k}{n}$, of a polygon of unit radius. The edge is denoted by d_1.

considered to be edges of various species of star polygon related to regular n-gons.

For odd n, the positive roots of the nth *Lucas polynomial*, $L(n)$, with alternating signs equal the distinct diagonal lengths d_k for $k > 1$ and edge d_1 of the n-gon of radius 1 unit where

$$d_k = 2\sin\frac{k\pi}{n} \quad \text{for } k = 1, 2, \ldots, \frac{n-1}{2} \tag{22.9a}$$

with the labeling of the $n - 1$ diagonals illustrated in Figure 22.5.

Example 22.6.1. For a pentagon, d_1 and $d_2 = \tau\, d_1$ where $d_1 = \frac{\sqrt{1+\tau^2}}{\tau}$ are the roots of $L(5)$:

$$x^5 - 5x^3 + 5x = 0.$$

This gives the familiar result that the ratio of the diagonal to the edge of a regular pentagon is the golden mean τ.

Example 22.6.2. For a heptagon, d_1, $d_2 = \rho d_1$ and $d_3 = \sigma d_1$ where

$$d_1 = \sqrt{\frac{\rho\sigma - 1}{\rho\sigma}}$$

are the roots of $L(7)$ where $\rho = 1.8019377...$ and $\sigma = 2.2469796...$:

$$x^7 - 7x^5 + 14x^3 - 7x = 0.$$

The numbers have additive properties much as the golden mean and this will be discussed in the next section.

For even n, the positive roots of the $(n-1)$th *Fibonacci polynomial* with alternating signs $F(n-1)$, equal the lengths d_k of the distinct diagonals of regular n-gons of radius 1 unit where

$$d_k = 2\sin\frac{k\pi}{n} \quad \text{for } k = 1, 2, ..., \frac{n-2}{2}. \tag{22.9b}$$

For polygons with even n, one of the diagonals is twice the radius or 2. This diagonal is not one of the roots.

Example 22.6.3. For a hexagon, d_1 and $d_2 = \sqrt{3}\,d_1$ where $d_1 = 1$ are the roots of $F(5)$:

$$x^5 - 4x^3 + 3x = 0.$$

Example 22.6.4. For an octagon, d_1, $d_2 = \sqrt{\theta\sqrt{2}}\,d_1$ and $d_3 = \theta d_1$ where

$$d_1 = \sqrt{\frac{\sqrt{2}}{\theta}}$$

are the roots of $F(7)$:

$$x^7 - 6x^5 + 10x^3 - 4x = 0.$$

The results for several polygons are summarized in Table 22.8. The diagonals are normalized to an edge value of 1 unit by dividing by d_1.

We find the curious property that both the sum and product of the squares of the diagonals of an n-gon (including the edge) equals an integer

Table 22.7 Lengths of normalized diagonals of n-gons.

n-gon		Lengths of normalized diagonals $\dfrac{d_k}{d_1}$			
n	d_1	$\dfrac{d_2}{d_1}$	$\dfrac{d_3}{d_1}$	$\dfrac{d_4}{d_1}$	$\dfrac{d_5}{d_1}$
3	$\sqrt{3}$				
4	$\sqrt{2}$				
5	$5^{1/4}\,\tau^{-1/2}$	τ			
6	1	$\sqrt{3}$			
7	$\sqrt{\dfrac{\rho\sigma-1}{\rho\sigma}}$	ρ	σ		
8	$\sqrt{\dfrac{\sqrt{2}}{\theta}}$	$\sqrt{\theta\sqrt{2}}$	θ		
10	$\dfrac{1}{\tau}$	$5^{1/4}\,\tau^{1/2}$	τ^2	$5^{1/4}\,\tau^{3/2}$	
12	$\sqrt{2-\sqrt{3}}$	$\sqrt{2+\sqrt{3}}$	$\sqrt{2}\sqrt{2+\sqrt{3}}$	$\sqrt{3}\sqrt{2+\sqrt{3}}$	$2+\sqrt{3}$

and that this integer equals n for odd values of n. For example, $d_1{}^2 + d_2{}^2 = 5$ and $d_1{}^2 \times d_2{}^2 = 5$ for the pentagon, while, $d_1{}^2 + d_2{}^2 + d_3{}^2 = 7$ and $d_1{}^2 \times d_2{}^2 \times d_3{}^2 = 7$ for the heptagon.

Not only are the diagonals of regular polygons determined by Equations (22.9a) and (22.9b), but the areas A of the regular n-gons with unit radii are computed from the elegant formula,

$$A = \frac{n}{2}\sin\frac{2\pi}{n}. \tag{22.10}$$

From Equation (22.10) the square is found to have area 2 units while the 12-gon has area 3 units. It can also be determined that if n approaches infinity, then A approaches π, the area of a unit circle.

Notice that the key numbers in the systems of proportions based on various polygons present themselves in Table 22.7: τ — pentagonal system; θ and $\sqrt{2}$ — octagonal; $\sqrt{3}$, $1+\sqrt{3}$, and $2+\sqrt{3}$ — dodecahedral; ρ and σ — heptagonal, and these are pictured in Figure 22.6.

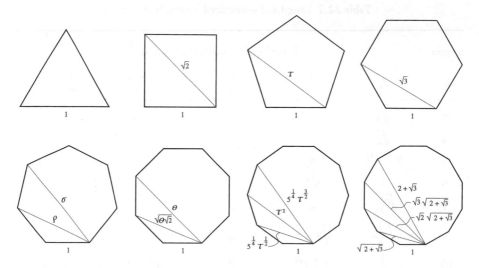

Figure 22.6 The diagonals of a n-gon whose edge length equals 1 are key proportions of the system of proportions related to that polygon.

22.7 The Relationship between Number and the Geometry of Polygons

Since the unique diagonals of an n-gon correspond to the roots of a polynomial, the fact that these diagonals recur in any m-gon where n is a multiple of m serves to factor the polynomial into polynomials of smaller degree with integer coefficients. For example, the polynomial $F(9)$ of the 10-gon factors into the product of $L(5)$ of the 5-gon and $F(4)$, i.e., $F(9) = L(5) \times F(4)$ or,

$$x^9 - 8x^7 + 21x^5 - 20x^3 + 5x = (x^4 - 3x^2 + 1)(x^5 - 5x^3 - 5x).$$

We can state this result as a theorem:

Theorem 22.7.1. *The polynomial $F(2n-1)$ of any $2n$-gon factors into the product of $L(n)$ and $F(n-1)$.*

By the same reasoning as for the 10-gon, the factor tree of Expression (22.8) can be used to factor $F(11)$, the polynomial representing the

12-gon. Of the six unique diagonals of the 12-gon, one occurs in the 3-gon (equilateral triangle), an additional one appears in the 6-gon (hexagon), another appears in the 4-gon (square), and two additional diagonals occur in the 12-gon. By Theorem 22.1, the polynomial of the 12-gon factors into,

$$F(11) = L(6) \times F(5)$$

corresponding to the factoring by the hexagon polynomial $F(5)$. The hexagon polynomial can then be decomposed further as,

$$F(5) = L(3) \times F(2)$$

corresponding to factoring by the triangle $L(3)$. These two factorizations can be combined to obtain,

$$F(11) = L(3) \times F(2) \times L(6)$$

or,

$$x^{11} - 10x^9 + 36x^7 - 56x^5 + 35x^3 - 6x = (x^3 - 3x)(x^2 - 1)(x^6 - 6x^4 + 9x^2 - 2).$$

Finally $L(6)$ factors into,

$$L(6) = (x^2 - 2)\ (x^4 - 4x^2 + 1).$$

The diagonal (edge) of the triangle comes from $L(3)$, the additional diagonal (edge) of the hexagon from $F(2)$, the diagonal of the square is the root of the first factor of $L(6)$ while the two additional diagonals of the 12-gon are the roots of the second factor of $L(6)$. Finally, the diagonal of the digon is the diameter of the 12-gon. This accounts for the six distinct diagonals of the 12-gon.

In what follows the symbol d_k will be used for diagonals of regular *polygons normalized to a unit edge* rather than the unit radius of the polygon with the hopes that this will not confuse the reader. For any n-gon, it is easy to determine from geometry that the length of the shortest diagonal when the edge has a length of one unit is given by the simple formula: $2\cos\frac{\pi}{n}$. This leads to the solution of the classical problem of geometry and to the generalization of the Vesica Pisces (see Appendix 6.A) presented in Appendix 22.A.

22.8 Additive Properties of the Diagonal Lengths

Similar to τ and θ, the diagonals of each of these systems of n-gons have additive properties. Steinbach has derived the following *Diagonal Product Formula* (DPF) that defines multiplication of the edge lengths in terms of their addition [Stein1,2],

$$d_h d_k = \sum_{i=0}^{h} d_{k-h+2i}, \quad \text{where } h \leq k$$

where the diagonals have been normalized to polygons with edges of $d_1 = 1$ unit. It is helpful to write these identities in an array as follows:

$$
\begin{array}{llll}
d_2^2 = 1 + d_3, & d_3^2 = 1 + d_3 + d_5, & d_4^2 = 1 + d_3 + d_5 + d_7, \\
d_2 d^3 = d_2 + d_4, & d_3 d_4 = d_2 + d_4 + d_6, & d_4 d_5 = d_2 + d_4 + d_6 + d_8, \\
d_2 d^4 = d_3 + d_5, & d_3 d_5 = d_3 + d_5 + d_7, & \quad\quad \cdots \quad\quad\quad (22.11) \\
d_2 d^5 = d_4 + d_6, & \quad\quad \cdots \\
\quad \cdots\cdots
\end{array}
$$

These formulas are applied to the pentagon and the heptagon.

Example 22.8.1. For the pentagon, $d_2 = d_3 = \tau$ and these relationships reduce to the single equation,

$$d_2^2 = 1 + d_3 \quad \text{or} \quad \tau^2 = 1 + \tau.$$

Example 22.8.2. The proportional system based on the heptagon is particularly interesting [Steinbach 1997], [Oga]. For the heptagon, $d_2 = d_5 = \rho$ and $d_3 = d_4 = \sigma$ and these relationships reduce to the four equations,

$$
\begin{array}{lll}
d_2^2 = 1 + d_3 & \text{or} & \rho^2 = 1 + \sigma, \\
d_2 d_3 = d_2 + d_4 & \text{or} & \rho\sigma = \rho + \sigma, \\
d_3^2 = 1 + d_3 + d_5 & \text{or} & \sigma^2 = 1 + \sigma + \rho.
\end{array}
$$

What is astounding is that not only are the products of the edge lengths expressible as sums but so are the quotients. Table 22.8 illustrates the quotient table for the heptagon.

Table 22.8 Ratio of diagonals (left/top).

	1	ρ	σ
1	1	$1 + \sigma - \sigma$	$\sigma - \rho$
ρ	ρ	1	$\rho - 1$
σ	σ	$\sigma - 1$	1

As a result of DPF and the quotient laws, Steinbach has discovered that the edge lengths of each polygon form an algebraic system closed under the operations of addition, subtraction, multiplication, and division. Such algebraic systems are known as *fields* and he refers to them as *golden fields*.

22.9 The Heptagonal System

The heptagonal system is particularly rich in algebraic and geometric relationships. The additive properties of DPF and Table 22.8 for the heptagon are summarized:

$$\rho + \sigma = \rho\sigma, \quad (\text{Compare this with } \tau + \tau^2 = \tau\tau^2)$$

$$\frac{1}{\rho} + \frac{1}{\sigma} = 1, \quad \left(\text{Compare this with } \frac{1}{\tau} + \frac{1}{\tau^2} = 1\right)$$

$$\rho^2 = 1 + \sigma,$$

$$\sigma^2 = 1 + \rho + \sigma,$$

$$\frac{\rho}{\sigma} = \rho - 1,$$

$$\frac{\sigma}{\rho} = \sigma - 1,$$

$$\frac{1}{\sigma} = \sigma - \rho,$$

$$\frac{1}{\rho} = 1 + \rho - \sigma.$$

(22.12)

The algebraic properties of each system of proportions are manifested within the segments of the n-pointed star (the n-gon with all of its diagonals)

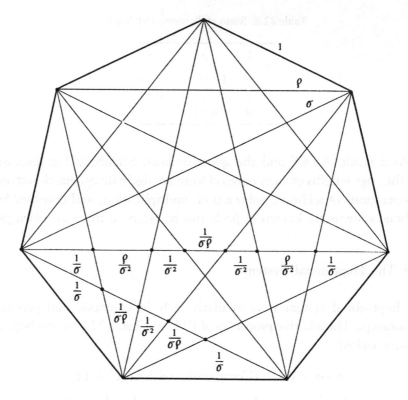

Figure 22.7 The diagonals of a heptagon subdivide themselves into lengths related to the lengths of the two principal diagonals ρ and σ.

corresponding to that system. For example, the pentagonal system of proportions is determined by the 5-star shown in Figure 20.3 while the octagonal system is determined by the 8-star is shown in Figure 7.2. Figure 22.7 illustrates the family of star heptagons. Notice that the short diagonal of length ρ (the edge is 1 unit) and the long diagonal of length σ are subdivided into the following segments depending on ρ and σ:

$$\rho = \frac{1}{\rho} + \frac{1}{\rho\sigma} + \frac{1}{\sigma^2} + \frac{1}{\rho\sigma} + \frac{1}{\rho} \quad \text{and,}$$

$$\sigma = \frac{1}{\sigma} + \frac{\rho}{\sigma^2} + \frac{1}{\sigma^2} + \frac{1}{\rho\sigma} + \frac{1}{\sigma^2} + \frac{\rho}{\sigma^2} + \frac{1}{\sigma}.$$

Thus we see at the level of geometry that the graphic designer encounters the same rich set of relationships as does the mathematician at the level of symbols and algebra.

The following pair of intertwining geometric σ-sequences and corresponding Fibonacci-like integer series exhibit these additive properties:

$$\ldots, \frac{1}{\sigma}, \frac{\rho}{\sigma}, 1, \rho, \sigma, \sigma\rho, \sigma^2, \sigma^2\rho, \sigma^3, \sigma^3\rho, \sigma^4, \ldots,$$ (22.13a)

$$1, 1, 1, 2, 3, 5, 6, 11, 14, 25, 31, \ldots .$$ (22.13b)

The integer series is generated as follows:

(1) Determine the first five terms $xyzuv$ beginning with 111.
(2) Let $y + z = u$ and $u + x = v$, i.e., $1 + 1 = 2$ and $2 + 1 = 3$ to obtain 11123.
(3) Repeat step 2 beginning with the zuv, i.e., from 123, $2 + 3 = 5$ and $5 + 1 = 6$ to obtain 12356.
(4) Continue.

The ratio of successive terms of this sequence equals, alternatively ρ and $\frac{\sigma}{\rho}$ while the ratios of successive terms of the integer series asymptotically approaches ρ and $\frac{\sigma}{\rho}$, e.g., $\frac{25}{14} = 1.785\ldots \approx \rho$ while $\frac{31}{25} = 1.24 \approx \frac{\sigma}{\rho}$. Also σ is obtained as the product of these ratios, i.e., $\frac{31}{14} = 2.214 \approx \sigma$. Just as every power of the golden mean τ can be written as a linear combination of 1 and τ with the Fibonacci numbers as coefficients [Kap3], every power of σ can be written as the following linear combinations of 1, ρ, σ where the integers of Sequence (22.13b) appear as the coefficients:

$$\sigma = 1\sigma + 0\rho + 0,$$
$$\sigma^2 = 1\sigma + 1\rho + 1,$$
$$\sigma^3 = 3\sigma + 2\rho + 1,$$
$$\sigma^4 = 6\sigma + 5\rho + 3,$$ (22.14)
$$\sigma^5 = 14\sigma + 11\rho + 6,$$
$$\sigma^6 = 31\sigma + 25\rho + 14,$$
$$\ldots$$

Notice that the first coefficient in the equation for σ^{n+1} is the sum of the three coefficients of the equation for σ^n while the second coefficient is the

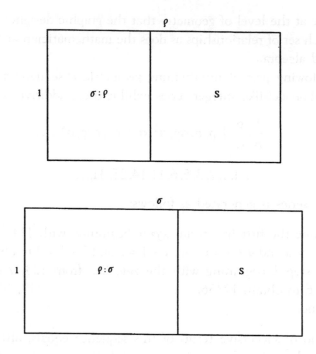

Figure 22.8 When a square is removed from rectangles of proportions 1:ρ and 1:σ rectangles of proportion ρ:σ in different orientations remain.

sum of the first two coefficients and the last coefficient is the same as the first of the previous equation, e.g., in the equation for σ^4: $6 = 3 + 2 + 1$, $5 = 3 + 2$, and $3 = 3$.

A geometric analogy to the golden mean can be seen by considering the pair of rectangles of proportions ρ:1 and σ:1 in Figure 22.8. By removing a square from each, we are left in both cases with rectangles of proportion ρ:σ although oriented differently.

22.10 Self-Referential Properties of the Silver Mean Constants

In Section 14.4 it was seen that the solution to $>a = a$ resulted in the infinite chain:

$$a = >>>> \cdots .$$

In fact all self-referential processes result in infinite processes. See Figure 18.9 for the multiple reflections of an image in a painting of a painting of a painting or an image in a mirror in a mirror in a mirror... .

In general the equation $T(x) = x$ expresses a *self-referential* relationship. Replacing x by $T(x)$ gives $T(T(x)) = x$ or $TTx = x$. Continuing this process results in,

$$TTT...Tx = x$$

from which it follows that we can formally set,

$$x = TTT...,$$

an infinite process. For example, in Section 14.5, $T(x) = \frac{-1}{x}$. Setting $x = T(x)$ yields the formal solution,

$$TTT... = -1/-1/-1/-1/... .$$

Although this infinite compound fraction has no mathematical meaning, the infinite process can be defined to be the imaginary numbers $\pm i$ since these are the solutions to $\frac{-1}{x} = x$.

We also saw that the solutions to the liar's paradox in Section 13.4, $\overline{x} = -x$, where x is the truth value of a proposition, were the two infinite processes I and J.

We now come to a set of self-referential statements related to the SM_1 and SM_2 constants. These constants are solutions to the self-referential equations $T(x) = x$ where,

$$T(x) = N + \frac{1}{x} \quad \text{and} \quad T(x) = N - \frac{1}{x}.$$

If $N = 0$ in the second of these transformations, $TTT...$ is identified with the imaginary number i. So in a sense, the silver means are generalizations of i. The solutions x can be shown to be the two infinite processes,

$$TTT... = N + \cfrac{1}{N + \cfrac{1}{N + \cfrac{1}{\ddots}}} \qquad \text{and} \qquad TTT... = N - \cfrac{1}{N - \cfrac{1}{N - \cfrac{1}{\ddots}}}$$

These are continued fraction representations of the silver mean constants of types 1 and 2. $SM_1(N) = [N; \overline{N}]$ in the notation of Section 14.4. $SM_2(N) = [N; \overline{N}]^-$ are expressed in terms of another form of continued fraction not discussed in this book. Adamson has found that the convergents of,

$$[\bar{i}] = 1 \quad \text{and} \quad [\bar{i}]^- = 1$$
$$\overline{i+1} \qquad\qquad \overline{i-1}$$
$$\overline{i+1} \qquad\qquad \overline{i-1}$$
$$\overline{i+1} \qquad\qquad \overline{i-1}$$
$$\ddots \qquad\qquad \ddots$$

are respectively, the repeating 12-cycle:

$$[\bar{i}]: \frac{1}{i}, \frac{i}{0}, \frac{0}{i}, \frac{i}{-1}, \frac{-1}{0}, \frac{0}{-1}, \frac{-1}{-i}, \frac{-i}{0}, \frac{0}{-i}, \frac{-i}{1}, \frac{1}{0}, \frac{0}{1}, \quad \text{and}$$

$$[\bar{i}]: \frac{1}{i}, \frac{i}{-2}, \frac{-2}{-3i}, \frac{-3i}{5}, \frac{5}{8i}, \frac{8i}{-13}, \frac{-13}{-21i}, \frac{-21i}{-34} \cdots.$$

The first series is illustrated on the wheel shown in Figure 22.9.

Notice that numerators and denominators at opposite positions on the wheel have different parities (signs). Also the *modulus* of adjacent terms equals ± 1, e.g.,

$$\begin{vmatrix} 0 & -1 \\ -1 & -i \end{vmatrix} = (0 \times i) - ((-1) \times (-1)) = -1.$$

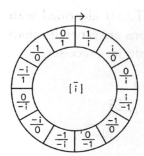

Figure 22.9 The convergents of the repeated continued fraction $[\bar{i}]$ forms Adamson's 12-cycle wheel.

The second series follows the pattern of the Fibonacci sequence. It can also be shown, using DeMoivre's theorem, that

$$[\bar{i}] = e^{i\pi/6} = \cos\frac{\pi}{6} + i\sin\frac{\pi}{6} \quad \text{and therefore } [\bar{i}]^{12} = 1.$$

This indicates that the powers of $[\bar{i}]$ lie at the vertices of a 12-gon inscribed in a unit circle, i.e., they are what mathematicians call *roots of unity* (see Section 23.2). There is also a fascinating relation involving the imaginary number i and the golden mean τ,

$$(i\tau) + \frac{1}{(i\tau)} = i.$$

In other words, according to Equation (22.3), $SM_2(i) = i\tau = iSM_1(1)$. In a similar manner, it can be shown that each silver mean constant is related to an integer multiple of i.

The self-referential character of the golden and silver means have been already described in previous chapters. For example, Figure 20.1 shows the infinitely reproducible nature of the F-sequence. The sacred cut described in Chapter 6 is ultimately based on the silver mean θ. The harmony of the Roman system of proportions and the Amish quilt designs based, as they are on the sacred cut, were illustrated by the tiling of Figure 6.6, the Amish quilt tilings of Figure 6.5 and the Sacred Cut panel of the Laurentian Library shown in Figure 10.3.

22.11 Conclusion

With the aid of Pascal's triangle, the golden mean and Fibonacci sequences were generalized to a family of silver means. The Lucas sequence was then generalized with the aid of a close variant of the Pascal's triangle. These generalized golden means and generalized F- and L-sequences were shown to form a tightly knit family with many properties of number. Perhaps it is for this reason that they occur in many dynamical systems as we shall see in the final three chapters. The numerical properties of the silver mean constants are the result of their self-referential properties which, in turn, derive from their relationship to the imaginary number i. I have shown that

all systems of proportion are related to a set of polynomials derived from Pascal's triangle. These systems are related to both the edges of various species of regular star polygon and the diagonals of regular n-gons, and they share many of the additive properties of the golden mean. The heptagon was illustrated in detail. The next chapter will show how the edges of star polygons characterize the cycles of the logistic equation in a state of chaos.

Appendix 22.A Generalizations of the Vesica Pisces

Problem: Given an n-gon inscribed within circle C_1 of radius R_1, and a sequence of n identical circles C_2 of radius R_2 each of which intersect the center of C_1 and two adjacent vertices of the n-gon, find the ratio $\frac{R_1}{R_2}$. H.E. Huntley [1970] has stated and solved this problem for $n = 5$ (see Figure 22.A1).

Let circle C_2 have a unit radius. For 3 circles (i.e., $n = 3$), the solution is the rosette pattern shown in Figure 10.13a in which the equilateral triangle is marked on the circumference of the pitch circle by the three dotted lines and for which $\frac{R_1}{R_2} = 1$. In Figure 22.A1, OA and therefore $\frac{R_1}{R_2} = \tau$ for the case of five circles (i.e., $n = 5$). For the case of six circles (not shown) the circles intersect in the Vesica Pisces (see Appendix 6A) and $\frac{R_1}{R_2} = \sqrt{3}$. Adamson has discovered the remarkably simple result that,

$$\frac{R_1}{R_2} = 2\cos\frac{\pi}{n}$$

Figure 22.A1

for the n-circle problem where $2\cos\frac{\pi}{n}$ is the length of the shortest diagonal of the n-gon when its edge length is 1 unit. The proof, using trigonometry, is left to the reader. The oblong regions between adjacent circles can be considered to be generalized vesicas. The values of $\frac{R_1}{R_2}$ for $n = 1, 2, 3, \ldots, 12$ are the values $\frac{d_2}{d_1}$ listed in Table 22.7. For example, for the heptagon, $\frac{R_1}{R_2} = \rho$.

23
Polygons and Chaos

> ...there is a God precisely because Nature itself, even in chaos,
> cannot proceed except in an orderly and regular manner.
>
> *Immanuel Kant*

23.1 Introduction

The previous chapter showed that the diagonals of regular polygons and edge lengths of regular star polygons are related to the roots of a family of polynomials derived from Fibonacci and Lucas sequences. This chapter will describe a remarkable connection between the edges of star polygons and dynamical systems in the state of chaos that I discovered in collaboration with Gary Adamson. A sequence of dynamical maps are derived from the Lucas polynomials. These maps exhibit periodic trajectories of all lengths with each regular polygon having its own characteristic cycle length. The first Lucas polynomial is the logistic equation, described in Chapter 19, at a value of its parameter corresponding to the extreme point of the Mandelbrot set. This leads to new connections between chaotic dynamics and both Euclidean geometry and the theory of numbers. If the polygons are viewed as tone circles much as the equal tempered scale can be looked at as a regular 12-gon, then cycles can be considered to represent a sequence of tones. Two such tone sequences will be shown to be of musical interest. Additional mathematical details can be found in [Kap13].

23.2 Edge Cycles of Star Polygons

The proper framework for the study of the edges of star polygons are the roots of the simple polynomial,

$$z^n - 1 = 0 \quad \text{for } z \text{ a complex number and } n \text{ an odd integer.}$$

Certainly $z = 1$ is a root, but there are $n - 1$ additional roots, the so-called roots of unity. These roots exist in the complex plane. If the root $z = 1$ is excluded, the others are roots of the nth *cyclotomic* polynomial,

$$\frac{z^n - 1}{z - 1} = z^{n-1} + z^{n-2} + \cdots + z^3 + z^2 + z + 1 = 0. \tag{23.1}$$

The roots of this polynomial are complex numbers distributed at the vertices of a regular n-gon, that I refer to as a cyclotomic n-gon, whose center is the origin and whose radius is 1 where n is an odd integer. The vertices are at the points, $\left(\cos\frac{2\pi k}{n},\ \sin\frac{2\pi k}{n}\right)$ given by DeMoivre's theorem,

$$\cos\frac{2\pi k}{n} + i\sin\frac{2\pi k}{n} = \exp^{2\pi k i/n} \quad \text{for } k = 0, 1, 2, 3, \ldots, n-1.$$

As an example, the cyclotomic 7-gon is shown in Figure 23.1.

Consider the cyclotomic 7-gon to be a clock with 7 numbers (see Appendix 23A) proceeding counterclockwise from $0 - 7$ o'clock situated at $(1, 0)$. Next we consider the transformation,

$$\operatorname{Re} z \mapsto \operatorname{Re} z^2 \quad \text{where } \operatorname{Re} z = \cos\frac{2\pi k}{7} \tag{23.2}$$

where $\operatorname{Re} z$ signifies the real part of the complex number z. In this transformation, point 1 maps to point 2, i.e., $1 \to 2$. Similarly, $2 \to 4, 4 \to 8$, etc. since the angle of a complex number doubles when the complex number is squared (see Section 19.3). But on this clock 8'oclock $\equiv 1$ o'clock and $4 \equiv -3$ and since we are only considering the real part of z, $-3 \equiv 3$. In fact, for Transformation (23.2), $-k \equiv k$ on any clock with n numbers for n odd. Therefore, this map exhibits a cycle of length three corresponding to k values:

$$1 \to 2 \to 3 \to 1. \tag{23.3}$$

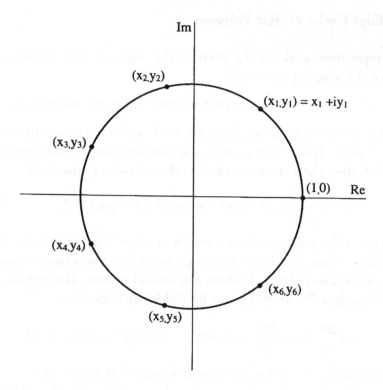

Figure 23.1 A cyclotomic 7-gon with unit radius and vertices located at the roots of unity.

In a similar manner, Transformation (23.3) will have its own characteristic cycle for every cyclotomic n-gon for n odd. The same cycle holds if the terms in Transformation 23.2 are doubled to yield,

$$2\operatorname{Re} z \mapsto 2\operatorname{Re} z^2. \tag{23.4}$$

Now consider $2\operatorname{Re} z = 2\cos\frac{2\pi k}{n}$ for $k = 1, 2, 3, \ldots$, and n odd. It can be shown that for arbitrary k-values, there is a j-value such that

$$2\cos\frac{2\pi k}{n} = 2\sin\frac{\pi j}{2n} \quad \text{for } 4k + j = n. \tag{23.5a}$$

Recall from Section 22.5 that each star $2n$-gon for $2n$ and j relatively prime (i.e., even values of j do not represent star $2n$-gons) is represented by the symbol $\left\{\frac{2n}{j}\right\}$ for $j > 0$ and $\left\{\frac{2n}{2n+j}\right\}$ for $j < 0$. The length of the edges (or

diagonals) of each of these star polygons were shown in Section 22.6 to be $2\sin\frac{\pi j}{2n}$ units. Therefore twice the real part of the roots of the nth cyclotomic polynomial are edge lengths of the family of star polygons associated with the $2n$-gon with unit radius.

As a result, applying (23.5b) to Sequence (23.3) of k values, yields the sequence of j values and star 14-gon edges:

$$3 \to -1 \to -5 \to 3 \tag{23.6a}$$

and

$$\left\{\frac{14}{3}\right\} \to \left\{\frac{14}{13}\right\} \to \left\{\frac{14}{9}\right\} \to \left\{\frac{14}{3}\right\}. \tag{23.6b}$$

We now apply this result to chaos theory.

23.3 The Relationship between Polygons and Chaos for the Cyclotomic 7-gon

Consider the Lucas polynomials of Table 22.5 with alternating signs. It can be shown that the entire sequence of Lucas polynomials $L_m(x)$ has the property,

$$L_m(2\cos\theta) = 2\cos m\theta. \tag{23.7}$$

As a result of this equation and Equation (23.1) the Lucas polynomials map edges of star $2n$-gons one to another.

Notice that the polynomial $L_2(x) = x^2 - 2$, represents the logistic equation, described in Section 19.3,

$$x \mapsto x^2 + c \tag{23.8}$$

when c is set equal to -2, i.e.,

$$x \mapsto x^2 - 2. \tag{23.9}$$

The notation of Equation (23.9) means that beginning with a seed value x_0 and placing it in the equation maps it to the value x_1, then x_1 maps to x_2, etc., i.e., $x_0 \to x_1, x_1 \to x_2, x_2 \to x_3, \ldots$. The sequence x_0, x_1, x_2, \ldots is

referred to as the trajectory of the map. If $x_n = x_0$, the trajectory repeats and is said to be an n-cycle.

As we saw, $c = -2$ corresponds to the extreme left-most point on the real axis of the Mandelbrot set (see Figure 19.5). This map is a transformed version of the logistic map,

$$x \mapsto \lambda x(1-x) \quad \text{for } \lambda = 4 \tag{23.11}$$

which has been studied in great detail (cf. [Pei], [Schr]). The fact that $c = -2$ in Equation (23.9), means that this map is in a state of chaos. It can be shown that for values of $0 \le \lambda \le 4$ (or $-2 \le c \le \frac{1}{4}$) all points on the unit interval are "imprisoned" in the sense that their trajectories remain in the unit interval $[0,1]$ for Equation (23.11) or for values of c corresponding to λ in Equation (11a), the trajectories remain on the interval $\left[\frac{-\lambda}{2}, \frac{\lambda}{2}\right]$. However, beginning at $\lambda = 4$ (or $c = -2$), orbits can escape; in fact the only imprisoned orbits lie on a Cantor set within the unit interval $[0,1]$. For any complex value of c, the boundary in the complex plane of the prisoner set is what is called the Julia set. Therefore, the Julia sets for real values $\frac{1}{4} \le c \le -2$ are what we refer to as "Cantor dusts".

The theory of dynamical system shows that as λ is increased to the *Feigenbaum limit* 3.569... the trajectories of the system go through period doubling bifurcations, i.e., cycles of length $2n$ for $n = 1, 2, 3,...$ (see Section 17.2). At the value 3.831... a trajectory with a cycle of length 3 appears, after which periods of every length are present according to the theorem of Sharkovskii. As a result of our analysis when λ is further increased to a value of 4, or alternatively c is decreased to $c = -2$, the cycles can be characterized as edges of star $2n$-gons for n odd in which each value of n has its own characteristic cycle length. Therefore, in a sense, the edges can be thought to dance about on the grains of a Cantor dust as I shall now demonstrate.

23.4 Polygons and Chaos for the 7-cyclotomic Polygon

Take $x_0 = 2\cos\frac{2\pi}{7}$ as the seed in the logistic map (23.9). As a result of Equation (23.7) for $m = 2$, Transformation (23.9) is identical to Transformation (23.4) and yields identical results. We find that just as for

Transformation (23.4), the iterates are the sequence of edge lengths of different species of star 14-gons corresponding to $2\cos\frac{2\pi k}{7}$ for,

$$k \equiv 1, 2, 4, 8,\ldots \ (\text{mod } 7). \tag{23.12}$$

Since $8 \equiv 1$ (mod 7) the sequence repeats with the 3-cycle,

$$x_0 \to x_1 \to x_2 \to x_0,$$

or

$$2\cos\frac{2\pi}{7} = 1.2469\ldots \to 2\cos\frac{4\pi}{7} = -0.44509\ldots \to 2\cos\frac{8\pi}{7}$$

$$= -1.80189\ldots \to 2\cos\frac{16\pi}{7} = 1.2469\ldots.$$

Appendix 23.A describes the system of modular arithmetic.

As a result of the fact that $\cos\frac{2\pi(n-k)}{n} = \cos\frac{2\pi k}{7}$, values of the edge lengths corresponding to k and $-k$ are identical. Therefore $4 \equiv -3$ (mod 7) which corresponds in Sequence (23.12) to $k = 3$, and so the 3-cycle is represented by the k-values $1 \to 2 \to 3 \to 1$ in Table 3 corresponding to the cycles of j-values: $3 \to -1 \to -5 \to 3$ which in turn correspond to the sequence of star $2n$-gons: $\left\{\frac{14}{3}\right\} \to \left\{\frac{14}{13}\right\} \to \left\{\frac{14}{9}\right\} \to \left\{\frac{14}{3}\right\}$.

If the vertices of the 14-gon are numbered from 0 to 13 then a sequence of edges can be associated with these star $2n$-gons as shown in Figure 23.2. The cycle of edges extend from vertex number 0 of the 14-gon to the darkened vertices: $3 \to 13 \to 9 \to 3$. The *orders* of the edges in the cycles are also indicated in Table 3, beginning with the seed $i = 0$ and in Figure 23.2 by the boxed integers. Notice the regular skip pattern of highlighted vertices: 4, 4, 6. This pattern holds for all cycles for which n is an odd prime number as proven in Appendix 23.B. Also note that for each edge cycle, its mirror image, illustrated in Figure 23.2 by open vertices within the $2n$-gon, is also a cycle, i.e., $11 \to 1 \to 5 \to 11\ldots$ is another 3-cycle of edges for the cyclotomic 7-gon. Each edge cycle of a cyclotomic n-gon will have a corresponding mirror image cycle. Finally, Adamson has discovered that the product of the cycle values equals -1, e.g.,

$$(1.2469\ldots)(-0.44509\ldots)(1.80189\ldots) = -1,$$

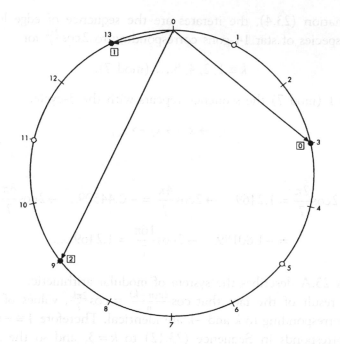

Figure 23.2 The edge-lengths from vertex 0 to vertex k (closed circles) of the star 14-gon, $\left[\frac{14}{k}\right]$ are elements of the 3-cycle of the logistic equation related to the 14-gon. The number in the square boxes are the order of the points in the 3-cycle. The open circles represent the edges of a mirror image 3-cycle.

and that the product of edges within any cycle will always equal ±1 for the logistic equation, a result that can be proven from a dynamic/number theoretic description.

The results of applying this procedure to the cyclotomic 11- and 13-gons are shown in Table 23.1 and Figure 23.3. The cyclotomic 11-gon results in a 5-cycle of edges of the star 22-gon family while the cyclotomic 13-gon results in a 6-cycle within a 26-gon. Once again, the edges of various species of star 22 and 26-gons are the line segments (not shown) drawn from vertex 0 to the vertex denoted by the appropriate darkened circle and with sequence numbers indicated by the boxed numerals. A second mirror image sequence is denoted by the open circles for the 22-gon.

Table 23.1 Cycles for the logistic equation corresponding to cyclotomic polygons.

Cyclotomic 7-gon

k	$2\cos\frac{2\pi k}{7}$	$2\sin\frac{\pi j}{14}$	$\left\{\frac{14}{j}\right\}$ or $\left\{\frac{14}{14+j}\right\}$	Order i
1	1.24696...	3	3	0
2	0.44509...	−1	13	1
3	1.80189...	−5	9	2

Cyclotomic 11-gon

K	$2\cos\frac{2\pi k}{11}$	$2\sin\frac{\pi j}{22}$	$\left\{\frac{22}{j}\right\}$ or $\left\{\frac{22}{22+j}\right\}$	Order I
1	1.68250...	7	7	0
2	0.83082...	3	3	1
3	−0.28462...	−1	21	3
4	−1.30972...	−5	17	2
5	−1.91898...	−9	13	4

Cyclotomic 13-gon

k	$2\cos\frac{2\pi k}{13}$	$2\sin\frac{\pi j}{26}$	$\left\{\frac{26}{j}\right\}$ or $\left\{\frac{26}{26+j}\right\}$	Order i
1	1.77090...	9	9	0
2	1.13612...	5	5	1
3	0.24107...	1	1	4
4	−0.70920...	−3	23	2
5	−1.49702...	−7	19	3
6	−1.94188...	−11	15	4

The equal-tempered chromatic scale can be represented by a tone circle with 12 tones to the octave, or a 12-gon with each tone equidistant from the next by a semitone. Since a 24-sided polygon can be thought of as a tone circle in which each tone represents the interval of a quarter-tone, the 5- and 6-cycles of the cyclotomic 11- and 13-gon, along with their symmetric opposites can be viewed as tonal subsets of almost quarter-tone chromatic scales, one with tones slightly greater than quarter-tones and the other with tones slightly less.

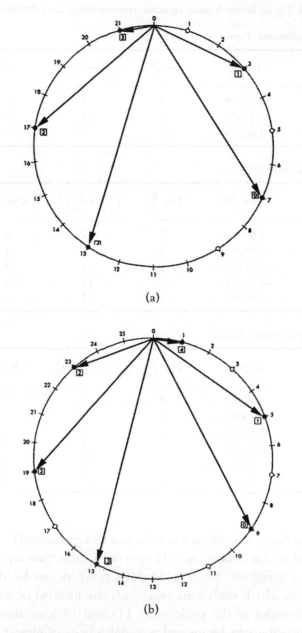

(a)

(b)

Figure 23.3 The edge-lengths from vertex 0 to vertex k (closed circles) represent the (a) 5-cycle of the 22-gon; and (b) the 6-cycle of the 26-gon.

23.5 Polygons and Chaos for Generalized Logistic Equations

We have demonstrated that, for the cyclotomic 7-gon, a sequence of selected edges of a regular 14-gon corresponds to a 3-cycle of the logistic equation. We have gone further and shown that any cyclotomic n-gon for n-odd corresponds to one or more cycles of edge lengths of a $2n$-gon and that each value of $2\cos\frac{2\pi k}{n}$ for $k = 1, 2, \ldots, \frac{n-1}{2}$ for k relatively prime to n occurs in one of the cycles. As a result, an edge of a star $2n$-gon maps to the edge of another star $2n$-gon.

Also, what we discovered for the second Lucas polynomial, holds true for all of the other Lucas polynomials from Table 22.5. For example, the third Lucas polynomial L_3 with alternating signs leads to the recursive map,

$$x \mapsto x^3 - 3x.$$

With $m = 3$, taking the seed $x_0 = 2\cos\frac{2\pi}{n}$ for odd n, results in the sequence $\{2\cos\frac{2\pi k}{n}\}$ where this time $k = 1, 3, 9, 27, 81, \ldots$ (mod n), i.e., 3^k (mod n) for $k = 0, 1, 2, 3, \ldots, p - 1$. The sequence is based on powers of 3 since we are using the 3rd Lucas polynomial. This generalizes to the mth Lucas polynomial L_m with alternating signs in which case the iterates correspond to k-values that are powers of m. Presumably, these polynomial maps are also related to dynamical systems in a state of chaos.

We have also proven that the cycle length corresponding to any cyclotomic n-gon for n prime or the power of a prime is equal to the smallest exponent p such that

$$(m^2)^p \equiv 1(\text{mod } n). \tag{23.13}$$

Where m is the index of the mth Lucas polynomial. Equation (23.13) is a sufficient condition for a cycle for any odd n. However, each such case must be checked. Values of p are listed in Table 23.2 for values of $n = 7, 9, 11, 13, 17$ and $m = 2, 3, 4, 5$.

From this table we see that the cyclotomic 7-gon has a 3-cycle for $m = 2, 3, 4$, and 5 as described above for $m = 2$. The 11-gon has a 5-cycle for Lucas maps $m = 2, 3, 4$, and 5. The trajectory values correspond to $2\cos\frac{2\pi k}{11}$ for $k = 1, 2, 3, 4, 5 = \frac{11-1}{2}$ and the results are shown in Figure 23.3 for the case of $m = 2$. Notice that the 9-gon has only a 3-cycle corresponding to $2\cos\frac{2\pi k}{n}$ for $k = 1, 2, 4 = \frac{9-1}{2}$ with $k = 3$ missing since 3 and 9 are not

Table 23.2 Exponents p such that $(m^2)^p = 1 \pmod{n}$.

m^2	$n = 7$	$n = 9$	$n = 11$	$n = 13$	$n = 15$	$N = 17$
4	3	3	5	6	4	4
9	3	...	5	3	...	8
16	3	3	5	3	2	2
25	3	3	5	2	...	8

relatively prime as can be seen in Table 23.2. Note that the cyclotomic 17-gon has only a 4-cycle corresponding to $2\cos\frac{2\pi k}{n}$ for $k = 1, 2, 4, 8, 16, \ldots$ (mod 17) since 16 (mod 17) $= -1$ which is equivalent to $k = 1$. However there is a second 4-cycle corresponding to $k = 3, 6, 12, 24, 48, \ldots$ (mod 17) since 48 (mod 17) $= -3$ which is equivalent to $k = 3$, the seed value of the trajectory. In general, the period corresponding to an odd valued cyclotomic n-gon for any generalized Lucas trajectory is a factor of the number of integers and relatively prime to n. Therefore since eight integers less than or equal to 8 are relatively prime to 17 (i.e., 1, 2, 3, 4, 5, 6, 7, 8), the cycle lengths can have values 2, 4, or 8 which are observed in Table 23.2.

23.6 New Mandelbrot and Julia Sets

Each of the Lucas polynomials has new "Mandelbrot" and "Julia" sets associated with it defined by the dynamical map:

$$z \to L_m(c, z)$$

where $L_m(c, z)$ is generated by the same recursion relation that generated the Lucas polynomials with alternating signs in Table 22.5, i.e.,

$$-c, x, x(x) + c = x^2 + c,$$
$$x(x^2 + c) - x = x^3 + x(c - 1),$$
$$x(x^3 + x(c - 1)) - (x^2 + c) = x^4 + (c - 2)x^2 - c, \text{ etc.}$$

When $c = -2$, these polynomials result in the Lucas polynomials with alternating signs.

Fig. 23.4 Generalized Mandelbrot set for $m = 6$.

Fig. 23.5 A new Julia set for $m = 3$ and a value of $c = 0.1683 + 0.7543i$.

Figure 23.4 illustrates the new "Mandelbrot set" for $m = 6$ while Figure 23.5 shows one of the new Julia sets for $m = 3$ and a value of $c = 0.1683 + 0.7543i$. These were created by Javier Barrallo [Baro]. Additional generalized Mandelbrot and Julia sets can be found on the cover of the book.

23.7 Chaos and Number

There is an intimate relationship between chaos theory and number. We have shown that properties of number also lie at the basis of the polygon cycles. Let us once again consider the 2nd Lucas polynomial map. Expanding $\frac{1}{7}$ in the base 4 (the square of 2), $\frac{1}{7} = 0.021021021... = 0.\overline{021}$, a repeating decimal with a 3-cycle. Likewise $\frac{1}{11} = 0.\,0.\overline{01131}$ expanded in base 4, a 5-cycle (see Appendix 23.B). Our conjecture is that for n odd, $\frac{1}{n}$ expanded in base 4, has the identical cycle length as the cyclotomic n-gons analyzed in the previous section. Furthermore, the identical cycle lengths occur for $\frac{1}{n}$ in base 9, 16, 25 or any base m^2 as for the cycle lengths of cyclotomic n-gons corresponding to the mth Lucas polynomial maps as shown in Table 23.2. The validity of this claim and other parts of this analysis were computer checked by Malcolm Lichtenstein [Lic].

23.8 Conclusion

Many things have come together in this chapter. We have shown the close relationship between chaos and number. The well known theorem of Sharkovskii predicts that once a period 3-cycle appears in a dynamical system, periods of all lengths occur. We have shown that at the critical point of the Mandelbrot set where orbits of the logistic equation begin to escape, each of these periods can be characterized by a sequence of edge lengths of a family of star $2n$-gons for odd n. Coxeter has shown star polygons to be related to the two-dimensional projections of higher-dimensional polyhedra or polytopes (see Figures 6.9e and 6.19) [Cox3]. Geometry has shown itself once again to be the rich well-spring of mathematics. Rather than jettisoning these roots, the theory of dynamical systems and chaos has strongly embraced them.

Each of these star polygons can be looked at as a tone circle with the cycles represented by tones from the "octave". In particular, the 5-cycle from the 22-gon and 6-cycle of the 26-gon are promising candidates for new musical scales. After all, the chromatic scale was built from the circle of fifths related to the $\left\{\frac{12}{5}\right\}$ star 12-gon (Chapter 3). Star polygons were expressions of balance and symmetry in such sacred symbols as the Hindu

Sri Yantra and the Hebrew star of David (Chapter 3), they were keys to Anne Macaulay's analysis of the Megalithic stone circles (Chapter 11), the ancient Roman theory of proportions (Chapter 7), Stan Tenen's enneagram diagram organizing the Hebrew letters (Chapter 12), and some of Ben Nicholson's reconstructions of the Laurentian pavements (Chapter 10). Recent scientific developments have shown that certain supercooled gaseous condensates known as Bose–Einstein Condensates (BECs) form huge vortices that self-organize in polygonal forms [Col]. In the next chapter star polygons will be shown to be a structure underlying the growth of plants.

Appendix 23.A

Modular arithmetic can be thought to be a kind of "clock" arithmetic. For example, on the mod 12 clock, twelve numbers are equally spaced on the circumference of a circle as on an actual clock. The position on the clock at "noon" is given the value of 0. However, it can also be considered to have the value 12, 24, 36, etc. We use the notation $0 \equiv 12 \equiv 24 \equiv 36$ (mod 12), etc. to signify the values on the clock corresponding to "noon". Similarly, 1 o'clock can also be thought of as 13, 25, 37,.... Therefore $1 \equiv 13$ (mod 12), etc. Eleven o'clock can be taken to be 23, 35, or -1 going counter-clockwise from 0, i.e., $-1 \equiv 11 \equiv 23$ (mod 12). The values $0, 1, 2, \ldots, 11$ seen on the face of the clock are called its principal values.

For any integer, n, its principal value can be determined as the remainder when n is divided by the clock value, e.g., $2 \equiv 38$ (mod 12) since 38, when divided by 12, leaves a remainder of 2. Two numbers are defined to be equivalent to each other on the mod m clock whenever the numbers differ from each other by a multiple of m. For example, $-3, 2$, and 12 are all equivalent on a mod 5 clock since they differ from each other by multiples of 5. As a result of this equivalence, the integers on the mod m clock are partitioned into m different classes, with numbers in each class differing by multiples of m. As a result of its definition, mod is a symmetric relationship, i.e., if $a \equiv b$ (mod m) then $b \equiv a$ (mod m).

We can expand the notion of mod beyond integers and consider the equivalence classes of all real numbers. Any pair of numbers are considered to be in the same equivalence class if they differ by an integer. Clearly, the

integers are the class corresponding to 0. Each real number $0 \leq x < 1$ is a representative of its own class. These can be considered to be the principal values of a mod 1 system. In other words, $r \pmod 1$ is the fractional part of r when r is expressed as a decimal.

Appendix 23.B

Theorem 23.B1 *If n is an odd prime number then the trace of the trajectory on the 2n-gon intercepts every fourth vertex and one spacing of 6 vertices.*

Proof. For n an odd prime number, successive vertices of the trace of the trajectory on the $2n$-gon correspond to the k-values: $1,2,3,\ldots,\frac{n-1}{2},1,2,\ldots$. Successive j values follow from Equation (23.5b),

$$j = (-4k + n) \bmod 2n.$$

The difference $\Delta j = j_{k+1} - j_k$ of successive j values corresponding to successive values of Δk is determined from,

$$\Delta j = -4 \Delta k \bmod 2n \qquad\qquad (23.B1)$$

where Δj refers to the principal value. From Equation (23.B1), $\Delta j = 4$ for $\Delta k = -1$ and $\Delta j = (6 - 2n) \bmod 2n = 6$ for $\Delta k = \frac{n-1}{2} - 1 = \frac{n-3}{2}$. For example, referring to Table 23.1 for an 11-cyclotomic polynomial, the k-values and their corresponding j are,

$$k: 1, 2, 3, 4, 5, 1, 2,\ldots;$$
$$j: 7, 3, -1, -5, -9, 7.$$

which equals the following trace on the mod 22 clock,

$$7, 3, 21, 17, 13, 7.$$

The spacings between these values are seen to be the sequence: 4, 4, 4, 4, 6.

Appendix 23.C

A decimal in base 10 can be written in any other base by the following procedure illustrated for converting $\frac{1}{7} = 0.\overline{142857}$ in base 10 to the base 4.

1. Multiply the decimal in base 10 by 4 and record a 0 if the result is less than 1, otherwise record the integer part. For example, $0.\overline{142857} \times 4 = 0.57148...$ so record a 0 as the 1st in the first decimal place.
2. Multiply the result again by 4 to get $2.2857142...$ and record a 2 as the 2nd decimal place.
3. Multiply the decimal part of the preceding number by 4 to get: $1.1428568...$ and record a 1 as the 3rd decimal place.
4. Again multiply the decimal part of the preceding number by 4, but since the decimal part repeats we have the repeating decimal in base 4: $0.\overline{021}$

In general, consider the rational fraction $\frac{1}{n} = a_0$ where a_0 is the decimal expansion of $\frac{1}{n}$ in base 10. Its decimal expansion in base m is then: $0.b_1 b_2 b_3...$ where $b_n =$ the integer part of: $a_{n-1} \times 4 \pmod 1$ for $n = 1, 2, 3,...$ (see Appendix 23.A for an explanation of mod 1).

24
Growth of Plants: A Study in Number

> Who or What runs the Universe? Is there a plan behind the daisy,
> the hummingbird, the whale, the world?
>
> *Guy Murchie*

24.1 Introduction

Many scientists and keen observers of nature such as the the architect
Le Corbusier and the composer Bela Bartok have observed the elaborate
spiral patterns of *stalks*, or *parastiches*, as they are called, on the surface of
pine cones, sunflowers, pineapples, and other plants. It was inevitable that
the symmetry and order of plants so evident to the observer and so evocative
of sentiment to the artist and poet should become a source of mathematical
investigation.

Irving Adler, a pioneer in modern theories of plant growth, has studied
the history of this subject [Adl2]. Adler has traced the very general observa-
tions of the regular spacing of leaves as far back as Theophrastus (370 B.C.–
285 B.C.) and Pliny (25 A.D.–79 A.D.). Leonardo Da Vinci (1452–1519)
observed the spiral patterns of plants, while Johannes Kepler (1571–1630)
conjectured that Fibonacci numbers were somehow involved in the struc-
ture and growth of plants. The first detailed study of the regular intervals
at which leaves or florets are placed around the base of a plant was made
by Schimper (1836). He observed that after some number of complete turns
around the stem of a plant, another leaf lies almost directly above the first.
He gave the name *divergence angle* to the number of intervals divided by
the number of leaves in the cycle. Schimper observed that this divergence
angle was, generally, equal to the ratio of two Fibonacci numbers. The

Bravais brothers (1937) first discovered that the angle between successive stalks, the divergence angle, is in most plants $\frac{2\pi}{\tau^2}$ radians or 137.5 degrees cf. ([Jea1,2,3], [Eri], [Cox1], where $\tau = \frac{1+\sqrt{5}}{2}$, the golden mean. It was also recognized by P.G. Tait that plant stalks were arranged on logarithmic spirals. In a sense, the path curves of Lawrence Edwards (see Section 2.7 and Figure 2.18) can be thought of as generalizations of these spirals.

When laid down with this angle, each stalk is an element of two or three *logarithmic spirals*, one from each of two or three sets, and the numbers of spirals in these sets are successive numbers from the Fibonacci series (F-series) 1, 1, 2, 3, 5, 8,... . This plant growth is often referred to as *normal phyllotaxis*. It has also been observed that in some plants the total number of spirals is composed of successive numbers of other Fibonacci series such as the Lucas series, 1, 3, 4, 7, 11,..., with correspondingly different divergence angles referred to as *abnormal phyllotaxis*. The observed angles all come from the class of *noble numbers* given in Section 14.4.14. The function of the golden mean is to space florets in such a manner that each floret has "the most room" [Mar-K], and nature has chosen a hierarchy of ways in which to implement this demand of plants for space.

This chapter will explore the relationship between number and phyllotaxis. The Farey series and continued fractions (see Section 14.4.15) will be related to a hierarchy of phyllotaxis numbers. Three models of plant growth introduced by Coxeter [Cox1,2], Van Iterson [VanI] and N. Rivier [NOL] will be described. Spacing properties of florets will be related to the golden mean. A simplified model of phyllotaxis, due to Adamson and Kappraff, will be described, showing the relationship of this subject to dynamical systems on a torus.

To this day, the physical processes involved in phyllotaxis are a mystery. In this chapter we ignore physical processes, and give only fleeting reference to the geometry of plant growth, in order to underscore the number theoretic relationships that lie at the basis of this subject.

24.2 Three Models of Plant Growth

The stalks, or florets of a plant lie along two nearly orthogonal intersecting spirals, one clockwise and the other counterclockwise. The numbers of

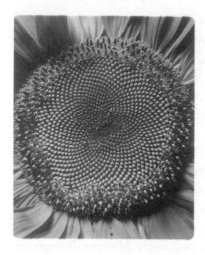

Figure 24.1 A sunflower exhibiting two sets of logarithmic spirals on its surface.

counterclockwise and clockwise spirals on the surface of the plants are generally successive numbers from the F-sequence. These successive numbers are called the *phyllotaxis numbers* of the plant. For example, there are 55 clockwise and 89 counterclockwise spirals lying on the surface of some sunflowers (see Figure 24.1); thus sunflowers are said to exhibit 55, 89-phyllotaxis. On the other hand, pineapples are examples of 5, 8-phyllotaxis (although since 13 counterclockwise spirals are also evident on the surface of a pineapple, it is sometimes referred to as 5, 8, 13-phyllotaxis). Three equivalent phyllotaxis models will be described. Each makes use of the fact that florets are arranged so as to "have the most space".

24.2.1 *Coxeter's model*

In Figure 24.2, H.S.M. Coxeter transforms the pineapple to a semi-infinite cylinder which has been opened up to form a period strip (meaning that the left and right sides of the rectangle are identified). Notice the three families of spirals. Also notice that the stalks are labeled chronologically, according to the order in which they appear in the growth process. The center of each stalk makes up a lattice of points which are successively numbered along another *generative spiral*. Each stalk is defined as the set of points nearer to that lattice point than any of the other centers, what in mathematics is

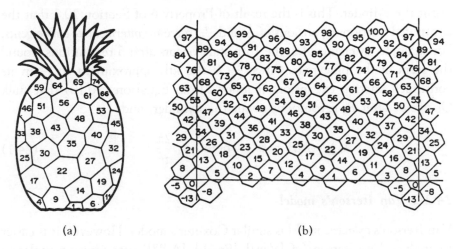

(a) (b)

Figure 24.2 A pineapple transformed to a semi-infinite cylinder by H.S.M. Coxeter.

known as a *Dirichlet domain* (*D-Domain*). In general, the Dirichlet domains of a lattice are hexagons, although at certain critical points they may be rectangles. Since the 5th, 8th, and 13th stalk (hexagon) border the initial stalk (labeled 0), this diagram represents 5, 8, 13-phyllotaxis. In the most prevalent form of phyllotaxis, the center of each stalk occurs at an angle, $\lambda = \frac{2\pi}{\tau^2}$ radians or 137.5 degrees displaced from the preceding one where λ is the *divergence angle*. Other forms of phyllotaxis have been observed with anomalous angles related to other *noble numbers* as described in Section 14.4.14.

The lattice points also rise as if moving along a slightly inclined ramp by an amount called the *pitch*. If the pitch is less steep, then larger numbered stalks will border the initial stalk giving rise to larger phyllotaxis numbers. Notice that a sequence of stalks alternates on either side of the initial stalk numbered by Q_k from the Fibonacci series. This is a consequence of the properties, described in (14.4.13), of the convergents $\frac{P_k}{Q_k}$,

$$\frac{1}{3}, \frac{2}{5}, \frac{3}{8}, \frac{5}{13}, \ldots$$

of the continued fraction expansion of $\frac{1}{\tau^2}$. The next closest approach to the zero point occurs after the entire sequence has rotated P_k times

about the cylinder. This is the result of Property 6 of Section 20.3 that the continued fraction expansions of $\frac{1}{\tau}$ and $\frac{1}{\tau^2}$ have no *intermediate convergents*. For example, in Figure 24.2, the 13th stalk occurs after 5 revolutions around the stem of the pineapple. Since $\frac{P_k}{Q_k}$ is the kth approximant to $\frac{1}{\tau^2}$ in its continued fraction expansion, it follows from Equation (20.10) that stalk Q_k occurs after P_k revolutions about the cylinder, and

$$\lambda Q_k - 2\pi P_k \approx 0 \quad \text{where } \lambda = \frac{2\pi}{\tau^2}. \tag{24.1}$$

24.2.2 Van Iterson's model

Van Iterson's *cylindric model* is similar Coxeter's model. However, it is easier to analyze. Van Iterson (cf. [VanI], [Pru-L], [Adl2]) uses tangent circles to model the florets as shown in Figure 24.3 for m, n-phyllotaxis. A clockwise spiral rises from the origin in increments of m florets while a counterclockwise spiral rises in increments of n florets, both spirals intersecting at the mnth floret. Also floret numbers m and n are both tangent to the initial floret labeled, 0. Figure 24.4 illustrates this for $2, 3, 5$-, $3, 5$-, $3, 5, 8$-, and $5, 8$-phyllotaxis. Notice in Figure 24.4a that for for $2, 3, 5$-phyllotaxis, floret number 2, 3, and 5 are tangent to the initial floret, 0. As the floret diameter d decreases, the lattice undergoes a transformation from one set of phyllotaxis numbers to another. As shown in Figure 24.4, and on the phyllotaxis tree of Figure 24.5, $2, 3, 5$-phyllotaxis is a transition point at which the $2, 3$-branch of the phyllotaxis tree bifurcates to $2, 5$- and $3, 5$-phyllotaxis. The divergence angles at general transition points, $m, n, m + n$-phyllotaxis are shown in Figure 24.5. At a transition point each circle is tangent to six circles in a close-packed arrangement. Also angle $\gamma + \beta$ in Figure 24.4 becomes 120 degrees, and a third spiral becomes evident as shown in Figures 24.4a and 24.4c.

 Van Iterson used his model to compute the pitch h, measured as the distance between any two successive lattice points, the divergence angle λ, and the phyllotaxis numbers m,n. He then determined the relationship between these quantities, illustrated by the phyllotaxis tree in Figure 24.5. The positions of the vertices are slightly altered from Figure 14.2, and located at angles equal to numbers from the infinite Farey tree (see

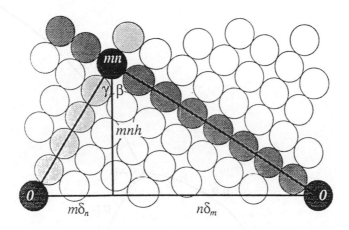

Figure 24.3 An opposite parastichy triangle (as in Erickson [1983]). The base is formed by the circumference of the cylinder. The sides are formed by the parastichies.

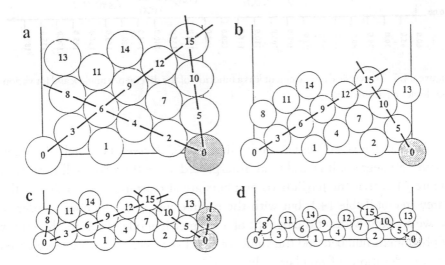

Figure 24.4 Patterns of tangent circles drawn on the surface of a cylinder as a function of circle diameter.

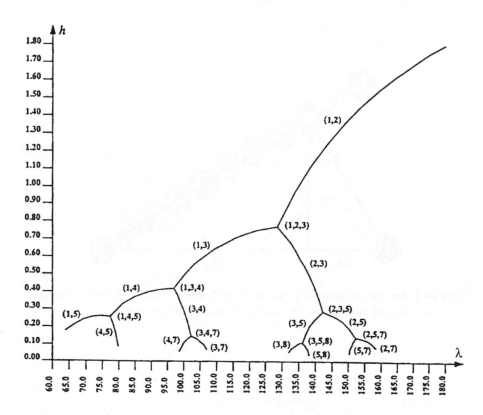

Figure 24.5 The vertical displacement h as a function of the divergence angle λ and for various phyllotactic patterns (m, n).

Table 14.1) between 0 and $\frac{1}{2}$ multiplied by 360 degrees, i.e., angles between 0 and 180 degrees. If m and n are interpreted as $\frac{m}{n}$ then you will notice, in Figure 24.5, that the phyllotaxis numbers are also arranged according to the Farey tree of Table 14.1, but with the numbering of its branches reordered. So we see that without the benefit of a geometric model, both the hierarchy of phyllotaxis numbers and the values of the divergence angles are represented by considerations of number only [Kap7].

Figures 24.5 and 14.2 also show that any pair of phyllotaxis numbers is consistent with a limited range of divergence angles, the angles between the transition points at both ends of the appropriate branch of the phyllotaxis tree. For example, in Figure 24.5, 2, 3-phyllotaxis is consistent with angles

between 128.5 degrees and 142.1 degrees or, correspondingly in Figure 14.2, to angles between 120 degrees and 144 degrees Also the diameter of the floret circle d decreases for higher phyllotaxis angles. Furthermore h and d at the bifurcation points can be uniquely determined from the phyllotaxis numbers m,n by simple geometry [Pru-L].

Any relatively prime pair of integers can serve as phyllotaxis numbers, and all such possibilities are arranged in the Farey tree depicted in Figures 24.5 and 14.2. Each branch in Figure 24.5 corresponds to a pair of phyllotaxis angles gotten by zigzagging left–right or right–left down the tree from that branch according to the sequence LRLRLR... or RLRLRL.... These phyllotaxis angles correspond to the noble numbers described in Section 14.4.15. Further details are found in [Kap7].

24.2.3 Rivier model

N. Rivier, *et al.* (1984) have developed a model of phyllotaxis on a *circular disc*. They define the stalks as the *D-Domains* of a sequence of computer-generated growth centers given by the algorithm

$$r(l) = a\sqrt{l}, \quad \theta(l) = 2\pi\lambda l$$

where r and θ are the polar coordinates of the disc, l labels individual cells, λ is the divergence angle, and "a" is the typical cell's linear dimension. Figure 24.6a shows the results of a growth process with divergence angle $\lambda = \frac{13}{21}$, a close Fibonacci approximation to $\frac{1}{\tau}$. Contrast its spider web appearance with the plant-like appearance of Figure 24.6b which has a divergence angle of $\lambda = \frac{1}{\tau}$. Thus, even close rational approximations to are $\frac{1}{\tau}$ are not enough to properly space the florets of a plant, and so the morphology of plants is extremely sensitive to measurements. This goes against our common experience in which there can be no difference between rationals and irrationals since measurements are always in error and there is always a rational number arbitrarily close to any irrational. The dynamics of oscillating systems will be discussed in the next chapter, and they too will be shown to be governed by these subtle differences between rational and irrational numbers beyond the capability of measurement.

Although most of the Dirichlet domains in Figure 24.6b are hexagons, there are concentric rings of D-domains with 5 or 7 sides. Rivier has

(a)

(b)

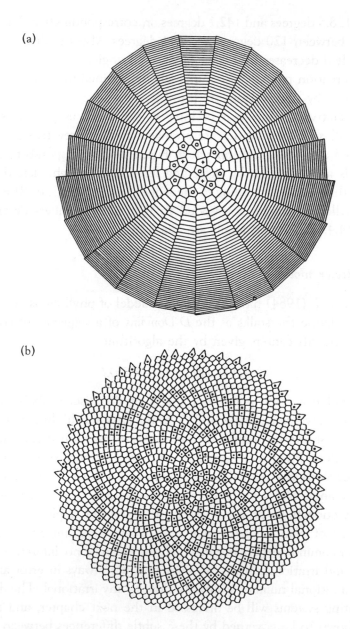

Figure 24.6 (a) A computer generated model of plant phyllotaxis with rational divergence angle $\lambda = \frac{13}{21}$. Note the spider web appearance; (b) irrational divergence angle $\lambda = \frac{1}{\tau}$. Note the daisy-like appearance.

shown that as the radius of the disc increases it can accommodate a greater number of spirals and as a result the phyllotaxis numbers increase across the boundary.

24.3 Optimal Spacing

The question remains as to why divergence angles are related to the golden mean. Wherever numbers or other quantities are to be evenly distributed in space, the golden mean quite naturally makes its appearance (see Appendix 24.A). The following spacing theorem appears to lie at the basis of why the golden mean arises naturally in the growth of plants and other biological organisms.

Theorem 24.3.1. *Let x be any irrational number. If the points* $[x]_f$, $[2x]_f$, $[3x]_f, \ldots, [nx]_f$ *are placed on the line segment* $[0,1]$. *Then the n + 1 resulting line segments have at most three different lengths. Moreover,* $[(n+1)x]_f$ *will fall into one of the largest existing segments* ($[\]_f$ *means "fractional part of"*).

It turns out that segments of various lengths are created and destroyed in a first-in-first-out manner. Of course, some irrational numbers are better than others at spacing intervals evenly. For example, an irrational number that is near 0 or 1 will start out with many small intervals and one large one. The two numbers $\frac{1}{\tau}$ and $\frac{1}{\tau^2}$ lead to the "most uniformly distributed" sequence among all numbers between 0 and 1 [Mar-K]. These numbers section the largest interval into the golden mean ratio $\tau:1$.

Theorem 24.3.1 is illustrated in Figure 24.7a for a sequence of points $\left[\frac{n}{\tau}\right]_f$ for $n = 1$ to 10. This is equivalent to placing the points at angles, $\frac{2\pi n}{\tau^2}$ (mod 2π), for $n = 1$ to 10, around the periphery of a circle as shown in Figure 24.7b. The way in which the intervals, labeled 0 and 1 of the Fibonacci spiral in Figure 20.15a, intersperse themselves, graphically illustrates this behavior. The implications of this spacing property will be explored further in the next section.

If the center of mass of each stalk of a plant is projected onto the base of the period rectangle in the case of Coxeter's and Van Iterson's models, or onto a circle in the case of Rivier's model then the next stalk divides the

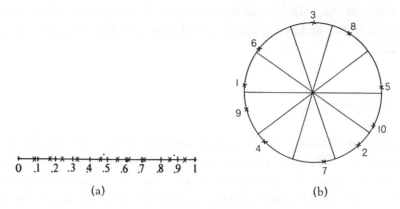

(a) (b)

Figure 24.7 (a) The points $[\frac{n}{\tau}]_f$ for $n = 1, 2, 3,\ldots, 10$ are evenly spaced on the unit interval; (b) the points $\frac{2\pi n}{\tau}$ mod 2π are evenly spaced on the circumference of a circle.

Figure 24.8 The cross section of a celery plant showing successive stalks evenly placed about the periphery.

largest of the three intervals predicted by Theorem 24.3.1 in the golden section. Any other divergence angle would place stalks too near the directions of other stalks, and therefore make the stalks less than optimally spaced. However, the divergence angle $\frac{2\pi}{\tau^2}$ leads to the most uniformly distributed set of stalks. For example, the cross section of a celery plant is illustrated in Figure 24.8. The centers of mass of successive stalks are numbered. If the positions of these centers are projected onto a circle, they are found to closely match the points shown in Figure 24.7b. We see that golden mean divergence angles ensure that successive stalks are inserted at positions on the surface of the plant "where they have the most room".

24.4 The Gears of Life

In order to gain a clearer understanding of how a single number, the golden mean, operates as a coordinator of space in the natural world, consider a very much simplified mathematical model of plant phyllotaxis that nevertheless encompasses its essence. In this model the florets are projected onto a circle. Figure 24.9a shows a number wheel with the numbers 1 through 5 placed on its rim. The numbers are arranged clockwise every 72 deg., i.e., $\frac{360}{5}$ degrees, beginning with 0 = 5 at the apex. In other words the angles around the circle are ordered by the numbers 0 through 5. Begin at the order number 0 and progress clockwise two spaces, or 144 degrees, on the number wheel to reach order number 2 where floret number 1 is laid down, and clockwise two spaces repeatedly to 4, 1, 3, and ending the cycle at 5 = 0 where floret numbers 2, 3, 4, and 5 are deposited. The sequence of moves is indicated by the star pentagon $\left\{\frac{5}{2}\right\}$. Notice that in order to complete a cycle of the five vertices of the star requires a rotation twice around the circle. So we have obtained Adamson's *Primary Phyllotaxis Sequence* (PPS) in the following order:

$$\begin{array}{lllllll} \text{Floret number } y: & 3 & 1 & 4 & 2 & 5 & \qquad (24.2) \\ \text{Order number } x: & 1 & 2 & 3 & 4 & 5 \end{array}$$

The relationship of this wheel to Coxeter's phyllotaxis model in Figure 24.2 is revealed when the floret number is graphed as the y-coordinate and the order number of the angle around the circle as the x-coordinate shown in Figure 24.9b with the floret number listed on the graph.

Figure 24.9b should be visualized as a square in which the bottom and top sides have been *identified*, (meaning that when a point passes through the top edge of the square, it enters the bottom edge; top and bottom are considered to be identical) and the left and right sides have been identified. In other words Figure 24.9b represents a *torus* or rubber tire that has been cut open into a *period rectangle* (see Section 12.4). On a torus one can trace two distinct cycles shown by the two pairs of lines in Figure 24.9b. If each interval on the x-axis corresponds to $\frac{360}{5} = 72$ degrees, then successive floret numbers are, counterclockwise from each other by an angle of $\frac{2}{5} \times 360 = 144$ deg., which is an approximation to the phyllotaxis angle of 137.5 deg. A counterclockwise spiral making two turns on the surface of

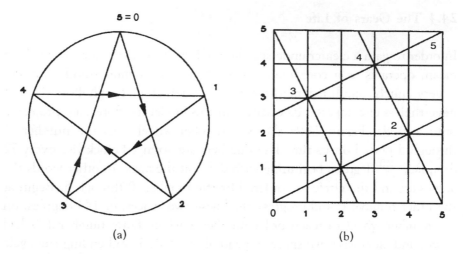

Figure 24.9 (a) A number wheel with the numbers 1 through 5 on the rim. Beginning at 3 and progressing counterclockwise successively 2 units results in Adamson's Primary Phyllotaxis Sequence (PPS) graph for five florets graphed on a period torus in (b).

the torus is shown intersecting florets (1, 3, 5) on the first turn and (2, 4) on the second. A clockwise spiral intersects florets (1, 2) on the first turn and (3, 4, 5) on the second. Therefore, this pair of spirals corresponds to 1, 1-phyllotaxis. No consideration has been given to the pitch of the spiral so that this diagram merely shows the relative ordering of the florets, not their proximity to other florets as in Figure 24.2.

The dynamics of this simplified model of plant phyllotaxis can also be represented by a pair of gears. One gear has two teeth while the other has five (see Section 14.5.1 and Appendix 14.C). The gear with five teeth must have a diameter $\frac{5}{2}$ times the one with two teeth in order to accommodate the greater number of teeth. Five turns of the small gear in a clockwise direction results in two turns of the large gear in a counterclockwise direction. Musically, this is equivalent to two instruments playing with a rhythm in which two beats of one match five beats of the other.

The same dynamics which we have described for a wheel with five numbers can be repeated for a wheel with any Fibonacci number of teeth, for example, the Primary Phyllotaxis Sequence for a wheel with 34 teeth. Begin at point 0 and move 13 spaces at which point floret number 1 is laid

down and then repeatedly progress 13 spaces to successively deposit all 34 florets. One obtains Sequence (24.3) for a wheel with 34 spokes corresponding to the star polygon $\left\{\frac{34}{13}\right\}$, the equivalent of Sequence (24.2) for a wheel with 5 spokes:

$$
\begin{array}{cccccccccccccccccccc}
21 & 8 & 29 & 16 & 3 & 25 & 11 & 32 & 19 & 6 & 27 & 14 & 1 & 24 & 9 & 30 & 17 & 4 & 25 & 12 & 33 \\
1 & 2 & 3 & 4 & 5 & 6 & 7 & 8 & 9 & 10 & 11 & 12 & 13 & 14 & 15 & 16 & 17 & 18 & 19 & 20 & 21 \\
H & L & H & & L & & H & & & L & & & & & & & & & & & H
\end{array}
$$

$$
\begin{array}{cccccccccccccc}
20 & 7 & 28 & 15 & 2 & 25 & 10 & 31 & 18 & 5 & 26 & 13 & 34 = 0 \\
24 & 25 & 25 & 25 & 26 & 27 & 28 & 29 & 30 & 31 & 32 & 33 & 34 \\
& & & & & & & & & & & & L
\end{array}
$$

$$(24.3)$$

The divergence angle between successive florets in a counterclockwise direction is now $\frac{13}{34} \times 360 = 137.54$ degrees, an even closer approximation to the phyllotaxis angle.

The PPS graph on a period torus is shown in Figure 24.10 with a counterclockwise spiral (solid line) making 13 turns on the surface of the torus and, on each successive turn, intersecting points: $(1, 14, 27)$, $(6, 19, 32)$, ..., $(4, 17, 30)$, $(9, 22, 1)$. A second clockwise spiral is shown approximating one that encircles the torus 8 times. The pair of spirals comprise a schematic diagram of 8,13-phyllotaxis. As a warning to the reader, although Figure 24.10 is relatively correct, some of the coordinate points are slightly misplaced.

Notice at the bottom of Figure 24.10 can be found the same relative ordering of the points $1, 2, 3, 4, 5$ that appears in Figure 24.9. In a similar manner, the same relative ordering for the diagrams corresponding to wheels with 8, 13, and 21 numbers can be found in both Figure 24.10 and Primary Phyllotaxis Sequence (24.3). These gears were also shown in Figure 14.5 to be a "kissing" sequence of Ford circles (see Section 14.5.1). This self-similarity, inherent in the growth process, is a manifestation of the self-similarity inherent in the golden mean. A corresponding wheel unrelated to the golden mean would result in an entirely different PPS diagram for each new wheel. So long as $\frac{2\pi}{\tau^2}$ lies in the interval, $\left[\frac{P_k}{Q_k}, \frac{P_{k-1}}{Q_{k-1}}\right]$ or $\left[\frac{P_{k-1}}{Q_{k-1}}, \frac{P_k}{Q_k}\right]$, then the stalks corresponding to the *gear* with Q_k spokes will have the same qualitative ordering. This is an example of a phenomenon called *mode locking*, to be discussed in Section 25.6.

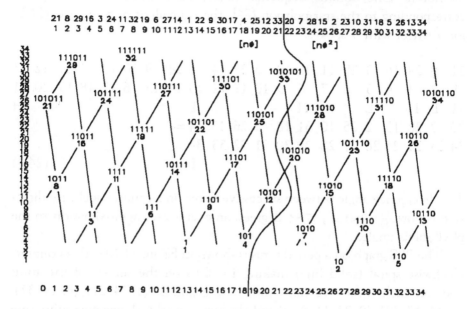

Figure 24.10 The PPS graph on a period torus for 34 florets graphed on a period torus. The line drawn through the figure divides Gray code representations of floret number ending with 1 from those ending with 0.

Other interesting properties of the PPS sequence are:

i. The first 21 floret numbers of this sequence correspond to $\lfloor n\tau \rfloor$ while the last 13 numbers correspond to $\lfloor n\tau^2 \rfloor$, the two classes of Wythoff pairs (see Table 20.1).

ii. Proceeding from left to right, notice that the running high (H) and low (L) values of the floret numbers occur at order numbers corresponding to the Fibonacci numbers. This is a consequence of property 6 of Section 20.3.

iii. If the floret numbers are written in Zeckendorf notation (see Section 20.5), all of the $\lfloor n\tau \rfloor$ end in 1 while the $\lfloor n\tau^2 \rfloor$ end in 0, a fact that was also illustrated by the Wythoff Wheel of Figure 20.13. For that matter, notice that identical sequences of digits in Zeckendorf notation are grouped together, another manifestation of self-similarity.

iv. The rabbit sequence (see Sequence (20.12a)): 101101011011... is replicated by the last digit of the Zeckendorf notation of the floret sequence: 1, 2, 3, 4,.... We shall see in Section 25.4, that this sequence is indicative of chaos.

v. The PPS sequence corresponds to a situation in which the positions of all 34 florets are projected onto the *x*-axis. The differences between adjacent floret numbers of this sequence are 13 21 13 13 21 13..., equivalent to the Rabbit Sequence (20.12a).

The relationship between the numbers of the PPS sequence is summarized on Adamson's Primary Phyllotaxis Wheel shown in Figure 24.11. Here the

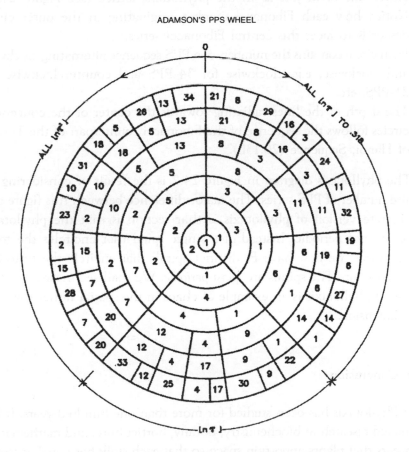

Figure 24.11 Adamson's Primary Phyllotaxis Wheel.

numbers are arranged around a circle. The wheel is identical in structure to Figures 20.12a and 20.13. Notice in the outer circle the same distribution of integers as for the floret numbers of PPS (24.3). Also each successive floret is displaced from the next by the angle $\frac{13}{34} \times 360$ degrees in a clockwise direction, an approximation to the phyllotaxis angle of 137.5 degrees.

Properties of this wheel are:

i. The distribution of numbers around each circle is the most equitable. In fact, the wheel is a discrete replica of the distribution of the numbers $\frac{2\pi n}{\tau^2}$ around the circle in Figure 24.7b.

ii. The Fibonacci numbers descend the central radial line, alternating on either side of it, just as in the phyllotaxis lattice (see Figure 24.2). Notice how each Fibonacci number originating in the outer circle descends to meet this central Fibonacci series.

iii. Each circle contains the numbers of a PPS sequence alternating clockwise and clockwise, e.g. clockwise for 34-PPS and counterclockwise for 21-PPS, etc.

iv. The depth of the lines radiating towards the center of the concentric circles follows the sequence of the Fibonacci counterpart of the Towers of Hanoi, Sequence (20.13b).

The phyllotaxis diagram in Figure 24.2 is the result of considering an infinite number of PPS series. The major difference between this figure and the discrete version of phyllotaxis is that section is that the phyllotaxis spirals are not periodic. Instead of a single spiral that encircles the torus with F_n turns, we now have F_n distinct spirals that encircle the torus but do not close up. The spirals are *quasi-periodic*. We shall see in Section 25.4 that plant phyllotaxis is an example of chaos in the spatial rather than the time dimension.

24.5 Conclusion

Plant Phyllotaxis has been studied for more than one hundred years. It has stimulated research in biochemistry, botany, horticulture, and mathematics. It appears that plants apportion space so that each stalk has equal access to

light and other resources. In order to accomplish this task, plants exhibit an elaborate numerology.

Without the hint of a physical mechanism, or even the artifice of a geometric model, the essentials of the growth process are still manifested through Farey series and continued fractions, Wythoff's game as depicted in Adamson's wheels, and the symbolic dynamics of the rabbit tree and sequence.

Without even the concept of pitch or divergence angle, the Farey sequence reveals the relationship between these quantities in remarkable detail, and it even permits us to compute all possible divergence angles observed on actual plants. Without the concept of a lattice of florets, the primary phyllotaxis system (PPS) reveals the ordering of florets into spiral arrangements. We are led into a Platonic mode of thought in which the concepts of number, existing entirely within the mind, can be seen in the plant world.

Decoupling phyllotaxis from science and geometry suggests that this numerical structure is universal and manifests itself in other biological processes and dynamical systems. For this reason, I have given the PPS the name "gears of life". Can a relationship between phyllotaxis and other biological processes be demonstrated?

In the next chapter, the foundation of number characteristic of phyllotaxis will be seen in other dynamical systems.

Appendix 24.A The Golden Mean and Optimal Spacing

The ability of τ to evenly distribute numbers can be seen by observing the first 103 decimal places of Adamson's Golden Ratio Phyllotaxis Constant (GRPC):

.6284073951740628517395284063951730628417395184062951739
6284073951740628417395284062951730628407395184406...

A first glance might lead you to believe that the sequence .6284073951740... is repetitious, but a closer examination of the number reveals a long-term, non-periodic structure with only local repetitions. Exhibiting the digits as follows reveals interesting Fibonacci properties:

Lengths of sequences beginning with "6":

13 units	Golden Ratio Phyllotaxis
13	Constant arranged in "6"
8	columns.
13	
8 units	Data at left — shows that up to
13	the first 103 digits, the GRPC
13	number can be grouped by
8	Fibonacci number of sequences
13	beginning with 6.

This sequence follows the pattern of the rabbit sequence. As you can easily discover, a similar situation exists for each digit.

How is GRPC computed? To some extent it is analogous to Wythoff's game (see Section 20.5), except that the decimal part of multiples of $\frac{1}{\tau}$ and $\frac{1}{\tau^2}$ are extracted instead of the integer parts. Multiply $\frac{1}{\tau} = 0.618...$ successively by the integers, discard the integer part and extract the first number after the decimal point. This yields the GRPC. For example, $\frac{12}{\tau} = 7.416...$. Therefore the 12th number in GRPC is 4. The complement of GRPC, 0.3715926048, is generated by multiples of $\frac{1}{\tau^2}$, and GRPC and its complement sum to 1.000... just as $\frac{1}{\tau}$ and $\frac{1}{\tau^2}$ do. Some properties of GRPC are:

(1) Differences between each digit are *maximized*: 4, 6, 4, 4, 4, 7, 4, 6....
(2) The number is *transcendental* and has long-range *aperiodicity*.
(3) It is easy to calculate any digit (unlike pi).
(4) It has a long range *equitable distribution* and frequency of each digit 0 through 9: First 103 digits of the GRPC have 11 — 0's, 10 — 1's, 10 — 2's, 10 — 3's, 11 — 4's, 10 — 5's, 10 — 6's, 11 — 7's, 10 — 8's and 10 — 9's.

25
Dynamical Systems

A harmonious universe — like a harp. Rhythms of moon and tide.
One single rhythm in planets, atoms, sea.

Ernesto Cardenal

25.1 Introduction

Plants have a dynamic which transcends the details of each individual plant. In the past two decades a new branch of mathematics has arisen to study the manner in which a dynamical system evolves in time and space. This gives the mathematician and scientist an opportunity to penetrate the secret world of plants and other dynamical systems from the physical or biological world.

This final chapter will introduce the reader to some of the ideas from this new discipline and its applications to the study of quasicrystals, plants, and a special problem of interest to physicists known as the Ising problem. I will pay special attention to the boundary between order and chaos. Once again, number plays a key role.

25.2 Quasicrystals

According to D.R. Nelson [Nel].

"In 1984 investigators working at the National Bureau of Standards found that a rapidly cooled sample of an aluminum-manganese alloy, named Schectmanite after one of its discoverers, seemed to violate one of the oldest and most

539

fundamental theorems of crystallography. Although the material appeared to have the same kind of order that is inherent in a crystal, it also appeared to be symmetrical in ways that are physically impossible for any crystalline substance [Sche]."

Beams of x-rays directed at the material scattered, as if the substance were a crystal with fivefold symmetry, whereas the conventional wisdom of crystallography says that only two-, three-, four-, and six-fold symmetry can occur in crystals. Further investigations into the microstructure of this material have shown that it embodies a new kind of order, neither crystalline nor completely amorphous. Materials structured around this new kind of order seem to forge a link between conventional crystals and the materials called metallic glasses, which are solids formed when molten metals are frozen so rapidly that their constituent atoms have no time to form a crystalline lattice. The new materials have therefore been called quasicrystals (cf. [Kap3], [Step-G]).

The nonperiodic Penrose tilings with the two golden rhombic shapes, such as the one illustrated in Figure 20.8b, provides an excellent two-dimensional model of how pentagonal symmetry can arise in x-ray patterns. Like Schechmanite, the Penrose tilings have both approximate fivefold symmetry and the long-range orientational order that is usually associated with conventional crystal lattices.

The relationship between the rabbit Sequence (20.12a) and quasicrystals can be illustrated by drawing a line with slope τ through a square lattice with its origin at one point of the lattice, as shown in Figure 25.1. If lattice points closest to the line are projected onto the line, they subdivide the line into small and large intervals. If the large intervals are labeled "1" and the small "0", then the sequence of large and small follows the rabbit Sequence 101101011.... This result is equivalent to the sequencing of black squares in the game "corner the lady" (see Figure 20.12). To construct a two-dimensional quasiperiodic lattice, Schroeder illustrates a region of a five-dimensional *cubic* lattice projected onto an appropriately inclined plane in Figure 25.2. It is interesting to note that the points in this image correspond to the vertices of a non-periodic tiling of the plane by Penrose tiles. A three-dimensional quasiperiodic lattice can be generated similarly by projecting a six-dimensional cubic lattice onto three dimensions.

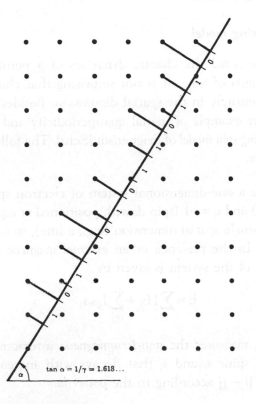

Figure 25.1 The one-dimensional quasicrystal obtained by projections from a square lattice.

Figure 25.2 A two-dimensional quasicrystal, obtained by projections from a five-dimensional hypercubic lattice.

25.3 The Ising Problem

25.3.1 *The Ising model*

Chapter 17 presented the chaotic dynamics of a point moving through successive instants of time. It is not surprising that chaotic behavior can also be found entirely in the spatial dimension. Besides plant phyllotaxis, another simpler example of spatial quasiperiodicity and chaos is the one-dimensional *Ising spin model* of magnetism [Schr]. The following is excerpted from Schroeder:

> "Imagine a one-dimensional system of electron spins, $s_i = +1$ (spin up) and $s_i = -1$ (spin down), positioned at equal intervals along a single spatial dimension (e.g., a line), as considered in [Bak-B]. In the presence of an *external magnetic field* H, the *energy* E of the system is given by
>
> $$E = \sum_i H s_i + \sum_{i \neq j} J_{ij} s_i s_j \qquad (25.1)$$
>
> where J_{ij} measures the *anti-ferromagnetic* interaction ($J_{ij} > 0$) between spins s_i and s_j that decays with increasing spatial distance $|i - j|$ according to the *power law*
>
> $$J_{ij} = |i - j|^{-\alpha}$$
>
> with $\alpha = 2$ for example.
>
> The fact that J_{ij} is positive means that adjacent spins would like to have opposite sign (to minimize energy). This is why an interaction such as the one in Equation (25.1) is said to be anti-ferromagnetic. (In a *ferromagnet*, adjacent spins tend to align themselves in the same direction, creating a strong external magnetic field, such as that of a horseshoe magnet.)"

> "Of course, with adjacent spins having opposite signs, spins at alternating locations have the same value, giving a positive though smaller contribution to the energy E (for $H = 0$). Thus, without an external field H, the minimum energy is obtained

by a fraction $w = \frac{1}{2}$ of spins pointing up. Setting $s_0 = +1$ as an initial condition, we have

$$s_{even} = +1 \text{ and } s_{odd} = -1,$$

which is a perfectly periodic anti-ferromagnetic arrangement."

25.3.2 The Devil's staircase for Ising spins

What happens to the Ising spins when H is not zero?

For nonzero values of the external field H, $w = \frac{1}{2}$ may no longer give the minimum energy. In fact, for $H \rightarrow \infty$ all spins would turn up, so that w the fraction of up-spins would go to 1. But how?

For small changes of H (and zero temperature), no spins will flip; they are locked into their given configuration. In fact, for each rational $w = \frac{p}{q}$, there is a range of H values, $H\left(\frac{p}{q}\right)$, for which w remains fixed, just as there was a range of divergence angles in Figure 24.5 for which the phyllotaxis numbers of a plant are fixed. As a result, the plot of w versus H looks like a 'devil's staircase' (see Figure 25.3). The staircase is 'complete' in that the rational plateaus in Figure 25.3 add up to the entire H interval.

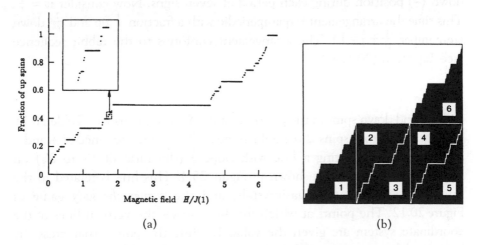

(a) (b)

Figure 25.3 (a) Fraction of up-spins as a fraction of magnetic field for an Ising spin glass exhibiting a devil's staircase; (b) the devil's staircase subdivided into six self-similar parts.

The (locked) plateau for $w = \frac{1}{2}$ has a relative length of 0.44, leaving two lengths of 0.28 remaining for $w \neq \frac{1}{2}$. Irrational values of w occur at values of H that form a Cantor set (see Section 18.4 and Figure 18.7). The larger the denominator of the rational fraction, the smaller the locked plateau. The "staircase" is *self-similar* at varying scales as illustrated by the segment of the staircase magnified in the box. The self-similarity is made more explicit in Figure 25.3b in which the devil's staircase is subdivided into six identical parts.

25.3.3 Spatial distribution of spins

How are the spins arranged for $w \neq \frac{1}{2}$? The answer is the simplest imaginable. For any rational value, $w = \frac{p}{q}$, they are arranged periodically with period q and with p in the up (+) position and $q - p$ down (−). Given w, compute $[n(1-w)]_f$, where $[\]_f$ means "the fractional value of". If $[n(1-w)]_f$ is less than w then assign s_n the value +1 otherwise $s_n = -1$. For example, if $w = \frac{3}{7}$ then the sequence of spins in a single period is:

$$\cdots - + - + - - + \cdots .$$

Since $p = 3$, there are three spins in the up (+) position and $q - p$ in the down (−) position during each period of seven signs. Now consider $w = \frac{1}{\tau}$. This time the arrangement is quasiperiodic with a fraction $\frac{1}{\tau}$ up and $\frac{1}{\tau^2}$ down (remember $\frac{1}{\tau^2} + \frac{1}{\tau} = 1$). The arrangement conforms to the rabbit sequence (see Equation (20.12a)):

$$+ - + + - + - + + \cdots \quad (25.2)$$

with up and down spins in the positions of the Wythoff pairs (see Table 20.1). The ratio of + to − spins is the golden mean. The same sequence of + and − are attained by plotting a line with slope $\frac{1}{\tau}$ (the ratio of 1's to 0's) on Cartesian coordinates, as shown in Figure 25.4. This line is related to the one in Figure 25.1 for quasicrystals, and the *corner the lady* game of Figure 20.12. The points at which this line crosses the vertical lines of the coordinate system are given the value 1, while the points that cross the horizontal lines are assigned 0. As you can see, the rabbit sequence is the result. This represents a fully chaotic arrangement.

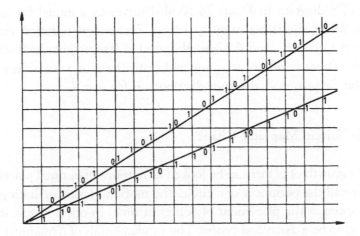

Figure 25.4 Square lattice and straight line $\frac{\sqrt{5}-1}{2} = \frac{1}{\tau}$ slope generates the rabbit sequence 10110.... The lower straight line has the silver-mean slope $\sqrt{2}-1=\frac{1}{\theta}$ and generates another self-similar sequence.

Another interesting arrangement is obtained for $w = \frac{1}{\sqrt{2}} = 0.7071....$ In this case $1 - w = 0.2928... = \frac{1}{\theta\sqrt{2}}$ where $\theta = 1 + \sqrt{2}$, the silver mean. The resulting sequence of 1's and 0's (+ and −) is given by the line with slope $\frac{1}{\theta} = \sqrt{2} - 1 = 0.414...$ in Figure 25.4. The sequence,

$$110110111011011110110110...$$

referred to as the *symbolic dynamics*, is self-similar in the same sense as the rabbit sequence; if 1 is replaced by 110 and 0 is replaced by 1 in this sequence, it replicates itself. The sequence can also be generated, starting with 0, using the rules: $1 \rightarrow 110$, $0 \rightarrow 1$. Also notice that this sequence of 0's and 1's reproduces the approximating sequence to $\frac{1}{\sqrt{2}}$ given by Sequence (7.8) up to the 3rd position of the sequence (e.g., 110) $\frac{2}{3}$ of the digits are 1's, up to the 7th position (e.g., 1101101) $\frac{5}{7}$ of the digits are 1's, up to the 17th position $\frac{12}{17}$ of the digits are 1's, etc. The symbolic dynamics could also have been produced by applying Beatty's Theorem (see Section 20.5) to the numbers $x = \sqrt{2}$ and $y = \theta\sqrt{2}$ since $\frac{1}{x} + \frac{1}{y} = 1$. I have found close connections between the symbolic dynamics that arises in the study of dynamical systems and systems of proportion in Architecture [Kap9].

The PPS diagram in Figure 24.10 also serves as a model for the Ising problem. When the floret numbers whose Zeckendorf notation ends in 1 represent the up spins, and the ones that end in 0 represent the down spins, then if the floret numbers are projected onto the x or y-axes they assume the Rabbit Sequence — the spin distribution for $w = \frac{1}{\tau}$.

25.4 The Circle Map and Chaos

Just as the growth of plants can be looked at in terms of optimal placement of points around the periphery of a circle, the motion of any oscillating system can be viewed as the placement of points in time. In other words, it can be considered to be a *dynamical system*. The fundamentals of dynamical systems have been described by the physicist Leo Kadinoff [Kad] as follows:

> "In general, in a mapping problem one investigates the properties of a sequence of points z_0, z_1, z_2,... each point generated from the last by the application of a defined function R,
>
> $$z_{j+1} = R(z_j).$$
>
> These problems serve as simple models of dynamical behavior in which one can think of z_j as a description of the state of the system at a time $t = j$. One is particularly interested in universal or generic properties of the set $\{z_j\}$ — that is, properties which do not depend in detail upon the form of R. Any such robust property has a chance of being important for the behavior of the more complex dynamical systems manifested in the physical world."

One kind of universal behavior concerns maps in which z is a real number and R is a map that obeys a kind of *periodicity condition*,

$$R(z + 1) = 1 + R(z).$$

For example,

$$R(z) = z + \Omega - \frac{K}{2\pi} \sin 2\pi z, \qquad (25.2)$$

where the parameter K is a coupling strength parameter that is roughly related to the energy of the system and Ω is a frequency ratio called the *bare winding number*. This frequency ratio may represent the ratio of a driving force frequency and the natural resonance frequency of an oscillator. (Think of a swing with a natural frequency of oscillation in which someone gives it a push at the height of its back-swing, or contemplate the frequency ratios of planetary or lunar orbits and spins.) In this model, the oscillation of points around a circle, i.e., mod 2π are represented by their movement through the interval $[0, 1]$, i.e., mod 1 just as the optimal spacings of florets on a sunflower were represented by a sequence of points on a circle and an interval in Section 24.3.

The *dressed winding number* w is defined as the limit of $\frac{z_n - z_0}{n}$ as $n \to \infty$. This winding number describes the average number of revolutions of the trajectory per time step. When w is rational, the system is said to be *commensurable*. For example, if $w = \frac{P}{Q}$, then the orbit repeats itself after Q iterations after cycling P times through the interval $[0, 1]$ as in Coxeter's lattice model of phyllotaxis (see Section 24.2.1). Irrational winding numbers correspond to trajectories that never repeat themselves, although, as we have shown in Sections 14.3 and 14.4, they can be best approximated by rationals using continued fractions. The generative spiral of Coxeter's model (see Section 24.2.1) in Figure 24.2 is an example of such a trajectory in the space dimension rather than time.

One can talk about the stability of these orbits. As described in [Schr]:

> "Roughly speaking, if the frequency ratio of two coupled oscillators is a rational number $\frac{P}{Q}$, then the coupling between the driving force and the "slaved" oscillator is particularly effective because of a kind of *resonance*: for every Q cycles of the driver the same physical situation prevails so that energy transfer effects have a chance to build up in a resonance-like manner. This resonance effect is strong, particularly if Q is a small integer (reasons will be described in the next section). This is precisely what happened with our moon: resonant energy transfer between the moon and the earth by tidal forces slowed the moon's spinning motion until the spin period around its own axis locked (the concept of mode locking will be

> discussed in the next section) into the 28-day cycle of its
> revolution around the earth. As a consequence, the moon always
> shows us the same face."

Perturb the initial point of an orbit with a rational winding number ever so slightly, and the resulting orbit is no longer periodic and may differ significantly from the original. Such orbits are said to be *unstable*. What about the stability of irrational orbits? Their stability depends on the value of the parameter K in Equation (25.2). If $K < 1$, then the trajectories $\{z_j\}$ with irrational winding numbers fill up the entire interval as $j \to \infty$. However, depending on whether the orbit with an irrational winding number has "sufficiently close" neighboring orbits with rational winding numbers, the trajectories will be more or less stable. Orbits possessing sufficiently close neighboring orbits with rational winding numbers destabilize first as K is increased.

When $K = 1$, all orbits with irrational winding numbers have been destabilized, and further increase in K results in *chaos*. In the chaotic regime ($K > 1$), the nature of the orbit depends on the exact position of the starting point, in that the smallest perturbation of the starting point may result in a totally different kind of orbit. Also, the trajectory may no longer spread out to fill the entire circle (or interval), but instead bunches into a set of narrow disconnected regions of what mathematicians call *total measure zero*. Kadinoff has found that these intervals are directly related to a system of hierarchies within hierarchies of *Fibonacci numbers*.

It is now easy to see why the golden mean is the key to understanding the structure of ordered and chaotic orbits. Since, as we showed in Section 20.3, the golden mean is the "most irrational number", the orbit with the golden mean winding number has the most distant neighboring rational orbits of any winding number, and it is therefore the last orbit to be destabilized as the energy of the system K is increased. At $K = 1$ the golden mean orbit is destabilized, after which chaos ensues. At the "critical point" $K = 1$, it can be shown [Schr] that if the trajectory point is assigned the number 1 when $0.5 \le z_j < 1$, and 0 when $0 \le z_j < 0.5$, the *symbolic dynamics* of the trajectory follows the rabbit sequence: 1011010.... In this sense, the phyllotaxis *trajectory* described by the PPS of Section 24.4 could be thought of as the result of a *circle map* in a state of chaos. Florets are assigned a 1 (the last

digit of their Fibonacci or Zeckendorf representation is 1) when they are located to the left of the barrier in Figure 24.10, and are assigned a 0 (the last digit of their Zeckendorf representation is 0) if they fall to the right; then the phyllotaxis sequence along the generative spiral (see Section 24.3) takes the form of the rabbit sequence.

Section 17.4 showed that the *symbolic dynamics* of the *logistic equation* of chaos theory is related to the *Towers of Hanoi sequence* (20.13a). Now we see that the symbolic dynamics of the *circle map* is related to the *rabbit sequence*.

25.5 Mode Locking

Mode locking is an important phenomenon exhibited by many dynamical systems. Perhaps the simplest illustration of this concept was given in [Schr] and involves the dynamics of a pedestrian traversing a series of streets with a traffic light at each corner. Depending on the pedestrian's walking speed he will sooner or later reach his destination. However, even two people with somewhat different walking speeds may reach their destinations at the same time. Although the faster walker may reach the corner sooner than his slower friend, he will have to wait for the red light, giving the slower walker a chance to catch up. The following is excerpted from Schroeder:

"Suppose the pedestrian's speed is just under two-thirds of the 'speed' of the traffic lights (i.e., the distance between cross streets divided by the period of one complete green-yellow-red cycle). The red lights will force him to wait at every intersection and slow him down his speed by a factor of two.

Assuming for simplicity that the green cycle, during which the walker can safely traverse the cross street, lasts exactly half a period, and that all lights are perfectly synchronized (as they certainly would not be on a one-way avenue), then, in the walker's speed range $\frac{1}{2} < s < \frac{2}{3}$, he is locked into an effective velocity $v = \frac{1}{2}$. In general, in the speed range

$$\frac{1}{n+1} \le s \le \frac{2}{2n+1} \tag{25.3}$$

where $n = 1, 2, 3,...$, he is locked into an effective velocity $v = \frac{1}{(n+1)}$. But the walker can be locked into many other rational speeds. In fact, for

$$\frac{2(k-1)}{2(k-1)n+1} \leq s \leq \frac{2k}{2kn+1} \tag{25.4}$$

for $k = 2, 3, 4,...$, the walker's effective velocity is locked into the lower limit of s.

The staircase function corresponding to these locked intervals is illustrated in Figure 25.5. Although the graph of v versus s is not exactly self-similar, the locking pattern in the interval $\frac{1}{2} < s < 1$ is approximately re-scaled and repeated in the intervals $\frac{1}{n+1} \leq s \leq \frac{1}{n}$. One also notices that the locked-in plateaus become smaller and smaller for increasingly larger denominators in Inequalities (25.3) and (25.4). In fact, the locked–in speed intervals equal 1 divided by the product of the two denominators."

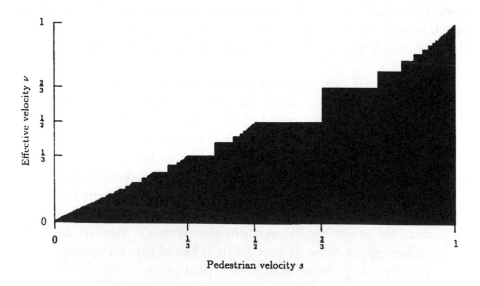

Figure 25.5 (a) Progress of the frustrated Manhattan pedestrian as an illustration of mode locking.

25.6 Mode Locking and Natural Resonances

This scenario of locked intervals, being reciprocally related to the denominators of certain reduced fractions, goes far beyond the street pedestrian. In fact, this is the principle behind the *devil's staircase*. In the natural world the winding number can be thought of as the ratio of two natural frequencies, and these frequencies lock preferentially onto frequency ratios involving small integers. For example two grandfather clocks placed in different rooms within a house and started off vibrating at slightly different frequencies will, after an exchange of energy with each other, end up vibrating at the same frequency. The ratio of the planet Mercury's orbital frequency around the sun to its spin frequency around itself equals $\frac{2}{3}$, the ratio of two small integers. For similar reasons, the period of rotation of the moon around its axis equals the period of its movement about the earth. It is possible that the musical ratios that relate the periods of adjacent planets (see Section 5.6) may be another example of mode locking.

In general, the ratio of these two natural frequencies, corresponding to the winding number, can be thought of as the number of windings of a spiral as it wraps around each of the two circuits on a torus (see Figure 12.4) during one cycle as we described in the "gears of life" (see Section 24.4). Figure 24.5 represents a devil's staircase in which each pair of phyllotaxis numbers (m, n) along the edges can be represented by a rational number $\frac{m}{n}$ (analogous to v in Figure 25.5). For each such $\frac{m}{n}$ there corresponds a range of possible divergence angles spanning the interval between a pair of rationals $\frac{P_n}{Q_n}$ and $\frac{P_{n+1}}{Q_{n+1}}$ (analogous to s in Figure 25.5). The higher the pair of rationals are on the Farey tree, the broader is the divergence angle plateau.

25.7 Mode Locking and the Harmonics of the Musical Scale

From the musical point of view, a long thin string of uniform dimensions, fixed tension, and perfect elasticity displays its natural nodal points as it vibrates simultaneously in aliquot divisions of 2, 3, 4, etc. equal segments. In Figure 25.6a the Farey Sequence of Table 14.2 are reorganized to show how rational numbers equipartition the string. The first eight partials of an harmonic sequence on C are shown in Figure 25.6b. Luminous tones known

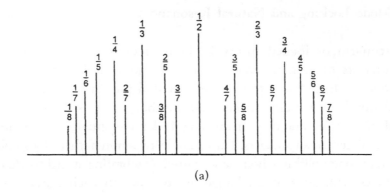

(a)

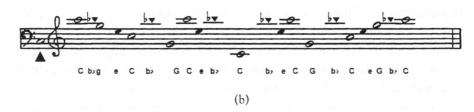

(b)

Figure 25.6 Farey sequence (a) natural nodal points on a vibrating string; (b) the first eight partials of an harmonic sequence based on C.

as harmonics are obtained by bowing, plucking, or striking the string at an antinode, and then touching very lightly at a node to suppress other harmonics. The lower harmonics gain power from nodal coincidences with higher harmonics. In performing experiments one should be aware that higher harmonics can always intrude at their own proper loci on the string when accidentally energized. Numbers from the Farey sequence (see Tables 14.1 and 14.2) with larger denominators require more care in activating and damping vibration. String stiffness can displace nodes near the ends. The cello A string is a perfect experimental instrument for sounding all Farey loci up to at least 16 (integer values of the denominator) when bowed at optimum positions.

The octave $\left(\frac{1}{2}\right)$ is the most stable of intervals and appears in row 0 of the Farey sequence while the musical fifth $\left(\frac{2}{3}\right)$ and fourth $\left(\frac{3}{4}\right)$ are the next most stable intervals appearing in rows 1 and 2. By stable here we mean a small tolerance to the left or right of the midpoint still produces the musical

harmonic. This is a form of mode-locking. The greater the tolerance the more stable the musical interval. In other words, the fifth is a less stable interval than the octave in that its position must be located more precisely on the string, while the third $\left(\frac{4}{5}\right)$ is less stable than the fifth since $\frac{2}{3}$ is in row 1 while $\frac{1}{2}$ is in row 0 and $\frac{4}{5}$ is in row 2.

Row n of Figure 25.6a represents the sequence of harmonics that can be gotten by subdividing the string into n equal parts. An actual musical tone generally contains a superposition of these harmonics with different energies depending on the instrument, and they are best understood through the study of Fourier analysis. The following sequence of tones (Row 8 of the Farey sequence given by Table 14.2) is gotten by arranging in order all of the rationals in Figure 25.6, i.e., all rationals with denominator 8 or less lying between 0 and 1:

$$0, \frac{1}{8}, \frac{1}{7}, \frac{1}{6}, \frac{1}{5}, \frac{1}{4}, \frac{2}{7}, \frac{1}{3}, \frac{3}{8}, \frac{2}{5}, \frac{3}{7}, \frac{1}{2}, \frac{4}{7}, \frac{3}{5}, \frac{5}{8}, \frac{2}{3}, \frac{5}{7}, \frac{3}{4}, \frac{4}{5}, \frac{5}{6}, \frac{6}{7}, \frac{7}{8}, 1.$$

Notice that the ratios between $\frac{1}{2}$ and 1 represent all tones of the Just scale with the exception of the wholetone and semitone. Also included are the diminished seventh, $\frac{4}{7}$, augmented wholetones, $\frac{7}{8}$ and $\frac{6}{7}$, and the tritone $\frac{5}{7}$. These 21 harmonics are also illustrated in Figure 8.7 as the equipartition points derived from the Brunes star. This may also explain why the preferred ratio of periods between adjacent planets described in Section 5.6 are ratios from the diatonic scale, and it validates Kepler's intuition that the motion of the planets are in some way correlated with the tones of the Just scale.

25.8 Mode Locking and the Circle Map

Returning to the circle map, without coupling ($K = 0$), the so-called dressed winding number w equals the bare winding number Ω. But for $K > 0$, w "locks" into rational frequency ratios, preferably ratios with small denominators. Figure 25.7 shows some of the frequency-locked regions in the K plane. The shaded regions are called Arnold tongues, after their discoverer, the Russian mathematician V.I. Arnol'd. In a sense, the infinite Farey tree, as depicted in Table 14.1, is a discrete version of the Arnol'd tongues. The regions corresponding to rational dressed winding numbers occur in the

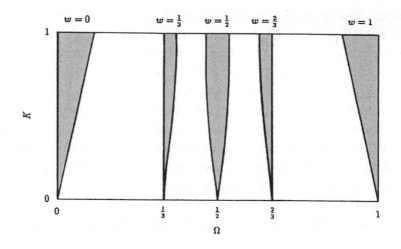

Figure 25.7 Arnold tongues: locked frequency intervals.

same order as found in the infinite Farey sequence with the wider regions corresponding to rationals that appear higher on the infinite Farey tree. In a complete diagram, all rational winding numbers would be represented. This hierarchical arrangement is also shown in the devil's staircase of the circle map in Figure 25.8.

For $K = 0$, "most" of the unit interval is occupied by irrational dressed winding numbers in the same way that "most" of the interval $[0, 1]$ is occupied by irrational numbers (mathematicians say that the irrationals occupy a set of *measure 1*). We have stated in Section 25.4 that the trajectories corresponding to these winding numbers are stable in contrast to the unstable trajectories with rational winding numbers. Although the rational numbers within the interval $[0, 1]$ are densely placed (between any two rational numbers there is another), they are nevertheless far less numerous than the irrationals (they occupy a set of *measure 0*).

As K increases the rational values of the dressed winding numbers occupy larger and larger islands of instability within a sea of irrational winding numbers of stable trajectories. Each rational winding number is mode-locked into an interval consistent with a range of values of Ω. For K values between 0 and 1 the irrational winding numbers correspond to stable trajectories and occupy sets of measure between 0 and 1.

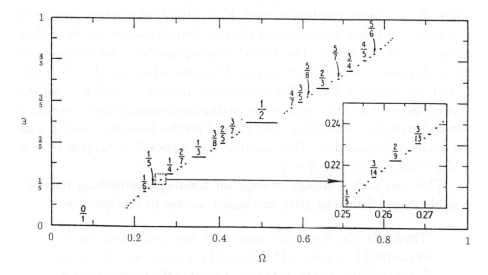

Figure 25.8 Devil's staircase with plateaus at every rational number.

For the critical value $K = 1$ of the coupling parameter, the infinitely many locked frequency intervals, corresponding to all the rational dressed winding numbers w between 0 and 1, actually cover the entire range of bare winding numbers except for a set of measure zero. Irrational values of w correspond to an uncountably infinite set (see Section 14.2) of zero measure — in other words the irrationals are "squeezed" into a *Cantor dust* (see Section 18.4) between the rational values. As the trajectories corresponding to the irrational winding numbers are gathered into this Cantor dust they are destabilized. In a sense, the "last" irrationals gathered into the "dust" are the phyllotaxis angles $\frac{1}{\tau}$ and $\frac{1}{\tau^2}$ (the most irrational of all numbers). The intervals of bare winding numbers corresponding to each dressed winding number reveal the approximately self-similar devil's staircase shown in Figure 25.8. In a sense, the devil's staircase is nothing other than a representation of the limiting row of the *Infinite Farey Sequence* in Table 14.2, F_n as $n \to \infty$, with each rational weighted according to its position in the Farey tree of Table 14.1.

For $K > 1$, all of the irrational winding numbers are squeezed out, and remaining intervals of rational dressed winding numbers begin to intersect each other, which indicates that the realm of chaos has been entered. Now

adjust the nonlinear coupling strength K and the bare winding number Ω to a point just below the crossing of the two Arnold tongues for the locked frequency ratios $\frac{1}{2}$ and $\frac{2}{3}$. The dressed winding number w for this point in the Ω–K plane must be rational because $K > 1$, but what should be its value? In fact, the rational value $\frac{P}{Q}$ that w assumes is given by $\frac{1}{2} < \frac{P}{Q} < \frac{2}{3}$ with Q as small as possible. This raises an interesting mathematical question with a curious but simple answer: What is the rational number between $\frac{1}{2}$ and $\frac{2}{3}$ with the smallest denominator? This question was answered in Section 14.3; it is the Farey sum of $\frac{1}{2} \oplus \frac{2}{3} = \frac{3}{5}$.

What can such a strange strategy for forming intermediate fractions possibly mean? Schroeder gives an elegant answer to this question:

> "Physically, the frequency ratio $\frac{1}{2}$ of two oscillators can be represented by a pulse: (1) followed by a non-pulse; (0) of the slower oscillator during every pair of beats of the faster oscillator. Thus the frequency ratio $\frac{1}{2}$ is represented by the sequence 101010... or simply $\overline{10}$. Similarly, the frequency ratio $\frac{2}{3}$ is represented by two 1's repeated with a period of three, $\overline{110}$. Now to form an intermediate frequency ratio, we simply alternate between the frequency ratios $\frac{1}{2}$ (i.e., $\overline{10}$) and $\frac{2}{3}$. (i.e., $\overline{110}$), yielding $\overline{10110}$, which represents the frequency ratio $\frac{3}{5}$ (3 pulses during 5 clock times). So in averaging frequency ratios, taking mediants, as this operation is called, is not so strange after all."

25.9 Blackmore's Strain Energy: A Unifying Concept

Denis Blackmore and I have reapproached the range of physical models presented in this chapter — phyllotaxis, the Ising problem, and quasicrystals — using the modern theories of dynamical systems (cf. [Bla], [Kap7]). We have used the concept of a *lattice* on a *period torus*, introduced in Section 24.4 under the title "gears of life." We have modeled the action of nature upon a physical system, be it a plant, quasicrystalline structure, or magnetized set of charges by a "smooth" transformation that preserves *lattice points*, i.e., lattice points which are mapped smoothly to other lattice points in such a

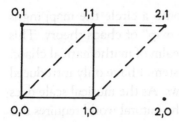

Figure 25.9 An area preserving transformation transforms the coordinates of a lattice $(1, 0)$ and $(0, 1)$ to a pair (p_1, q_1) and (p_2, q_1).

way that the area of each cell within the lattice is preserved. If a fundamental cell of a two-dimensional lattice is specified by vectors drawn to the coordinates $(0, 1)$ and $(1, 0)$, as shown in Figure 25.9, then an area preserving transformation transforms these coordinates to another pair of coordinates (p_1, q_1), (p_2, q_2) with unit modulus, i.e., $|p_1 q_2 - p_2 q_1| = 1$, two adjacent numbers from the infinite Farey Sequence (see Section 14.3.12).

Blackmore has introduced a *strain energy* on this lattice that measures the degree of deformation of the lattice cells, and he has shown that the transformation that *minimizes* this strain energy is the very transformation that transforms the coordinates of the unit cell: $\{(0, 1), (1, 1)\}$ successively to: $\{(1, 1), (1, 2)\}$ then $\{(1, 2), (2, 3)\}$, $\{(2, 3), (3, 5)\}$, $\{(3, 5), (5, 8)\}$..., in other words a Fibonacci sequence of coordinates. The minimum strain energy of a three-dimensional lattice maps the point $(0, 0, 1)$ successively to $(0, 1, 1)$, $(1, 1, 2)$, $(1, 2, 4)$, $(2, 4, 7)$, $(4, 7, 13)$ related to tribonacci numbers (see Section 21.3); higher dimensional lattices are analogously related to *n–bonacci numbers*. Low values of the strain energy are related to pairs of coordinates found for small values of numerator and denominator from the Farey sequence. With this approach, many of the themes considered in this book are found to be interrelated.

The recent work of Blackmore has created a rigorous framework for future study of phyllotaxis in the realm of dynamic systems theory, in which these self-organizing principles are orchestrated by the plant's need to minimize energy.

25.10 Conclusion

The golden mean plays a central role in chaos theory and plant phyllotaxis while phyllotaxis exhibits phenomena familiar to other dynamical systems.

When the centers of the florets are projected onto a circle the mapping is structurally similar or isomorphic to the "circle map" of chaos theory. This leads to the conclusion that plants exist in the realm of mathematical chaos.

Of course, through our study of dynamical system, I have only introduced some of the scaffolding at the basis of physical laws. As the musical scale does not constitute a symphony, to properly describe the natural world requires this scaffolding to be overlaid with information gathered with all of the senses. Nothing will replace the careful observer passionately involved with a study of the actual phenomena.

Epilogue

Beyond Measure has given some examples of the profound transformation of human consciousness that has taken place from ancient to modern times. In the opening chapter, the Australian Aborigines and the Fali tribe of the Cameroons were shown to be directly involved with the world around them. Their dwellings were as much a part of the natural order as are the beehive or the bird's nest. Birth, death, and other rites of passage were marked by symbols never far removed from their association to the Earth and the Heavens. From our modern Judeo-Christian perspective, these depictions have often been mistaken for idols rather than vehicles of direct participation that formed the world view of these people. Theodore Schwenk captures some of this direct participation through his association of flowing water with the metabolic, rhythmic, and sensitive functions of the human body. The Earth's atmosphere and biosphere were pictured as sensitive membranes mediating between Heaven and Earth.

At some point in time however, the inner and outer worlds of consciousness divided and our modern experience of self-consciousness and introspection emerged from this split [Jay]. Now man could have access to symbol systems detached from markers in the external world. Written language and the concept of number were the direct results. There was now access to imagination with which to build new worlds. Phenomena were not merely a source of direct outer experience, but were internalized as a set of hypotheses about how the world worked. Later, in our scientific era, these hypotheses were given a higher status and looked upon as truths about the nature of things. Lost in this transformation was the recognition that in order to describe phenomena, countless abstract notions not directly experienced such as atoms, forces, electromagnetic fields, etc. had to be created. Theories primarily concerned themselves with relations between

these quantities rather than the phenomena themselves. In all of this the observer was relegated to the role of an objective bystander.

In the past century, in response to a series of paradoxes concerning the nature of previously established theories, science and mathematics have assumed more modest roles as interpreters of phenomena. Now science is satisfied merely with the creation of mathematical models that correlate observations rather than "final" explanations of events. The philosopher, Owen Barfield [Barf], refers to this kind of scientific inquiry as "saving the appearances" in a book by the same name. Science no longer seeks final causes but concerns itself with predictive power and its ability to act upon nature. In the last chapter of this book, all sights and smells of plants, animals, mountains and rivers have been suppressed leaving only nuances in their places in the guise of dynamical systems. However, these systems express certain outer characteristics of the observed phenomena while, at the same time, bringing to light certain hidden aspects.

To a large extent, the models that we are creating to describe an outer world may well be more of a description of our own minds than of the phenomena that they claim to represent. Every inquiring mind now participates in creating the world, displacing the One God or panoply of Gods that once ruled the world. We now have it in our power to use this rich storehouse of symbolic imagery to create a world of beauty and bounty or chaos and inanity. The future will depend in large measure on the quality of our creations.

Part I of the book explored, through number and geometry, man–made systems of language: systems of music, written language, and design as they may have been expressed at the threshold of these momentous changes. It is forever lost to us how ancient civilizations actually conceived of these systems. However, remnants of these creative impulses are to be found in Kepler's attempts to build a planetary system from the "harmony of the spheres", Brunes' recreations of the methods by which ancient temples might have been constructed, Michelangelo's preservation of the principles of an ancient geometry in the pavements of the Laurentian Library, and Tenen's description of the creation of the letters of the Hebrew alphabet.

Part II followed the trail of this split in consciousness into the role that number and geometry has played in describing modern theories of fractals,

chaos theory, models of plant growth, and other dynamical systems. We saw that the richly textured system of number itself is the result of human creation from fullness and void or 1 and 0 and that star polygons that have been enshrined as sacred symbols are also at the basis of systems of proportion and cycles of dynamic systems in a state of chaos. Number and geometry could now be used to express notions beyond direct experience such as the infinitely large and the infinitesmal, higher dimensional spaces, the application of self-similarity to build complex systems from their simplest elements, and the manner in which a mind is able to think about itself. However, here we are also on shaky ground. To what degree are our detached symbol systems new idols rather than, as science portrays them, objective realities? What is the role of imagination in the creation of scientific theories? To what degree has imagination replaced direct perceptions of the natural world? I have tried to show that our innate sense of number resonates with our observations of the macroscopic and quantum worlds.

Chaos theory is hinting to us that our symbol systems have built-in limits beyond which we have no access through the world of science. Our physical theories appear to have predictive power only for a finite duration of time. As we peer into the fractal structure of matter or out into the fractal structure of galaxies we see the same structure of solidness and gaping holes however strongly we resolve our telescopes or microscopes without a hint of reaching a limit. However, this built-in limitation to our observations and theories is nothing new. Ancient civilizations appear to have been aware that the solar and lunar cycles were incommensurate and that this found an echo in the problem of creating a musical scale that required only a finite number tones. This unresolvable dilemma in the description of the musical scale is an example of what I have meant by the expression "beyond measure". Nevertheless, astronomers have accommodated their instruments to these incommensurabilities, musicians have used these commas to acclimate the ear to the compromises inherent in the equal-tempered scale, and great artists such as Michelangelo became adept at hiding these deviations in the grout lines of their creations. In a similar manner, artists of today are finding ways to build their art from the limitations inherent in the notions of fractals and chaos theory. Even with this inherent sense of limit our systems of scientific inquiry have led to extraordinary discoveries. Yet their incompleteness deny us access to worlds beyond. Are

our scientific and mathematical systems helping us to see the world clearly, or are they merely "saving the appearances"?

These are important questions. How we answer them will determine whether we use our powers to build a world which honors the exquisite forces that led to its creation or become so infatuated by shadows of this world that bubble up into our consciousness that we destroy the context in search of the atoms and genes at its base. Unlike our ancestors whose direct participation in the universe enabled them to be part of it, our tendency is to bend the world to our will. Here Plato's caution to heed a sense of limit is good tonic as is Goethe's warning to not mistake the scaffolding for the edifice.

I would like *Beyond Measure* to be seen as an invitation to remove the barriers between disciplines within the sciences and mathematics, and even more, between the arts and the sciences. There is evidence that early man had already incorporated the diatonic scale into his music, a scale that Kepler believed to orchestrate the heavens. The musical scale also provided a context from which our modern concept of number was derived. Is it not possible that our brains are wired to the tones of the diatonic scale, an area for neuroscientists to explore? Why should the growth of plants remain the province only of botanists when this process bears the imprint of the golden mean and has the same signature as other natural systems at the edge of chaos? Systems of proportion should not be of interest only to architects when they embody numbers that also supply the points of stability for dynamical systems of all kinds. Perhaps it was prescient for the architects of the Renaissance to proportion their buildings based on tones from the musical scale. Knowledge of these connections could also provide archaeologists with tools to decipher the fragments of the ancient world in our possession. When a butterfly's wings can radically change the results of a measurement, what do we mean by measure? We are thrown back to a priori resonances present already in our number system ready to be coaxed out to explain the world of our everyday reality as well as our dreams. Finally, why not make the artist's and musician's insight that the world cannot be observed from a single perspective also a credo that informs the sciences? Just as music is distinct as we move from key to key, and the scene of a painting depends on where the observer is placed, scientific theories

could be constructed which incorporate the observer along with the observed. These are the themes that I have tried to weave into this book.

This book represents 20 years of collaboration during which time I have applied an interdisciplinary lens, centered upon mathematical analysis, to obtain many new insights into existing theories. I have tried to form an amalgam between the material in Part I of this book which is closer to the world of observation and the material in Part II which calls upon the concept of number to go beyond the world of the senses. During the course of this study many common threads have emerged within and between diverse fields of science and technology, including the application of the musical scale, the development of measure, and the power of symmetry. By continuing this process in the future, we may be further along in appreciating our ancestor's understandings and thereby be closer to discovering the fundamental laws governing nature.

Bibliography

[Abr] D. Abram, *The Spell of the Sensuous*, New York: Pantheon (1996).

[AdamC] C. Adams, *The Knot Book*, New York: W.H. Freeman (1994).

[AdamG] G. Adams, *The Lemniscatory Ruled Surface in Space and Counterspace*, London: Rudolph Steiner Press (1979).

[Adam1] G.W. Adamson, private communication (1991–2001).

[Adam2] G.W. Adamson, *Straightedge contruction of any rational fraction*, FRACTALIA **25** (June 1998).

[Adl1] I. Adler, private communication (1995).

[Adl2] I. Adler, *Generating phyllotaxis patterns on a cylindrical point lattice* and *Prologue*, in *Symmetry of Plants*, eds. R.V. Jean and D. Barabe, Singapore: World Scientific (1997).

[Ahl] F.M. Ahl, *Amber, Avallon and Apollo's singing swan*, Am. Jour. of Philology, **103** (1982) 375–411.

[Alb] L.B. Alberti, *The Ten Books of Architecture*. (1755), Reprint, New York: Dover (1986).

[Art] B. Artmann, *The Cloisters of Hauterive*, The Mathematical Intelligencer **13**(2) (1991) 44–59.

[Bae] S. Baer, *The discovery of space frames with fivefold symmetry*, in *Fivefold Symmetry*, ed. I Hargittai, Singapore: World Scientific (1992).

[Bak1] P. Bak, *The devil's staircase*, Physics Today (Dec. 1986).

[Bak2] P. Bak, *How Nature Works: The Science of Self-organized Criticality*, New York: Springer Verlag (1996).

[Bak-B] P. Bak and R. Bruinsma, *One-dimensional Ising model and the complete devil's staircase*, Phys. Rev. Lett. **49** (1982) 249–251.

[Barb] J.M. Barbour, *Tuning and Temperament*, Da Capo (1972).

[Barf] O. Barfield, *Saving the Appearances: A Study in Idolatry* (2nd Ed.), Westleyan University Press (1988).

[Barn] M. Barnsley, *Fractals Everywhere*, San Diego: Academic Press (1988).

[Baro] J. Barrallo, private communication (2001).

[Barr] J.D. Barrow, *Pi in the Sky*, New York: Oxford Press (1992).

[Ben] S. Bender, *Plain and Simple*, New York: Harper and Row (1989).

[Bern] M. Bernal, *Black Athena: The Afroasiatic Roots of Classical Civilizations*, Vols. 1 and 2, New Brunswick: Rutgers University Press (1992).

[Berr] M. Berry, *Quantum physics on the edge of chaos*, in *Exploring Chaos*, ed. N. Hall, New York: W.W. Norton (1991).

[Bic-H] M. Bicknell and V. Hoggatt, eds., *A Primer for the Fibonacci Numbers*, Santa Clara: Fibonacci Association (1973).

[Bla-K] D. Blackmore and J. Kappraff, *Phyllotaxis and Toral Dynamical Systems*, ZAMM (1996).

[Bla] D. Blackmore, private communication (2001).

[Boc] J. Bockemuhl, *Awakening to Landscape*, Dornach, Switz.: The Goetheanum (1992).

[Boe] Boethius, *Fundamentals of Music*, Trans. By C.M. Bower. New Haven: Yale Press (1989).

[Boo1] D. Booth, *The new zome primer*, in *Fivefold Symmetry* ed. I. Hargittai, Singapore: World Scientific (1992).

[Boo2] D. Booth, *Finsler Set Theory*, Basel: Birkhauser (1996).

[Bru] T. Brunes, *The Secrets of Ancient Geometry — And its Use*, **1**, Copenhagen: Rhodos (1967).

[Bul] A. Bulckens, *The System of Proportions of Parthenon and its Meaning*, Geelong, Aust.: Phd Thesis from School of Architecture, Deakin University (2002).

[Bur] A. Burl, *The Stone Circles of the British Isles*, New Haven: Yale (1976).

[Clop] A. Clopper, *Path curves and plant buds: An introduction to the work of Lawrence Edwards*, Unpublished manuscript (1979).

[Col] G.P. Collins, *Bose-Einstein condensates are one of the hottest areas in experimental physics*, Scien. Am. (Dec. 2000).

[Coo] T. Cook, *Curves of Life*, New York: Dover (1979).

[Cox1] H.S.M. Coxeter, *Golden mean phyllotaxis and Wythoff's game*, Scripta Mathematica, **XIX**(2,3) (1953).

[Cox2] H.S.M. Coxeter, *Introduction to Geometry*, New York: Wiley (1961).

[Cox3] H.S.M. Coxeter, *Regular Polytopes*, New York: Dover Press (1973).

[Cox4] H.S.M. Coxeter, *Projective Geometry*, New York: Springer Verlag (1987).

[Cri] K. Critchlow, *Time Stands Still*, New York: St. Martin's Press (1982).

[D'Oo] M.L. D'Ooge, *Introduction to Arithmetic*, Ann Arbor: University of Michigan Press (1938).

[D'Or] G. D'Orssat, *La Sagrestia Nuova*, in *Umberto Baldiniand Bruno Nardini*, eds. San Lorenzo Florence: Mardini Editori (1984).

[de-D] G. de Santillana and H. von Dechend, *Hamlet's Mill*, Lincoln, MA: David R. Godine Publishers (1979). Originally published by Gambit (1969).

[deW] J.A. de Waele, Der Entwurf des Parthenon, in E. Berger (ed.), Parthenon-Kongress Basel, Vol. 1, pp. 99–100, Mainz: Philipp von Zabern (1984).

[Dev] R.L. Devaney, *Chaos, Fractals, and Dynamics*, Menlo-Park: Addison-Wesley (1990).

[Dil] O.A.W. Dilke, *Reading the Past: Mathematics and Measurement*, British Musical Publishers (1987).

[Dou-H] A. Douady and J.H. Hubbard, On the dynamics of polynomial-like mappings, Ann. Sci. Ecole Norm. Sup. **18** (1985) 287–344.

[Ebe] S. Eberhart, *Mathematics through the Liberal Arts: A Human Approach*, Northridge, CA: California State University Bookstore Printshop (1994).

[Ech] M. Echols, *Fifty Quilting Projects*, Rodale Press (1990).

[EdE] E.B. Edwards, *Pattern and Design with Dynamic Symmetry*, Originally published as *Dynamarhythmic Design* (1932). New York: Dover (1967).

[Edw1] L. Edwards, *Field of Form*, London: Floris Books (1982).

[Edw2] L. Edwards, *Projective Geometry*, London: Rudolph Steiner Institute (1985).

[Edw3] L. Edwards, *The Vortex of Life*, Vols. **1**, **2** and **3**, London: Floris Books (1993).

[Egl] R. Eglash, *African Fractals*, New Brunswick: Rutgers University Press (1999).

[Ehr] E. Ehrenkrantz, *Modular Number Pattern*, London: Tiranti (1956).

[Eli] M. Eliade, *The Sacred and the Profane*, New York: Harper and Row (1961).

[Eri] R.O. Erickson, The Geometry of Phyllotaxis, in *The Growth and Functioning of Leaves*, eds. J.E. Dale and F.L. Milthorpe, pp. 54–88, New York: Cambridge University Press (1983).

[Fal] K. Falconer, *Fractal Geometry: Mathematical Foundations and Applications*, New York: Wiley (1990).

[Far] H.G. Farmer, *The music of ancient Mesoptamia*, The New Oxford History of Music, Vol. **1**, Oxford Press (1957).

[Fed] J. Feder, *Fractals*, New York: Plenum Press (1988).

[Fer] E. Fernie, *The Greek metrological relief in Oxford*, Antiquaries Journal **LXI** (1981) 255–263.

[Fou] H. Fountain, *After 9,000 years, oldest flute is playable again*, NY Times (Sept. 28, 1999).

[Gard1] M. Gardner, *Towers of Hanoi: in the Icosian Game*, Sci. Am. (May 1957).

[Gard2] M. Gardner, *White and brown music, fractal curves and one-over-f fluctuations*, Sci. Am., **238**(4) (1978).

[Gard3] M. Gardner, *Knotted Doughnuts*, New York: Freeman (1986).

[Ghy] M. Ghyka, *The Geometry of Art and Life*, New York: Dover (1978).

[Gin] O. Gingerich, *The Eye of Heaven: Ptolemy, Copernicus, Kepler*, New York: Am. Inst. of Phys. (1993).

[Gle] J. Gleick, *Chaos, Making a New Science*, New York: Viking (1987).

[God] J. Godwin, *Harmonies of Heaven and Earth*, Rochester, VT: Inner Traditions (1995).

[Goo] B. Goodwin, *How the Leopard Changed his Spots*, New York: Scribners (1994).

[Gui] E. Guidoni, *Primitive Architecture*, New York: Abrams (1978).

[Gut] M.C. Gutzwiller, *Quantum Chaos*, Scien. Am. (Jan. 1992).

[Haa] R. Haase, *Harmonics and sacred tradition*, in *Cosmic Music*, ed. J. Godwin. Rochester, VT: Inner Traditions (1989).

[Hal] N. Hall, *Exploring Chaos*, New York: W.W. Norton (1991).

[Halu] P. Halurick, *Tin in Antiquity*, The Institute of Metals (1986).

[Ham] J. Hambridge, *The Fundamental Principles of Dynamic Symmetry*, New York: Dover (1967).

[Haw1] G.S. Hawkins, *Mindsteps to the Cosmos*, New York: Harper and Row (1983).

[Haw2] G.S. Hawkins, *From Euclid to Ptolemy in English Crop Circles*, Bull. Am. Astro. Soc. v29, n5, p1263 (1997).

[Haw3] G.S. Hawkins, *Diatonic ratios continue...*, The Cereologist **21** (1998).

[Heg] D.C. Heggie, *Megalithic Science: Ancient Mathematics and Astronomy in North-west Europe*, London: Thames and Hudson (1981).

[Hin] A. Hinz, *Pascal's Triangle in the Tower of Hanoi*, Math. Hudson, NY: Lindasfarne Press (1996).

[Hol] C. Holdrege, *Genetics and the Manipulation of Life: The Forgotten Factor of Context*, Hudson, NY: Lindisfarne Press (1996).

[Hol-Der] E.K. Holmes and S.F. Dermott, Signatures of Planets: Observations and Modeling of Structures in the Zodiacal Cloud and Kuiper Disk, in *Proceedings of the American Astronomical Society Meeting* (2002).

[Hoo] S.H. Hooke, *Babylonian and Assyrian Religion*, Norman: University of Oklahoma Press (1963).

[Hor] Y. Horibe, A *Fibonacci theme on balanced binary trees*, Fib. Quart. (Aug. 1992).

[Hun] H.E. Huntley, *The Divine Proportion: A Study in Mathematical Beauty*, New York: Dover (1970).

[Jay] J. Jayne, *The Origins of Consciousness in the Breakdown of the Bicameral Mind*, Boston: Houghton Miflin (1976).

[Jea1] R.V. Jean, *Mathematical Approach to Pattern and Form in Plant Growth*, New York: Wiley-Interscience (1984).

[Jea2] R.V. Jean, *Phyllotaxis*, Cambridge University Press (1994).

[Jea3] R.V. Jean and D. Barabe, *Symmetry of Plants*, Singapore: World Scientific (1997).

[Jos] G. Joseph, *The Crest of the Peacock*, London: Tauris (1991).

[Kad] L.P. Kadinoff, *Supercritical behavior of an ordered trajectory*, James Franck and Enrico Fermi Inst. Research Paper (1985).

[Kap1] J. Kappraff, *A course in the mathematics of design*, in *Symmetry: Unifying Human Understanding*, ed. I. Hargittai. Also published in Comp. and Math. with Appl. **12B** (1986) 913–948.

[Kap2] J. Kappraff, *The geometry of coastlines*, in *Symmetry: Unifying Human Understanding*, ed. I. Hargittai. Also published in Comp. and Math. with Appl. **12B** (1986).

[Kap3] J. Kappraff, *Connections*, 2nd ed, Singapore: World Scientific (2001).

[Kap4] J. Kappraff, *Secrets of ancient geometry: An Introduction to the Geometry of Tons Brunes*, unpublished monograph (1992).

[Kap5] J. Kappraff, *Eleven videotapes on Mathematics of Design*, produced by the Center for Distance Learning and the Media Center, NJIT (1993).

[Kap6] J. Kappraff, *Linking the musical proportions of the Renaissance, Modulor of Le Corbusier, and Roman system of proportions*, Int. Journ. of Space Struct. **11**(1,2) (1996).

[Kap7] J. Kappraff, D. Blackmore and G. Adamson, *Phyllotaxis as a dynamical system: a study in number*, in *Symmetry of Plants*, eds. R.V. Jean and D. Barabe, Singapore: World Scientific (1997).

[Kap8] J. Kappraff, *The Hidden Pavements of Michelangelo's Laurentian Library*, in the *Mathematical Tourist Section of Mathematical Intelligencer* (June 1999).

[Kap9] J. Kappraff, *Systems of Proportion in Design and Architecture and their relationship to Dynamical Systems*, in *Visual Mathematics* (www.members.tripod.com/vismath). **1** (1999). Also published in the *Proceedings of the Bridges Conference* ed. R. Sarhangi (1999).

[Kap10] J. Kappraff, *The Arithmetic of Nicomachus of Gerasa and its Applications to Systems of Proportion*, Nexus Network Journal (www.nexusjournal.com) **4**(3) (October 2000).

[Kap11] J. Kappraff, *A Secret of Ancient Geometry*, in *Geometry at Work*, ed. C. Gorini, Mathematics Association of America Geometry MAA Notes **53** (2000).

[Kap12] J. Kappraff, *Ancient Harmonic Law*, unpublished (2000).

[Kap-H] J. Kappraff and G. Hawkins, *The Music of the Spheres: Was Kepler Wrong?*, unpublished (2000).

[Kap-A] J. Kappraff and G.W. Adamson, *A Fresh Look at Number*, Visual Mathematics (an electronic journal) **2**(3) (2000). Also appeared in *Bridges: 2000*, ed. R. Sarhangi, Winfield (KS): Central Plains Books (2000).

[Kap13] J. Kappraff, *Polyons and Chaos*, in *Bridges: 2001*, ed. R. Sarhangi, Winfield (KS): Central Plains Books (2001).

[Kap14] J. Kappraff, Workbook on the Mathematics of Design, under a grant from the Natl. Endowment for the Arts, (1993).

[Kapu] J. Kapusta, *A New Class of Geometric Constructions with Ancient and Modern Roots*, in *Bridges: Mathematical Connections in Art, Science, and Music*, ed. R. Sarhangi, Winfield (KS): Central Plains Books (2000).

[Kau1] L.H. Kauffman, *Some Notes on teaching Boolean Algebra*, unpublished manuscript (1979).

[Kau-V] L.H. Kauffman and F.J. Varela, *Form dynamics*, J. Soc. and Bio. Struct **3** 171–206 (1980).

[Kau2] L.H. Kauffman, *Self-reference and recursive forms*, J. Soc. Bio. Strs. (1987).

[Kau3] L.H. Kauffman, *Imaginary values in mathematical logic*, in *17th International Symposium on Multiple-Valued Logic*, IEEE Pub. (1987).

[Kau4] L.H. Kauffman, *Knot logic*, in *Knots and Applications*, ed. L. Kauffman, Singapore: World Scientific (1995).

[KauS1] S.A. Kauffman, *The Origins of Order — Self-organization and Selection and Complexity*, Oxford University Press (1993).

[KauS2] S.A. Kauffman, *At Home in the Universe: Search for the Laws of Self-organization*, Oxford University Press (1995).

[Kay] H. Kayser, *Harmonical Studies. Harmonical analysis of a proportion study in a sketchbook of the medieval gothic architect, Villard de Honnecourt*, its title is *Ein Harmonikaler Teilungskanon* (A Harmonical Division-Canon) (1946).

[Kep] J. Kepler, *The Harmonies of the World*, in Great Books of the Western World, **16**: *Ptolemy, Copernicus, Kepler*, ed. R.M. Hutchins, Chicago: Encyclopedia Britannica, Inc. (1939).

[Khi] I.A. Khinchin, *Continued Fractions*, Chicago: University of Chicago Press (1964).

[KLZ] S. Kivelson, D. Lee and S. Zhang, *Electrons in flatland*, Scientific American (Mar. 1996).

[Koe] D.C. Koepp, *New Discoveries in Euclidean Geometry*, Recreational and Educational Computing (REC), Vol. II(6) (1997).

[Kra] E.E. Kramer, *The Nature and Growth of Modern Mathematics*, Vol. **1**, Greenwich, Conn.: Fawcett (1970).

[Lal1] H. Lalvani, *Structures on Hyperstructures: Multidimensional Periodic Arrangements of Transforming Space Structures*, New York: Self-published (1981). It is also a Ph.D. thesis held in Ann Arbor, Michigan University Microfilms Institute (1981).

[Lal2] H. Lalvani, *Coding and generating complex periodic patterns*, Visual Computer 5 (1989) 180–202.

[Lal3] H. Lalvani, *Continuous transformations of non-periodic tilings and space-fillings*, in *Fivefold Symmetry* ed. I. Hargittai, Singapore: World Scientific (1992).

[Lal4] H. Lalvani, Private Communication, (1990).

[Lam] L. Lamy, *Egyptian Mysteries: New Light on Ancient Knowledge*, Thames and Hudson (1989).

[LeC] Le Corbusier. *Modulor*, Cambridge: MIT Press (1968).

[Lev-L] S. Levarie and E. Levy, *Tone: A Study of Musical Acoustics*, Kent: Kent State (1968).

[Lic] M. Lichtenstein, Private communication (1997,2001).

[Lin] V. Linacre, *6000 years of customary measures: the yardstick, the rod, fathom and foot in Megalithic Britain*, Edinburgh: Britsh Weights and Measures Association (1999).

[Mac] A. Macaulay, *An Anne Macaulay Trilogy: Megalithic Mathematics-Science set in Stone; Science and the Gods in Megalithic Britain; The Quest for Apollo-Music and Megalithic Britain*. Edited from unpublished manuscripts by V. Linacre, R.A. Batchelor and K. Ralls-Macleod. In preparation (2003).

[Mai] G.R. Mair, *Aratus' Phaenomena*, in *Loeb Classical Library*, London: Wm. Heinemann (1921).

[Mal] R. Malhotra, *Migrating Planets*, Scient. American (Sept. 1999).

[Man] B.B. Mandelbrot, *The Fractal Geometry of Nature*, New York: Freeman (1982).

[Mar] P. Marchant, *Unity in pattern: A study guide in traditional geometry*, London: Prince of Wales's Inst. of Arch. (1997).

[Mari] Marinelli, R. *et al.*, *The Heart is not a Pump*, in Frontier Perspectives 5(1) Philadelphia: Temple University Press (1996).

[Mar-K] C. Marzec and J. Kappraff, *Properties of maximal spacing on a circle relating to phyllotaxis and to the golden mean*, J. Theor. Biol. 103(1983) 201–226.

[McC1] E.G. McClain, *The Myth of Invariance*, York Beach, ME: Nicolas-Hays (1976, 1984).

[McC2] E.G. McClain, *The Pythagorean Plato*, York Beach, ME: Nicolas-Hays (1978, 1984).

[McC3] E.G. McClain, *Meditations through the Quran*, York Beach, ME: Nicolas-Hays (1981).

[McC4] E.G. McClain, *Musical theory and ancient cosmology*, The World and I (Feb. 1994).

[McC5] E.G. McClain, *The star of David as Jewish harmonical metaphor*, International Journal of Musicology 6 (1997).

[McC6] E.G. McClain, A priestly view of Bible arithmetic, in Philosophy of Science, Van Gogh's Eyes, and God: Hermeneutic Essays in Honor of Patrick A. Heelan, ed. B.E. Babich, Boston: Kluwer Academic Publisher (2001).

[McC-S] E.G. McClain and L. Siegmund, Temple Tuning Systems, International Journal of Musicology 3 (1994).

[Men] M. Mendelsohn, Das Herz ein Secondares Organ, Berliner Verlag Axel Juncker (1928).

[Mer] J. Merlo Ponti and B. Morando, The Rebirth of Cosmology, Ohio University Press (1982).

[Miy] K. Miyazaki and I. Takada, Uniform ant-hills in the world of golden isozonohedra, Structural Topology 4 (1980).

[Mos] F. Mosteller, Fifty Challenging Problems in Probability with Solutions, New York: Dover (1987).

[Nak] K. Nakaseko, Symbolism in ancient Chinese musical theory, J. of Musical Theory 1(2) (1957).

[Nee] J. Needham, Science and civilization in China, Vol. 3, New York: Cambridge Press (1959).

[Nel] D.R. Nelson, Quasicrystals, Sci. Am., (August 1987).

[Neu1] O. Neugebauer, The Exact Sciences in Antiquity, 2nd edition, New York: Dover (1957).

[Neu2] O. Neugebauer and A. Sachs, Mathematical Cuneiform Texts, American Oriental Series 29, New Haven, CT: Am. Oriental Soc. (1945).

[Nic] B. Nicholson, Architecture, Books + Geometry, in CD Rom: Thinking the Unthinkable House ed. B. Nicholson, Chicago: Renaissance Society at University of Chicago (1997).

[NKH1] B. Nicholson, J. Kappraff and S. Hisano, A Taxonomy of Ancient Geometry Based on the Hidden Pavements of Michelangelo's Laurentian Library, in Mathematics and Design' 98: Proceedings of the 2nd International Conference, ed. J. Barallo, (1998).

[NKH2] B. Nicholson, J. Kappraff and S. Hisano, The Hidden Pavement Designs of the Laurentian Library, in Nexus '98 ed. K. Williams, Fucecchio, Italy: Edizioni dell'Erba (1998).

[Oga] T. Ogawa, Generalization of golden ratio: any regular polygon contains self-similarity, in Research of Pattern Formation, ed. R. Takaki, KTK Scientific Publishers (1990).

[Pei-R] H.-O. Peitgen and P.H. Richter, The Beauty of Fractals: Images of Complex Dynamical Systems, New York: Springer Verlag (1986).

[Pei] H.-O. Peitgen, et. al. Fractals for the Classroom, Strategic Activities, Vol. 1 and 2, New York: Springer Verlag (1991 and 1992).

[PJS] H.-O. Peitgen, H. Jurgens and D. Saupe, *Chaos and Fractals: New Frontiers of Science*, New York: Springer Verlag (1992).

[Pen] R.D. Pen Hallurick, *Tin in Antiquity*, The Inst. of Metals (1986).

[Pes] C.S. Peskin, *Fiber architecture of the left ventricular wall: an asymptotic analysis*, Comm. on Pure and Appl. Math. **42** (1989) 79–113.

[Pet] I. Peterson, *Newton's Clock: Chaos in the Solar System*, New York: Freeman (1993).

[Pic] C. Pickover, *Computers, Pattern, Chaos, and Beauty*, New York: Saint Martin's Press (1990).

[Pol] M. Polyani, *Personal Knowledge: Towards a Post-Critical Philosophy*, Chicago: University Of Chicago Press (1958).

[Pru-L] P. Prusinkiewicz and A. Lindenmayer, *The Algorithmic Beauty of Plants*, New York: Spinger Verlag (1990).

[Pur] J. Purce, *The Mystic Spiral*, London: Thames and Hudson (1974).

[Rad1] H. Rademacher, *Lectures on Elementary Number Theory*, New York: Blaisdell (1964).

[Rad2] H. Rademacher, *Higher Mathematics from an Elementary Point of View*, Boston: Birkhauser (1993).

[Ras] R.A. Rasch, *Farey systems of musical intonation*, Contemporary Music Review **2**(2) (1988).

[Ren] C. Renfrew, *Archaeology and Language*, Jonathan Cape (1987).

[Rie-W] M. Riegner and J. Wilkes, *Art in the service of nature: The story of flowforms*, Orion Nature Quart. **7**(1) (Winter 1988).

[ROL] N. Rivier, J. Occelli and A. Lissowski, *Structure of Benard convection cells, phyllotaxis and crystallography in cylindrical symmetry*, J. Physique **45** (1984) 49–63.

[Rob] T. Robbin, *Fourfield: Computers, Art, and the Fourth Dimension*, Boston: Bullfinch Press (1992).

[Rot] D. Rothenberg, *Hands End: Technology and its Limits*, Berkeley: University of California Press (1993).

[Roy] A.E. Roy, *The origins of the constellations*, Vistas in Astronomy **27**(4) (1984).

[Ruc] R. Rucker, *Infinity and the Mind*, Boston: Birkhauser (1982).

[Sche] Schechtman, D., et. al. *Metallic phase with long-range orientational order and no translational symmetry*, Phys. Rev. Lett., **53**(20) (1984) 1951–1953.

[Sch] R.A. Schwaller Di Lubicz, *The Temple of Man*, translated by R. Lawlor, Inner Traditions (1996).

[Sag] C. Sagan, *The Demon-Haunted World: Science as a Candle in the Dark*, New York: Ballantine Books (1996).

[San] L. Sander, *Fractal growth*, Scientific American (Jan. 1987).

[Schoe] A. Schoen, *Rhombix*, Kadon Enterprises, Inc. (1992).

[Schol] P.H. Scholfield, *The Theory of Proportion in Architecture*, New York: Cambridge Univ. Press (1958).

[Schr] M. Schroeder, *Fractals, Chaos, and Power Laws*, New York: W.H. Freeman (1991).

[Schw] T. Schwenk, *Sensitive Chaos*, New York: Schocken Books (1976).

[Schw-S] T. Schwenk and W. Schwenk, *Water: The Element of Life*, Hudson, NY: Anthroposophic Press (1989).

[Sil] T. Siler, *Breaking the Mind Barrier*, New York: Simon and Schuster (1990).

[Spe-B] G. Spencer-Brown, *Laws of Form*, London: George Allen and Unwin Ltd. (1969).

[Spi] V. Spinadel, *From the Golden Mean to Chaos*, Buenos Aires: Nueva, Libreria (1998).

[Ste] B. Stephenson, *The Music of the Heavens*, Princeton: Princeton University Press. (1994).

[Stein1] P. Steinbach, *Golden fields: A case for the heptagon*, Math. Mag. **70**(1) (1997).

[Stein2] P. Steinbach, *Sections Beyond Golden*, in *Bridges:2000* ed. R. Sarhangi, Winfield (KS): Central Plains Books (2000).

[Step-G] P.W. Stephens and A.I. Goldman, *The structure of quasicrystals*, Scientific Americal (Apr. 1991).

[Stew1] I. Stewart, *God Does not Play Dice*, Penguin Books (1989).

[Stew2] I. Stewart, *Another Fine Math You've Got Me Into...*, New York: Freeman (1992).

[Stol] K.B. Stolarsky, *Beatty sequences, continued fractions, and certain shift operators*, Canad. Math. Bull. **19**(4) (1979).

[Ten] S. Tenen, The Journal of the Meru Foundation. **1,2,3,4** (1993–1994).

[Ten1] S. Tenen, *The God of Abraham, A Mathematician's View: Is there a Mathematical Argument for the Existence of God?*, Neotic Journal **2**(2) (1999) 192–205.

[Ten2] S. Tenen, *Geometric Metaphor and the Geometry of Genesis*, Berkeley: Frog Ltd., in preparation (2002).

[The] Theon of Smyrna, *The Mathematics Useful for Understanding Plato* (trs. from the Greek/French edn. of J. Dupuis by R. and D. Lawlor), San Diego: Wizard's Bookshelf (1979).

[Tho] A. Thom, *Megalithic Sites in Britain*, Oxford Press (1967).

[Tho-T1] A. Thom and A.S. Thom, *Megalithic Remains in Britain and Brittany*, Oxford Press (1978).

[Tho-T2] A. Thom and A.S. Thom, *Megalithic Rings*, BAR British Series **81** (1980) 342–343.

[Tyn] A. Tyng, *Geometric extensions of consciousness*, Zodiac **19** (1969).

[Vand] B.L. Van der Waerden, *Geometry and Algebra in Ancient Civilizations*, New York: Springer Verlag (1983).

[Van] G. Van Iterson, *Mathematische and mikroskopish-anatomische Studien uber Blattstellungen*, Jena: Gustav Fischer (1907).

[Ver] H.F. Verheyen, *The icosahedral design of the Great Pyramid*, in *Fivefold Symmetry* ed. I. Hargittai, Singapore: World Scientific (1992).

[Vos-C] R.F. Voss and J. Clarke, *1/f noise in music; music in 1/f noise*, J. of the Acoust. Soc. of Amer. **63** (1978) 258–263.

[Wal] K. Walter, *Tao of Chaos: Merging East and West*, Austin: Kairos Center (1994).

[War] F. Warrain, *Essai Sur L'Harmonics Mundi ou Musique du Monde Johann Kepler*, 2 vols, Paris (1942).

[Wat-W1] D.J. Watts and C.M. Watts, *A Roman apartment complex*, Sci. Am. **255**(2) (Dec. 1986).

[WatC] C.M. Watts, *The Square and the Roman house: Architecture and Decoration at Pompeii and Herculaneum*, in *Nexus: Architecture and Mathematics* edited by K. Williams. Fucecchio: Edizioni Dell'Erba (1996).

[Wat-W2] D.J. Watts and C.M. Watts, *The role of monuments in the geometrical ordering of the roman master plan of Gerasa*, Journ. of the Soc. of Arch. Hist. **51**(3) 306–314 (1992).

[WatD] D.J. Watts, Private communication (1996).

[Wes] J.A. West, *Serpent in the Sky*, Theos Press (1993).

[Whi] O. Whicher, *Projective Geometry*, London, Rudolph Steiner Press (1971).

[Whip] F. Whipple, *Earth, Moon, and Planets*, Cambridge: Harvard Univ. Press (1963).

[Wilf] J.N. Wilford, *New Discoveries complicate the meaning of planets*, New York Times (Jan. 16, 2001).

[Wilk] J. Wilkes, *Water as a Mediator for Life*, Elemente der Naturwissen Schaft, No. 74. (English) Philosophisch Anthroposophischer Verlay, Goethernum Schweiz (Jan. 2001).

[Will1] K. Williams, *The sacred cut revisited: The pavement of the Baptistry of San Giovanni, Florence*, The Math. Intelligencer. **16**(2) (Spring 1994).

[Will2] K. Williams, *Michelangelo's Medici Chapel: The cube, the square, and the $\sqrt{2}$ rectangle*, Leonardo **30**(2) (1997).

[Wit] R. Wittkower, *Architectural Principles in the Age of Humanism*, first published in 1949 as Vol. 19 of Studies of the Warburg Inst., New York: John Wiley (1998).

[Wol] S. Wolfram, A New Kind of Science, Champaigne. IL: Wolfram Media, Inc. (2002).

[Yan] J.F. Yan, DNA and the I-Ching: The Tao of Life, North Atlantic (1991).

[YouA] A. Young, The Reflexive Universe: Evolution of Consciousness, Rob Briggs (1984).

[YouD] D. Young, Origins of the Sacred, New York: Harper Perrenial (1992).

[YouJ] J.W. Young, Projective Geometry, The Mathematics Assoc. of America (1930).

[Zel1] S. Zellweger, Untapped potential in Pierce's iconic notation for the sixteen binary connectives, in Studies in the Logic of Charles Saunders Pierce, eds. N.D. Hauser, D. Roberts and J.V. Evra. Bloomington: Indiana Univ. Press (1994).

[Zel2] S. Zellweger, A symmetry notation that cultivates the common ground between symbolic logic and crystallography, Symmetry: Culture and Science 6 (1995) 556–559.

Index

SERIES ON KNOTS AND EVERYTHING

Editor-in-charge: Louis H. Kauffman *(Univ. of Illinois, Chicago)*

The Series on Knots and Everything: is a book series polarized around the theory of knots. Volume 1 in the series is Louis H Kauffman's Knots and Physics.

One purpose of this series is to continue the exploration of many of the themes indicated in Volume 1. These themes reach out beyond knot theory into physics, mathematics, logic, linguistics, philosophy, biology and practical experience. All of these outreaches have relations with knot theory when knot theory is regarded as a pivot or meeting place for apparently separate ideas. Knots act as such a pivotal place. We do not fully understand why this is so. The series represents stages in the exploration of this nexus.

Details of the titles in this series to date give a picture of the enterprise.

Published: